VISIONS OF THE INDUSTRIAL AGE, 1830–1914

Visions of the Industrial Age, 1830–1914

Modernity and the Anxiety of Representation in Europe

Edited by
Minsoo Kang and Amy Woodson-Boulton

ASHGATE

Published by
Ashgate Publishing Limited
Gower House
Croft Road
Aldershot
Hampshire GU11 3HR
England

Ashgate Publishing Company
Suite 420
101 Cherry Street
Burlington, VT 05401-4405
USA

Ashgate website: http://www.ashgate.com

British Library Cataloguing in Publication Data
Visions of the industrial age, 1830-1914 : modernity and
 the anxiety of representation in Europe
 1. Arts and society - Europe - History - 19th century
 2. Arts and society - Europe - History - 20th century
 3. Modernism (Aesthetics) - Europe - History - 19th century
 4. Modernism (Aesthetics) - Europe - History - 20th century
 I. Kang, Minsoo II. Woodson-Boulton, Amy
 700.9'4'09034

Library of Congress Cataloging-in-Publication Data
Visions of the industrial age, 1830-1914 : modernity and the anxiety of representation
 in Europe / edited by Minsoo Kang and Amy Woodson-Boulton.
 p. cm.
 ISBN 978-0-7546-6488-8 (hardcover : alk. paper)
 1. Arts and society--Europe--History--19th century. 2. Arts and society--
Europe--History--20th century. 3. Modernism (Aesthetics)--Europe--History-
-19th century. 4. Modernism (Aesthetics)--Europe--History--20th century. I.
Kang, Minsoo. II. Woodson-Boulton, Amy.

NX180.S6V46 2008
700.94'09034--dc22

ISBN: 978-0-7546-6488-8

2008004811

Mixed Sources
Product group from well-managed forests and other controlled sources
www.fsc.org Cert no. SA-COC-1565
© 1996 Forest Stewardship Council
FSC

Printed and bound in Great Britain by
MPG Books Ltd, Bodmin, Cornwall.

Contents

Figures

2 Adorning the landscape: images of transportation in nineteenth-century France

2.1 Thérond (artist); Laly (engraver). *Les viaducts et le paysage* (Viaducts and the Landscape). Wood engraving. Amédée Guillemin, *Simple explication des chemins de fer* (Paris: Hachette, 1862), 142. Author's collection

2.2 Unidentified photographer. *Viaduc de Chaumont*, after 1857. Collotype (photolithograph). Édouard Collignon, *Les travaux publics de la France: Chemins de fer* (Paris: J. Rothschild, 1883), plate 4. Science, Industry & Business Library, The New York Public Library, Astor, Lenox and Tilden Foundations

2.3 Alfred Sisley (1839–99). *The Bridge at Villeneuve-la-Garenne*, 49.5 × 65.4 cm (19½ × 25¾ in), oil on canvas, 1872. The Metropolitan Museum of Art, New York. Gift of Mr and Mrs Henry Ittleson Jr, 1964 (64.287). Image © The Metropolitan Museum of Art

2.4 Alfred Sisley (1839–99). *Drying Nets*, 42 × 65 cm (16½ × 25⅝ in), oil on canvas, 1872. Kimbell Art Museum, Fort Worth (APx 1977.01). Photo Credit: Kimbell Art Museum, Fort Worth, Texas/Art Resource, NY

2.5 Pérat (engraver). *Paris: L'accident du pont de Constantine—Chute du tablier du pont dans la Seine* (Paris: Constantine Bridge Accident—Fall of the Bridge's Roadway into the Seine). Wood engraving. *L'Illustration*, 60 (October 19, 1872): 252. Courtesy of the Free Library of Philadelphia

3 Armand Guillaumin: the industrial Impressionist

3.1 Armand Guillaumin, *Sunset at Ivry* (1869), Musée d'Orsay, Paris

3.2 Armand Guillaumin, *Railroad Bridge over the Marne at Nogent* (1871), The Metropolitan Museum of Art, New York, The Robert Lehman Collection

4 Picturing the supernatural: spirit photography, radiant matter, and the spectacular science of Sir William Crookes

4.1 Dr. James Manby Gully taking the pulse of Katie King. Photograph, William Crookes, 1874. Source: www.survivalafterdeath.org

4.2 William Crookes escorting Katie King around the séance room. Photograph, William Crookes, 1874. Source: www.survivalafterdeath.org

Rocket, 1875. Gift of Dexter M. Ferry, Jr. Photograph © 1988 The Detroit Institute of Arts

7.2 John Everett Millais, *Autumn Leaves*, 1856. Image © Manchester City Galleries.

7.3 Titian and workshop, d.1576. *Danaë*, 121 × 170 cm (47½ × 66¾ in), after 1554, oil on canvas. Extended loan from the Barker Welfare Foundation, New York, New York, 9.1973. 225 MB file. Photograph by Robert Hashimoto. Reproduction, The Art Institute of Chicago

7.4 Rembrandt Harmenszoon van Rijn, *A Bearded Man in a Cap*, 1653 or 1657. Photo © The National Gallery, London.

8 From will to wallpaper: imaging and imagining the natural in the domestic interiors of the Art Nouveau

8.1 The Crystal Palace Wallpaper— Heywood, Higginbotham & Smith (*c.* 1853–55). Reproduction courtesy of the Victoria and Albert Museum

8.2 A Showroom from a Poster Printed in Cleveland, Ohio (*c.* 1895–1900). Reproduction courtesy of The Whitworth Gallery, The University of Manchester

8.3 Illustrations from Linnaeus's *Systema Naturae* of 1748. Research Library, The Getty Research Institute, Los Angeles, California

8.4 *Poppies and Birds* by De Fourcroy (*c.* 1700). Reproduction courtesy of the Musée des Arts Dècoratifs, Paris

8.5 Wallpaper Sample Book by Jones & Bolles of Hartford (1821–28). Reproduction courtesy of Old Sturbridge Village

8.6 Pugin Wallpapers for the Palace of Westminster (*c.* 1851–54). Reproduction

courtesy of the Victoria and Albert Museum

8.7 Victor Horta, Hôtel Tassel Winter Garden. Reproduction courtesy of SOFAM, Brussels. Photograph by Alistair Carew-Cox

8.8 Victor Horta, Hôtel Tassel, Mezzanine Balustrade Looking Down to Salon. Reproduction courtesy of SOFAM, Brussels. Photograph by Alistair Carew-Cox

8.9 Victor Horta, Hôtel Tassel, Main Stair. Reproduction courtesy of SOFAM, Brussels. Photograph by Alistair Carew-Cox

9 Pissarro's crowds: cityscape as wish image

9.1 Camille Pissarro, *La Mi-Carême sur les Boulevards*, 64.9 × 80.1 cm, oil on canvas, 1897. Reproduction courtesy of the Fogg Art Museum, Harvard University, Cambridge

9.2 Camille Pissarro, *Mardi-Gras, soleil couchant, Boulevard Montmartre*, 1897, 54 × 65 cm, oil on canvas. Reproduction courtesy of Kunstmuseum, Winterthur

9.3 Camille Pissarro, *Boulevard Montmartre, Mardi-Gras*, 63.5 × 80 cm, oil on canvas, 1897. Reproduction courtesy of The Armand Hammer Collection, Los Angeles

10 Victorian stained glass as memorial: an image of George Boole

10.1 Boole Memorial Window, University College Cork. Reproduced from Barry, Patrick D., ed., *George Boole: A Miscellany*. Cork: Cork University Press, 1969

10.2 Augustus Welby Pugin, "Contrasted Residences for the Poor." Top: "Modern Poor House"; bottom:

Contributors

Gerry Beegan is a design historian and an associate professor in the Visual Arts Department of Mason Gross School of the Arts, Rutgers University. His main research interest is the history of mass reproduction, and he has published essays and given talks on this subject internationally. His book *The Mass Image: A Social History of Photomechanical Reproduction in Victorian London* is published by Palgrave Macmillan.

Jane E. Boyd is a Ph.D. candidate in Art History at the University of Delaware, completing a dissertation entitled "The Mapping of Modernity: Impressionist Landscapes, Engineering, and Transportation Imagery in 19th-Century France." She is also a Research Curator at the American Philosophical Society Museum in Philadelphia, where she works on thematic exhibitions that explore the intersections of history, art, and science in eighteenth- and nineteenth-century America and Europe.

Haejeong Hazel Hahn is an associate professor of European History at Seattle University in Seattle. She has published articles in *Romantisme*, *Fashion Theory* (in English and Russian versions), *Embodied Utopias: Gender, Social Change, and the Modern Metropolis*, and *The City and the Senses: European Urban Culture Since 1500*. She is completing a manuscript on urban culture and advertising in nineteenth-century Paris.

Katherine Hover-Smoot is a graduate student in the History of Art at Williams College. Her work focuses on French nineteenth century painting, with an emphasis on the avant-guerre constructions of landscape and identity in Paris and the provinces.

Minsoo Kang is an assistant professor of European History at the University of Missouri–St Louis, specializing in the cultural and intellectual history of France, England, and Germany in the eighteenth and nineteenth centuries.

His essays and reviews have appeared in *Intertexts*, *Rethinking History*, *American Historical Review*, *Comitatus*, *Manoa*, *The Times Literary Supplement*, and two anthologies. As of 2008 he is writing a book on the history of the automaton as a symbol in the European imagination.

AMY CATANIA KULPER is an assistant professor of architecture at the University of Michigan's Taubman College of Architecture and Urban Planning, and completed her doctoral work in 2008 at the University of Cambridge. Her research will culminate in a book with the working title Immanent Natures that examines the propagation of an interiorized, introverted, and instrumentalized version of the natural world in architectural discourse within the disparate historical contexts of the *fin-de-siécle*, the 1960s and the contemporary.

KEVIN LAMBERT is an assistant professor in the Liberal Studies Department at Cal State Fullerton. He is a historian of science with a research focus on the physical sciences of the eighteenth and nineteenth centuries. As of 2008 he is working on a book about James Clerk Maxwell and Victorian mathematics.

PAULA YOUNG LEE received her doctorate in Art History from the University of Chicago. She is the recipient of numerous grants and awards, including fellowships from the National Endowment for the Humanities, the Graham Foundation for Advanced Studies in the Fine Arts, and the Institute for Humanities Research at Arizona State University. Her articles on animal enclosures, the architecture of knowledge, and the foundation of modern museums have appeared in the *Art Bulletin*, *Journal of the Society of Architectural Historians*, *Journal of Architecture*, *Journal of Architectural Education*, *Science in Context*, *Gender & History*, *Raritan*, *Assemblage*, as well as in numerous anthologies and reprints. She is the editor of two collections of papers examining the rise of the modern slaughterhouse, and author of a forthcoming book on the foundation of the Muséum d'Histoire Naturelle in Paris during the Revolutionary Decade. As of 2008, her projects include a history of animal enclosures in nineteenth-century Paris.

COURTENAY RAIA-GREAN received her Ph.D. in European cultural and intellectual history from the University of California, Los Angeles in November of 2005 and is employed as a lecturer at UCLA. Her article, "Ether Theory and Ether Theology: The Scientific Epistemologies of Faith in the Victorian *Fin de Siècle*," won the John C. Burnham early career award from the Forum for the History of the Human Sciences and was published in the January 2007 issue of *The Journal of the History of the Behavioral Sciences*. Her dissertation, titled *The Substance of Things Hoped For: Faith, Science and Psychical Research in the Victorian Fin de Siècle*, explores some of the synergies

between psychical research and important aspects of nineteenth- and early twentieth-century science.

James H. Rubin is a professor of Art History and former Chair of the Art Department at Stony Brook, SUNY. He also teaches at the Cooper Union in New York City. His field is eighteenth- and nineteenth-century European painting, on which he has published over 30 articles and nine books. His recent focus has been primarily on the French artists Courbet, Manet, Cézanne and the Impressionists. His most recent book is *Impressionism and the Modern Landscape: Productivity, Technology and Urbanization from Manet to Van Gogh* (University of California Press, 2008). As of 2008 he is working on a new monograph on Manet.

Natasha Ruiz-Gómez is the Research Councils United Kingdom Academic Fellow in the Department of Art History and Theory at the University of Essex. She received her doctorate in the history of art from the University of Pennsylvania in 2006; her dissertation, "Morceaux d'Amphithéâtre: Science and the Sculpture of Auguste Rodin," contextualizes the artist's oeuvre for the first time in the lively *fin-de-siècle* dialogue between the artistic and scientific communities of Paris. She has published in *Modern & Contemporary France*, *Nineteenth-Century Art Worldwide*, and *Thresholds* and has an essay in the forthcoming anthology *Portraiture and Masculine Identity in France, 1780–1914*. As of 2008 she is conducting research for a new project on the intersections of art and science in late nineteenth-century photography.

Carla Spivack is an assistant professor of Law at Oklahoma City University School of Law. Her articles and book reviews have appeared in *The New York University School of Law Journal of International Law and Politics*, *The University of Pennsylvania Journal of International Economic Law*, *The William and Mary Journal of Women and the Law*, *The Yale Journal of Law and the Humanities*, and the *law*, a law and humanities web site and discussion group. As of 2008 she is working on a study of the legal doctrine of undue influence.

Hiroko Washizu is a professor of American Literature at the Graduate School of the University of Tsukuba. She is also the chair of the American Literature Society of the University of Tsukuba (2003–present), editor of the biennial *Review of American Literature* (1998–2007), and a co-editor of three books: *American Literature and Technology* (2002, Japanese), *In Context: Epistemological Frameworks and Literary Texts* (2003, Japanese), and *Domain of Knowledge: Epistemological Frameworks and Literature in English* (2007, Japanese). Her recent papers on American literature have been revised for publication in *Daughters of Time: Art and Nature in Antebellum American Prose* (2005, Japanese).

GABRIEL K. WOLFENSTEIN is a Post-Doctoral Fellow in the Humanities at Stanford University. His writing has appeared in *History and Technology*, *The Encyclopedia of Social Measurement*, and *Centaurus* (forthcoming). His work, broadly conceived, is concerned with the manner in which social and cultural identities are formed. As of 2008 he is revising his dissertation into a book on the history of the census and statistics in Britain and the British Empire in the nineteenth century. His next projects concern popular magazines at the end of the nineteenth century, and understandings of the British Empire in the late nineteenth and twentieth centuries as seen through governmental bodies.

AMY WOODSON-BOULTON is assistant professor of Modern British and Irish History at Loyola Marymount University in Los Angeles, California. She has published articles and reviews in the *Journal of British Studies, museums & society*, *The Journal of Victorian Culture*, and *The History Compass*. As of 2008 she is revising a manuscript based on her doctoral dissertation (UCLA), *Temples of Art in Cities of Industry: Municipal Art Museums in Birmingham, Liverpool, and Manchester, 1870–1914*. Her work concentrates on cultural reactions to industrialization, particularly the history of art museums in industrial English cities and nineteenth-century attempts to bring art to the masses. Her next project will focus on comparisons between English and Irish celebrations of rural, pre-industrial culture, and the imagined place of art and the artist in non-industrial society.

Preface

What is the relationship between modernity and visual culture? How can scholars use visual evidence to better understand the nature of modernity and the particular cultural changes associated with industrial capitalism? From the vantage point of the early twenty-first century, it seems that there is some crucial connection between the rise of visual culture and modernity itself. This volume places the origins of our contemporary visual culture in the nineteenth century. We concentrate on Western Europe during the period of accelerated change from the 1830s onward, which witnessed a tremendous rise in the use of the visual as a mode of mass communication, as increasingly powerful media created a superfluity of images designed to attract, allure, convince, seduce, persuade, enlighten, and teach. The rise of modern science and the Industrial Revolution created the technology that made possible the nineteenth-century inventions of photography and, later, the cinema, and the subsequent twentieth-century phenomena of television, the digital computer, and eventually the internet. (Some recent works of popular history have overtly linked nineteenth-century calculating machines and the telegraph to the modern computer and the internet.[1]) The related developments of industrialization, capitalization, urbanization, population growth, and the rise of the public sphere and consumer culture generated mass-market advertising and entertainment through the expansion of visual media. The chapters in this volume, however, also argue that the proliferation of images was not simply the result of new technology or even of new socio-economic factors. Rather, the rise of visual culture both engendered, and was engendered by, the essential fact of modernity, the condition of impermanence.

The chapters explore the anxiety-producing effects of rapid and constant change, and how the visual functioned as the means of expressing and allaying that anxiety through constant efforts to process and integrate the centrifugal experience of industrial capitalism. Together, they show that it was often precisely when writers, scientists, artists, and designers tried to

contain or represent modernity that their work exposed the fractures and fissures in representation and hermeneutics inherent in the modern world. Through a series of multidisciplinary case studies, we see how the visual culture of nineteenth-century Europe developed into forms distinguished by hybridity, the reinvention and transformation of genres, and the creative crossing of traditional boundaries. New media, ideas, anxieties, techniques, styles, and economics produced a startling range, proliferation, and use of images that sought synthesis but often revealed jarring juxtapositions of old and new.

Nineteenth-century Europe struggled with the modern condition of flux; cultural critics from William Blake to Émile Zola showed how industrial capitalism remade all aspects of society, redefining categories as basic as nature and culture, class and politics. More recently, scholars have investigated how these radical changes created continuous crises of representation, compelling European society to explore new possibilities of creative expression. As noted above, the culture put great emphasis on the visual with new forms of mass communication—photography, lithography, newspapers, advertising, and later, cinema—but it also transformed older forms as varied as poetry, the novel, painting, interior decoration, scientific inquiry, and architecture. These chapters show how, in the wake of continuous social and cultural transformation and fragmentation, artists and writers attempted to reconstitute a meaningful new *Weltanschauung* that would allow them and their audiences to gain some sense of order and hope in a constantly changing world. Yet as these studies demonstrate, the resulting images and the use of the images show not seemless integration but hybridity of forms, transformation of genres, transgression of boundaries, and anxiety—not only at the situation of the culture at large but also over the very feasibility of the project. Even as many of the most imaginative and courageous figures embraced the new culture of uncertainty, many betrayed their own doubts within works that sought wholeness and surety, which is some of the most convincing evidence of the nature and extremity of social change in the period.

By examining the role of images and imagery in nineteenth-century representation in a variety of contexts, we seek to delve into both the origins of contemporary visual culture and the ways in which the first moderns struggled with their hopes and fears about their own time and the future to come. In order to examine the nineteenth-century crisis of representation in terms of the visual, the pictorial, and the metaphoric, this volume presents studies of such varied media as photography, painting, interior decoration, scientific instruments, graphic art, and literature, and in such disparate contexts as the museum, the factory, the laboratory, the art studio, and the private home. To explore this topic as broadly as possible, we have gathered scholars from multiple fields: cultural and intellectual history,

architecture, art history and theory, history of science, and literature. It is truly an interdisciplinary study in the best sense of the word, as an effort has been made to find connections in the topics of concern and methodology in the different disciplines in order to delve into this rich and provocative subject in a complementary way. The chapters differ in the scope of their interests; some dealing with broad cultural themes while others perform in-depth analysis and close readings of specific cultural forms and ideas. Yet they all converge around four central themes: the efforts by nineteenth-century European writers, artists, scientists, and philosophers to grapple with modernity through the use of the visual; their attempts to make sense of the fate of humanity in a world changing at a breakneck speed; the apparent sense of anxiety that emerges from even the most hopeful visions of the industrial age; and the resulting hybridity and transformation of traditional forms. Our hope is that this work will make a significant contribution not only to the study of the cultural history of nineteenth-century Europe in the industrial period, but also to the examination of image's dominance in modern culture and, ultimately, to the unending project of representing modernity.

The first group of chapters on "Envisioning the industrial" deals with literary and artistic representation of industrial technology in the nineteenth century and the problems that arose in these early attempts to deal with the dilemma of modern life through image and imagery. Minsoo Kang analyzes the common practice of describing locomotives as living creatures in late nineteenth- and early twentieth-century writings. He places such depictions in the context of the Industrial Revolution when the powerful steam-driven machinery of the era was envisioned as a new class of being. He also shows how the growing anxiety and ambivalence toward the rapid industrialization of the West was evident in the shift that occurred in the second half of the nineteenth century from the dominant trope of trains as powerful but docile servants of humanity to their reinvention as fearsome monsters of irrational will. Jane Boyd looks at the more specific topic of French engineering drawings that feature trains and transportation structures such as bridges and viaducts. She shows that the creators of those images were concerned not only with rendering those subjects accurately but also with making them blend in harmoniously with the natural environment in an aesthetically satisfactory way. She further demonstrates that this concerted effort to reconcile the natural with the artificial exemplifies the anxiety of living in the modern industrial era, as more overtly (and famously) expressed in the omissions, revisions and extenuations of man-made structures in the works of Impressionists like Monet, Sisley, and Caillebotte. James Rubin analyzes the works of the neglected Impressionist Armand Guillaumin, whose paintings produced in the 1870s focus on scenes of industry and labor. Rubin asserts that Guillaumin's art not only documents the expansion of the French economy and public works, but that also embodies an ideology of industrial

recovery following the Franco-Prussian War and the Commune. Given the timeliness of his effort to represent that historical moment of technological transformation, it is all the more unfortunate that Guillaumin's relative obscurity is due in part to the subsequent reputation of Impressionism as primarily an anti-industrial art of bourgeois leisure.

The next group of chapters on "Photographing the (un)real" looks at the role of that quintessentially modern technology of imaging, the photograph, in the contexts of nineteenth-century science, commercial illustration, and high art. Courtenay Raia-Grean analyzes the puzzling phenomenon of spirit photography in the mid-nineteenth century, or the effort to capture the images of ghosts and other supernatural entities on camera. She demonstrates that the activity was found not just in the realm of 'hoaxers and humbugs' but that it drew the interest of serious scientists and other intellectuals who sought to both ascertain the verity of the images as well as to construct workable theories of their possibility. What emerges is a picture of the mechanistic-materialist world of the modern that is haunted by a longing for a realm beyond what can be glimpsed even through the use of high technology. Gerry Beegan traces the complex application of image making and reproduction technologies in English illustrated periodicals of the 1890s, showing that many pictures featured in those journals were not just simple photographs but amalgams created through various photomechanical techniques that combined the photograph with wood engraving and drawing. By analyzing how and why old and new technologies were used together in the production of those images, Beegan asserts that they offered the readers multiple viewpoints on modernity, a modernity not of clarity and established facts but of destabilization and constant flux. Natasha Ruiz-Gómez looks into the well-known antipathy toward the photographic image professed by the great sculptor Auguste Rodin, a somewhat paradoxical attitude from an artist who believed that truth could be found only through faithfulness to Nature, which is precisely what was at the time the camera's most touted value. She demonstrates that Rodin's resistance to the photograph may have led him to create bodies that contested the medium's "objectivity," which in turn elicited criticism of his partial and pieced-together works as formless and unnatural. As his works seemed to have tapped into contemporary anxiety about industrialization, Ruiz-Gómez further argues that by reacting to the new visual language of science, Rodin created a potent sculptural idiom that is distinctly modern.

The third section, "Framing the environment," investigates the complex relationship between the ideas of Nature, the emergence of new art markets, and the practice of art, architecture and design in the nineteenth century. Again, even as artists, designers, and critics hoped to find a new ability to present the world to an increasingly large audience—whether through narrative art, public art museums, wallpaper, or design manuals—these

attempts at visual synthesis created new hybrid forms that reveal key anxieties. Amy Woodson-Boulton looks at the development of what she calls the "aesthetic ideology" in nineteenth-century England—the ways in which art critics, reformers, and the public understood art's social function, visual language, and artistic parameters. She argues that, based on Romanticism, natural theology, a growing art market, and the ideas of John Ruskin and his many followers, art was thought of as a universally accessible form of communication that could uniquely link beauty and morality through the representation of nature, broadly defined. This understanding of art led to wide-spread movements to bring art to the people through exhibitions and public art museums. By the end of the century, however, artists increasingly rejected the previous connections between the realistic depiction of the natural world and morality or social purpose, and the earlier hope of art as the "salvation of mankind" faded with the development of the new aesthetic ideology of Modernism. Amy Catania Kulper also explores the tense nineteenth-century relationship between nature and representation, looking at the shift early in the century when the natural ceased to be affiliated with man's rational mind and came to be equated with his capricious will. Her chapter examines pictorial evidence of the shift from rational to volitional conceptions of the natural through an exploration of the unlikely, yet highly revelatory, example of wallpaper. Kulper shows how designers depicted nature either pictorially or as a systematic pattern, and uses Victor Horta's abhorrence of wallpaper as a case study of the problems involved with representing volitional nature. Finally, Katherine Hover-Smoot explores how, in three paintings from 1897, Camille Pissarro proposed an imagery that was fundamentally more fragile than the "sunny" and "big" boulevards collectors preferred and Pissarro's dealer, Durand-Ruel, requested. Rather, the paintings of carnival imagine a moment of pre-modern anxieties, of subversion and transgression that runs counter to the licensed, festive gaiety of fin-de-siècle France. Foregrounding the presence of the crowd, Pissarro's paintings thus give way to a moment of upheaval and collective desire—a dream image of insurrection. Once again, art here figures as a site where opposition to the commercial and regulated society appears—not in a Bakhtinian moment of release, but in a moment revealing anxiety and doubt even when trying to imagine wholeness, meaning and purpose. Together, the three chapters present the complex ways in which art and design changed, and argue that these transformations reveal significant anxieties about the very idea and role of art and design in an age uncertain about the status of nature, the relationship between artist and market, or the implications of industrial production.

The next group of chapters, "Depicting the scientific," looks at ways in which modern scientific ideas and worldviews were represented in visual forms, and how this translation into imagery again reveals deep faultlines

and contradictions, even as pictorializations sought a new synthesis. Kevin Lambert begins with an analysis of two stained glass windows dedicated to the British mathematician and logician George Boole after his death in 1864. Lambert asserts that the images memorialize his great contribution to the articulation of universal laws of reason subject to the same divine order as external nature. These representations also point to his effort to find a new and more modern foundation of moral truth in mid-century Britain, a task that was seen as particularly urgent and important in a culture that was undergoing rapid and enormous intellectual and social changes. Gabriel Wolfenstein turns to the popular realm in examining how scientific ideas were presented to a mass audience in late nineteenth century Britain, specifically through the journal *The Strand*, most famous for its publication of the Sherlock Holmes stories. He shows that in an era of tremendous and often intimidating scientific and technological discoveries and innovations, the publication allayed people's anxiety about change through its popularized discussions of new ideas and devices. Wolfenstein argues that publications like *The Strand*, aimed in particular at commuters, sought to create a set of common interests and values in the populace and thus played an important role in the formation of a dominant middle-class culture. By using the whole of the magazine, including both articles and advertisements, he shows that we get a much fuller picture of the evolution of the mass press and the role it played in shaping controversial ideas in science. Hiroko Washizu examines the device of the Orrery, or a mechanical representation of the universe that features revolving heavenly bodies, named after Charles Boyle, the Earl of Orrery to whom the object was dedicated. While it was popular in the eighteenth and nineteenth centuries for its entertaining depiction of the new scientific view of the mechanistic cosmos, Washizu shows that it also embodied a serious anxiety-inducing dilemma of the modern worldview. The Orrery demonstrated the absolute certainty of the rational God who set the world in motion according to regular laws, but it also suggested a self-moving system in which the Creator played an insignificant role, perhaps even hinting at a Godless universe run by an impersonal vital force inherent in matter itself—the very image of modernity itself that horrified so many.

The final three chapters, gathered together as "Exposing the modern," trace a number of disorienting encounters that have defined modern art and literature's attempts to depict modernity, particularly the commercialization of culture, imperialism, and the rise of the working class. Paula Young Lee considers Gustave Caillebotte's disturbing 1883 painting *Veau à l'étal*, arguing that its portrayal of a splayed, skinned veal carcass, decorated with flowers and presented on clean white sheets ready for sale, strips the commercialized body to its animal essentials, and quietly exposes the troubled underbelly of capitalism as something irredeemably bloody as well as hollow. Her chapter positions this painting inside the economic/erotic

compulsions of nineteenth-century Paris, and interprets it in relationship to the gendered representation of flesh as a marketplace commodity. Vulgar to the extreme, the painting consequently offers intriguing insights into the visual codes of the industrial age, and expands historical understanding of the avant-garde challenge to middle-class morality through the exploration of difficult imagery. Haejeong Hazel Hahn investigates another project that tries to expose bourgeois values through a series of encounters, in this case Jean-Jacques Grandville's 1843-44 illustrated book *Un Autre Monde*. Seeing Grandville's work as a series of *mise-en-abymes* or frames within frames, and giving close readings of the relationship between image and text, Hahn shows that the various narratives address the manifold process of the commercialization of culture during the July Monarchy, when advertising was coming into its own with attendant controversy, and the world of publishing and journalism was rapidly changing and expanding. Containing an encyclopedic anatomy of contemporary rhetoric and techniques of advertising, in parodied forms, the book's combination of word and image and its self-referentiality are deliberately disorienting and critical of commodified, mechanized, bourgeois society. Finally, Carla Spivack's chapter discusses how visual images of the colonies and colonized peoples of the British Empire disrupt the text of nineteenth-century novels, specifically, Charles Dickens' *The Mystery of Edwin Drood* and Wilkie Collins' *The Moonstone*. She explores how both mysteries turn on the question of identity, and reveal, through their use of visual imagery, that the encounter with the Other of colonialism is a force which undermines its stability. Ultimately, she shows that the disruptive impact of these images helped create modernity as it appears in these novels, and that the destabilizing encounter with the Other—destabilizing partly because it is visual—is at the heart of the detective novel genre these works helped create.

The words "image" and "imagine" come from the same Latin root, "imago." Together, these chapters point to how modern culture has constantly attempted to imagine itself; the studies, in all their variety, point to the extent to which we find the most pressing problems of the modern period—the impact of industrialization, the commercialization of culture, the development of extensive imperial projects, and the transformation of older hierarchies of nature, gender, class, and power—expressed through visual culture. The chapters take us through the fraught portrayal of locomotives and industrial landscape; the uses of photography to depict a variety of realities; the changing relationships among markets, art, and nature; attempts to visualize the scientific worldview; and disorienting encounters that critique modern commercial culture. The collection argues that this translation of modern anxieties into imagery is not accidental; in all of these studies, visual culture proves particularly able to attempt synthesis even while admitting fracture, doubt, and hybridity. Thus we can understand the

proliferation of image and imagery in the modern period not simply as the development of new technologies of reproduction or expanding markets, but as the result of a changing culture, one which constantly demanded new ways of understanding itself and conceptualizing the very experience of constant change. Of course, new technologies have been put to work on this endless project, most obviously cinema, television, and now the vagaries of YouTube. These studies help us understand modernity as a condition of ever-expanding visuality, that attempts to imagine and comprehend, if only for a moment and only partially, a state of constant flux.

<div align="right">Minsoo Kang and Amy Woodson-Boulton</div>

Note

1. See Tom Standage, *The Victorian Internet* (New York: Walker and Co., 1998), and Doron Swade, *The Difference Engine: Charles Babbage and the Quest to Build the First Computer* (New York: Viking, 2001).

Acknowledgments

The editors would like to acknowledge the generous support of the Marymount Institute, the History Department, and the Bellarmine College of Liberal Arts at Loyola Marymount University for their support of the Visions of the Industrial Age Symposium in May 2006. We are also extremely grateful to the History Department at the University of Missouri– St. Louis, the History Department of Loyola Marymount University, and the Bellarmine College of Liberal Arts at Loyola Marymount University for their generous coverage of the costs of additional images, printing, and indexing. The editors would also like to thank all of the institutions which granted us rights to publish their images for this volume. Finally, the editors would like to thank their families for all of their help and encouragement.

Part I
Envisioning the industrial

The happy marriage of steam and engine produces beautiful daughters and bloody monsters: descriptions of locomotives as living creatures in modernist culture, 1875–1935

Minsoo Kang

A modernist fairy tale

The following narrative can be read as a kind of fable of the modernist era, or even a quintessential allegory of the radical transformation Western civilization underwent in the period of the Industrial Revolution.

In January of 1875, a festival was held for the founding of the Prussian *Verein für Gewebfleiss* (Union for Business Diligence) that was attended by the most important industrialists of Berlin. A major part of the event was a celebratory banquet commemorating the centennial of James Watt's perfection of the steam-engine, the very invention that brought unprecedented changes to the economic, social, as well as natural landscapes of Western Europe. Ernst Engel, the director of the Prussian Statistics Office, delivered a toast on the occasion in which he extolled a truly happy and productive marriage that had taken place a century before. The husband was "a true child of Nature, of ancient stock," whose hot-headed ancestors went so far back as to have witnessed the creation of the world, while the wife's family was much younger, as not long ago "they were very simple and roughhewn people."[1] As Engel continued to describe the union:

The marriage performed in 1775 is, despite the vast differences between the spouses, one of the happiest on the face of the earth and is still in its heyday. And it is also the most fruitful. Its offspring number in the hundreds of thousands. With very few exceptions, they are the best bred, hardest working, and most docile of creatures. They never rest by day or night and are veritable models of obedience and temperance... Wherever we build huts for them and treat them properly, their entrance is followed by success and abundance close at their heels.[2]

The marriage he described was between steam as husband and engine as wife, their children being the myriad machines of the industrial age.

Engel remarked on the admirable obedience and diligence of the offspring of steam and engine, but in France, Jean des Esseintes, the protagonist of J.K. Huysmans's decadent novel *A Rebours* (1884), was impressed by different qualities of two daughters of the married couple. The solipsistic and impotent aristocrat, sitting alone in his apartment to indulge in his strange possessions and even stranger thoughts, denigrates Nature and all of her supposed splendors:

Nature has had her day; she has definitely and finally tired out by the
sickening monotony of her landscapes and skyscapes the patience of
refined temperaments. When all is said and done, what a narrow, vulgar
affair it all is…what a tiresome store of green fields and leafy trees, what
a wearisome commonplace collection of mountains and seas![3]

What he prefers are the artificial creations of man which, he believes, have surpassed those of Nature in beauty. The example he thinks of is a "living, yet artificial organism"—the locomotive—like the two that recently went into service on the Northern Railroad of France. As he describes them in his fevered imagination:

the Crampton, an adorable blonde, shrill voiced, slender-waisted, with her
glittering corset of polished brass … the perfection of whose charms is almost
terrifying when, stiffening her muscles of steel, pouring the sweat of steam
down her flanks, she sets revolving a puissant circle of her elegant wheels …

… the Engerth, a massively built, dark browed brunette, of harsh-toned
utterance, with thick-set loins, panoplied in armour-plating of sheet iron, a
giantess with disheveled mane of black eddying smoke, with her six pairs of
low, coupled wheels, what overwhelming power when, shaking the very earth,
she takes in tow, slowly, deliberately, the ponderous train of good wagons.[4]

Des Esseintes compares them favorably to actual women and thinks that man has done as well as God in creating these fair creatures of steel. So, unlike Engel who saw the children of steam and engine as ideal slaves at the service of humanity, the vision here is of powerful and erotic beings of goddess-like proportions whose primary characteristic and attraction is their sublime beauty.

Jacques Lantier, the locomotive engineer in Émile Zola's novel *La Bête Humaine* (1890), takes the next natural step by actually falling in love with a beautiful daughter of steam and engine. A disturbed individual who feels an urge toward violence whenever he is aroused by an actual woman, Lantier harbors a pure and intense passion for the train under his charge that he has given the name of Lison:

She was gentle, obedient, moved off easily, and kept up a regular, continuous
pace thanks to her good steaming. Some made out that her getting under

way so easily was due to the excellent tyres on the wheels and above all the perfect adjustment of the slide valves ... But [Lantier] knew that there was something more, for other engines, identically built, assembled with the same care, showed none of these qualities. There was the soul, the mystery in creation, the something that the chance hammering bestow on metal, that the knack of the fitter gives to the parts—the personality of the machine, its life. So he loved Lison with masculine gratitude[5]

Toward the end of the novel, when the train is destroyed in an act of sabotage, Lantier sees its end as the death of a living creature:

For a little while it had been possible to see her organs still working in her torn-open body, her pistons still beating like twin hearts, the steam circulating through her slide-valves like the blood in her veins; but as though they were arms in convulsion her driving rods were now only quivering in the last struggles for life, and her soul was departing along with the strength which had kept her alive, that powerful breath she still could not completely expel. The disemboweled giant quietened down still more, then gradually dozed off into a gentle sleep and final silence. She was dead.[6]

The loss of his beloved proves so traumatic to Lantier that he ends up losing his mind and murdering a real woman. He himself meets his death by being torn to pieces in the wheels of another train, falling into them during a violent struggle with its engineer. After his demise, the vehicle goes on its way with no one controlling its direction or restraining its power:

Now out of control, the engine tore on and on. At last the restive, temperamental creature could give full rein to her youthful high spirits, like a still-untamed steed that has escaped from its trainer's hands and was galloping off across the country. The boiler was full of water, the newly stoked furnace was white-hot, and for the first half-hour pressure went up wildly and the speed became terrifying.[7]

In the final paragraph of the work, a new image of the locomotive as a living creature emerges, this time not as an obedient servant of man or a beautiful goddess, but a fearful monster, the very image of the person Lantier became before his terrible end:

What did the victims matter that the machine destroyed on its way? Wasn't it bound for the future, heedless of spilt blood? With no human hand to guide it through the night, it roared on and on, a blind and deaf beast let loose amid death and destruction...[8]

This violent and terrifying child of steam and engine, the dark brother of the beautiful daughters, appears again in many different forms.

Back in Germany, the title character of Gerhart Hauptmann's celebrated naturalist story "Bahnwärter Thiel" (1887) works as a lineman (bahnwärter) for the railways, stationed at a post alongside the tracks. Thiel regards the train as a fearful creature from the outset:

From the distance a snorting and thundering came in waves through the air. Then suddenly the stillness was rent. A furious raging and roaring filled the whole place, the lines beat, the ground trembled—a mighty pressure of air—a cloud of dust, steam and smoke, and the black, snorting monster was past.[9]

As in the case of Lantier, this terrifying vision of the locomotive is connected to the unstable mental state of the beholder. Thiel becomes increasingly disturbed by the fact that his second wife Lena is abusing his retarded son Tobias, the child of his first marriage, but he feels powerless to intervene. The stress from the unbearable situation causes the lineman to have frenzied dreams of the train passing by his station. Just before the tragic accident that kills Tobias, he has another prophetic vision of the machine as monster:

Two round red lights pierced the darkness like staring eyes of some enormous monster. A blood-red glow preceded them, transforming the raindrops in its proximity into drops of blood. It was as though the heavens were raining blood. Thiel experienced a shudder of horror and, as the train came nearer, an every-growing anxiety; dream and reality fused into one for him.[10]

After the death of his son, Thiel, like Lantier, becomes what he beheld and turns into a crazed murderer.

The mechanical monster motif appeared in the literature of the United States as well, most notably in Frank Norris's novel *The Octopus* (1901), which details the epic struggle between wheat farmers of California and a railway corporation that seeks to take over their land to fulfill its expansionist plans. Norris was a great admirer of Zola and a follower of his naturalist style, and *The Octopus* was in fact directly inspired by the latter's *La Bête Humaine* and other works. Early in the story, the character of Presley, a poet who seeks to write a grand work of the American West and becomes a witness to the bloody events of the ensuing struggle, comes across a site where a train, described as an "iron monster," killed a number of sheep that blundered onto the tracks. As he envisions the nature of that terrifying mechanical creature, the machine comes to represent the very corporation that is trying to take over the natural landscape:

abruptly Presley saw again, in his imagination, the galloping monster, the terror of steel and steam, with its single eye, cyclopedian, red, shooting from horizon to horizon; but saw it now as the symbol of a vast power, huge, terrible, flinging the echo of blood and destruction in its path; the leviathan, with tentacles of steel clutching into the soil, the soulless Force, the iron-hearted Power, the monster, the Colossus, the Octopus.[11]

Sixty years after Ernst Engel toasted the marriage of steam and engine, Germany, now under the Nazi regime, reached another centennial that occasioned a celebration—the hundredth anniversary of the building of the

first railways across Prussia, which initiated the so-called Second Industrial Revolution in the land. To mark the momentous occasion, the directors of the Reich Office of Railway Transportation decided to commission a film on the glorious history of German railways. The man chosen for the task was an avant-garde director by the name of Willy Zielke who produced a work he entitled *Das Stahltier* (The Steel Animal). When it was screened for the officials in 1935, however, they were horrified by what they saw. As the famed filmmaker Leni Riefenstahl describes the movie in her memoir:

[Zielke's] locomotive looked like a living monster. The headlights
were its eyes, the instruments its brain, the pistons its joints, and the
oil dripping from the moving pistons looked like blood. This overall
impression was intensified by the revolutionary sound montage ...
The railway cars smashed together so violently when they were being
switched that the viewers jumped out of their seats. It was a shock for the
railway directors who wanted train travel to be smooth and gentle.[12]

Riefenstahl herself thought it was an absolutely brilliant film, "a grand visual symphony, such as I hadn't experienced since Eisenstein's *Potemkin*," that was decades ahead of its time.[13] But the Railway Transportation directors were so offended by the work that they tried to destroy all prints of the film.

Zielke appealed to Riefenstahl, who had recently completed *Triumph des Willens* and was well connected with the Nazi leadership. She attempted to save the work by getting a hold of a copy of the film and arranging a screening for the Propaganda Minster Joseph Goebbels, who was also the head of the German film industry. After the viewing, Goebbels thought the director talented but found his work "too modern and too abstract; it could be a Bolshevist film," and refused to intervene on his behalf.[14]

In the course of the modernist period, then, the happy marriage of steam and engine produced not only obedient and diligent servants of humanity but also goddesses of sublime beauty and bloody monsters of destructive power. What are we make of these rather strange and startling images of the locomotive as living beings and their recurrence throughout the late nineteenth and early twentieth centuries? To fully understand its symbolic significance in the modernist imagination, two distinct elements of this fairy tale must be examined. First, the very idea of a machine as a living entity, which must be seen in the larger context of the cultural reaction to the Industrial Revolution; and second, the interesting variety in the ways these living trains were described—alternatively as helpfully docile, sublimely beautiful, erotically charged, and nightmarishly frightening. My analysis of both elements will show that the image of the living machine functioned as a central symbol in the modernist imagination as it attempted to both make sense of and express its anxiety over the great transformation occurring throughout the industrial period.

The age of the living machines

By the time Ernst Engel delivered his toast to the marriage of steam and engine, Germany was in its fifth decade of industrialization with almost 15,000 miles of railroads stretching across the new empire of northern states created by Bismarck.[15] In an age when the country's industrial power was challenging that of Britain for supremacy, Engel's fairy tale was both an enthusiastic ode to the mechanical control of nature and an optimistic look forward to a high-tech utopia. In the larger cultural realm of Western Europe, however, there were myriad responses to industrialization that were far from celebratory, as they articulated concerns over the rapidity and extent of changes brought about by the Industrial Revolution, sometimes expressing sheer outrage at the negative consequences of those changes.

Already in early-nineteenth-century Britain, where the revolution first began in the last decades of the previous century, William Blake decried English factories as "dark Satanic Mills" in his 1804–1808 work *Milton*, while Thomas Carlyle, in his influential 1829 essay "Signs of the Times," anxiously declared his to be the Mechanical Age: "It is the Age of Machinery, in every outward and inward sense of that word ... Nothing is now done directly, or by hand; all is rule and calculated contrivance ... On every hand, the living artisan is driven from his workshop, to make room for a speedier, inanimate one."[16]

In many of the most polemical and imaginative responses to industrialization in the mid-century onward, machines are depicted precisely as living creatures, superhuman in size and power, and often dangerous and seemingly beyond human control and understanding. In Charles Dickens's *Hard Times* (1854), which takes place in the fictional industrial city of Coketown, the steam-engine that powers each factory moves its piston "up and down, like the head of an elephant in a state of melancholy madness."[17] Karl Marx, in *Das Kapital* (1867), characterizes the organized system of machines in factories as "a mechanical monster whose body fills whole factories, and whose demonic power, at first hidden by the slow and measured motions of its gigantic members, finally bursts forth in the fast and feverish whirl of its countless working organs."[18] In the United States as well, Herman Melville, in the story "The Tartarus of Maids" (1855), describes a paper-making factory in which the machines are "iron animals" fed by female workers: "Machinery—the vaunted slave of humanity—here stood menially served by human beings, who served mutely and cringingly as the slave served the Sultan."[19] It is significant here that two decades before Ernst Engel celebrated the beneficial servitude of machines to man, Melville was pointing out that for some (i.e. the workers) the position was reversed in that it was humans who seemed to be the servants of the machines.

The most elaborate and obsessive use of living machine imagery can be found in the writings of Samuel Butler. In the rural environment of Canterbury Settlement in New Zealand, where he was a successful sheep farmer from 1860 to 1864, Butler wrote a series of articles for the Christchurch newspaper *The Press* on the subject of the recently published *The Origin of Species* (1859) by Charles Darwin. Although after his return to England he went on to challenge Darwin over differing ideas on the mechanisms of evolution, at the time he considered himself an enthusiastic admirer of Darwin's work.[20] In an 1863 piece entitled "Darwin among the Machines," he applies evolutionary ideas to artificial creations, pointing to the great advancements in technology made in only a few centuries—from simple tools such as the lever and the pulley to the locomotive—before asking where all of this is heading and what it means for humanity. He then connects this progress to evolutionary development in nature:

We have used the words "mechanical life," "the mechanical kingdom," "the mechanical world," and so forth, and we have done so advisedly, for as the vegetable kingdom was slowly developed from the mineral, and as in like manner the animal supervened upon the vegetable, so now in these last few ages an entirely new kingdom has sprung up, of which we as yet have only seen what will one day be considered the antediluvian prototypes of the race.[21]

For Butler, given the speed with which machines have evolved, it was inevitable that they would one day challenge mankind for the mastery of the world. The article ends with a call to arms as well as a dire warning about the coming age of intelligent and autonomous machines:

Our opinion is that war to the death should be instantly proclaimed against them. Every machine of every sort should be destroyed by the well-wisher of his species. Let there be no exceptions made, no quarter shown; let us at once go back to the primeval condition of the race. If it be urged that this is impossible under the present condition of human affairs, this at once proves that the mischief is already done, that our servitude has commenced in good earnest, that we have raised a race of being whom it is beyond our power to destroy, and that we are not only enslaved but are absolutely acquiescent in our bondage.[22]

Butler elaborated on this idea throughout his life, most comprehensively in his 1872 novel *Erewhon* which describes a utopian community that has rejected technology completely after a persuasive prophet convinced the people of the machine's danger. In the section of the book on the prophet's "The Book of the Machines," Butler rearticulates many of the ideas found in his earlier pieces "Darwin among the Machines" and an 1865 article entitled "The Mechanical Creation."[23] In those works, Butler envisioned the development of machines into living creatures, different from humans to be sure but no more so than animals from vegetables. Yet even as he used the human-machine comparison to blur the distinction between the organic and

the artificial, he saw a disastrous future for mankind if we allow this new "race" to keep growing in power and number.

Some works went so far as to express the sublime awe one felt before the power of modern machinery in what can only be described as supernatural terms. H. G. Wells's 1894 story "The Lord of the Dynamos" features an electrician named Holroyd, who is in charge of great generators that power the railways of England, and his assistant, a dark-skinned, primitive man from "the mysterious East."[24] The latter regards the largest of the dynamos as a god and prays to it for deliverance from his alcoholic master who abuses him at every turn. Holroyd, who "doubted the existence of the Deity but accepted Carnot's cycle," ridicules his subaltern for his superstition but even he sees the religious potential of the awesome machines: "'Look at that,' said Holroyd; 'where's your 'eathen idol to match 'im? ... Kill a hundred men. Twelve per cent on the ordinary shares,...and that's something like a Gord.'"[25] The assistant becomes convinced that he must make a sacrifice to the deity in order to attain his freedom, and murders his boss by throwing him into the machine. When he is foiled in an attempt to do this to Holroyd's replacement, he commits suicide by the same means. Wells concludes: "So ended prematurely the worship of the Dynamo Deity, perhaps the most short-lived of all religions. Yet withal it could at least boast a Martyrdom and a Human Sacrifice."[26]

Similarly, when Henry Adams attended the Great Exposition in Paris he was awed by the machines in the great hall of dynamos. As he writes about the experience in the famous chapter on "The Dynamo and the Virgin" in his *The Education of Henry Adams* (1907):

As he grew accustomed to the great gallery of machines, he began to feel the
forty-foot dynamos as a moral force, much as the early Christians felt the Cross.
The planet itself seemed less impressive, in its old-fashioned, deliberate, annual
or daily revolution, than this huge wheel, revolving within arm's-length at some
vertiginous speed, and barely murmuring — scarcely humming an audible warning
to stand a hair's-breadth further for respect for power — while it would not wake the
baby lying close against its frame. Before the end, one began to pray to it; inherited
instinct taught the natural expression of man before a silent and infinite force.[27]

In direct contrast to the negative and fearfully cautionary view of the living devices, others celebrated their power as the force that would usher in an exciting new world. The most prominent example of this in the modernist period can be found in the writings of F.T. Marinetti who organized the Futurist movement, inaugurated in 1909 with the publication of its first manifesto. His works, and those of Futurist artists such as Umberto Boccioni, Giacomo Balla, Gino Severini, and Antonio Sant'Elia, are filled with images of machines as dynamic beings of great power and sublime beauty. In his 1908 poem "A mon Pégase," which originally appeared under the title "A l'Automobile," he praises the power of his car in animistic terms:[28]

Vehement god of a race of steel,
space-intoxicated Automobile,
stamping with anguish, champing at the bit!
O formidable Japanese monster with eyes like a forge,
fed on fire and mineral oils,
hungry for horizons and sidereal spoils,
I unleash your heart of diabolic puff-huffs,
and your giant pneumatics, for the dance
that you lead on the white roads of the world.
At last I release your metallic reins...You leap,
with ecstasy, into liberating Infinity![29]

In his 1912 work "Le Monoplan du Pape," the narrator of the "political novel in free verse," envisions his liberation from an earth-bound existence with the help of a living airplane:[30]

Horror of my room like a coffin with six walls!
Horror of the earth! Earth, dark lime
trapping my bird feet! ... Need to break free!
Ecstasy of climbing! ... My monoplane! My monoplane!

In the breach of the blown-out walls
my great-winged monoplane sniffs the sky.
Before me the crash of steel
splits the light, and my propeller's cerebral fever
spreads its roar.[31]

On one occasion, he described even the machine gun in such a manner after he witnessed its use as a reporter in the 1911 battle of Tripoli fought by Italy and Turkey:

Ah yes! you, little machine gun, are a fascinating woman, and sinister,
and divine, at the driving wheel of an invisible hundred horsepower,
roaring and exploding with impatience. Oh! soon you will leap into
the circuit of death, to a shattering somersault or to victory![32]

The recurrent theme in all of these depictions of machines as living creatures is the idea of the devices having transcended their original purpose of serving humanity, in order to take on a life of their own. This marks the imagery as part of the cultural reaction to the rapid industrialization of the West in the second half of the nineteenth century. The situation was described very well by Marshall Berman in his classic study *All That is Solid Melts into Air*, where he examines modernist culture in terms of its expression of both the great hope for a new world to come as well as the anxiety over an uncertain future in an era of accelerated transformation.[33] For those like Samuel Butler who were disturbed by the fast-moving developments, the living machines were depicted as going out of human control and understanding, with potentially disastrous results for the fate of humanity, while for those like the Futurists

who yearned for great changes in human society, the autonomous machines represented a powerful hope for transcendence. This ambivalence leads to an important point on what is specifically "modernist" about these images of the living machine.

Modernity as a living machine

The celebration of the living machine in later works likes those of Marinetti may seem like a continuation of the optimism about the industrial future that was expressed in Ernst Engel's toast to the marriage of steam and engine. There are, however, crucial differences in their views on machinery and the nature of its power that goes to the heart of what makes the later depictions of living machines modernist. As fanciful and provocative as Engel's allegory was, the central idea behind it was a part of a well-established tradition of what could be called classical technophilia that can be traced back to the Enlightenment project of the control of nature, exemplified by the celebration of the factory system and the industrial use of advanced machinery in Denis Diderot and Jean D'Alembert's *Encyclopédie* (1751–1766), Adam Smith's *The Wealth of Nations* (1776) and in later works such as Charles Babbage's *On the Economy of Machinery and Manufactures* (1832).[34] In this view, machines were the instruments with which human beings imposed reason upon nature, ordering her unruly forces and harnessing them for the benefit of humanity in an increasingly useful and efficient manner. In Engel's tale, the husband-steam is described as a "true child of Nature" who is given to venting "his native temperament" by "smashing everything around him to smithereens and sparing nothing that stands in his way" when he is neglected.[35] The act of his marriage to his wife-engine is one of control and moderation so that the offspring that are produced through their union turn out to be powerful but obedient servants of humanity.

Jeffrey Herf has pointed to an early twentieth-century political ideology he calls "reactionary modernism," with roots in Weimar Germany and espoused by such figures as Ernst Jünger, Oswald Spengler, Werner Sombart, and later the Nazi ideologues of the Third Reich. What he finds paradoxical in their view is that while it was essentially a conservative position that rejected the ideals of the Enlightenment, including the rationalist outlook and liberal democratic politics associated with the bourgeois state, it embraced modern technology, the very product of Enlightenment science and rationalism.[36] This aspect of the movement, which constitutes its modernism, distinguished it from traditional forms of conservatism that tended to repudiate all aspects of modernity, including technology and industrialization. The reactionary modernists made the move by seeing in modern machines not the tools of rational control of nature but rather products of irrational will. Herf analyzes

this idea in the context of early twentieth-century political ideology, but significant precedents for such depictions of modern technology can be found in the nineteenth century.

Classical technophiles saw the process of industrialization as the harnessing and rationalization of uncontrolled forces in nature, like the violent steam-husband in Engel's allegory. However, a kind of return of the repressed occurs in the modernist imagination as the living machine is seen increasingly as irrational, out of control, and mysterious even to a supernatural degree, as seen in the later depictions of locomotives. This view of the irrationality of the machine, whether regarded with fear or hope, is precisely what constitutes its modernist nature, in direct contrast to the rationalist outlook of classical technophilia. This idea is clearly a part of the cultural reaction to the continued expansion of industrialization in the second half of the nineteenth century. The pace and pervasiveness of change produced anxiety in the sense that, in Marx's words, "all that is solid melts into air," but also, more specifically, it provoked a widespread feeling that things have gone beyond the control and understanding of human beings, that the progress of modernity itself had taken on a life of its own.

In the cases of Zola and Norris, this symbolic representation of modernity as an irrational, out-of-control living machine is used to depict the tragic helplessness of individuals before superhuman forces and institutions. At the end of *La Bête Humaine*, we learn that the train that moves on its own after the death of its engineer is carrying French soldiers heading into the disaster of the Franco-Prussian War, which Zola wrote about in the follow-up novel *La Débâcle* (1892). The monstrous train that accelerates into the dark future becomes the image of the inexorable march of history itself, and the inevitable accident to come, that of the coming conflict. Likewise, the mechanical Cyclops in Norris's novel represents the impersonal and all-powerful railway corporation that destroys anyone and anything that stands in the way of its unending pursuit of wealth and power.

In the case of other modernists like the Futurists, however, the enormous changes brought on by the monstrous, irrational machines were something to be celebrated, as they promised to wipe out the stultifying bourgeois society to make room for the new age to come. This points to another central difference in Engel and Marinetti's celebrations of the living machine. For a classical technophile like Engel, the rational human self was an unproblematic being, as his role was that of the ultimate master-controller of the obedient machine-servants that were used to maintain the status quo of industrial society. In the age of irrational machines, however, when those very machines seemed to take on lives of their own and threatened to overwhelm their creators, modernists like Marinetti thought that humanity must also change radically in order to not only survive but also thrive. Marinetti envisioned this change in terms of the fusion of man and machine, resulting in the creation of a new

irrational man-machine. In "L'uomo moltiplicato e il regno della macchina" ("Multiplied Man and the Reign of the Machine," from the larger work *Guerra sole igiene del monde,* "War, the World's Only Hygiene," 1911–15), Marinetti begins with his description of what he calls "mechanical beauty," how those who work with machines naturally regard them as living beings:

Have you never seen a mechanic lovingly work on the great
powerful body of his locomotive? His is the minute, knowing
tenderness of a lover caressing his adored woman ...

You surely must have heard the remarks that the owners of automobiles and factory
directors commonly make: motors, they say, are truly mysterious ... They seem
to have personalities, souls, or wills. They have whims, freakish impulses. You
must caress them, treat them respectfully, never mishandle or overtire them.[37]

From this point, Marinetti leaps to a vision of the merging of man and machine, the creation of a mechanical superman, to whom the future belongs:

... we must prepare for the imminent, inevitable identification of man with
motor, facilitating and perfecting a constant interchange of intuition, rhythm,
instinct, and metallic discipline ... It is certain that if we grant the truth of
Lamarck's transformational hypothesis we must admit that we look for the
creation of a nonhuman type in whom moral suffering, goodness of heart,
affection, and love, those sole corrosive poisons of inexhaustible vital energy,
sole interrupters of our powerful bodily electricity, will be abolished ...

This nonhuman and mechanical being, constructed for an omnipresent
velocity, will be naturally cruel, omniscient, and combative. He will be
endowed with surprising organs: organs adapted to the needs of a world
of ceaseless shocks. From now on we can foresee a bodily development in
the form of a prow from the outward swell of the breastbone, which will
be the more marked the better an aviator of the future becomes.[38]

The central program of Futurism was the radical destruction of all things bourgeois—in the realms of art, literature, and social mores as well as politics. Consequently, the Futurists were anarchist in political alignment and overtly anti-Romantic in their aesthetics, their works filled with dynamic images of motion, speed, transformation, and cataclysmic destruction followed by an equally awesome rebirth. What appealed to Marinetti about modern technology was precisely its ability to bring about such rapid changes by forcing people to reconsider the very notions of space and time, a process that was under way in the general culture of Western Europe during this period, through the expanding use of machines such as trains, automobiles, airplanes and the telegraph.[39] Marinetti, therefore, was the furthest thing from a classical utopian like Engel who hoped that the greater improvement and use of technology would set people free from work to lead genteel bourgeois lives. As Jeffrey T. Schnapp points out in his essay on the 1912 "Manifesto tenico della letteratura

furitista" ("Technical Manifesto of Futurist Literature"), Marinetti's vision of man as a living machine was a highly volatile, ceaselessly changing, and supremely individualist one that was the very opposite of the quantified and obedient worker-machine of the factory.[40] This connection Marinetti makes between the nature of the machine and that of man leads us to a significant aspect of the modernist depiction of both as irrational entities.

In the industrial age, just as machines were being described as living creatures, humans and the workings of their bodies were being examined in mechanical terms. Anson Rabinbach has demonstrated the cultural importance in this period of the study of the human body as a type of motor, and its application in industrial planning and reform.[41] This was greatly facilitated by Hermann von Helmholtz, Sir William Thomson (Lord Kelvin), Rudolf Clausius and others' mid-nineteenth-century formulations of laws of thermodynamics and their application to physiology, which provided a new way of understanding the workings of the natural body in terms of energy that could be quantified and expressed mathematically.[42] Etienne-Jules Marey, one of the most prominent proponents of this man-as-motor idea, claims in his 1873 work *La Machine animale, locomotion terrestre et aérienne* that "modern engineers have created machines which are much more legitimately to be compared to animated motors; which, in fact, by means of the little combustible matter which they consume, supply the force requisite to animate a series of organs, and to make them execute various operations."[43]

To regard the natural body as a machine and the machine as a living being at the same time may seem like a contradiction, until the period's ideas on the human-machine connection is seen in terms of questioning the essential difference between the function of the organic and the artificial. Mechanistic physiologists like Marey and Helmholtz did not seek to merely reduce the natural body to a machine, but to establish a way of understanding its operation through a universal theory of energy that could be applied just as well to an engine as to a body. As Rabinbach puts it, the energeticist theory showed that "work performed by any mechanism, from the fingers of a hand, to the gears of an engine, or the motions of the planets, were essentially the same."[44] Under this rubric, bodies could be described as organic machines, and machines as mechanical organisms, since they are essentially constructs that convert energy into work under uniform principles.

Once scientists had established the connection between machines and human beings, this idea spread across the larger culture and was transformed in an interesting manner toward the end of the century. The changing view of industrial technology occurred in conjunction with that of humanity itself, the man-machine analogy shifting to include the psyche as well as the body. In other words, when machines began to be portrayed in an increasingly irrational manner, the same thing occurred in the depiction of humanity and human nature, as exemplified by the ideas of Sigmund Freud on the unconscious and

the irrational impulses we are all subject to. It is within this context that we can understand the relationship between the view of locomotives as irrational monsters and the depictions of psychotic breakdowns that, in the works of Zola and Hauptmann, turn the railway workers Lantier and Thiel into crazed murderers. This works on a metaphorical level, the out-of-control machine mirroring the out-of-control psyche in shock and despair that results in the destruction of lives in both cases. There was, however, also a much more literal connection being made between modern technology and the human psyche in the medical discourse of the time.

Wolfgang Schivelbusch has shown that starting from the mid-nineteenth century onward, there was a growing discussion in the medical community of Western Europe about the physical and psychological stresses of living in a modern society, and especially those caused by technology.[45] In the case of the railways, it was thought that in addition to actual physical injury from accidents, the exposure to high speeds and the shocks of the vehicle's movements caused nervous disorders in both workers and passengers. Andreas Killen has described how in the late nineteenth century the German state sought to deal with such unfortunate but ultimately manageable side effects of modernity through a comprehensive system of social insurance.[46] When that ceased to be a viable solution to the problem in the crisis period after World War I (the war itself was also imagined as "an immense runaway locomotive," according to Killen[47]) there was a tendency toward skepticism in the scientific community at claims of nervous injury, with accusations of malingering on the part of the claimants. In the larger modernist culture before and after the war, however, there was a continued linkage of out-of-control machines, psychological breakdowns, and social crisis, exemplified most vividly by Fritz Lang's 1927 film *Metropolis*.

The story begins with the depiction of a society divided into the subterranean world of workers toiling, machine-like, in a gigantic factory, and the idyllic world of masters enjoying the fruits of their inferiors' labor. This is the classical technophile's utopian dream come true, where docile machines and machine-men serve their masters without complaint. As the story progresses, however, a crisis brought on by the insertion of a female robot into the world below results in both the malfunctioning of the machines and the revolt of the workers.[48] In one terrifying scene, the character of Freder, the son of the master of Metropolis, envisions a great machine of the underground as a pagan god into whose fiery mouth workers are thrown in as human sacrifices. In Thea von Harbou's (Fritz Lang's then wife) novel of the story, Freder describes what he saw in terms reminiscent of the animistic descriptions of machines from Samuel Butler to Henry Adams:

I went through the machine-rooms—they were like temples. All the great gods were living in white temples. I saw Baal and Moloch, Huitzilopochtil and Durghas ... all machines, machines, machines, which, confined to their

pedestals, like deities to their temple thrones, from the resting places which
bore them, lived their god-like lives ... And near the god-machine, the slaves
of the god-machines: the men who were as though crushed between machine
companionability and machine solitude ... They have nothing else to do but
eternally one and the same thing, always the same clutch at the same second.[49]

Andreas Huyssen, in his analysis of the film, points to the connection between
the fear of modern machinery and the fear of female sexuality in the figure
of the female robot. For the story to come to a reassuring end, both must be
destroyed, since:

the destructive potential of modern technology, which the expressionists
rightfully feared, had to be metaphorically purged. After the dangers of a
mystified technology have been translated into the dangers an equally mystified
female sexuality poses to men, the witch could be burnt at the stake and, by
implication, technology could be purged of its threatening aspects.[50]

In another essay, Huyssen has described a tendency in modernist culture of
describing the masses and mass culture also in feminine terms.[51] What such
analyses expose is the operation of a binary opposition with a series of linked
entities on either side of the equation. On the one hand, there are industrial
technology, female sexuality, mass culture, and the working class (represented
by the "hand" in the film), all described as irrational, sensual, dark, and
feminine; on the other hand, there are male power, the ruling elite, and the
leisure class (represented by the "brain"), described as rational, cerebral, light,
and masculine. While the story begins with the latter's absolute control over
the former—the harnessing of the chaotic energy of nature and the lower order
of humanity for the rational production of work—the narrative is ultimately
about the futility of maintaining that state due to the inherent tension between
the classes within the system that can only lead to an eventual confrontation.
So through the master's own less-than-rational actions, all that unruly energy
below is finally released, erupting in a great flood and revolution. The happy
ending of the story, with the reconciliation between the master and the workers
(the brain and the hand) through the man who has connections to both (the
heart—or human sentiment and compassion), is no doubt the weakest and
least convincing part of the film, but it does reflect a hope, however feeble, for
a solution to the essential problem at the heart of modernity.

What industrial machinery, female sexuality, the worker and mass culture
had in common that allowed them to be linked together in the modernist
imagination is that they were all essential elements of modern life. From the
perspective of upper class males who wanted to maintain the status quo,
machines, women, and the working class were both necessary and beneficial
as long as they were kept under control and remained obedient servants,
like Engel's children of steam and engine (which highlights an interesting
aspect of his allegory in that irrational nature is depicted as the male and

the harnessing machinery female, when in most modern expression it is nature that is portrayed as feminine and technology masculine). But they were also the source of profound anxiety since they were perceived as having natures that were essentially irrational and chaotic, which always carried the potential of going out of control, challenging the established order of society, and leading either to utter destruction and anarchy or to a dynamic utopia. And just as much as in the cases of female sexuality and the working class, it was this uncertainty toward modern industrial technology that made the living machine such a powerful and provocative image in the modernist imagination.

Torbjörn Wandel has demonstrated the futility of attempting to define modernism in terms of either the celebration of the great changes brought on by the Industrial Revolution or the rejection of them, when the cultural movement clearly featured both reactions. "Modernity, therefore, is the simultaneous sense of exhilaration and anxiety about the now and what it might hold in store. Each modern expression is characterized by this inherently ambivalent attitude toward the present."[52] The image of the locomotive as a living being is that of modernity itself. In that case, is modernity an obedient and diligent machine-servant, the child of nature and technology; or is it a great goddess of awesome and sublime beauty; or is it a bloody monster of terrifying power that devours everything that stands in its way? Modernity was envisioned as all of those things; the differing images represented the full range of the darkest fears and the brightest hopes in the modernist imagination as it gazed anxiously at the emerging brave new world that has such machines in it.

Notes

1. Dolf Sternberger, *Panorama of the Nineteenth Century*, trans. Joachim Neugroschel (New York: Urizen Books, 1977), 17.

2. Sternberger, *Panorama of the Nineteenth Century*, 17–18.

3. J.K. Huysmans, *Against the Grain (A Rebours)*, trans. anonymous (New York: Dover, 1969), 22.

4. Huysmans, *Against the Grain*, 22–3.

5. Émile Zola, *La Bête Humaine*, trans. Leonard Tancock (London: Penguin Books, 1977), 151.

6. Zola, *La Bête Humaine*, 300.

7. Zola, *La Bête Humaine*, 365.

8. Zola, *La Bête Humaine*, 366.

9. Gerhart Hauptmann, *Lineman Thiel and Other Tales*, trans. Stanley Radcliffe (London: Angel Books, 1989), 68.

10. Hauptmann, *Lineman Thiel*, 72.

11. Frank Norris, *The Octopus* (New York: Penguin Books, 1986), 51.

12. Leni Riefenstahl, *A Memoir* (New York: St. Martin's Press, 1992), 174.

13. Riefenstahl, *A Memoir*, 174.

14. Riefenstahl, *A Memoir*, 175. For the fate of Riefenstahl's only copy of the print after World War II, see 324. It has apparently been found since then as it has been shown in several recent film festivals.

15. David S. Landes, *The Unbound Prometheus: Technological Change and Industrial Development in Western Europe from 1750 to the Present* (Cambridge: Cambridge University Press, 1969), 194. For more on German industrialization, see Landes, *The Unbound Prometheus*, 193–358; and Eric Dorn Brose, *The Politics of Technological Change in Prussia: Out of the Shadow of Antiquity, 1809–1848* (Princeton: Princeton University Press, 1993).

16. William Blake, "Milton," in *The Portable Blake* (New York: Penguin Books, 1974), 412. Thomas Carlyle, "Signs of the Times," in *Critical and Miscellaneous Essays* (London: Chapman and Hall, 1899), 59. See also John M. Ulrich, *Signs of Their Times: History, Labor and the Body in Cobbett, Carlyle, and Disraeli* (Athens: Ohio University Press, 2002), 58–105. For more comprehensive discussions of cultural attitudes toward industrialization in the nineteenth century see, for the British context, Herbert L. Sussman, *Victorians and the Machine* (Cambridge: Harvard University Press, 1968), and Nichols Fox, *Against the Machine: The Hidden Luddite Tradition in Literature, Art, and Individual Lives* (Washington D.C.: Island Press, 2002), especially, 24–117, and 150–85; for the French, Jacques Noiray, *Le romancier et la machine: L'image de la machine dans le roman français (1850–1900), I. L'univers de Zola* (Paris: Librarie José Corti, 1981), *Le romancier et la machine: L'image de la machine dans le roman français (1850–1900), II. Jules Verne-Villiers de l'Isle Adam* (Paris: Librarie José Corti, 1982), and Kai Mikkonen, *The Plot Machine: The French Novel and the Bachelor Machines in the Electric Years (1880–1914)* (Amsterdam: Rodopi, 2001); for the American, Leo Marx, *The Machine in the Garden: Technology and the Pastoral Idea in America* (New York: Oxford University Press, 1964), John F. Kasson, *Civilizing the Machine: Technology and Republican Values in America, 1776–1900* (New York: Grossman, 1976), Mark Seltzer, *Bodies and Machines* (New York: Routledge, 1992), and Fox, *Against the Machine*, 118–49, and 186–218; and for the German, Sternberger, *Panorama of the Nineteenth Century*, 7–38. See also Christoph Asendorf, *Batteries of Life: On the History of Things and their Perception in Modernity*, trans. Don Reneau (Berkeley: University of California Press, 1993).

17. Charles Dickens, *Hard Times* (New York: Penguin Books, 1995), 28.

18. Karl Marx, *Capital, Volume One*, trans. Ben Fowkes (New York: Vintage, 1977), 503.

19. Herman Melville, "The Paradise of Bachelors and the Tartarus of Maids," in *Billy Budd and Other Stories* (New York: Penguin Books, 1986), 277–8.

20. See Sussman, *Victorians and the Machine*, 135–61. Also, for a discussion of Butler and his views on evolution and technology, and their link to contemporary debates on artificial intelligence, see George B. Dyson, *Darwin among the Machines: The Evolution of Global Intelligence* (Cambridge: Perseus Books, 1997), 15–34.

21. Samuel Butler, "Darwin Among the Machines," in *A First Year in Canterbury Settlement and Other Early Essays* (London: Jonathan Cape, 1923), 209.

22. Butler, "Darwin Among the Machines," 212–13.

23. See Samuel Butler, *Erewhon* (New York: Penguin Books, 1970).

24. H.G. Wells, "The Lord of the Dynamos," in *Selected Short Stories* (New York: Penguin Books, 1979), 184.

25. Wells, "The Lord of the Dynamos," 186.

26. Wells, "The Lord of the Dynamos," 192.

27. Henry Adams, *The Education of Henry Adams* (Oxford: Oxford University Press, 1999), 318.

28. For a general discussion of Marinetti's depiction of machines see Shirley Vinall, "The Emergence of Machine Imagery in Marinetti's Poetry," *Romance Studies*, 6 (1985): 78–95.

29. F.T. Marinetti, "To My Pegasus," in *Selected Poems and Related Prose*, trans. Elizabeth R. Napier and Barbara R. Studholme (New Haven: Yale University Press, 2002), 38.

30. On Marinetti's interest in aviation and its influence on his works, see Jeffrey T. Schnapp, "Propeller Talk," *Modernism/Modernity*, 1.3 (1994): 153–78.

31. F.T. Marinetti, "The Pope's Monoplane," in *Selected Poems and Related Prose*, 43.

32. F.T. Marinetti, "Technical Manifesto of Futurist Literature," in *Let's Murder the Moonshine: Selected Writings*, trans. R.W. Flint and Arthur A. Coppotelli (Los Angeles: Sun & Moon Classics, 1991), 94.

33. Marshall Berman, *All That is Solid Melts into Air* (New York: Penguin Books, 1982).

34. For a concise discussion of this topic in the eighteenth-century context see Simon Schaffer, "Enlightened Automata," in William Clarke, Jan Golinski, and Simon Schaffer, eds, *The Sciences in Enlightened Europe* (Chicago: University of Chicago Press, 1999), 126–74.

35. Sternberger, *Panorama of the Nineteenth Century*, 18.

36. Jeffrey Herf, *Reactionary Modernism: Technology, Culture, and Politics in Weimar and the Third Republic* (Cambridge: Cambridge University Press, 1984), 1–17.

37. F T. Marinetti, "Multiplied Man and the Reign of the Machine," in *Let's Murder the Moonshine*, 98–9.

38. Marinetti, "Multiplied Man and the Reign of the Machine," 99.

39. For a detailed study of those changes, see Stephen Kern, *The Culture of Time and Space, 1880–1918* (Cambridge: Harvard University Press, 1983).

40. Schnapp, "Propeller Talk," 161.

41. Anson Rabinbach, *The Human Motor: Energy, Fatigue and the Origins of Modernity* (Berkeley: University of California Press, 1992).

42. See Thomas S. Kuhn, "Energy Conservation as an Example of Simultaneous Discovery," in *Essential Tension: Selected Studies in Scientific Tradition and Change* (Chicago: University of Chicago Press, 1977); and Rabinbach, *The Human Motor*, 45–68.

43. Etienne-Jules Marey, *Animal Mechanism: A Treatise on Terrestrial and Aërial Locomotions*, trans. anonymous (New York: D. Appleton and Company, 1893), 1.

44. Rabinbach, *The Human Motor*, 47.

45. Wolfgang Schivelbusch, *The Railway Journey: The Industrialization of Time and Space in the 19th Century* (Berkeley: University of California Press, 1977), 113–23.

46. Andreas Killen, *Berlin Electropolis: Shock, Nerves, and German Modernity* (Berkeley: University of California Press, 2006).

47. Killen, *Berlin Electropolis*, 130.

48. There is a substantial literature on this classic film. A good place to begin is Michael Minden and Holger Bachmann, *Fritz Lang's Metropolis: Cinematic Visions of Technology and Fear* (Rochester: Camden House, 2000). See also Siegfried Kracauer, *From Caligari to Hitler: A Psychological History of the German Film* (Princeton: Princeton University Press, 1947), 162–64; Peter Gay, *Weimar Culture: The Outsider and Insider* (New York: W.W. Norton, 2001), 141–2; Roger Dadoun, "*Metropolis*: Mother-City – "Mittler"– Hitler," in Constance Penley, Elisabeth Lyon, Lyn Spigel, Janet Bergstrom eds, *Close Encounters: Film, Feminism, and Science Fiction* (Minneapolis: University of Minnesota Press, 1991), 133–59; and Peter S. Fisher, *Fantasy and Politics: Visions of the Future in the Weimar Republic* (Madison: University of Wisconsin Press, 1991), 126–42.

49. Thea von Harbou, *Metropolis*, trans. anonymous (Rockville: Sense of Wonder Press, 2001), 23.

50. Andreas Huyssen, "The Vamp and the Machine: Fritz Lang's Metropolis," *After the Great Divide: Modernism, Mass Culture, Postmodernism* (Bloomington: Indiana University Press, 1986), 81.

51. Huyssen, "The Vamp and the Machine," 44–62.

52. Torbjörn Wandel, "Too Late for Modernity," *Journal of Historical Sociology*, 18, 3 (2005): 262.

Adorning the landscape:
images of transportation in nineteenth-century France

Jane E. Boyd

In 1883, in his introduction to the "Railroads" volume of *Les travaux publics de la France* (The Public Works of France), a collection of engineering photographs, civil engineer Édouard Collignon wrote that railroad viaducts, "when constructed with taste and ... good materials, always contribute to adorning the landscape."[1] The book's pictures illustrate his assertions. In the plates, lofty stone arches stride across valleys (as in Figure 2.2) and iron trusses span wide rivers. The structures are presented as heroic monuments of industrial progress, but the images are not simply emblems of man's triumph over nature. As Collignon's words suggest, building in harmony with the terrain was important for engineers, and success was partly judged by aesthetic standards.

Though nineteenth-century viaducts and bridges were built to serve as key components of rapidly growing transportation networks, their significance extended beyond their utilitarian value. Frequently described and depicted, they became symbols of the modern age. In this chapter, I will examine a particular aspect of that symbolism as it appeared in visual imagery: the intersection of engineering structures with their natural surroundings. Two contrasting types of structures, arched masonry viaducts for railroad lines and iron-cable suspension bridges for road traffic, will serve as examples. Images of viaducts and suspension bridges appear in a variety of media, from printed illustrations to photographs and paintings. Some of these pictures seem to support the assertion that transportation structures beautified the terrain. A closer look, however, can reveal unexpected elements in the images, such as extensive manipulations and alterations. These changes show that the pictures were not straightforward documentary images, but instead imaginative works of art reflecting ideal visions of a harmonious industrialized landscape.

Stone railroad viaducts, for example, were greatly admired as contemporary monuments, engineering feats that rivaled ancient Roman aqueducts. As evidence for the adorning power of viaducts, illustrators created numerous appealing images of the arcaded structures, some almost completely imaginary. Photographers, not content with the existing scenery surrounding their subjects, sometimes added vegetation to their negatives by hand, a radical intervention meant to bring the photographs in line with aesthetic expectations. Suspension bridges, by contrast, were viewed as innovative, modern structures, even though they had roots in primitive bridge forms. As discussed below, one painting of a village suspension bridge by the Impressionist Alfred Sisley contrasts the curves of the iron cables with the heavy stone piers at the bridge's base. Two other canvases are quite different, showing the bridge at a distance with its pillars and cables hidden or barely visible, the structure paradoxically adorning the landscape by vanishing into its surroundings. Such elisions, however, also evoke the dangerous instability of suspension bridges, dramatized in illustrations of deadly collapses.

Historians of nineteenth-century France have described how the growth of travel, made possible by ever-expanding transportation networks, was an important catalyst for the rise of landscape imagery. Landscape pictures of all sorts were produced and packaged largely for the urban bourgeoisie, who increasingly experienced nature in the suburbs or the countryside through the mediation of these images, along with such texts as guidebooks and travel accounts.[2] Railroad and transportation images have also been discussed, particularly by scholars of Impressionist painting and of photography.[3] Relatively little attention, however, has been paid to the unique characteristics of the engineering structures in these pictures, and connections across different media have not always been explored. By beginning to fill those gaps in this chapter, I hope to illuminate some of the complexities and ambiguities of France's struggles with modernization.

Though French railroads were slow to develop, as was French industry overall, there were more than 4,000 miles of train lines in use by 1865, with nearly 3,000 additional miles of track under construction.[4] Railroads demanded more infrastructure than any other form of transportation. To ensure the traction of wheels on the tracks, railroad lines needed to be as flat and straight as possible; only very slight angles of incline and limited amounts of curvature were allowed. Since "the shape of the earth's surface … is not susceptible to geometric definition, and obeys no laws," in the words of one engineer,[5] enormous effort was expended to create pathways for the railroad tracks. Trenches were dug through hillocks and ridges to form embankments, depressions were filled in, and where necessary, tunnels were made through mountains. Short bridges usually sufficed to carry railroad lines (as well as regular roads) over rivers or small declivities. For broader valleys or deeper gorges, however, a more ambitious type of

structure was required. This was the viaduct (*viaduc* in French), which took both its Latinizing name and its multi-arched form from ancient Roman aqueducts.

There were sound practical reasons for adapting an old form to a new purpose. A line of tall, narrow arches of stone (less often brick or concrete) was an effective and structurally reliable way of crossing a valley, equally well suited to carrying a channel of water or a multi-ton train. Metal bridges and viaducts had been built throughout the nineteenth century, becoming more common after the 1850s, but metal construction was demanding and maintenance difficult.[6] Masonry construction, by contrast, was well developed and well understood, solid and long lasting. As late as 1894, a railroad handbook for civil engineers stated firmly, "when you can use masonry, you should never hesitate to do so."[7]

Though practicality was the main motive for choosing the arched masonry viaduct, the symbolism of the structure was also important. Borrowing an ancient, revered form reassured nineteenth-century people that they were capable of high achievement, equal to or even greater than the ancients, dispelling fears that modern men were merely pygmies standing on the shoulders of giants. Alexandre Dumas, traveling in the south of France in the 1830s, expressed the prevailing reverence towards Roman monuments in his description of the Pont du Gard, a colossal aqueduct near Avignon dating from the 1st century BC: "It is impossible to form any idea of the effect of ... these three stories of porticoes magnificently gilt by the suns of eighteen centuries." For Dumas, this "magnificent epic in granite" outshone all other man-made and natural "wonders of the world," even the Colosseum in Rome and Mont Blanc in the Alps.[8]

Gabriel-Joseph-Hippolyte Laviron, writing just a few years later in 1840, had a dissenting view. Attributing French "fetishism" for antique monuments to his countrymen's classical education, he complained: "What, after all, were these temples carved out of mountainsides, these pyramids, these lighthouses, these aqueducts, these immense amphitheaters? Nothing other than children's games in which the first societies ... tested the strength of their precocious virility."Modern societies, Laviron declared, needed to shake off the bonds of antiquity in order to fulfill the demands of industry.[9] Ancient monuments, however, retained a strong grip on the public imagination. Even two decades later, during the Second Empire's railroad-building boom, Amédée Guillemin lamented that "the ancients have left us models so imposing, that there are bound to be people quite ready to disparage modern constructions in favor of the works of antiquity."[10]

The Ministère des Travaux Publics (Ministry of Public Works) and the engineers under its supervision were particularly aware of their roles as latter-day monument-builders. Léonce Reynaud, an inspector-general of the national engineering corps, claimed in 1879 that:

our works, considered in and of themselves, greatly outmatch those of the ancients. Our railways alone have constructed in Europe, in barely half a century, more works similar to the celebrated aqueducts of the Romans than have been produced for thousands of years.[11]

Furthermore, he continued, modern structures displayed both "science and boldness" (*hardiesse*), and would doubtless last as long as the classical ones that were "too often ... exalted to excess."[12] Reynaud's remarks proved prophetic; many nineteenth-century masonry viaducts still stand and are in active use, including the Chaumont Viaduct discussed below. Other commentators shared his opinions on the relative worth of ancient and modern constructions. Pierre Larousse, in the railroads entry of his influential *Grand dictionnaire universelle du XIX^e siècle* (Great Universal Dictionary of the Nineteenth Century), quoted Jean-Jacques Rousseau's awed reaction to the Pont du Gard. Larousse conjectured that the Enlightenment *philosophe* would have been even more amazed by contemporary viaducts, iron bridges, and tunnels.[13]

Viaducts were not only prominent in discussions of railroads; they were also quickly adapted into visual imagery, becoming one of the most frequently depicted types of railroad structure. Artists' familiarity with the viaduct's basic form may have contributed to this popularity. Since arches and arcades often appeared as exercises in handbooks of drawing and perspective, masonry viaducts may have been easier and more appealing to draw than other railroad structures with less familiar forms, such as metal truss bridges. For instance, the frontispiece of an early edition of J.P. Thénot's frequently reprinted *Traité de perspective pratique* (Treatise on Practical Perspective) shows a section of a ruined aqueduct receding sharply into the distance.[14]

Images of viaducts played a role in debates about the effects of engineering structures on their natural surroundings. In his popular 1862 book on railroads, Amédée Guillemin declared that the new technologies of transportation were not "enemies of art or of the picturesque in the landscape," as many had claimed.[15] He may have been answering those critics, such as novelist, poet, and art critic Arsène Houssaye, who objected primarily to the visual effects of industrialization. For Houssaye, writing in 1844 at the dawn of France's railroad age, factories and large-scale agriculture were the principal culprits in the desecration of the countryside. The railroad, relatively new at the time, was an additional threat: simply "to go faster," it "cut down the old tree, the streams, the rock, the fountain, and finally the mountain," depriving poets and artists of their subject matter as well as their spaces for solitary reverie.[16] Guy de Maupassant, writing forty years later, laid the blame for ruining beautiful prospects specifically on engineers, "men of the compass ... inspired by ... the genius of the Ugly ... [who] spoil everything with a simple stroke of the pen."[17]

Appropriately, Guillemin's response to such aesthetic criticism was not a quotation from an authority or a closely reasoned argument, but an

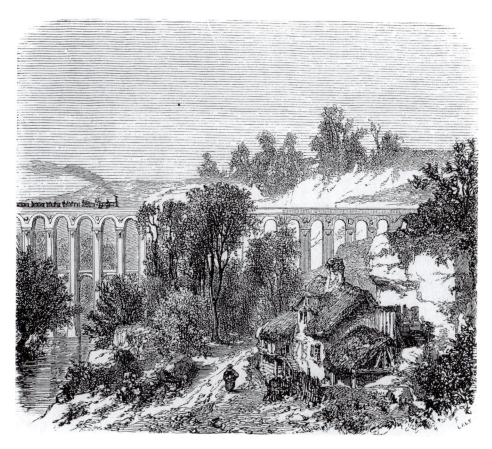

2.1 Thérond (artist); Laly (engraver). *Les viaducts et le paysage* (Viaducts and the Landscape). Wood engraving. Amédée Guillemin, *Simple explication des chemins de fer* (Paris: Hachette, 1862), 142

illustration in his book (Figure 2.1). Captioned "Viaducts and the Landscape," Émile Thérond's engraving, described by Guillemin as a "charming sketch, so wittily drawn," depicts a thatched-roof cottage on a rocky, tree-covered hillside by a river.[18] An ornate double-arcaded viaduct neatly bisects the composition, with a train entering the picture from the left. The scene is most likely imaginary or a composite. All other images of bridges and viaducts in Guillemin's book are identified. This is the only structure without a name, and its narrow arches and elaborate decoration are unusual. The landscape setting, however, is generic, with the cottage and peasant-like figure serving as visual clichés of an older, agricultural nation facing an industrial future.

Despite the artifice of the scene, it is typical of most nineteenth-century landscapes with viaducts. In many of these images, which appear in a wide range of media, the structure appears in the middle ground or background, set

parallel or at a slight angle to the picture plane. This composition emphasizes the large scale and regularity of the structure, and also shows all the arches clearly. Not all viaduct images include buildings, people, or even trains. The landscape setting, however, is crucial to these pictures, acting as both the foil and the frame for the man-made structure. As Guillemin pointed out, the appeal of such a scene comes from the interaction between the viaduct and its natural surroundings: "It seems to me that these beautiful viaducts, with their long lines of white arcades, masked now and then by rocks or by masses of greenery, have a decorative effect that is very simple and very pleasing."[19]

Guillemin strengthened his defense of viaducts as positive additions to the terrain by eliding the distinction between the actual landscape and pictures of it. He spoke of Thérond's engraving as if it were a real scene ready to be painted, rather than an imaginary picture already created by an artist, asking rhetorically: "Do you think that a landscape painter would have showed bad taste in taking this point of view for the subject of one of his canvases?" On the following page, Guillemin pressed his argument further, reproducing an image of a double-arcaded viaduct in a completely treeless landscape near Dijon. "Don't you find," he asked, that the "somewhat firm lines" of the structure "form a harmonious ensemble with the arid nature of the surroundings?"[20] The illustrations answered the questions, seemingly leaving no room for dispute.

Some commentators, however, did object to the grandeur of such viaducts. Writing in the journal *La Revue contemporaine* in 1866, Émile Level spoke of the "magnificent works erected by the [railroad] companies over valleys and rivers."[21] His description juxtaposed monumental structures with lowly rural laborers, just as Thérond did in his engraving. Level, though, used the contrast to argue that elaborate viaducts were both aesthetically and socially inappropriate for their settings:

There, the art of the builder is pushed to its furthest limits; one cannot imagine anything more grandiose or more magnificent. All the luxury of decoration is consecrated to the embellishment of these sumptuous works, of which the ordinary admirers are shepherds and countrywomen gathering sheaves during the harvest.[22]

For Level, overemphasis on the appearance of viaducts was misguided, as it detracted from the structures' utilitarian value. His remarks also reveal the class biases inherent in nineteenth-century notions of landscape appreciation. Since uneducated peasants supposedly lacked the discerning eyes of the urban bourgeoisie, there was no purpose in creating a fine prospect just for them, especially "in the middle of savage and deserted country."[23]

Of the dozens of viaducts depicted throughout the nineteenth century, one exceptional structure received particular attention, making it a useful case study for the issue of the adorned railroad landscape. The Chaumont Viaduct (Figure 2.2) crosses the Suize River valley near the town of the same name,

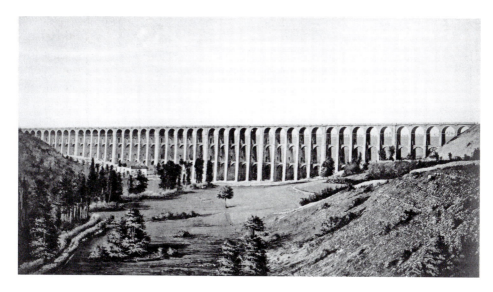

2.2 Unidentified photographer. *Viaduc de Chaumont*, after 1857. Collotype (photolithograph). Édouard Collignon, *Les travaux publics de la France: Chemins de fer* (Paris: J. Rothschild, 1883), plate 4

located on the railroad line from Paris to Belfort built by the Compagnie des chemins de fer de l'Est (Eastern Railroad Company). Erected in only fourteen months in 1856 and 1857, it has 50 arches on its top level, and is nearly 2,000 feet long and 165 feet tall at its highest point. The viaduct's construction was documented in the weekly publication *L'Illustration* in April of 1857.[24] *Le Magasin pittoresque* described and illustrated the viaduct in 1861, praising it as "the most beautiful work of masonry to be found on our railroads."[25] Called a "magnificent viaduct ... boldly thrown across the Suize," it appeared in the Haute-Marne volume of Adolphe Joanne's popular series of departmental geographies.[26] A section of it was diagrammed for a course on railroads taught by prominent engineer Auguste Perdonnet at the École Centrale des Arts et Manufactures (Central School of Arts and Manufactures).[27] Artist Adolphe Maugendre, who specialized in attractive, large-scale colored lithographs of industrial scenes, included it in a group of views of eastern railroad lines.[28] All these descriptions, both textual and visual, exalted the viaduct as a splendid example of modern construction.

The Chaumont Viaduct was also the subject of numerous photographs. As scholars have noted, photography and the railroad, both mechanical wonders of the industrial age, were ideally suited to each other.[29] Photography's seemingly miraculous capturing of perspective, structure, and details gave the medium an unsurpassed aura of truthfulness and clarity, qualities highly valued by engineers. For them, however, photography was only the latest

development in a long line of innovative picture-making methods. The national engineering school, the École des Ponts et Chaussées (School of Bridges and Roads) had originated as a drawing workshop in 1744, and as its curriculum developed, drawing retained an important place. Many surviving drawings from the late eighteenth century are of exceptional artistic quality, particularly the elaborate works created for map-making competitions.[30] In 1817, the school set up one of the first lithographic presses in France, using the new printing technique to reproduce drawings and texts for study and dissemination.[31] This emphasis on images and visuality made the École, and the profession as a whole, quick to realize the usefulness of photography. In 1858, soon after the introduction of wet-collodion-on-glass negatives made photography easier and more widespread, the school started lectures on the medium, established a photographic laboratory, and began collecting photographs.[32]

The texts of several of these lectures were reproduced lithographically and remain in the collections of the engineering school. Little studied, they provide valuable evidence both for engineers' everyday use of photography and for the development of a photographic aesthetic. For instance, L. Bordet, the school's lecturer on the subject in the 1880s and 1890s, concluded his course by declaring photography a "powerful medium" that filled the "need for easy and rapid communication among men that characterizes our epoch."[33] In this view, photographers and engineers were working towards the same goal: the perfection of means of communication, whether roads for traveling or images for exchanging information. Alphonse Davanne, Bordet's predecessor in the 1870s and early 1880s, praised photography for its "exactitude, finesse, [and] authenticity of details,"[34] precisely the qualities needed to construct a new road, bridge, or railway viaduct. Speaking from his own experience in documenting *grands travaux* (great works), Davanne explained that photography could be a useful working tool for both planners and builders. Engineers commissioned photographers to record the area before work started and collect visual data to be used in drawing up site plans; make copies of the finished maps and plans for distribution; document the daily progress of construction; and finally, create images of the finished project that would testify to the success of the endeavor.[35]

One photograph of the Chaumont Viaduct falls into the last category, as it was made for public display rather than everyday use. It is also a landscape image, in which the structure and its setting are equally important. The picture seen here (Figure 2.2) is a high-quality photolithographic reproduction known as a collotype (*phototypie* in French),[36] published by the Ministry of Public Works as part of a series documenting France's engineering achievements. Upon its completion in 1883, *Les travaux publics de la France* (The Public Works of France) comprised five volumes on particular types of construction overseen

by the Ministry: roads and bridges, railroads, rivers and canals, seaports, and lighthouses and buoys. Each volume contained 50 large collotype plates and a lengthy introduction, written by an engineer and illustrated with technical diagrams.

The *Travaux publics* series, as the introduction to the "Railroads" volume explained, intended "to join the useful with the agreeable and to give a serious character to a deluxe work."[37] The project had its genesis in photograph albums displayed for the millions who flocked to the 1873 Universal Exposition in Vienna and the United States' 1876 Centennial Exhibition in Philadelphia.[38] French viaducts, bridges, railroads, and lighthouses thus joined the host of exports on view in the century's grandiose showcases of industry and nationalist competition: porcelain, hosiery, soap, wine, brass instruments, statuary, agricultural implements, and steam engines, among many others. Unlike ribbons or plows, though, neither the *grandes œuvres* (great works) themselves nor their natural settings could be displayed. Instead, the Ministry of Public Works showed numerous models, drawings, and photographs. Three-dimensional models presented visitors with miniature facsimiles of structures. These models improved on the originals in some ways, for they could be viewed and admired from all angles, with supplementary models focusing on special aspects of construction. Drawings included large-scale elevations and cross-sections, often rendered in color for greater visual appeal, as well as highly detailed technical diagrams. Printed books combined illustrations with explanatory texts. With their ease of multiplication, photographs could portray several views of the same structure, or single views of many structures.[39] But they also provided something more: equal attention to the structure and to its surroundings.

The medium's great gift, the portrayal of all objects encompassed by the camera lens, could also be the photographer's bane. Engineering draftsmen were able to exclude all extraneous items such as buildings or vegetation from their renderings of viaducts or bridges, often reducing the landscape to its barest elements: strips of brown or blue to represent earth or water, basic outlines of rocks, and perhaps one or two trees. Furthermore, such drawings were usually elevations or cross-sections that turned three-dimensional structures into two-dimensional patterns.[40] The resulting images are marvels of clarity, simplicity and precision, portraying ideal structures in an abstracted world.

Photographers endeavored to create images of actual constructions that would complement such drawings. In his 1888 lecture on photography at the École des Ponts et Chaussées, L. Bordet cautioned the engineering students about perspective. When depicting structures, he said, it was imperative to:

place the camera so that the perspective obtained is exact ... the picture plane, that is, the ground glass [on which the image appears before exposing the negative] ... must be perfectly vertical. If it is tilted, the vertical lines will no longer

produce the parallel lines of images in perspective ... you will have monuments with pointed or flared forms, houses that seem to fall into the street, etc.[41]

Since parallel lines are the most prominent defining features of grand engineering works, creating pointed or flared monuments would result in photographic caricature. The engineers and the government that sponsored them wished to portray the structures as stable and solid, at one with the terrain. Strange camera angles might cast doubt on the strength of the monuments themselves.

Distortion in perspective rarely arose with structures photographed frontally from a distance, as the Chaumont Viaduct was in this instance. The image reproduced in the *Travaux publics* railroad volume (Figure 2.2), however, bears evidence of another sort of manipulation. Virtually all of the trees and shrubs in the foreground, as well as the small trees seen through the arches of the viaduct, were added to the image by hand. In many cases, brushstrokes are clearly visible, with the shape and texture of the plants betraying their non-photographic nature. Retouching is also visible in many other parts of the photograph; stippling was added to the slope on the right, brushwork appears on the inner sides of some of the viaduct's arches, and subtle clouds were added to the sky.[42] These additions are remarkable interventions for a photograph that purports to show the structure and its surroundings truthfully. For the unidentified photographer and his clients, it was evidently more important to show an attractive image than to be completely accurate. The Chaumont photograph is not an anomaly; at least a dozen of the hundred images in the two *Travaux publics* volumes on roads and bridges and on railroads display changes ranging from the enhancement of reflections in a river to the addition of vegetation, though only a few have changes as extensive as seen here.

Nineteenth-century photographers claimed to oppose such heavy retouching, at least in their written statements. It was on a par with hand-coloring of photographs: acceptable for the common run of portraiture, but not permitted for any practitioner with serious artistic ambitions. The topic was frequently debated at the Société française de photographie, with the exhibition jury unanimously deciding in 1856 to eliminate from competition any "mixed works of the photographer and the painter" as "fatal" to both media.[43] Beyond such minor repairs as erasing dust specks and using tinted varnish to improve the overall tone of an image, retouching was also frowned upon in engineering photography. Photographer Adolphe Davanne told Ponts et Chaussées students in 1883 that they should take care to avoid any interventions that "completely modify the work of the light by substituting the work of the hand."[44]

As inauthentic as the picture of the Chaumont Viaduct appears, it may have been intended to portray an actual transformation of the landscape. The

author of the 1861 article in *Le Magasin pittoresque* praised the close relationship between the structure and its setting, stating that "the surrounding landscape brings out this majestic construction very well." The writer then described the town of Chaumont's success in "creating a real forest of pines and firs in absolutely sterile and denuded soil" on "bald hills," concluding that it was "a fine example to cite to those who deny the possibility of reforestation."[45] The coming of the railroad, with its promise of increased tourism, may have been the impetus for improving the aesthetics of the area. Such reforestation projects were increasingly common in the nineteenth century, as authorities gradually realized that wooded areas needed to be nurtured and managed, rather than simply stripped for lumber or cleared for agriculture.[46] Thus, the artificial trees in the photograph perhaps reflected a future reality, itself rooted in an ideal vision of the modern landscape.

Suspension bridges, like viaducts, were vital connectors in France's growing transportation network. Their design and construction, however, were quite unlike those of the arched stone structures. Images of suspension bridges often portrayed them as having a different relationship to the surrounding landscape, sometimes even blending the spans into the background. Texts and visual imagery emphasized the form's elegance, but also often alluded to its instability.

Suspension bridges became popular in the 1820s and 1830s partly because of advances in metalworking, especially the ability to "spin" cables of thick bundles of wires. Used in France solely for roads, and usually reserved for smaller spans, the bridges were quick and economical alternatives to masonry structures.[47] They were normally not considered reliable enough or strong enough to carry railroad lines; the suspension bridge over Niagara Falls was a well-known exception, greatly admired for its daring. In an 1888 lecture on "grand metal constructions," Gustave Eiffel mentioned the Niagara Bridge, praising the innovative spirit of American engineers "who have applied themselves to perfecting the type of suspension bridges that we know in France and who have obtained the most remarkable results, even making trains pass safely across them, which we have always hesitated to do in Europe."[48]

A small group of Impressionist canvases reveals some of the complexities inherent in portraying such unique structures.[49] In the spring and summer of 1872, Alfred Sisley included a suspension bridge in several of the paintings he made in Villeneuve-la-Garenne, a small town on the Seine near Paris. In one canvas, titled *The Bridge at Villeneuve-la-Garenne* (The Metropolitan Museum of Art, New York; Figure 2.3), the bridge appears at the side of the picture. By including houses and people in the painting, Sisley emphasized the bridge's function as a connector, part of the fabric of town life. He also carefully delineated its structure, just as an engineer might, noting the different shapes and textures of its stone piers, iron pillars, and interlacing cables.

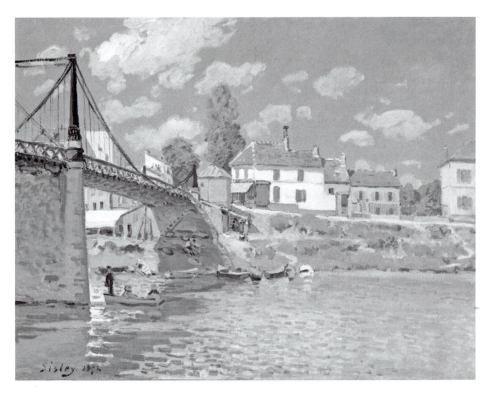

2.3 Alfred Sisley (1839–99). *The Bridge at Villeneuve-la-Garenne*, 49.5 × 65.4 cm
(19½ × 25¾ in), oil on canvas,1872. The Metropolitan Museum of Art, New York

In two other paintings from the same year, however, Sisley treated the
bridge quite differently. In both *The Bridge at Villeneuve-la-Garenne* (Fogg Art
Museum, Harvard University) and *Drying Nets* (Kimbell Art Museum, Fort
Worth; Figure 2.4), the structure is shown in the middle distance, parallel
to the picture plane, and has been radically simplified, even obscured.
Sisley made significant changes to the bridge structure in these paintings,
completely eliminating the small vertical cables that transmit the weight
of the roadbed to the large curved cables. The bridge, as he has shown it,
would not support itself, let alone the people and vehicles crossing it. In
the Fogg painting, he used brushstrokes of varying thickness to portray
the large cables, adding different strokes to successive paint layers and
even changing the position of the cables in several places. Had Sisley been
painting in a precise, academic manner, he would have had to render the
bridge consistently and geometrically, with its cables in a perfect curve,
as he did in the Metropolitan painting. The looseness of handling in this
painting, however, made such strictures less necessary, even allowing him
to leave his changes fully visible.

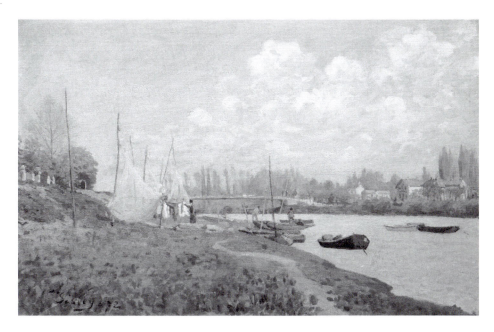

2.4 Alfred Sisley (1839–99). *Drying Nets*, 42 × 65 cm (16½ × 25⅝ in), oil on canvas, 1872. Kimbell Art Museum, Fort Worth

In the Kimbell canvas, the bridge is even more fragile. The thin lines representing the cables do not make structural sense, and much of the bridge is obscured behind the fishing nets hung out on poles to dry. The thin poles and gossamer forms, beautifully painted, hint at the insubstantiality of the structure that they cloak. Wood posts and woven fibers may seem to be odd surrogates for iron pillars and wire cables, but the earliest suspension bridges were made of similar materials. This ancestry may have been familiar to nineteenth-century viewers, since reports of such bridges appeared in travel accounts and other popular texts.

Readers of *Le Magasin pittoresque*, for instance, learned from an 1833 article that suspension bridges had supposedly originated in the "hilly, steep lands" of South America, "where crevasses are frequent and waters torrential."[50] Peruvian natives crafted "ponts de hamac" ("hammock bridges"), 120 feet or more long, out of fibrous agave roots slung between rough wood pillars. Such structures, which were like "ribbons suspended over a crevasse or torrent," were precarious and dangerous. A person alone did not fare too badly, as long as he went "as fast as possible, throwing his body forward," but if a native guide stepped more quickly than a traveler, or if, "frightened by the appearance of the water through the intersections of bamboo," the Westerner had the "imprudence to stop in the middle of the bridge ... the oscillations of the cords would become very strong."[51] Seen in this light,

European suspension bridges like the one at Villeneuve-la-Garenne were not simply sleek and modern. Rather, they had associations with "primitive" cultures, exotic adventures, and fantastical landscapes.

Another possible source for the insubstantiality of the structures in Sisley's two canvases is an optical illusion known to affect suspension bridges. An 1837 contributor to *Le Magasin pittoresque*, describing the newly erected Fribourg Bridge in Switzerland, testified that at a distance "the suspension cables are hardly visible, and the spectator could believe that the bridge is no more than a plank long enough to unite the two opposed rocks; he is tempted to attribute all the merit of this work to the art of carpentry."[52] The author was examining the bridge not as an isolated structure, but as one element in a landscape scene. Only by looking carefully could he see the black lines of the supporting cables. But a disjunction remained between the eye's evidence and the mind's ability to process it; as the writer concluded, "the artifice of suspension is thus unveiled; but one still does not see how the engineer overcame the[se] difficulties."[53] Sisley's treatment of the bridge can be partly interpreted as a record of the perceptual complications in examining such a structure from a distance and capturing it in paint. His changes and varying brushstrokes highlight the paradox between the stability of the roadbed and the delicacy and near invisibility of the cables that miraculously support it.

Suspension bridges also had associations with one of the most innovative, contemporary art forms of the era: the ballet. Author Alexandre Dumas, traveling in southern France in the early 1830s, described a structure at Remoulins similar to the Villeneuve-la-Garenne span: "an iron suspension-bridge attached to four fluted columns as delicate and aerial as the bridge itself." He continued, "The effect produced by this model of lightness is so striking that an amateur of the Terpsichorean art has written on one of the columns, *Pont Taglioni* (Taglioni's Bridge); and this name has clung to it ever since."[54]

The anonymous graffiti artist, and those who took up the name, were evidently admirers of Marie Taglioni, a star ballet dancer of the day renowned for her ethereal appearance in such ballets as *La Sylphide* and *Flore et Zéphire* and frequently depicted in prints.[55] Poet and playwright Alfred de Musset praised Taglioni's 1832 performance in *La Sylphide*, calling her "a floating soul … a fluttering flame." She apparently did not need the mechanical aids that others relied on to convey the illusion of flight: "They do not make her fly through the air at the end of a wire like her fellow dancers; yet she glides much higher than them in the sky without barely leaving the ground."[56] The use of wires in such stagecraft was a further link between the dancer and the bridge, though the two shared much more: formal innovation, graceful movement, delicacy based on underlying strength, and romantic appeal.

Movement, however, could be dangerous. The deadliest suspension bridge failure in France was the collapse of the Basse-Chaîne Bridge in the

city of Angers, southwest of Paris. Completed in 1839, the bridge featured Egyptianate obelisks supporting the cables. In April of 1850, a troop of soldiers was crossing the bridge. Strong winds from a storm were making the bridge sway slightly, and some of the men began marching in time with the motion. Suddenly, two of the pillars supporting the cables at one end of the bridge gave way, spilling the men into the water. The engraving in *L'Illustration* captured the sickening minutes just after the collapse, with the tightly packed mass of soldiers struggling to stay afloat.[57] By contrast, the *Illustrated London News* depicted the sad landscape as seen after the event, with the cables' ends hanging raggedly as people in small boats searched for the remaining corpses.[58] Of the 487 who fell into the water, nearly half perished; the final death toll was 226. It was later determined that the storm, combined with the marching and some rusting of the cables, caused the disaster.[59]

One of the most dramatic images of a suspension bridge collapse appeared in *L'Illustration* in 1872 (Figure 2.5), the same year Sisley painted the Villeneuve-la-Garenne span. The Constantine Bridge, near the current Sully Bridge, was a suspension footbridge. In October, while the structure was undergoing extensive repairs, several of the cables suddenly snapped, sending the roadbed plunging into the Seine. The engraving purports to capture the precise moment of the disaster. The geometrical perfection of the suspension bridge is instantly transformed into a nightmare of twisted cables, writhing like angry serpents. The stone triumphal arches and their piers, however, are unaffected.

Such tragedies intensified already existing fears about suspension bridges. Their skeletal forms, which apparently concealed nothing, were vulnerable to the smallest threats. Rust, for instance, ate away at the ends of the cables (supposedly securely anchored in masonry foundations) or dissolved them invisibly from within, one wire at a time. The very calculations and formulae that made the structures possible were undone by the phenomenon of periods of vibration, which itself followed mathematical laws. Wind gusts and footsteps, combined in the right patterns, could destroy iron and stone. No wonder that one engineer claimed as early as 1853 that "in the first fifteen years of their construction, at least a third of these bridges were lost as a result of unforeseen accidents."[60] Though exaggerated, this statement does show the growing awareness of suspension bridges's vulnerability, which soon led to a nearly complete abandonment of the form in France until the twentieth century.[61]

For Alexandre Dumas, the monumental Pont du Gard aqueduct and the ballerina-like Remoulins suspension bridge were "emblems of the two states of society which created them." Ancient Rome and modern France, he wrote, could not be more different:

The one, full of confidence in itself, reposing on its colossal base, and believing in an existence of ages, built for eternity; the other, skeptical,

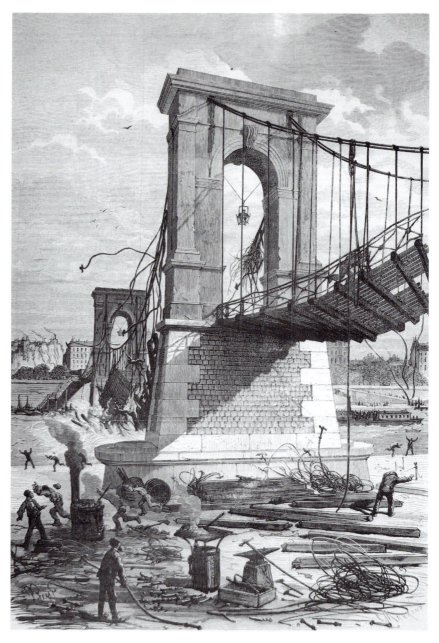

2.5 Pérat (engraver). *Paris: L'accident du pont de Constantine—Chute du tablier du pont dans la Seine* (Paris: Constantine Bridge Accident—Fall of the Bridge's Roadway into the Seine). Wood engraving. *L'Illustration*, 60 (October 19, 1872): 252

inconstant, frivolous, and alive to the progress that is made every
day, erects temporary structures for the passing generation.[62]

Beyond such rhetoric, however, the divisions between ancient and modern
were not so clear-cut. By building enormous masonry viaducts, nineteenth-
century engineers sought to emulate and even surpass the Romans. They
saw no paradox in using age-old icons of stability and permanence in
order to carry the railroad, one of the era's most powerful symbols of speed
and progress. Visual imagery added yet more layers to these tissues of
representations. Pictures of viaducts bolstered the engineers' claims that their
structures enhanced their surroundings, rather than destroying them. The
drive to adorn the landscape was so strong that photographers sometimes
even took matters into their own hands, retouching extensively in violation
of the tenets of photographic practice. As impure as these photographs may
seem today, they were highly valued at the time of their creation, since many
were specifically chosen to represent France's best technical achievements
to a wide public. The photographers and their clients evidently found no
contradictions in creating scenery to serve as a better frame for a precisely
rendered *grande œuvre*.

As for suspension bridges, what Dumas saw as frivolity was the
engineers' innovative economy, mathematics embodied in the elegant
curve of iron cables. Developing from old and even "primitive" prototypes,
suspension bridges stood at the pinnacle of high technology in the 1830s
and 1840s. Images of these bridges in their landscape settings might seem
at first to be simple and straightforward, the engraved or painted lines
traced on the depicted landscape to copy the structures' delicate cables
decorating the actual terrain. But just as the bridges could seem to vanish
into their natural surroundings when seen at a distance, the masking,
elisions, and erasures in Alfred Sisley's paintings reflect not only artistic
license, but also the uncertainties engendered by such daring feats of
engineering. These anxieties crystallized in images of bridge failures,
which demonstrated both the flaws in the structures and the ever-present
potential for dangerous ruptures in the fabric of modernity itself.

Acknowledgment

I would like to thank the participants in the "Visions of the Industrial Age"
symposium for their feedback on an earlier version of this paper. Specific
contributions are noted below. I am also very grateful to Joseph Rucker
and Kristel Smentek for their careful reading and helpful comments. All
translations from the French are mine unless otherwise noted.

Notes

1. Édouard Collignon, *Les travaux publics de la France: Chemins de fer*, vol. 2 of *Les travaux publics de la France*, ed., Léonce Reynaud (Paris: J. Rothschild, 1883); reprinted with additional photographs as *Les chemins de fer au XIXᵉ siècle, d'après l'œuvre de Léonce Reynaud "Les travaux publics de la France"* (Paris: Presses de l'École nationale des Ponts et Chaussées, 1988), 27: "On donne le nom de *viaducs* à ces grands ouvrages, qui, quand ils sont construits avec goût et qu'on y emploie de bons matériaux, contribuent toujours à orner des paysages."

2. Much has been written on nineteenth-century French landscape imagery. The late Nicholas Green's *The Spectacle of Nature: Landscape and Bourgeois Culture in Nineteenth-Century France* (Manchester: Manchester University Press, 1990) remains the principal analysis of the consumption of the French landscape. Another useful source for the period is Steven Adams, *The Barbizon School and the Origins of Impressionism* (London: Phaidon, 1994). Among the many exhibition catalogues examining the topic are Bonnie L. Grad and Timothy A. Riggs, *Visions of City and Country: Prints and Photographs of Nineteenth-Century France* (Worcester, MA: Worcester Art Museum; New York: American Federation of Arts, 1982) and Richard Brettell et al., *A Day in the Country: Impressionism and the French Landscape* (Los Angeles: Los Angeles County Museum of Art, 1984, 1990).

3. For Impressionist painting, see especially James H. Rubin, *Impressionism and the Modern Landscape: Productivity, Technology, and Urbanization from Manet to Van Gogh* (Berkeley and Los Angeles: University of California Press, 2008). See also Robert L. Herbert, *Impressionism: Art, Leisure and Parisian Society* (New Haven: Yale University Press, 1988), chapter 6; and Paul Hayes Tucker, *Monet at Argenteuil* (New Haven: Yale University Press, 1982), chapter 3. For photography, see Malcolm Daniel and Barry Bergdoll, *The Photographs of Édouard Baldus* (New York: Metropolitan Museum of Art; Montreal: Canadian Centre for Architecture, 1994); and Elizabeth Anne McCauley, *Industrial Madness: Commercial Photography in Paris, 1848–1871* (New Haven: Yale University Press, 1994), chapter 5 (on Hippolyte Auguste Collard).

4. In kilometers, the figures are respectively 6,500 and 4,750; conversions from metric measurements are approximate. Roger Price, *The Modernization of Rural France: Communications Networks and Agricultural Market Structures in Nineteenth-Century France* (London: Hutchinson, 1983), 209.

5. Léon Durand-Claye, "Notes prises au cours de routes. Annexe. Lever des plans et nivellement …," lithographed text, 1884 (Fonds ancien, Bibliothèque de l'École nationale des Ponts et Chaussées [hereafter ENPC], Champs-sur-Marne), 1: "la forme de la surface de la terre … n'est pas susceptible de définition géométrique, et n'obéit à aucune loi."

6. Charles Bricka, *Cours de chemin de fer, professé à l'École nationale des ponts et chaussées*, vol. 1, *Études, construction, voie et appareils de voie* (Paris: Gauthier-Villars et fils, 1894), 139.

7. Ibid.: "Lorsqu'on peut employer la maçonnerie, il ne faut jamais hésiter à le faire."

8. Alexandre Dumas, *Pictures of Travel in the South of France* (London: Offices of the National Illustrated Library, n.d. [1850s]), 171.

9. Gabriel-Joseph-Hippolyte Laviron, "Revue générale de l'architecture et des travaux publics," *L'Artiste*, 2ⁿᵈ ser., vol. 5 (1840): 136, 137: "cette sorte de fétichisme dont les ouvrages de l'antiquité était devenus l'objet … . Qu'était-ce que ces temples taillés aux flancs des montagnes, ces pyramides, ces phares, ces aqueducs, ces amphithéâtres immenses? Rien autre chose que des jeux d'enfants dans lesquels les premières sociétés … essayaient la puissance de leur précoce virilité."

10. Amédée Guillemin, *Simple explication des chemins de fer* (Paris: Hachette, 1862), 134: "Les anciens nous ont laissé des modèles si grandioses, qu'il ne manquera pas de gens tout prêts à rabaisser au profit des œuvres de l'antiquité, les constructions modernes."

11. *Les chemins de fer au XIXᵉ siècle*, 3: "nos oeuvres, considérées en elles-mêmes, l'emportent de beaucoup sur celles des anciens. Nos chemins de fer seuls ont fait construire en Europe, depuis un demi-siècle à peine, plus d'ouvrages analogues aux célèbres aqueducs des Romains que n'en produisaient jadis des milliers d'années."

12. Ibid.: "nos constructions témoignent de plus de science et de hardiesse, sans présenter pour la plupart moins de garanties de durée, que celles dont on se plaît trop souvent à exalter outre mesure les mérites." Reynaud went on to point out an additional virtue of modern public works: they were built without the use of slave labor (3–4).

13. Quoted in Daniel and Bergdoll, *The Photographs of Édouard Baldus*, 85–6.

14. J.P. Thénot, *Traité de perspective pratique pour dessiner d'après nature* (Liège: Avanzo, 1845), frontispiece.

15. Guillemin, *Simple explication des chemins de fer*, 141–2.

16. Arsène Houssaye, "De la poésie, de la vapeur, et du paysage," *L'Artiste*, 3rd ser., vol. 1 (1844): 101: "le chemin de fer de Paris à la mer couperait le vieil arbre, les buissons, le rocher, la fontaine, enfin la montagne, pour aller plus vite."

17. Guy de Maupassant, "Petits voyages: En Auvergne," *Gil Blas* (July 17, 1883); reprinted in Maupassant, *Chroniques 2: 1er mars 1882–17 août 1884* (Paris: 10/18, 1980), 235, 236: "inspirés par … le génie du Laid, ils gâtent tout d'une simple coup de plume"; "ces gens à compas."

18. Engraver Émile Thérond was known for his book illustrations and images for *L'Illustration* and other periodicals. Guillemin, *Simple explication des chemins de fer*, 142: "Voyez plutôt ce charmant croquis, si spirituellement dessiné par Thérond."

19. Guillemin, *Simple explication des chemins de fer*, 142: "Il me semble que ces beaux viaducs, leur longues files de blanches arcades, tour à tour masquées par des rochers ou des massifs de verdure, sont d'une effet décoratif à la fois très-simple et très-heureuse."

20. Ibid., 142–43: "Pensez-vous qu'un peintre de paysage eût fait un choix de mauvais goût, en prenant ce point de vue pour le sujet d'un de ses tableaux? … Ne trouvez-vous pas aussi que les lignes un peu fermes de cet autre viaduc … forment avec la nature aride d'alentour un harmonieux ensemble?"

21. Émile Level, "Les chemins de fer d'intérêt local et la loi du 12 juillet 1865," *Revue contemporaine*, 15th year, 2nd ser., vol. 49 (1866): 516: "On connaît les magnifiques ouvrages élevés par les compagnies sur les vallées et sur les fleuves."

22. Ibid.: "L'art du constructeur y est poussé à ses dernières limites; on ne peut rien imaginer de plus grandiose et de plus majestueux. Tout le luxe de la décoration est consacré à l'embellissement de ces somptueux travaux, dont les admirateurs ordinaires sont les pâtres et les campagnardes ramassent les gerbes lors de la moisson."

23. Level, "Les chemins de fer d'intérêt local et la loi du 12 juillet 1865," 517: "une grande magnificence au milieu de pays sauvages et déserts."

24. *L'Illustration* 29 (April 25, 1857): 272. J. Caildrau was the engraver; the caption states that the engraving was based on a photograph by Carrier.

25. "Ce qu'on voit sur un chemin de fer," *Le Magasin pittoresque* 29 (1861): 123: "Le plus bel ouvrage de maçonnerie que l'on rencontre sur nos lignes de fer."

26. Adolphe Joanne, *Géographie du département de la Haute-Marne* (Paris: Hachette, 1881), 56: "Magnifique viaduc … hardiment jeté sur la Suize."

27. Auguste Perdonnet and André-Auguste Jacquin, *École centrale des arts et manufactures, cours professé par M. A. Perdonnet: Nouvel album des chemins de fer, par A. Jacquin …* (Paris: Lacroix et Baudry, [c. 1858]), plate 6.

28. Adolphe Maugendre, *Chaumont: Vue du viaduc prise du bois du Fays, c.* 1860, colored lithograph, Compiègne, Musée de la voiture, RMN33122.

29. See, for instance, Anne M. Lyden, *Railroad Vision: Photography, Travel, and Perception* (Los Angeles: J. Paul Getty Museum, 2003), and Jean Desjours and Bertrand Lemoine, *Le grand œuvre: Photographies des grands travaux, 1860–1900* (Paris: Centre national de la photographie, 1983).

30. Antoine Picon and Michel Yvon, *L'ingénieur artiste: Dessins anciens de l'École des Ponts et Chaussées* (Paris: Presses de l'École nationale des Ponts et Chaussées, 1989), 24–5.

31. Antoine Raucourt de Charleville was a senior student at the École when he was asked to oversee the new lithographic press; see his *Mémoire sur les expériences litrographiques* [sic] *faites à l'École royale des Ponts et Chaussées de France, ou Manuel théorétique et pratique du dessinateur et de l'imprimeur lithographiques …*.(Toulon: Auguste Aurel, 1819). The first published portfolio of lithographed drawings from the École appeared in 1821: Charles Berigny, ed., *Collection de 350 dessins, relatifs à l'art de l'ingénieur et lithographiés à l'École royale des Ponts et Chaussées* (Paris: École royale des Ponts et Chaussées, 1817–21). Several more collections followed.

32. *Les chemins de fer au XIXe siècle*, v.

33. ENPC, "Conférences sur la photographie par M.L. Bordet, ancien élève de l'École polytechnique," lithographed text, 1888 (Fonds ancien, Bibliothèque de l'ENPC), 170: "la photographie est un moyen puissant pour donner satisfaction au besoin de communications faciles et rapides entre les hommes qui caractérisent notre époque."

34. ENPC, "Conférences sur la photographie par M.A[lphonse] Davanne," lithographed text, 1883 (Fonds ancien, Bibliothèque de l'ENPC), 1: "l'exactitude, la finesse, l'authenticité des détails."

35. Ibid., 2–3.

36. In its detail and tonality a collotype strongly resembles an original photographic print, partly because it is made using a glass-plate negative. A difficult and demanding reproductive process, collotype was largely reserved for use in such luxury publications as the *Travaux publics* volumes. For a description of the process, see Gordon Baldwin, *Looking at Photographs: A Guide to Technical Terms* (Los Angeles: J. Paul Getty Museum in association with British Museum Press, 1991), 29–30.

37. Quoted in *Les chemins de fer au XIXᵉ siècle*, v: "joindre l'utile à l'agréable et de donner un caractère sérieux à un ouvrage de luxe."

38. The total number of visitors for the 1876 Centennial Exhibition, which lasted for six months, was 9,910,966 people. Edwin Wolf 2nd, *Philadelphia: Portrait of an American City* (Harrisburg, Pa.: Stackpole Books, 1975), 235.

39. Judging from photographs of the 1876 Centennial Exhibition taken by the Centennial Photographic Company, the major French contributions in the main exhibition halls were luxury goods, artworks, clothing and accessories, and foodstuffs. Views of the interior of the separate French Public Works Building show drawings and maps on the walls. On the tables are models and dozens of portfolios, albums, and books of various sizes for visitors to leaf through. Centennial Exhibition Digital Collection, Free Library of Philadelphia, http://libwww. library.phila.gov/CenCol/index.htm, nos. c021575 and c021576, accessed September 18, 2006. The collection contains two other images of the Public Works building; no. c021577 shows the exterior, and no. c090190 is a colored lithograph depicting it and two other of the French Commission's buildings. Twenty-two of the albums on display in the Public Works Building contained photographs. There were three albums on bridges, one on roads, and seven on railroads; the rest covered rivers, canals, harbors, lighthouses, waterworks, and public buildings. Ministère des Travaux Publics, *Universal Exhibition at Philadelphia in 1876; France: Notices on the Models, Charts, and Drawings Relating to the Works of the "Ponts et Chaussées" and the Mines, Collected by Order of the Ministry of Public Work*s (Paris: Government Printing Office, 1876), 348–9.

40. See, for instance, Antoine Picon and Michel Yvon, *L'ingénieur artiste: Dessins anciens de l'École des Ponts et Chaussées* (Paris: Presses de l'École nationale des Ponts et Chaussées, 1989), 108–13.

41. ENPC, "Conférences sur la photographie par M.L. Bordet," 49.

42. Such retouching was done on the original glass-plate negative, which could then be contact printed to make either an albumen print or a collotype printing plate of hardened gelatin. See Baldwin, *Looking at Photographs*, 29–30.

43. "Rapport du jury chargé de juger la section de photographie à l'Exposition universelle des arts industriels de Bruxelles," *Bulletin de la Société française de la photographie* 2 (1856): 350: "Il faut donc rejeter ces œuvres mixtes du photographe et du peintre; elles sont fatales à la Photographie aussi bien qu'à la peinture." The retouching debate continued well into the next decade; see also "Procès-verbal de la séance du 12 février 1864," *Bulletin de la Société française de la photographie* 10 (1864): 34–7.

44. ENPC, "Conférences sur la Photographie par M. A[lphonse] Davanne," 69: "modifient complètement l'oeuvre de la lumière pour y substituer le travail de la main."

45. I would like to thank Paula Lee, whose questions led me to take a closer look at the significance of the vegetation in this image. "Ce qu'on voit sur un chemin de fer," 125, 126: "Le paysage environnant fait très-bien ressortir cette majestueuse construction. D'un côté, on aperçoit la ville de Chaumont avec sa vieille église, ses fortifications et ses promenades; de l'autre, la montagne de Saint-Roch, autre promenade fort pittoresque, où la ville a réussi, à force de persévérance, à créer une véritable forêt de pins et de sapins sur un sol absolument stérile et dénudé: aussi continue-t-elle ses plantations sur les autres collines chauves du voisinage. Bel exemple à citer aux gens qui nient la possibilité du reboisement!"

46. Raphaël Larrère and Olivier Nougarède, *Des hommes et des forêts* (Paris: Gallimard, 1993), 80–7.

47. For an overview of suspension bridge construction in France, see Bernard Marrey, *Les ponts modernes, 18ᵉ–19ᵉ siècles* (Paris: Picard, 1990): 114–33. Eda Kranakis provides an in-depth comparative study of the development of suspension bridge technology in *Constructing a Bridge: An Exploration of Engineering Culture, Design, and Research in Nineteenth-Century France and America* (Cambridge, MA: MIT Press, 1997).

48. Gustave Eiffel, *Les grandes constructions métalliques: Conférence à l'Association française pour l'avancement des sciences, le 10 mars 1888* (Paris: Chaix, 1888); quoted in Sylvie Deswarte and Raymond Guidot, "Gustave Eiffel et les grands ponts métalliques du XIX^e siècle," *Monuments historiques* 3 (1977): 75–6: "qui se sont appliqués à perfectionner le type de ponts suspendus que nous connaissons en France et qui sont arrivés aux résultats les plus remarquables, en y faisant passer avec sécurité même des trains de chemin de fer, ce devant quoi on a toujours reculé en Europe."

49. I would like to thank James H. Rubin for helping me develop my ideas about Sisley's paintings.

50. "Ponts suspendus en corde," *Le Magasin pittoresque*, 1 (1833): 96: "des contrées monteuses, abruptes, où les crevasses sont fréquent et les eaux torrentueuses."

51. Ibid.: "des rubans suspendus au-dessus d'une crevasse ou d'un torrent"; "aussi vite que possible, et en jetant le corps en avant"; "effrayé par l'aspect de l'eau qu'il découvre à travers les interstices des bambous, il a l'imprudence de s'arrêter au milieu du pont"; "les oscillations des cordes deviennent très forte."

52. "Pont suspendu de Fribourg, en Suisse," *Le Magasin pittoresque*, 5 (1837): 195–6: "les câbles de suspension sont à peine visibles, et le spectateur peut croire que le pont n'est qu'une planche assez longue pour unir entre eux les deux rochers opposés; il est tenté d'attribuer à l'art de la charpenterie tout le mérite de ce travail."

53. Ibid., 196: "L'artifice de suspension est alors dévoilé; mais on ne voit pas encore comment l'ingénieur à surmonté les difficultés."

54. Dumas, *Pictures of Travel in the South of France*, 170–1. Only the columns of the bridge now remain.

55. See Parmenia Migel, *Great Ballet Prints of the Romantic Era* (New York: Dover Publications, 1981), especially plates 8, 9, 11, and 13.

56. Alfred de Musset, "Chronique de la quinzaine," *Revue des deux mondes*, 7 (August 30, 1832): 641: "C'est une âme qui flotte. C'est une flamme qui voltige. On ne lui fait pas, comme à ses compagnes, traverser l'air au bout d'un fil, et cependant, sans presque quitter la terre, elle plane bien plus haut d'elles dans le ciel."

57. *L'Illustration*, 1 (April 1850): 260; reproduced in Marcel Prade, *Ponts et viaducs au XIX^e siècle: Techniques nouvelles et grandes réalisations françaises* (Paris: Errance; Poitiers: Brissaud, 1989), 119. The engraving shows a few soldiers momentarily buoyed by their knapsacks; most, however, have gone under quickly, leaving only their caps floating on the surface. A great number of the falling soldiers frantically wave their rifles in the air. These were the source of many injuries; as the *Journal du Maine et Loire* reported, most men "were found to be wounded by the bayonets or by the fragments of the bridge falling on them." Quoted in "Fall of the Suspension-Bridge at Angers," *Illustrated London News*, 16 (April 27, 1850): 282.

58. "Fall of the Suspension-Bridge at Angers," 282. The engraving appeared on the front page of this issue, captioned "Remains of the Suspension-Bridge at Angers, after the Late Accident."

59. Prade, *Ponts et viaducs au XIX^e siècle*, 118–19.

60. Émile Beysselance, *L'Ingénieur*, 1853; quoted in Marrey, *Les ponts modernes*, 132: "dans les quinze premiers années de leur construction, le tiers au moins de ces ponts disparaissait par suite des accidents imprévus."

61. Marrey, *Les ponts modernes*, 130–3.

62. Dumas, *Pictures of Travel in the South of France*, 172.

Armand Guillaumin:
the industrial Impressionist[1]

James H. Rubin

Of the 12 Impressionists who exhibited together and shared many attitudes and styles, Armand Guillaumin (1841–1927) is undoubtedly the least known and studied. He was a close companion of Paul Cézanne, Camille Pissarro, Paul Gauguin, Vincent Van Gogh, and Paul Signac. Why, then, this neglect? I believe the reason is that during the years of the Impressionists' close association, when they were defining themselves as a group, Guillaumin's work was the most overtly oriented towards scenes of industry and labor. Although his Impressionist cohorts were certainly committed to painting modern life, other artists, such as Claude Monet, represented modernity more frequently through images of pleasure and leisure. Once the Impressionists gained patrons and recognition in the 1880s, these themes took over almost completely. Even Guillaumin seems to have shifted his orientation somewhat in his later work, especially when he won the lottery in 1891, and could live wherever he wanted. His many fine early representations of industrial scenes and elements of modern infrastructure in the landscape were more or less forgotten.

As an introduction, a few words about the famous painting by Claude Monet, *Impression: Sunrise* (1873, Musée Marmottan, Paris) may be useful. Monet is certainly the best known of the Impressionists. This painting is justifiably admired, not just because its representation of mist and early morning light is extraordinarily beautiful and skillful but also because this is the painting that gave Impressionism its name. It was shown with four other of Monet's paintings at the first Impressionist exhibition, which took place in 1874. It should be observed that it was far more sketchily painted than any of his other pictures, for example, his second painting of *Le Havre, Fishing Boats Leaving the Port* (1874, Los Angeles County Museum of Art) that was exhibited alongside it. All art historians know the story of how a satirical critic coined the term "Impressionism."[2] But the majority of art historians still have to be

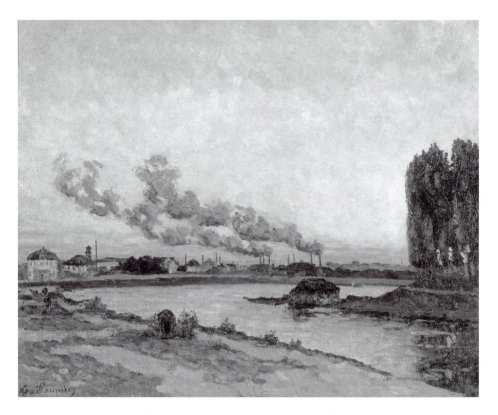

3.1 Armand Guillaumin, *Sunset at Ivry* (1869), Musée d'Orsay, Paris

reminded to look beyond *Impression: Sunrise*'s aesthetic beauties to discover that it represents the industrial port of Le Havre, France's busiest port at this particular time in history, and one that was expanding and modernizing. The importance of Le Havre for Monet was such that he did ten paintings showing different views, the largest group on a single topic until his 11-part series of train stations in 1877. Having escaped damage during the Franco-Prussian War, Le Havre was a leading economic engine for French post-war recovery.[3] An understanding of the painting that takes these factors into account is only relatively new, and it has had little impact on the overall characterization of Impressionism, which is still regarded as an art of bourgeois leisure in the countryside. However, in 1874, countryside was present in only one painting among the five that Monet exhibited, *Wild Poppies* (1873, Musée d'Orsay, Paris). And although there is general agreement about *Impression: Sunrise*'s celebratory emotion, that feeling is now most often associated in the public mind with artistic freedom rather than with economic activity and national pride.

In 1869, Armand Guillaumin did a painting of the *Sunset at Ivry* (1869, Musée d'Orsay, Paris; see Figure 3.1) that exhibits many characteristics of

Monet's views of Le Havre. Although made before the Franco-Prussian War, as well as before Monet's painting of Le Havre, it, too, was exhibited at the first Impressionist exhibition in 1874. It caused little stir, perhaps because it was not so freely painted as *Impression: Sunrise*. Yet, like *Impression: Sunrise*, which was part of Monet's large group of paintings at Le Havre, *Sunset at Ivry* was part of a sizeable number of works Guillaumin did at Ivry, and several versions exist of it. The group included a signed and dated drawing and sketch-like studies, one of which (*The Seine at Ivry*, c. 1869, Musée du Petit Palais, Geneva) seems almost as freely painted as Monet's famous picture, but which Guillaumin neither exhibited nor described with a word like "impression." Another picture, of similar dimensions to *Sunset at Ivry* (*Snow at Ivry*, 1873, Musée du Petit Palais, Geneva), is something like a companion piece to it.

Just as Monet, who was raised in Le Havre, was representing familiar territory, so was Guillaumin. A clerk for the Paris-Orléans Railway, which was based at the train station now known as the Gare d'Austerlitz, Guillaumin knew the industrial banks of the river Seine in the southeastern part of Paris well. They had already been and would continue to be the main center of his activity. Indeed, some of his very earliest works, dating from about 1865, document industrial activity on both the river bank and the river itself.

Two grand enterprises dominated Ivry: the Guibal rubber factories and the scrap metal forges founded by the Coutant family. In his late-nineteenth-century study of French and foreign factories, Julien Turgan described the rubber plant, on the banks of the Seine, about two kilometers from the Paris city limits. Docks permitted the direct arrival of both coal and raw materials, and the finished product could be shipped out via the nearby rail station. The plant itself was a monumental, three-story structure within a larger complex that included a gasoline storage building, a distillery, a lamp shop, a wood shop, and a storage area for crates and flammables. In the midst of all these buildings was always a huge pile of coal, as rapidly replenished as it was consumed by the furnaces necessary to maintain steam in a set of boilers that produced about 100 horsepower.[4] Even more impressive were the 35,000-square-meter ateliers of the scrap metal forges at Ivry, to which Turgan devoted an unprecedented number of pages and illustrations.[5]

Few guidebooks bothered to describe Ivry at the time, but an exception, published in 1886 by one Louis Barron, covered it extensively as the traveler's first encounter along the Orléans railway line leaving Paris:

Wood construction sites along the [Ivry] station platform obscure the view toward the plains. The Rue Nationale, of recent construction, lies before us, full of workers. The high furnaces and workshops of the Forges of Ivry, organized for melting down and recasting scrap metal, stand at the entrance to the street, a vast location on either side of it. The forge and the neighboring rubber plant employ hundreds of laborers, residing in this Ivry section, which is highly animated For approximately thirty

years, the incessant backwash of Paris has covered Ivry with factories In all the suburbs, there is no more productive town. It has factories that produce pigments and varnishes, fertilizer, oils, fats, glue, gelatin, albumin, candles, waxed papers, chemicals, hardware; it has a coal depot and a glass factory. Of these industries, some discharge suffocating odors, fortunately carried away and diluted by the lively and salubrious regional air. The population is ... rapidly increasing; today it is up to 18,000, most of whom are laborers or farmers. The municipality is prosperous...[6]

If Guillaumin's images can be interpreted in the light of such descriptions, one senses their evocation of the dominating power of Ivry's industry. Guillaumin includes both its darker polluting effects and its heroic scale, signaling its contribution to growth and prosperity. The setting sun dramatizes some views, while the snow lends another a sense of quiet, steady and reliable productivity.

Along with *Sunset at Ivry*, Guillaumin exhibited a larger and more finished picture at the first Impressionist exhibition entitled *The Seine in Paris, Rainy Weather* (1871, Museum of Fine Arts, Houston). Following *Sunset at Ivry* by two years, it was probably painted just a few months after the defeat of the Paris Commune. Its view is from the Quai Henri IV, close to the Ile Saint-Louis, which is seen in the middle distance to the right. The apse of Notre-Dame cathedral, on the Ile de la Cité, is at the center of the background. Linking the left bank of the Seine to the Ile Saint-Louis is the pedestrian Passerelle de Constantine, which was replaced after its collapse by the vehicular Pont de Sully (1876).[7] At their moorings across the river are barges delivering wine, since the central wine market (Halle aux Vins) was nearby at Jussieu, where an important campus of the University of Paris is now. Barrels lie in rows on the river bank behind the barges. Two horse-drawn carts used for hauling barrels are visible on the opposite bank as well. An illustration from Guy Le Bris' book on metal construction of several years later (showing the brand new Pont de Sully) clearly indicates the site and the system for moving barrels by carts.[8] At the very center of Guillaumin's composition are a steamboat and tug.

Figures along the riverbank enjoy the green space and watch the commercial activity. They are dressed exclusively in working-class attire. Four men, in groups of two, wear mariner's garb and hats. A woman holding a child looks over the railing, perhaps awaiting her husband. Two men eye a second woman near them. This is not a place where crowds congregate or numerous bourgeois promenade. Although many boats are tied up near the railing, there is no indication that they are pleasure craft. The overcast sky and the title *Rainy Weather* suggest that Guillaumin was more interested in an ordinary, workaday reality than in the carefree pleasures of sunny times. At this same time, Paul Cézanne painted the *Jussieu Wine Market* (1871–72, The Portland Art Museum, Oregon), which he could have observed from the window of the flat he was renting across the street. That he and Guillaumin shared similar

commitments in the early 1870s is indicated by the presence of Guillaumin's painting in the background of one of Cézanne's self-portraits. Guillaumin was clearly not working in a vacuum.

During the 1870s, Guillaumin made many other views of the busy riverbanks in this southeastern part of Paris. Several show construction of embankments or the dredging necessary to make the Seine more navigable for heavier boats. For example, *The Seine at Bercy* (1874, Kunsthalle, Hamburg) shows a steam dredge, anchored just offshore, performing this activity. Workers in the foreground transfer the sand to carts for use as construction material. In another version of this scene, *Works at the Pont National* (1874, Musée du Petit Palais, Geneva) a woman fishes in the foreground, unless she is looking for scrap metal; behind her is a horse-drawn cart into which sand is being loaded. A workman stands above an elevated bin behind the cart with a coarse screen used for sifting the sand. In the distance of both compositions is the Pont National, originally named Pont Napoleon III, but renamed after his abdication. It was the outermost bridge on this side of Paris. The view is from the Quai de Bercy on the right bank. This industrial area was expanding rapidly, hence the efforts to improve the navigable shore line. Areas of barren shore and open space in the paintings imply its potential. They also show Guillaumin's use of bright raw colors to suggest the powerful and unresolved forces shaping the landscape.

Despite his commitment to representations of industry and his connection to the Compagnie des Chemins de Fer d'Orléans, Guillaumin's railway pictures are relatively rare, but two of them are major. In both, however, it seems that the publicly financed works of infrastructure—"ouvrages d'art," as they were called in the profession—are featured at least as much as the trains themselves. In *Railroad Bridge over the Marne at Nogent* (1871, The Metropolitan Museum of Art, Robert Lehman Collection; see Figure 3.2) a red brick-faced railroad bridge over the Marne river dominates the composition. The structure was well known, for including its viaduct approaches it was nearly a kilometer long, and it was notable for its Roman-style brickwork. According to historian Marcel Prade, at the time of its construction from 1855 until 1856, it was the most important railway project in the Paris region.[9] The overland viaduct still stands, while the bridge over the Marne had to be replaced by a more modern structure when the retreating World War II German army destroyed it.[10] The red color so prominent in Guillaumin's painting was intended to evoke monuments from Roman times. Guillaumin views it from the west looking east, with the northern approach to the left. To the right is the Ile des Loups in the middle of the Marne, which the bridge used for part of its footing. Designed by the engineers Collet-Meygret and Pluyette of the Bridges and Roads (Ponts et Chaussées) division of the Compagnie de l'Est (Paris-Strasbourg and Mulhouse), the overall structure is pictured twice in Auguste Perdonnet's 1865 *Traité élémentaire des chemins de fer*.[11] It was opened

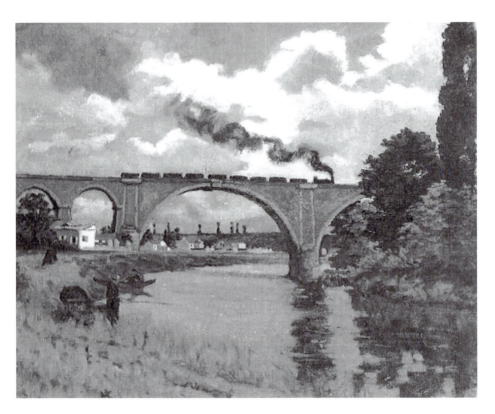

3.2 Armand Guillaumin, *Railroad Bridge over the Marne at Nogent* (1871), The Metropolitan Museum of Art, New York, The Robert Lehman Collection

in 1856. In Guillaumin's painting, a locomotive with eight carriages and a coal tender steams across it, leaving a trail of black smoke at the center of a bright blue sky with fluffy white clouds. As the smoke blends into the wind, it darkens the sky to the left.

The location is just east of Paris beyond the Bois de Vincennes, north of Joinville-le-Pont, in the municipality of Nogent-sur-Marne. The Marne, a major tributary of the Seine, joins the Seine in the southeastern outskirts of Paris, at Charenton and Ivry. The viaduct's intersection with the Seine is upriver from the industrial area of Paris between Ivry and the Gare d'Orléans. This southeastern part of Paris and its environs in general were at the heart of Guillaumin's work, just as the northwestern suburbs from Argenteuil and Clichy to Paris were for Monet. At both Nogent and Joinville, the Marne was popular for sailing and fishing, as it is even today, having never been subjected to the same level of industrialization as is today's Argenteuil. There are still makeshift seasonal bars and restaurants along the embankment. In Emile Zola's novel of 1881, *Au Bonheur des Dames*, the heroine Denise spends

a day at Nogent with her friends. Indeed, in this picture, Guillaumin seems to share the optimism of Monet's paintings. Harmony reigns between the figures and their surroundings. The bridge's brick facing and form echo age-old building traditions and its color complements and enhances the various greens of its environment. This is certainly not an image of dislocation but of access and interdependence. The whole is structurally bold, technically sure, and fresh in color, resulting in one of Guillaumin's most overtly pleasing works.

Guillaumin's image of the train crossing the river, like Monet's *Train in the Countryside* (1870, Musée d'Orsay) corresponds to a familiar motif found in guidebooks and repeated in many paintings. For example, Joanne's 1856 *Guide de Paris à Saint-Germain, à Poissy et à Argenteuil* features an illustration of the spectacular viaduct and bridge over the Seine near Saint-Germain.[12] As if one could only distinguish between a railroad bridge and a regular road bridge by the presence of a train, there is a train moving across it. Yet, according to mid-nineteenth-century schedules, there was one train per hour in each direction.[13] An observer might be forced to wait a considerable time before experiencing such views as they were so often represented. Therefore, other, parallel and complementary explanations for the near ubiquity of trains on images of such bridges and viaducts might focus on the development of the railroad as the impetus for such structures. They were certainly a novelty, required by the train's speed and lack of maneuverability, compared with vehicular traffic. Still, more fundamentally, the innovative movement and energy of contemporary progress is surely better embodied by the movement of the train itself than by its nonetheless spectacular stationary support.

Obviously, such public works were themselves objects of admiration. Edouard Baldus's photograph, *Landscape near the Chantilly Viaduct*, from the Chemins de Fer du Nord Album (*c.* 1860), shows a locomotive and tender with their crew atop the structure. Because Baldus's exposure time was in seconds (rather than a fraction of a second), one knows the train was stopped there, certainly for the purpose of being photographed. As was often the case in public works photographs, engineers, supervisors, and/or workers posed for the camera. Here, even more clearly than in Guillaumin's case, and certainly more than in the Monet's, the composition focuses attention on the viaduct — on the man-made contribution to the landscape. The pride the architect and builders took in such work is reflected in Perdonnet's 1856 comment that, at the expense of economic factors, "they attained an excessively expensive level of artistic perfection."[14]

The relationship between such structures and the machinery they carried is suggested in the title-page illustration for Louis Figuier's 1867 book *Les Merveilles de la science*.[15] The image is dominated by a double viaduct, of which there were several, such as the one in Brittany at Morlaix; another

closer by at Val de Fleury, near Meudon, on the left bank Paris-Versailles line; and a third, the Viaduc d'Auteuil of the Petite Ceinture line, which was frequently illustrated. In Figuier's image, trains are running in both directions. In his foreground is a steam-driven threshing machine; in the middle ground, on the river, is a paddle-wheel steamboat and, on land, a factory. By featuring a dizzying array of machines in motion, Figuier accepts and even celebrates the alteration of the countryside by the literal machinery of human progress.

This relationship may illuminate a second painting by Guillaumin in which a railroad motif is again dominated by the stone arches of a man-made span. In *Aqueduct at Arcueil, Sceaux Railroad Line* (1874, The Art Institute of Chicago) the Aqueduc de la Vanne is as much a principal motif as the train tracks, which went due south from Paris to the comfortable suburb of Sceaux. The Sceaux line, which departed from its station at the rue d'Enfer (now Denfer-Rochereau), was owned by Guillaumin's former employer, the Compagnie d'Orléans. (It has been part of the Paris Regional Express Network (RER) system since 1969.) The 11.45 kilometer line was inaugurated in June 1846 and was known for its sinuous route, which required special carriage-wheel technology.[16] Arcueil lies between Gentilly, which borders on Paris, and Sceaux. Guillaumin's view looks south along the tracks, away from Paris, towards where the 157-kilometer-long aqueduct turns north from a brief east-west run across the valley on its way toward Paris. Originally built in the seventeenth century to bring water from Rungis (near Orly), its extension was part of the system of recent improvements to the Paris water supply.[17] It was completed in 1874, bringing water harvested from the Vanne River near the city of Sens in Burgundy to the Montsouris Reservoir, which still supplies half of Paris's needs.[18] It was photographed by Hippolyte Collard around 1867 (*Deviation of the Vanne Waters*, photograph, *c.* 1867, Bibliothèque Historique de la Ville de Paris). In a landscape including bourgeois travelers—possibly visitors to the park at Arcueil or the nearby castle—who are casually awaiting the arrival of their train, one thus discovers the intersection of two important facets of modern infrastructure. With dappled sunlight from a blue sky falling on the partly grassy roadbed, Guillaumin's world, with its industrial emphasis, is an optimistic and harmonious one.

Notes

1. Some of the material in this chapter appears in my *Impressionism and the Modern Landscape: Productivity, Technology and Urbanization from Manet to Van Gogh* (Berkeley, CA: University of California Press, 2008), but is presented here in much different form.

2. Louis Leroy, "L'Exposition des Impressionistes," *Charivari*, 25 (April 1874): 79–80 in Ruth Berson, ed., *The New Painting: Impressionism 1874–1886, Documentation, vol. I* (San Francisco: Fine Arts Museum of San Francisco, 1996), 26.

3. Paul Tucker, "Monet's Impression: Sunrise and the First Impressionist Exhibition: A Tale of Timing Commerce, and Patriotism," *Art History*, 7 (December 1984): 465–76.

4. Julien Turgan, *Les Grandes Usines: études industrielles en France et à l'étranger, VIII* (Paris: M. Lévy, 1860–95), 177ff.

5. Turgan, *Les Grandes Usines*, 1–32. Whereas the rubber plant is not illustrated, Turgan dedicated seven plates to the forges.

6. "Les chantiers de bois bordant le quai nous cachent les plaines Devant nous débouche la rue Nationale, de construction moderne, très laborieuse. Les hauts-fourneaux et les ateliers des forges d'Ivry, organisés pour la refonte et la transformation de riblons—pièces de fer hors d'usage— occupent à l'entrée de la rue, de chaque côté, un vaste emplacement. Les forges et la manufacture de caoutchouc, qui en est voisine, emploient ensemble plusieurs centaines d'ouvriers fixés dans ce quartier d'Ivry, plein d'animation.

 "Depuis trente ans environs, le reflux incessant de Paris a couvert Ivry d'usines ...; dans la banlieu, point de bourg producteur plus important. Il a des fabriques de couleurs et de vernis, d'engrais, d'huiles, de graisse, de colle et de gélatine, d'albumine, de bougies, de papiers cirés, de produits chimiques, de boulons, un entrepôt de charbon de boix, une verrerie De ces industries, quelques-unes dégagent de suffocantes odeurs, heureusement emportées, diluées par l'air vif, salubre du terroir. La population s'accroît rapidement; elle est aujourd'hui de 18.000 individus, la plupart des ouvriers et cultivateurs. La commune prospère ..." Louis Barron, *Les Environs de Paris* (Paris: Maison Quantin, 1886), 174–6.

7. Charles Duplomb, *Histoire des Ponts de Paris* (Paris: J. Mersch,1911), 113–14.

8. Guy Le Bris, *Les Constructions métalliques* (Paris: Ancienne Maison Quantin, 1894), 50, fig. 30.

9. Marcel Prade, *Ponts et viaducs au XIXe siècle: techniques nouvelles et grandes realisations françaises* (Poitiers: Brissaud, 1988), 188. The lines for which it was built linked the Gare de l'Est to Strasbourg and Basel.

10. Nazi troops destroyed the four major arches over the river.

11. For example, Auguste Perdonnet, *Traité élémentaire des chemins de fer, I*, 3rd ed. (Paris: Garnier Fréres, 1865) between 484 and 485.

12. See *General View of the Viaduct of Saint-Germain*, engraving, in Adolphe Joanne, *Guide de Paris à Saint-Germain, à Poissy et à Argenteuil* (Paris: Hachette, 1856), 53.

13. Schedule in Joanne, *Guide de Paris à Saint-Germain, à Poissy et à Argenteuil*, 1.

14. "On s'est appliqué à atteindre une perfection artistique excessivement coûteuse," in Perdonnet, *Traité élémentaire*, quoted by François Caron, *Histoire des chemins de fer en France* (Paris: Fayard, 1997), 132–3.

15. Louis Figuier, *Les Merveilles de la science, I* (Paris: Furne, Jouvet, 1867).

16. Victor Bois, *Les Chemins de fer français* (Paris: Hachette, 1853), 139–40.

17. Prade, *Ponts et viaducs*, 228–30.

18. David H. Pinkney, *Napoleon III and the Rebuilding of Paris* (Princeton: Princeton University Press, 1958), 123–126.

Part II
Photographing the (un)real

Picturing the supernatural: spirit photography, radiant matter, and the spectacular science of Sir William Crookes

Courtenay Raia-Grean

Amongst the most provocative images of the industrial age are those of spirit photography. The sight of a doctor (Figure 4.1) expertly clasping the wrist of a ghost in order to take its pulse as he consults his timepiece for accuracy has an arresting flagrancy.[1] With this picture, we have stumbled onto a bizarre *mise en scène* we have no means of contextualizing or countenancing as modern observers. It is a fascinating and alien tableau. Other spirit photographs draw us in precisely because we can relate to them. They are the memento mori documenting the scene of loss and death in the nineteenth century. A grieving mother sits alone in a photographer's studio, the ghostly image of a child framed in the open door behind her. She'll only see him after the plate has been developed, and for now, her face wears a look of unanswerable longing. In another picture, a widower sits with an air of hopeful expectancy surrounded by his children. He had evidently been told that this photographer was a reliable medium, and for a certain fee, his dead wife might complete this family photo as a cloud of light, a ghostly face or even perhaps a hovering human form.[2]

This hope of course is what is commonly understood to have fueled the rather lucrative trade in ghost pictures. Double exposure and image manipulation became common arts in the 1850s, but under the entrepreneurial oversight of men like Frederick Hudson, William Mumler, and Édouard Isidore Buguet, this home-spun trick photography became the studio-based, for-profit enterprise of ghost portraiture by the 1860s and 1870s in Britain and America.[3] A stream of steady customers, including some very high-profile patrons, ponied up as much as ten dollars per photograph in the hopes of being united to their loved ones through this new form of spirit mediumship. Despite the numerous efforts of skeptics and legal authorities to curb what they saw as pure hucksterism—defrauding dead and living alike—spirit

4.1 Dr. James Manby Gully taking the pulse of Katie King. Photograph, William Crookes, 1874. Source: www.survivalafterdeath.org

photography flourished alongside its critics. Indeed, such photos were often waved in the face of skeptics as proof positive of the spiritual phenomena that "materialistic science" sought to deny.[4]

To be fair to the enterprising Mumlers of this story, the pervasive disposition to believe that such a thing as a spirit photo was even possible preceded the popular phenomena of spirit photography. And indeed, ever since the Fox sisters had their first communication from spirits rapping on the barn wall in Hyde Park in 1848, Victorians had seized upon any means or media by which to facilitate further communication with the dead. At first, the phenomena were confined to knocks, pops, taps, or turns of tables, inexplicably extinguished candles, or voices whispering in the dark. But, as if running parallel to the scientific progress of the day, ghosts and their mediums applied themselves with studied mastery and soon began levitating tables, hurling candlesticks, and manifesting body parts. Verbal communications from the spirit world became much more elaborate. Writing appeared mysteriously on slates, words tumbled out of gliding

planchettes, and ghostly voices began making speeches and singing songs, all causing one skeptic to protest that one might "die and be made to talk twaddle by a 'medium' hired at a guinea a *séance*."[5] Full-blown, walking, talking apparitions soon escaped the photographic plane and began to make the rounds of the séance circles. By the early 1870s, spiritualism had become quite a spectacle as mediums in Britain and America vied with each other for patrons and press attention, using the spirit photo to document their phenomena for popular spiritual journals such as *The Medium and Daybreak, The Spiritualist, The Spiritual Magazine,* or *The Spiritual Telegraph.*[6]

Even as we may sympathize with the lonely mother hoping for a momentary encounter with her dead child, there is a certain point at which these ghostly phenomena and photographic images became so emboldened and bizarre that they would seem to strain the limits of the most desperate credulity. In fact, the more preposterous the photo, the more it was likely to arouse learned scrutiny, ironically stimulating an increasingly creative output of spirit tableaux—to be consumed not just by the hungry gaze of a motherless child or grieving widow but by the "objective eye" of learned investigators. Despite the lawsuits, exposés, and derision heaped upon the ghost-traders, it would appear that no amount of infamy could dislodge the faith that religionists, spiritualists, and even some scientists put in these photos and the spiritual phenomena they documented.[7] Prominent intellectuals like Charles Richet, Dr. Albert von Schrenck-Notzing, Camille Flammarion, and Arthur Conan Doyle defended spirit photography well into the twentieth century, continuing a precedent of educated enthusiasm begun by men like Alfred Russell Wallace, William T. Stead, and the Rev. Stainton Moses in the nineteenth. Understanding the popularity of such phenomena as a purely emotionally-driven self-delusion held together by dimly understood "scientific ideas" becomes an insufficient historical explanation when considering the breadth and complexity of spiritualism's support. Victorians were not just led by their emotions into spiritualistic beliefs or caught up in a faddish stampede; they had their reasons as well, reasons often furnished, directly or indirectly, by elite opinion, theory, and persons.

The language of spiritualism stressed its "modern" outlook, speculating about the phenomena in the idiom of ascendant scientific theories. Scientists actively publicized the wonders of their physical discoveries, prompting a mood of expectant revelation, which for the spiritualist might reasonably include the secrets from "the great beyond." Men like Faraday, Kelvin and Maxwell infused space with fields of force, waves of light, currents of electricity and a universal meta-substantive plenum called "the ether." These physical concepts, sometimes with the encouragement of mid-century scientific interlocutors like electrician Cromwell Varley and mathematician Augustus De Morgan, advanced eager spiritualistic speculations *pari passu*.

Certainly, a major factor in sustaining belief in haunted pictures and ghosts with pulses was not just a gullible public with grief issues but rather a heterodoxy on high. For all its emerging institutional oversight in the realm of scientific knowledge, the Victorian era fostered such a plurality of elite opinion that "orthodoxy," even in academic circles striving towards such definitions, was often curiously elusive. Such organizations as the Royal Society and the British Association for the Advancement of Science might actively police their journals and proceedings, but what their membership did outside their institutional borders, trailing the tag *FRS*, was largely beyond their control. Elite sources sympathetic to spiritualism played an important role in manufacturing belief while the Mumlers and Buguets of the world were merely low-level operatives at the retail end.

No one was more important in sustaining the plausibility of spirit photography than Sir William Crookes, the renowned chemist and physicist, discoverer of Thallium (1861), Fellow of the Royal Society (1863), winner of the Davy Medal (1888), Knight Bachelor (1897), President of the British Association (1898), recipient of the Order of Merit (1910), and finally, President of the Royal Society (1913). Wedged amongst these honors was his investigation of the controversial medium Florence Cook between mid-December, 1873, and late May, 1874, verifying Miss Cook's extraordinary claims to materialize the full-formed spirit of "Katie King," the daughter of a seventeenth-century Welsh pirate.[8] This stunning assertion was not just made in a written report, but visually and incontrovertibly proclaimed in a series of 44 prints made by Crookes himself in an excess of experimental zeal, using five different synchronized cameras "to bear upon Katie at the same time on each occasion on which she stood for her portrait."[9] The effort Crookes made to obtain these photos was to be exceeded later only by the effort he made to suppress them. In one surviving picture (Figure 4.2), Crookes comes striding toward the camera arm-in-arm with the ghost herself, having just completed their historic promenade about the room—an image that would haunt him for the rest of his life.

The pictures themselves were not so exceptional in the context of the 1870s; rather it was Crookes himself (not the ghost) made them so. True-believers may have eagerly devoured the melodrama of the beautiful pirate princess in the pages of *The Spiritualist*, but eventually the accusations of fraud, the exhausted novelty, or rival apparitions would have swept the story aside in favor of newer and better ghostly phenomena. But the powerful purveyorship of William Crookes, F.R.S., allowed Katie King, seventeenth-century-pirate-princess, to bound over the seemingly insurmountable credibility gap facing a 200-year-old corporeal spirit in order to create a public sensation and lasting mythology. The prosecutions and exposures at the lower end of the social scale that tainted most mediums could not pollute the higher sources of authority from which these photos issued, sources that provided crucial replenishment to an otherwise evaporating reservoir of belief. Elite support,

4.2 William Crookes escorting Katie King around the séance room. Photograph, William Crookes, 1874. Source: www.survivalafterdeath.org

or even just elite curiosity, placed the legitimacy of spiritualism at a safe remove from contamination by its fraudulent practitioners and in a sense authorized the move in mediumship towards more and more sensational phenomena. Thus, despite their extravagant showmanship, mediums like Florence Cook can be seen to satisfy rather than to create demand as they capitalized on a credulity that had highly complex cultural sources.

When trying to penetrate this popular phenomenon of spirit photography, we understand most plainly what motivates the entrepreneur. However, what about the involvement of scientific investigators like William Crookes, men who financed these researches rather than profited by them? Should we understand their interest as part of the expansion of scientific knowledge, wanting—as Crookes announced at the Presidential Address of the British Association in 1898—"science to transcend all we now think we know of matter, and to gain new glimpses of a profounder scheme of Cosmic Law"?[10] What other draw beyond financial incentives and cosmic revelations might entice them to the séance table? Many scientists besides Crookes investigated

spiritual phenomena, but few actually trafficked in its artifacts—that was left to the professional class supplying the phenomena under investigation. But Crookes was more than an observant, scientific by-stander. Caught both behind the camera and in front of it, in the very arms of a ghost, he is hopelessly entangled with the asserted facts of the séance. Any implication that these phenomena were not genuine would likewise implicate Crookes himself as being disingenuous. His reputation was thus yoked to a life-size, flesh-and-blood ghost, whose photograph circulated the globe for over a century before ascending to the internet.

In the wake of these controversial researches, Crookes did a rather abrupt and mysterious about-turn in May of 1874, distancing himself from spiritualism through a lifelong campaign of silence on the subject. His early-twentieth-century biographer, E.E. Fournier D'Albe, offered the preferred explanation of Crookes's behavior held by his friends and colleagues that "He probably in the end suspected that all was not well and decided to have done with the matter for ever. Having publicly committed himself to raps, levitations and materializations he did not like to retract. But he abruptly closed a rather unfortunate chapter in his career and made amends by an unparalleled devotion to pure science which brought forth abundant and refreshing fruit."[11] This interpretation is problematic insofar as it assumes that a) Crookes was the dupe of Florence Cook rather than her confederate; b) he did not retract the phenomena because he did not want to appear a fool (rather than a liar); and c) Crookes's subsequent scientific researches were entirely independent of his allegedly aberrational interest in spiritualism and Florence Cook. This "unfortunate chapter" of spiritualism was rather longer than the four months spent investigating Florence Cook and much more entangled with Crookes's "devotion to pure science" than this portrayal might suggest.

Crookes had already come to public prominence as a scientific investigator of spiritualism by the late 1860s, and even before his investigation of Florence Cook his name appeared several times in *The Report on Spiritualism of the Committee of the London Dialectical Society* (1871).[12] George Henry Lewes, in writing to decline the Dialectical Society's invitation to join their investigation in December of 1869, nonetheless made encouraging mention of Crookes, "I am glad to hear the serious way in which your Committee is investigating the matter; and with such men as Mr Wallace and Mr Crookes we have a right to expect some definite results."[13] John Tyndall's letter likewise made enthusiastic reference to Crookes: "If earnestly invited by Mr Crookes, the editor of *The Chemical News* to witness phenomena which in his opinion tend to demonstrate the existence of some power (magnetic or otherwise) which has not yet been recognized by men of science, I should pay due respect to his invitation."[14] Interestingly enough, Crookes was not formally associated with the Society

and sat on none of its subcommittees, but clearly by reputation he was prominently associated with its aims.

Up until the late 1860s, when he began his involvement in spiritual researches, Crookes had labored assiduously along the scientific straight and narrow. He began his career modestly in 1848, enrolling in the newly minted Royal College of Chemistry and taking his degree two years later in 1850. During this time, Crookes labored patiently to master highly complex chemical procedures (which contributed to his later reputation among spiritualists for exacting standards of investigation), and was selected to continue on at the College as Senior Assistant to Professor August Wilhelm Hofmann until 1854. His duties mainly involved analyzing and isolating chemical substances—quantitative, meticulous work that D'Albe suggests left Crookes fundamentally dissatisfied, noting that, "The state of chemical science in the fifties may not have been sufficiently inspiring to secure the whole-hearted allegiance of a young devotee of science," especially one who "felt fit to be in the front rank, asserted his right to be there ... [and] maintained it against all competitors to the end of his life."[15] Crookes's romantic and even somewhat grandiose temperament ill suited him to a purely industrial science concerned with waste management, guano, mining, and commercial deodorizers. The profession of chemistry seemed to offer him few opportunities for theoretical grandstanding about the natural—let alone the supernatural—realm. And even though his family was prosperous, the money was from trade and thus lacked the sort of connections that might have been useful to Crookes's advancement in this still class-bound realm of academic science.[16]

Finally in 1861 Crookes made his break-out discovery of thallium, promising an end to his drudging obscurity. As Frank James observes, this discovery should in no way be confused with serendipity, but was rather Crookes's calculated effort to optimize his time, skills, and resources in such a way as to advance most readily in the world of science.[17] Discovering an element was certainly amongst the high-profile achievements attainable by someone in Crookes's particular circumstances. So when the thin green line appeared one day in the spectral band of the compound he was analyzing, it was the anomaly he had been searching for. Recognition for his discovery was far from instantaneous, but eventually "Crookes, the inventor of thallium" joined the parade of nationally renowned scientists leading the march of progress. Crookes used the occasion of his discovery to make a foray into scientific philosophy, contemplating spiritual life in the light of energy conservation for the *Popular Science Review* (1861) and arguing for some kind of integrated understanding: "Mechanical motion is equally capable of being transformed into heat, light, electricity, or chemical energy ... these living forces do not die, but become absorbed in that vast reservoir of energy which is the source of all life and light upon this globe If

philosophy can thus prove that the latter [physical life] never dies, shall not faith accept the same proof that our own spiritual life is continued after the vital spark is extinguished?"[18]

In 1863, in the wake of his public recognition, Crookes received the coveted invitation to join the Royal Society, and assumed the editorship of the *Quarterly Journal of Science* that same year, bracing himself for a rapid professional ascent. Yet, despite this seeming enrollment into the world of scientific celebrity, Crookes soon realized his profitably glorious career in science was far from assured. Complaining to a colleague, Dr. Angus Smith, in a letter dated October 31, 1864, Crookes wrote:

No doubt if I were to advertise constantly and give puffing testimonials to tradesmen I could get a connection and make a decent living out of my Laboratory, but as for respectable work as consulting or analytical chemist, I get next to none. I have made possibly £100 in six years at that work … my Laboratory and chemical education are only of money value in so far as they enable me to exercise editorial supervision over the *Chemical News* … . This being an amount of knowledge than any sharp person could get up in six months, nine-tenths of my 'brain-force' is lying idle … I was scientifically fortunate, but pecuniarily unfortunate some years ago in discovering thallium. This has brought me in abundance of reputation and glory, but it has rendered it necessary for me to spend £100 to £200 a year on its scientific investigation. Of course, it brings more than the value of this ultimately in reputation and position, but whilst the grass grows the horse starves and it is the utter despair that I feel of ever making anything out of my London Laboratory that makes me anxious to leave.[19]

At this point in his career, Crookes had a wife and children and had already suffered a series of rejections to salaried appointments that fell hard upon him. The idea that Crookes was somehow handily funded by his father and spent the 1850s and 1860s at his ease in his home laboratory is to discount the genuine struggle and anxiety he had about succeeding as a professional scientist, operating as he was under the dual constraints of class prejudice and a limited education. In D'Albe's words, Crookes felt "honour bound (if not compelled by necessity) to make his way in the world."[20]

He also clearly had idealized notions about his identity as a scientist, refusing what he found to be vulgar sources of remuneration and praising abstract scientific research over applied science.[21] Crookes's ambitions fared no better in the next few years, and in September 1867 he received the devastating news that his brother Phillip had died of typhoid on the ill-fated Cuba and Florida Cable Expedition. Incensed by what he considered to be the scandalous incompetence of the managing company, Crookes's public denunciations landed him in court in a slander suit brought by the maligned executives. He lost the case, but comfort did come in the form of a friendship with noted electrician and spiritualist Cromwell Varley, who, on hearing of the case in the papers, contacted Crookes about "contacting" his brother. Varley, a well-known engineer of the transatlantic cable operation, laced the

language of spirit communication with the techno-mystical jargon of spirit telegraphy, which proved attractive bait to the grieving scientist. Varley's circle also had a certain promising social luster, one far more penetrable than the aloof Oxbridge atmosphere of the Royal Society where social foundlings like Crookes were still something of anomalies who had to earn their exception to the genteel rule.[22]

Crookes's initial spiritual inquiries with Varley were discreet and private, entirely detached from any public program of investigation or scientific research. But there were powerful friends to be made in these spiritual circles, and Crookes found that his reputation as a scientist had a special luster for them. It was through this circle that Crookes made contact with members of the Dialectical Society and became a sort of genie's lantern of scientific legitimacy, frequently rubbed by spiritualists to bring forth more and more of Crookes's scientific credibility, burnishing his reputation as they made their uses of it. The glow of the green line of thallium, dimmed in the public imagination in the intervening years, seemed to burn the brighter for their attentions, as did Crookes's professional prospects. In December 1870, Crookes was invited to join in the prestigious Government Solar Eclipse Expedition to Spain and Algiers. It was a highly publicized event whose participants became icons of the national honor.[23] *The Daily Telegraph* of December 12 contained a leading article unctuous enough to salve any wounded pride:

The ship the *Urgent* carries a cargo of brain which would be all but irreplaceable for civilization. If we ran though the entire list of the scientific company on board that vessel each name would be a good plea for the favor from Neptune. On to select specimens: there are Professor Tyndall and Dr Huggins, there are Captain Noble, Mr Crookes and Mr Carpenter, there are R.F. Howlett, Mr Ladd and Admiral Ommaney with others whose loss altogether would be far worse than the sinking of a whole armada of Spanish galleons loaded to the gunwales with silver. We cannot underwrite such a cargo for who is going to put a price upon Professor Tyndall, who to estimate the discoveries of Dr Huggins during the rest of his natural life, or to put a market value upon the next metal identified by the discoverer of thallium?[24]

Crookes's attachment to this expedition came not from any Royal Society nomination or British Association endorsement but at the invitation of the American astronomer and Dialectical Society member, William Huggins, who had become friendly with Crookes through spiritualist circles. Such were the strange patterns of interference between science and spiritualism in mid-Victorian society that Crookes found himself ironically having more traction advancing his career in the former by operating through connections with the latter.[25]

Despite the publicity and praise surrounding the expedition, the Government Solar Eclipse Expedition was a failure due to a total eclipse of the eclipse by cloud cover. The *Urgent* meandered home in a mood of

decrescendo in early January 1871. But Crookes managed to keep his name in the papers that year by embarking on a new series of scientific investigations far more sensational than the concentration of hydrogen in the sun's chromosphere. Crookes announced in the *Quarterly Journal of Science* on July 1 his decision to investigate the famed spiritual medium Daniel Douglas Home—not in the dimly lit séance milieu with its phosphorous lamps, trick cabinetry, concealed confederates, and wily impresarios—but in the cold hard light of his scientific laboratory. With this he effectively answered the call for further inquiry put out by that reputable organ, the Dialectical Society, whose own research methodologies had failed to come up with anything conclusive.[26] Indeed, when explaining the inspiration for his proposed researches, he stated that he "began an inquiry suggested to [him] by eminent men exercising great influence on the thought of the country."[27] Thus Crookes could only be accused of (or praised for) advancing an investigation already underway.

Crookes's planned researches would trump anything undertaken by the Dialectical Society and its 40 subcommittees, raising his scientific profile in bold relief against the background of benighted spiritualism. His program was chaste, his proposed methods of inquiry unimpeachable, and the apparatus he designed for the investigation guaranteed a quantitative objectivity which would moot the hypothesis of hallucination or mal-observation which usually dogged such testimony. Crookes, as chemist and man of science, contrasted his meticulous standards of data analysis against the haphazard, impressionistic claims made by spiritualists, speaking in numbers to salve the most fastidious scientific sensibility:

The Spiritualist tells of bodies weighing 50 or 100 lbs. being lifted up into the air without the intervention of any known force; but the scientific chemist is accustomed to use a balance which will render sensible a weight so small that it would take ten thousand of them to weigh one grain. The Spiritualist tells of objects being carried through closed windows, and even solid brick-walls … the chemist asks for the 1,000th of a grain of arsenic to be carried through the sides of a glass tube in which pure water is hermetically sealed. [28]

Crookes's homage to minute calculation seemed to recognize the towering implacability of natural laws, laws possessing so profound a regulatory power that even the slightest deviation from their rule had thunderous implications for the cosmos. Crookes's actual experiments made good on this quantitative emphasis, supplementing his own observations with elaborately devised scientific instruments to effect both the documentation and precise measurement of the force phenomena in question.[29] Crookes's series of reports confirmed "the now almost undisputed fact" that, "from the bodies of certain persons having a special nerve organization, a Force operates by which, without muscular contact or connection, action

at a distance is caused." Yet he gave this result with seeming reluctance, beginning with the disclaimer that "the phenomena I am prepared to attest are so extraordinary and so directly oppose the most firmly rooted articles of scientific belief—that, even now, on recalling the details of what I witnessed, there is an antagonism in my mind between reason, which pronounces it to be scientifically impossible." Crookes named the phenomena "psychic force," designating that it could "be traced back to the Soul or Mind of the Man as its source," a sound inference based on observing the clear connections between Home and these effects.[30]

Despite Crookes's deprecatory assessment that his report appeared "scientifically impossible," it was enthusiastically received by spiritualists of all walks and even raised speculative interest amongst hitherto aloof intellectuals. "Psychic force" offered the possibility that spiritual activity might be theorized within the context of thermodynamics and explored through scientific methodologies, giving spiritualism safe cover and broadening its appeal. Crookes's timely intervention in the wake of the lukewarm results of the Dialectical Society propped up the claims of supernatural force at a time when elite toleration for such speculation was waning. By the 1870s, there had already been two decades of scientific inquiry into séance phenomena which had produced a reliable body of negative opinion.[31] Those whose status and education imposed certain obligations of skepticism found relief in Crookes's scientific sanitization of spiritualism. Spiritual phenomena like "materializations" and ghost photography, as well as the kinetic events like table turning, tilting, and levitation, were by their very nature *physical* forms of evidence and the attempt to use them as such reflect the deep empirical pre-occupation of mid-Victorians. This gave spirituality a physical basis in reality even as its narrative sources in the form of scriptural religion evaporated into metaphor and mythology.[32] "Psychic force" was a powerful refinement of this tendency towards the tangible, installing supernatural agency within real physical systems of energy and also giving it an exclusively scientific handle. Crookes, like Newton before him, attempted to tame his mysterious force through quantification, holding out the hope that psychic energy could be enfolded into the conservation and conversion equations governing electrical, chemical, thermal, kinetic, magnetic, and gravitational energies through dedicated scientific discovery, a hygienic alternative to séance convocations.

Crookes's status as a member of the Royal Society and his high-handed claim that psychic force was an "undisputed fact" put the entire affair in the cross-hairs of polemical marksmen such as W.B. Carpenter, John Nevil Maskelyne, and E. Ray Lankester.[33] For these rationalists appalled by the rise of spiritualism and looking to reinforce a stern boundary between science and the supernatural, credulous intermediaries like Crookes posed a serious danger with their hybrid agenda. Crookes was particularly chafed

by his nemesis Carpenter and, as Crookes later wrote, the "grossness of the imputation that the Royal Society admitted [Crookes] although [his] investigations had only a merit purely technical" and that he, Crookes, was "regarded among chemists as a specialist of specialists, being totally destitute of any knowledge of chemical philosophy."[34] Crookes vigorously defended himself against these accusations of "specialism," a grenade deftly tossed by Carpenter to explode Crookes's cherished cosmological pretensions. ("Specialism" and "technical merit" here both effectively reduced Crookes to a hired-hand of science rendered incapable by class and education of contributing to its intellectual capital.) The rejection of Crookes's paper by the Royal Society in the wake of Carpenter's taunts infuriated Crookes with its elitest, insular orthodoxy. Unable to access the Royal Society's scientific cachet, he set about discrediting this form of institutional opposition, along with it skeptical champions of orthodoxy. According to Crookes, Royal Society watchdogs like Carpenter "damaged the true interests of science and the cause of truth, by thus throwing low libelous mud upon any and every body who steps at all aside from the beaten paths of ordinary investigation. The true business of science is the discovery of truth, to seek it wherever it may be found, to follow the pursuit through by-ways and high-ways, and, having found it, to proclaim it plainly and fearlessly without regard to authority, fashion or prejudice."[35]

Riding such a high horse of self-regarding scientific legitimacy — and walking such a high-wire of professional credibility with potential assailants like Carpenter — what would make Crookes compromise himself with a risky venture like spirit photography? How did he get from mechanical drawings of psychic force curves in 1871 to an arm-and-arm promenade with a ghost in 1874? Crookes's skirmish with Carpenter and subsequent institutional rejection may have stoked this reckless, pugilistic mood, along with the desire to prove his critics wrong. Crookes, who still commanded widespread support for his researches outside official venues, felt he potentially had the means to do so by mobilizing public support for his psychic science. At this crossroads between acclaim and criticism, Crookes understandably chose to continue through the "by-ways and high-ways" of a maverick mission of discovery that promised more of the former. Indeed, the professional successes of the past few years had been largely reaped by Crookes's association with men like Varley and Huggins; his potential for scientific fame appeared perhaps more tied to the limitless possibilities of psychic force than to the finite investigative future of thallium. Having been snubbed by the Royal Society and verbally assaulted by Carpenter, Crookes may have felt the futility of further courting an establishment that to some degree had always failed to appreciate him.

When Florence Cook showed up on his door unsolicited one evening in December 1873, part of her appeal was no doubt in offering a ready-made

opportunity for this newly forming ambition. As one of the most talked about physical mediums of the past few years, she presented a very visible subject for Crookes's further experimental research. According to Crookes, the Home investigation had already incontrovertibly proven the existence of a psychic force. What remained to be done was to see if this force, as he had hypothesized, "could be traced back to the soul or mind of man." Having met the criteria of determining psychic force's objective status, it was now perfectly legitimate to test specific hypotheses in regard to its deeper nature; amongst the most prominent of these was the spiritualistic hypothesis. In agreeing to investigate Florence Cook in December 1873, Crookes recaptured the public's interest in his investigation of Home's psychic force concluded over a year before, this time raising the stakes from a mental to a spiritual agency. While he fired up popular support, Crookes reasserted his scientific authenticity vis-à-vis his orthodox detractors with what he called his "protest against this attempt to stop the progress of investigation."[36]

This of course goes only to explain how Crookes found himself pledged to investigate a walking, talking ghost; it does not, however, explain his descent into confederacy. Beyond the strategic opportunity Florence Cook presented to the embattled Crookes, the other part of Florence's appeal was no doubt personal. She came to him very much in the capacity of distressed damsel, having fallen under a cloud of suspicion. William Volckman, an influential Dialectical Society investigator, had apparently tackled the ghost of Katie King during one of her séance perambulations, sending the injured ghost rushing back to her cabinet in a state of deshabille. Katie may have carried away some of Volkman's beard, but he, alas, had been able to grab hold of more than just Katie's ghostly garb, irresistibly forcing the conviction upon him "that no ghost, but the medium, Miss Florence Cook herself, was before the circle."[37] The sensationalistic assault brought the issue of her imposture before the public, and though Florence retained some sympathizers at this "gross outrage," the episode clearly threatened her reputation and livelihood. She would be unlikely to command the type of press and profit she had been enjoying for the last three years now that her phenomena were discredited. Even her gullible sponsor, a wealthy industrialist named William Blackburn, notified the Cook family, "I shall stop payment."[38] Desperate to restore her credibility and income stream, the beguiling Florrie went personally to Crookes to plead with him to support her cause. If she could persuade Crookes, the great man of science, to investigate and confirm her mediumship, the power of his word would drive all doubt away.

Crookes had his own reasons for wanting to involve himself in such a celebrated case of mediumistic materialization, but it is also possible that Crookes felt moved to act by gallantry (or some other less altruistic motive

sublimated as gallantry). In describing his reasons for undertaking the study, Crookes explained, "When a few lines from me may perhaps assist in removing an unjust suspicion which is cast upon another … [a]nd when this other person is a woman—young, sensitive, and innocent—it becomes especially a duty for me to give the weight of my testimony in favour of her whom I believe to be unjustly accused."[39] No details of this December meeting between Crookes and Cook survive, but by the end of it, Crookes had agreed to investigate her mediumship and soon after announced this plan to the press.

There is no reason to believe that Crookes embarked on these experiments with anything but honest intentions. The sense of his own moral and scientific infallibility, reinforced by the appearance of Florence Cook's youthful innocence and dependency, led Crookes to the fatal miscalculation that he would be running the show. Florence Cook made a living running a confidence game and the over-confident Crookes seems to have taken the bait. At some point it seems reasonably clear that Crookes became Cook's collaborator, the passive object of his research coming to fully implement him in an experiment, or rather gamble, of her own. Florence not only managed to extract his public endorsement of her phenomena but even commanded his assistance in producing its proofs.[40] Trevor Hall's analysis of the details of the séance leave little doubt about Crookes's strategic involvement in orchestrating its events, characterizing him as far more of an "impresario" exhibiting the spirit phenomena in question than a scientist investigating them. And Hall also leaves little doubt as to why: the enfatuated Crookes and the enterprising Cook had in fact become sexually involved. (Florence Cook was alleged to have confessed as much nearly 20 years later to a young man visiting her home with whom she likewise became involved.[41])

The affair seems to have become the guiding logic of Crookes's involvement in the investigation. He himself had little to gain and much to lose from these researches beyond his relationship with Florence, whereas Florence managed to regain both financial compensation from her sponsor and spiritualists' faith in her mediumistic powers. Crookes's reports progressively lost their scientific character and reflected less and less attention to research protocols, going so far as to eventually include fawning scraps of love poetry. Even the objective powers of his camera apparatus seemed to fail their task; as the despairing Crookes wrote, "photography is as inadequate to depict the perfect beauty of Katie's face as words are powerless to describe her charms of manner … how can it reproduce the brilliant purity of her complexion, or the ever-varying expression of her mobile features?"[42] With this sort of copy, Crookes was obviously no longer trying to participate in a scientific discourse and confined these reports to exclusive release through the spiritualist press (where it would presumably do him the least professional harm and Florence Cook the most professional good). But Crookes overestimated his ability to contain the story.

The séances, like many things motivated by passion, came to a rather abrupt conclusion on May 21, 1874, when Katie King made her tearfully dramatic announcement that she would return no more to the earthly plane, banished no doubt at Crookes's, not Cook's, insistence. Like any compromising acquaintance from one's unsavory past, Katie King was to be permanently dropped from all social, or in this case séance, circles. After all the public testimony Crookes had made on the ghost's behalf, he could not afford the possibility that Katie King might eventually be investigated (and exposed) in some future séance scenario beyond Crookes's control. Crookes, with the clarity of the morning after, seems to have taken immediate and final measures to reverse course. However, this did not prevent Katie and Crookes from taking a most mutually estimable leave of each other, per his obligations to Florence. In his final letter to *The Spiritualist*, Crookes described the ghost's noble words of farewell: "Mr Crookes has done very well throughout, and I leave Florrie with the greatest confidence in his hands." As for Florrie, Crookes assured his readership that he wished "to make the most public acknowledgment of the obligations I am under to her for her readiness to assist me in my experiments. Every test that I have proposed she has at once agreed to submit to with the utmost willingness; she is open and straight-forward in speech. I have never seen anything approaching the slightest symptom of a wish to deceive."[43] That being said, both ghost and girl were politely dropped curbside while Crookes sped away as fast as he could.

On the subject of Katie King, Crookes remained ever terse and evasive thereafter, refusing permission to republish the articles from *The Spiritualist* and suppressing the photos when he could.[44] When Tyndall raised the question of spiritualism to Crookes at a chance encounter at the Royal Institution, Crookes "was silent and it seemed to give so much pain that he [Tyndall] concluded never to mention the subject again."[45] His other friends and colleagues all maintained a quiet conspiracy around these otherwise highly remarkable events, allowing them to remain silently deplored.[46] However, we cannot leave Florence Cook on the outside of any meaningful investigation into Crookes's professional and personal biography, as much as Crookes may himself have wished this. One's folly, having the virtue of being uniquely one's own, also has a certain improvisational quality that makes it of compelling historical interest, filling out the range of any given individual's social means and private motives. When Crookes returned to his laboratory to make his "amends by an unparalleled devotion to pure science," he did so with a new theoretical grandeur seemingly fostered by these earlier spiritualist impulses and energized by the anxiety of their failed fruition in the Katie King episode. His new research program, though thoroughly orthodox, was far more ambitious than any of his previous chemical researches, venturing into the deepest nature of force and

matter with a passion for discovery that made the next few years the most astonishingly productive period of his lifetime and laid the foundation for the accumulation of future honors. Even as he moved into the scientific arena, he refused to abandon spiritualism's enlarged scope and clearly encrypted some of its metaphysical agenda in a bold new program of experimental physics.

In April 1874, we see the outline of this vanguard science in Crookes's public demonstration of his newly invented radiometer. (A windmill-like object consisting of four vanes, each silvered on one side and blackened on the other, suspended in an evacuated globe.) Crookes was investigating the possibility that light exerted a mechanical or motive force "directly due to the impact of the [light] waves upon the surface of the moving mass," in this case the vanes of his "solar mill" in vacuo.[47] The idea that light waves could produce motive power was denounced as a mystification by some scientists and immediately investigators set to work to overturn this hypothesis. But Crookes maintained his defense of the controversial hypothesis, stating in a paper read before the Royal Society on April 22, 1875 that "this instrument revolves under the influence of radiation, the rapidity of revolution being in proportion to the intensity of the incident rays."[48] Crookes made no reference whatsoever to supernatural human agencies in any of his scientific papers concerning force phenomena *in vacuo*, yet apparently in some private demonstrations he did intimate these connections, exploiting the productive potential of light as a psychical metaphor. In a letter to Charles Darwin, Francis Galton (himself an avid spiritual investigator) tried to engage his disdainful cousin on the topic of spiritualism, writing, "What will interest you very much is that Crookes had needles of some material not yet divulged which he hangs *in vacuo* in little bulbs of glass ... Now different people have power over the needle and Miss F (medium) has extraordinary power. I moved it myself and saw Crookes move it ... Crookes believes he has hold of quite a grand discovery."[49] Crookes's long-time nemesis, W.B. Carpenter, also wasted no time making this connection. In a chastising letter to *Nineteenth Century* (April 1877), Carpenter derided "the mechanical action of light" by way of comparison to psychic force, ridiculing Crookes's research as an ongoing quest to find a mysterious force and to astound the world with the sort of grand discovery confessed to Galton.[50]

Even after Arthur Schuster succeeded in overturning Crookes's controversial hypothesis of a luminous motor power (the occasion of Carpenter's gloating letter), Crookes merely redirected his research *in vacuo* away from "radiant force" and towards the perhaps even more compelling phenomena of what he would come to call "radiant matter." He began a fascinating series of studies with a new experimental apparatus, the now famous "Crookes tube," developed in the wake of the radiometer. He began with an evacuated glass vessel, but this time rigged it to an electrical

circuit discharging electricity into the tube itself through a heated electrical wire (or cathode) inserted at one end.[51] The crescendo of Crookes's career researches came in 1879 at the annual meeting of the British Association for the Advancement of Science at Sheffield, when he unveiled his Crookes tube before the astonished assembly, making an auroral demonstration of its strange world of physical possibilities. Inside the evacuated chamber, gasses glowed green, purple, red, and orange, developing bands of color that intensified then faded in response to Crookes's mysterious orchestrations as he released various substances in and out of the vessel. Under his test conditions, "molecular rays" streamed across the length of the tube, bending to magnetic influences; its glass walls phosphoresced an electric green while gems radiated exotic colorations, and dark spaces formed amidst the glowing gasses, forming eerie globes of invisible matter.[52]

What Crookes claimed to have bottled and put on display was nothing less than "the fourth state of matter," predicted, but not proven by his great experimenter hero Michael Faraday in 1819. Faraday had proposed the hypothesis that matter, moving in a hierarchical progression from solid to liquid, from liquid to gas, was capable of yet higher states of transformation "that were as yet undiscovered by man"—until now. Crookes, by rarifying matter *in vacuo* and then subjecting it to electrical stimulation, claimed to have created the trigger conditions which propelled matter to this heretofore mythical higher state. He offered evidence; not just a theory, but the stuff itself, the fourth state of matter held in scientific captivity within his Crookes tube. Calling it "radiant matter," he demonstrated through his vivid exhibition of its various behaviors that it was indeed qualitatively different from solid, liquid, or gaseous matter. Crookes dazzled the scientific assembly with effects so extraordinary that they rivaled the spectacles produced by spiritualistic mediums, expanding the physical horizons of this world so that they seemed to nearly converge upon the next, a fact Crookes subtly proclaimed in his speech to the Association:

> We have seen that in some of its properties Radiant Matter is as material
> as this table, whilst in other properties it almost assumes the character of
> Radiant Energy. We have actually touched the border land where Matter
> and Force seem to merge into one another, the shadowy realm between
> Known and Unknown which for me has always had peculiar temptations.
> I venture to think that the greatest scientific problems of the future
> will find their solution in this Border Land, and even beyond, where it
> seems to me, lie ultimate Realities, subtle, far-reaching, wonderful.[53]

The fourth state of matter retained for Crookes Faraday's sense of hierarchy. It was in fact a kind of "exalted matter" with a highly resistant threshold of transformation that made it a rare phenomenon in the mundane world (as were psychic phenomena) and was clearly a medium capable of transcending the limits of ordinary material states. It exhibited capacities strangely

similar to light: the triggering of phosphorescent effects; the organization into a "molecular ray" not unlike a ray of light; the display of magnetic characteristics; and the ability to produce certain thermal, spectrographic, and radiant properties. As a substance, radiant matter was highly generalized and rarified, appearing more like the *prima materia* of the ether than the ordinary, highly specified matter of the manifest world, and this strange meta-material was capable of both vanishing and luminescing, just like the etheric forms of séance apparitions. Matter in the fourth state seemed to have profound mutational qualities that allowed it to imitate light or revert to a material form that was highly potentialized, i.e., it seemed to be able to become or do anything, thus highly making probable even the apparent absurdity of photogenic spirits.[54]

Again, Crookes kept clear of any explicit spiritualistic analogies in his speech to the assembly, but he was explicit that radiant matter bordered on a higher realm of "ultimate realities" which had always held for Crookes "peculiar temptations." But perhaps these temptations were too strong for Crookes, attaching him too fondly to the misconceived idea of "radiant matter," so appealing in its exquisite consonance with its naturalized language of the supernatural. As Robert K. DeKosky observes, "William Crookes is a puzzle to historians of late nineteenth century physical science. Despite his achievements we are forced to ask why he did not accomplish more? Why was it not Crookes, say who discovered x-rays or identified the electron as early as the 1880s?"[55] DeKosky explains that it was Crookes's commitment to the fourth state of matter that kept him so conceptually rigid, but it is better argued that it was Crookes's commitment to spiritualism that compelled such theoretical loyalty to the fourth state in the first place. The Crookes tube, with its controlled display of an eerie, hitherto unseen class of phenomena, made a scientific exhibit of the secret potential of nature and promised profound future disclosures. Given the spectacular faculties of radiant matter, other latent phenomena might reasonably extend to apparitions, levitations, transmutations, and of course, corporeal spirits and photographs thereof. Radiant matter, by maintaining the possibility that "supernatural" phenomena were the normal operations of extraordinary states of matter, i.e., the fourth state, promised not only a philosophically satisfying future science, but likewise had the potential to retroactively vindicate Crookes for his involvement with Katie King, overcoming the prima facie implausibility of the notorious photos.[56]

The researches in the wake of 1874, which climaxed with his dramatic declarations at Sheffield, brought Crookes both fame as a scientist and genuine hope as a spiritualist, and allowed him to potentially redeem the lies he told on behalf of Florence Cook by proposing the scheme of a world in which those lies might indeed be true. Crookes rode this rising tide in the 1880s and 1890s, garnering many honors and offices along the way,

culminating in the highest distinctions of the order of merit (1910) and the Presidency of the Royal Society (1913). But he was never able to fully resolve the potential threat of the Florence Cook affair beyond a strict silence that was the condition of his acceptance in the world of official science. Ironically, the higher Crookes climbed in this world, the less effective this strategy became. His growing prestige further enhanced his potential to validate spiritualistic phenomena and thus motivated spiritualists all the more to firmly attach themselves to his coattails. The more science hallowed Crookes, the more difficult it was to maintain the silence its institutional investment required. As Fournier D'Albe noted in his 1923 biography, "Hardly a week passes but his name is flourished in the face of a skeptical world, often in support of the grossest fraud."[57] Crookes's own refusal to deny the episode was universally interpreted by spiritualists as an implicit endorsement of Florence Cook's validity, thus the photos retained the power of Crookes's scientific testimony long after he himself had ceased to mention them. This failure to set the record straight maintained the faith of not only nineteenth-century spiritualists but preserved this hope for future generations, continuing on today as part of the faith-sustaining canon of modern spiritualism, making Crookes a permanent captive of a spiritualist audience.

Beyond the impact the Katie King photos had on the faith of Victorian spiritualists, Crookes's investigation of D.D. Home likewise played a powerful role in sustaining a more secular supernatural belief amongst sympathetic elites. Crookes's research on Home cocooned spiritualism in the scientific rhetoric of psychic force, helping it to survive the intellectual materialism of the 1870s and be born again as "psychical research" in the 1880s and 1890s.[58] By the end of the century, Crookes's "psychic force" had germinated into an elaborate object of study with its own scientific discipline and institutional cover in the form of the Society for Psychical Research. Further support for Crookes's psychic force came from the new branch of radiation physics, which like Crookes's radiant matter of 20 years before, offered a paradigm adapted to metaphysical speculation, with roentgen rays, gamma-rays and even "n-rays" blurring the boundary between matter and energy and feeding the idealistic zeitgeist of *fin-de-siècle* science. In 1898, the same year he assumed the Presidency of the British Association (BA), Crookes also became President of the Society for Psychical Research, achieving the long-awaited union of his physical and psychical researches. He used his inaugural address to the BA to re-absorb D.D. Home back into his official biography and revive the outstanding mystery of psychic force:

No incident in my scientific career is more widely known than the part I took many years ago in certain psychic researches … To ignore the subject would be an act of cowardice—an act of cowardice I feel no temptation to commit. I have nothing to retract. I adhere to my already published statements. Indeed, I might add much thereto … I think I see a little farther now. I have glimpses of

something like coherence among the strange elusive phenomena; of something like continuity between those unexplained forces and laws already known. This advance is largely due to the labors of another Association of which I have also this year the honor to be President—the Society for Psychical Research ... Steadily, unflinchingly, we strive to pierce the inmost heart of Nature, from what she is to reconstruct what she has been, and to prophesy what she yet shall be. Veil after veil we have lifted, and her face grows more beautiful, august, and wonderful, with every barrier that is withdrawn.[59]

Even if Florence Cook has been notably exiled from Crookes's re-telling of his story to the BA, she remains very much a part of it, illuminating Crookes's career in science in terms of both its successes and failures. Crookes's first brush with spiritualism in the late 1860s revitalized his scientific prospects and provided the inspiration for the inauguration of "psychic research" in 1871. His subsequent investigations of Cook may have utterly failed to integrate spiritualism into a scientific or "psychic" platform, but the very travesty of it energized the most creative period in his extraordinary career as an experimental scientist. Crookes not only worked with redemptive fury in the wake of his affair with Florence Cook, but the potential scandal forced him to fully surrender his spiritual and psychic programs to this penitential exigency—leaving his orthodox scientific research to assume the entire burden of this metaphysical inquiry. This in part explains the cosmographical, meta-materiality of radiant matter. Practically speaking, in his modeling of radiant matter in the mid-1870s, Crookes furnished late-nineteenth-century science with exploratory models that proved highly productive for scientists like the Curies and J.J. Thomson, who were themselves "pierc[ing] the inmost heart of Nature" through their discovery of the subatomic world. Crookes's "psychic force" also broadly predicated an idealistic discourse on mind that flourished in *fin-de-siècle* philosophy and psychology, drawing people as diverse as Henri Bergson, William James, William McDougal, Karl Jung, and Frederic Myers into the sphere of the Society for Psychical Research. This trail of contingencies was strangely linked through the objective power of a spirit photo which, by placing an eminent scientist ineluctably arm-in-arm with a beautiful ghost, turned a mere momentary indiscretion into a decisive moment of cultural and intellectual significance with multiple lines of descent.

Notes

1. T. H. Hall, *The Spiritualists* (London: The Trinity Press, 1962), 40–1. Dr. James Manby Gully (1808–83), was a prominent member of the British National Association of Spiritualists who assisted William Crookes in his investigations of Florence Cook. Two years after this photo was taken, Gully found himself under investigation for the poisoning of one of his patients, who was also his lover's husband. Crookes was unlikely to have had this knowledge at the time of his investigations of Florence Cook, at which time Gully was still a member of good standing in medical society.

2. F. Gettings, *Ghosts in Photographs: The Extraordinary Story of Spirit Photography* (New York: Harmony Books, 1978) and C. Permutt, *Beyond the Spectrum: A Survey of Supernormal Photography* (Cambridge: Stephens Press, 1983) offer two excellent collections of nineteenth- and twentieth-century ghost photographs as interpreted by committed spiritualists.

3. The Boston engraver and photographer William Mumler is widely credited with producing the first spirit photo in 1861 and by the late 1860s the commercial enterprise of spirit photography was well under way with Mumler in Boston, Frederick Hudson in London, and Edouard Isidore Buguet in Paris. The photographers either worked with professional mediums or themselves claimed the powers of mediumship. Their clientele were largely the bereaved but "scientific" investigators interested in this research were also willing to pay to observe the phenomena.

4. A.R. Wallace argued such a point in his article, "Are there objective apparitions?", *Arena* (January, 1891), 145, asking the skeptics, "What is the use of elaborate arguments to show that all the phenomena are to be explained by the various effects of telepathy and that there is no evidence of the existence of objective apparitions occupying definite positions in space, when the camera and the sensitive plate have again and again proved that such objective phantasms do exist?"

5. Letter from T.H. Huxley to the Committee of the London Dialectical Society written January 29, 1869 as published in the *Report on Spiritualism of the Committee of the London Dialectical Society Together with the Evidence, Oral and Written and a Selection from the Correspondence* (London: Longmans, Green, Reader and Dyer, 1871), 230.

6. For more on science and spiritualism see Richard Noakes, "Telegraphy is an occult art: Cromwell Fleetwood Varley and the Diffusion of Electricity to the Other World," *The British Journal for the History of Science* 32, no. 115 (1999): 421–56; Janet Oppenheim, *The Other World: Spiritualism and Psychical Research in England, 1850–1914* (New York, NY: Cambridge University Press, 1985); John Cerullo, *The Secularization of the Soul* (Philadelphia: Institute for the Study of Human Issues, 1982).

7. William H. Mumler was charged with fraud in 1869 for the selling of spiritual photographs but won the case in court. Buguet however was not so fortunate, being found guilty on similar charges and sentenced to a year in prison in 1875. Hudson and Parkes were likewise subject to public criticism and investigation by skeptics angered by their profiteering in ghost pictures. See Alison Ferris, *The Disembodied Spirit* (Brunswick: Bowdoin College Museum of Art, 2003), 1–23.

8. "Katie King" was, according to the biography circulated amongst spiritualists, the ghost of Annie Owen Morgan, daughter of Captain Morgan, whose spirit name was "John King." Katie had begun manifesting in Spiritualist circles in the 1850s in America, and her father "John King" was a frequent manifestation of Florence Cook's mentor in mediumship, Frank Herne and made popular as well by famed physical medium "Eusapia Palladino." See Alan Gauld, *Mediumship and Survival: A Century of Investigations* (London: Heinemann, 1982), 1–47.

9. William Crookes, *Researches in the Phenomena of Spiritualism* (London: J. Burns, 1874), 108.

10. William Crookes, "Part of The Presidential Address Delivered to the British Association At Bristol, Sept., 1898," *Proceedings of the Society for Psychical Research*, 14 (1898–99), 5.

11. E.E. Fournier D'Albe, *The Life of Sir William Crookes* (London: T. Fisher Unwin, Ltd., 1923), 175–6. D'Albe here presents the "rationalist" opinion reached by Crookes's scientific peers looking to excuse his conduct in the Katie King affair and minimize its importance.

12. London Dialectical Society, *Report on Spiritualism of the Committee of the London Dialectical Society Together with the Evidence, Oral and Written and a Selection from the Correspondence* (London: Longmans, Green, Reader and Dyer, 1871). Though published in 1871, the correspondence contained is largely dated 1869, indicating Crookes's rising profile as a serious spiritual investigator at least by that year.

13. London Dialectical Society, *Report*, 263.

14. London Dialectical Society, *Report*, 265.

15. D'Albe, *Life*, 24.

16. For more on the culture of science in the Victorian era see Jack Morrell and Arnold Thackray, *Gentlemen of Science: Early Years of the British Association for the Advancement of Science* (New York : Oxford University Press, 1982).

17. Frank A.J.L. James, "Of 'Medals and Muddles' the Context of the Discovery of Thallium: William Crookes' Early Spectro-Chemical Work," *Notes and Records of the Royal Society of London*, 39, no. 1 (1984): 65–90.

18. D'Albe, *Life*, 66.

19. D'Albe, *Life*, 88–9.

20. D'Albe, *Life*, 34.

21. Crookes, unable to find a substantial appointment as teacher or researcher in the 1850s and 1860s, supplemented his income with scientific writing for magazines such as *The Photographic Journal* and *Photographic News*, purchasing *The Chemical Gazette* and assuming its management in 1859 under the new title *Chemical News*.

22. Crookes faced comparative battles in his appointment to the presidencies of both the Royal Society and the British Association, and wrote to Oliver Lodge complaining about his sense of this prejudice against him, both on account of his psychic research and his background. Lodge writing to Chalmers Mitchell on December 15, 1927 wrote, "Take Crookes for instance. You say that nevertheless he was President of the Royal Society. So he was, for a short time though not I expect without many qualms and some objection." Lodge Collection, Archives for the Society for Psychical Research, Cambridge University Library, Cambridge, UK.

23. "Spiritualism" here for Crookes had a sort of irresistible momentum, a wind that would blow him out of his professional and personal doldrums. This is not to reduce Crookes's interest to mere "opportunism", but rather to see, instead of conflict, a convergence of opportunities. It is clear that early on Crookes, prior to his actual investigations, believed firmly in spiritual realities and in their religious paramountcy. But beginning with his friendship with Cromwell Varley, Crookes began to believe he was actually making physical contact with the spirit world. In his journal written on board the *Urgent* on New Year's Eve 1870, Crookes recalled New Year's Eve of 1869: "I cannot help reverting thought to this time last year. Nelly [Crookes's wife] and I were then sitting together in communion with dear departed friends, and as 12 o'clock struck they wished us many happy New Years. I feel that they are looking on now, and as space is no obstacle to them, they are, I believe looking over my dear Nelly at the same time. Over us both I know there is one whom we all—spirits as well as mortal—bow down to as Father and Master … May He also allows us to continue to receive spiritual combinations from my brother who passed over the boundary when in a ship at sea more than three years ago." D'Albe, *Life*, 171.

24. D'Albe, *Life*, 137–8.

25. For an interesting collection of essays exploring this theme see *The Victorian Supernatural*, Nicola Brown, Carolyn Burdett, and Pamela Thurschwell, eds (Cambridge UK; New York: Cambridge University Press, 2004).

26. The 40 committees of the London Dialectical Society descended upon séance circles throughout the country, presumably exhausting this venue as a means of investigating spirit phenomena. The fact that their investigations yielded no satisfactory conclusions indicated alternatives would be required in the future since no stone had been left unturned as far as séances were concerned. The researches of the Dialectical Society had left the matter of spirit phenomena in a state of limbo, a position tending to favor the presumption that further study was required, the nature of which, however, was open to question.

27. Crookes, *Researches*, 6.

28. Crookes, *Researches*, 6–7, 45–80. Much of Crookes's *Researches in Phenomena Called Spiritual* included the vituperative correspondence between himself and W.B. Carpenter who tried to make a public case against Crookes and undermine his standing in the Royal Society.

29. Crookes, *Researches*, 9–43. He assessed the alteration of the weight of a body that Home could effect by the slightest pressure of his hand or the amount of foot/pounds of force he could remotely direct through his touch or attention, using a mechanical recording device that would actually sketch the force curve as it was simultaneously registered by the measuring index suspending the affected object.

30. Crookes, *Researches*, 6–7.

31. Scientific investigators had taken an interest in spiritual phenomena as early as the 1850s, but the conclusions of such hardliners as Michael Faraday, John Tyndall, E. Ray Lankester and W.B. Carpenter by the 1870s was that the phenomena had been well proven to be fraudulent. Many of those later involved with the Society for Psychical Research were inspired by Crookes's example of a scientific paradigm for investigating spiritualistic phenomena. The psychological framing of "psychic force" was adopted by the SPR to eschew overt association with the spiritualistic hypothesis, and the apparent credibility of his reports on Home buoyed the disappointed hopes of those who by the 1870s had grown weary and suspicious of the séance circus.

32. The mid-century movement in Biblical criticism by such continental intellectuals as David Friedrich Strauss (1808–74), Ludwig Feuerbach (1804–72), and Ernst Renan (1823–92) undermined the Revealed nature of the scriptures and probed the mythological construction of Christianity through historical analysis.

33. Jon Palfreman, "Between Scepticism and Credulity: A Study of Victorian Scientific Attitudes to Modern Spiritualism," in *On the Margins of Science: The Social Construction of Rejected Knowledge* (Monograph 27), ed., Roy Wallis (Staffordshire: University of Keele, 1979), 201–36.

34. Crookes, *Researches*, 58. When Crookes tried to counter Carpenter's assault with essentially the same charges, claiming that Carpenter's "mind lacks that acute, generalizing, philosophic quality which would fit him to unravel the intricate problems which lie hid in the structure of the human brain," he highlighted both the weapon of choice in battles for scientific legitimacy, and why he, William Crookes, the tailor's son and two-year technical college grad, might feel particularly touched by its blade.

35. Crookes, *Researches*, 65.

36. Crookes, *Researches*, 101 and 58.

37. Trevor Hall, *The Spiritualists* (London: Duckworth, 1962), 29.

38. Hall, *Spiritualists*, 31. Crookes focused his defense of Florence on ascertaining the separate existence of the medium and the ghost. In this manner he hoped to refute Volkman's threatening claim that Florence and Katie were in fact one and the same. Writing in his Researches (102), Crookes framed this essential problem: "No one has come forward with a positive assertion, based upon the evidence of his own senses, to the effect that when the form which calls itself 'Katie' is visible in the room, the body of Miss Cook is either actually in the cabinet or is not there. It appears to me that the whole question narrows itself into this small compass." Much of Crookes's subsequent testimony goes to arguing this "fact."

39. Crookes, *Researches*, 102.

40. Hall, *Spiritualists*, 54–73. Crookes personally undertook the guardianship of the medium's cabinet where she retired during the allegedly exhausting ordeal of the spirit manifestation, offering "the evidence of his own senses" that Florence slumbered within while Katie paraded without. This made Crookes's testimony critical to the credibility of the phenomena, and, as Trevor Hall maintains, offers reasonable proof of his collaboration. But Crookes may have felt compelled not just by physical attraction, but by a sort of gallantry toward Florence as well. This deception, we must not forget, effected in Crookes's mind the rescue of "an innocent schoolgirl" from financial and personal ruin, a girl who came to Crookes personally to make her appeal.

41. Francis G.H. Anderson reported to the SPR in 1922 that he had had an affair with Florence Cook (then Mrs. Elgie Corner) in January of 1893 when staying as a guest at her house near Monmouthshire. At that time, Cook confessed to Anderson that she and Crookes had been involved in a deception of both a sexual and a "spiritual" nature, using the séance as cover for the affair. It should be remembered that Cooks came to Crookes desperate for his help in clearing her name. The affair was probably for her, at least initially, a means to procure his scientific testimony, whereas as for Crookes, that same scientific testimony was probably the means to the affair. Thus describing the séance as cover for the affair, obscures some of the complexities of the Cook/Crookes dynamic. Details of Anderson's claims were investigated and supported by the SPR. At some point during the four months of the 1874 investigation, Florence Cook was installed at the Crookes's residence ostensibly to convenience Crookes's research and the two of them even traveled alone to France to demonstrate her phenomena, maintaining this helpful cover of medium and unimpeachable scientific investigator. Hall, *Spiritualists*, 99–108.

42. Crookes, *Researches*, 111.

43. Crookes, *Researches*, 111.

44. Crookes claimed that the publication of the book, *Researches*, in 1874 was done without his knowledge or permission. Years later, when Doyle tried to revive the topic of Katie King in a most supportive book, a contretemps ensued upon Crookes's refusal. Upon the Home investigation however Crookes did not remain quite so silent, recounting the events for the *Proceedings for the Society for Psychical Research (Vol. 6)* and allowing his reports to be republished elsewhere.

45. D'Albe, *Life*, 248.

46. In a letter to Oliver Lodge on October 4, 1894, William James warned his friend not to publish his own researches into spiritualism or he "will be but another Crookes case to be deplored." Lodge Collection.

47. D'Albe, *Life*, 248.

48. D'Albe, *Life*, 248.

49. Palfreman, *On the Margins of Science*, 222.

50. D'Albe, *Life*, 249–53.

51. The Crookes tube was adapted to many different modes of experimentation but the basic set up involved an evacuated glass cone wired into an electrical circuit. Where the electrically heated wire was introduced into the tube formed the cathode or negative discharge terminal, while at the opposite end of the tube was inserted an anode or positive terminal, forming an electrical circuit powered by a low-voltage power source. (Some set-ups varied the position and number of terminals in the tube.) Crookes did not understand this at the time of course, but the "radiant matter" he was observing was not the electrified evacuated gases but rather electrons being discharged from the cathode, hence "cathode ray." His apparatus however provided the experimental conditions under which J.J. Thomson, a member of the Society for Psychical Research, was able to identify the existence of "electrons" in 1897.

52. Crookes thought he was observing electrically excited molecules of evacuated gas traveling in a straight pathway, thus behaving more like a beam of light than gas molecules which move in a chaotic, multi-directional manner. He explained that in the absence of molecular interference, the mean free path of the molecule traveled in a straight line, and at high enough rates of evacuation, this pathway might extend the length of the tube. Hence, these electrically excited molecules of gas displayed properties and behaviors completely different from the more ordinary gas state—hence Crookes called this "the fourth state of matter." His demonstration of this molecular stream was done via the "Crookes Cross." In the center of the tube, Crookes raised an iron cross which then cast a shadow on the far wall of the tube where the streaming radiant matter was blocked from impacting the glass. The molecular stream itself was invisible, but its straight pathways could be inferred by the impact pattern which showed the dark mask of the cross in a surrounding field of phosphorescence where the unimpeded rays struck the glass. Only a linear pathway would have produced such a pattern. The dark space that formed around the cathode inside the tube was also a function of this extended free pathway of the unimpeded molecule. The more rarified the gas, the larger the dark space, where the excited matter moved freely without molecular collision and its concomitant emission of light. Thus energetic, rarified matter could be present, but invisible, not unlike the unseen corporeal essence of some spirit phenomena.

53. William Crookes, *Radiant Matter, A Lecture Delivered to the British Association for the Advancement of Science at Sheffield Friday, August 22, 1879* (London: Davey, 1879), 30. Crookes's proposition of "the fourth state of matter" was bolstered by Faraday's own dramatic predictions and allowed Crookes to define himself before the scientific community as a similarly visionary maverick who, like Faraday, would also be at last welcomed in from the outside.

54. In spirit photography, ghosts were understood to chemically activate photo images by their own "actinic" composition, modeling "light" as both the living essence and substance of the soul, the meeting place of radiant matter and radiant force somewhere along the electromagnetic continuum. A.R. Wallace, one of Crookes's earliest spiritualistic compatriots, described spirit photographs he investigated in 1873 taken by Dr. Thomson and M. Beattie making this connection with light: "Here we have a thorough scientific investigation undertaken by two well-trained experts, with no possibility of their being imposed upon; and they demonstrate the fact that phantasmal figures and luminosities quite invisible to ordinary observers, can yet reflect or emit actinic rays so as to impress their forms and changes of form upon an ordinary photographic plate. An additional proof of this extraordinary phenomenon is, that frequently, and in the later experiments always, the medium spontaneously described what he saw, and the picture taken at that moment always exhibited the same kind of figure. In one of the pictures the medium is shown among the sitters gazing intently and pointing with his hand. While doing so he exclaimed: 'What a bright light up there! Can you not see it?' And the picture shows the bright light in the place to which his gaze and pointing hand are directed." Wallace, "Are there objective apparitions?", Arena (January, 1891), 144. Wallace also wrote in "A Defence of Modern Spiritualism," in *On Miracles and Modern Spiritualism* (London: James Burns, 1875), "If a person with a knowledge of photography takes his own glass plates, examines the camera and all accessories, and watches the whole process of taking a picture then, if any definite form appears on the negative besides the sitter, it is a proof that some object was present capable of reflecting or emitting the actinic rays, although invisible to those present (186) … Before leaving the photographic phenomena we have to notice two curious points in connection with them. The actinic action of the spirit-forms is peculiar, and much more rapid than that of the light reflected from ordinary material forms; for the figures start out the moment the developing fluid touches them while the figure of the sitter appears much later (198)."

55. Robert K. DeKosky, "William Crookes and the Fourth State of Matter," *Isis*, 67, 1 (March, 1976): 36–60. Despite the importance of the phenomena modeled in the Crookes tube for future

developments in radiation science, Crookes himself failed to identify what he was in fact observing. Crookes's "molecular rays" and "radiant matter" seemed to be crisscrossing the boundaries between atom and energy because he was in fact looking at the particle energy of the electron. This would later be determined by J.J. Thomson, using Crookes's own research and instrumentation but drawing upon Thomson's grasp of higher mathematics. Crookes's experimental aptitude could well have compensated for the mathematical obstacles had he not been so attached to the theory of radiant matter, a viewpoint he maintained over the next 20 years as the science of radiation physics left him behind.

56. The fact that Crookes no doubt knew Florence's phenomena were false was secondary to the fact that he ultimately believed such things were potentially true and that, crucially, for the sake of his reputation, he needed others to believe they were potentially true.

57. D'Albe, *Life*, 179.

58. The Society for Psychical Research was founded in 1882 to institutionalize the scientific investigation of this elusive force and its varieties of phenomena. Many of its original members (W.F. Barrett, Frederic Myers, Henry Sidgwick, and Edmund Gurney) drew inspiration from Crookes's earlier laboratory investigation of D.D. Home, adopting as well his sanitized, psychological category of "psychic" or "psychical" as opposed to "spiritual."

59. Crookes, "Part of the Presidential Address Delivered to the British Association at Bristol, Sept., 1898," *Proceedings of the Society for Psychical Research*, 14 (1898–99): 2–3.

Finding Florence in Birmingham:
hybridity and the photomechanical image in the 1890s[1]

Gerry Beegan

Introduction

This chapter traces the complex applications of image-making and reproduction technologies in British illustrated periodicals of the 1890s. In particular it focuses on the many ways in which hand technologies were combined with mechanical techniques. This fusion of the manual and the mechanical was very usual in British industry. The English social historian Raphael Samuel has pointed out that mid-nineteenth century industrial production was much more likely to combine manual interventions with assembly line production than to be purely mechanized. This situation continued through the 1890s in many trades particularly those based in London, which was the center of British newspaper and magazine production. The large-scale factory manufacture undertaken in the huge Midland conurbations of Birmingham and Manchester was not suitable for the confined spaces of the capital where businesses tended to be small and specialized.[2] These mixed systems of production were well developed in the printing and the reproduction industries where much hand labor supplemented highly sophisticated and expensive mechanical equipment.

What is particularly interesting about these hybrid interventions and combinations in the area of reproduction and representation is the way in which the images that were produced articulated responses to industrialization. In many cases they embodied ambivalence regarding mass production and the mechanization of imagery. Images that had been photographically generated were altered by hand in order to soften photography's status as a mechanically produced artifact. Similarly, the repetitive grid of dots produced by the new photomechanical halftone was removed and disrupted by hand engraving. Photographs themselves were retouched in order to render them less severe

and more "artistic." Photographs were often transformed into line drawings. As the popular press of the 1890s embraced photography and photographic reproduction processes as modern methods of visualizing the world they simultaneously attempted to diminish the photomechanical character of these images. In this chapter I will tease out some of the motivations and meanings behind these practices and suggest why the new mechanical technologies of reproduction so often evoked the hand based methods they were replacing.

It was indeed during the 1880s and 1890s that image reproduction moved towards photographically based systems. The new photorelief image-making techniques that were developed and commercially applied during these decades were conceived at the time as direct mechanical conduits of reproduction. Now that they were no longer hand engraved, reproductions could claim a new objectivity and directness. The photomechanical nature of the halftone offered an ostensibly unmediated and truthful trace of the objects it depicted. Yet the images in the press usually went beyond mere photographic mimesis and were manually transformed in various ways.

As I have suggested above, these interventions were, in part, a means of making these images less mechanical and less photographic. In a wider sense the press imagery of the 1890s, like the magazines which printed them and the society in which they were produced, were intensely hybrid. This was a period in which industrialized methods of reproduction and distribution generated myriad fragments that were juxtaposed in compelling new ways. In *Suspensions of Perception* (1999), Jonathan Crary credits the invention of the halftone with a proliferation of imagery that demanded new forms of attentiveness from the modern subject. Crary suggests that the logic of capitalism created a visual regime of constant novelty and distraction. He notes that in order to gain a sense of a coherent, if contingent, reality the late-Victorian city dweller had to sort the continuous flow of stimuli into inevitably provisional forms. Resolution and coherence were no longer possible, so in their place the viewer performed a type of synthesis, putting one image with another. This process of visual fusion that Crary proposes is enacted in the hybrid images that I discuss in this chapter.[3]

The new halftone techniques enabled publishers to integrate photographic images alongside letterpress type in books and magazines. It was a complex process that was broken down into many stages, all of which involved manual work and subjective judgments regarding the exact length of exposures or of etching. The procedure used a glass screen to break up the continuous tones of a painting or photograph into raised printable marks. Exposing the original through the screen's mesh of intersecting lines produced tiny dots on the negative. These varied in size according to the light reflected by the different parts of the image, with smaller dots in the dark areas and larger dots in the light areas. The resulting negatives were developed and contact printed onto a sensitized copper or zinc plate. The plate was then developed before being

etched. Etching involved inking the image and then submerging it in an acid solution. Two or three etchings were usual and often "fine etching" was then undertaken to increase contrast and clarify detail. Fine etchers applied etching solution selectively to parts of the image. After the block was finished manual engraving might be needed to clarify the image and deepen the impression.[4]

The standard account of the halftone was expounded by William Ivins in his books *How Prints Look* (1943) and *Prints and Visual Communication* (1953), which have shaped much of the subsequent understanding of these technologies. Ivins claimed that the halftone offered, for the first time, a direct, detailed and objective method of reproduction. Tonal photorelief techniques were posited by Ivins as neutral channels of reproduction which swept aside the existing interpretive hand engraving methods. As the previous paragraph might suggest, the halftone process depended on a good deal of personal judgment, and it was certainly not a direct trace of some pre-existing reality. The finished reproduction was shaped in accordance with culturally defined standards of how certain objects, people and events should look. In addition, there were many ongoing interconnections and exchanges between image-making and reproduction technologies which challenge Ivins's description of a photographic and photomechanical hegemony in publishing.

Certainly, as Crary suggests, the halftone did lead to a huge increase in the number of images which the reader needed to deal with. Photomechanical reproduction accelerated the exchange, circulation and mobility of repeatable images. But equally as important as the growing number of images was the increase in their variety. There was an enormous expansion of tonal wash paintings in magazines, but even more important was the growth in line drawings. As far back as the 1870s, photorelief line processes had enabled line drawings to be reproduced. Yet it was only in the 1890s, with the increasing use of photographic halftones by the press, that there was a fashion for pen-and-ink line illustrations. It is clear, therefore, that the variety and number of images were not simply technologically determined and that all of these methods were interrelated.

Rather than the photographic hegemony based on informational clarity that Ivins described, the last decades of the nineteenth century saw the development and refinement of different conventions in illustration and image-making conforming to the expectations of particular audiences. Distinct types of illustration and reproduction methods were used for posters, for news images in the press, and for the illustration of fiction. For instance, photographic images were rarely used for magazine advertisements, many of which retained a hand-drawn and wood-engraved aesthetic.[5]

The most significant attribute of the new photographic reproduction methods was, therefore, that they heightened the nascent mass media's ability to mix and combine imagery. In effect the introduction of photomechanical technologies destabilized reproduction and representation so that the discrete

categories of "photograph," "wood engraving" and "drawing" took on a new fluidity. Imaging practices dissolved the boundaries of the image, melding wood engraving with process, and photography with drawing. The mass-reproduced image was, I suggest, essentially hybrid. This chapter queries the notion of opposition between the new photomechanical technologies of reproduction and the traditional wood engraving methods. In doing so it questions the purity of the technologies themselves, as both reproductive systems incorporated elements from the other. My reading of the concept of hybridity is informed by Homi Bhabha's *The Location of Culture* (1994) and the notion that the unsettling of fixed identities, or in this case fixed cultures of representation, can creatively bring together seemingly contradictory elements. Hybridity allowed images to be both modern and traditional, objective and subjective at the same time.

The new illustrated periodicals of the 1890s contained a malleable flow of images; a typical magazine would contain many wash drawings, line drawings, and photographs, all of which were reproduced by combinations of photographic and hand techniques. In many cases mechanical processes and hand techniques were merged together, not only on the same page but within the same image. Wood engravings were pirated, photographed, and printed by process. Halftone blocks and line process images were extensively retouched by hand. Pen-and-ink drawings were produced on top of photographs which were bleached out to produce apparently hand-made sketches. In photographic portraits the background and clothing might be completely re-engraved by hand. In some cases these mixtures were concealed, but many syncretic illustrations openly fused different systems of photographic and hand-drawn representation and reproduction.

These semi-mechanical systems of image production operated in a variety of ways to balance the actuality of the photograph with the subjectivity of the hand-drawn image. Illustrations that were produced by bleaching out or tracing photographs were able to animate, simplify and focus the photographic image, adding imperfection and variation to their photographic sources. Through the extensive retouching of negatives, prints, and process plates the photographic halftone in the press was able to emulate the visual impact of the wood engraving. In syncretic halftones where areas of the printed image were clearly hand engraved, the visible labor of the engraver reinserted artistic and cultural status into the photographic image.

These amalgamations were a means through which the press and the viewer negotiated ambivalence regarding technological change. Magazine editors wanted to incorporate photography with its connotations of directness, intimacy, and modernity, but they also did not want to appear cheap or vulgar. Photographs were readily obtainable, inexpensive objects available in quantity in *carte de visite* form, or even as Kodak snapshots. Readers of magazines wanted to see these seemingly truthful images but also desired images that

went beyond photographic realism. The use of extensive retouching and re-engraving on photographic halftones produced an image that communicated the factuality of photography while mitigating photography's association with mechanism and industry. These reproduction and representational practices straddled the old and the new in an attempt to negotiate a changing visual and cultural terrain. These were ambiguous and paradoxical images created in a period of uncertainty when the industrial achievements of the nineteenth century were being questioned in British society. As Britain's status as the world's leading industrial power was challenged by America and Germany, the nation's confidence in technological progress was ebbing.[6]

Although many sectors of British industry were suffering from foreign competition, publishing was one of manufacturing's most profitable and dynamic sectors. Press conglomerates were now producing mass market products that attracted both many middle-class readers and the advertisers who wished to appeal to these new consumers. Using modern methods of management, promotion, production, and distribution, the chains controlled by George Newnes, Arthur Pearson and Alfred Harmsworth produced popular illustrated magazines and newspapers for mass audiences. Publishing was one of the most highly industrialized sectors of British manufacturing in which large profits enabled conglomerates to invest in the latest printing, typesetting and reproduction technologies. The methods that magazines used to reproduce images were also moving towards systems of segmentation and industrialization. Yet as reproduction became more mechanized, it employed the engraver's and illustrator's hands to bring an ostensible individuality to mass-produced representation.

The hybrid representational and reproduction practices in the magazine fitted within the changing structures of periodical publishing itself. In order to attract wide readerships these conglomerates and their rivals produced a human-interest based journalism that was lively, fragmentary, heterogeneous, and visually attractive. The central characteristic of the new pictorial press was its ability to juxtapose a variety of written texts and images. In order to provide its readers with timely, entertaining information on the surfaces of modernity, the press deployed a variety of imaging and reproduction techniques that were synthesized and combined in various ways.

Reshaping the halftone photograph

By the mid-1890s the halftone photograph had established a place in illustrated magazines where it was a metaphor for realism, factuality, informality, and authenticity. These qualities were perhaps best epitomized by the photographs that accompanied the many interviews which became a hallmark of the popular press. The interview was a compelling new journalistic format that

depicted an apparently intimate spoken encounter between two individuals. Its seeming spontaneity and familiarity were augmented by the use of photographs of the interviewee.[7] Whereas the wood-engraved portrait added grandeur and distance to its subject, the halftone created a less formal and ostensibly more direct connection between the reader and the subject of the photograph.

Hand engraving did not suit the up-to-date press's ephemeral content. Wood engraving made its subjects look dignified and stable, whereas the process image made the world appear spontaneous and transitory. A wood engraving looked like a great deal of time had been spent cutting its myriad furrows whereas the process image, whether in line or in halftone, appeared to be instantaneous. Wood engraving is a relief process in which the negative spaces in an image are carved out to produce raised lines that can be printed alongside relief letterpress type. Linear and tonal images could be drawn or painted onto the woodblock and then translated into a fine web of printable marks. Moreover, the marks the engravers made were in themselves meaningful and situated images in very particular ways for specific nineteenth-century reading publics.[8] In the illustrated middle-class magazine the fine lines of wood engraving evoked the genteel approaches of artistic metal engraving and of book illustration. Engravers consciously adopted the linear codes that had been used by metal engravers for literary and artistic subjects and applied these to the illustration of topical events and individuals.

During the 1890s, wood engraving was ousted as the means of image reproduction in the press. Yet, these apparent divergences between the old and the new reproduction systems were not as clearly defined as they might appear. Photo-relief reproduction was indeed promoted as a means of achieving a direct facsimile but in practice it was not deployed to this end. Rather, it was combined with hand technologies of retouching and re-engraving to produce culturally acceptable and commercially successful images. In order to do so it had to conform, to a great extent, with the existing wood engraved images in the press. Wood engraving did not die but continued to be used *within* the process industry.

The printed wood engraving consisted of clearly differentiated black marks contrasting with distinct areas of white paper. The halftone's entire surface, on the other hand, appeared to be grey with no strong blacks or crisp whites. Commercial process engravers attempted to imitate the tonal qualities of the wood engraving by retouching and manipulating the process image and the photomechanical plate to achieve greater contrast. Throughout the production process, from the making of the negative to the finished plate, the aim was not photographic facsimile but the production of an image which matched the wood engraving's strong visual impact.

The fusion of hand work with chemical and photographic technologies was so pervasive throughout this period that it is more accurate to speak of "semi-

mechanical" rather than mechanical reproduction. From the 1880s until well into the twentieth century there was a great deal of manual manipulation involved in the reproduction of photographs, just as digital retouching and manipulation became the norm in the 1990s. The photographic image in the press was far from a direct transcription of the original; on the contrary, photographs were subject to modification at every single phase of their replication.

Firstly, the original negative was often retouched before a print was made. Next, the resulting print was painted on or "worked up" and the content of the print modified. During the etching of the halftone block areas of the image were subject to selective "fine etching" to improve clarity and detail. Finally, once the block was etched, its entire surface might be "engraved up" by hand in order to break up the intrusive regularity of the halftone's rows of dots. Re-engraving also increased the contrast of the image and brought it closer to the tonality of wood engraving. In some cases re-engraving was used to produce a syncretic image in which areas which looked like wood engravings were juxtaposed with those that looked like halftones. In the most extreme cases halftones were entirely re-engraved to become ersatz wood engravings.

This alteration of the mass-reproduced image was linked to a commercial photographic industry in which the retouching of negatives and prints was widely practiced. Retouching was described as "the Cinderella of the photographic arts" whose very existence was unsuspected by those who admired the results it achieved.[9] Retouchers developed specific conventions for portraiture in which wrinkles and frowns were removed, light was added in the eye, hair was highlighted and drapery softened. This was not only done to make the sitter more attractive, but had a psychological aspect. One expert advised "... any furrow between the eyebrows should be almost entirely removed, as it indicates uneasiness of mind"[10] The aim was not only to erase these physiognomic imperfections and signs of psychic agitation but to soften the harshness which was said to be inherent in photographs.[11] The negative was placed in a special holder and illuminated from behind. Pencils, knives, and watercolor paint were used to produce minute lines, whirls, and circles that modeled the image.

Once a print had been made from these negatives, if it was to be used in the press it was subject to further alteration. A direct halftone copy of a photograph produced results that were deemed to be flat and insipid. In order to rectify this perceived deficiency, retouchers added contrast to the print before it was screened. Highlights and shadows were embellished using brushes to produce an exaggerated contrast. Retouchers wore blue tinted spectacles in order to judge the effect of their work and when the photograph appeared balanced through these glasses it would produce a successful halftone.[12] In addition to adjusting contrast, retouching was also used to alter the content of the photograph. The extensive adjustment of originals became so prevalent

5.1 *Funeral of Queen Victoria. King and Kaiser entering Hyde Park. From the original snapshot … .* Photorelief halftone print. Henry Snowden Ward and Catharine Weed Ward, *Photography for the Press* (London: Dawbarn and Ward, 1901), 6

that tools were devised specifically for this task. The airbrush or aerograph which was developed in the 1890s produced a smoothly graduated tint which could be used to add or remove elements.

Press photographs were, in essence, raw material for the retoucher. So common was this retouching of prints that photographers who were intending to submit topical images for publication were advised not to worry about the technical qualities of their originals. In 1901 *Photography for the Press*, the first

5.2 *Funeral of Queen Victoria. King and Kaiser entering Hyde Park. Reduced from enlargement of snap-shot on page 6 … .* Photorelief halftone print. Henry Snowden Ward and Catharine Weed Ward, *Photography for the Press* (London: Dawbarn and Ward, 1901), 7

English book on the subject, stressed that clarity, point of view, and simplicity were the keys to journalistic success. "The weekly, inasmuch as it makes a halftone block, wants a fairly good print, but the worker-up of originals and the fine etcher have made editors very independent of brilliance and 'snap' in submitted prints." The ideal print for publication should be "a little hard" so that it survived the "slight degrading action of the half-tone ground."[13] It should essentially be a "large snapshot" in its harsh contrast, unlike the

5.3 *Funeral of Queen Victoria. King and Kaiser entering Hyde Park. From a worked-up print made from the photogram on page 7* Photorelief halftone print. Henry Snowden Ward and Catharine Weed Ward, *Photography for the Press* (London: Dawbarn and Ward, 1901), 9

breadth of tone, subtlety, and softness that a photographer would aim for in an exhibition print.[14]

Photography for the Press was illustrated using images of Queen Victoria's funeral, the most notable media event of the recent past. The degrees of retouching required for different types of magazine were demonstrated using a shot of the Prince of Wales and the Kaiser on horseback in the funeral procession (Figures 5.1, 5.2, 5.3). In the most elaborate example, which was regarded as suitable for a high class publication, the original photograph was all but erased by the redrawing. In the final version, retouching asserted the Prince's importance by differentiating him from the figures around him and by placing him at the centre of the composition. The details of his face, body and his horse were crisply defined. Both his beard and his face were trimmed down and his expression remodeled so that he looked directly and stoically into the camera. The higher the imagined reader's class, the more idealized and artistic the image appeared to become. The final, extensively retouched version told the story of the heir to the throne's appropriately dignified demeanor at his mother's funeral far more effectively than the original image.[15]

Women undertook much of the retouching of negatives and prints for the press and they were also heavily involved in the fine etching of plates. Women were not, in general, very visible in the printing and reproduction industries and they were effectively excluded from the higher levels of these trades by the apprenticeship system. They worked in labor-intensive areas such as typesetting and print finishing. Women retouchers were skilled, trained workers who were seen as more "acquiescent" than their male counterparts and were willing to work for lower rates.[16]

Photography and the pen-and-ink sketch

As I stated earlier in the chapter the growth in photographic imagery was accompanied by a fashion for line sketches of contemporary life. These included news images as well as humorous sketches of manners. In 1855 Charles Baudelaire had argued that the sketch rather than the photograph was the best way of communicating the vital signs of class and status in the fast-moving contemporary metropolis. In his seminal essay "The Painter of Modern Life," Baudelaire argued that the photograph was unable to capture modernity; it supplied far too much detail, and, at the same time, gave too little information. The sketch artist, on the other hand, could distill the essential elements from the contemporary urban scene. He could show the viewer the important aspects of an event, not overwhelm them with photographic superfluities. For Baudelaire the photograph was the epitome of what he dubbed the "industrial madness" of mercantile society with its soulless reliance on empirical data.[17] The sketches that Baudelaire discussed

5.4 Phil May, *Scarborough Spa*. Photorelief line print from pen-and-ink original, detail. Joseph Slapkins, pseud.; Phil May, *The Parson and the Painter; Their Wanderings and Excursions Among Men and Women* (London, Central Publishing and Advertising Co., 1893), 47

in his essay were used as the basis for wood engraving, but by the 1890s the press were using photorelief reproduction processes to capture the lines of pen-and-ink sketches. They appeared to be a much more direct trace of the illustrator's hand than the engravings of the 1850s. Although they were mechanically reproduced, these images provided magazines with a visual and conceptual contrast to the factual halftone photograph. The vitality, individuality, and subjectivity that these gestural drawings communicated provided a foil to static and detailed photographs.

However, while the sketch was positioned as the antithesis of the photograph, it relied on photography in a number of ways (Figure 5.4). Firstly, illustrations depended on photographic reproduction methods to convey the particular quality of the artist's drawing style, whether it was Aubrey Beardsley's fine sinuous marks or Phil May's bold energetic scratches. In addition, many drawings were based directly on photographs, traced on top of photographic prints before the prints themselves were bleached away in order

to conceal the mechanical origins of the finished sketch. In addition, illustrators increasingly depended on the photograph as a means of seeing the world.

In his 1896 book of photographic information and advice for artists, Hector Maclean maintained that the vast majority of contemporary painters made "free and full use of all the help they can get out of the camera." Although painters were reluctant to acknowledge their use of photography for fear it would damage their reputation as illustrators, he claimed, "unblushingly own up." These illustrators, working to tight deadlines, could coalesce raw data from photographs into meaningful and effective narratives. Maclean stated: "I may say that those who live by the newspapers cannot hope to succeed unless they are habituated to working from photographs, and have acquired the facility of rapidly combining photographic information supplied them into a telling and forcible statement of pictorial story."[18] The illustrator, as Maclean realized, was able to transform factual "information" into a meaningful narrative. One of the advantages that illustration possessed over photography was that it was able to combine elements from different moments in an event in order to tell a story. The photograph was limited to the separate temporal fragments that were captured by the camera.[19]

As Maclean's volume suggests, illustrators incorporated photography into their practices in numerous ways. Illustrators and artists used the camera as a research tool so that it became an adjunct to, or a replacement for, sketching. This role expanded when the huge demand for illustration in the 1890s required an increase in the pace of image production. The veteran news illustrator Frederick Villiers, dispatched to cover the Chicago Columbian Exposition of 1893 by *Black and White*, admitted that of the 150 illustrations he produced only around six were developed from observational drawings. The rest were based on snapshots. The publisher and critic Charles Blackburn commented in recording this: "The photographer is, … marching on and on, and the demarcation between handwork and photographic illustration becomes less marked every day."[20]

In addition to their use as reference, photographs also became the basis for tracing and for various bleach-out techniques in which a drawing was made directly on a photograph before the photograph was erased. These hybrid combinations of the photographic and the hand-drawn took a number of forms, and had a number of motivations. In many cases the conversion from tone to line was a means of quickly and cheaply producing clear printable images. Halftones were difficult to print on the fast presses used by the dailies, so photographs were converted into line images for photorelief line reproduction. Many of the news images in the press were black and white line sketches that were based directly on photographic sources. Magazines and newspapers on both sides of the Atlantic employed teams of illustrators to clarify and simplify photographic originals by tracing or by drawing directly on the photographic print before bleaching it out. In illustrated newspapers

the photographic origins of these drawings were not concealed. Indeed, in order to bolster the truthfulness of the image, the caption that accompanied the illustration often announced that it was based on a photograph.[21] Yet these drawings did not just simplify the photograph, they added narrative clarity, making the image more intelligible, more vivid and more lively.

The influential journalist, critic, and publisher Joseph Gleeson White was an expert on both photography and illustration and was well aware of the connections and differences between the two practices. He believed that photography had shaped contemporary illustration but also thought that illustration could reshape photography. In his 1897 book *Practical Designing*, Gleeson White provided students with detailed instructions for drawing on a photographic image before bleaching it out. He averred that this method should not be used as a substitute for observational drawing, but as a time-saving device particularly in portraits and architectural work. Gleeson White was a champion of pen-and-ink illustration who believed that suggestion was better than an over-detailed literalism. He saw the bleach-out technique as a means of providing a more direct and effective image than the photograph through "effacing the needlessly minute detail recorded by the camera." To achieve this it was necessary for the illustrator to ruthlessly remove most of the image. Gleeson White advised; "Of one hundred facts to the square inch ninety must be discarded." He cautioned that this editing was not easy to master, as the effect must not simply be a mechanical tracing of the photograph's outlines. Gleeson White compared the stiff over-elaborate approach of some illustrators to the lifeless perfection of machine-made woodcarving. But if the illustrator practiced and worked selectively, it was possible to produce an attractive image using only a few freely handled lines. He suggested that the appeal of these artistic drawings lay in the imperfections of their loosely sketched lines, which would contrast with the industrial regularity of the photographic halftone.[22]

Even when it was photographically derived, the pen-and-ink sketch was positioned as the antithesis of the photograph. Nevertheless, in a wider sense the production and reception of illustration could not escape the camera's influence. The photographic aesthetic had changed the entire visual terrain and its impact on illustration was unavoidable. As Gleeson White noted, the dramatically composed pen-and-ink sketch was used by publications as a counter to the grey halftone photograph. Yet, at the same time, the cropped forms and apparently chance framing, which became common in illustration, were themselves influenced by photography. In 1895 Gleeson White acknowledged that photography had shaped the public's expectation of all imagery. He noted that in the past illustrations had been symmetrical, composed, and artificial. White argued that contemporary illustrators' informal, asymmetrical compositions were a response to the photographic aesthetic. He urged his readers:

Turn to modern illustration, and you will find always an effort to be naturalistic—in the photographic sense—that is, an imitation of the accidental grouping of common life, in place of the arbitrary pose of grand opera. Today we find the figure, half cut off by the frame, or playing almost secondary parts amid their surroundings. A chair-back or a tree may be usurping the important place, and human beings be no more always to the front than they are in the common order of things.

White argued that although illustrators themselves might also have been influenced by the Japanese print in their boldly cropped compositions, public taste certainly had not. The public accepted this new style of illustration because the photograph had already made the fragmentary image familiar. "In this respect it seems hardly possible to over-estimate the importance of the silent teaching of the photograph." White also suggested that the photograph had prepared the viewer for a new type of subject matter, the everyday episodes which were central to the new illustration. Photography had, he argued, given the public a new appreciation of the "effects of ordinary life, heretofore deemed too common to be represented in high art."[23] Indeed, the most popular magazine illustrations of the 1890s were the pen-and-ink social caricatures in which illustrators depicted recognizable people in believable poses and everyday settings. These sketches were embedded in magazines whose photographs also conveyed a sense, both in their form and content, of an ever-changing contemporary world. There was something compellingly ordinary about the illustrative content of the photomechanically illustrated magazines of the 1890s as they visualized the new urban world of mass consumption for its inhabitants.

Photography and wood engraving

All technologies are hybrids that draw on their predecessors, and this was particularly true of photographic reproduction methods. The development of the photorelief tonal engraving was not a linear progression, rather it consisted of a complex series of overlapping exchanges, shifts, and transfers—of people, mechanisms, and above all visual forms. Wood engraving, the method through which mass produced images had been generated for nearly 50 years, shaped much of the development of the new mechanical processes of the 1880s and 1890s. Mechanical reproduction was not seen by its inventors and users as a new stage in image-making or simply as a means of accurately printing photographs, but was situated very much in relation to the existing techniques and aesthetics of periodical reproduction.

The two reproduction methods were closely connected. The first efforts at using a screen to break up the continuous tones of a photograph were Fox Talbot's experiments with folded gauze in 1852. He described the resulting

print as being "covered with lines very much resembling those produced by an engraver's tool, so much so that even a practical engraver would probably be deceived by the appearance."[24] The American inventor Frederick Ives described the halftone as "a typographic relief printing plate in which the smooth shading of a photograph is translated into a pattern of definite lines and dots suitably graduated in size, as in a wood engraving."[25] It is clear that Ives and his fellow inventors envisioned this new reproduction process in the context to the images which already existing in the press, not as a revolutionary break. Indeed, William Gamble, an early promoter of photomechanical reproduction, contended that the increasingly fine marks used in wood engraving had shown photomechanical pioneers that dots could produce the illusion of tone.[26]

Yet, at the same time, wood engraving itself had changed since the 1840s when it was first used in topical illustrated weeklies to reproduce the contemporary scene. The cultural ubiquity of photography, and its use as a means of reproducing artworks, influenced expectations of other reproduction systems. Although there had been a debate about facsimile in reproduction since the eighteenth century, this intensified with the coming of photography. In a positivist, realist shift, photography highlighted the subjective nature of other imaging methods and brought a new requirement for accuracy. There were growing expectations that reproduction processes would appear to be objective and truthful. From the 1860s onwards, wood engraving moved away from interpretative methods which had been the norm and increasingly adopted a facsimile approach. This move was aided by the use of photography within the wood engraving trade.

Wood engraving and photography had been closely linked from the 1840s. From the early days of the topical illustrated press, draughtsmen had copied daguerreotypes onto woodblocks for hand engraving, and from the 1850s images had been fixed photographically to blocks. The increasing use of photography on the wood block had accelerated the move to facsimile in wood engraving. In order to compete with the unbroken photographic surface, hand engraving became increasingly fine and increasingly tonal in its aesthetic. Wood engravers were forced to develop a new range of marks which were comparable to the tones of the photograph. Short, broken, scattered scratches and dots replaced the long curved lines of the past.

The continuous surface of the photograph has, since its invention, enabled viewers to imagine that it provides an objective mechanical trace of an external reality. Of course the photograph is not purely mechanical or objective; human agency operates at all stages, from the design and manufacture of equipment and film to decisions about what to shoot and how to shoot it. Indeed, the belief that photography was objective was breaking down in the 1890s in the face of a growing awareness that photography did not replicate human vision.[27] In the earlier part of the century, photography was conventionally regarded as true

because it was mechanical; in the 1890s, its mechanical nature was regarded as the source of its deficiencies. As a warning to illustrators against the slavish imitation of the photograph, Hector Maclean's *Photography for Artists* outlined some "photographic falsities." These shortcomings included the monocular nature of photography, its sharp allover focus, its distortion of perspective and perpendicular lines, and its misrepresentation of tones. Maclean concluded, "It may be at once accepted that no photograph ever displayed a scene as beheld by our eyes." This was, Maclean argued, because vision was both embodied and subjective, "A sympathetic and cultured onlooker sees much more than is before him" For Maclean, as for Gleeson White, there was more to the world than the camera could reveal.[28] For both of these figures, the subjectivity of the illustrator could enhance the photograph's mechanical limitations.

Photography was regarded by both liberal and conservative critics as too literal, as the epitome of what was wrong with mercantile, rational, middle-class society. Photography and mass reproduction were targeted in an anti-industrial critique that was a distinctive strand in late-Victorian English society. As the negative consequences of industrialization became unmistakably clear in the second half of the century, there was a decline of confidence in mechanical progress. Criticism of industrial society, the society that was developed and maintained by the middle classes, came from figures as diverse as Charles Dickens, John Ruskin, Matthew Arnold, John Stuart Mill, William Morris, and James McNeill Whistler.[29] For both Morris's Socialist Arts and Crafts followers and Whistler's elitist Aesthetes, the scientific pragmatism of middle-class culture was epitomized by the mechanical, unselective, and inartistic photograph.[30] Photography was the perfect means of depicting a mass-produced, materialistic, ersatz culture. Its excess of detail might be literally and mechanically true but the effect was brutally faithful, and microscopically ugly. In showing only the surface, it missed the substance.

Just as photography was criticized as mechanical and soulless, similar terms were used to condemn process technologies. The negative critical reaction to the photomechanical image emphasized its characteristics as a mechanically generated artifact, a monotonous, cheap, mass-produced replica. Those who looked at images in periodicals were accustomed to the varied lines of wood engraved images, lines that connoted the worlds of art and of feeling. The terms used to describe the appearance of the halftone, in contrast, evoked the industrial city and mechanized production. The *Telegraph* newspaper criticized line blocks but added that halftones were even worse: "More lamentable still are the blurred and sooty reproductions likewise due to processes of which lugubrious presentments surfeit the columns of the monthly and weekly periodicals."[31] The word "sooty" evokes the fetid smoke of the metropolis and the factory.

For critics of the halftone, the repetitive grid of dots that formed the image confirmed the halftone's machine-made character. The illustrator Joseph Pennell's principal objection to the halftone was that "the squares of lozenges produce a mechanical look."[32] This was a new visual formation that was clearly visible in most press images. It took many years for viewers to learn to ignore them. In the 1920s, the illustrator E.J. Sullivan referred to "the mechanical dots and squares of the halftone block that are so irritating to all but those who cannot see them."[33] Another illustrator, John Petrina, writing as late as the 1930s, argued that "Line reproductions are more faithful copies of the original than half-tones, because no screen is used, and thus the appearance of the reproduction is less mechanical."[34]

This visibility of the halftone grid was known by process workers as the "screeny effect" and the grid was said to be noticeable with screens of 120 lines to the inch and less. This was the ruling used for most general printing, and newspaper work was produced on much coarser screens of 85–100 lines to the inch. Magazines tried to soften the mechanical appearance of the grid by extensive hand retouching. Re-engraving or "tool work" was used to remove the "monotonous uniform mesh" of the halftone.[35] These hand-engraving techniques reduced the mechanical aesthetic by adding highlights and by disrupting the regular rows of halftone dots. Burnishers and roulettes with toothed wheels were used, and areas were hatched and stippled to break up the repetitive grain.

Re-engraving was also used to counter another photomechanical problem; the fact that the process image was simply too commonplace (Figure 5.5). The mechanical halftone screen treated all of the originals that it processed in the same way, whether they were photographs of potatoes or of politicians. In one sense this reproductive egalitarianism was democratic and liberating, but it could also be demeaning. Wood engraving, on the other hand, had conferred a sense of distinction on the individuals it depicted. Whereas Victorians of all classes became used to seeing photographs of their family and friends, they would not typically have seen engraved representations of their peers. Photography was quotidian; engraving was not. To be the subject of a time-consuming and expensive hand-made image suggested a person was of some importance, or at least of public interest. An incident or an individual had to be considered significant to warrant the expense of creating a drawing and transforming it into a wood block. This procedure therefore acted as a form of quality control in the press. Almost any image that was defined using the fine linear codes of wood engraving, with their stylistic affinities to metal engraving and fine art reproduction, attained a certain dignity and artistic status.

Tom Gretton has suggested that with the introduction of the halftone into periodicals, viewers were left to decide for themselves the status of the objects depicted, for status was no longer inscribed within the reproduction process

5.5 *Ruskin engraved by Jonnard from a Bust by Edgar Boehm.* Wood engraving, detail.
M.H. Spielmann, "The Portraits of John Ruskin," *Magazine of Art,* 14 (1891): 121

itself.[36] I would argue that the connotations produced by photomechanical reproduction might have been more subtle than those of wood engraving, but that they were there nevertheless. The halftone process connoted modernity, directness, and equality. In essence the halftone dot turned the printed image into an everyday object. Mechanical reproduction made the printed image more accessible and this reduction in the status of visual representation

was not always welcomed. A poem entitled "That Vile Process" that was reproduced in a process trade paper dwelt on the vulgar commercial nature of mechanical reproduction and showed an enlarged detail from a halftone of Lord Kelvin. The blow-up revealed that the venerable aristocrat had become a series of insignificant and apparently random geometric marks; he was reduced to "A pattern nebulous/and made of dots and squares." The poet complained that the distinguished sitter was degraded by being turned into meaningless particles for the sake of profit. He was part of a demeaning system "Where dignity is sacrificed/To tawdry art that pays."[37] The syncretic re-engravings of halftone portraits in middle-class magazines were attempts to reinsert a notion of status into photomechanical portraiture, even when the subjects were less noble than Lord Kelvin.

Through their various combinations of photography and wood engraving, magazines sought to provide a balance between the demands for objectivity and cultural refinement. The most extreme version of this mixture was the "New School" engraving that first appeared in American magazines such as *Scribners* and *Harper's* in the late 1870s. The New School was a small group of American engravers including Tim Cole, Frederick Juengling, Henry Wolf and A.V.S. Anthony who mainly worked on fine art reproductions in middle-class monthly magazines and in books. Their approach depended on the faithful and painstaking facsimile cutting of photographic images that had been fixed on the block. Previously engravers had used many tools to make a range of lines which would be varied in type and width according to the objects which they were depicting. This interpretive engraving approach responded to the content and meaning of the image; a cloud would be cut with a line which was distinct from that used when depicting a rock. New School engravers, in contrast, were concerned with surface rather than content and used one or two gravers to produce a minute arrangement of fine lines which treated everything in the same manner. As the style was very much influenced by the photographic aesthetic there was an even overall effect and few dramatic differences in tone, with no pure blacks or whites visible (Figure 5.6).

It is important to situate this development of photographic engravings in the context of middle-class American magazine publication. New School engravings first appeared in genteel parlor magazines that provided uplifting and improving literature for the bourgeoisie. Magazines such as *Scribners* and *Harper's* had championed and developed high-class wood engraving and spent considerable sums of money on commissioning, engraving and printing large, elaborate images. In these publications popular culture was seen as a threat, and the magazines regarded themselves as setting standards for elite culture that could then be diffused to the masses. Many subjects, such as depictions of working-class life, were excluded from these magazines as vulgar and inappropriate. The editors of these publications

5.6 Timothy Cole (engraving), *Delphian Sibyl, by Michelangelo*. Wood engraving, detail. Timothy Cole, *Old Italian Masters Engraved by Timothy Cole* (New York: The Century, 1892), 219

saw themselves as custodians of a cultural heritage which was an antidote to the excessive materialism of American society. The style of photographically-based engraving which these magazines pioneered allowed them to combine pragmatism with art, to make objectivity palatable.[38]

In the 1870s and early 1880s, only the expensive American monthlies had the time, money, and the accurate printing equipment necessary to reproduce the incredibly delicate images engraved by Cole and his comrades. However, the style was hugely influential through the following two decades on both sides of the Atlantic. In England the approach was known as the American School. In the 1890s, British engraving moved toward the ultra-fine American style first in the hugely successful monthly *The Strand* and then in the weekly *Black and White*.[39] However, the American School was criticized in England as too photographic and characterless, and as a bravura exercise in empty technique. The experienced engraver and publisher Henry Vizetelly stated that the American School had "a microscopic minuteness of execution which has more the character of mechanism than of art." The prominent art critic M.H. Spielmann condemned the American approach as a mechanistic copy rather than an interpretation. He complained that in this mimetic approach to engraving "What was an art, became a science—a process: Florence, so to speak, was supplanted by Birmingham."[40] However, this amalgamation of photography and engraving was intended to bring Florence and Birmingham together, to make down-to-earth industrial Birmingham more attractive and habitable by adding a touch of artistic Florence.

In 1893 Edwin Bale, writing in *The Magazine of Art*, roundly condemned Tim Cole's recently published book *The Old Italian Masters*. Bale noted that in the worst New School engravings enormous amounts of effort had created images that were indistinguishable from halftones. He argued that as the process block improved over the past few years the two methods had become interchangeable. In yet another instance of the complex links between hand engraving and photomechanical reproduction, Bale proposed that it was the public's familiarity with the tonal approach to engraving that had made it easier for them to accept halftone images in print.[41]

There were many physical connections between the photographic and hand-engraving industries as workers moved between the two trades. Younger engravers learned photography so that they could apply it to wood engraving and some of these craftsmen went on to found process firms.[42] Some engravers retrained as process workers, many others were employed in the retouching of process blocks. The extensive hand work that both line and halftone processes required called for the precise manual skills which wood engravers possessed. It was ironic, but also appropriate, that these redeployed engravers were involved in the production of photomechanical blocks which imitated the reproduction technique that process was destroying.

In what was known as "wood-cut finish," photographic portraits would have the background and clothing almost completely re-engraved. *Harper's* led the way in October 1894 and the fashion spread from there both in the

United States and Europe. The redeployment of in-house wood engravers at *Harper's*, and at long-established British magazines such as the *Illustrated London News* and *The Graphic* may have been one reason for the revival. As publishers moved to process reproduction they had to find some role for their employees. However, the style was not only used by reputable periodicals but also by new inexpensive publications such as the popular American monthly *Munsey's*.[43] There were many unemployed engravers who provided a ready pool of cheap labor for this type of work. By 1897, wood engraving was rarely being used as a reproduction method in the press; even *The Graphic*, the last bastion of the traditional methods, had gone over to process. However, wood engraving was still extensively used within the process industry.[44] While no longer seen as a viable method of reproduction, hand engraving had come to connote an artistic and superior image. One contemporary writer put it: "At present most of the ability of the wood engravers who survive is devoted to hand-working half-tone blocks, which often are engraved over almost their whole printing surface, and begin to rival wood-cuts in their elaborate retouching and finish."[45]

Visible hand engraving was a means of reinserting discernable artistic labor and significance into the mass image. All that was perceptible on the surface of the photographic halftone was a machine-made photograph replicated via a repetitive pattern of dots. The mechanical reiteration of the grid appeared to have been produced instantly and without effort. In Victorian art and design, the amount of tangible labor that had gone into the making of an object had moral and economic implications. Art involved work, visible work, and the art object was the evidence of diligent endeavors to solve technical difficulties and produce a highly finished surface. The celebrated libel dispute between Ruskin and Whistler that resulted in a pyrrhic victory for the painter revolved around the fact that little effort or time seemed to have gone into the flamboyant American's paintings. The photographic halftone's paradoxical dilemma was that neither the photographer's nor the process worker's skill and judgment were visible in it, indeed it appeared to have been created by machines. In actual fact there was, of course, a great deal of human labor involved in the reproduction process, but it was concealed, literally, behind the screen.[46] Visible re-engraving rectified this apparent deficiency by inscribing clear signs of artistic production on the mechanical surface of the halftone plate.

Prominent figures in the photomechanical industry approved of this method of refashioning the image. It might seem that in doing so they were acknowledging the aesthetic and, more importantly, the mimetic limitations of their own technologies. But the "wood-cut finish" not only allowed the halftone to look its best, it associated the new technology with the positive qualities of it predecessor.[47] Max Levy, who with his brother had developed the halftone screens that dominated the industry, along with Carl Hentschel

and Frederick Ives, believed that hand engraving allowed the halftone to be simultaneously an objective mechanical artifact and an artistic, hand-crafted object. But this positive view of these hybrid images was not universal. H.W. Bromhead, writing in *The Art Journal* in 1898, criticized the vogue for re-engraving and suggested that its mixture of the old and new, the interpretive and the mimetic, was jarring and unsuccessful rather than harmonious. He asserted: "The result is often a piece of hideous patch-work, a kind of bastard engraving, neither a satisfactory reproduction of the original, nor an artistic interpretation of it in another medium such as the old wood-engraving often was."[48]

Conclusion

As Bromhead's comments make clear, the hybrid image was intrinsically contradictory in its various attempts to negotiate the ambiguities of the late-Victorian visual realm. The types of image I have discussed in this chapter, including wood-engraved photographs and photographically-derived sketches, were composites of old and new methods. These hybrid images both revealed and attempted to navigate the social, economic and aesthetic tensions of this period. Magazines and their readers seemed unwilling to relinquish established and effective hand-based methods and move to purely photographic literalism. Magazine editors and publishers managed to have it both ways, employing photomechanical methods as a means of indicating the modernity of their magazines while using hand retouching to produce a refined image that was acceptable to their audiences. Retouching reinserted the appearance of variety, imperfection, and humanity into images that might otherwise have been seen as mechanically generated. Ironically, the work of adding an ersatz individuality to the mass-reproduced image was undertaken by engravers whose craft had been displaced by industrial reproduction and who were now enslaved by photomechanical process.

This situation is indicative of the awkward collaborations that this chapter has traced. In the photographically-derived sketch, for instance, the camera might be embraced as a means of producing an effective image, yet this chemical genesis was erased in order to assert an artistic individuality. In the case of New School engraving, the photograph was enthusiastically adopted as a means of generating a faithful image and as an inspiration of a new tonal approach to image reproduction. Yet the products of this alliance were criticized, as we have seen, for being unsuccessful hybrids, neither one thing nor the other. There seemed to be something inherently unstable about these attempts to combine sparkling Florence with sooty Birmingham.

Notes

1. Some of the material in this paper appears in my study *The Mass Image: A Social History of Photomechanical Reproduction in Victorian London* (Basingstoke: Palgrave Macmillan, 2008).

2. Raphael Samuel, "Workshop of the World: Steam Power and Hand Technology in Mid-Victorian Britain," *History Workshop*, 3 (1977): 6–72. On London's systems of industrial production see Gareth Steadman Jones, *Outcast London* (Oxford: Clarendon Press, 1971) in particular Chapter 1, "London as an Industrial Centre."

3. Jonathan Crary, *Suspensions of Perception: Attention, Spectacle, and Modern Culture* (Cambridge, MA: MIT Press, 1999).

4. For the details of the procedure, see G.H. Bartlett, *Pen and Ink Drawing* (Boston: Riverside Press, 1903).

5. There were a number of interrelated factors in the slow adoption of photography by advertisers. Henry Blackburn argued that the main reason was that wood engravings were easier to print than halftones. Henry Blackburn, *The Art of Illustration* (London: W.H. Allen, 1894). Yet, as Richard Ohmann suggests, the major reason was that photography was not yet able to appeal to fantasy and emotion in the same way as hand-drawn images. Richard Ohmann, *Selling Culture: Magazines, Markets, and Class at the Turn of the Century* (London: Verso, 1996).

6. On Britain's economic and industrial decline, see Martin Weiner, *English Culture and the Decline of the Industrial Spirit 1850–1980* (Cambridge: Cambridge University Press, 1981).

7. On the adoption of the American technique of the interview in British magazines and newspapers during the 1880s and 1890s, see Richard Salmon, " 'A Simulacrum of Power': Intimacy and Abstraction in the Rhetoric of the New Journalism," in Laurel Brake, Bill Bell, David Finkelstein, eds, *Nineteenth Century Media and the Construction of Identities* (Basingstoke: Palgrave, 2000): 27–39.

8. See Brian Maidment, *Reading Popular Prints 1790–1870* (Manchester: Manchester University Press, 1996), in particular "The Victorian wood engraving and its uses," 145–8.

9. E.C. Morgan, "Retouching," *British Journal of Photography*, 40 (1893): 280–2.

10. George Brown, *Finishing the Negative* (London: Dawbarn and Ward, 1901), 102.

11. As stated in the chapter "Retouching Portrait Negatives," in *Finishing the Negative*, "The brutal realism of the photographic image is not to be tolerated, and it falls to the retoucher to remedy the defect to just that nicety that there is no undue prominence of the unpleasing feature, nor yet that entire removal of it which will at once make it conspicuous by its very absence." Brown, *Finishing the Negative*, 91.

12. A. Seymour, "Pictorial Expression. Chapter 5. Illustrated Journalism," *British Printer*, 8 (1900): 290–3.

13. Henry Snowden Ward and Catharine Weed Ward, *Photography for the Press* (London: Dawbarn and Ward, 1901), 27.

14. Ward and Ward, *Photography for the Press*, 24.

15. Ward and Ward, *Photography for the Press*, 24. Page 6 is captioned "Funeral of Queen Victoria. King and Kaiser entering Hyde Park. From the original snapshot, with "N. & G." camera and "Planar" lens, by T.W. Dorrington, for J. Bulback & Co." Page 7 is captioned "Funeral of Queen Victoria. King and Kaiser entering Hyde Park. Reduced from enlargement of snapshot on page 6. Enlarged negative was slightly worked up, and prints from it were taken by all the leading papers" The final version on page 9 is captioned "Funeral of Queen Victoria. King and Kaiser entering Hyde Park. From a worked-up print made from the photogram on page 7"

16. The job required training at an art school followed by a year's experience in technical drawing at a process house. Then wages were £100 to £120 a year. According to the *Process Photogram*, women retouchers brought a feminine presence to the workplace, dressing in pretty blouses, decorating their studios with plants and occupying themselves knitting clothes for charity between plates. "Fine Etching for Women," *The Process Photogram* (1897): 10. William Gamble noted that in the USA fine etching was called "staging" and that in some firms as many as 30 young women were employed as fine etchers. Women were preferred as they worked for lower wages than men. William Gamble, "Halftones in 'News' Printing," *Process Photogram*, 12, 136 (1905): 138–9.

17. Charles Baudelaire, "The Painter of Modern Life," in *The Painter of Modern Life and Other Essays*, trans. and ed., Jonathan Mayne (London: Phaidon, 1964), 4.

18. Hector Maclean, *Photography for Artists* (Bradford: Percy Lund, 1896), 10, 16.

19. On the illustration's ability to encompass an extended time frame see Joshua Brown, *Beyond the Lines: Pictorial Reporting, Everyday Life, and the Crisis of Gilded Age America* (Berkeley: University of California Press, 2002), 68.

20. Henry Blackburn, *The Art of Illustration* (London: W.H. Allen, 1894), 171.

21. On *The Daily Graphic*'s illustrators, see A.S. Hartrick, *A Painter's Pilgrimage Through 50 Years* (London: Cambridge University Press, 1939).

22. Joseph Gleeson White, "Drawing for Reproduction," in Joseph Gleeson White, ed., *Practical Designing* (London: George Bell and Sons, 1897), 188.

23. Joseph Gleeson White, "Some Aspects of Modern Illustration," *Photographic Journal*, 19, 11 (1895): 350.

24. Henry Fox Talbot, "Photographic Engraving," *The Athenaeum* (1853): 533.

25. Frederick Ives, *The Autobiography of an Amateur Inventor* (Philadelphia: Privately Published, 1928).

26. J.S. Hodson, *A Historical and Practical Guide to Art Illustration in Connection with Books, Periodicals and General Decoration* (London: Sampson Low, 1884), 187–8.

27. On the diminishing faith in the truthful nature of photography and the complex status of the photograph as evidence in the late nineteenth century see Jennifer Tucker, *Nature Exposed: Photography as Eyewitness in Victorian Science* (Baltimore: Johns Hopkins University Press, 2005).

28. Maclean, 77.

29. For an overview of these critical positions in England, see Weiner, *English Culture and the Decline of the Industrial Spirit*.

30. In his discussion of French critical reactions to photography Allan Sekula points out: "The complaints against the emergent 'democratic' media are couched in aesthetic terms but devolve, almost always, into a schizophrenic class hatred aimed at both the middle and working classes coupled with a hopeless fantasy of restoration." Allan Sekula, "On the Invention of Photographic Meaning," in Victor Burgin, ed., *Thinking Photography* (London: Macmillan, 1982): 95.

31. Quoted in T.C. Hepworth, *The Camera and the Pen* (Bradford: Percy Lund, 1897).

32. Joseph Pennell, *Modern Illustration* (London: George Bell 1895), 45.

33. E.J. Sullivan, *The Art of Illustration* (London: Chapman and Hall, 1921), 196.

34. John Petrina *Art Work, How Produced, How Reproduced* (London: Sir I. Pitman and Sons 1934), 91.

35. C.S. Bierce, "Notes on Process Matters in the USA," *Process Photogram*, 75 (March 1900), 41. On re-engraving see G.H. Bartlett, *Pen and Ink Drawing* (Boston: Riverside Press, 1903), 197. On retouching in England specifically, see F.G. Kitton, "The Art of Photo-Etching and Engraving," *The British Printer*, 7 (1894): 218–31.

36. Tom Gretton, "Signs for Labour-Value in Printed Pictures After the Photomechanical Revolution: Mainstream Changes and Extreme Cases Around 1900," in *Oxford Art Journal*, 28.3 (2005): 371–90.

37. "That Vile Process," *Process Work* 5 (1897): 144.

38. On the New School, see Frank Weitenkampf, *American Graphic Art* (New York: Henry Holt, 1912). Also see Estelle Jussim, *Visual Communication and the Graphic Arts: Photographic Technologies in the Nineteenth Century* (New York: Bowker, 1974).

39. On the influence of the American School on English engraving, see E. Bale, "Mr. Timothy Cole and American Wood Engraving," *The Magazine of Art*, 16 (1893): 138–9.

40. Henry Vizetelly, *Glances Back Through 70 Years: Autobiographical And Other Reminiscences* (London: Kegan Paul and Co., 1893), 119. M.H. Spielmann, "The New Robinson Crusoe," *The Magazine of Art*, 15 (1892): 47–51.

41. Edwin Bale, "Timothy Cole and American Wood Engraving," *The Magazine of Art*, 16 (1893): 138–9.

42. Charles Booth found that process workers were drawn from many occupations, including engravers and photographers. Charles Booth, *Life and Labour of the People in London* (London: Macmillan, 1903), 117.

43. See H. Lamont Brown, "Engraved Half-tones," *Penrose Annual: Process Year Book* (London: Lund Humphries, 1896), 71.

44. William Gamble, "Process in Magazine and Book Illustration," *Penrose Annual: Process Year Book* (London: Lund Humphries, 1897), 3.

45. Henry Blackburn, *The Art of Illustration*, Second Edition (Edinburgh, John Grant, 1901), 183. Blackburn died before this edition of the book was published and information on current practices was from another source.

46. For a discussion of detail, finish and visible labor in Victorian art, see Dianne Sachko MacLeod, *Art and the Victorian Middle Class: Money and the Making of Cultural Identity* (Cambridge: Cambridge University Press, 1996), and also Peter Conrad, *The Victorian Treasure-House* (London: Collins, 1973), 106–33.

47. Frederick Ives clearly knew a good deal of this combined technique and told a meeting of the Royal Photographic Society that the hand engraving on a block in *Harper's* could cost £15. *Photographic Journal*, 20, 7 (1896): 184.

48. H.W. Bromhead, "Some Contemporary Illustrators," *The Art Journal*, 60 (1898): 304.

Auguste Rodin and the "scientific image": the sublime copy versus the photograph

Natasha Ruiz-Gómez

Photography can, in fact, popularize the knowledge of a great number of phenomena that are known only to passionate observers of nature.

Étienne-Jules Marey[1]

Science has taken out all the sap, with its admirable discoveries. Man becomes, more and more, one of the gears of the machine he directs, more or less toward the truth, but he can give the machine only what it gives him.

Auguste Rodin[2]

The French sculptor Auguste Rodin (1840–1917) declared in 1898, the year the highly criticized *Monument to Balzac* (Figure 6.1) was first exhibited, "I sought in *Balzac* ... to render an art that was not photography in sculpture. ... My principle is not to imitate only the form, but to imitate life. ... I seek a synthesis in the whole."[3] In another article published the same day, he asserted, "For me, modern sculpture cannot be photography. The artist should work not only with his hand, but above all with his mind."[4] The curious distinction that Rodin makes—the artist works with his mind, while the photographer does not—prompts a consideration of his ambivalent relationship to the photograph. Rodin's lifelong antipathy to the camera was widely reported, yet the sculptor's strongly worded statements against photography belie his broad and sophisticated utilization of the medium throughout his career.[5]

Artists had been grappling with photography since its birth in 1839, when Louis-Jacques-Mandé Daguerre in France and William Henry Fox Talbot in England announced, each independently of the other, having developed processes for fixing the elusive image created by light entering the dark interior of a box through a pinhole.[6] Two decades later, Baudelaire famously derided photography as art's "mortal enemy," which he warned

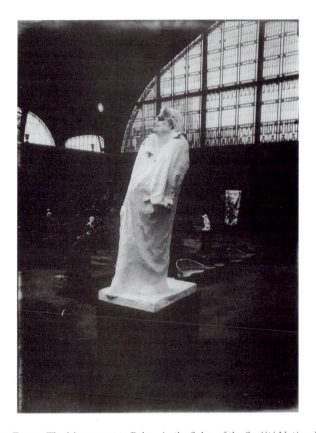

6.1 Eugène Druet, *The Monument to Balzac in the Salon of the Société Nationale des Beaux-Arts of 1898*, 39.5 × 29.5 cm, gelatin silver print, 1898. Inv. #Ph.375, Musée Rodin, Paris

would soon corrupt or even supplant art altogether if measures were not taken to stop it.[7] Artists and critics kept the camera's pretensions to art in constant tension with its industrial nature. Photography was not perceived exclusively as a rival, however; it became a powerful new tool for artists and scientists alike—the "handmaid" of art but also an instrument of science.[8] In fact, the photograph often blurred the boundary between science and art, as is evident in the chronophotographs of Eadweard Muybridge (1830–1904) and Étienne-Jules Marey (1830–1904).[9] Rodin took issue specifically with the purported objectivity of the photograph as a tool of physiology; his comments about the "scientific image" reveal an ambivalence to the new medium that is crucial to a proper understanding of its impact on his work.[10]

Rodin's mistrust of photography is paradoxical because he always professed his belief that truth could be found only through faithfulness to

nature—which, at the time, was the camera's most touted virtue. In a 1913 interview with painter and politician H.C.E. Dujardin-Beaumetz, Rodin said, "Art cannot be made except by approaching truth; thus nature is the only model that must be followed, since she inspires us and gives us the truth of the impression, shows us the truth of forms, and, when we copy her with sincerity, she shows us the means of uniting and expressing them."[11] His resistance to the photograph led him to create bodies that contested the medium's "objectivity" and the norms evident therein; figures such as Rodin's were not, after all, what would be captured by a photograph. By the first decades of the twentieth century, the sculptor's partial and pieced-together figures were decried as *informe* ("formless") and unnatural and led him to be regarded as a contemporary Doctor Frankenstein tampering with nature and creating monsters.[12] Rodin's bodies-in-pieces constituted nothing short of an attack on the body's integrity, affirming his role as a creator who took nature into his own hands.

* * *

Rodin saw chronophotography in particular as a threat to his sculpture. The origins of chronophotography can be traced to the 1870s, when the contested issue of the horse's gait was put to rest by Anglo-American photographer Eadweard Muybridge. Commissioned by former governor of California and avid racehorse owner Leland Stanford, Muybridge devised an electrical method of tripping a battery of camera shutters with the horse's body, producing a series of images on separate plates that revealed for the first time the actual positions of the animal's legs during a gallop.[13] These images demonstrated definitively that the horse raises all four hooves off the ground at once—although not in the "hobbyhorse" attitude in which it had been depicted for centuries.

Illustrated around the world, Muybridge's photographs brought to the fore debates about the difference between artistic and photographic vision. The horse's true postures could not be seen by the naked eye and, furthermore, looked ridiculous and oddly bereft of motion to a public accustomed to a contradictory artistic convention. American painter Thomas Eakins bought Muybridge's studies of horses and applied the photographer's discoveries to his own works, such as *A May Morning in the Park* (*The Fairman Rogers' Four-in-Hand*) (1879–80, Philadelphia, Philadelphia Museum of Art). The effect, however, was criticized by an American artist speaking to the London Camera Club:

If you photograph an object in motion, all feeling of motion is lost, and the object at once stands still. A most curious example of this occurred to a painter just after the first appearance in America of Mr. Muybridge's photographs of horses in action. This painter wished to show a drag coming

along the road at a rapid trot. ... [The horses'] legs had been studied and painted in the most marvellous [*sic*] manner. He then put on the drag. He drew every spoke in the wheels, and the whole affair looked as if it had been instantaneously petrified or arrested. ... He then blurred the spokes, giving the drag the appearance of motion. The result was that it seemed to be on the point of running right over the horses, which were standing still.[14]

The issue rested in the difference between artistic accuracy and scientific accuracy: the impression of movement was more important for the artist than a mechanically precise depiction of it.[15]

The debate came to France with an article illustrating Muybridge's photographs in the popular scientific journal *La Nature*.[16] On November 26, 1881, the academic painter Ernest Meissonier gave a party for the photographer in Paris; among the guests were painters Jean-Léon Gérôme and Alexandre Cabanel and writer Jules Claretie.[17] Muybridge amazed the guests by using a zoopraxiscope, a device he had invented, to project a sequence of photographs that gave the appearance of the animal in motion.[18] The photographer later wrote, "Meissonier was the first among Artists to acknowledge the value to Art design of the Author's researches."[19] Edgar Degas, too, was influenced by Muybridge's photographs; he probably saw the article about them in *La Nature*, in addition to later ones in *L'Illustration*.[20]

The publication of the photos in *La Nature* prompted French physiologist Étienne-Jules Marey to start a dialogue with Muybridge and to utilize photography in his efforts to develop an objective system of charting the body's rhythms.[21] He felt that this was necessary because of "the imperfection of our senses to discover truths, and then the insufficiency of language to express and to transmit those that we have acquired."[22] The mistrust of information acquired through the senses led him to experiment with the "graphic method," which he felt revealed an unseen order beneath the seeming chaos of life.[23] Marey, who invented diagnostic instruments that were—and remain—fundamental to the field of cardiology, astounded Paris in the early 1880s with his first "chronophotographs," a term he coined in 1889.[24] Unlike Muybridge, Marey took carefully timed photographs that captured the sequential phases of movement on a single plate (Figure 6.2), producing otherworldly images that often revealed figures in unimaginable attitudes.[25] Eventually, he captured the pattern of the body's movement by photographing against a dark background and in profile a person clad in black with bright metal bands affixed to his side—the abstracted body of his "geometric chronophotography" allowed motion to be more easily read.[26] Marey's photographs contributed, as Anson Rabinbach argues, to the "shattering of perceptual certainties and the radical questioning of the nature of forms in the spatiotemporal world" that defined the late-nineteenth-century "crisis of perception."[27]

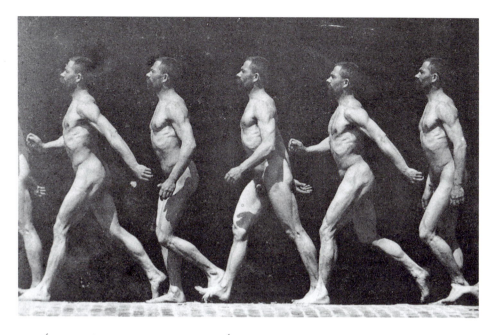

6.2 Étienne-Jules Marey, *La Marche*, from Étienne-Jules Marey and Georges Demeny, *Études de physiologie artistique faites au moyen de la chronophotographie. Première série, no. 1. Des mouvements de l'homme* (Paris: Société d'éditions scientifiques, 1893), plate VI.

Both chronophotographers created books intended for the use of artists.[28] In 1887 Muybridge published 11 volumes titled *Animal Locomotion* under the auspices of the University of Pennsylvania, where he established a laboratory in 1884 in order to study the movement of both humans and animals.[29] The plates show men, women, and children; the healthy and the pathological body; athletic movements and "aesthetic" poses (Figure 6.3).[30] Aaron Scharf calls this work "a nineteenth-century equivalent to the medieval pattern-book."[31] Marey's *Études de physiologie artistique faites au moyen de la chronophotographie* (1893), on the other hand, focuses exclusively on the healthy male body and includes chronophotographs on both single and multiple plates (see Figure 6.2).[32] Even before Marey published this very successful study of human movement, Paul Soriau's *The Aesthetics of Movement* (1889) recommended that artists utilize both Marey's and Muybridge's chronophotographs for inspiration.[33]

Statements made by Rodin suggest that he spent a great deal of time contemplating the dangers of photography to art and reveal his alarm over chronophotography in particular. Despite a lack of concrete evidence, it has been widely assumed that Rodin met Muybridge on the latter's visit to Paris and that the sculptor was one of the original subscribers to Muybridge's *Animal Locomotion*.[34] Whether Rodin knew Marey personally is

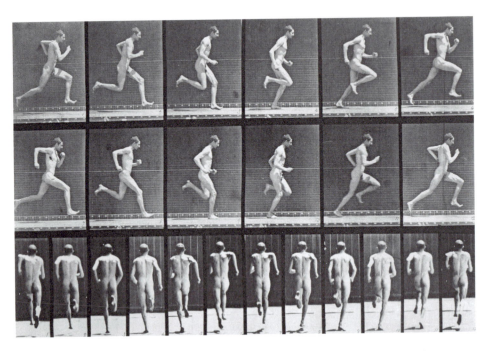

6.3 Eadweard Muybridge, *Running at Full Speed*, from Eadweard Muybridge,
*Animal Locomotion: An Electro-Photographic Investigation of Consecutive Phases of Animal
Movements, 1872–85*, vol. I (Philadelphia: J.B. Lippincott under the auspices of the
University of Pennsylvania, 1887), plate 62

also uncertain, although the sculptor's circle included important figures in
both the scientific and photographic communities, among them the "father
of neurology" Jean-Martin Charcot and the celebrated photographer Nadar,
who was friends with the physiologist.[35] It is surprising given the use of
photography generally in Rodin's sculptural practice that he should be so
wary of chronophotography specifically.[36] He contributed, for example,
to the debate about the "accuracy" of the depiction of the horse's gallop,
comparing chronophotographs with Géricault's *Le Derby d'Epsom* (1821,
Paris, Musée du Louvre): the latter appeared more "true" to the sculptor.[37]

A key to understanding Rodin's mistrust of photography may be found
in his self-proclaimed role as nature's "sublime copyist."[38] As Richard Shiff
argues, by the late nineteenth century the term "copy" "would assure strict
adherence to nature Nevertheless, ... there would always be a *difference*;
this difference, this individual identity, was not to be found in the appearance
of things but in a man."[39] In other words, artists interpreted the world
through their temperament, subordinating canonical convention to personal
inspiration. To the generation of Impressionists and other avant-garde artists
of the late nineteenth century, "copy" was a positive term that was meant

to convey the originality of their vision and their emotional response to the motif. Rodin echoed this sentiment in the last decade of his life, stating, "I obey Nature in everything, and I never pretend to command her. My only ambition is to be servilely faithful to her." He continues, however, that "the artist does not see Nature as she appears to the vulgar, because his emotion reveals to him the hidden truths beneath appearances."[40] The sculptor casts himself as a seer who can interpret nature in fantastic works that may seem to flout the laws of nature to the common individual. If the camera's "trace" captures "nature's own expression, without screen, echo or interference," as François Dagognet asserts, then the artist's act of "copying," which springs from feeling, is diametrically opposed to it.[41]

Rodin's pejorative statements about photography would lead to the assumption that for him the medium's role was necessarily limited, but his wide-ranging use of photography throughout his career belies his dismissive attitude.[42] Rodin left a collection of approximately seven thousand photographs to the French state upon his death.[43] He professed his need to work from a model but used photographs, albeit reluctantly, as *aides-mémoire* when individuals were unable to sit for their portraits or when he needed inspiration for posthumous subjects.[44] Rodin owned photographs of professional models in "the attitude of a cadaver on the dissection table," with "the peculiarities, or rather the anatomical deformities of the model" noted alongside views from the back.[45] The sculptor also bought photographs of models in academic poses from Belgian photographer Gaudenzio Marconi and others; in one image of a brazenly posed couple, a woman kneels and arches her back in order to rest it on the left shoulder of an awkwardly twisted young man.[46] Their poses differ significantly from the more classical stance of a model in another photograph owned by Rodin that may have come from the atelier of the sculptor Alexandre Falguière.[47]

Rodin presumably used these uncommissioned photographs for inspiration. The aforementioned image of the couple in the clumsily erotic pose, for example, is in one of the many albums in the collection of the Musée Rodin, Paris, that were apparently compiled by the artist himself.[48] These albums, which have been largely overlooked by scholars, serve as a window into Rodin's artistic interests and working methods. One includes such disparate images as a view of a sculpture gallery at the Louvre, an *ignudo* from the Sistine Chapel ceiling, the Parthenon marbles, architectural details of the chateau de Chambord, and busts of Roman emperors.[49] The last item in the album is a reproduction of a Michelangelo drawing of the flayed muscular leg of an *ignudo* bent at the knee, above which Rodin has drawn an architectural fragment—"chapiteau" is written in the sculptor's hand—that echoes the angle of the bent knee and transforms the architectonic structure of the musculature into ornament.[50] This remarkable detail provides a clue to Rodin's working method—the transposition of body to architecture, organic to

inorganic, and vice versa, suggests that Rodin may have used the photographs to nourish and exercise his imagination.

Although Rodin never seems to have picked up a camera, he commissioned many photographs of the works in his studio and of his exhibitions. He often used photography, just as he frequently took plaster casts, to mark stages in the process of reworking a sculpture.[51] Hélène Pinet points out a noteworthy parallel between photography and sculpture:

During this period, one is struck by the similarity between the terms used to describe the different mechanical procedures involved in the reproduction of a work of art, whether reproduced in two or three dimensions; in both types of reproduction, references are made to proofs, *tirages* (a term used to refer to prints, as well as to casts), enlargements, and reductions. All of these operations … gave both practices an industrial character that contradicted (and continues to contradict) many assumptions about artistic production … .[52]

While both media have deep roots in industrial processes, photography's purported transcription of nature would seem to deny the artist's hand. As the epigraph to this chapter makes clear, Rodin believed that the machine—for example, a camera—stifled artistic creativity.

Rodin's use of photography, however, was not limited to simply capturing appearances for practical purposes. On the contrary, he used the camera in radical ways. Some versions of his sculptural arrangements exist only in photographs.[53] Of course, his practice of bringing works together was not unique to his photographic oeuvre; he told Dujardin-Beaumetz, "When the figures are well modeled, they approach one another and group themselves by themselves. I copied two figures separately; I brought them together; that sufficed, and these two bodies united made *Francesa da Rimini and Paolo*."[54] Rodin may have used the camera to test certain compositions, or he may have even created certain sculptural groupings for the express purpose of photographing them. For instance, the bust of Victor Hugo surrounded by the doubled *Meditation* makes a particularly effective and surreal two-dimensional tableau, and the illustrations for Charles Baudelaire's *Les Fleurs du mal*, privately commissioned by Paul Gallimard, were drawings made by Rodin from photographs of his own work.[55]

Rodin regularly manipulated images in order to modify or explore new directions for a design. He had the studies for *The Burghers of Calais* (1884–95) photographed extensively, and his often dramatic notations may have been incorporated in subsequent studies. Rodin annotated the two-dimensional reproduction of *Young Girl Kissed by a Phantom* (c. 1898) by Eugène Druet, rotating the figures 90 degrees and transposing them into an architectural setting.[56] There are also more extreme instances, in which photographs would become works in their own right; using pencil and gouache, Rodin would transform images and subsequently name them. *Dans la mer* (c. 1889) is one of a series of photographs by an unknown photographer of two plaster figures

that show the sculptures repositioned in relation to each other.[57] Dark blue gouache surrounds the sculptures; waves of color border them above and below. Arms outstretched, the male figure is oriented vertically and seems to be diving toward the prone female figure as it appears to sink into the sea. The uncharacteristically literal title of the work emerges from the artist's spontaneous design, inspired by the arrangement of the figures. The meaning of each configuration shifts with the changes, not only in the relationship between the two bodies, but also in the angle from which they were photographed. As Hélène Pinet has written, each image becomes "a new work, half photo, half drawing, possible origin of a new sculpture, that meanwhile is never realized and remains simply dreamed."[58] This type of "play" can also be understood as an aspect of Rodin's modernity; Kirk Varnedoe explains:

Crucial for the development of modern sculpture was his constantly attentive self-examination, a faculty that led him to stop where others might have continued and to continue with what others might have thought finished. Photography, not only by affording him a quick method of objectifying his work, but also by providing him cheap and dispensable miniature surrogates, facilitated the roles of reflection, experiment, and play (in the most serious sense) in his process of creation.[59]

Ultimately, qualities inherent to the photograph—its two-dimensionality and its reproducibility—may have contributed to the innovations Rodin wrought on the medium of sculpture.

Beginning in 1896 at an exhibition at the Musée Rath in Geneva, Rodin began to exhibit photographs of absent pieces alongside sculpture in foreign exhibitions—an inexpensive way of showing more work.[60] Throughout his career, he used photographs as publicity aids and gave them as illustrations for journal articles.[61] Clearly thinking of public relations, Rodin had postcards made of his work—some even show works in progress—in addition to lantern slides.[62] A postcard Rodin received from a Japanese artist shows *The Little Shade* (c. 1885) from the back on a support over which is draped a richly patterned Oriental rug. It is unclear whether the postcard, printed in Japan, was commissioned by the sculptor.[63]

Rodin seems to have maintained strict control over the images that resulted from his collaborations with various photographers throughout his career.[64] Presumably at Rodin's request, Eugène Druet not only added the sculptor's signature to the photographs he printed but destroyed plates that Rodin rejected.[65] Druet's photographs from the turn of the century seem to have been taken expressly for public dissemination, which provides an insight as to how Rodin wanted his work seen.[66] Many of Druet's photographs present unexpected views of the sculpture: *The Helmet-Maker's Wife* (c. 1898), shot from below, appears to be serving judgement; the head of *Despair* (c. 1898) is obscured by drapery and lost in shadow; the *Clenched Hand* (c. 1898) emerges anxiously from a blanket.[67] These suggestive images may have served to accentuate the evocative nature of Rodin's sculpture

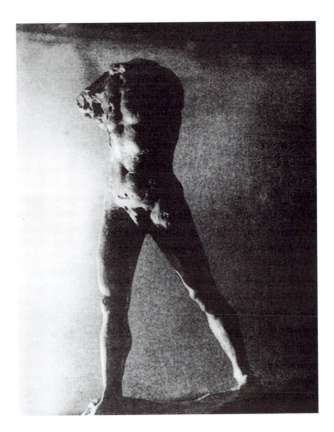

6.4 Stephen Haweis and Henry Coles, *The Walking Man*, 22.7 × 16.5 cm, carbon print.
Inv. #Ph.1423, Musée Rodin, Paris

for an audience attuned to Symbolist imagery; within a few years of being taken, several of Druet's photographs of *The Clenched Hand* illustrated an article on Rodin's sculptures of hands by Symbolist writer Gustave Kahn.[68] Some photographs are studies in the radical manipulation of form, while others revel in a sculpture's simulation of the human body. With the help of Druet and the other photographers who collaborated with Rodin, the sculptor was able to assemble a library of diverse images that he could use to target specific audiences.

Rodin's varied use of photography attests to his belief in the value of the medium as a sketchpad, a prod for his imagination and a tool for public relations. Yet he maintained an aggressive theoretical stance against photography—often amounting to outright rejection. The case of *The Walking Man* (1899) (Figure 6.4) clearly demonstrates Rodin's anxiety. In order to create this work, he attached casts of the legs of *Saint John the Baptist Preaching* (1880) to the earlier rough-hewn *Torso* (c. 1878), which was likely a study for it;

their obvious connection at the pelvis evinces the fabricated nature of the work.[69] In the decade before his death, Rodin recounted the conception of both the *Saint John* and *The Walking Man*. A "rough, hairy man" from the Italian region of Abruzzi was brought to Rodin's studio in the 1870s by a former model:[70]

The peasant undressed, mounted the model stand as if he had never posed; he planted himself, head up, torso straight, at the same time supported on his two legs, opened like a compass. The movement was so right, so determined, and so true that I cried: "But it's a walking man!" I immediately resolved to make what I had seen.

It was customary then, when looking over a model, to tell him to walk, that is, to make him carry the balance of the upright body onto a single leg; it was believed that thus one found movements that were more harmonious, more elegant, "well turned out." The very thought of balancing a figure on both legs seemed like a lack of taste, an outrage to tradition, almost a heresy. I was already willful, stubborn. I thought only that it was absolutely necessary to make something good, for if I didn't transmit my impression exactly as I had received it, my statue would be ridiculous and everyone would make fun of me. ... I promised myself then to model it with all my might, and to come close to nature, which is to say, to truth.[71]

César Pignatelli, as the model was known at the time, posed for *Saint John the Baptist Preaching*, whose firmly planted legs announce an earthly grounding but simultaneously suggest a transitional state of movement. Rodin's perhaps apocryphal account, told more than 30 years after their meeting, suggests that the model's pose was simply "found" by the sculptor, while also introducing the origins of *The Walking Man*. Cobbled together from fragments of *Saint John*, *The Walking Man* highlights the shift in Rodin's priorities in the intervening two decades. In the later work, the sculptor splayed the legs further, adding clay or plaster to the back leg in order to lengthen it and extend its reach—as is well known, the sculpture's left leg is twenty percent longer than the right—so that the soles of both feet are forced to the ground. By creating an anatomically impossible pose and removing the head and arms, he shifted the focus of attention from narrative to action. The crux of Rodin's argument against photography lies in the unnatural stance of this sculpture; the inclination of the torso and the front foot give the impression of movement despite the fact that the back foot stays decidedly put. Rodin discussed this at length in 1911, stating:

It is probable that an instantaneous photograph from a model making the same movement would show the back foot already raised and carried towards the other. Or else, on the contrary, the front foot would not yet be on the ground if the back leg occupied in the photograph the same position as in my statue. Now it is exactly for that reason that this model photographed would present the odd appearance of a man suddenly stricken with paralysis and petrified in his pose

And this confirms what I have just explained to you on the subject of movement in art. If, in fact, in instantaneous photographs, the figures, though taken while moving, seem suddenly fixed in mid-air, it is because, all parts of the body being reproduced exactly at the same twentieth or fortieth of a second, there is no progressive development of movement as there is in art.[72]

Chronophotography challenged Rodin to represent movement and the passage of time in the static medium of sculpture—art's superiority, according to Rodin, lay in its ability to misrepresent nature in the service of expression in a way that was impossible for the photograph. The shocking rapidity with which shutters could open and close to capture movement inspired a defensive stance on the part of the sculptor, who attempted to condense several moments into one.[73] As Pierre Sterckx argues, "the sculptor, faced with the unfolding of Muybridge's photograms at 1/2,000 of a second, feels himself dispossessed of that dense body, expressed in rhetorical postures, which makes him the prestigious keeper of History."[74] Chronophotographs could only capture arbitrary moments, whereas the artist had the ability to create significance.[75] Rodin pits the artist's imagination against the machine in a battle to best represent nature in art. He states bluntly: "Mechanics replace the work of the human mind with the work of a machine. That is the death of art."[76] The underlying angst of this statement points to the *paragone*, or competition, between sculpture and photography.

The issue was further energized by the perceived taint of industry on the medium of photography. Yet by the 1830s, the production of sculpture was becoming increasingly mechanized with the development of the Collas machine for reducing and enlarging works.[77] This led to a burgeoning trade in sculpture offered in editions of various sizes that fueled a growing demand for domestic-scale decorative sculpture in the homes of the rising bourgeoisie. Sculptors became entrepreneurs, producing work for a mass market.

On May 11, 1898, Rodin vigorously defended his *Monument to Balzac* (see Figure 6.1), which had just been rejected by the Société des gens de lettres; interviews with the sculptor published the next day reveal his fears about the industrialization of the medium. In a statement published in *Le Journal*, Rodin belittles the "genre of casting" that he sees as having spoiled the public's taste.[78] He sets "the commercial sculpture that overruns the Salon" against his own "true art" in an article in *Le Jour* by Adolphe Possien, who shockingly summarizes Rodin's views with the exclamation: "Down with modern sculpture!"[79] In an interview cited in *L'Aurore*, Rodin criticizes the Société des gens de lettres for having imagined the *Balzac* commission as "a commercial order," because in Rodin's view art and "commerce" have "no relation."[80] The sculptor avows in *Les Droits de l'Homme* that his *Balzac* marks a break with the past toward a "new synthetic sculpture" that "all the

makers of marbles for show-cases and shop-windows dread. ... Those who conduct this sort of business, the works of art for export or for mantelpieces, are worried!"[81] Finally, Rodin gave the rallying cry: "Photographic sculpture has had its time!"[82] In sum, industrial art *tout court* was the enemy of his sculpture.[83]

The assault on artistic sculpture that Rodin perceived may have begun with the invention of photosculpture. This short-lived but faddish technique of mechanically creating portrait sculpture was patented by François Willème in France in the 1860s: 24 cameras encircling a sitter would take photographic profiles; as the images from the glass negatives were successively projected onto a screen, a worker would transfer the profiles onto a rotating block of clay, using a device similar to the Collas machine; the sum of the profiles would yield a likeness that would simply need to be smoothed and detailed by the resident artist, producing a sculpture in about 48 hours.[84] The hand of the artist was thereby almost completely replaced by the machine. Critic Théophile Gautier, among others, saw photosculpture—and photography—as useful tools for the artist: they were both "docile slaves that take notes on his account, prepare his work for him, conduct tedious business, and disencumber of all material obstacles the domain of the ideal for him."[85]

Unlike other sculptors of the time, Rodin attempted to work on all sides of a sculpture at once, turning the work continuously and studying it from different orientations.[86] As scholars have argued, Rodin may have adopted the practice of studying contours from Willème's method of creating inexpensive portrait sculptures, in vogue when he was sculpting his first important works, *Man with the Broken Nose* (c. 1862–64) and *The Age of Bronze* (1877).[87] Yet Rodin never acknowledged the industrial source of his technique. Its suppressed origins emerged, however, late in his life when he was discussing his study of contours: "In art, the mind is the surest calculator; it must participate in the work, whereas, in the method by measurements, it is the machine which makes judgements."[88] The machine, therefore, could never replace human imagination; Rodin asserts that only the artist could maintain "the grand tradition" of sculpture, "never [imitating] form servilely, but [drawing] as near as possible to life."[89]

Physiologists who utilized photography's indexicality to create more "truthful" sculpture were likely seen by Rodin as another threat. Practitioners of "photographic sculpture" included Marey, whose sculptures broke down movement, echoing the visual revelations of the chronophotograph. His sculptures of a bird in flight, for example, mimic his photographic experiments: *The Flight of the Gull* (1887, Beaune, Musée Marey) shows the flapping of the bird's wing in overlapping phases, creating a fluid, undifferentiated figure, while *The Flight of the Pigeon* (1887, Paris, Collège de France) breaks down the movement of the bird into distinct,

6.5 Photograph of Georges Engrand, *Single Phase of the Run Made from a Chronophotograph*, 1887, from the Marey album entitled "*Mélanges*." Courtesy of the Archives of the Collège de France, Paris

successive stages. Apparently not trusting his talents to render the human form, Marey commissioned an academic sculptor, Georges Engrand, to produce a sculpture of a running man (Figure 6.5), which Marta Braun

describes as displaying "both awkwardness and a prosaic stillness."[90] Engrand also made a series of bas-reliefs representing the various stages of a man running, which Marey then presented to the French Académie des Sciences in 1888. These were "accompanied by his comparisons of correct and incorrect representations of human locomotion in art," in order to demonstrate that "only the ancient Greeks came close to 'seeing' motion correctly and to incorporating that vision into their art. Photography, he showed, now enabled us to return to that original true vision."[91]

French philosopher Henri Bergson also compared the depiction of movement in the sculpture of the ancient Greeks and in chronophotography. He was Marey's colleague at the Collège de France in the first years of the twentieth century, and they seem to have collaborated on experiments.[92] In his *Creative Evolution* of 1907, the philosopher considers the "cinematographical mechanism" evident in both Greek sculpture and in Marey's photographs, although he does not identify the physiologist by name. Discussing the Parthenon frieze, Bergson observes:

Of the gallop of a horse our eye perceives chiefly a characteristic, essential or rather schematic attitude, a form that appears to radiate over a whole period and so fill up a time of gallop. It is this attitude that sculpture has fixed on the frieze of the Parthenon. But instantaneous photography isolates any moment; it puts them all in the same rank, and thus the gallop of a horse spreads out for it into as many successive attitudes as it wishes, instead of massing itself into a single attitude, which is supposed to flash out in a privileged moment and to illuminate a whole period.[93]

Bergson's theory of "durée," or duration, privileges a synthetic vision and denigrates the positivistic division of movement—and of time—provided by chronophotography. His statements echo comparisons made by others at the time. French critic Robert de la Sizeranne, in his important essay "La Photographie est-elle un art?," concludes "that science is one thing and that art is another." He continues:

The truth of science is a truth of detail; the truth of art is a truth of the whole. When the chronophotographer furnishes us with proof where he has noted one of the thousand phases of which movement is composed, we respond to him: This is a part of movement,—this is not movement. It is very true that, in movement, there exists the attitude that you discovered, but it is no less true that there are hundreds of others in it and that *it is the result of all the attitudes—each one immobile during an instant of reason—that forms what one calls movement.* My eyes perceive only the whole; your machine perceives only a part.[94]

The issue for Sizeranne—as for Bergson—is the difference between part and whole, sequence and synthesis. Movement, according to Sizeranne, can only be understood as the eye perceives it: a fluid series of stages that proceed from one to the next.[95] The role of art is to convey movement, the role of chronophotography is to dissect it.

The intellectual community identified the portrayal of movement as the critical difference between art and (chrono)photography, which should be borne in mind when considering Rodin's comments on the matter:

To judge a work of art with the logical precision of a philosophical premise of [*sic*] the analyses of experimental science is a fundamental error. It is even difficult to talk about it. ... Art contains some expressions which could not be exactly demonstrated by reason. The artist's sensibility shows him beauties in nature which go beyond what his intelligence alone could have conceived. The artist makes tangible that which was invisible.[96]

The sculptor's apparent difficulty in expressing his view may arise from the fact that chronophotography also "makes tangible that which was invisible" to the naked eye. Therefore, Rodin delivered the anatomically impossible pose of *The Walking Man* as art's bold riposte to the photograph's stilted depiction of movement and the passage of time. In a defensive mode, the sculptor complains, "it is the artist who is truthful and it is photography which lies, for in reality time does not stop, and if the artist succeeds in producing the impression of a movement which takes several moments for accomplishment, his work is certainly much less conventional than the scientific image, where time is abruptly suspended."[97] Rodin, then, believed that the imagination was a more important tool for seeing movement than scientifically mediated sight. In fact, he specifically cites the use of the "mind's eye" in an unsigned article about *The Walking Man*: "The interest lies not in the figure itself, but rather in the thought of the stage he has passed through and the one through which he is about to move. This art that by suggestion goes beyond the model requires the imagination to recompose the work when it is seen from close up. It is, I believe, a fertile innovation."[98] Therefore, the imaginations of both the artist and the viewer are necessary to complete the sculpture. Certainly, the "scientific image"— the chronophotograph—could not be trusted. A three-dimensional figure— represented with deliberate anatomical (that is, scientific) inaccuracies— could convey a sense of movement; in comparison, the body captured in a moment of motion, frozen in a photographic frame, comes up short.

* * *

Rodin's willing involvement with mechanical processes such as the photography he commissioned throughout his career—in addition to those as fundamental to his production as the creation of bronze sculpture and the casting of studies in plaster—problematizes his apparent anxiety about new technology and industrialization. Rodin accepted the centrality of industrial processes to sculpture, seeing them as necessary and traditional tools of the medium, as sculptors had for centuries. He utilized photography as an aid to his creative work: to stand in for absent models, to inspire new compositions,

and to promote his work in France and abroad. He rejected photography, however, insofar as its purported objectivity—its indexicality—threatened to undermine the deeper truthfulness of artistic vision. Rodin ultimately countered the photograph's trace with the traces of the very process of making sculpture and of his own hand. His "copy of nature," as opposed to that of the photograph, displayed the "personal expressive style of the artist," announcing and confirming his sacrosanct role as nature's "sublime copyist."[99] Paradoxically, Rodin's reaction against photographic "objectivity" severed his work from naturalism, leading him to fragment his figures, to inflict gashes on them, and to leave casting lines as evidence of their industrial reproduction.[100] These idiosyncratic touches—the very characteristics that differentiated Rodin's art from the machine-made—contributed to the public's unease regarding his work.[101] Throughout his career, and even after he began to enjoy popular and critical success, his aberrant bodies were seen as discomfiting distortions of nature.

Once Rodin began to exhibit partial figures and more experimental works, there was a shift in critics' tone; whether their words were meant to be derisive or simply descriptive, they betrayed an underlying anxiety. The word *informe* was often used, especially in descriptions of the *Monument to Balzac* (see Figure 6.1).[102] A critic writing in *Le Nord Maritime* in 1899 venomously stated, "The 'Master' has presented a formless creature, a sort of rough study crowned with a lugubrious visage, telling us that this is how he understood the prodigious novelist of *The Human Comedy*... ."[103] It is worth noting that the critic saw fit to suggest that Rodin's reputation was in danger by including quotation marks around the word "master." And at the Salon of 1896, a reviewer wondered whether Rodin was actually mocking the public by exposing "formless plasters under the pretext of statuary."[104]

The word *acéphale*, or headless, was also frequently used in descriptions of his work.[105] Writing about the sculptor's retrospective exhibition at the Pavillon de l'Alma, erected by Rodin outside the grounds of the 1900 Universal Exposition in Paris, a critic from *La Presse* found his art to be far from "the true beauty appreciated by all" and quotes a "fine arts civil servant" who exclaimed, "We are asked for an allotment of land to set up a museum of horrors!"[106] A writer from *L'Illustration* compared the sculpture in the Pavillon to the works one might expect to find in the "private collection of the marquis de Sade!"[107] In addition to calling *The Walking Man* "a soccer amateur," Gentil-Garou sarcastically announces works for the next Salon, inspired by the "simplified type, the Rodin type":

"The dusting man" ... a hand holding a feather.
"The talking man" ... a mouth.
"The looking man" ... two eyes in a glass of water.
"The dreaming man" ... a skull.[108]

Le Gil Blas delivered the crowning insult, labeling Rodin's work simply "anti-aesthetic."[109]

The sculptor's creation of a new kind of figure for which he took nature's rules of form into his own hands—and largely did away with them—led to a comparison between Rodin and God, articulated both by critics and by the artist himself. In referring to *The Walking Man*, a writer in a 1912 edition of *La Presse* writes, "When an individual is born without hands or without a head, one accuses Providence of negligence or error; no one considers the monster the pearl of creation."[110] The cast of Rodin's own hand holding a female figure (1917, Paris, Musée Rodin) considered alongside his massive *Hand of God* (1902, Paris, Musée Rodin) supporting the original human couple makes the analogy clear.[111] The cast, created only a few weeks before his death, is stiff, dense, inert. Rodin's admonition that the cast and the photograph—both indexes—replicate form but fail to capture life is made manifest in this work.[112] By the early twentieth century, the title of creator was being applied sarcastically: one critic wrote, "The slightest plaster where Rodin, 'rival of God,' has placed his creative fingers, representing an indistinct form emerging from a mass that's even more indistinct, is a masterpiece, and *le bon ton* commands that one be enraptured before it."[113]

* * *

Given the sculptor's antipathy to Marey's chronophotographs, it is perhaps ironic that Dagognet's eloquent description of them is equally applicable to Rodin's work: "He [Marey] simplified, halted, and merged; things were made uniform and blurred. The tumultuous, abrupt and multiple would be unleashed on all sides … ."[114] Rodin's sculpture was not a reaction to advances in photography and the attendant discoveries of scientists like Marey, whose influence on the visual arts, according to Braun, was the greatest since perspective was introduced in the Renaissance.[115] Instead, Rodin's oeuvre should be seen as participating in the *fin-de-siècle* "crisis of perception" that elicited those discoveries. Sara Danius writes, "Specific technoscientific configurations and their conceptual environments enter into and become part of the aesthetic strategies, problems, and matters they help constitute. Stated differently, technology and modernist aesthetics should be understood as *internal* to one another."[116] *The Walking Man* is a testament to the ways in which chronophotography affected Rodin's production. This was clearly not a simple matter of influence—rather, the issues raised by photography at the end of the nineteenth century changed the way that Rodin conceived his sculpture.

Acknowledgments

I would like to thank Amy Woodson-Boulton and Minsoo Kang for including me in the "Visions of the Industrial Age" symposium at Loyola Marymount University in May 2006—and for generously publishing a version of my talk—and all of the participants for their thoughtful and challenging comments; Hélène Pinet, Virginie Delaforge, and Anne Marie Chabot of the Musée Rodin, Paris, and Véronique Leroux-Hugon of the Bibliothèque Charcot, Hôpital de la Salpêtrière, Paris, for their patience and assistance; Beck Feibelman, Meredith Malone, Freyda Spira, and especially Christine Poggi for their insightful critiques of this essay; and Miriam Ruiz-Gómez and Raffi Yegparian, who have encouraged my love of photography—in very different ways—for decades.

Notes

1. "Elle [la photographie] peut, en effet, vulgariser la connaissance d'un grand nombre de phénomènes que connaissent seuls les observateurs passionnés de la nature"; all translations are the author's own unless otherwise indicated. É[tienne]-J[ules] Marey, *La Chronophotographie. Conférence faite au Conservatoire National des Arts et Métiers, le Dimanche 29 janvier 1899* (Paris: Gauthier-Villars, 1899), 40.

2. "Rodin's Reflections on Art, recorded by Henri Charles Etienne Dujardin-Beaumetz" [1913], trans. Ann McGarrell, *Auguste Rodin: Readings on His Life and Work*, ed., Albert Elsen (Englewood Cliffs: Prentice-Hall, 1965), 152.

3. "J'ai cherché dans *Balzac* […] à rendre un art qui n'est pas de la photographie en sculpture. […] Mon principe, ce n'est pas d'imiter seulement la forme, mais d'imiter la vie. […] [J]e cherche dans l'ensemble une synthèse… ." Last ellipsis in the original; X, "M. Rodin & la Société des Gens de Lettres," *Le Journal* (May 12, 1898). Article located in the press files for "*Balzac*," courtesy of the Archives du Musée Rodin, Paris. Art critic Gustave Geffroy wrote that the daguerreotype of Balzac that aided Rodin's studies "suffirait à lui seule à motiver l'invention de la photographie"; Gustave Geffroy, "L'Imaginaire," *Le Figaro* (August 28, 1893). Article located in the "personne" file for Gustave Geffroy, courtesy of the Archives du Musée Rodin, Paris.

4. "Pour moi, la sculpture moderne ne saurait être de la photographie. L'artiste doit travailler non seulement avec sa main, mais surtout avec son cerveau." Rodin quoted in Charles Chincholle, "La Statue de Balzac," *Le Figaro* (May 12, 1898). Article located in the press files for "*Balzac*," courtesy of the Archives du Musée Rodin, Paris.

5. Rodin spoke positively about photography in relation to the work of Edward Steichen, who took photographs of the *Monument to Balzac* in 1908. In an interview published in Alfred Stieglitz's *Camera Work*, the sculptor asserted his newfound appreciation for the medium: "I believe that photography can create works of art, but hitherto it has been extraordinarily bourgeois and babbling. […] I care only for the result, which however, must remain always clearly a photograph. It will always be interesting when it be the work of an artist." Rodin quoted in George Besson, "Pictorial Photography—A Series of Interviews," *Camera Work*, 24 (October 1908): 14.

6. For a general history of the development of photography before 1839, see Naomi Rosenblum, *A World History of Photography* (New York: Abbeville Press, 1997), 192–5. Daguerre had signed a partnership agreement in 1829 with Joseph Nicéphore Niépce, who died before the announcement was printed in the French Academy of Sciences bulletin in January 1839. When Daguerre sold the process to the French state a few months later—which, in turn, gave the process to the world—he received a life pension that was shared with Niépce's son. See Dominique François Arago, "Report," *Classic Essays on Photography*, ed., Alan Trachtenberg (New Haven: Leete's Island Books, 1980), 25 and Rosenblum, *A World History of Photography*, 194.

7. Charles Baudelaire, "The Modern Public and Photography" [1859], *Classic Essays on Photography*, ed., Alan Trachtenberg (New Haven: Leete's Island Books, 1980), 88.

8. Baudelaire, "The Modern Public and Photography," 88.

9. Marey coined the term "chronophotograph" to describe photographs that captured movement on a single plate, but the term has been applied to the photographs of Eadweard Muybridge, who captured the phases of movement on multiple plates. In fact, Marey practiced both kinds of chronophotography. I will be using the term to describe the work of both photographers. Marey defines it thus: "La Chronophotographie, c'est l'application de la Photographie instantanée à l'étude du mouvement; elle permet à l'oeil humain d'en voir les phases qu'il ne pouvait percevoir directement; et elle conduit encore à opérer la reconstitution du mouvement qu'elle a d'abord décomposé." Marey, La Chronophotographie, 5.

10. Auguste Rodin, Rodin on Art and Artists. Conversations with Paul Gsell [1911], trans. Romilly Fedden (New York: Dover Publications, 1983), 34. The issue of the purported objectivity of the photograph will be discussed throughout this chapter. That the inventors of the medium thought of it this way is paradoxical since, for instance, the slow process and long exposure time failed to capture the hustle and bustle of the street and forced the first portrait sitters to remain as immobile as corpses for extended lengths of time. For a discussion of the empty streets captured by Daguerre, see Shelley Rice, Parisian Views (Cambridge, MA: MIT Press, 1997), 3–7. For the theoretical relationship between the portrait and death, see Roland Barthes, Camera Lucida: Reflections on Photography, trans. Richard Howard (New York: Hill and Wang, 1981); Thierry de Duve, "Time Exposure and Snapshot: The Photograph as Paradox," October 5 (Summer 1978): especially 116–25; and Geoffrey Batchen, Each Wild Idea: Writing, Photography, History (Cambridge, MA: MIT Press, 2001), 130.

11. "Rodin's Reflections on Art," 157.

12. Steiner argues, "Dr. Frankenstein's monster is a reflection not only of the Kantian sublime but of industrial production." Wendy Steiner, Venus in Exile: The Rejection of Beauty in Twentieth-Century Art (New York: The Free Press, 2001), 7.

13. For more on the reasons for the commission and Muybridge's experiments, see Robert Bartlett Haas, "Eadweard Muybridge, 1830–1904," Eadweard Muybridge: The Stanford Years, 1872–1882, ex. cat. (Stanford: The Stanford Museum of Art, 1972), 11–35.

14. Joseph Pennell, British Journal of Photography, 38 (1891): 677; quoted in Beaumont Newhall, The History of Photography from 1839 to the Present (New York: The Museum of Modern Art, 1982), 122.

15. For more on this debate, see, for example, W. de W. Abney, "Are Instantaneous Photographs True?," International Annual of Anthony's Photographic Bulletin and American Process Year-Book (1889): 285–7; Aaron Scharf, Art and Photography (London: Allen Lane, 1968), 172–4; and Françoise Forster-Hahn, "Marey, Muybridge and Meissonier: The Study of Movement in Science and Art," Eadweard Muybridge: The Stanford Years, 1872–1882, ex. cat. (Stanford: The Stanford Museum of Art, 1972), 103–6.

16. Gaston Tissandier, "Les Allures du cheval," La Nature, 289 (December 14, 1878): 23–6.

17. Forster-Hahn, "Marey, Muybridge and Meissonier," 85. Rodin and Meissonier probably knew each other; the sculptor was present at Meissonier's funeral in 1891. G.C., "Obsèques de Meissonier," Le Figaro, February 4, 1891. Article located in the "mondanités" file for 1891, courtesy of the Archives du Musée Rodin, Paris.

18. Robert Taft, "An Introduction to Eadweard Muybridge and His Work," The Human Figure in Motion, by Eadweard Muybridge (New York: Dover Publications, Inc., 1955), vii. Muybridge's first lecture in Paris was given on September 26, 1881 at the invitation of Marey; Janine A. Mileaf, "Poses for the Camera: Eadweard Muybridge's Studies of the Human Figure," American Art, 16, no. 3 (Autumn 2002): 32 and Forster-Hahn, "Marey, Muybridge and Meissonier," 86. Marey wrote that Muybridge's projection of images through "une sorte de phénakisticope" was "une révélation. La Photographie n'était jamais allée si loin dans la reproduction de la nature." Marey, La Chronophotographie, 23. The zoopraxiscope was a forerunner of the film projector; for a short discussion of Muybridge's role in the history of film, see Phillip Prodger, Muybridge and the Instantaneous Photography Movement (New York: Oxford University Press, 2003), 154–61.

19. Eadweard Muybridge, Descriptive Zoopraxigraphy or the Science of Animal Locomotion, published on the occasion of the World's Columbian Exhibition, 1893, 6–7; quoted in Mileaf, "Poses for the Camera," 32–3.

20. Charles W. Millard, The Sculpture of Edgar Degas (Princeton: Princeton University Press, 1976), 21. Tinterow believes that Muybridge's influence can be observed in Degas's work after the publication of Animal Locomotion in 1887; Gary Tinterow, "1881–1890," Degas, by Jean Sutherland Boggs et al., ex. cat. (New York: The Metropolitan Museum of Art, 1988), 459. See also Elizabeth

C. Childs, "Habits of the Eye: Degas, Photography, and Modes of Vision," *The Artist and the Camera: Degas to Picasso,* by Dorothy Kosinski et al., ex. cat. (New Haven: Yale University Press, 1999), 75–6.

21. Their first communication with each other was published in *La Nature*: É[tienne]-J[ules] Marey, "Sur les allures du cheval reproduites par la photographie instantanée," *La Nature,* 291 (December 28, 1878): 54 and [Eadweard] Muybridge, "Photographies instantanées des animaux en mouvement," *La Nature,* 303 (March 22, 1879): 246.

22. "la défectuosité de nos sens pour découvrir les vérités, et puis l'insuffisance du langage pour exprimer et pour transmettre celles que nous avons acquises." É[tienne]-J[ules] Marey, *La Méthode graphique dans les sciences expérimentales et principalement en physiologie et en médecine* (Paris: G. Masson, 1885), i. See also his comments on iii.

23. Marey, *La Méthode graphique,* iii. Some of these "graphic methods" include the cardiograph, pneumograph, thermograph, and myograph; Anson Rabinbach, *The Human Motor: Energy, Fatigue, and the Origins of Modernity* (New York: Basic Books, 1990), 96. For a brief biography of Marey, see Marta Braun, *Picturing Time: The Work of Etienne-Jules Marey (1830–1904)* (Chicago: The University of Chicago Press, 1992), 2–7. According to Mannoni, "Between about 1850 and 1880 there was one precise phenomenon that allowed the emergence of chronophotography. Like other engineers and physicians, Marey observed that the graphical method had a defect, in that the inscribing stylus had an inertia that slightly distorted the marks it made. The only possible remedy was to use an inscribing system that had no inertial force—the ray of light." Laurent Mannoni, "The Art of Deception," trans. Richard Crangle, *Eyes, Lies and Illusions: The Art of Deception,* by Laurent Mannoni et al., ex. cat. (London: Hayward Gallery, 2004), 47.

24. Braun, *Picturing Time,* 66 and 396, n. 46.

25. Delpire writes, "Chronophotographiant l'aigrette en vol, le chat qui tombe, l'homme qui saute, il [Marey] génère des images dont la fugace précision et la confondante plasticité appartiennent au rêve plus qu'à la physiologie." Robert Delpire, "Avant-propos," *Le Temps d'un mouvement. Aventures et mésaventures de l'instant photographique,* ex. cat. (Paris: Centre National de la Photographie, 1986), 5.

26. "chronophotographie géométrique." See his discussion of this innovation in Marey, *La Chronophotographie,* 12 and 14. As Doane summarizes, "[Marey] moves from the graphic method to the photographic method only to defamiliarize, derealize, even de-iconize the photographic image." Mary Ann Doane, *The Emergence of Cinematic Time: Modernity, Contingency, the Archive* (Cambridge, MA: Harvard University Press, 2002), 54. This aspect of his photography influenced Marcel Duchamp, the Futurists, and other modern artists; see, for example, Braun, *Picturing Time,* 264–318; Rosenblum, *A World History of Photography,* 255; Mannoni, "The Art of Deception," 51; and Rabinbach, *The Human Motor,* 88. Interestingly, Le Normand-Romain has linked Umberto Boccioni's sculpture *Unique Forms of Continuity in Space* (1913) to Rodin's *Walking Man* because they both make manifest the "fourth dimension"; Antoinette Le Normand-Romain in *Rodin et l'Italie,* ex. cat. (Rome: Académie de France, 2001), 135; cited in Catherine Lampert et al., *Rodin,* ex. cat. (London: Royal Academy of Arts, 2006), 258.

27. Rabinbach, *The Human Motor,* 86–7.

28. It seems that they also intended to collaborate with Meissonier on a book about animal locomotion in the art of the Assyrians, Egyptians, Romans, Greeks and "masters of modern times"; Forster-Hahn, "Marey, Muybridge and Meissonier," 95.

29. Eadweard Muybridge, *Animal Locomotion: An Electro-Photographic Investigation of Consecutive Phases of Animal Movements, 1872–1885,* 11 vols. (Philadelphia: J.B. Lippincott under the auspices of the University of Pennsylvania, 1887).

30. The unscientific character of many of Muybridge's plates has been discussed by Mileaf, among others; she writes: "The goal of revealing truths about the human body [in Muybridge's images] was almost always confused with notions about aesthetics, artifice, and visual pleasure." Mileaf, "Poses for the Camera," 37. Lajoux sees the subject of Muybridge's photographs of women as primarily aesthetic and not about the analysis of movement; Jean-Dominique Lajoux, "Marey, Muybridge et les femmes," *Marey/Muybridge: pionniers du cinéma. Rencontre Beaune/Stanford* (Beaune: Palais des Congrès, 1995), 90–105.

31. Scharf, *Art and Photography,* 168.

32. Étienne-Jules Marey and Georges Demeny, *Études de physiologie artistique faites au moyen de la chronophotographie. Première série, no. 1. Des mouvements de l'homme* (Paris: Société d'éditions scientifiques, 1893). Danius comments that this work was a "tremendous success"; Sara Danius, *The Senses of Modernism: Technology, Perception, and Aesthetics* (Ithaca: Cornell University Press, 2002), 101.

33. Danius, *The Senses of Modernism*, 100. For more on Soriau's influential essays, see Braun, *Picturing Time*, 275–77.

34. A page of facsimile signatures in Muybridge's *The Human Figure in Motion* [1901] purports to list the subscribers to the 1887 *Animal Locomotion*; Rodin's name is listed on this page and is apparently the source of the rumor that Muybridge and Rodin met. Elsen was the most influential supporter of this deeply entrenched claim; see Albert E. Elsen, *In Rodin's Studio: A Photographic Record of Sculpture in the Making* (Ithaca: Cornell University Press, 1980), 11. However, there is no proof in the archives of the Musée Rodin, Paris, nor has evidence been uncovered elsewhere, that they met. It is possible that Rodin's name may have been used simply to lend prestige to the publication; conversation with Hélène Pinet, Chargée des collections de photographies, Musée Rodin, Paris, March 7, 2006. My heartfelt thanks to Mme Pinet for generously sharing her encyclopedic knowledge of Rodin's collection of photographs. The only publication by Muybridge in the collection of the Musée Rodin library is a small volume on *Zoopraxography or the Science of Animal Locomotion* (Philadelphia: University of Pennsylvania, 1893), but it is unclear if it entered the library during Rodin's lifetime. Inventory #4907, courtesy of the Bibliothèque du Musée Rodin, Paris. Rodin's study of the hand has been linked to Muybridge's chronophotographs of hands; see John L. Tancock, *The Sculpture of Auguste Rodin: The Collection of the Rodin Museum, Philadelphia* (Philadelphia: Philadelphia Museum of Art, 1976), 616. The sculptor's interest in the expressive hand, however, began years before the publication of Muybridge's *Animal Locomotion*. For more on Rodin's sculpted hands, see the author's "Essence and Evanescence in the *Hands* of Rodin," *Thresholds*, 31 (May 2006): 102–9 and Hélène Marraud, *Rodin. La main révèle l'homme* (Paris: Collection Tout L'oeuvre aux éditions du musée Rodin, 2005).

35. Michel Frizot, "Speed of Photography: Movement and Duration," *A New History of Photography*, ed., Michel Frizot (Köln: Könneman, 1998), 248. For details on the relationship between Charcot and Rodin, see the fourth chapter of the author's "*Morceaux d'Amphithéâtre*: Science and the Sculpture of Auguste Rodin" (Ph.D. diss., University of Pennsylvania, 2006). For more on Rodin and Nadar, see Joy Newton, "Rodin and Nadar," *Laurels*, 52, no. 3 (Winter 1981–82): 163–70.

36. Rodin was also good friends with the photographer Charles Aubry in the early 1860s. A few of Aubry's photographs of Rodin are illustrated in Ruth Butler, *Rodin: The Shape of Genius* (New Haven: Yale University Press, 1993), figures 9, 12, and 13.

37. Rodin states, "Now I believe that it is Géricault who is right, and not the camera, for his horses *appear* to run; this comes from the fact that the spectator from right to left sees first the hind legs accomplish the effort whence the general impetus results, then the body stretched out, then the forelegs which seek the ground ahead. This is false in reality, as the actions could not be simultaneous; but it is true when the parts are observed successively, and it is this truth alone that matters to us, because it is that which we see and which strikes us." Rodin, *Rodin on Art and Artists*, 34.

38. Rodin said that it was "nature which makes the artist—when he has understood and translated her—a creator, or rather her sublime copyist"; "Rodin's Reflections on Art," 158.

39. Emphasis in the original. Shiff is here analyzing Émile Zola's statements on Édouard Manet's portrait of the author; Richard Shiff, "Representation, Copying, and the Technique of Originality," *New Literary History*, 15, no. 2 (Winter 1984): 352.

40. Rodin, *Rodin on Art and Artists*, 11.

41. François Dagognet, *Etienne-Jules Marey: A Passion for the Trace*, trans. Robert Galeta with Jeanine Herman (New York: Zone Books, 1992), 63.

42. Rodin's use of photography and his relationship with the various photographers that worked with him throughout his career have been described in detail elsewhere, especially by Hélène Pinet, who has worked with the photography collection at the Musée Rodin, Paris, for several decades. For more information, see Hélène Pinet, *Rodin sculpteur et les photographes de son temps* (Paris: Philippe Sers, 1985); Hélène Pinet, *Rodin et ses modèles. Le portrait photographié*, ex. cat. (Paris: Éditions du musée Rodin, 1990); Kirk Varnedoe, "Rodin and Photography," *Rodin Rediscovered*, ed., Albert E. Elsen, ex. cat. (Washington, DC: National Gallery of Art, 1981), 202–47; and Elsen, *In Rodin's Studio*. As this book went to press, the Musée Rodin published another useful resource: Hélène Pinet, ed., *Rodin et la photographie*, ex. cat. (Paris: Éditions Gallimard/ Musée Rodin, 2007).

43. Hélène Pinet, "'Montrer est la Question Vitale': Rodin and Photography," trans. Geraldine A. Johnson, *Sculpture and Photography: Envisioning the Third Dimension*, ed., Geraldine A. Johnson (Cambridge: Cambridge University Press, 1998), 68.

44. "Rodin's Reflections on Art," 164. Nadar shared his images of Balzac and Baudelaire with the sculptor; see Newton, "Rodin and Nadar," 163–70. For more on *aides-mémoire* in relation to Rodin's oeuvre, see Pinet, *Rodin et ses modèles*.

45. "L'attitude du cadavre sur la table de dissection" and "les particularités, ou plutôt les déformations anatomiques du modèle." Pinet links these images visually to those of the Paris police under Bertillon. Pinet, *Rodin et ses modèles*, 16.

46. This photograph, Inv. #Ph.9315, is located in Album Rodin #1, Musée Rodin, Paris. Courtesy of the Musée Rodin, Paris. Rodin's albums will be discussed in more detail as part of a larger future project on Rodin by the author. My sincere thanks to Hélène Pinet for patiently showing me the sculptor's albums. Pinet writes, "Parmi la collection de photographies de Rodin, nous avons retenu quelques tirages de modèles anonymes qu'il avait achetés chez des photographes spécialisés du style de Marconi, grand fournisseur des artistes. [...] Certains tirages pour être mis dans la commerce devaient porter l'étiquette: 'La vente de cette photographie est autorisée à la condition qu'elle ne soit pas mise à l'étalage.'" Pinet, *Rodin et ses modèles*, 18. The label on the Marconi photograph probably protected the photographer from charges of pornography, as there was a fine line during this time between pornography and photographic *académies*. See Elizabeth Anne McCauley, *Industrial Madness: Commercial Photography in Paris, 1848–1871* (New Haven: Yale University Press, 1994), 153–85.

47. Elsen, *In Rodin's Studio*, 30.

48. Another album contains a surprising juxtaposition of a photograph showing Rodin's *Saint John the Baptist Preaching* (1880) in profile above images of antique sculpture from Roman museums: *Faun in Red Marble* from the Capitoline Museum, *Sophocles* from the Lateran Museum, and the *Genius of Augustus* from the Pio-Clementino Vatican Museum. Inventory #Ph. 9432, #Ph. 9431, #Ph. 9433, #Ph. 9434, respectively, located in Album Rodin #3. Courtesy of the Musée Rodin, Paris. Rodin may simply be comparing his work to those of antique sculptors, but the placement of his *Saint John* at the top of the page, above the other images, could also be understood as a statement about his artistic ancestry and his position as master of their legacy.

49. These are located in Album Rodin #1, Musée Rodin, Paris.

50. "Chapiteau" can mean either capital or cornice. Notes written above Inventory #Ph. 9338, Album Rodin #1, Musée Rodin, Paris. For the same kind of transposition by Rodin, see the metamorphosis of a moulding into a face in drawing #D.3450 (Musée Rodin, Paris), illustrated in Marie-Pierre Delclaux, *Rodin: A Brilliant Life* (Paris: Éditions du musée Rodin, 2003), 136, figure 118.

51. Rodin probably used the photographs to see his sculpture with fresh eyes. His colleague Émile Zola, who had taken up photography as a hobby, told a reporter: "In my opinion, you cannot say you have thoroughly seen anything until you have got a photograph of it, revealing a lot of points which otherwise would be unnoticed, and which in most cases could not be distinguished." Zola quoted in *Photo-Miniature*, 21 (December 1900): 396; cited in Newhall, *The History of Photography*, 136.

52. Pinet, "'Montrer est la Question Vitale,'" 70. Pinet notes that the comparison of photography and casting was widespread during the period; Hélène Pinet, *Rodin sculpteur et les photographes de son temps*, x.

53. These works bring to mind Constantin Brancusi's later experiments, such as the autonomous work *L'Enfant au monde, groupe mobile* (1917), comprised of *Little French Girl*, *The Endless Column*, and *Cup*, that exists only in the space of the photograph. See Friedrich Teja Bach, Margit Rowell, and Ann Temkin, *Constantin Brancusi, 1876–1957*, ex. cat. (Philadelphia: Philadelphia Museum of Art, 1995), 154 and 322. In creating photographs such as these, Brancusi may have been inspired by his memories of Rodin's studio, where he worked from March 24 through April 27, 1907. These dates are listed in the journal of Ottilie Cosmutza, who probably introduced the sculptors on January 3, 1907. Mircea Nicoara, "Marturii despre Brancusi," *Tribuna* (November 21, 1963); cited in Remus Niculescu, "Bourdelle et Anastase Simu," *Revue Roumaine d'histoire de l'art*, 3 (1966): 57, n. 19.

54. "Rodin's Reflections on Art," 159.

55. *Bust of Victor Hugo with Two Meditations* by Stephen Haweis and Henry Coles, Inv. #Ph.965, Musée Rodin, Paris. For more on the Gallimard commission, see Pinet, *Rodin sculpteur et les photographes de son temps*, xiv and Varnedoe, "Rodin and Photography," 208, n. 14.

56. Inv. #Ph.348, Musée Rodin, Paris.

57. Inv. #Ph.350, Musée Rodin, Paris. See also Inv. #Ph.349, #Ph.1047 and #Ph.1049.

58. "une nouvelle oeuvre, mi-photo, mi-dessin, origine possible d'une sculpture nouvelle, qui cependant n'est jamais réalisée et demeure simplement rêvée"; Hélène Pinet, "Les Photographes de Rodin," *Photographies*, 2 (September 1983): 44.

59. Varnedoe, "Rodin and Photography," 204.

60. Rodin also sold photographs as souvenirs; Elizabeth C. Childs, "The Photographic Muse," *The Artist and the Camera: Degas to Picasso*, by Dorothy Kosinski et al., ex. cat. (New Haven: Yale University Press, 1999), 30.

61. Pinet, "'Montrer est la Question Vitale,'" 75.

62. See Elsen, *In Rodin's Studio*, 21 and Varnedoe, "Rodin and Photography," 227.

63. Elsen, *In Rodin's Studio*, 22.

64. Varnedoe believes that all of Rodin's photographs, "regardless of photographer, clearly bear the impress of the artist's active participation as 'director' of lighting and point of view; and thus allow us to see the sculpture mediated by his own vision." Varnedoe, "Rodin and Photography," 203.

65. Letter dated January 6, 1901 from Druet to Rodin; quoted in Varnedoe, "Rodin and Photography," 216–17.

66. Varnedoe, "Rodin and Photography," 215.

67. These are, respectively, Inv. #Ph.315, #Ph.359 and #Ph.940, Musée Rodin, Paris.

68. Gustave Kahn, "Les Mains chez Rodin," *Auguste Rodin et son Oeuvre*, by Octave Mirbeau et al. (Paris: Editions de 'La Plume,' 1900), 28–9.

69. The fact that *The Walking Man* does not have genitals may point to a *fin-de-siècle* crisis of masculinity, a discussion of which is outside the purview of this chapter.

70. According to Rodin's story, Pignatelli had arrived from Italy the night before his visit to the studio. The sculptor recounts that he "thought immediately of a St. John the Baptist" as soon as Pignatelli walked in. "Rodin's Reflections on Art," 166. Years later, Pignatelli, known then as Bévilaqua, became the model for Henri Matisse's sculpture *The Serf* (1900–1904).

71. "Rodin's Reflections on Art," 166. The stance of the *Saint John* seems to have inspired the kind of feeling that Rodin hoped; Belgian novelist Camille Lemonnier wrote: "I don't know of any other work in the Salon with a more expressive stance or a more germane gesture … it is perhaps the only truly great movement of the year." Camille Lemonnier, "Le Salon de Paris. La Sculpture," *L'Europe* (Brussels), June 11, 1880; quoted in Frederic V. Grunfeld, *Rodin: A Biography* (New York: Henry Holt and Co., 1987), 129.

72. Rodin, *Rodin on Art and Artists*, 34. The work that Rodin uses to illustrate this point is actually his *Saint John the Baptist Preaching*.

73. Ironically, Rodin's cinematographic vision is more related to chronophotography than he would have liked. Chronophotography contributed to the development of early cinema; Marey took about 800 chronophotographic films. Mannoni, "The Art of Deception," 47. As Doane convincingly argues, "Marey's work is undergirded by an investment in time as continuum," yet because his chronophotographs captured only intermittent moments, he was "haunted by this lost time." Doane, *The Emergence of Cinematic Time*, 35 and 59.

74. "le sculpteur, face à un déroulé de photogrammes au 2.000ème seconde de Muybridge, se sentit dépossédé de ce corps dense, exprimé en attitudes rhétoriciennes, qui faisait de lui le prestigieux responsable de l'Histoire." Pierre Sterckx, "Le mouvement virtuel en sculpture, de Rodin à Woodrow," *ArtStudio* (Autumn 1991): 45. Article located in the press files for "*Homme qui marche*," courtesy of the Archives du Musée Rodin, Paris.

75. Marey struggled with the illegibility of his chronophotographs. Doane notes that "Marey's chronophotography evinces a desire for a pure representation of time that would ultimately, if it were attainable, be antithetical to the notion of the legible trace (which was the support and goal of his endeavor)." Doane, *The Emergence of Cinematic Time*, 61.

76. Quotation from Rodin's notebook in Judith Cladel, *Rodin: The Man and His Art with Leaves from His Note-Book*, trans. S.K. Star (New York: The Century Co., 1918), 206.

77. For a description of the process, see Robert A. Sobieszek, "Sculpture as the Sum of Its Profiles: François Willème and Photosculpture in France, 1859–1868," *Art Bulletin*, 62, no. 4 (December 1980): 624.

78. "genre de moulage"; X, "M. Rodin & la Société des Gens de Lettres." The use of life casts in sculpture can be traced back to the ancient Greeks; see H.W. Janson, "Realism in Sculpture: Limits and Limitations," *The European Realist Tradition*, ed., Gabriel P. Weisberg (Bloomington: Indiana University Press, 1982), 294.

79. "la sculpture commerciale qui inonde le Salon," "art vrai," and "Guerre à la sculpture moderne!"; Adolphe Possien, "Le 'Balzac' de Rodin," *Le Jour*, May 12, 1898. Article located in the press files for "*Balzac*." See also Rodin's comments in Georges-Michel, "Rodin et les trois beautés de Rome," *Gil Blas*, February 17, 1912; article located in the press files for "*Homme qui marche*." Articles courtesy of the Archives du Musée Rodin, Paris.

80. "une commande commerciale" and "aucun rapport." Ph. Dubois, "Chez Rodin," *L'Aurore*, May 12, 1898. Article located in the press files for "*Balzac*," courtesy of the Archives du Musée Rodin, Paris.

81. "nouvelle sculpture synthétique" and "tous les fabricants de marbres pour vitrines et étalages redoutent. […] Ceux qui font ce genre de travail, les oeuvres d'art pour exportations ou pour dessus de cheminées, se sont inquiétés!"; Auguste Blosseville, "Chez Rodin," *Les Droits de l'Homme*, May 12, 1898. Article located in the press files for "*Balzac*," courtesy of the Archives du Musée Rodin, Paris. Of course, Rodin also participated in the business of producing small bronzes for bourgeois consumption; see Grunfeld, *Rodin*, 86.

82. "La sculpture photographique a fait son temps!"; Dubois, "Chez Rodin."

83. Of course, one aspect of Rodin's modernity was his use of the cast and of multiples. As Didi-Huberman writes about Rodin's use of the cast, "[…] il y a une *heuristique* des procédés, des processus, des procédures réelles: une heuristique si exubérante, si obstinée dans son ouverture expérimentale que l'oeuvre de Rodin, *pratiquement*, fait exploser cela même que, jusqu'alors, on avait pu entendre par 'sculpture.'" Emphases in the original; Georges Didi-Huberman, *L'Empreinte*, ex. cat. (Paris: Éditions du Centre Georges Pompidou, 1997), 96. For more on Rodin's innovations with casting and its implications, in addition to Didi-Huberman's discussion, see Leo Steinberg, "Rodin," *Other Criteria: Confrontations with Twentieth-Century Art* (New York: Oxford University Press, 1972), 353–61 and Rosalind E. Krauss, "The Originality of the Avant-Garde," *The Originality of the Avant-Garde and Other Modernist Myths* (Cambridge, MA: MIT Press, 1985), 151–70.

84. For a full description of the process and its genesis, see Sobieszek, "Sculpture as the Sum of Its Profiles," 618–22.

85. "dociles esclaves qui prennent des notes pour son compte, lui préparent le travail, font les besognes ennuyeuses, et lui désencombrent de tout obstacle matériel le domaine de l'idéal." Théophile Gautier, *Photosculpture* [pamphlet extracted from *Le Moniteur universel*, January 4, 1864] (Paris, 1864), 90; quoted in Sobieszek, "Sculpture as the Sum of Its Profiles," 627.

86. Camille Mauclair noted that Rodin "eut l'idée de ne point travailler ses figures d'un seul côté à la fois, mais de tous ensemble, tournant constamment et faisant des dessins successifs, à même le bloc, de tous les plans, modelant par un dessin simultané de toutes les silhouettes et les unissant sommairement […]." Camille Mauclair, "Auguste Rodin," *La Revue des revues* (June 15, 1898); quoted in Pinet, *Rodin sculpteur et les photographes de son temps*, xiv-xv.

87. Sobieszek, "Sculpture as the Sum of Its Profiles," 617–19 and Pinet, *Rodin sculpteur et les photographes de son temps*, xiv–xv. The ancient Greeks also sculpted on all sides at once; see John Boardman, *Greek Sculpture: The Classical Period* (London: Thames and Hudson, 1985), 14. Rodin, believing that the study of contours was of vital importance to the creation of sculpture, would place his model against the light so that the contours of the body would become clearly visible. "Rodin's Reflections on Art," 154–8. See Varnedoe for the relation of Rodin's photographs to his method of backlighting; Varnedoe, "Rodin and Photography," 203–4 and 208, n. 8. Rodin may have had strong feelings about the issue of life casting because he was accused of using the technique with *The Age of Bronze*. The scandal followed him to the Salon of 1877 from Belgium, where the rumor that this work had been simply cast from life began. In defense of his own work, Rodin had casts taken of Belgian soldier Auguste Neyt, who posed for the work over a period of eighteen months, and commissioned Marconi to take photographs of the young man. He turned to these "objective" media for help in order to save his reputation and prove that *The Age of Bronze* was not a cast. For more on the scandal, see Butler, *Rodin*, 104, 109–11, and 120. More than a decade later, Rodin would equate the cast and the photograph, writing critically about sculptors who take shortcuts: "Beaucoup moulent sur nature, c'est à dire [*sic*] remplacent un objet d'art par une photographie. Cela va vite mais n'est pas de l'art." This letter in the "Omer Dewavrin" correspondence file is undated but was written in approximately 1888, courtesy of the Archives du Musée Rodin, Paris.

88. "Rodin's Reflections on Art," 157.

89. "la grande tradition" and "à ne point imiter servilement la forme, mais à se rapprocher le plus possible de la vie." Rodin quoted in Dubois, "Chez Rodin."

90. Braun, *Picturing Time*, 137.

91. Braun, *Picturing Time*, 137. This was not the first time that Marey discussed the horses on the Parthenon frieze; he issued the "famous comparison" in "Moteurs animés: Expériences de physiologies graphiques," *La Nature*, 278 (September 28, 1878): 273–8 and *La Nature*, 279 (October 5, 1878): 289–5; cited in Rabinbach, *The Human Motor*, 111.

92. Rabinbach argues that Bergson had been aware of Marey's chronophotographs since the late 1880s and that they had influenced his theories; Rabinbach, *The Human Motor*, 110–11. For more on the influence of Marey's chronophotographs on Bergson, see Braun, *Picturing Time*, 278–81. For insights into the relationship between cinema and the theories of time of Marey, Bergson, and Sigmund Freud, see Doane, *The Emergence of Cinematic Time*, 45 and 66–7.

93. Henri Bergson, *Creative Evolution* [1907], trans. Arthur Mitchell (New York: Henry Holt, 1911), 332. Braun writes that artists were nevertheless attracted to chronophotographs in part because they "provided a language for representing simultaneity—what was popularly understood to be Bergson's idea of time"; Braun, *Picturing Time*, 281.

94. "que la science est une chose et que l'art en est une autre" and "la vérité de la science est une vérité de détail; la vérité de l'art est une vérité d'ensemble. Quand le chronophotographe nous apporte une épreuve où il a noté l'une des mille phases dont se compose un mouvement, nous lui répondons: Ceci est une partie du mouvement,—ce n'est pas le mouvement. Il est très vrai que, dans un mouvement, il y a l'attitude que vous avez découverte, mais il est non moins vrai qu'il y en a des centaines d'autres et que *c'est la résultante de toutes ces attitudes,—chacune immobile durant un instant de raison,—qui forme ce qu'on appelle le mouvement.* Mes yeux ne perçoivent qu'un ensemble; votre appareil ne perçoit qu'une partie." Emphasis in the original; Robert de la Sizeranne, "La Photographie est-elle un art?," *Les Questions esthétiques contemporaines* (Paris: Hachette et Cie, 1904), 199–200; this essay first appeared in *La Revue des deux mondes* (November 1897): 564–95. He mentions earlier some of Marey's experiments and inventions specifically, along with chronophotography generally; see Sizeranne, "La Photographie est-elle un art?," 197–8.

95. Bergson discusses this series of sequential phases too, but states, "A single movement is entirely […] a movement between two stops; if there are intermediate stops, it is no longer a single movement. At bottom, the illusion arises from this, that the movement, *once effected*, has laid along its course a motionless trajectory on which we can count as many immobilities as we will. From this we can conclude that the movement, *whilst being effected*, lays at each instant beneath it a position with which it coincides. We do not see that the trajectory is created in one stroke, although a certain time is required for it; and that though we can divide at will the trajectory once created, we cannot divide its creation, which is an act in progress and not a thing." Emphases in the original; Bergson, *Creative Evolution*, 309.

96. "Rodin's Reflections on Art," 177.

97. Rodin, *Rodin on Art and Artists*, 34. By 1900, the organizers of *Le Musée Retrospectif de la Photographie à l'Exposition Universelle de 1900* could confidently claim about photography: "L'avenir lui appartient, et nul ne saurait assigner de limites au domaine qu'elle a si rapidement conquis et qu'elle ne cesse d'étendre en s'associant à toutes les manifestations de l'activité et de l'intelligence humaines." A[lphonse] Davanne, Maurice Bucquet, and Léon Vidal, *Le Musée Rétrospectif de la Photographie à l'Exposition Universelle de 1900* (Paris: Gauthier-Villars, 1903), 95.

98. *La Revue* (November 1, 1907): 105; quoted in Albert Elsen et al., *Rodin & Balzac: Rodin's sculptural studies for the monument to Balzac from the Cantor, Fitzgerald Collection* (Beverly Hills: Cantor, Fitzgerald and Co., 1973), 12. Rodin revealingly said in 1911 that his sculptures "awaken the imagination of the spectators […]. And yet, far from confining it in narrow limits, they give it rein to roam at will. That is, according to me, the rôle [*sic*] of art. The form which it creates ought only to furnish a pretext for the unlimited development of emotion." Rodin, *Rodin on Art and Artists*, 70.

99. Shiff, "Representation, Copying, and the Technique of Originality," 348.

100. As Varnedoe writes, "For all their forceful truth to life, many of Rodin's most dramatic gestures of movement are anatomically impossible assemblages of body fragments, synthetic inventions seeking freedom from, rather than truth to, the 'photographic' moment." Varnedoe, "Rodin and Photography," 205. Didi-Huberman comments, "cette fragmentation apparaît également comme une conséquence habituelle du processus d'empreinte qui, pour chaque forme complexe, nécessite plusiers moules et suppose donc la mise en morceaux du tout. L'*assemblage* […] fait partie de la procédure du moulage […]." Emphasis in the original; Didi-Huberman, *L'Empreinte*, 98.

101. Of course, the casting lines are a result of an industrial process.

102. For example, "La Sculpture au Salon du Champs-de-Mars," *Le Journal des Artistes*, May 9, 1897, article located in the documentation file for *"Méditation"*; and Geraldine Bonner, "Paris Sight Seeing in the Rain," *The Argonaut* (San Francisco), December 3, 1900, article located in the press files for "1900-Alma." Lecomte's characterization of the Balzac as *informe* is actually positive: "Ce Balzac, une ébauche informe! Et les mêmes gens qui se sont mis à vingt pour rédiger cette sottise, s'extasient, je pense, avec tout le monde, sur les belles synthèses de la statuaire égyptienne, de certaines sculptures gothiques. Et ils ne reconnaissent pas dans l'oeuvre de Rodin une volonté pareille de simplification!" Georges Lecomte, "Le Balzac de Rodin," *Les Droits de l'Homme*, May 12, 1898; article located in the press files for *"Balzac."* Interestingly, a critic who lauds *The Walking Man* and Rodin's use of the *informe* criticizes the imitators who have sprouted to copy his style: "D'ignares auteurs ont l'outrecuidance d'invoquer l'autorité de Rodin pour justifier leurs informes bégaiements alors que leur paresse tôt satisfaite d'eux-mêmes les rend incapables de jamais saisir ce qu'il entre dans l'oeuvre du maître de patiente volonté, d'étude sincère de la nature, de savoir conquis et d'instinctive logique." "La Sculpture aux Salons de 1907," *L'Art Décoratif* (June 1907): 213; article located in the press files for *"Homme qui marche."* All articles courtesy of the Archives du Musée Rodin, Paris.

103. "Le 'Maître' avait présenté un être informe, sorte d'ébauche couronnée d'un visage lugubre, nous disant qu'il comprenait ainsi le prodigieux romancier de la 'Comédie Humaine' […]"; "Lettre de Paris, Le musée Rodin," *Le Nord Maritime* (Dunkerque), July 8, 1899. Article located in the press files for "1900-Alma," courtesy of the Archives du Musée Rodin, Paris.

104. "d'informes plâtras [*sic*] sous prétexte de statuaire"; A. Pallier, "Salons de 1896," *La Liberté*, undated. Article located in the documentation file for *"Méditation,"* courtesy of the Archives du Musée Rodin, Paris.

105. For example, Henri Debusschère, "Par ici, par là," *La Presse*, February 12, 1912, and Gentil-Garou, "Notes Fantaisistes, L'Homme qui marche," *Liberté du Sud-Ouest* (Bordeaux), February 19, 1912. Articles located in the press files for *"Homme qui marche,"* courtesy of the Archives du Musée Rodin, Paris.

106. "la vraie beauté appréciée par tous," "fonctionnaire des beaux-arts," and "On nous demande une concession pour installer un musée des horreurs!" *La Presse*, July 14, 1899. Article located in the press files for "1900-Alma," courtesy of the Archives du Musée Rodin, Paris. It should be noted that an exhibition by Marey on the history of chronophotography was also on display at the 1900 Universal Exposition; see Margit Rowell, "Kupka, Duchamp, and Marey," *Studio International*, 189, no. 973 (January/February 1975): 49.

107. "collection privée du marquis de Sade!" *L'Illustration*, June 30, 1900. Article located in the press files for "1900-Alma," courtesy of the Archives du Musée Rodin, Paris.

108. "l'amateur de footing," "type simplifié, type Rodin," and "'L'homme qui époussette' ... une main tenant un plumeau./'L'homme qui parle' ... une bouche./'L'homme qui regarde' ... deux yeux dans un verre d'eau./'L'homme qui songe' ... un crâne."; Gentil-Garou, "Notes Fantaisistes."

109. Santillante, "La Danse A l'Exposition," *Le Gil Blas*, April 11, 1900. Article located in the press files for "1900-Alma," courtesy of the Archives du Musée Rodin, Paris.

110. "Quand un individu naît sans bras ou sans tête, on taxe la Providence de négligence ou d'érreur; nul ne considère le monstre comme la perle de la création"; Debusschère, "Par ici, par là." This is also the language of science and medicine—the Musée Dupuytren, where Rodin sketched in the 1860s, holds vitrines replete with malformed fetuses in jars. This type of description was also used for the work of other sculptors: "Et cette chose informe et immonde, dans laquelle on a voulu voir la révélation d'un génie 'La valse', par Mlle *Julia* [*sic*] *Claudel!* De la même ce morceau de plâtre innomable qui semble moulé sur un foetus." Emphasis in the original; Jean Wilfrid, "Salon Alsacien-Lorrain (Champ de Mars). Sculpture," *L'Alsacien Lorrain*, July 9, 1893. Article located in the press files for *"Porte de l'Enfer,"* courtesy of the Archives du Musée Rodin, Paris. These criticisms are interesting to consider in light of sculptural caricatures produced in the *fin-de-siècle* of "Celebrities in Jars" by Adrien Barrère, which depict as fetuses famous individuals, such as Queen Victoria and Rodin's friend René Waldeck-Rousseau. See Phillip Dennis Cate, ed., *Breaking the Mold: Sculpture in Paris from Daumier to Rodin*, ex. cat. (Rutgers: Jane Voorhees Zimmerli Art Museum, 2005), 179–80.

111. Rodin was also photographed more than once with the *Hand of God*; see, for example, Marraud, *Rodin. La Main Révèle l'Homme*, 56, figure 75 and Elsen, *In Rodin's Studio*, figure 107.

112. Rodin's hand was cast by Paul Cruet at the order of Léonce Bénédite, later the first curator of the newly founded Musée Rodin. It is unknown who decided to rest the small torso in its palm. Musée Rodin, *Rodin, les mains, les chirurgiens*, ex. cat. (Paris: Éditions du musée Rodin, 1983), 76. Janson assumes that the torso was added posthumously and notes that the cast hand was part of a long tradition in Western sculpture. He sees the cast of Rodin's hand as "a memorial, an act of homage

that is at the same time a commentary on Rodin's own *The Hand of God*, which is, of course, not derived from a life cast of the artist's hand but represents it by implication." Janson, "Realism in Sculpture," 298. In reference to this work, Didi-Huberman insightfully writes, "le moulage, par une ultime ruse de l'histoire, reprend ses droits séculaires—funéraires, anatomiques et fétichiques—sur la personne de Rodin lui-même, trois semaines avant sa mort, comme s'il avait fallu que le moulage consommât, non seulement la mort de la sculpture, mais encore *la mort du sculpteur* en tant que modeleur génial […]." Emphasis in the original; Didi-Huberman, *L'Empreinte*, 101.

113. "Le moindre plâtre [*sic*] où Rodin, 'rival de Dieu', posa ses doigts créateurs, représentât-il une forme vague émergeant d'une masse plus vague encore, est un chef-d'oeuvre, et le bon ton commande de s'extasier devant lui"; Debusschère, "Par ici, par là."

114. Dagognet, *Etienne-Jules Marey*, 11. The expressive surfaces of Rodin's sculpture could be further analogized to Marey's mapping of the interior of the body on the exterior with the physiologist's 1860 invention of the sphygmograph, which for the first time allowed the pulse to be charted from the surface of the body. Danius writes that with Marey's new tools "[t]he physiological interior thus became subject to new matrices of legibility"; Danius, *The Senses of Modernism*, 98.

115. Braun, *Picturing Time*, 264.

116. Emphasis in the original. Danius, *The Senses of Modernism*, 11.

Part III
Framing the environment

A window onto nature: visual language, aesthetic ideology, and the art of social transformation

Amy Woodson-Boulton

In the late winter of 1885, American expatriate painter James McNeill Whistler sent out invitations to the high and mighty of London Society, including luminaries in art, politics, and letters, to a mysterious lecture that would begin at 10 o'clock in the evening on Friday, February 20, at the Prince's Hall, Piccadilly, London.[1] They turned out in droves, and were not disappointed: Whistler gave them a brilliant, caustic, witty, and passionate address on Art. The audience would not have been surprised to see Whistler take the role of gadfly to the art world. Already in 1878, he had caused a scandal by suing the revered art critic John Ruskin for libel over comments made about Whistler's painting "Nocturne in Black and Gold, the Falling Rocket" (Figure 7.1).[2] Whistler's "Ten O'Clock Lecture" proved to be part of his extended attack on the art establishment in general, and art critics in particular. He argued against the then-dominant understanding of art: he proposed that the assumed universality of art, and thus its imagined utility for social reform, was based on a fundamental misunderstanding of it. With the general populace, unlike great artists, Whistler said:

> sentiment is mistaken for poetry, and for [them], there is no perfect
> work, that shall not be explained by the benefit conferred upon
> themselves—Humanity takes the place of Art—and God's creations
> are excused by their usefulness—Beauty is confounded with Virtue,
> and, before a work of Art, it is asked, "What good shall it do?"[3]

Whistler told his appreciative audience that in fact, art "is withal selfishly occupied with her own perfection only—having no desire to teach—seeking and finding the beautiful in all conditions, and in all times—"[4] For Whistler, art existed for art's sake, not society's betterment, and its quality was not connected to the nature of the society that created it.

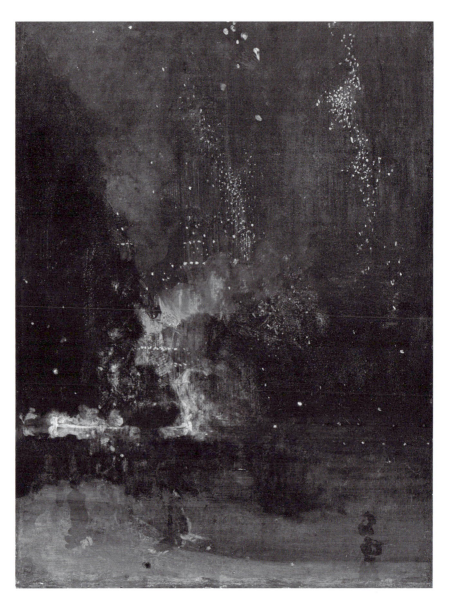

7.1 James Abbott McNeill Whistler, *Nocturne in Black and Gold, the Falling Rocket*, 1875. Gift of Dexter M. Ferry, Jr. Photograph © 1988 The Detroit Institute of Arts

Whistler connected the purposive role for art with a mode of reading and interpreting paintings, namely, a concentration on *what* was represented, not *how* it was represented. He claimed that judging works of art in terms of their social utility depended on a particular way of seeing them: "the people have acquired the habit of looking, as who should say, not *at* a picture, but *through*

it, at some human fact, that shall, or shall not, from a social point of view, better their mental, or moral state."[5] According to Whistler, most people had come to judge art in terms of the improvement or education that the works could offer to viewers, and this kind of judgment depended on analyzing paintings for their content, not for their status or quality *as paintings*. Instead, critics encouraged the public to judge paintings on whether they portrayed their subjects as truthfully as possible, thus enabling viewers to ignore the surface of the painting (what one would look "*at*"). Whistler blamed this development on a new group of middle-class art collectors and the art critics—John Ruskin in particular—who told them what to buy. For Whistler, art was not about truth to nature, but the inspiration of the artist to use nature; art was not for the many, but the few; art was not connected to morality, but to beauty, which had no necessary relationship to virtue or the good society; and art was about surface, not readable stories or subjects. In thus opposing nearly every tenet that Ruskin and his followers held dear, Whistler argued for "art for art's sake," not what we might call "art for society's sake."

It is intriguing that 40 years and a world war later, another modernist made precisely the same points. In his 1925 book *The Dehumanization of Art*, José Ortega y Gasset wrote, "To the young generation art is a thing of no consequence ... I do not mean to say that the artist makes light of his work and his profession; but they interest him precisely because they are of no transcendent importance." Ortega explains that the only way to understand why this is a new development is to:

compare the role art is playing today with the role it used to play thirty years ago and in general throughout the last century ... In view of the downfall of religion and the inevitable relativism of science, art was expected to take upon itself nothing less than the salvation of mankind. Art was important for two reasons: on account of its subjects which dealt with the profoundest problems of humanity, and on account of its own significance as a human pursuit from which the species derived its justification and dignity.[6]

Ortega thus argues that, in nineteenth-century Europe, art took on a new role as modern society fractured with secularization and the rapid pace of social change. In contrast, he finds early twentieth-century art to have abandoned both the language and goal of the "salvation of mankind." Ortega, of course, welcomes this new irrelevance, and, echoing Whistler (among others) before him, thinks that art might finally "free [itself] from formal fetters, [and] begin to cut whimsical capers." Regardless of whether we accept his idea that "all peculiarities of modern art can be summed up in this one feature of its renouncing its importance," his observations about the role of art in the nineteenth century remain particularly relevant for the connection he makes between visual language and social role. Like Whistler, Ortega links the nineteenth-century emphasis on subject matter with a particular vision of art as able to communicate the highest human aspirations.

Whistler and Ortega converge on the idea that the nineteenth-century connection between art and morality, and hence between art and social reform, depended on understanding painting as a window onto nature. These very different modernists, observing the nineteenth-century art world from separate vantage points, raise a key question: What is the relationship between different modes of visual representation and art's social role? We might call this relationship the "aesthetic ideology" of any given period—the ways in which art critics, reformers and the public understand art's social function, visual language, and artistic parameters. Nineteenth-century British aesthetic ideology underwent two easily identifiable periods of change that illustrate the connection between modes of representation and art's social use. The first redefinition of art made it into a universally accessible form of communication that could uniquely link beauty and morality through the representation of nature, broadly defined.[7] This idea had its basis in eighteenth-century thought, but became especially popular in mid-nineteenth-century Britain through the art and social criticism of John Ruskin and his many followers who advocated art as part of a broad vision of social transformation. The second major redefinition of art took place at the end of the nineteenth century, as artists increasingly rejected the connection between beauty and morality or social purpose. To distinguish the new art movements of the late nineteenth century from what came before, cultural historians have collected these changes in aesthetic ideology within the idea of "Modernism." Carl Schorske, for example, characterizes Modernism as "ahistorical aestheticism," which emphasizes the representational historicism of the previously dominant mode of visual representation, while also highlighting the new emphasis on "art for art's sake," the search for beauty without a social or moral purpose.[8]

This chapter seeks to understand and trace the origins of the particular aesthetic ideology of late-nineteenth-century Britain. Both Whistler and Ortega identify an urgency to the use and dissemination of art in this period, finding a sometimes desperate sense that society needed something that reformers hoped art might provide. Indeed, late-nineteenth-century Britain in particular grappled with change as profound and rapid as the world had ever known. The society created by industrial capitalism was now fully evident, with all that it entailed: cyclic economic depression, threats from other industrializing nations, the grim realities of working-class slums, the perceived need for a new and vigorous imperialism to protect national interests, the increasing irreligion of the urban masses, and the empty materialism of the middle-class culture of consumerism that drove the new economy. It was not a democracy, but (through the Reform Acts of 1867 and 1885) was in the process of radically expanding the franchise. It did not promise equality of opportunity, but (with the Education Act of 1870) began a national system of elementary education while still largely advocating laissez-faire and self-help. The nation struggled to contain the social and economic transformations that generated enormous

wealth and imperial power but also threatened to tear down traditional forces of order. Into this cauldron of the 1870s, perhaps unexpectedly, came groups of reformers who wanted to transform their society by making art available to the mass public. This became a widespread movement; in the last decades of the nineteenth century, nearly every town in Britain built a city art museum. As Whistler and Ortega observed, art had become a means of social improvement, part of a larger reaction to industrial capitalism's radical remaking of European society. What could art do to heal a society dealing with such unrelenting transformation?

As Whistler and Ortega noted, the people I call "art reformers" considered art a means of social reform because they understood paintings as being able to communicate the glory of God's creation directly to the viewer, mediated through the artist's ability to select a worthy subject and perceive nature truthfully. Using this idea, reformers worked to bring art to the masses, primarily through museums but also through local exhibitions and world fairs, publications, and design reform. For example, in 1895 Manchester reformer T.C. Horsfall argued that the city art museum there could provide "the inhabitants of the poorer parts of the town knowledge of the beauty and wonderfulness of the world and of the nobler works of Man."[9] (Note here the exact formulation that Ortega specified: emphasis on both subject matter and human craftsmanship.) By the end of the century, when Horsfall was writing (here, advocating the Sunday opening of the Manchester City Art Gallery), this had become an established trope.[10] Indeed, Art had been reified as part of the governing structure of most British towns in the form of city museums, often using a version of this argument that the visual arts were universally accessible and could communicate morality. Where did this idea come from?

I will argue in this chapter that the nineteenth-century aesthetic ideology of art as reform built on earlier traditions, particularly the links between beauty and moral sense developed by the Earl of Shaftesbury in the early eighteenth century, the connections the English Romantics made (often using German aesthetics) among beauty, nature, and divine unity, and a pervasive natural theology that understood nature as evidence of divine craftsmanship (even after the challenges to traditional religion presented by Darwin's theory of evolution through natural selection). I will connect the art reform movement to how nineteenth-century critics and artists, particularly John Ruskin and William Morris, transformed the established relationships between aesthetics, religion, and morality. In addition, I will outline how the changing nature of the production and consumption of art also changed nineteenth-century visual practice. As middle-class consumers entered an increasingly anonymous art market, landscape, genre works, and new art movements like the Pre-Raphaelite Brotherhood pushed art to an eclectic understanding of beauty that looked for truth to nature and emphasized the particular detail over the generalizing idealism of the eighteenth century. In this sense the essay that

follows attempts to trace a continual feedback relationship among artists, critics, and audiences, arguing that all participated in defining the social role of art and dominant modes of representation. In other words, nineteenth-century British art itself helped make it possible for others to think that it would be beneficial to society to make art accessible to the masses.

All of these transformations created an aesthetic ideology unique to the age of industrial capitalism, and helped create the context for movements to make art universal through museums, exhibitions, and design.[11] This chapter attempts to understand how art became a mode of social reform, and how a particular visual language made that transformation possible. Art would be good for viewers because paintings could act as windows onto nature. In this reasoning, art and nature are both conduits of morality, or reflective of higher purpose, and these qualities in art and nature are universally accessible. As this chapter hopes to show, nineteenth-century aesthetic ideology developed as a reaction to the centrifugal forces of industrial capitalism, which unmoored traditional society, remade the natural landscape, and seemingly destroyed the bonds among man, nature, and God. Nineteenth-century art reformers hoped that art would heal those wounds. They derived their ideas in part from the Romantic movement that had first identified and explored these issues.

Nineteenth-century art reformers linking art and morality did so as part of a much longer tradition. The major eighteenth-century works on aesthetics, particularly by Edmund Burke and David Hume, in turn built on ideas put forward by Anthony Ashley Cooper, the third Earl of Shaftesbury, earlier in the century.[12] Shaftesbury, a Whig and tutee of John Locke, attempted to reconcile his teacher's idea of the *tabula rasa* with the question of innate morality. He came to see beauty as a potent metaphor that could preserve a "moral sense" along with other modes of perception.[13] Shaftesbury reasoned that everyone possesses an innate ability to perceive beauty, and therefore it would be rational to consider the moral sense as functioning in the same way, as a natural ability to distinguish right from wrong. The universal sense of beauty thus served for Shaftesbury as evidence of universal equality and ultimately the possibility of social harmony.[14] These analogies between beauty and morality, aesthetics and the ideal State, would be widely influential. However, this conflation of aristocratic, educated tastes and a universal aesthetic sense created deep contradictions in the drive to universalize art in later periods.[15] Was art, as nineteenth-century Ruskinian reformer Thomas Greenwood held, "essentially democratic in its character"?[16] Or did Shaftesbury impose on everyone the same tendencies as himself and his educated, aristocratic friends?[17]

The terms of the debate having been set up by Locke and Shaftesbury, eighteenth-century philosophers debated the universality of an aesthetic and/ or moral sense as well as the relationships between beauty, morality, and the State.[18] Romantic poets and philosophers pushed these ideas even further,

redefining beauty as evidence of divine will in nature *and* in man, a concept crucial for later claims for the socially redemptive power of art. In the beauty of nature—and crucially, man's *perception* of beauty in nature—the Romantics found evidence of the unity of being. In the Romantic imagination, the genius of the artist could achieve a reconciliation of man and nature through which man, divided from nature by the Fall, redeems himself through knowledge and feeling, maturing into a wiser, re-unified self.[19]

These developments were part of a larger reaction to the emergence of political revolution and industrial capitalism; the tumultuous end of the eighteenth century led Romantic thinkers to make new connections between art, nature, and the search for divine unity. Romantics tried to solve the problem of individuation and alienation particular to modern societies. For example, Schiller's understanding of individuals as "fragments" comes out of Adam Ferguson's analysis of the unique conditions of modern civilization, particularly of increased socio-economic divisions through capitalist development.[20] In a dialectical move typical of Romantic thinking, for Schiller this fragmentation leads to a higher synthesis and "progress" via "a higher Art."[21] According to M.H. Abrams:

This higher art turns out to be the art of the beautiful, or the fine arts. Schiller thus inaugurates the concept of the cardinal role of art, and of the imaginative faculty which produces art, as the reconciling and unifying agencies in a disintegrating mental and social world of alien and warring fragments—a concept which came to be a central tenet of Romantic faith, manifested in various formulations by thinkers so diverse as Schelling, Novalis, Blake, Coleridge, Wordsworth, and Shelley.[22]

Percy Shelley's *Defence of Poetry* (1819), for example, explicitly argues that, firstly, the pleasure derived from beauty is not based on hedonism, but on the perception of the divine, and secondly, that artists are those who "imagine and express" this "indestructible order."[23] This Romantic framework would become the basis of nineteenth-century aesthetic ideology. As Abrams reminds us, English and German Romantic thinkers imagined art as having a profound social role:

These poets [Wordsworth and Shelley], like their German counterparts, had inherited the severe and conscientious spirit of radical Protestantism, which fostered views at an extreme from the later French development of art for art's sake and of life for art's sake. The Romantic aesthetic was of art for man's sake, and for life's sake.[24]

The Romantics redefined art as uniquely able to reconcile the particular centrifugal forces of both revolution and capitalism, through the imaginative reworking of the basic relationship between man and nature.

As we try to understand how these ideas echoed in nineteenth-century aesthetic ideology, it is worth considering what happened to the category of "nature," particularly after the impact of both the industrial revolution and,

later, Darwinian evolutionary theory. The Romantics' idea of "nature" was connected to both the sublime and the picturesque. Even before the industrial revolution, the social and economic changes of the eighteenth century transformed the British countryside through enclosures, evictions, and capitalist agriculture. "Nature" and "countryside" are problematic concepts because they are in fact the result (at least in part) of the social transformations that we are interested in here. Indeed, according to Raymond Williams' classic account, the idea of "nature" or the "country" as distinct from "society" developed at precisely this moment, when literature formulated the idea of the countryside as an "escape" from the city and even from industrial capitalism itself, even though (as Williams argues) the "country" was thoroughly imprecated in the same economic transformations that created and sustained the new cities.[25]

In this understanding, "nature" is thus as much a product of industrial capitalist society as its apparent opposites, "society," "civilization," or "the city." By 1851, the industrial revolution had transformed England into the first nation in which more people lived in cities than in the countryside. The new cities were not the only testament to man's unprecedented ability to alter the landscape; coal fields, railroads, canals, reservoirs, and air and water pollution were increasingly visible evidence of the redefinition of such seemingly essential categories as "man" and "nature." Tim Barringer has investigated the ways in which nineteenth-century landscape painters participated in the same process that Williams describes for literature, re-creating the countryside for bourgeois consumption, part of a larger reification of the "country" and the wider development of urban-rural tourism.[26] The development of landscape painting as the dominant British genre in the nineteenth century, then, needs to be understood not as a simplistic response to the depredations of the countryside, but as part of a complex series of changes by which people came to understand the very category of "nature" in a new way, as something to be aestheticized and consumed.[27]

Writers and artists were not the only ones, however, to place new emphasis and importance on the changing category of "nature." While the Romantics and their later followers aestheticized "nature" and invested it as the category through which the artist or individual might discover the underlying unity between self and universe, many—including scientists and theologians—viewed nature as the potential proof of the Christian God. Natural theology, the idea that evidence of God's existence could be found as much in his works (nature) as through revelation (scripture), remained a pervasive trope throughout the nineteenth century, and central to many arguments for bringing art to the people. William Paley's *Natural Theology* (1802) used a mechanistic model to argue for nature as God's work, using then-current industrial technology to compare man-made and anatomical structures.[28] Paley's familiar example that a watch found on the road implies

a watchmaker (an argument that is apparently still active, as I once heard a version of it from a devout member of the Salvation Army in the 1990s) led him to illustrate the very complexity of nature as proof of a higher design. While Romantics emphasized the vitality and beauty of nature, rather than Paley's reductive mechanism, both strains of natural theology found God in the natural world and in man's reaction to it. This continued in the popular imagination, and provided the foundation for defining art as able to communicate the wonder of God's work in a universally-accessible way. Discoveries in geology and biology that challenged the Biblical account and even God's role in Creation failed to shake these long-standing concepts.[29] According to Robert Young, amongst scientists and intellectuals, of course, nineteenth-century science overturned the cruder interpretations of natural theology, but it remained within a theological framework and "aim[ed] to reconcile nature, God, and man."[30] "Nature" was thus a changing category for educated elites, but even for them it was still a source of wonder and even proof of a higher design in the increasingly sophisticated understanding of geological time, natural selection, and the uniformity of natural laws.

The Romantic legacy, then, formed the basis of nineteenth-century aesthetic ideology by imagining the artist and the higher arts as uniquely suited to reconnecting nature, man, and God. Both mechanistic and Romantic or vitalist forms of natural theology remained influential throughout the century; despite challenges to the Biblical account from the natural sciences, nature remained, with scripture, key proof of God's existence and beneficent design. At the same time, both literature and the visual arts framed "nature" and the "countryside" as categories which were essentially different and separate from the increasingly fragmented experience of urban, industrial, capitalist modernity. These developments worked alongside changes in artistic practice and art criticism to create new forms of visual representation and an expanded social role for art.

The particular aesthetic ideology in nineteenth-century Britain that connected "readable" paintings with a clear social purpose for art shows the fascinating connections between ideas about art (art criticism and theory), patronage, and artistic practice. I want to outline how these interactions created a context in which art became a means of social reform. Many art historians have recently interpreted nineteenth-century British art as heavily influenced by the new presence of middle-class patrons in the art market.[31] The idea that art could be an active force in society, and the subsequent social movement to bring it to a mass audience, depended on the particular visual language of the Victorian period, which allowed viewers to read art in terms of its content rather than in terms of its technique. This language, in turn, had been shaped by the entry of patrons into the art market who looked to art to help define middle-class culture, and who wished art to reflect their own priorities and values.[32] Purchasing works by contemporary British artists allowed newly wealthy middle-class patrons to reject the aesthetic traditions

of the aristocracy and begin to shape the realm of high culture even as they were remaking religious life and the political establishment.

A substantial body of scholarship has emphasized that middle-class patrons' entry into the art market in the 1830s and 1840s had several significant consequences, creating what Robert Hewison has called a new "visual economy."[33] First, the taste for Old Masters diminished, and the market for contemporary British art increased.[34] Second, as artists lost their traditional sources of patronage, an exhibition system developed in London and the great regional cities to connect the artists to their new, anonymous public.[35] Third, a periodical press sprang up to guide the new buyers in aesthetic decisions and explain the merits of the rapidly multiplying numbers of artists.[36] Fourth, a market developed for art that reflected a moral and religious purpose, art that could be read in terms of narrative and subject matter by patrons and critics more familiar with literature than with the visual arts.[37]

The new class of collectors bought contemporary British art and shunned Old Masters—limited in number and hence out of the price range of most buyers—not least to differentiate themselves from aristocratic connoisseurs.[38] Artists and buyers found each other through exhibitions in London and the regional cities that were publicized in the national and local press and new, specialized journals.[39] The explosion of museum-building in the last half of the nineteenth century thus both arose out of and in turn fuelled a new enthusiasm for contemporary British art; the most important regional art museums such as those in Manchester and Liverpool held annual exhibitions of new works for sale to raise revenue, and often bought from these exhibitions.[40] The Royal Academy, commercial galleries, and regional art museums, in concert with the national press, all participated in the diffusion and popularization of contemporary British art.

Over the course of the nineteenth century, all of these developments had a profound impact on the role and prominence of art in British society. Many individual choices by single collectors gradually created a new art market and a new visual language. The new practice of professional art criticism was both a sign of and a continuing catalyst to art entering mainstream culture, as art critics helped to justify and popularize art in new ways. Most influential among the new art critics was John Ruskin, and most prominent among the new art movements was the Pre-Raphaelite Brotherhood. The close relationship between this art critic and these artists has been told often and well; what is important here is how the Pre-Raphaelites tried to put Ruskin's ideas into practice. In the relationship between Ruskin and the young Oxford undergraduates, art criticism and art practice combined to redefine categories of traditional aesthetics.

Just as all the above changes were getting underway in the early years of Victoria's reign—a new class of collector looked for art, sought advice from

new periodicals, attended new exhibitions, and began to purchase the works of living artists—a new voice burst onto the art scene that would have such an impact that it is difficult to measure. Combining art criticism with social commentary in his long life (1819–1901), John Ruskin combined the Romantic idea of the artist as revealing the "invisible world" with Evangelical language that no doubt comforted his many middle-class readers.[41] Yet Ruskin's oeuvre was enormous, contradictory, and dense, and his ideas changed throughout his lifetime. His middle-class upbringing combined strict Evangelical doctrine, family trips in Europe, and art collecting, and from an early age he began developing a new mode of visual interpretation that would justify aesthetic pleasure in terms of religious experience and, eventually, social critique.[42] His multi-volume work *Modern Painters* brought a new urgency to art criticism, as he combined the campaigning zeal of A.W.N. Pugin and Thomas Carlyle with his own religiously inflected aesthetics.[43] Like the Romantics before him, Ruskin emphasized the continuity of beauty and morality, arguing that the pleasure derived from beauty was not based on sensuality, but on the perception of the divine.[44] He argued that it was the role of the artist to act as an "*eye*-witness" whose sight testified to the glory of nature as God's creation: "Nothing must come between nature and the artist's sight; nothing between God and the artist's soul."[45] His 1850s works on architecture—*The Seven Lamps of Architecture* and *The Stones of Venice*—placed a new emphasis on social criticism and the problems wrought by urban industrial capitalism, issues that would become his focus in his later years.[46] Inspiring the works of the Pre-Raphaelite Brotherhood and countless artists and reformers, including both the prodigiously creative craftsman William Morris and the social revolutionary Mohandas Gandhi, Ruskin convinced many that art was both inherently moral and a potentially active force for healing a society sick with the traumas and inequities of industrial capitalism.

From the first volume of *Modern Painters*, the basis of Ruskin's art and social criticism was his bifurcated understanding of both beauty and perception. Ruskin separated his definition of beauty into both "typical beauty," that is, external form, and "vital beauty," that is, "the felicitous fulfillment of function in living things," the unhampered being-ness of any living thing or any object's maker.[47] At the same time, Ruskin understood the act of sight as also comprising both the perception of outward form and of deeper truth which required imagination and greatness.[48] Thus, for Ruskin Turner's works were great because—contrary to what other critics wrote about the artist's late work—they were more true to nature than the works of others. This "truth to nature" appeared both in Turner's close observation of natural forms and in how his work displayed the grandeur and glory of God's creation; for Ruskin, Turner was able to perceive and communicate "typical" and "vital" beauty, because he saw and painted both the outward form and the deeper significance of that form. Later, in his architectural criticism—particularly in

the famous chapter "The Nature of Gothic" — Ruskin came to understand this unity of form and function as including conditions of production. Thus, the repetitive perfection that Classical architecture (or factory labor) demanded of a worker, while it might produce "typical beauty," could never include the "felicitous fulfillment of function" for the worker.[49] This simultaneous understanding of perception and beauty as comprising both form and function allowed Ruskin to write a moral critique of painting, architecture, and later, industrial capitalism that would echo through the Arts and Crafts movement and beyond.

Ruskin's redefinition of the categories of beauty and perception meant that he encouraged new kinds of visual practice. Sir Joshua Reynolds had advocated — and thus Royal Academicians continued to strive for — the "grand manner" of the Old Masters. In contrast, for Ruskin, the best art did not aim to idealize and generalize nature. Instead, Ruskin overturned traditional hierarchies and aesthetic standards, and in arguing for Turner's genius, called for art that would truly represent and communicate the artist's particular experience. Ruskin's art and architecture criticism of the 1840s and 1850s identify the works of Turner, Gothic masons, and, later, the Pre-Raphaelite Brotherhood, as all participating in this same basic artistic enterprise: namely, creating works based on seeing nature freshly, without prejudice or tradition.[50] This ability to see nature truly — "truth to nature" — was never simple mimeticism, but showed the greatness of the artist's soul in being able to translate awe, majesty, and wonder through color, line, and form. Steeped in the natural theology of his time, Ruskin used the idea of "truth to nature" to make art a mode of registering the glory of God's creation as well as the moral health of a society.[51]

Ruskin thus made crucial connections between a painting's subject matter, moral weight, artistic merit, and visual language. On the one hand, he tried to get the public to *see* — to see the beauty of nature and the ugliness of modern society, as well as the use of color, light, and shade that allowed his favorite artists to depict nature in all its divine glory. On the other hand, however, he insisted on a moral reading of symbol and form that was ultimately based on the idea of nature as a kind of scripture, so that Ruskin wrote that the best paintings "give inner and deeper resemblance" to nature.[52] Thus he wrote:

if it were offered to me to have, instead of [these works of art], so many windows, out of which I should see, first, the real chain of the Alps from the Superga; then the real block of gneiss, and Aiguilles Rouges; then the real towers of Fribourg, and pine forest; the real Isola Bella; and, finally, the true Mary and Elizabeth; and beneath them, the actual old monk at work in his cell, – I would very unhesitatingly change my five pictures for the five windows; and so, I apprehend, would most people, not, it seems to me, unwisely.[53]

This idea that painting was not only or even primarily about the artist's technique, but about nature — and therefore ultimately about God — helped

reformers redefine it as a necessity for modern civilized society, not as a luxury suspect for its decadence and sensuality. Art was a window onto nature, and thus ultimately onto God.

Even outside of Ruskin's "truth to nature," art as a means of bringing people to an idealized nature, and thus to God, became a common argument for providing art for the people. Charles Kingsley gives a typical example in a piece from 1848, writing that

> picture-galleries should be the townsman's paradise of refreshment. Of course, if he can get the real air, the real trees, even for an hour, let him take it, in God's name; but how many a man who cannot spare time for a daily country walk, may well slip into the National Gallery, or any other collection of pictures, for ten minutes. *That* garden, at least, flowers as gaily in winter as in summer. Those noble faces on the wall are never disfigured by grief or passion. There, in the space of a single room, the townsman may take his country walk…and his hard-worn heart wanders out free, beyond the grim city-world of stone and iron, smoky chimneys, and roaring wheels, into the world of beautiful things—*the world which shall be hereafter*—ay, which shall be![54]

Kingsley envisions this picture gallery functioning in the same way as the walk above Wordsworth's Tintern Abbey, allowing the mind of the visitor to contemplate that "presence that disturbs me with the joy/Of elevated thoughts." Here we have a perfect example of the artist's vision of the natural world as antidote to industrial urban modernity, as well as the natural theology that connects the beauty of nature with religious belief and ultimate meaning.

In the 1850s, Ruskin's ideas from *Modern Painters* burst onto the British art scene with vivid force with the appearance of a new group of artists who mysteriously signed their works with the acronym "PRB." This was, of course, the Pre-Raphaelite Brotherhood, initially founded by painters Dante Gabriel Rossetti, William Holman Hunt, John Everett Millais, and others.[55] While these artists would change considerably in their tone and style in later years, the crisp color, meticulous realism, and strained perspective in their works revolutionized British painting and helped to define the British School of Art. The Pre-Raphaelites developed in practice a new visual language that aimed to avoid Academic symbolism in favor of a language accessible to all through a Ruskinian "truth to nature." They translated Ruskin's ideas about the divinity of nature and the morality of sight into paint and canvas, and transformed the color, style, and interpretation of the visual arts for the remainder of the nineteenth century. This new visual language helped reformers reconceptualize art as an active moral force in society.

Victorian art is not unlike pornography, easy to recognize but difficult to define. The full subject is of course too broad for this essay, but we can note a key feature of nineteenth-century British art that helped create the particular aesthetic ideology that I have identified: narrativity. As discussed above, the

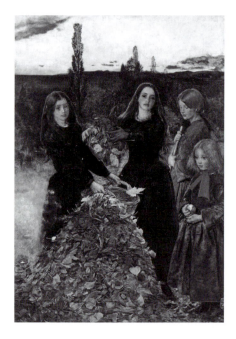

7.2 John Everett Millais, *Autumn Leaves*, 1856. Image © Manchester City Galleries

new collectors sought out and encouraged landscape and genre paintings suitable for home display. This not only changed the kind of art produced, but the way in which critics, museums, and the press "read" art; the development of the art-critical press, indeed, encouraged this kind of exegesis.[56] Nineteenth-century British painting was eclectic, from the meticulous realism and smooth facture of the Pre-Raphaelites (Figure 7.2); to the novelistic, popular genre paintings like those by William Frith and Randolph Caldecott; to the work of historicist Academicians like Frederic Leighton and Lawrence Alma-Tadema; or to the loose brushwork and high concept works of painters like Dante Gabriel Rossetti and G.F. Watts. Within this range of styles, however, both artists and viewers tended to explicate paintings in terms of narrative or a moral.[57] Narrative painting was extremely popular among all socio-economic classes, appearing in the Royal Academy Summer Exhibitions, the more "progressive" Grosvenor Gallery shows, and in countless local exhibitions and museums.[58]

E.T. Cook (later co-editor of Ruskin's collected works) tried to define the English School of Art in his 1889 *A Popular Handbook to the National Gallery*. It is noteworthy that he does not turn to style, but defines English art in terms of its moral qualities:

Is there an English School at all? In the fullest sense of the term, there certainly is not... taking all the English pictures together, one cannot detect any uniformity of method

and style, such as would justify the application, in the strict sense, of the term 'English School.' ... But in another sense there certainly is an English School. Not only do the separate manifestations of English art form a considerable and noteworthy whole; but considered broadly, they reflect many aspects of the national mind. In the first place that seriousness of purpose, that predominance of the moral element, which has been said to distinguish the English character, is very conspicuous in English art...[59]

Cook recognizes several distinctly English "modes" of painting: historical, domestic drama, literary, landscapes and seascapes, and portraits. Moreover, he links these subjects with the "moral element" he had already identified; in contrast, "both decorative and sensuous forms of art are in England exotics, and there is nothing as yet to show that the movement in such directions is not a backwater, rather than a progressive stream."[60] For Cook, then, the Pre-Raphaelite movement "tended in the old direction, founded as it was on seriousness in aim and sincerity of conception."[61] Cook thus gives us a perfect example of nineteenth-century aesthetic ideology: a particular visual language—which emphasizes subject over style—leads to a "moral" reading of painting and hence to a clear social function (or, in this case, to a nationalist definition of Englishness). The emergence of painting styles that spoke to new classes of patrons and audiences in a "readable" way, and could thus speak to anyone, regardless of education level, relied on treating paintings as "windows" onto their subjects, making the surface of the painting itself transparent. Indeed, Cook implies that viewing a painting for its surface—for purely "decorative and sensuous forms"—is in fact somewhat suspect, and definitely un-English. It is precisely this idea of paintings as windows onto subjects that have a universally accessible moral impact that made art into a vehicle for social reform.

We can see nineteenth-century aesthetic ideology at work in the formation of municipal art museum collections. For the art museums in Birmingham, Liverpool, and Manchester, purchasing decisions involved issues of taste, decency, cost, the intended audience, and their wider cultural goals. Of course, these city museums could not compete with national museums for Old Masters, especially as wealthy American institutions such as the Metropolitan Museum in New York entered that market. However, the issue must also to some extent have been ideological, and some decisions show the close connection between the practice of nineteenth century British painting and the goals of these art museums. For example, in November 1892 one Max Pollack of Paris wrote to the Art Gallery Committee in Manchester referring to a "Titien" that he had offered to them—according to another letter, a version of "Dan'ae" (perhaps like Figure 7.3, now at the Art Institute of Chicago)— "which you and your colleagues admired, but which you found a little too nude."[62] In its place Pollack offered, for £1,500, "Rabbi Wel" by Rembrandt, perhaps something like this painting at the National Gallery in London (Figure 7.4, bought in 1844 as "A Jewish Rabbi," and now called "Bearded

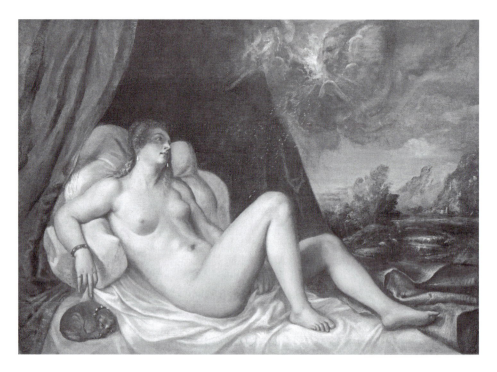

7.3 Titian and workshop, d.1576. *Danaë*, 121 × 170 cm (47½ × 66¾ in), after 1554, oil on canvas. Photograph by Robert Hashimoto. Reproduction, The Art Institute of Chicago

Man in a Cap"). After reading this letter, the Committee "Resolved that whilst desiring to acquire for the Permanent Gallery an authenticated Rembrandt" they did not have the necessary funds at their disposal. However, one month later, they purchased John Everett Millais' "Autumn Leaves" (Figure 7.2) from James Leatheart for £1,300.[63] Whether they believed that the painting on offer was *not* an "authenticated Rembrandt" we will most likely never know; what is clear, however, is that unlike Old Masters, the Pre-Raphaelites fit remarkably well into the museum's aim of reaching a wide audience while still communicating high ideals.

Indeed, championed by Ruskin in the 1850s, by the end of the century Millais, Holman Hunt, and Rossetti had become the "must-haves" of these city art museums. Acknowledged as the most important original movement in contemporary British painting, the Pre-Raphaelites could stand for artistic integrity, unimpeachable respectability and a desirable celebrity status. What I want to suggest here is that Victorian museums' combination of popular narrative works and Pre-Raphaelites was not accidental. Indeed, it was the existence of this kind of art that formed a key part of the aesthetic ideology that made these museums possible in the first place. To the purchasing committees, contemporary British art offered

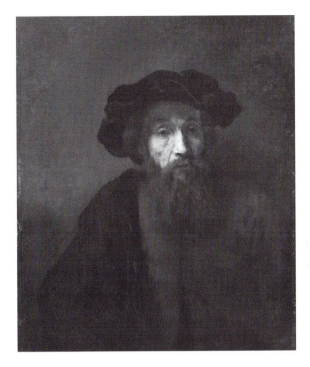

7.4 Rembrandt Harmenszoon van Rijn, *A Bearded Man in a Cap*, 1653 or 1657. Photo © The National Gallery, London

moralizing tales, approachable stories, and truth to nature—was art, that is, that they hoped would reach and positively influence the widest possible audience. Within this general category, the Pre-Raphaelites' works could exhibit all the best qualities and highest aspirations of Ruskin's idealizing, and museum committees bought them so that visitors might devote time to—as Ruskin described the goal of any museum—"'the concerns of their immortal souls,' that is to say, to the contemplation and study of the works of God."[64]

Now, as I noted at the outset, at this very moment, the Aesthetic movement was challenging the basis of this understanding and practice of art. I began this essay with James McNeill Whistler's rejection of the dominant, Ruskinian aesthetic ideology and his call for a new understanding of art's social role directly related to his new visual approach (Figure 7.1). Whistler and other members of the British Aesthetic movement took on the originally French idea of *l'art pour l'art*. As Oscar Wilde wrote in his 1905 essay *The Decay of Lying*, "Art never expresses anything but itself … . All bad art comes from returning to Life and Nature, and elevating them into ideals … Lying, the telling of beautiful untrue things, is the proper aim of Art."[65] The nineteenth-century aesthetic ideology connecting nature, art, and morality, that depended on

seeing art as a window onto nature, was passé. Artists now argued that art existed for its own sake.

Whistler and Wilde, early or proto-Modernists, thus began to articulate what observers like José Ortega y Gasset would see so clearly after World War I: the dominant nineteenth-century aesthetic ideology viewed art as socially useful because it defined art in terms of representation and subject matter, as witness to human achievement and to the wonder of God's creation. In its place, Modernism rejected representation and developed multiple modes of exploring "pure" form, color, and experience. On the other hand, the easily accessible, representational art forms that the Victorians associated with bringing art to the people became truly public art by entering the new forms of twentieth-century mass media: radio, cinema, print journalism, and later television. Museums of modern art, in fact, lost audiences to these new, competing forms of leisure by the early years of the twentieth century. If we bemoan the state of our culture, the industrial age presents us with a fascinating case study: in Britain, Victorians had a clear aesthetic ideology that brought together a mode of visual practice, an understanding of art's social role, and new institutions to make art public. They hoped that this view of art might help heal the rifts created by industrial society itself; instead, their aesthetic ideology collapsed under the weight of its own unrealistic expectations, as well as the combined challenge of both the Modernist avant-garde and mass-media kitsch. Yet the museums that came out of it remain, and many contemporary museum projects continue to hope, that art might offer a uniquely accessible experience, and aesthetics a singularly unifying philosophy, to counteract the dislocations of modern society.

Acknowledgments

I must first acknowledge the generous support I received from Loyola Marymount University's Bellarmine College of Liberal Arts, which provided a Continuing Faculty Summer Research Grant in 2006 that allowed me to write this essay. I would also like to thank Aimee Marshall at the Art Institute of Chicago, Sylvia Inwood at the Detriot Institute of Arts, Tracey Walker at the Manchester City Art Gallery, and Daragh Kenny at the National Gallery in London for their help with obtaining the images. Finally, thanks very much to Mom, Dad, Ben, Luke, and Gabriel Wolfenstein for their thoughts and comments.

Notes

1. See "Mr Whistler's 'Ten O'Clock.' Opinions of the Press. 1885. Extracts from press reviews," in James McNeill Whistler, *Whistler on Art: Selected Letters and Writings of James McNeill Whistler.*

Edited and with an Introduction by Nigel Thorp (Washington, D.C.: Smithsonian Institution Press, 1994), 95–102.

2. Whistler won, but Ruskin was ordered to pay only a symbolic farthing in damages, and the costs of the trial effectively bankrupted Whistler. See Shearer West, "Tom Taylor, William Powell Frith, and the British School of Art," *Victorian Studies*, 33, no. 2 (Winter 1990), 307–26.

3. "Mr. Whistler's 'Ten O'Clock', 20 February 1885," in James McNeill Whistler, *Whistler on Art*, 81.

4. "Mr. Whistler's 'Ten O'Clock', 20 February 1885," in Whistler, *Whistler on Art*, 80.

5. "Mr. Whistler's 'Ten O'Clock', 20 February 1885," in Whistler, *Whistler on Art*, 81. Emphasis in original.

6. José Ortega y Gasset, "The Dehumanization of Art," in James B. Hall and Barry Ulanov, *Modern Culture and the Arts* (New York: McGraw-Hill Book Company, 1967): 42–3.

7. As Richard Altick notes, "The age's criteria of acceptable art are usually summed up in the term 'moral aesthetic.' The idea that art should teach and inspire as well as give pleasure was not new; it was, indeed, older than Horace's *dulce et utile*. But seldom had it been so firmly established as it was in this period, when society's need for self-understanding, criticism, and direction was so urgent." Richard D. Altick, *Victorian People and Ideas* (New York: Norton & Co, 1973), 272.

8. Carl E. Schorske, *Thinking With History: Explorations in the Passage to Modernism* (Princeton, NJ: Princeton University Press, 1998).

9. T.C. Horsfall, *The Government of Manchester. A Paper Read to the Manchester Statistical Society, November 13th, 1895, With Additions.* (Manchester: J.E. Cornish, 1895).

10. See for instance Amy Woodson-Boulton, "Temples of Art in Cities of Industry: Municipal Art Museums in Birmingham, Liverpool, and Manchester, c1870–1914" (unpublished doctoral dissertation, University of California, Los Angeles, 2003); Giles Waterfield, *Art for the People: Culture in the Slums of Late Victorian Britain* (London: Dulwich Picture Gallery, 1994); Frances Borzello, *Civilising Caliban: The Misuse of Art 1875–1980* (London and New York: Routledge & Kegan Paul, 1987); Shelagh Wilson, "'The Highest Art for the Lowest People': the Whitechapel and other Philanthropic Art Galleries, 1877–1901," in Paul Barlow and Colin Trodd, *Governing Cultures: Art Institutions in Victorian London* (Aldershot: Ashgate, 2000), 172–86; Michael Harrison, "Social Reform in Late Victorian and Edwardian Manchester With Special Reference to T.C. Horsfall" (unpublished doctoral dissertation, University of Manchester, 1987); Michael Harrison, "Art and Social Regeneration: The Ancoats Art Museum," in *Manchester Region History Review*, VII (1993): 63–72; Michael Harrison, "Art and Philanthropy: T.C. Horsfall and the Manchester Art Museum," in Alan J. Kidd and K.W. Roberts, eds, *City, Class, and Culture: Studies of Social Policy and Cultural Production in Victorian Manchester* (Manchester: Manchester University Press, 1985), 120–47; and Seth Koven, "The Whitechapel Picture Exhibitions and the Politics of Seeing," in Daniel J. Sherman and Irit Rogoff, eds, *Museum Culture : Histories, Discourses, Spectacles* (Minneapolis : University of Minnesota Press, 1994), 22–48.

11. The story of how art became a means of social reform, and became physically separated out into art museums, is part of the process that Raymond Williams identified in *Culture and Society*, namely the development and separation of "Culture" as a category able to critique industrial capitalist society. Raymond Williams, *Culture & Society: 1780–1950* (New York: Columbia University Press, 1983). Pierre Bourdieu has explored the power relationships maintained by the contradictions inherent in public museums, namely the extent to which they hide the education such institutions require by celebrating the universality of the visual arts. I believe that we can trace the origins of this contradiction in the British case in the claims made for art in the nineteenth century. See Pierre Bourdieu, trans. Richard Nice, *Distinction: A Social Critique of the Judgement of Taste* (Cambridge, MA: Harvard University Press, 1984) and Pierre Bourdieu, Alain Darbel, and Dominique Schnapper, *The Love of Art: European Art Museums and Their Public* (Stanford, CA: Stanford University Press, 1991).

12. See Linda Dowling, *The Vulgarization of Art: The Victorians and Aesthetic Democracy* (Charlottesville: University Press of Virginia, 1996); Terry Eagleton, *The Ideology of the Aesthetic* (Oxford, UK and Cambridge, MA: Blackwell, 1990); Henry Andrews Ladd, *The Victorian Morality of Art: An Analysis of Ruskin's Esthetic* (New York: Octagon Books, 1968); James A. Schmiechen, "The Victorians, the Historians, and the Idea of Modernism," in *American Historical Review*, 93, no. 2 (1988): 287–317; and Raymond Williams, *Culture & Society*.

13. Dowling, *The Vulgarization of Art*; Eagleton, *The Ideology of the Aesthetic*.

14. Dowling, *The Vulgarization of Art*.

15. Dowling, *The Vulgarization of Art*.

16. Thomas Greenwood, *Museums and Art Galleries* (London: Simpkin, Marshall and Co., 1888), 10.

17. Locke's *tabula rasa* provided the material against which Shaftesbury formulated his conception of an innate morality and aesthetics, but Locke's theories of education through experience provided another way of connecting beauty, morality, and universal accessibility and applicability. Locke did seem to indicate that beauty in the environment could have a transformative effect on the morality and health of those who experienced it; one can thus imagine beauty as a transformative power even without the assumption that everyone can understand it in the same way. James Schmiechen has traced this "assimilationist" idea back to Locke, and demonstrated the extent to which this concept influenced Victorian architecture. Schmiechen, "The Victorians, the Historians, and the Idea of Modernism." It does not seem a strange argument to us now that as a society— perhaps even supported by the State—we should aim to create beautiful living environments for all. However, the telling aspect of this argument is that aesthetically better environments would create better people—an idea that lasted at least through the innovations of the Bauhaus, the writings of Le Corbusier, the housing boom after World War II, and perhaps into the "broken windows" theory of policing recently championed by Rudolf Giuliani and William Bratton in New York City and Los Angeles. Indeed, as others have recognized (particularly Tony Bennett), this connection brings up the problem that many aesthetic theories that link beauty and morality later became tools for social control. See Tony Bennett, *The Birth of the Museum: History, Theory, Politics* (London and New York: Routledge, 1995).

18. See M.H. Abrams, *Natural Supernaturalism: Tradition and Revolution in Romantic Literature* (New York: W.W. Norton & Company, 1971); Dowling, *The Vulgarization of Art*; Ladd, *The Victorian Morality of Art*; Eagleton, *The Ideology of the Aesthetic*; and Williams, *Culture & Society*.

19. See Abrams, *Natural Supernaturalism*.

20. Abrams, *Natural Supernaturalism*, 210–211.

21. Friedrich Schiller, sixth *Aesthetic Letter*, quoted in Abrams, *Natural Supernaturalism*, 212.

22. Abrams, *Natural Supernaturalism*, 212. In the British context, Coleridge and Carlyle would prove to be important transmitters of German metaphysics in general and of Schiller's ideas in particular.

23. Percy Bysshe Shelley, *Defence of Poetry, Part First* (1821), section 5, at http://rpo.library.utoronto. ca/display/displayprose.cfm?prosenum=6, from Michael O'Neill, editor, *The Bodleian Shelley Manuscripts: A Facsimile Edition*, XX (New York and London: Garland, 1994), 20–83. Accessed on December 4, 2006.

24. Abrams, *Natural Supernaturalism*, 429.

25. Raymond Williams, *The Country and the City* (New York: Oxford University Press, 1973).

26. See Tim Barringer, *Men at Work: Art and Labour in Victorian Britain* (New Haven and London: Yale University Press, 2005). Rosemary Treble also sees landscape painting as an urban product, but emphasizes this as a backward-looking movement: "the profound nostalgia of the urban middle classes for their rural past ensured the survival, in however changed a form, of the English landscape in art." Rosemary Treble, "The Victorian Picture of the Country," in G.E. Mingay, *The Rural Idyll* (London: Routledge, 1989): 50–60, 59.

27. This is part of the same process of aestheticization that led to the formation of National Parks in the United States and later in Britain.

28. See Neal C. Gillespie, "Divine Design and the Industrial Revolution: William Paley's Abortive Reform of Natural Theology," in *Isis*, 81, no. 2 (1990): 214–29, and Ernst Mayr, "The Nature of the Darwinian Revolution," in *Science*, 176, 4038 (1972): 981–9.

29. See Mayr, "The Nature of the Darwinian Revolution," and Robert M. Young, *Darwin's Metaphor: Nature's Place in Victorian Culture* (New York: Cambridge University Press, 1985).

30. Robert M. Young, *Darwin's Metaphor*, 10. For Young, the debate through at least the 1870s focused not on religion vs atheism, but on the uniformity of nature, that is, whether to find God in the consistency and ordered structure of the universe, or whether to find God in the traditional understanding of miracles and frequent divine intervention. Young, *Darwin's Metaphor*, 8–9.

31. See for example Dianne Sachko Macleod, *Art and the Victorian Middle Class: Money and the Making of Cultural Identity* (Cambridge: Cambridge University Press, 1996).

32. According to Melvin Waldfogel, these new buyers were usually "affluent merchants or industrialists": "Their preference for contemporary English painting, and especially the narrative picture, was a natural extension of their social and other cultural beliefs; even their pragmatism directed them toward an art product where authenticity was never in doubt."

Melvin Waldfogel, "Narrative Painting," in Joseph L. Altholz, *The Mind and Art of Victorian England* (Minneapolis, MN: University of Minnesota Press, 1976), 166. See also Jesús Pedro Lorente, *Cathedrals Of Urban Modernity: The First Museums Of Contemporary Art, 1800–1930* (Brookfield, VT: Ashgate Press, 1998), 18, and Macleod, *Art and the Victorian Middle Class: Money and the Making of Cultural Identity*, 30.

33. "With the end of the Napoleonic wars and the profitable peace that followed, there was a rapid expansion in demand for visual imagery of all kinds, driven by burgeoning, mainly middle-class, wealth, and fed by new technologies in printing and engraving. The numbers of artists, patrons and the means to bring seller and buyer together through public exhibitions all increased, as did the demand for critical commentary and guidance in the form of reviews in newspapers, periodicals and books on art. We have seen an even greater expansion in what we may term this visual economy since the end of the Second World War." Robert Ian Warrell and Stephen Wildman Hewison, *Ruskin, Turner and the Pre-Raphaelites* (London: Tate Gallery Publishing, 2000), 11. See also Williams, *Culture & Society*; Ladd, *The Victorian Morality of Art*; George P. Landow, "There Began to Be a Great Talking about the Fine Arts," in Altholz, *The Mind and Art of Victorian England*; and H.E. Roberts, "Exhibition and Review: the Periodical Press and the Victorian Art Exhibition System," in Joanne Shattuck and Michael Wolff, eds, *The Victorian Periodical Press: Samplings and Soundings* (Leicester, UK: Leicester University Press, 1982), 79–105.

34. According to Helene Roberts, "[w]ith the entry of the middle classes into the art market, not only had the number of patrons increased, they were more willing to buy the work of contemporary English artists instead of the Old Masters preferred by the aristocratic connoisseurs and they were willing to pay high prices." Roberts, "Exhibition and Review," 88.

35. According to George Landow, "Most Victorian commissions came not from church, state, or aristocracy but from merchants and manufacturers. But to attract this new, expanding group of potential buyers the artist had to make them aware of his works, and this he could only do by exhibiting them in public. Such public display of paintings in turn produces periodical criticism." George P. Landow, "There Began to Be a Great Talking about the Fine Arts," 125–6.

36. Richard Aldington, ed., *The Religion of Beauty: Selections From the Aesthetes, With an Introduction by Richard Aldington* (London: William Heinemann Ltd, 1950), Introduction; Roberts, "Exhibition and Review," and Landow, "There Began to Be a Great Talking about the Fine Arts." I am grateful to Dr. William McKelvy for recommending the Aldington book.

37. Macleod, *Art and the Victorian Middle Class*, 30, and Roberts, "Exhibition and Review," 88.

38. Macleod, *Art and the Victorian Middle Class*, 30, and Roberts, "Exhibition and Review," 88.

39. Landow, "There Began to Be a Great Talking about the Fine Arts," 125–6.

40. Woodson-Boulton, *Temples of Art in Cities of Industry*, chapters 2–4, and Amy Woodson-Boulton, "'Industry without Art is Brutality': Aesthetic Ideology and Social Practice in Victorian Art Museums," *Journal of British Studies*, 46, no. 1 (January 2007): 47–71.

41. A point made well in the Introduction to Aldington, *The Religion of Beauty*, especially 13–14. See also Eagleton, *The Ideology of the Aesthetic*; Williams, *Culture & Society*, and Bertram Morris, "Ruskin on the Pathetic Fallacy, or on How a Moral Theory of Art May Fail," in *The Journal of Aesthetics and Art Criticism*, 14, no. 2, Second Special Issue on Baroque Style in Various Arts (December 1955): 248–66.

42. Hewison, *Ruskin, Turner and the Pre-Raphaelites*, 13. My understanding of the relationship between Ruskin's background, his ideas on art, and his political and economic ideas has also been inspired by Williams, *Culture & Society: 1780–1950*, Timothy Hilton, *John Ruskin: The Early Years* (New Haven: Yale University Press, 2000), Timothy Hilton, *John Ruskin: The Later Years* (New Haven, CT: Yale University Press, 2000), Tim Barringer, *Reading the Pre-Raphaelites* (New Haven, CT and London: Yale University Press, 1999), and the teaching of Debora Silverman.

43. For a good discussion of how Pugin's and Ruskin's ideas played out in practice, see Robert Macleod, *Style and Society: Architectural Ideology in Britain, 1835–1914* (London: RIBA Publications Limited, 1971).

44. Ibid.

45. Cook, *The Works of John Ruskin*, vol. 11, no. 49; reference in Hewison, *Ruskin, Turner and the Pre-Raphaelites*, 13.

46. J. Mordaunt Crook, *The Dilemma of Style* (Chicago: University of Chicago Press, 1987) writes that Ruskin argued for the Italian Gothic as a solution to the search for an appropriate historical model for modern architecture, stalled in the "Battle of Styles" between Classical and Gothic.

47. Ruskin, *Modern Painters*, vol. II, Part III, Section 1, Chapter 3, paragraph 16, quoted in Williams, *Culture & Society: 1780–1950*, 135. See also Ladd, *The Victorian Morality of Art*, Chapter II, 167–201; especially 184–98; George P. Landow, "Ruskin's Version of "Ut Pictura Poesis"," in *The Journal of Aesthetics and Art Criticism*, 26, no. 4 (Summer 1968): 527; Williams, *Culture & Society*, 135–40. See also the interesting discussion in John Macarthur, "The Heartlessness of the Picturesque: Sympathy and Disgust in Ruskin's Aesthetics," in *Assemblage* 32, 1997): 126–41.

48. Barringer, *Reading the Pre-Raphaelites*, 57.

49. I am particularly indebted to Debora Silverman for her lucid interpretations of Ruskin's works in conversations and lectures at UCLA.

50. See for example Barringer, *Reading the Pre-Raphaelites*, 57; Altick, *Victorian People and Ideas*, 274; Ladd, *The Victorian Morality of Art*; Morris, "Ruskin on the Pathetic Fallacy"; and William C. Wright, "Hazlitt, Ruskin, and Nineteenth-Century Art Criticism," in *The Journal of Aesthetics and Art Criticism*, 32, 4 (1974): 509–23.

51. Ladd, *The Victorian Morality of Art*, especially 168, 184–91, 197, 323, 325.

52. Ruskin, "Of the Use of Pictures," *Modern Painters*, vol. III, in Cook, *The Works of John Ruskin*, vol. 5, 172.

53. Ruskin, "Of the Use of Pictures," 171.

54. *Charles Kingsley: His Letters and Memories of His Life, Edited by His Wife* (London: Henry S. King & Co., 1877), 168–9. Emphasis in original.

55. On the Pre-Raphaelite Brotherhood, I have benefited in particular from Macleod, *Art and the Victorian Middle Class* and Barringer, *Reading the Pre-Raphaelites*, as well as from the lectures of Debora Silverman at the University of California, Los Angeles.

56. The majority of art critics even supported such an approach; many of them had a literary background, which, according to Helene Roberts, "produced reviewers who emphasized the subject matter over technical qualities and who gave prominence to those paintings with the more interesting subjects." Roberts, "Exhibition and Review," 83. Indeed, John Stokes defines the New Critics like D.S. MacColl at the turn of the century as explicitly rejecting the established connection between subject and moral weight that came from reading paintings as literature: "The New Critics began by asserting that it was no longer possible to judge a painting by the moral intention which choice of subject implied . . . New Critics expressed this idea . . through their stricture that painting should on no account be confused with 'literature.'" John Stokes, *In the Nineties* (Chicago: University of Chicago Press, 1989), 34–5. The battle between these different views of art came into conflict in the Ruskin/Whistler trial of 1878 and again in the Parliamentary hearings over the Chantrey bequest in 1904. See Linda Merrill, *A Pot of Paint: Aesthetics on Trial in Whistler v Ruskin* (Washington, D.C.: Smithsonian Institution Press, 1992) and Gordon Fyfe, "The Chantrey Episode: Art Classification, Museums and the State, c1870–1920," copy sent from author, University of Keele. Compressed version published as "A Trojan Horse at the Tate: Theorizing the Museum as Agency and Structure," in Susan Macdonald and Gordon Fyfe, eds, *Theorizing Museums: Representing Identity and Diversity in a Changing World* (Cambridge, MA: Blackwell, 1996), 203–28.

57. "Whatever else was required of Victorian art, it had to be faithful to familiar human experience. In Ruskin's aesthetic this was a basic principle, never used to better purpose than in his opportune defense of the Pre-Raphaelites ... To convey its intended meaning to people—people in general, not connoisseurs—art must renounce tired stereotypes and conventions and speak the language of fresh, everyday observation and experience, which is the indispensable bond of communication between artist and audience." Waldfogel, "Narrative Painting," 163. For an extended discussion of the emphasis on narrative in the interpretive strategies used in museum guidebooks, see Woodson-Boulton, *Temples of Art in Cities of Industry*, especially Chapter 6.

58. As Melvin Waldfogel writes, narrative painting was appreciated by an "extremely large" public: "Queen Victoria and Albert purchased them, as did many aristocrats; Ruskin approved of them; and they were admired and enjoyed uncritically by virtually the entire middle class." Waldfogel, "Narrative Painting," 163.

59. Edward T. Cook, *A Popular Handbook to the National Gallery, Vol. 2* (London: Macmillan & Co., 1888), 387–90.

60. Cook, *A Popular Handbook to the National Gallery*, 390.

61. Cook, *A Popular Handbook to the National Gallery*, 391.

62. According to a letter from that summer, this was Titian's "Danae"; see Manchester City Art Gallery (hereafter MCAG) Archives Art Gallery Committee (hereafter AGC) Minutes Volume I, June 30, 1892, 88.

63. Purchase approved in Art Gallery Committee Minutes, MCAG Archives AGC Minutes Volume I, December 29, 1892, 111–12.

64. *Fors Clavigera*, vol. v, 310, quoted in Howard Swan, *Preliminary Catalogue of the St. George's Museum, Walkley, Sheffield ... Compiled by Howard Swan* (Sheffield: W.D. Spalding, 1888), 6–7.

65. Oscar Wilde, "The Decay of Lying," in *Oscar Wilde: the Major Works*, edited by Isobel Murray (Oxford: Oxford University Press, 2000), 215–39.

From will to wallpaper: imaging and imagining the natural in the domestic interiors of the Art Nouveau

Amy Catania Kulper

Preserved in the archives of the Belgian art nouveau architect, Victor Horta, is a receipt, signed by his nemesis Henry van de Velde in 1897 for the seemingly innocuous purchase of English wallpaper.[1] For Horta, this inconsequential document became indicting evidence, proof that his rival was not the great architect the public believed him to be, but rather, a glorified "decorator." It would be easy to dismiss this anecdote as the jealous ranting of a creative personality, or to position this incident as an important precursor to the twentieth-century high culture/pop culture divide, but I believe that something more substantive was at stake for Horta in this critique.

There is little question that by the close of the nineteenth century, wallpaper had captured the bourgeois imagination and polarized public opinion. However, for Horta, the issue raised by wallpaper was neither fashion nor décor, it was the appropriate representation of the natural. Throughout the nineteenth century, there was a marked shift in the conceptualization of the natural. If, with the eighteenth-century ruminations of Kant, nature was rendered a polemical concept and thereafter conceived of as a reflection of the mind, then with the nineteenth-century speculation of figures like Schopenhauer, Nietzsche, and Riegl, the natural ceased to be affiliated with man's rational mind and came to be equated with his capricious will.[2] For Horta, nineteenth-century wallpaper clung, quite literally, to outmoded representations of the natural; it was incapable of the volitional, emergent concept of nature that was essential to the art nouveau aesthetic.

A critical ingredient in this account of art nouveau wallpaper is the pejorative connotation of the decorative that is both specific to the history of wallpaper and an implicit bias of the nineteenth-century European cultural milieu. As far back as the seventeenth century, waste paper was commonly used in the production of decorative papers, which were printed on the reverse side of

unwanted documents or banned literature in a process called "damasking." A compelling example of this practice is found in a letter written by the Bishop of London to the Stationers Company in 1673, authorizing them to damask or obliterate banned copies of Hobbes's *Leviathan*.[3] The practice of damasking establishes a critical precedent to the architectural discourse on décor in which the decorative is actively engaged in the repression of content, and contributes to an evolving cultural consensus that the decorative is the very antithesis of the meaningful. Wallpaper detaches ornament from its situational role of mediating and communicating meaning. Ornament, once engaged in the articulation of spatial decorum and character, is emancipated and relegated to a paper-thin veneer that can be universally applied.[4] Wallpaper's emancipation from meaningful ornament is a purging of its ethical content in which decorum and character, subject to the whims of individual choice and personal taste, become décor and style.[5]

There are two prominent trajectories for depicting natural motifs in nineteenth-century wallpaper. The first is pictorial and is firmly rooted in the tradition of the picturesque garden. These scenic wallpapers appropriated the natural as a picture or sanitized scene, much as a picturesque traveler might do with a "Claude-glass" (see below). The second trajectory is taxonomic and traces its lineage to the botanical garden and the conceptualization of the natural as a classification of reified, and minutely differentiated, objects. This inquiry will examine these trajectories and their Kantian foundation, and compare them to the conceptualization of nature as capricious will embodied in the writings of Schopenhauer, Nietzsche, and Riegl as well as in the murals of Horta's domestic interiors.

In his formulation of the thing-in-itself (*Ding an sich*) in *The Critique of Pure Reason* of 1781, Kant rendered nature a polemical concept.[6] For Kant, the thing-in–itself, the essence behind the appearance, is the thinking ego or man's rational nature. With the designation of the thing-in-itself, matter and space are relegated to the realm of mere appearances, behind which lurks the hegemony of the rational mind. When nature is conceived as a mere reflection of the mind, when it becomes a contingency of human reason, it is at once subject to the rational ordering principles of taxonomic schemas and appropriated as an individual perspective. Thus, the foundation for the taxonomic and picturesque renditions of the natural found in nineteenth-century wallpaper resides in the Kantian formulation of the thing-in-itself.

From this moment in the eighteenth century, one can trace two parallel trajectories for the representation of the natural in nineteenth century wallpaper: the first trajectory is pictorial; the second is taxonomic. The pictorial trajectory begins with the eighteenth-century phenomenon of the picturesque, described by garden historian John Dixon Hunt as follows:

By the end of the eighteenth century the picturesque had become another example of how humans came to accommodate potentially unprepossessing scenery. The physical

world could be seen more pleasantly, occupied and visited more safely, if it were thought of as a painting … . William Gilpin, the great popularizer of this picturesque mode, helped his readers to travel and look at the various parts of Great Britain as if its various topographies were safely pictorialized; the world "out there" … was turned into "landscapes" or "scenery." Both of which terms, by alluding respectively to paintings and theatrical sets, announced the safe and sanitized nature of the picturesque vision.[7]

This picturesque categorization of the natural in terms of landscape or scenery was predicated upon a model of subjective appropriation embodied in the practices of the Claude-glass. Named after the painter Claude Lorraine, though never used by him, the Claude-glass was a small convex mirror employed to capture the natural world *as a picture*.[8] In order to further personalize or customize this picture of the natural world, tinted lenses could be selected and combined *au choix*.[9] The Claude-glass played a pivotal role in the privatization of the natural world and the formation of the concept of inner nature. As Hunt writes, "There is … the exquisite solitariness, the privacy of the glass, into which a large scene was gathered by the slightly convex surface of the mirror … This private occupation would have been further emphasized by the necessity for … [the viewer] to turn his back upon the scene to be viewed in his glass."[10] To eschew the natural world in favor of such a personally appropriated picture of nature, a picture that is customized to one's own taste, became a primary agenda for representing the natural in the wallpaper of nineteenth-century domestic interiors.

A critical juncture in the translation of this picturesque precedent into the domestic interior is the folding screen. In European interiors of the early eighteenth century, it was common to decorate upholstered screens with a selection of large-scale colored engravings, chosen for their harmony as an ensemble. Once again, the images were selected based on the criterion of individual taste and, in most cases, their ability to synthesize with the desired décor. By the end of the century, these folding screens depicted a continuous picture, each leaf covered by a single width of textile or paper that, seen collectively, consolidated into a single image. Consistent with the personal choice of the view and the colored lens in the Claude-glass, some of these screens could be rearranged to produce numerous customized pictorial variations.

The early nineteenth century witnessed the emergence of scenic or panoramic wallpaper. The original names for these wallpapers, *papiers peints-paysages* (landscape wallpapers) or *tableaux-tentures* (paintings as wall-hangings), allude to the picturesque heritage of pictorializing the natural as "landscapes" or "scenery." Like the Claude-glass in the picturesque garden, panoramic wallpapers involve the individual appropriation of the natural, an act governed largely by choice and personal taste. Many of these wallpapers simply capture scenes from picturesque gardens and import them into the domestic interior. This peculiar tautology of nature conceptualized as picture, implemented in the form of a garden, and then represented as picture in the

guise of panoramic wallpaper illustrates the degree to which such sanitized pictures of nature are indifferent to their particular situations. If the very act of capturing the natural landscape on a tinted mirror is a form of domestication, then rendering these images on panoramic wallpapers simply carries this process to its logical conclusion.

Thematically, many panoramic wallpapers represented natural locales that were both exotic and primitive. If the idea of travel and doing the grand tour was central to the proper Enlightenment education, then in the nineteenth century, this sort of cultivation could take place in the comfort of one's own domestic environment. Just as style played a critical role in the elicited effect of a garden folly, panoramic wallpapers relegated architectural style to the surface. However, the subject matter of panoramic wallpapers extended far beyond the exotic, bucolic and pastoral nature of its picturesque predecessors. Images of urban industrialization and scenes from everyday life stray from the standard themes of the picturesque, yet receive the same sanitized pictorial treatment. A common practice in many picturesque gardens was to borrow scenery from adjacent properties, visually appropriating monuments outside of the boundaries of the garden proper. Like a *capriccio*, panoramic wallpapers also appropriated significant cultural artifacts. For example, Dufour produced wallpaper immortalizing the various monuments of Paris. The individual appropriation of the natural found its corollary in the recounting of history as personal history. Thus, many of the panoramic wallpapers commemorated heroic acts of significant historical agents. Here, simply imagine a bourgeois salon decorated with wallpaper dedicated to the important battles of the Duke of Wellington. The problematic legacy of the Kantian thing-in-itself is that it made reality a contingency of the individual worldview. The picturesque, in its propensity to represent the world as a sanitized picture, clearly belongs to this legacy.

A panoramic wallpaper, commemorating the Great Exhibition of 1851 (Figure 8.1), is the ideal segue from the picturesque to the taxonomic representation of the natural world, both of which have a foundation in the Kantian thing-in-itself. The Great Exhibition demonstrated that the ongoing classification of the natural world found a parallel enterprise in the taxonomy of culture, and nowhere was this more evident than in the production of wallpaper.[11] This leads to the second trajectory of wallpaper's appropriation of the natural world, the taxonomic trajectory. This trajectory begins with the advent of botanical gardens in the sixteenth and seventeenth centuries. Also known as "scientific gardens," botanical gardens were devoted to the cultivation of medicinal herbs and the collection of New World plant specimens, rigorously arranged according to genus and species. Consistent with the belief that the natural world is an aggregate of distinct, intelligible entities subject to the organization of the rational mind, this practice of

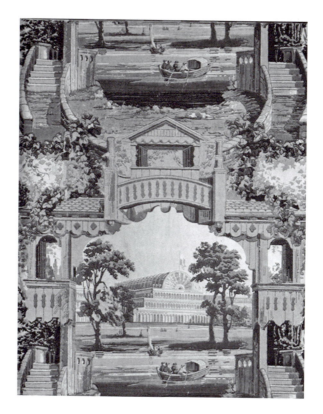

8.1 The Crystal Palace Wallpaper—Heywood, Higginbotham & Smith (*c.* 1853–55). Reproduction courtesy of the Victoria and Albert Museum

collecting, naming, classifying, and describing specimens relegates the natural to the category of the taxonomic. The physical placement and organization of the plant species within the nineteenth-century botanical garden differed from its Renaissance and Baroque predecessors. As Lucia Tongiorgi Tomasi writes:

Even the flowerbed, one of the fundamental elements of the garden, underwent a change: complex polygonal and other geometric shapes gave way, in a gradual process of simplification, to rectangles laid out on a plan based on the cardinal points of a compass…very much in the way monastic gardens—also devoted largely to the cultivation of medicinal herbs—had been designed in medieval time. The square plan, subdivided into various sections, could be doubled in size, turning it into a rectangle if required, and was therefore easily adapted and extended.[12]

Within the design of botanical gardens, simple square or rectangular beds supplanted the assertion of individual and distinct geometric forms, with an eye towards repeatability, extension, and overall pattern.

The sixteenth-century model of botanical knowledge was largely based upon the local and particular understanding of a plant and its medicinal uses. However, with the constant influx of New World plant specimens in the seventeenth and eighteenth centuries, the search was on for universal taxonomies that would pertain ubiquitously.[13] One of the most notable taxonomies, by the Swedish naturalist Linnaeus, is *Systema Naturae* of 1735. Here, "flora" and "fauna" (both terms coined by Linnaeus) are organized into a taxonomy based upon sexual difference. Foucault describes the conceit of the Linnaean sexual taxonomy when he writes:

The structure selected to be the locus of pertinent identities and differences is what is termed the *character*. According to Linnaeus, the character should be composed of 'the most careful description of the fructification of the first species. All the other species of the genus are compared with the first, all discordant notes being eliminated; finally, after this process, the character emerges.' The system is arbitrary in its basis, since it deliberately ignores all differences and all identities not related to the selected structure.[14]

For Linnaeus, character is determined by the appearance or absence of certain morphological elements, in this case, the forms responsible for reproduction. Foucault, then, calls attention to Linnaeus's systematization of character, or the fact that character is now a product of strictly formal attributes.

Similarly, the taxonomy of wallpaper speaks to the systematization of architectural character. No longer is the character of the domestic interior determined by its specific situation, now it can be changed at whim through alteration of the surface appearance of the space (Figure 8.2). In a poster illustrating a wallpaper showroom in Cleveland, Ohio, an eager customer selects the décor for her home just as she would choose a new dress. The choices she examines are, from top to bottom, Adamesque, Rococo Revival, realistic floral, and art nouveau. The formal affinities that comprise a taxonomy's genus and species, have their corollary in the spectrum of possible styles, and the botanical naming conventions become forms of commercial seduction.

Linnaeus's "natural system" consisted of simple line drawings of plant specimens and the designation of popular names. His botanical renderings correspond to the practices of contemporary botany. In order to illustrate the verisimilitude and difference of a plant's sexual organs within a given genus and species, repetitive images of plant structures are used to facilitate the desired comparison (Figure 8.3). Thus, Linnaeus's botanical taxonomies anticipate and resonate with the patterned floral wallpapers of the eighteenth and nineteenth centuries: both propagate the aesthetic of the repeated image. In a typical example of eighteenth-century wallpaper, *Poppies and Birds* by De Fourcroy (Figure 8.4), the poppies are rendered with

8.2 A Showroom from a Poster Printed in Cleveland, Ohio (*c.* 1895–1900).
Reproduction courtesy of The Whitworth Gallery, The University of Manchester

the precision of a botanical taxonomy. Whereas the taxonomical image is repetitive for the sake of comparison, the repetition of the wallpaper image is integrally linked to the technique of its production. Before the invention

8.3 Illustrations from Linnaeus's *Systema Naturae* of 1748. Research Library, The Getty Research Institute, Los Angeles, California

of the continuous paper roll in 1799 and the industrial development of offset printing in the nineteenth century, wallpaper was produced through a process of block printing. In early wallpapers, this led to the repetition of the same motif from a single wood block, and in later wallpaper, more complex patterns were generated by the combination of several wood blocks. As a result, by the end of the nineteenth century, there were abundant examples of complex, repetitive block printed patterns.

If the currency of the botanical taxonomy is the plant specimen, then the currency of the wallpaper taxonomy is the sample. The wallpaper sample in the eighteenth century was both a vehicle for communication between a decorator and a client (much as it is today) and an advertising ploy used by various retailers. By the nineteenth century it was a common practice to bind these samples into a swatch or sample book (Figure 8.5). Sample books are evidence of the degree to which the décor of the nineteenth-century domestic interior was determined by personal taste and the production of the desired effect (Figure 8.6). This page of a sample book compiled by the decorators Crace & Co., for the home of a Sergeant-at-Arms, contains several samples of paper designed by Pugin between 1851 and 1854. The

8.4 *Poppies and Birds* by De Fourcroy (*c.* 1700). Reproduction courtesy of the Musée des Arts Dècoratifs, Paris

page includes dates, inventory details, wallpaper samples, and the name of the designated room for each. The taxonomy of wallpaper embodied in the sample book speaks to the systematization of architectural character. No longer is the character of the domestic interior determined by its specific situation, now it can be changed at whim through an alteration of the surface of the space.

If wallpaper production in the nineteenth century belongs to taxonomic and picturesque manifestations of the natural, then it is critical to consider the other prevalent representation of the natural in this period. Fueled by the philosophical writings of Schopenhauer and Nietzsche, the art historical ruminations of Riegl, and vitalist tendencies in biology and religion, this emerging concept of the natural was no longer synonymous with man's reason, but rather with his capricious will.

8.5 Wallpaper Sample Book by Jones & Bolles of Hartford (1821–28). Reproduction courtesy of Old Sturbridge Village

Arthur Schopenhauer was preoccupied with Kant's idea of the thing-in-itself, in his text *The World as Will and Representation* of 1819, he argued that the thing-in-itself is the will, which is an identical force in nature as it is in man. The world is the representation of that will:

But only the *will* is *thing-in-itself*; as such it is not representation at all, but *toto genere* different therefrom. It is that of which all representation, all object, is the phenomenon, the visibility, the *objectivity*. It is the innermost essence, the kernel, of every particular thing and also of the whole. It appears in every blindly acting force of nature, and also in the deliberate conduct of man, and the great difference between the two concerns only the degree of manifestation, not the inner nature of what is manifested.[15]

If, prior to Romanticism, art had a mimetic function as the mirror of nature, then Schopenhauer took the subjectivity of the Kantian thing-in-itself to its expressive extreme, and posited the world as the mirror of man's inner nature, of his will. He argued: "As the will is the thing-in-itself, the inner content, the essence of the world, but life, the visible world, the phenomenon, is only the mirror of the will, this world will accompany the will as inseparably as the body is accompanied by its shadow; and if will exists, then life, the world, will exist."[16] With this shift from inner nature as reason to inner nature as will, form is de-emphasized, and an interest in morphogenesis, or the emergence of form, takes its place. For

8.6 Pugin Wallpapers for the Palace of Westminster (*c.* 1851–54). Reproduction courtesy of the Victoria and Albert Museum

Schopenhauer, the will is sheer unadulterated action, whether manifested in the "blindly acting force of nature" or the "deliberate conduct of man," and by its very existence, it privileges the emergent over the static: "Eternal becoming, endless flux, belong to the revelation of the essential nature of the will."[17] The capricious nature of Schopenhauer's formulation of a world whose very existence is contingent upon the subjective whim of the will is mitigated by the fact that this *will* is not a *free will*. He claims that the decision-making process is achieved "with just as free a will ... as if water spoke to itself; 'I can make high waves ... I can rush down hill ... I can plunge down foaming and gushing ... I can rise freely as a stream of water in the air (... in the fountain) ... but I am doing none of these things now, and am voluntarily remaining quiet and clear in the reflecting pond.'"[18] The premise of voluntary inaction in Schopenhauer's analogy belongs to an extensive metaphysical tradition that conceptualizes culture and nature in terms of the voluntary and the involuntary, or freedom and necessity. In this tradition, any expression of will is also a negotiation with

necessity—water has the inherent capacity to make waves, but rarely in the restrictive context of the reflecting pool.

Like Schopenhauer, Nietzsche likens the will to a force, but Nietzsche finds it necessary to distinguish the inner will, the will possessed by man, and so he designates it the *will to power*:

The victorious concept *force*, by means of which our physicists have created God and the world, still needs to be completed: an inner will must be ascribed to it, which I designate as *will to power*, i.e., as an insatiable desire to manifest power; or as the employment and exercise of power, as a creative drive, etc.[19]

Also like Schopenhauer, Nietzsche's will to power is an expression of the hegemony of man's inner nature over the external world. In fact, Nietzsche criticizes Darwin for overestimating the influence of "external circumstances" and advocates an inverted world in which external conditions are increasingly dictated by the interiority of the will: "Life is not the adaptation of inner circumstances to outer ones, but will to power, which, working from within, incorporates and subdues more and more of that which is *outside*."[20]

While the philosophies of Schopenhauer and Nietzsche demonstrate the consanguinity of the creative force of the will in nature and human nature, there was a concurrent tendency to project the will into the domain of objects, both animate and inanimate. A number of factors contributed to this development, including the Romantic propensity for pantheism, vitalism in biological and philosophical discourse, and a movement in German aesthetics known as empathy theory. From the German word *Einfühlung*, literally "in-feeling," the aesthetics of empathy was primarily concerned with the problem of emotional projection and was instrumental in Alois Riegl's art historical formulation of the concept of *Kunstwollen*. For Riegl, the *Kunstwollen*, or artistic will, attempted to place the will in the service of recovering something more essential or more fundamental about the work of art. In Riegl's writings, art historical inquiry is reframed in terms of the will to make art. As Christopher Wood writes:

As the basic unit of art history Riegl proposed not the work of art, but the drive to make art, the ineradicable impulse to design and figuration that he named the *Kunstwollen*. He left the work of art behind by burrowing deeper into it, below the technologies of illusionism, below the level of content, below style to this fundamental level of figuration where the maker had carried out some primal negotiation with space-time and the material conditions of existence.[21]

Clearly, Riegl's refocusing of art historical interest in the drive to make art, belongs to the ideational lineage of Schopenhauer who eschewed form while embracing morphogenesis. The idea of the artistic will as something prior—prior to material choice, prior to selected technique—establishes the

Kunstwollen as a creative fundament that has its counterpart in the natural world. Riegl writes: "in every period there is only *one* orientation of the *Kunstwollen* governing all four types of plastic art in the same measure, turning to its own ends every conceivable practical purpose and raw material, and always and of its own accord selecting the most appropriate technique for the intended work of art."[22] If nature is indeed a polemical concept, as Hans-Georg Gadamer claims, then the *Kunstwollen* brings a trace of determinism to the idea of a volitional immanent nature. Thus, in the ideational trajectory from Kant, to Schopenhauer, to Nietzsche, to Riegl, we witness the shift from nature conceptualized as rational, logical, systematic and discursive to nature theorized as volitional, capricious, emergent, and generative.

It is precisely in this transition from rational to volitional concepts of the natural, that Horta's condemnation of Van de Velde's use of wallpaper should be positioned. For Horta, the industrial production of wallpaper represents a betrayal of the principles of the art nouveau, a movement whose primary ambition is to represent generative, emergent, volitional nature. It is for this reason that Horta eschews the use of wallpaper in the primary topography of his houses, opting instead for site-specific murals.[23] However, Horta does not entirely escape taxonomic or picturesque representations of the natural world. One can find examples of classificatory thinking in Horta's work, as evidenced by archival drawings illustrating the taxonomy of door hardware used in his various houses, or the repetitious and almost indiscriminate use of similar ornamental motifs in vastly different circumstances in his body of work. And while he manages to avoid any obvious references to the picturesque, his window and mirror designs suggest that he would rather pictorialize the generative nature of his own designs than frame nature as it exists outside of the domestic interior.[24]

There is a situational specificity to Horta's use of murals. They respond to the program of the designated space, the overall grammar of ornament of his architecture, and the content orientation of the desired experience. Three examples of murals from Horta's Hôtel Tassel (1893–97) illustrate the situational specificity of murals in his domestic work and demonstrate the full representational spectrum of nature conceptualized as volitional, generative, and emergent.

Working from the most encumbered instances of generative nature to the most emancipated, the winter garden mural (Figure 8.7) represents a reified, rational, and repetitive immanent nature that may have emergent aspirations, but ultimately capitulates to the conditions of containment and cultivation of the domestic interior. The mural depicts a sinuous vine-like botanical structure repeated as if it were a wallpaper motif. The choice of a repetitive natural motif for the winter garden suggests that the mural is specific to the program of the space. The winter garden was a place of repose for displaying the owner's collection of exotic curiosities. Consistent with

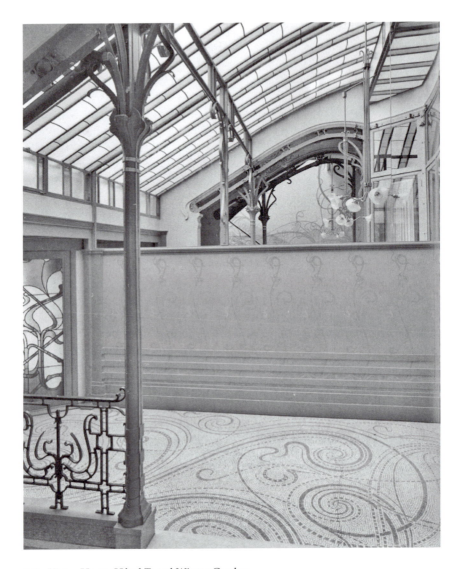

8.7 Victor Horta, Hôtel Tassel Winter Garden.
Photograph by Alistair Carew-Cox

the reification of the natural that is part and parcel of the nineteenth-century culture of collecting, the choice of a repeated, wallpaper-like motif for the mural intimates a level of programmatic specificity. While the vines in this mural appear to represent movement and growth, their repetition and the precise containment of their figure within the confines of the eye-level-height wall, indicate that the immanent nature being represented is dictated by the vicissitudes of local necessity. A winter garden is the embodiment of

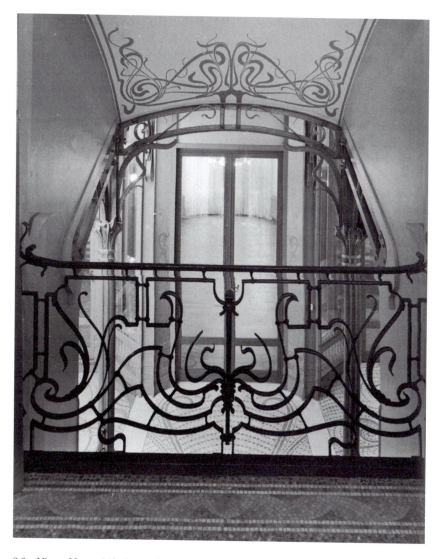

8.8 Victor Horta, Hôtel Tassel, Mezzanine Balustrade Looking Down to Salon.
Photograph by Alistair Carew-Cox

a delicate moment of equipoise, balancing the generative and the static, the wild and the domesticated, the unwieldy and the manicured dimensions of the natural world. That Horta's winter garden mural approximates the repetitive patterns of the wallpaper suggests that in this specific place, he is interested in visually manicuring, domesticating, and taming this generative immanent nature until it succumbs to the demands of ongoing confinement and interiority.

In another site-specific mural (Figure 8.8), this one occupying a curved soffit that connects the mezzanine balcony to the salon below, the balustrade rotates to accommodate magic lantern projections, and thus the space is, programmatically, a space for illusions.[25] Horta's mural also engages in the production of illusion. Rendered in the same color as the ironwork of the ground floor structural system, this mural propagates the illusion of a seamless transition from three-dimensional structure to two-dimensional decoration. Without the benefit of an indeterminate zone of transition as, for example, with the *rocaille* of Bavarian Rococo architecture, one ornamental logic abuts another in a stark juxtaposition of the pictorial and the spatial, the abstract and the concrete, the illusory and the real. The ornament of the mural becomes frame, imitating and completing the logic of the structural system below, while programmatically anticipating the frame, both implied and actual, of the magic lantern projection. Located on the literal threshold between photographic and architectural illusion, between ornament and structure, this mural speaks not only to the stark juxtaposition of the two enterprises, but suggests a potentially seamless continuity between the beautiful and the useful.

Finally, the mural occupying the main stairwell deserves consideration (Figure 8.9). Responding to the programmatic specificity of a stairwell, a place of movement and ascension, and a locus of the mobilized viewer, this mural has a generative inner nature that seems to resist pictorial capture. The content orientation of the mural reflects the thematic topography of the house, which moves from the dark, compressed cavernous space of the entry vestibule to the light, extended and ethereal space of the first floor landing. This metaphorical movement from earth to sky, and from darkness to light, is depicted in the mural's transitions of coloration, density, and materiality, as the tendrils that extend to the upper landing seem almost to dissolve or dematerialize in the intense light.

Thus, for Horta, wallpaper de-situates ornament. It has the capacity to rip ornament from its intimate dialogue between spatial setting and occupant, making universal claims instead. It is predicated upon the belief that this wallpaper will confer this style, or catalyze this décor, regardless, or even in spite of, its spatial situation. With his strategic deployment of murals, Horta is attempting both to situate ornament and to reinvigorate the dialogue between ornament and its spatial environment through his use of vital, generative, and emergent natural motifs. Seen collectively, these three murals represent varying gradations of generative nature relative to the spectrum of necessity and freedom. None is a product, solely, of the demands of necessity or the liberties of freedom, but rather each embodies a negotiation between these competing extremes. Their site specificity, the degree to which they successfully negotiate with the requirements of program, ornamental grammar, and content orientation,

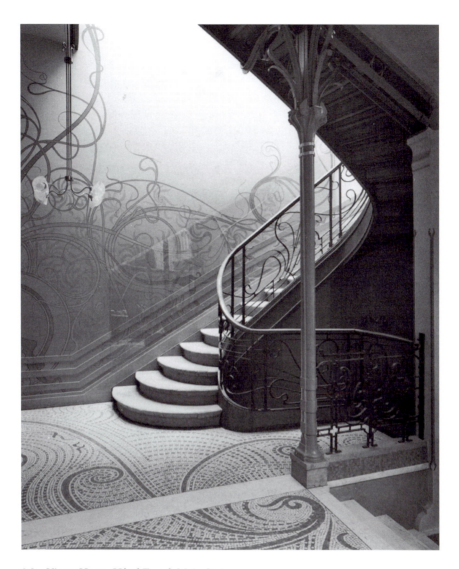

8.9 Victor Horta, Hôtel Tassel, Main Stair.
Photograph by Alistair Carew-Cox

suggests that the generative nature that they represent belongs to the reciprocity of necessity and freedom, and the continuity of experience that resides in that reciprocity. Thus, Horta's choice to deploy site-specific murals in his domestic interiors, rather than the universally applicable wallpaper brandished by many of his contemporaries, reflects a desire to access and reveal the ontology of the natural world that is the foundation of his generative natural motifs.

In a preparatory manuscript entitled *Anatomy Course* for a class he was invited to teach at the Academy, Horta recounts an Asian tale that had a tremendous impact on his representational thinking. He tells the story of an animal illustrator who repeatedly painted images of a wild boar, and then showed these images to trappers to get their impressions. Again and again, the trappers conclude that the artist had painted an image of a dead wild boar, and frustrated, the artist would return to his task and produce another image. Finally, one day, the trappers concluded that the artist had painted a sleeping wild boar, and the artist was completely elated by his success. Upon recounting this tale, Horta concluded:

I confess that few stories ... have showed me the importance, the great importance, of patience and of the strenuous labor which an artist must perform before he is the master of nature, nature, whose face is infinitely varied. Since then I have studied the life, the sleep and the death of plants, animals and people, with keen interest. How much my vision has been broadened, I could not say. From leaves newly unfurled, and growing into maturity, to those encountered in full bloom, scorched by the ardor of the sun in high August, to the same leaves dead of old age in October; from the leaves of dawn to those of noon, of sunset, and of night. I have studied all their countenances with an interest which, unfortunately, my schedule is chary of letting me fulfill. In such a way have I studied a few animals, a few too rare human characters. And always, in proportion as I observe, the nature before me opens more widely: my own life has taken on all the more interest.[26]

Horta's interest in this tale resides in the affirmation of the intersection and complicity of lived experience (that of the trappers) and aesthetic experience (that of the illustrator).[27] The dialogue between experience that is acquired, practiced and routine and that which is appropriated as style, appearance, décor and fashion was a preoccupation of Horta's domestic architecture. Horta's critique of Van de Velde's use of wallpaper resides in this distinction. For Horta, wallpaper can only propagate aesthetic experience; it is not able to tap into the depths of lived experience. The illustrator, conversant in the world of appearances, consulted the trappers for their expertise in the behavior of the wild boar. For Horta, it is only through an interrogation of the *behavior* of the natural world that the art nouveau could claim to be an authentic style, rather than historicism's last gasp. If architects merely represent the *appearance* of nature in their work, then, for Horta, they are forever after relegated to the category of dead *bores*.

Notes

1. Cécile Dulière, *Victor Horta: Mémoires* (Bruxelles: Atelier Vokaer, 1985), xii.

2. The second half of Hannah Arendt's seminal text, *The Life of the Mind*, takes up the transformation of metaphors of the mind from rational to volitional models, and the fashioning of inner nature in this article is indebted to the contours of her argument. See Hannah Arendt, *The Life of the Mind* (New York: Harcourt Brace & Company).

3. François Teynac, Pierre Nolot, and Jena-Denis Vivien, *Wallpaper: A History* (New York: Rizzoli International Publications, Inc., 1981), 21.

4. In his essay "The Work of Art in the Age of Mechanical Reproduction," Walter Benjamin writes: "One might subsume the eliminated element in the term "aura" and go on to say: that which withers in the age of mechanical reproduction is the aura of the work of art … . One might generalize by saying: the technique of reproduction detaches the reproduced object from the domain of tradition. By making many reproductions it substitutes a plurality of copies for a unique existence." Though my argument will assert that it is the ethical content of the spatial situation that is lost with the advent of mechanically produced wallpaper rather than its "aura," my interest in the role of the technique of reproduction in detaching wallpaper from the decorum of spatial settings is consistent with Benjamin's argument.

5. Dalibor Vesely, "Architecture and the Poetics of Representation," *Daidalos*, 25 (September (1987): 28. In this essay Dalibor Vesely describes architectural discourse's migration towards the realm of appearances in terms of the transition from *decorum* to *décor*. In other contexts, decorum refers to one's ability to act appropriately in a given situation, and Vesely argues that this ethical content also belongs to architectural decorum. Vesely describes architectural character as follows: "In *character* we can see quite clearly a tendency to move towards the surface of the building, an interior or a garden, towards the experience of appearances … ." In this shift towards appearances decorum, with the help of technique, loses its situation, its tradition, and its ethical content, and becomes décor.

6. Here, I am borrowing the notion of nature as a polemical concept from Hans-Georg Gadamer. In *Truth and Method*, Gadamer states that since the time of Rousseau (and here I would add Kant by extension): "As the counterpart of the mind, as the non-I, nature became a polemical concept, and as such it has none of the universal ontological dignity possessed by the cosmos, the order of beautiful things." See: Hans-Georg Gadamer, *Truth and Method* (London: Sheed & Ward, 1989), 480.

7. John Dixon Hunt, *Gardens and the Picturesque* (Cambridge: MIT Press, 1992), 5.

8. Hunt, *Gardens and the Picturesque*, 174.

9. Hunt, *Gardens and the Picturesque*, 175.

10. Hunt, *Gardens and the Picturesque*, 175–8.

11. For a discussion of the parallel processes of natural classification and cultural taxonomy see, Amy Catania Kulper, "Of Stylized Species and Specious Styles," *The Journal of Architecture*, 11, n. 4 (September 2006): 391–406.

12. Lucia Tongiorgi Tomasi, "Botanical Gardens of the Sixteenth and Seventeenth Centuries," in *The Architecture of Western Gardens*, ed., Monique Mosser and Georges Teyssot (Cambridge: MIT Press, 1991), 81.

13. Londa Schiebinger, "Gender and Natural History," in *Cultures of Natural History*, ed., N. Jardine, J.A. Secord, and E.C. Spary (Cambridge: Cambridge University Press, 1996), 171.

14. Michel Foucault, *The Order of Things: An Archeology of the Human Sciences* (New York: Vintage Books, 1970), 140.

15. Arthur Schopenhauer, *The World as Will and Representation*, trans. E.F.J. Payne, vol. one (New York: Dover Publications, Inc., 1969), 110.

16. Schopenhauer, *The World as Will and Representation*, volume one, 275.

17. Schopenhauer, *The World as Will and Representation*, volume one, 164.

18. Arendt, *The Life of the Mind*, Book Two, 24.

19. Friedrich Nietzsche, *The Will to Power*, ed., Walter Kaufmann, trans. Walter Kaufmann and R.J. Hollingdale (New York: Vintage Books, 1968), 332–3, no. 619.

20. Nietzsche, *The Will to Power*, 361, no. 681.

21. Christopher S. Wood, ed., *The Vienna School Reader: Politics and Art Historical Method in the 1930s* (New York: Zone Books, 2000), 26.

22. Wood, ed., *The Vienna School Reader*, 94–5.

23. Horta did, in fact, use wallpaper in the ancillary spaces in a number of his domestic projects. In the primary topographies of his houses, and here I am referring to the sequences beginning with

dark, chthonic entry vestibules, extending to elaborate main stairs, and culminating in spectacular laylights and mirrors, Horta exclusively deployed site-specific murals.

24. For an architect purportedly interested in the representation of the natural world, Horta's archive boasts very few site plans. This suggests that pictorializing what lay beyond the building envelope could not sate his interest in emergent and generative nature, nor could it be satisfied through the manicure or stewardship of existing natural conditions.

25. Horta's client, Emile Tassel, was a professor of descriptive geometry with a passionate interest in optics and photography. The inclusion of the magic lantern mount in the program of the house served the social function of entertaining Professor Tassel's guests, while simultaneously fueling his personal fascination with photography.

26. Yolande Oostens-Wittamer, *Victor Horta: L'Hôtel Solvay* (Louvain-La-Neuve: Institut Supérieur D'Archéologie et D'Histoire de L'Art, 1980), 248.

27. There is an etymological shift in both the German and French languages in the nineteenth century that acknowledges the advent of aesthetic experience. In the 1870s, *Erlebnis* emerged as a new term for aesthetic experience in the German language, a connotation that differentiated itself from the sense of acquired or lived experience embodied in the term *Erfahrung*. In French, the term *expérience*, in the sense of scientific experimentation, emerged at the close of the sixteenth century and by the beginning of the nineteenth century, this connotation eclipsed the word's original meaning of acquired experience. In both cases, experience "has been subject to an epistemological schematization … that truncates its original meaning." See Hans-Georg Gadamer, *Truth and Method* (London: Sheed & Ward, 1989), 346. See also *Dictionnaire Nationel Où Dictionnaire Universel De La Langue Française, Dix-Septième Édition*, vol. I (Paris: Garnier Frères, 1879).

Pissarro's crowds: cityscape as wish image

Katherine Hover-Smoot

I firmly believe that our ideas, permeated with anarchist philosophy, influence our works, and from that moment, they are antipathetic to current ideas.[1]

<div align="right">Camille Pissarro</div>

I'm at the end of my rope ... I've had enough of this depressing art, this exacting, stupid painting which takes so much attention and reflection. It's too serious. By now, seeing and feeling should be easy and enjoyable. Besides, what good is art? Can it be eaten? No. Oh well.[2]

<div align="right">Camille Pissarro</div>

Magellan sails, Fourier Soars.
The frivolous and ironical crowd
Sees nothing in their dreams[3]

<div align="center">Victor Hugo</div>

For Hugo, Fourier's dreams—dreams that were unflinchingly and maddeningly utopian—remained beyond the purview of Pissarro's workaday concerns and melancholic resignation. Yet underpinning Pissarro's early, clipped forbearance was an anxious tone: if Fourier's dreams had gone unrealized by the end of the century, then Pissarro's rhetoric of the 1890s signaled a desire to recuperate the visibility and capacity of such utopic gestures, to render them in a way that Hugo's "ironical crowd" would grasp not only their form, but also their power and immediacy. For the "seeing and feeling" of Pissarro's painting was a fraught process precisely because what was "good" in art was its material ability to register (*se déteindre*) the inflections of individual perception. That Pissarro's characteristic political bravado and pictorial uncertainty were necessarily *reciprocal* and productive strands in his career, however, is often neglected in favor of a reductive, teleological view of Pissarro's trajectory that moves with ease from the lean 1870s to the solidly commercial 1890s.[4] It is not that such characterizations are inaccurate—rather they are strategic, providing a structure for Pissarro's works and words that undeniably ran the gamut. But I want to propose that

the scale was a lateral and permeable set of convictions that shifted and abraded against one another, rather than a progressive series of "isms" or influences. When Pissarro's words alone are used to measure his political and pictorial gambits, the complexities of his practice remain roughly sketched and the dialogic nature of his investments underdeveloped; indeed it has been precisely this coterminality that has proved difficult to maintain in the face of the late series paintings.[5] Given little critical play in the oeuvre, this urban coda has been considered, instead, as a marker of Pissarro's gradual acquiescence to the gallery/cash nexus of the late nineteenth century.[6]

This chapter attends to the need for an aesthetic and political reexamination of Pissarro's late cityscapes by focusing on three paintings Pissarro produced in 1897 of the Boulevard Montmartre during carnival (Figures 9.1, 9.2, 9.3). For if recently there has been a renewed interest in the series paintings, then the questions asked of Pissarro's late work have remained superficial. Indeed, I want to turn from asking whether these paintings mark a departure from, or an attenuation of, Pissarro's previous work—and contingently (and certainly more tendentiously) his anarchist politics; the answers are, of course, yes *and* no.[7] Rather, I want to pressure how Pissarro's series paintings negotiate personal and public histories, histories that were preeminently national, political, and as this chapter will argue, revolutionary, in the final decade of the nineteenth century. By examining Pissarro's sub-series of the Boulevard Montmartre, then, it will become clear that Pissarro proposed an imagery that was fundamentally more fragile than the "sunny" and "big" boulevards collectors preferred and Pissarro's dealer, Paul Durand-Ruel, requested.[8] Rather, the paintings of carnival imagine a moment of pre-modern anxieties, of subversion and transgression that runs counter to the licensed, festive gaiety that defined *fin-de-siècle* France. Foregrounding the presence of the crowd, Pissarro's paintings thus give way to a moment of upheaval and collective desire—a dream image of insurrection. The terms at play here—dream, collective, insurrection, and desire—signal their imbrication in Walter Benjamin's concept of the "wish image" (*Wunchbilder*).[9] Indeed Pissarro's paintings index their revolutionary potential by semantically and rhetorically crystallizing around Benjamin's notion, realizing (avant la lettre) Benjamin's dialectical "blasting" by nesting specters of revolution (crowd and carnival) into the commodity (the series painting).

Benjamin first defined the wish image in his 1935 draft of *Paris, Capital of the Nineteenth Century* as the material site through which the dreaming collective negotiated and mediated its revolutionary potential and utopian drives.[10] According to Benjamin, collective desires became visible when new technologies were articulated in a mythic vernacular, witnessing the coincidence of the present, the now of the instant, with an ur-past. For example, Benjamin speaks of iron taking on the shape of classical columns, or "wood as an archaic element in street construction."[11] As Benjamin puts it, "Corresponding to the form of the new means of production … are

images in the collective consciousness in which the new is permeated with the old."[12] More importantly, the material coincidence of the "new" and the "old" reveals a longing for collective actualization and a return to a "classless society" or "social utopia."[13] However, this "awakening" is hampered by "what [Ernst] Bloch recognizes as the darkness of the lived moment."[14] That is, the collective, in its inability to capitalize on the promise of new modes of production, grafts these forms onto a set of archaic-myth symbols in order to mediate the "redemptive" potential of the new.[15] Or, to put it more plainly, the sleeping collective is unable to dream of the future without telescoping it, to use Benjamin's phrasing, through the "elements of primal history."[16]

It was not, however, an entirely new concept, but borrowed—in a deft act of materialist *bricolage*—from Karl Marx's *The Eighteenth Brumaire of Louis Bonaparte*.[17] Benjamin's collective was farcical, although not yet tragic, precisely because it could not dream without mining past idioms. For Marx, this recurrence, a kind of recrudescence, of past language prevented social change: "The social revolution of the nineteenth century cannot draw its poetry from the past, but only from the future. It cannot begin with itself before it has stripped off all superstition in regard to the past."[18] The words are ones with which Benjamin was surely familiar, but while Marx's tone is splenetic, Benjamin's is utopic.[19] To Benjamin's mind, the mediation of the new language by the "borrowed" language of the past *identified* the desire of the collective, a desire that he held was inevitable and revolutionary. In fact, it was the structure of the wish image, as a site that *presupposed* actualization, that became Theodor Adorno's main difficulty with the 1935 text. It was, he claimed, an "undialectical" schema, within which "lurk[ed] a deeply romantic element."[20] For Adorno, the wish image—an image he believed to be a dialectical image (successfully or not)—undermined the empiricism of Benjamin's project to write a primal history of the nineteenth century.[21] Nevertheless, Benjamin's wish image opened up a space within the structure of the commodity for symbolic subversion. The "new" contained the seeds of its own remaking, if only the collective could capitalize on them. It is precisely this concept of semantic negotiation and iteration, of revolution always suspended between the mythic and the instant, that has purchase on Pissarro's paintings of carnival.

I realize this detour from Pissarro to Benjamin has been abbreviated and dense. And indeed, the reader may be wondering what these webs of materialist theory have to do with Pissarro painting carnival in 1897. The concern is not without merit, so allow me to clarify the argument by returning squarely to the question of Pissarro's series paintings. As already noted, Pissarro's involvement—it is often given an air of collusion—in the dealer system has given license to view the series paintings as legible and commercial.[22] These interpretations translate into an unthreatening proposal for painting, an almost un-modern[23] (or maybe ur-modern) transparency between Pissarro's subject matter and Durand-Ruel's desires, between legibility and consumption. This

chapter will argue instead that Pissarro's depiction of carnival, as an ur-old repertoire of festivity, has been grafted onto the emergent taxonomic anxieties surrounding the figure of the crowd in late-nineteenth-century France. Moreover, this action—one of "telescoping the past through the present," to reintroduce Benjamin—signifies the Third Republic's concerns over the burgeoning repertoires of labor insurrection.[24] To negotiate such histories in painting places a "deliberate static" into the commercialized Montmartre series, thereby reiterating Pissarro's longstanding commitment to the power and relevancy of painting.[25] Indeed, if the introduction to the 1992 issue of *Apollo* devoted to Pissarro observed, "Pissarro's pictures, not his politics are the most fascinating thing about him,"[26] this chapter will argue for a conflation of these terms—even in the commercialized series paintings. Pissarro's paintings *were* his politics.[27] And it was this dictum that was still on the table; he was still fighting—by turns winning and loosing—at the end of the century.

To paint *fin-de-siècle* Paris meant dealing with the vicissitudes of a decade that was, as Susanna Barrows has written, "as beleaguered as it was belle."[28] And indeed, carnival as Pissarro would have seen it in 1897 was no exception to this trend of cultural fatigue.[29] By the end of decade, the state program of civic festivals had largely overrun the once local and extemporaneous tradition of carnival.[30] Complaints surfaced in *Le Petit Journal*, *Le Matin*, and *Le Temps* that carnival was not only rapidly loosing ground to competing festivals, but also that the breakdown of the Parisian *quartier* and the rise of leisure opportunities outside of the city were to blame for diminished attendances.[31] From this cottage industry of criticism, however, arose a polemical consensus that the state was the source of carnival's disfavor with the public. Cultural critic Louis Morin's concerns were paradigmatic: "it is scandalous that so much money produces so little art, and that one parades through town such examples of bad taste."[32]

Certainly bad taste was still at issue in 1897 when carnival, or *Boeuf Gras*, processed up the Boulevard Montmartre twice during the three-day long festivities.[33] That year, the *chariots* of carnival were a motley and phlegmatic bunch. Inclusive and vaguely patriotic, they ascribed to a unified format that consisted of a main *chariot* accompanied by a loose cortege of costumed "revelers" either on foot or on horseback. There were agricultural *chariots* with vegetables and fruits from the merchants of *Les Halles*, pigs and peasants atop the *chariot de la charcuterie*, potatoes from Normandy, and crêpes, sponsored by the patisseries of Paris.[34] It was, in a sense, a way of rehearsing national unity by displaying the *produits du terroir* as spectacles of consumption. Complex visual metaphors confirmed and encouraged oral and commercial impulses, but always so as to reaffirm the economic primacy of the capital. In this respect it resembled a mobile *Exhibition Universelle*, incorporating recent scientific discoveries—the x-ray had its own *chariot*—as well as national artistic endeavors—painting and music too were represented, sandwiched between the crêpes and the Japanese chrysanthemums. The entire elaborate

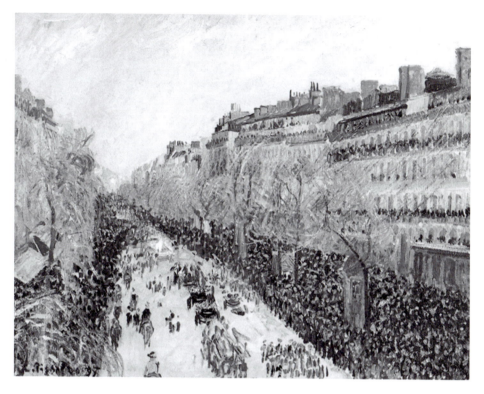

9.1 Camille Pissarro, *La Mi-Carême sur les Boulevards*, 64.9 × 80.1 cm, oil on canvas, 1897. Reproduction courtesy of the Fogg Art Museum, Harvard University, Cambridge

and spectacular procession was led by the traditionally crowned King of Carnival who rode on a steam-powered tricycle—he was both, modernity's masthead and effigy.

Humor aside, the integration of carnival into a system of regularized state festivals was a gamble that hoped to make legible an otherwise ludic tradition that had in the past been "messy and heterodox."[35] Such *chariots* visually and rhetorically scripted the semantic play of the carnival procession, removing the possibility of symbolic ad-libbing and subversive gestures. And yet, it is fair to ask whether this mitigated, modernized carnival—legible and controlled—is the festival of Pissarro's paintings? For Pissarro has given play, rather, to the extemporaneity of the crowd, the point at which, as Morin wrote at the end of the century, "[the parade] ceases to be a monotone procession, to become a joyous melee, at times even a little brutal."[36] If we take the most structured of the three paintings, the canvas now at the Fogg Museum (Figure 9.1), it becomes clear that Pissarro is pushing at the fragile limits of authorized festivity. Indeed, the painting has clear spatial

demarcations, with the parade participants and spectators firmly cordoned off from the street in the foreground and bounded on either side by the blocks of apartment buildings, while the procession itself is orderly, if highly caricatural. It is, however, caricatural to the point of dissolution, with mere wisps of paint indexing the bodies participating in the parade—just as the crowd is hinted at only by daubs of tan and streaks of black, built out of an armature of miniature snares, as if they were rents in the canvas. There is, in fact, a thematization of erasure in Pissarro's painting, with suggestion walking a fine line between figure and facture, parade and pictorialism. In the left foreground of the canvas this slippage is brought to a crisis. Here, the garlands attached to the trees have obscured the participants, winding into a network of greens, yellows, and reds that overlay and fragment the black strokes. And yet, the alternation of Pissarro's marks is not between the red and green of the garlands and the black of the participants, but between the garlands, the participants, and motes of blank, unpainted canvas. The sketchy, uneven cadence of paint moving from the thick swipe of green to the weave of the tan surface, and the repeated to-and-fro of such brushwork was a kind of limit towards which Pissarro had been pushing, and with whose borders he had been toying for many years.

It was a kind of illegibility, then, but it was not a new critical trope for Pissarro in the late 1890s, and as early as 1877, Ernest Fillonneau wrote, "M. Pissarro is becoming completely unintelligible … he is violent, hard, brutal."[37] Twenty years later, Pissarro was still toying with the possibility of pushing painting in all its "hardness" and "brutality" in the direction of abstraction. The built-up facture, the swaths of raised black giving way to depressions of white and cream, the cipher-figures on the balconies of the Haussmann's buildings, the nested visual regimes of participant and spectator, all speak the language of the urban modern, of the street. T.J. Clark's vim is contagious here, "The street, the street! How it rose like a phoenix out of Haussmann's fire … there was something like a crowd again and something like charm … even in old Pissarro's views from his hotel window."[38] I want to resist these modernist frenzies. Abstraction, yes, was on Pissarro's mind, and so too were the legacies of the street, legacies that were both political and pictorial; but that is not to say the Fogg canvas (Figure 9.1), is illegible, or even as "hard" or as "brutal" as the paintings from the 1870s. For objects are finely delimited: the sinewy tree limbs, the Morris columns, the stony facades of the apartment buildings—these are the solid, material, *definable* structures in the painting. They are also, however, the least *painted*. The weave of the tan canvas is easily visible beneath the architectural elements; the foreground too is a matte white, without the thickness Pissarro often lavished on his Montmartre streets to produce the effect of a liquid sheen. Standing in stark contrast to the underdeveloped urban structures, the crowd emerges with its meticulous aggregation of marks, at several degrees higher than the picture plane.

The shift in focus from the urban context to the action and its participants is central to Pissarro's conceptualization of the carnival sub-series. For Pissarro—painting 30 years after Monet's inimitable 1873 *Boulevard des Capuchins* or Manet's 1878 *Rue Mosnier*, or even Renoir, Caillebotte, Guillemet or Rafaelli—the street as a pictorial device, as the modern *sine qua non*, needed to be reworked. By the Third Republic, such pictorial histories had created a tightly sutured pastiche of Paris, a web of representations with which Pissarro did not break, but within which he was perennially enmeshed. The carnival sub-series, thus, lies between Monet and Manet, more specifically, between Manet's paintings of Rue Mosnier and Monet's paintings of June 30, 1878. These paintings—small series in their own right—imagine the unity and loss that come to the fore during moments of orchestrated nationalism, models of collectivity (or the lack thereof) that Pissarro reintuited. Indeed, Pissarro's sub-series shies from Manet's anecdote, the way in which his figural abjection and divisive orthogonal teeter on the threshold between suggestion and specificity, presenting a set of signs—street repair, pavé repository, cripple, the great abrasive swath of red—that are legible signifiers, as T.J. Clark has suggested, of the recent Commune. National unity, Manet seems to be saying, cannot be envisioned even in paint. And yet, it is in the rejection of Manet's stiff, almost swollen figure in favor of collective festivity that Pissarro's paintings initially appear to resonate with Monet's figuration of June 30. And surely, the shared raised viewpoints, the apartment block brackets, the barely localizable figures, *do* speak to Pissarro's carnival sub-series. Monet's buildings and flags, however, dwarf the human component of the paintings. His paint is applied in an all-over equanimity, thick, meaty swabs of red and blue, white and black; the touch is not discriminating, not specific in its emphasis in the way Pissarro's brush strokes are, reserving the lavish, deliquescent points for the spectators.

Nevertheless, the *jouissance* of the Monet, its good-natured civic tone (even if it may have been lip service), is the sensibility scholars have isolated in the "harmless collective enthusiasm" of Pissarro's paintings of carnival.[39] Read alternately as orderly,[40] detached,[41] and topographical, "belong[ing] firmly to a touristic imagery that presents a given view as a fascinating, yet unthreatening spectacle,"[42] the sub-series is often bracketed unproblematically as a literal, almost tautological, view of the city. And indeed, the case made for the resemblance between Pissarro's cityscapes and postcards or topographical maps is a strong one; but whether the "spectacle" in the carnival paintings can be rightly termed "unthreatening" is less certain. For the nineteenth-century postcard is, as Naomi Schor tells us, "the chief perpetuator of the lightly controlling panoptic gaze."[43]

Surely, this is why the spectacle appears harmless, because of the subtle, self-regulating control of the Panopticon. However, Pissarro's paintings of carnival are precisely what the panoptic eye hopes to dismantle, in Foucault's

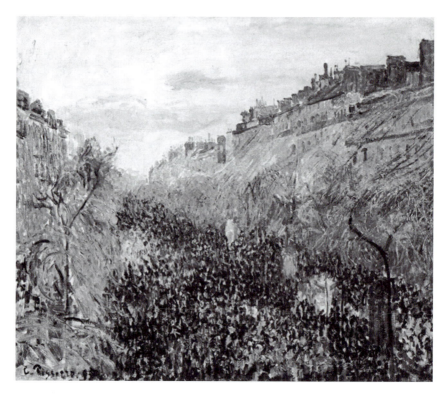

9.2 Camille Pissarro, *Mardi-Gras, soleil couchant, Boulevard Montmartre*, 1897,
54 × 65 cm, oil on canvas. Reproduction courtesy of Kunstmuseum, Winterthur

words "The crowd, a compact mass, a locus of multiple exchanges, individuals merging together, a collective effect is abolished [under the panoptic gaze] and replaced by a collection of separated individualities."[44] I would argue that the "collective effect" the Panopticon hopes to abolish is precisely what Pissarro is proposing in the carnival sub-series. The painting now in Winterthur (Figure 9.2) is a strong case against the controlled topographic (i.e. panoptic) reading of these paintings. Dense and cramped, the bodies of this painting push up against one another, creating a kind of somatic patchwork. But each network of touches snags on its neighbor, so that the marks of black overlay each other; piecemeal, the system accumulates to give the sense of "something like a crowd again" to replay Clark's phrasing. It is, I think, this congerie, this *crowd*, that signals the potential of Pissarro's painting to dream, or envisage insurrection as an emergent socio-political force.

The power of the crowd qua revolutionary force emerged, during the Third Republic, as a locus of considerable concern.[45] Such anxieties had been voiced throughout the final decade of the century in literature and art, and reached

a crescendo only seven years prior to Pissarro's paintings of carnival, when the celebration of May Day, the international worker's holiday, drew large crowds and quickly escalated from a festival to, according to Barrows, "a dress rehearsal for a revolution."[46] Events such as the strikes at Dacazeville and Fourmies that not only drew crowds, but *depended* on them for their remonstrative actions, intensified existing apprehensions that the crowd, if mobilized, would move against the tenuous "moral order" of the Republic.[47] The slippage between striking and the presence of the crowd seemed to grow apace during the 1890s, and increasingly, there appeared to be a "coupling of the crowd with the hope for revolution."[48] Thus the crowd became entwined with the new "proactive" repertoires of labor redress.[49] And yet, to the confluence of the crowd and labor insurrection, we can further interpolate carnival. For, as Michelle Perrot has demonstrated, the institution of the strike in the nineteenth century was "consubstantial with … the element of festival."[50] All these figures—carnival, the crowd, and the strike—suggested the possibility of revolution.[51]

To be clear, however, this network of interrelations and exchanges does not add up to an argument that Pissarro painted a carnival qua strike, per se, nor even that such slippages were cleanly demarcated in the nineteenth century, but rather, that it is necessary to attend to the fact that during the later decades of the nineteenth century these factors—the crowd, the strike, and carnival—operated in the same semantic space.[52] Moreover, it seems that the mutable and fragile fabric of these revolutionary repertoires contributed to the repression of spontaneous collective action during the Third Republic. There was a sense that the line between order and overthrow, between festival and revolution, between crowd and strike, were both thin and delible. To scrupulously maintain the boundaries between these categories, to subject them to the taxonomic and lexical mania of the 1890s, was to create an artificial semantic cordon sanitaire. For if order could not continue to carry the day—albeit with varying degrees of success—then the Third Republic's failure appeared inevitable.

Let us linger on this note of inevitability, for it triggers Theodor Adorno's complaint to Walter Benjamin regarding his definition of the wish image in the 1935 Exposé.[53] Adorno took issue with Benjamin's structure of the wish image, as a configuration that considered revolution to be a priori, i.e. necessarily present within the wish image, even if dormant. That "the conception of the dialectical image as immanent" alarmed Adorno is hardly surprising, for it speaks to the realities of Benjamin's messianic tendencies.[54] The dialectical image, or wish image—it is telling that Adorno felt so comfortable immediately eliding the two—was in fact a teleological proposition. At the point where the past and the present no longer negotiated dialectically, the wish image belied "its linear—I would almost say, historico-developmental—relation to the future as utopia."[55] This axis of awakening abrogated Benjamin's earlier notion of the

"dialectical image of the nineteenth century as hell."[56] Immanence, then, became the undialectical aspect of the wish image for Adorno. While his nineteenth century was dystopically awake, Benjamin's was still dreaming towards utopia. Or, as Clark has it, "Benjamin wanted the wonderful too much."[57]

The question, however, of whether Pissarro would have perceived the immanent utopia in the carnival crowd remains unresolved. Joachim Pissarro has written that "there is no mythologizing, no 'mythography' in Pissarro's paintings; no stories, no 'rhetoric,' as Flaubert would have put it."[58] The difficulty here, once again, stems from the insistent separation of Pissarro's words, his "rhetoric," from his painting. Painting for Pissarro functioned in a very similar fashion to Benjamin's conception of the "new" materials by registering extrinsic rhetoric in paint, and thus entwining the two in a reciprocal and productive relationship. Clark has argued that this reciprocity is the marker of Pissarro's modernism, "Don't try to figure the values that matter to you, have them be instanced by what you do. This is the central modernist instruction as Pissarro understands it."[59] If this was the dictum upon which Pissarro predicated his practice in the early 1890s, the question remains whether these formulations, whether these "values"—values that were both pictorial and political—were still at play in the series paintings. To argue that Pissarro would have been inclined to read revolution in the crowd, to sympathize with the possibility of insurrection, brings us around squarely to the sticky—and inexorable—question of Pissarro's own politics, namely, the extent and fervor of his anarchism.

Put simply, Pissarro was an anarchist, yet I am uninterested in disputing or defending this fact here.[60] Rather, Pissarro's anarchism has purchase at this juncture only in so far as it facilitates an understanding of Pissarro's approach to the crowd. Indeed, his first sustained attempt to visualize the urban crowd came in the form of a private portfolio of anarchist drawings, the *Turpitudes Sociales* (1889–90). If we take as examples *Waiting for Bread* and *The Burial of the Cardinal*, it will be possible to pressure Pissarro's figuration of the crowd in the carnival sub-series, that is, to read it as a motif that maintained both proletarian and revolutionary undertones. Both *Turpitude* drawings appear initially moderate, their participants either malnourished, as in *Waiting for Bread*, or orderly and architectonic, as in *The Burial*. Neither crowd appears poised for revolt; however, Pissarro's chosen *mise-en-scène* in both drawings is a semantically unstable and culturally fraught site. In the recent past the *bouché du pain* had been a location at which anarchists posted calls to arms: "Tomorrow is Mi-Careme, a sad holiday for the hungry! In two months, the Exposition will open: the anniversary of '89, date of an illusory and false emancipation … the frightened bourgeoisie attempts to seduce the starving masses with a mouthful of bread and the spectacle of a masquerade."[61] Moreover, Pissarro's recourse to the pictorial motif of the funeral forced the question of revolution even more explicitly, as over the course of the century funerals had become,

as Perrot writes, "a major form of popular demonstration in the nineteenth century," linked specifically to labor revolts.[62] Thus, both drawings figure the crowd in scenarios that double as potential revolutionary settings. This is not to say that Pissarro considered these depictions to be strictly such, but surely he was aware of the connotations, the inherent slippage in these venues.

If this chapter has argued that in yoking carnival (as an ur-old repertoire of subversion, rather than a caricatural modern festival) to the emergent urban crowd (as the new technology of collective protest), Pissarro had generated a wish image, then it still remains to be dealt with how the wish image, which is also a commodity fetish, plays out in relation to the series paintings.[63] Indeed, for Pissarro the urban series were his "market niche,"[64] paintings that stood for the encroachment of the capitalist commodity-mania into the world of art.[65] Earlier in his career, Pissarro had looked to the Impressionist exhibitions and then to the Neos as a way of short-circuiting commercial modes of artistic reception; however, he operated solidly within the dealer system in the final decade of the nineteenth century. And yet, Pissarro's series paintings were not, like Monet's, strictly fiscal affairs that sold out before their exhibitions closed, as Monet's *Grain Stacks* had done in 1891. Rather, Pissarro relationship to the gallery system was difficult, and at times even tenuous. Nevertheless, as Martha Ward has written, it was during the late 1890s that "Pissarro arrived, after the lean years of his neo-impressionist engagement, to find prosperity at Durand-Ruel's, [where] he tried to keep his typical watch on the distance between principle and practice."[66] The distance between "principle" and "practice," we are left to assume, grew apace in that final decade.

However, Ward's suggestion wrongly, I think, implies that Pissarro's acquiescence to the gallery system was both natural and fluid, although certainly, Pissarro did "come to rest *chez* Durand-Ruel."[67] The series paintings were made "specifically to appeal to the dealer market," with Durand-Ruel specifying the motifs he felt would be the most lucrative and Pissarro diligently producing the canvases.[68] Yet these observations often neglect the fractious and uneasy relationship between dealer and painter.[69] For following the completion and delivery of the Montmartre series, Pissarro became increasingly anxious that his dealer had not mentioned the paintings. Pissarro complained to his wife, "Durand said nothing to me about the paintings, he is so mute!"[70] Then again, almost a week later, he penned similar concerns to Monsieur Portier, stating "I sent my boulevards to Durand and still do not know if he is satisfied, he has not said one word to me, which seems to me a little unnerving."[71] Unnerving, surely, because if unsatisfied with the Montmartre series Durand would be unlikely to commission further works from Pissarro, and the relationship, though cordial, was nevertheless one of a creditor to debtor—depending, of course, on when the last shipment of paintings had arrived. In the same letter Pissarro continues, "It's the same,

I'm not reassured … but then, it's between us."[72] The final entreaty, to keep the complaint "between us," is ambiguous whether Pissarro meant between himself and Portier, or himself and Durand-Ruel.

Pissarro was within the dealer-gallery system by the final decade of the nineteenth century, but that is not to say that his critical gambits fell away entirely. Rather, it is from within this system of sale and production that we can see Benjamin's concept of the wish image at work. For if, as Benjamin wrote, "capitalism was a natural phenomenon with which a new dream-filled sleep came over Europe, and, through it, a reactivation of mythic forces," then Pissarro took the dreaming capacity of art earnestly, while working through the rhetoric of the mythic in his paintings of carnival.[73] The uncertainty and instability Pissarro replayed with Durand was a tacit acknowledgement that the series paintings registered the potential of the dream. Indeed Peter Kroptokin, whom we know Pissarro read assiduously asked artists to, "Narrate for us in your vivid style or in your fervent pictures the titanic struggles of the masses against their aggressors; enflame young hearts with the beautiful breath of revolution."[74] Kropotkin's dream of a revolutionary art found an eager audience in Pissarro, who wrote to Mirabeau, "I am reading Kropotkin's book. It must be said, that if it's utopic, in any case it's a beautiful dream. And as we often have examples of utopias becoming reality, nothing can stop us from believing it may be possible one day."[75] If the dream contained the elements, the seeds of utopia, then the problem remained, even within the series paintings, of how to produce a dream that would have currency in a waking state.

How Pissarro reworked the concept of the dream as a utopian signal, or "tremor," to use Benjamin's phrase, was dependent on the bodies that made up the crowd—the essentially human quality of utopia. For in the Winterthur painting (Figure 9.2), Pissarro's sticky—"viscous and woolly," as Charles Ephrussi once put it—facture builds up to a crescendo.[76] The difference in the density of paint between the crowd and the buildings, the way the black builds up, and stands up against the two-dimensional plane, all emphasize the centrality of the crowd. Indeed, even the canvas now in the Hammer collection (Figure 9.3) gives equal attention to the bodies of the spectators—though the boulevard too is a worked-up pinkish hue, watery and over-wrought, standing in contrast to the light touch of the Fogg painting. We can read, then, a kind of narrative progression between the paintings: from opaque and textured white, to dense and sticky pink, and finally, to the black of the crowd bleeding across the street. This ordering, this sequence reads as a linear development, a progression borne out, even, by the events of carnival in 1897.

For in the 1890s, a new invention permanently altered the experience of carnival in France: confetti. It was a brutal and offensive—blinding, the newspapers said—invention developed to turn a profit from paper waste.

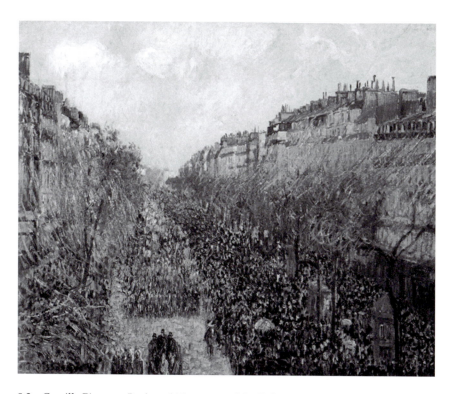

9.3 Camille Pissarro, *Boulevard Montmartre, Mardi-Gras*, 63.5 × 80 cm, oil on canvas, 1897. Reproduction courtesy of The Armand Hammer Collection, Los Angeles

In 1897, the reaction against its use at carnival was fierce and public, during which *Le Figaro* ran a weeklong debate between victims and manufacturers. It was, surely, a bit humorous to the public at large, much like the steam-powered tricycle and 30-foot-diameter crêpes—carnival, everyone knew, was a farce. But the rhetoric of the argument against confetti is well worth reconsidering in light of Pissarro's paintings. In 1897, confetti clogged the boulevards of Paris, with the newspaper *Le Temps* claiming that the small discs added to the "barbarism" of the festival, transforming it into a "battle of confetti."[77] Two days later, *Le Figaro* escalated the discussion by claiming that confetti was generating "barricades" in certain parts of Paris, and that the three days of carnival resembled *"les trios glorieuse"* of 1848.[78] This hyperbole—claiming confetti resembled barricades and that carnival resembled the revolution—was French journalistic bombast at its very best, but for each measure of intentional irony there was an equally earnest edge in the voice of its authors. Over the course of the week, confetti manufacturers ardently defended their product.[79] These were strange bedfellows indeed: barricades and confetti. And of course, they held no direct link, but rather

operated in what Hubert Damisch has characterized as the "complexes, historically constituted systems, in which the lateral link between one sign and another is more important that the direct, vertical link between signifier and signified."[80]

However, I want to once more pressure the conflation of confetti/barricade and carnival/strike, and pivot it towards painting. For in the 1890s, confetti became a key term for describing the avant-garde painting practice of the Neo-Impressionists.[81] This is not to say that Pissarro was resurrecting pointillism — that misses the mark entirely — but if Pissarro was "learning to do without the dot" in the 1890s, he had, by the end of the decade, recommitted himself to the power of painting.[82] Indeed, in a situation such as carnival, there was an ideal semantic confluence for Pissarro. Confetti was at once the symbolic force on the street and on the canvas, providing a kind of conflation where paint as material troped itself in an act of self-referentiality and lateral slippage. The materiality of paint, gamed with the ephemerality of confetti, only to signify the barricade. Surely, as Clark observed, Pissarro was pushing towards modernism, but I would argue that in the series paintings, Pissarro knew all too well that the 'modern' was headed towards abstraction. It was, however, paint as a material register of ideology and individuality, not paint as a stopgap towards abstraction or flatness, that was Pissarro's modernism. Painting for Pissarro retained too many associations, too many political and cultural gambles, for him to release its significatory power completely. Painting for Pissarro was the site of Benjamin's wish image on the verge of awakening, both new and old, fragile and tenuous; painting, Pissarro believed, could rouse the sleeping collective.

It is fitting, finally, that Benjamin and Pissarro should be placed in a dialogic — if at times paratactic — relationship throughout the course of this chapter. For if Benjamin was a kind of Fourier of the Frankfurt school, utopian and earnest, with (as John Beecher has described Fourier) a great "capacity for indignation [and] compassion" then Pissarro too, had strains — strains I think he nurtured and guarded — of such utopianism.[83] Both were convinced, *fundamentally*, that their work would carry their politics, better, in fact, than any other competing cultural endeavor. This is not to say that there were not moments of dystopia. We often see Pissarro working through resignation and exhaustion, and Benjamin too, felt the specter of his gargantuan project to be a bit mad. Their nineteenth century was both of these currents, or, as Adorno put it to Benjamin in a letter in 1935, the "Golden Age" of the nineteenth century was an image of both "underworld and Arcadia," or, to paraphrase T.J. Clark, the Arcadia made the underworld bearable. I want to equivocate once more: yes *and* no. Benjamin and Pissarro saw in Adorno's image of hell, like Clark's spectacle of distraction and redirection, the desires and the drives of the collective as being, again, *supremely*, liberating and inevitable, despite their mediation. Painting fought the wordless battle, but not once did Pissarro truly believe it lacked rhetoric.

Notes

1. "Je crois fermement que nos idées imprégnées de philosophie anarchique se déteignent (*sic*) sur nos œuvres et dès lors (sont) antipathiques aux idées courantes." Camille Pissarro to Lucien Pissarro, April 13, 1891. *Correspondance de Camille Pissarro, Tome 3*, Janine Bailly-Herzberg, ed. (Paris: Editions du Valhermeil, 1988), 63, letter no. 653 (hereafter, *CP Corr.*).

2. Camille Pissarro, quoted in Michel Melot, "Camille Pissarro in 1880: An Anarchist Artist in Bourgeois Society," in *Marxist Perspectives* (Winter 1979/80): 35.

3. Victor Hugo, *L'Année Terrible: Les Précurseurs*, quoted in Walter Benjamin, *The Arcades Project* (Cambridge: Harvard Belknap Press, 1999), 620 (hereafter, *AP*).

4. It is often difficult to establish a middle ground between painting and politics with Pissarro's varied but nevertheless interwoven investments. Several studies of Pissarro's oeuvre have nuanced the relationships between these factors. See Martha Ward, *Pissarro, Neo-Impressionism and the Spaces of the Avant-Garde* (Chicago: University of Chicago Press: 1996); John Hutton, *Neo-Impressionism and the Search for Solid Ground* (Baton Rouge: Louisiana State University Press, 1994); Richard R. Brettell, *Pissarro and Pontoise: The Painter in a Landscape* (New Haven: Yale University Press, 1990); Philip Nord, *Impressionists and Politics: Art and Democracy in the Nineteenth Century* (London: Routledge Press, 2000).

5. The reviews and articles that emerged following the 1993 exhibition of the series paintings demonstrates the need for a new interpretative paradigm to treat these paintings. See Richard R. Brettell and Joachim Pissarro, *The Impressionist and the City: Pissarro's City Paintings* (New Haven: Yale University Press, 1992) and John House, "Anarchist or Esthete? Pissarro in the City," *Art in America* (November, 1993).

6. As Richard Brettell has noted, "The economic success the urban paintings enjoyed was presumably a motivating factor in Pissarro's decision to paint so many of them. Quite simply, they sold better and more quickly than any of the paintings he had ever produced." This fact, however, has allowed the paintings to be passed over as unrepresentative of Pissarro's pictorial commitments. Brettell and Pissarro, *The Impressionist and the City*, xxix.

7. The anxiety surrounding the series paintings stems not only from the collaborative issues raised by Pissarro's relationship with Durand-Ruel at the time, but also from the difficult of charting Pissarro's pictorial trajectory and influences. See John House, "Camille Pissarro's Idea of Unity," in *Studies on Camille Pissarro*, Christopher Lloyd, ed. (New York: Rutledge & Kegan Paul, 1986), 15–34.

8. Pissarro wrote in February of 1897 to his son Georges about Durand-Ruel's desire for bigger boulevards, "Les petites que j'ai faites ont plu beaucoup à Durand, il m'a conseillé d'en faire des boulevards, mais grandes bien entendu." *CP Corr. Tome 4*, 323, no.1366. Indeed, he wrote again in March to Gerogres, "heureusement que mes tableaux marchent et se finissent, mais ces diables de gris des rues de Paris sont tellement difficiles à faire qu'il faut y revenir longtemps. Et dire que Durand n'aime que les effets de soleil!" *CP Corr.Tome 4*, 337, no. 1381.

9. The notion of the wish image is explored by Walter Benjamin in "Paris, Capital of the Nineteenth Century [Exposé of 1935]", *AP*, 4–5. The concept is also lucidly examined by Susan Buck-Morss in *The Dialectics of Seeing* (Cambridge: MIT Press, 1999), 110–59.

10. Benjamin's passage is worth quoting in some length here: "Corresponding to the form of the new means of production, which in the beginning is still ruled by the form of the old (Marx), are images in the collective consciousness in which the new is permeated with the old. These images are wish images; in them the collective seeks both to overcome and to transfigure the immaturity of the social product and the inadequacies in the social organization of production." *AP*, 4.

11. *AP*, 89.

12. *AP*, 4.

13. Buck-Morss, *Dialectics*, 116.

14. Benjamin is talking of Bloch's concept of the "*nunc stans*," *AP*, 389. Buck-Morss has characterized the influence of Bloch's *nunc stans* on the wish image, by observing "Even as a wish image, utopian imagination needed to be interpreted through the material objects in which it found expression, for (as Bloch knew) it was upon the transforming mediation of matter that the hope of utopia ultimately depended: technology's capacity to create the not-yet-known." Buck-Morss, *Dialectics*, 114–15.

15. The importance of this grafting is that it occurs precisely so as to mark out the terms of the utopic dream. The linking of the primeval signifier to the emergent, but not yet articulated, material serves to both trap the potential for change, for "social utopia," as much as to identify it. Thus the two actions, stasis and revolution, are locked in a dialogic exchange that Benjamin characterized as "dialectics at a standstill." See *AP*, "Convolute N," 456–88.

16. *AP*, 4.

17. Buck-Morss identifies Marx's text as central to Benjamin's definition of the wish image. See Buck-Morss, *Dialectics*, 121–24. For another analysis of Marxism in Benjamin's *Arcades Project*, see T.J. Clark, "Should Benjamin Have Read Marx?" in *Boundary*, 2, 30, no. 1 (2003), 31–49.

18. Karl Marx, *The Eighteenth Brumaire of Louis Bonaparte* (New York: International Publishers Co., 2004).

19. Marx, *The Eighteenth Brumaire*, 18.

20. As Clark has it, "Benjamin's Paris is not frightening enough—not empty enough, disenchanted enough … Benjamin's Paris is all dream and no spectacle." Clark, "Should Benjamin Have Read Marx?" 47.

21. Theodor Adorno to Benjamin, November 10, 1938, in a letter regarding "The Paris of the Second Empire in Baudelaire" essay. Quoted in Walter Benjamin, *Selected Writings, Volume 4* (Cambridge: Harvard Belknap Press, 2003), 103 (hereafter, *SW, 4*). Or, again we have Adorno reiterating his concerns: "If you locate the dialectical image in consciousness as "dream," not only has the concept thereby become disenchanted and commonplace, but it has also forfeited its objective authority, which might legitimate it from a materialist standpoint."

22. Adorno to Benjamin in a letter from 1935, quoted in, *SW* v. 3, 54. Although the presence of the crowd has often been noted, the influence of carnival is generally omitted in analyses of Pissarro's sub-series. Moreover, approaches to the crowd in the paintings have argued that Pissarro's crowd is indeed a controlled force. I will return to these interpretations in greater detail later in the chapter. See Richard Thomson, *The Troubled Republic* (New Haven: Yale University Press, 2005), 101; Linda Nochlin, "Camille Pissarro: The Unassuming Eye," in *Studies on Camille Pissarro*, 10.

23. Richard Brettell has referenced the paintings' un-modern overtones: "Pissarro's urban paintings are curiously anti-modern in their refusal to deal overtly with the consciousness of the artist himself." Brettell and Pissarro, *The Impressionist and the City*, xxix.

24. *AP*, 471.

25. I am taking the concept of "deliberate static" loosely from Roland Barthes in his book *S/Z*, wherein he notes that the secondary action of signification, namely connotation, releases "the double meaning on principle, [it] corrupts the plurality of communication: it is deliberate "static," painstakingly elaborated, introduced into the fictive dialogue between author and reader, in short, a counter communication." Roland Barthes, *S/Z* (New York: Hill and Wang, 1992), 9.

26. See "Camille Pissarro 1830–1903," *Apollo* (November 1992): 277.

27. This argument has been put forward with respect to Pissarro's earlier work, most eloquently by T.J. Clark, "We Field Women," *Farewell to an Idea* (New Haven: Yale University Press, 1999), 55–137. I will return to Clark's argument in greater detail later in the chapter. Also see John Hutton, *Neo-Impressionism and the Search for Solid Ground* (Baton Rouge: Louisiana State University Press, 1994).

28. Susanna Barrows, *Distorting Mirrors: Visions of the Crowd in Late Nineteenth Century France* (New Haven: Yale University Press, 1981), 2.

29. For a history of carnival during the Third Republic, see Alain Faure, *Paris Careme-Prenant: du Carnaval à Paris au XIXeme Siècle* (Paris: Hachette, 1978) and Charles Rearick, *Pleasures of the Belle Époque* (New Haven: Yale University Press, 1985). For a broad analysis of the changes the Third Republic carried out on festivals, see Roger Shattuck, *The Banquet Years* (New York: Anchor Books, 1961) and Eugene Weber "The Way of All Feasts," in *Peasants into Frenchmen* (Stanford: Stanford University Press, 1976).

30. The decline of carnival is well document by Alain Faure, *Paris Careme-Prenant*.

31. Charles Rearick, *Pleasures of the Belle Époque*, 23, 208.

32. Louis Morin makes this point in his 1897 publication, *Carnavals Parisiens*, "il est scandaleux que tant d'argent produise si peu d'art, et que l'on promène par la ville de tels exemples de mauvais goût." Louis Morin, *Carnavals Parisiens* (Paris: Editions Illustre, 1897), 171.

33. A list of participants and parade routes can be found in *Le Figaro* of February 28, 1897. Carnival ran from February 28 through March 2 in 1897, however, it did not process up the boulevard Montmartre on Monday, March 1.

34. *Le Figaro*, February 28, 1897.

35. Peter Stallybrass and Allon White, *The Politics and Poetics of Transgression* (Ithaca: Cornell University Press, 1986), 183.

36. "Si, dans les bals, le Carnaval avait cessé d'être une parade vide de sens, dans la rue, il avait cessé d'être une promenade monotone, pour devenir une joueuse mêlée…parfois même un peu brutale." Louis Morin, *Carnavals Parisien*, v.

37. Quoted in Rachael Ziady DeLue, "Pissarro, Landscape, Vision, and Tradition", *Art Bulletin* (December 1998), 718.

38. T.J. Clark, *The Painting of Modern Life* (Princeton: Princeton University Press, 1984), 77–8.

39. Thomson, *The Troubled Republic*, 101.

40. "These canvases represent images of civilian order." Thomson, *The Troubled Republic*, 101.

41. Christopher Lloyd, "Camille Pissarro: Towards a Reassessment," *Apollo* (November 1992): 60.

42. House, "Anarchist of Esthete? Pissarro in the City," 87.

43. Naomi Schor, "*Cartes Postales*: Representing Paris 1900" in *Critical Inquiry* (Winter 1992): 216.

44. Michel Foucault, "The Panopticon," quoted in *Nineteenth Century Visual Culture Reader*, Vanessa R. Schwartz and Jeannene M. Przyblyski, eds (London: Routledge, 2004), 75.

45. See Gustave Le Bon, *Pyschologie des Foules* (Paris: F. Alcan, 1921); Thomson, *Troubled Republic*; Barrows, *Distorting Mirrors*; Jean-Marie Paul, *La Foule, Mythes et Figures* (Rennes: Presses Universitaires de Rennes, 2004).

46. Barrows, *Distorting Mirrors*, 8.

47. As Barrows notes, "Among authorities, so strong was the association between crowds and proletarians that, when repression came, it was directed at the workers." *Distorting Mirrors*, 37.

48. Barrows, *Distorting Mirrors*, 24.

49. The term "proactive" is one adopted from Charles Tilly who proposed that collective violence took two forms: "reactive" and later, "proactive" with the establishment of the capitalist state. Williams Sewell Jr has formulated proactive action as the moment when "groups are no longer resisting the expansion of the state but are attempting to control or influence it." William H. Sewell Jr, "Collective Violence and Collective Loyalties in France: Why the French Revolution Made a Difference," *Politics and Society*, 18, no. 4 (1990): 527–52. Also see Charles Tilly, *The Contentious French* (Cambridge: Harvard University Press, 1986) and "Models and Realities of Popular Collective Action," *Social Research*, 52, no. 4 (Winter 1985): 717–47.

50. Michelle Perrot, *Workers on Strike: France, 1871–1890* (New Haven: Yale University Press, 1987), 145.

51. Such events had precedents in the revolutions of 1830 and 1848, during which "carnival and revolution linked arms to dance in the streets." Charles Tilly, "Charivaris, Repertoires and Urban Politics," in *The French City in the Nineteenth Century*, John Merriman, ed. (New York: Hutchinson, 1987), 75.

52. Alain Faure has highlighted the strong association between the festival and the revolution, "Dans la longue suite de révolutions et d'insurrections qui constitue alors l'histoire tumultueuse de la capitale, les masses populaires interviennent de plus en plus puissamment, aidant d'abord la bourgeoisie à se hisser a pouvoir, puis entrant en lutte contre elle. Une fête aussi essentielle que carnaval ne pouvait transverser cette atmosphère sans en être profondément contaminée, et il est naturel de retrouver au cœur de la fête qui etait au fond de tous les bouleversements du moment: la remise en cause des inegalities, la contestation de l'ordre social." Alain Faure, *Paris Careme-Prenant*, 90.

53. See Note 19.

54. Adorno to Benjamin in 1935, quoted in *SW v.3*, 55.

55. *SW v.3*, 54.

56. *SW v.3*, 55.

57. Clark, "Should Benjamin Have Read Marx," 47.

58. Joachim Pissarro, *Pissarro a Critical Catalogue of Paintings* (Milan: Skira, Wildenstein Institute Publications, 2005), 67.

59. Clark, *Farewell to an Idea*, 65.

60. On Pissarro's anarchism see: Martha Ward, *Pissarro, Neo-Impressionism and the Spaces of the Avant-Garde*; Michel Melot, "Pissarro in 1880" as in Note 2; John Hutton *Neo Impressionism and the Search for Solid Ground*; T.J. Clark, "We Field Women," in *Farewell to an Idea*, esp. 105–16.

61. Quoted in Allison Jane MacDuffee, "Camille Pissarro: Modernism, Anarchism, and the Representation of the 'People', 1888–1903" (University of Michigan Dissertation, 2004), 195.

62. Perrot, *Workers on Strike*, 157.

63. Commodity fetishes and dream fetishes become indistinguishable … dream symbols are the fetishizes desires that advertise commodities." Buck-Morss, *Dialectics*, 120.

64. John Klein, "The Dispersal of the Modernist Series," *Oxford Art Journal*, 21, no. 1 (1998): 125.

65. As Clement Greenberg once observed, the avant-garde is connected to the world of capital by an "umbilical cord of gold," however in the nineteenth century, the links between artists and capital were still fragile and tentative. See: Harrison White and Cynthia White, *Canvases and Careers: Institutional Change in the French Painting World* (New York: John Wiley & Sons, 1965).

66. Martha Ward, *Pissarro, Neo-Impressionism, and the Spaces of the Avant-Garde*, 242.

67. Ward, *Pissarro, Neo-Impressionism, and the Spaces of the Avant-Garde*, 241.

68. House, "Anarchist or Esthete?" 142.

69. Pissarro's letters contain many references to the, at times, difficult relationship he maintained with Durand. It is worth quoting at some length these concerns that he was still voicing, to Lucien especially, as he began the Montmartre series: "J'appréhende à chaque instant une tuile du côté de Durand, et pas moyen d'échapper, pas l'ombre d'un espoir nulle part … Durand m'avait refusé les gouaches qu'il m'avait commandées; non pas qu'il ne les aime pas, mais parce que la vente qu'il comptait faire s'est évanouie: les gens ont changé d'idée par suite des conseils de marchands allemands. J'en suis pour un mois du travail (ou trois mille cent francs sur lesquels je comptais. Je me demande si Durand ne va pas me refuser ma série de peintures prochaines) je suis très découragé, car il n'y a pas un seul autre marchand qui veuille faire des affaires." *CP Corr. Tome 4*, 316, no. 1,360.

70. "Durand ne me dit rien de la maladie de Lucien comme s'il l'ignorait—il ne me dit rien des tableaux non plus! Comme ils sont muets!!" *CP Corr. Tome 4*, 360, no. 1,407.

71. "Avant de partir, j'avais expédié ma série des boulevards à M. Durand-Ruel; je ne sais s'il en a été satisfait, il ne m'en a pas soufflé mot, ce qui me paraît inquiétant." *CP Corr Tome 4*, 361, 1,408.

72. "Avant de partir, j'avais expédié ma série des boulevards à M. Durand-Ruel; je ne sais s'il en a été satisfait, il ne m'en a pas soufflé mot, ce qui me paraît inquiétant. Néanmoins je lui ai demandé des fonds qu'il m'a expédiés. C'est égal, je ne suis pas rassuré … c'est entre nous …" *CP Corr Tome 4*, 361, 1, 408.

73. *AP*, 391.

74. Peter Kroptokin, *Paroles d'un Revolte*, quoted in Robert and Eugenia Herbert, "Artists and Anarchism: Unpublished Letters of Pissarro, Signac, and Others—I," *Burlington Magazine*, 102, no. 692 (November 1960): 518.

75. "Je viens de lire le livre de Kropotkine. Il faut avouer que, si c'est utopique, dans tous les cas c'est un beau rêve. Et comme nous avons souvent l'exemple d'utopies devenues des réalités, rien ne nous empêche de croire que ce sera possible un jour, à moins que l'homme ne sombre et ne retourne à la barbarie complète." Pissarro to Mirabeau, April 1, 1891 quoted in Herbert, "Artists and Anarchism," 480.

76. Quoted by François Cachin, "Looking at Pissarro," in *Pissarro 1830–1903* (London: Arts Council of Great Britain, 1980), 44.

77. *Le Temps*, March 2, 1897.

78. *Le Figaro*, March 4, 1897.

79. See, "En Faveur des Confetti," in *Le Figaro*, March 5, 1897.

80. Hubert Damisch, *Theory of /Cloud/: Towards a History of Painting* (Palo Alto: Stanford University Press, 2001), 44.

81. Ward, *Pissarro, Neo-Impressionism, and the Spaces of the Avant-Garde*, 107.

82. Clark, *Farewell to an Idea*, 67.

83. The words are John Beecher's describing Charles Fourier, however, they nevertheless apply to Benjamin as well. Jonathan Beecher, *Charles Fourier: The Visionary and His World* (Berkeley: University of California Press, 1986), 6.

Part IV
Depicting the scientific

Victorian stained glass as memorial:
an image of George Boole

Kevin Lambert

Overlooking the University College Cork examination hall, or Aula Maxima, is a memorial stained glass window dedicated to the University's first Professor of Mathematics, George Boole. Its imposing presence gives credence to the claim, made by the *Cork Examiner* on its completion in 1866, that this "singularly beautiful memorial" now rendered the "noble Gothic" examination hall "fit to be a royal banqueting chamber." It was, rhapsodized the *Examiner*, "very happily conceived and most appropriate to the purpose it is intended to serve, displaying as in the series of tableaus, the leaders of science from the days when Grecian philosophers and Egyptian sages were laying broadly its foundation, down to modern times when minds of equal power are giving apparently unlimited extension to its inquiries."

One of those modern Victorian minds was, of course, George Boole and he appears in the memorial window sitting writing in front of Aristotle and Euclid in a panel representing mathematical logic, a discipline in which he was a pioneer.[1] And yet, just as Boole seems slightly out of place rubbing shoulders with Aristotle and Euclid, so a magnificent stained glass window in the gothic style does not appear as an entirely appropriate medium for the celebration of the progress of science. The gothic setting, in terms of both the image of a gabled royal banqueting chamber and form of the window itself, seem so utterly un-modern and un-scientific as to tweak historical curiosity.

More intriguing still, the Cork memorial window was not the only stained glass window dedicated to George Boole. A second window soon followed, erected in Lincoln Cathedral, a church which John Ruskin considered the most important example of British gothic architecture. As we shall see, both windows make symbolic reference to Boole's mathematical logic, quite obviously in the case of the Cork window, more obliquely in the Lincoln window. As stained

glass windows, they also appear to have a religious reference but this time much more obviously in the Lincoln than the Cork window.

Given their careful design and construction, it seems reasonable to think that a better historical understanding of these memorials could offer some insight into George Boole's Dissenting religious belief and its importance for his work on mathematical logic. The difficulty of that problem begins with Boole himself and his Dissenter's reticence to make any clear statement about his personal faith. A letter Boole wrote to a pupil from his days as a schoolteacher in Lincoln amply illustrates the impenetrability of Boole's religious thinking. "I hesitate not to avow myself a Christian. I place my hopes for future happiness on the great propitiatory sacrifice and atonements of the Saviour ... Here I fear it will be necessary for me to stop. I cannot go on and say with you that in deed and reality I am a Christian. ... I doubt whether I am a Christian at all except in mere speculation. And now that I have expressed my opinions on this important matter much more fully than I am in the habit of doing let me add that I cannot agree to enter into any correspondence on the subject of personal religion."[2] No wonder that historians of mathematics such as Ivor Grattan Guiness have argued that "[t]he psychological and religious aspects of Boole's logic largely disappeared with him, and they do not feature in his manuscripts. Perhaps he could not see how to build them in effectively — and since they came from his Dissenting heart how to convey them honestly."[3]

Nevertheless, there is one valuable source for the psychological and religious aspects of Boole's logic, the testimony of his wife Mary Everest Boole. Everest Boole was a keen mathematician herself, an interest she inherited from her father Thomas, who included well-known Cambridge mathematicians Charles Babbage and John Herschel among his friends. Very different in age, Mary and George were eighteen and thirty-five respectively when they met and it appears George was always paternal towards her. Their correspondence through the early 1850s contains some moments of warmth but largely concerns Mary's education in mathematics. Then, in 1855 when Mary's father died, George offered to marry her, a proposal that appears to have had more to do with a sense of duty than love since she was now left ill and destitute. But whether because of duty, love, or some combination of both, the marriage turned out to be a happy one and they became extremely close.[4]

More than ten years after George Boole's death, Mary Everest Boole began publishing a considerable number of her own writings, which she claimed drew upon her husband's work. All subsequent accounts of her husband's religious belief and its relation to his logic are largely taken from these writings, even though Mary's later close association with late Victorian and Edwardian spiritualists have also cast some doubt on the accuracy of their portrayal of her husband.[5] For example, in 1905 H.J. Falk, a friend of Alicia Boole (Mary's daughter), would complain that "Mrs Boole holds various metaphysical views as to Boole's logic based chiefly on Gratry, which I have never been able to

follow. But I cannot for that reason conclude that they are without foundation. She must remember much of her husband's thought, which no one now can know. These views are not shared by her very able daughters and especially not Mrs. Stott [née Alicia Boole], who has most of her father's mathematical and logical genius."[6] Thus, by the turn of the nineteenth century, a moment in the history of logic in which the wider religious meanings of Boole's logic were of little interest, Mary's insistence that they were not forgotten was increasingly seen as obstructive. Alicia Boole eventually decided that the publication of a new edition of *The Laws of Thought*, along with some of the manuscripts held at the Royal Society, should be postponed until after her mother's death because, as she confided to H J. Falk, "Mrs Boole will not only disown any connection with the new edition but will attack it as an inadequate presentation of Boole's thought."[7] The project of producing a new edition of Boole's *Laws of Thought*, edited by French logician Louis Couturat, soon foundered.[8]

The question of the credibility of Mary Everest Boole's accounts of the religious aspects of her husband's logic have been taken up directly in the Boole historiography, most notably by Luis M. Laita, who concluded that the "inner consistency of Mary Everest's writings, Boole's own writings, and other sources, lead to the conclusion that there are sound reasons to accept Mary Everest's viewpoint."[9] By generating some credibility for Everest Boole's account, Laita established the importance of Boole's Dissenting religious belief as a strong motivation and resource for his work on logic, but we are still left with an image of Boole as an isolated historical figure, largely unconnected to the main cultural and religious movements of his time.

That perceived cultural isolation is partly due to Dissenting and professional sensitivities about the privacy of personal religious beliefs, reflected in the principal Boole archive at the Royal Society in London. It was Mary Everest Boole, working with her daughter, Alicia, and with some aid from mathematicians William Spottiswoode, Isaac Todhunter, and Augustus De Morgan, that sorted through Boole's letters and unpublished manuscripts following his death. A large number of these letters and manuscript materials were eventually deposited at the Royal Society in London.[10] The Boole papers at the Royal Society offer very little material on Boole's personal life, reflecting, at least to some degree, attempts by colleagues such as Spottiswoode and Todhunter as well as Dissenting friends such as Augustus De Morgan, to construct Boole's "after life," in terms of a rather narrow scientific image.[11] It is not surprising, therefore, that the Royal Society archives do not provide much in the way of evidence for the religious dimension of Boole's work on logic.[12] Indeed, there is also a substantial collection of letters between Boole and De Morgan among the De Morgan papers at University College London which despite, or rather because of, their shared Dissenting beliefs, are almost entirely concerned with matters of logic and mathematics and make virtually no reference to religion at all.[13]

The other major Boole archive, acquired from the United States by University College Cork in 1983, holds a substantial amount of personal letters and notebooks that may have been collected by Boole's sister, Mary.[14] This record, largely biographical, appears to be independent of nineteenth-century attempts to fashion Boole's professional afterlife. It is, therefore, a useful source to use in conjunction with Everest Boole's testimony for exploring the religious dimension of Boole's mathematical logic.[15] The purpose here is not, however, to ask Laita's question: to what degree we should believe Mary Everest Boole's testimony? Instead I want to attempt a reconstruction of George Boole's alternative afterlife as represented by the Cork and Lincoln Memorial windows. The explicit assumption here is not that meaning is fixed in a text, including a mathematical text, or indeed in any material work such as stained glass windows. Rather, meaning is understood to be subject to struggles of authority over both the construction and interpretation of material works such as, for example, the Boole archive. I am not arguing that the Boole memorial windows offer a more authentic perspective on Boole's logic, but rather that they suggest one particular way Boole's mathematics were read by close colleagues such as the Vice President of Queen's College Cork, John Ryall, mathematician Augustus De Morgan, and Boole's wife, Mary Everest Boole. Indeed I would go further and argue that Mary Everest Boole's attempts to shape her husband's afterlife through the memorial stained glass windows, particularly the one in Lincoln, were also attempts to encourage a very particular interpretation of George Boole's books on logic, especially his most well-known, *An Investigation of the Laws of Thought* (1854).[16]

Given the importance Everest Boole always laid on the religious dimensions of her husband's work, her acquiescence in allowing the narrow representation of her husband's work in the Royal Society archive suggests she considered those religious dimensions already represented by the memorial windows at Cork and Lincoln. The question I wish to ask, then, is what we can learn from how Everest Boole and other close friends and colleagues set about preserving that different public memory of George Boole in the memorial stained glass windows at Cork and Lincoln? Since the Boole windows required significant support from close friends and colleagues in order to be constructed as memorials, they represent a collective view of those both personally and professionally close to Boole. As rich symbolic representations of Boole and his work on mathematical logic the Boole memorial windows therefore provide both valuable examples of Victorian gothic architecture and rich historical sources. Along with more conventional textual sources, particularly the archive at Cork, the Boole memorial windows will be used here to place Boole's work on logic in the context of larger Victorian discussions of religion and social order, issues that those living and working closest to him understood as being addressed by his work on mathematical logic.

"A real mathematician … must also be something of a poet."

The decision to create a memorial for Boole in Cork was made at a meeting of the professors of Queen's College Cork only ten days after his death. Originally there was also to be a Boole mathematical scholarship but in *The Times* it was pointed out that to raise money for a scholarship was absurd when Boole had left his wife and three young children practically destitute.[17] There is no evidence of the scholarship ever being awarded, but it is unlikely that it was due to the poverty of the Boole family because a substantial sum of more than two hundred pounds was raised to pay for the Cork window.

John Ryall, vice president and professor of Greek at Queen's College Cork, was instrumental in the campaign to raise money and support for the Cork memorial. Ryall, to whom Boole had dedicated his most famous work of logic, *The Laws of Thought*, was both a member of the Boole Memorial fund managing committee and its largest contributor (twenty-five pounds).[18] He was also Mary Everest Boole's uncle, and it was through Ryall that Mary first met George. Given Ryall's close relationship to Mary, the prospect of financial hardship for both Mary and her children following Boole's death must have weighed heavily on him. Even given the fact that financial support was quickly made available through a Civil List pension of one hundred pounds a year, the period directly following George Boole's death (a time which coincided exactly with the decision to fund the window) must have looked precarious. It seems likely, therefore, that Mary was at least consulted, and probably advocated for, the decision to raise money for a memorial for her husband instead of raising funds to support herself and the children. Her reasons for doing so had to do with a sense of duty to a larger ideal Mary associated with her husband.[19]

George was given a conventional burial at a cemetery attached to St Michael's Church in Blackrock near Cork, Ireland.[20] In general, middle-class Victorians mourned their dead with personal visits to the graveside, a ritual largely unknown before the eighteenth century and indicative of a new set of sentimental pieties concerning the dead. The guaranteed integrity of the dearly departed's body in the individual grave site offered bereaved Victorians a presence that helped facilitate the dead's resurrection, through imagination and memory, that kept them within the circle of the loving bourgeois family.

It is significant, therefore, that Mary quickly came to the decision that there was little future for herself in Ireland, giving up the chance of both support from Lyall, at least until her financial future was secured, and mourning her husband in the typical Victorian middle-class manner. Instead, Mary decided to move to London and to work for Reverend Frederick Denison Maurice (a figure of some importance to her husband) as a librarian at

Queen's College London, the first English academic institution to offer higher education to women.[21] Whilst working for Maurice she wrote "Home-side of a Scientific Mind," one of the most valuable accounts of Boole's personal beliefs. Maurice objected to its publication, probably because it suggested that Boole had doubts about the divinity of Christ and it was not published until after Maurice's death in 1872.

In "Home-side," Everest Boole quotes her husband as saying, "A real mathematician ... must be something more than a *mere* mathematician, he must be also something of a poet."[22] Mary clearly thought of her husband as having something like poetic genius and the religiosity of the Boole memorials reflect her sense that Boole's work in mathematics should be seen as a contribution to English spiritual and moral progress.[23] For the Victorians, nineteenth-century poets such as Wordsworth, and later Tennyson, increasingly took on an exalted role as sacred figures that Samantha Matthews has described as brightening "the dark materialism of the age with the affective power of their poetry."[24] This was especially true after a poet's death, when they were claimed for a greater spiritual English heritage; symbolized by their burial in privileged spaces such as Westminster's poets' corner. Memorials and statuary of the kind that celebrate both Wordsworth and Shakespeare in Westminster were also important reflections of (as well as a means of promoting) English poets as central figures in a broad English spiritual communion. Victorian poet Theodore Watts reflecting on the deaths of leading literary figures such as Carlyle, Eliot, Arnold, and Browning in the pages of *the Athenaeum*, put it this way:

It is almost startling to notice how their death radically alters their relation to us. Not only is their work rounded off, finished in a double sense, completed into a system, informed with a new life, as if, indeed, the poet's soul had passed at once from the body to the works ... Yet a still more vital change comes over our relations to the imaginative creator when his bodily presence is withdrawn. He ceases to be ours alone; Robert Browning no longer speaks only for and to Victorian England. He becomes part of England of the past and future—part of the spiritual heritage for which Englishmen have in the past shown themselves willing to die.[25]

Mary's decision to leave Ireland, work for Maurice, and write a biographical account of her husband suggests she felt that now that George was dead, he no longer belonged to her or even to himself, but to a greater purpose, to something like Watt's "spiritual heritage." Directly following his death, Everest Boole determined that what she considered to be the purpose of her husband's life and work would not be forgotten. She would now use every means she could to preserve the meaning of her husband's work as she understood it, beginning with the Boole memorial window at Cork (Figure 10.1).

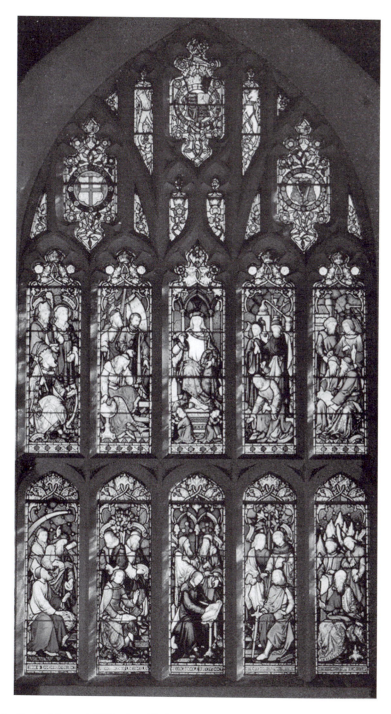

10.1 Boole Memorial Window, University College Cork. Reproduced from Barry, Patrick D., ed., *George Boole: A Miscellany*. Cork: Cork University Press, 1969

The Cork window: George Boole's secular religion and the Victorian gothic

The most striking feature of the Cork memorial window is the contrast between its gothic form and scientific content. It is exactly that contrast that makes the window appropriate for a symbolic representation of the secular religious nature of Boole's mathematical logic. The idea of a secular religion might appear to be an oxymoron but it was not uncommon in the nineteenth century, especially in France. French secular religions were philosophical systems that sought to provide a complete replacement for Catholic Christianity.[26] They included "social religions" like those of Saint Simon and Auguste Comte and "metaphysical religions" like the "natural religion" of Victor Cousin. In France, the tradition of religions such as Robespierre's "Cult of the Supreme Being" inherited from the revolution offered models for those who could no longer believe in Christianity but still thought that some kind of commitment to an ethical, metaphysical, or even political system was essential to the nation. The Catholic Church offered little to these largely rational thinkers and the repressive measures of the Church during the restoration put the revolution of 1830 in opposition to the power of the Catholic Church.

In Britain the situation was different. The protestant Anglican Church had a strong tradition of natural theology offering some scope for compromise for those seeking to reconcile rationalism and religious belief—the Bridgewater Treatises of the 1830s are an obvious example. However, there was also a strong tradition of Dissent from Anglicanism, especially among the artisanal class, in which the natural religion of deism was well represented. Challenges from Dissenters as well as more secular philosophical positions such as Utilitarianism meant that the Anglican Church was kept under pressure to reform in order to maintain itself as the religious authority in Britain.

As Susan Cannon has observed, the idea that the natural philosopher and the theologian were seeking the same truth was a distinguishing feature of early Victorian Britain.[27] However, Cannon's unity of truth should more accurately be seen as buttress of a middle- and upper-class social and cultural authority, which would continue to be subject to challenge from both within the middle class and from the more radical sections of the working class through the 1830s and 1840s. Charles Southwell, editor of the radical working-class penny paper, *The Oracle of Reason*, would be prosecuted in 1841 for calling the Bible "a history of lust, sodomies, wholesale slaughtering, and horrible depravity" among other things.[28] *The Oracle* was only one of the unstamped penny papers that used blasphemy and materialism as a means to undermine the Victorian intellectual order at a time when the Chartist movement was building to its peak. But this was not the only reason why

blasphemy was becoming politically sensitive. The "higher criticism" of German theologians such as D.F. Strauss's *Das Leben Jesu*, informed by the latest philological and historical methods, was also making the literal truth of the Gospels a genuine intellectual problem, one that was of major concern to George Boole.

Mary Everest Boole would remember her husband as saying that "his reason for being so desirous to do something for the advance of the science of logic was that, if it were in a right state, everyone would be able to see that the historical evidence for the truth of the bible is worth nothing; and then people would be driven to choose between having faith in God and having no religion at all."[29] Boole actually dedicated a chapter of his *Laws of Thought* to the question of logical proofs of the existence of God, concluding from their impossibility that a more modern foundation for faith in God and Victorian morality was required.[30]

By offering his mathematical logic as a new, more modern foundation to Victorian morality, Boole contributed to a particularly British kind of progressive utopianism. By 1866, when the Cork window was constructed, the hopes and anxieties that fed what might be called Boole's secular religious ideals were finding expression in Victorian gothic architecture, and that is why the gothic form of the Boole memorial window must have appeared so appropriate to contemporary observers such as the writer of the piece for the *Cork Examiner*. That is not to say, however, that Victorian gothic architecture had always been, or indeed would ever become, incontestably associated with progressive ideals.

A leading figure of the British gothic revival was architect Augustus Welby Pugin. Deeply conservative, and in complete opposition to what he saw as the ugly irredeemable materialism of early Victorian modernity, Pugin found the good and the beautiful manifested in fifteenth century civilization. For Pugin, medieval British society exemplified a community founded on a unified faith in God that could be contrasted with the cold, repressive, atomistic rationality of modern society.

The cultural historian Carl Schorske has used Pugin, along with other nineteenth-century European intellectuals, to exemplify a set of cultural practices he has called "Thinking with History," broadly defined as characteristically nineteenth-century attempts at mastering modernity in which the resources of past are used in order to manage the present.[31] Schorske provides example of two broad strategies for nineteenth-century "thinking with history." He offers Pugin's aesthetics as an example of the first of these strategies, which takes elements from the past in order to construct a more acceptable present and future. Pugin made pictorial arguments of exactly this kind in a book called *Contrasts; or, A Parallel between the Noble Edifices of the Middle Ages and Corresponding Buildings of the Present Day Showing the Present Decay of Taste*, which first appeared

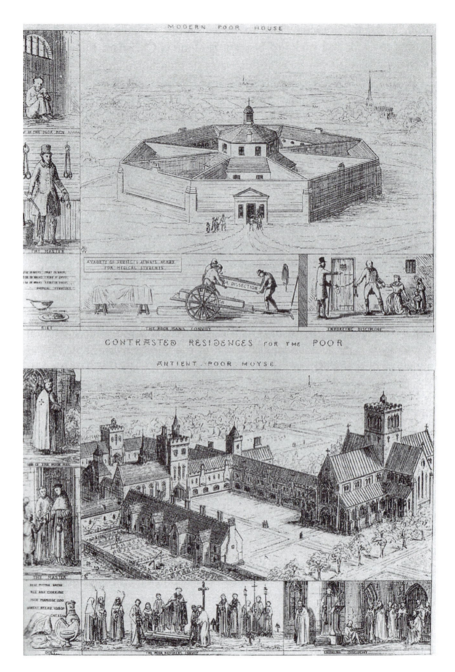

10.2 Augustus Welby Pugin, "Contrasted Residences for the Poor." Top: "Modern Poor House"; bottom: "Antient Poor Moyse." Reproduced from Augustus Welby Pugin, *Contrasts; or, A Parallel between the Noble Edifices of the Middle Ages, and Corresponding Buildings of the Present Day, Shewing the Present Decay of Taste* [2nd ed.] (London : C. Dolman, 1841)

in the late 1830s (Figure 10.2). By juxtaposing examples of gothic and modern Victorian architecture in his *Contrasts*, Pugin sought to illustrate how medieval architecture was more natural and charitable in contrast with the repressive legalistic modern style. One such comparison matches a "modern poor house" styled along the lines of the repressive geometric form of Bentham's panopticon with the open, more organic style of an "antient poor moyse" or medieval poor house. The "modern poor house" is bordered by sketches of men in chains and prison, Spartan food, and even a coffin being shipped off for dissection. Pictures of ritual Anglican worship, charities to the poor, and, of course, a good Christian burial border the picture of the medieval residence for the poor.

Pugin's conservative gothic style was important in establishing new criteria for the value and function of modern Victorian architectural design, but only in a form modeled on thirteenth- and fourteenth-century examples that he saw as being uncorrupted by the damaging effects of the reformation. What Schorske identifies as a second, more dynamic and progressive way of "thinking with history," offered an escape from the conservative dead end of Pugin's gothic revival, finding expression in stained glass window design somewhere around the end of the 1850s. In this more progressive way of thinking, history is thought of less as a resource that can be exploited to highlight the decadence of the present and more as a process in which we can place ourselves.

Pugin designed stained glass windows for some of the pioneering stained glass window manufactures of the 1840s such as William Wailes of Newcastle. But while the windows Pugin designed for Wailes and others remained within traditional religious themes, Wailes also developed another side to the business, memorial windows, the first of which was completed in 1842. Memorial stained glass design encouraged the development of more innovative styles of Victorian gothic design because its subject matter inevitably demanded an original approach to design. By the mid-1840s, stained glass memorial windows offered illustrative examples of how imaginative design could remain faithful to medieval craft. Thus an important defender of the Victorian gothic revival, lawyer, antiquarian, and amateur stained glass window enthusiast Charles Winston, would make a point of encouraging the use of stained glass as memorial in his two volume *An Inquiry into the Difference of Style Observable in Ancient Glass Paintings* of 1847.[32]

However, it was later manufacturers such as William Morris, who formed his Morris, Marshall, Faulkner & Co. firm in the 1860s, that finally moved Victorian stained glass beyond the restrictions of Pugin's gothic revival. Morris employed designers associated with the Pre-Raphaelite art movement, especially Edward Burne-Jones, Dante Gabriel Rossetti and Ford Madox Brown. Although much of the commissions undertaken by progressive stained glass firms such as Morris and Co. remained religious since they were often

intended for churches, increasingly both the content and form of the windows exhibited an imaginative freedom that moved beyond the restrictions of the gothic revival.[33]

Although we know very little about the design or construction of the Cork window, except that it was installed under the supervision of an R.D. Williams in 1866, it does now appear as a very good example of the more progressive and secular movement in the design of Victorian stained glass. For example, the way the window commemorates Boole as participating in progressive history of science by portraying him in a panel next to Aristotle and Euclid, gives symbolic form to Schorske's second mode of "thinking with history" in which the historical present, and indeed a better future, is represented as a development of the past. The Cork window's modern gothic form and secular content were also appropriate to its institutional setting. "Godless Colleges," such as Queen's College Cork, were founded in the late 1840s to provide the Irish Catholic middle class with greater access to education. They were a source of controversy from the moment they were proposed, evoking opposition by the Catholic Church in Ireland and splitting the Catholic political movement.[34] Thus the Cork window had to avoid any direct reference to the religious aims of Boole's logic, its symbolism simply celebrating the triumphant march of science.

The Lincoln window: scientific evangelism in Catholic Ireland

It is doubtful that the principal motivation for the Lincoln window was to give a freer expression to the religious dimensions of Boole's life and work than the one in Cork although, I will argue, that ended up being the case. One of Boole's modern biographers, Desmond MacHale, writes that "in Lincoln there was widespread regret at the news of Boole's death and his friends there were determined that a memorial should be erected in his native city equal to, if not better than, that provided in Cork."[35] That determination raised somewhere around one hundred and ninety pounds for a Lincoln memorial which was to be constructed by one of the biggest Victorian stained glass firms, Ward and Hughes (Figure 10.3).[36]

The Lincoln Boole window is one of a series of stained glass windows that line the north aisle of Lincoln Cathedral memorializing eminent figures of Victorian Lincoln society. A memorial on such a grand scale required a design, an opportunity that gave Everest Boole and some of Boole's closer Lincoln friends the chance to give a more direct expression (prohibited by the more sensitive religious and political context of nineteenth-century Ireland) of their understanding of the religious dimensions of Boole's life and work. It is the religious symbolism of the Lincoln window I wish to pursue in this section.

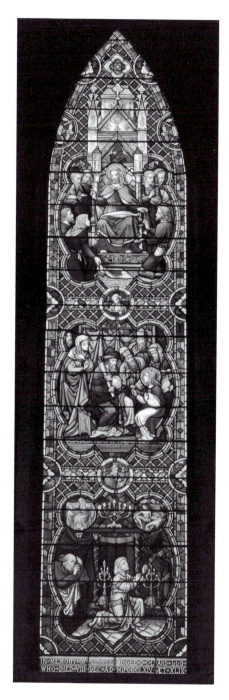

10.3 Boole Memorial Window, Lincoln Cathedral. Bottom Panel: "The Calling of Samuel"; Center Panel: "Christ Among the Teachers"; Top Panel: "Christ Teaching." Image provided by the Corporate Body of Lincoln Cathedral

The dominant theme of the Lincoln window, chosen by Mary Everest Boole, is the "Calling of Samuel" represented in a single panel below two other panels of "Christ teaching" and "Christ among the teachers." Samuel was an Old Testament prophet who began to hear the voice of God as a young boy and followed it for the rest of his life. The reference to Samuel's experience might be read as referring to a calling to teaching (Boole was a teacher before he became a mathematician) except for Everest Boole's explanation of it as an allusion to Boole's search for moral truth:

It is a curious thing that all my husband's early friends speak of him as if he had been a saint from the cradle ... I gave the best explanation I knew of [his goodness] when I suggested the "Calling of Samuel" as the subject for a memorial window ... I doubt if it ever entered his head since he was born that he had a right to dispose of his own life at all. In speaking to me once of the alarm excited by the "Leben Jesu" of Strauss, he said that, however the idea of the life of Christ got into the world, there it was, and God sent it, and it was the true life for him evidently. Comparing him with most Christian people whom I have known, I should say that whereas they did things because a certain person did them, or commanded them, his goodness was more like that of one who had become so absorbed in the contemplation of an ideal that he had forgotten himself altogether.[37]

As noticed earlier, the "higher criticism" of German theologians such as D.F. Strauss, whose work was translated into English by George Eliot [Marian Evans] in 1846, had made the literal truth of the Gospels problematic by rejecting both dogmatic supernaturalist interpretations of the Gospels and liberal humanistic and scientific reinterpretations of Christ's miracles. Instead, Strauss offered an historical analysis of the Gospel as myths created by the early Christians on which to found their new religion. In an interpretation that owed something to G.W.F. Hegel, Strauss argued that the Gospel stories were a symbolic representation of a new stage in the historical development of human consciousness. For Strauss, the story of Jesus represented the awakening of a consciousness of the divine within man. As is well known, rationalist critiques of the authority of the Bible such as those by Strauss were part of a wider crisis in the Anglican church. Pugin and the so-called Oxford Movement were representative of a conservative movement which sought to return the Anglican Church to its early Christian origins. Indeed, Pugin eventually would convert to Catholicism.

Everest Boole's comments suggest that she understood her husband's logic as responding to the same crisis of Anglican authority but from a progressive liberal perspective rather than a conservative one. Boole's first book on logic, *The Mathematical Analysis of Logic*, which appeared in 1847, and the later more developed, *Laws of Thought* of 1854, were both concerned with providing a new modern religious authority with historical roots in the Christian Church. In fact, the final formulation of his logic (with which he was never fully satisfied) was written, at least in part, in response to a related but more local religious

controversy, this time in the even more sensitive religious environment of Queen's College Cork.

At the center of the controversy in Cork was a very close friend of Boole's, Raymond De Vericour, Professor of Modern Languages at Cork. De Vericour was a cosmopolitan figure, well traveled in Europe and the nephew of François Guizot, premier of France at the time of the 1848 revolution.[38] In 1850, a year after arriving in Ireland, and whilst both Boole and De Vericour were still sharing lodgings at Cork, De Vericour published a book, dedicated to "M. Guizot, late prime minister of France," called *Historical Analysis of Christian Civilization*. De Vericour's book is a history of Europe from Christ's birth until the beginning of the nineteenth century. In his book, De Vericour argued that the life and teachings of a historical Jesus Christ are the origin of "a new morality and of sublime principles unknown before ... — liberty to the enthralled, — equality to all, —brotherhood of nations, —human unity."[39] For De Vericour, these ideals are the "moving power" of moral progress, discernible from the history of Europe, which will finally bring unity to all the human races. Thus De Vericour insisted that progress was not to be measured by material advance but was the result of a spiritual law, "manifest and working in the depths of human nature ... the spirit of Christ ... the general inspiration of enlightened humanity."[40]

Something like De Vericour's spirit of Christ—as a symbol of moral progress —offers some correspondence to the ideal Mary Everest Boole describes as being so absorbing for Boole. Certainly, Boole was familiar with Guizot's *History of Civilization*, the principal source for De Vericour's book; he had recommended it in his address to the Lincoln Early Closing Association in 1847.[41] As we shall see, Boole had some important religious differences with his friend De Vericour, particularly over the issue of representing Christ as a historical figure. But there was also some significant common ground that informs the religious symbolism of the Boole window at Lincoln. Of particular importance is a formulation of the self that emerged in the first half of the nineteenth century as one of the principal expressions of the political ideology of the July monarchy in France, Victor Cousin's *Le Moi*.[42]

Jan Goldstein has described the Cousinian self as being made up of three elements: sensation, volition, and reason.[43] These three internal elements also corresponded with external counterparts: volition, or the will, with mankind; sensation with nature; and reason with God. For Cousin, the will alone should be identified with personality; sensation with the perception of the outside world; and reason as belonging not to the individual, but to God. Cousin's claim that reason was not human but belonged to God provided the foundation for a powerful argument in support of common values that could serve as the basis for social order. As Cousin argued to his students in a course given in 1828, "universal and absolute reason" made it completely legitimate to "declare entirely crazy (*en delire*) those who do not accept the

truths of arithmetic or the difference between beauty and ugliness, justice and injustice."[44]

There was a close intellectual kinship between Cousin and Guizot. It is hardly surprising then that De Vericour's book, which is dedicated to Guizot, contains such Cousinian declarations as "The end of humanity cannot emanate from human will. Its basis must be far more solid. It must be a duty ordained by God, and it is called morality ... Morality is the supreme law of societies, of individuals, and of humanity."[45] This "morality" also brings order to history. At the end of his book, De Vericour looks back to the French Revolution, the beginning of his fifth and final historical period. Like Guizot, De Vericour believed the revolution had led to chaos, but it had also created a "general solicitude for the amelioration of the condition of the working classes ... one of the characteristics of the nineteenth century" which will eventually bring Europe conscientious government informed by "Christian-social-eclecticism."[46] Out of the chaos of the revolution had come genuine moral advance that would finally bring order to nineteenth-century Europe.

Unfortunately, in the context of a mid-century Ireland still recovering from the political upheavals of 1848 and the horrors of the famine, De Vericour's book proved highly controversial. As a protestant and student of Guizot, De Vericour was sharply critical of the role of the Catholic Church in the march of Christian progress. As a consequence, his book was immediately placed on the Papal index much to the embarrassment of the College Council, which quickly moved to censure De Vericour. De Vericour managed to survive by removing reference to the College from the frontispiece of his book and lying low in Europe for a while, but the incident exposed the religious sensitivities the creation of the secular colleges in Ireland had to navigate.

Boole, dutifully took De Vericour's part in the controversy but as he wrote to a friend "temperately," maintaining "throughout a friendly correspondence with the Catholic President and Protestant Vice-President."[47] The controversy was finally smoothed over although the problems it highlighted, particularly the difficulty of providing a non-denominational education in religiously sensitive Ireland, would continue to haunt the university. Even some 20 years later, the Catholic Church would still be complaining that the British Government might appoint Frenchmen and German professors "who would bring Hegelism and infidelity with them as Mr. Vericour, a nephew of Guizot, did to the Cork College."[48]

Boole made the most public statement of his theology shortly after the De Vericour controversy when he addressed the college on *The Claims of Science, especially as founded in its relations to Human Nature*, in 1851.[49] He considered this lecture important enough to send to London to be published at his own expense. It represents a more general and accessible statement of the mathematical argument Boole was now writing in his *Laws of Thought*. Although Boole avoided all mention of Christianity, his address shared

common cause with De Vericour's *Historical Analysis of Christian Civilization,* in that both were calls for a moral order built on a conception of the self related to the Cousinian "le Moi."

At the beginning of his *Claims of Science* lecture, Boole defines science as not only "physical truths relating to the material universe" but also "moral truths relating to the constitution of our nature."[50] He goes on to describe this knowledge as being produced by "the joint result of the teachings of experience, and the desires and faculties of the human mind. Its inlets are the senses; its form and character are the result of comparison, of reflection, of reason ... The order of its progress is from particular facts to collective statements, and so on to universal laws. In Nature, it exhibits to us a system of law *enforcing* obedience, in the Mind a system of law *claiming* obedience. Over the one presides Necessity; over the other, the unforced obligations of Reason and the Moral Law."[51] In this short statement, Boole exploits all three components of the Cousinian psychology: sensation, reason and the will. The will is not named, but is implied in the distinction between the natural and mental order. While science reveals a system of law that has dominion over nature, in the mind Moral Law claims but cannot force its obligations on the will.[52]

Boole saw the origin of the human desire for scientific knowledge as also following from the harmony between the psychological and natural order. For Boole, scientific knowledge owed its origin to the desires and faculties of the human mind because "it bears to them a certain fitness and correspondency."[53] This fact may be observed by considering "that whenever the pressure of the merely animal wants is removed, other and higher desires occupy their place. These are not to be regarded as modifications of the selfish principle." The desire for knowledge, which "exists in solitary strength," is one of these higher desires, evidence that the pursuit of knowledge does not begin with human beings—which in Cousinian terms corresponds to the will—but is instead a "designed end."[54] Such a claim requires a "Divine Architect" and indicated to Boole that the pursuit of science, when "not interfered with by other obligations, [is a] duty, the neglect of which cannot be altogether innocent."[55]

The project of science also created a moral duty for Boole in another sense. Even though he believed that careful scientific inquiry could show the association (invisible to our senses alone) "of cause and effect between [say] an undrained, uncleansed condition in our towns ... and a general high rate of mortality," Boole also recognized that the causal connection revealed by reason could still be ignored leaving the "scene of desolation ... renewed from year to year."[56] Consequently, although invisible laws revealed by science indicate a course of action, moral duty can only ask but not require us to carry that action through. This social duty, which directly follows the call for action implicit in the need for social improvement and progress revealed

by scientific inquiry, is paralleled by the demands of individual duty made by moral reason on the self interested will. Just as we are not compelled to clean up the "noisome alley" by the scientific knowledge that it will improve the whole town, so the self interested will can chose to ignore a course of action suggested by moral reason, especially when such action is "contrary to personal interests as judged by common standards."[57] The demands of Boole's moral reason, just like those of scientific discovery, are for the good of the whole of society and are not confined by the myopic vision of the individual self represented by the will.

Standing behind this larger vision of Boole's faculty of reason is the belief in a "Supreme Intelligent Cause."[58] Such a notion demands a natural order suggested to Boole by the mathematical expression of the scientific laws of nature. For Boole, his work on logic had discovered mathematical laws that could represent our intellectual constitution. The will was not subject to these laws, just as it was not bound to follow actions suggested by the discoveries of science. Nonetheless, the symmetry suggested in this internal and external order of things lent "all the weight of its analogies in support of the trustworthiness of human convictions, and the reality of some deep foundation of the moral order of things, behind the changeful contradictions of the present scene."[59]

Just as De Vericour's ideal of Christ was the underlying principle of a law of moral progress discernible in the march of Europe toward greater social equality, so Boole's faculty of reason, particularly when used for moral reasoning, was also an engine of progress. For Boole, as for De Vericour, progress comes not only when the intellect assents to what is true, but also when the will chooses to do that which is good. This idea of the good is discovered through the faculty of reason which, as for Cousin and De Vericour, belongs not to the individual but to God. Universal and absolute reason provide both Boole and De Vericour with a basis for social order and give meaning, in the form of historical progress, to the vicissitudes of the present. It is in this sense that Boole's logic represents an example of "thinking with history" consonant with the modern Victorian gothic forms of the memorial windows.

Conclusion

The memorial windows bring us back to an important difference between Boole and De Vericour. The Cork window, as representative of a secular religion, draws attention to Boole's notion of the workings of the human intellect as mechanical, in the sense that mathematical law can represent them. Mary Everest Boole commented that, "It is sometimes said that materialistic views of brain-action have an irreligious and immoral tendency. I certainly never met anyone more invariably conscientious and reverent than my husband; nor

anyone who seemed so constantly to remember that thought and emotion are carried on by means of the physical machinery of the brain."[60] Boole was quite happy to make God an intelligent cause, and the human intellect something "designed" to produce human knowledge, a vision of the world that De Vericour, with his distaste for materialism, might have found objectionable.

But while making God an unknowable intelligent cause, Boole also transformed the Biblical figure of Christ into a symbol of historical progress generated by reason. For Boole, all historical representations of Christ were blasphemous and so must inevitably lead to controversy and division. Only by following reason could nature and the individual be reconciled to create harmony and unity. I would argue that Everest Boole was trying to give symbolic representation to this process of reconciliation in the Lincoln memorial window through the story, "The calling of Samuel." Recall the story: that Samuel was an Old Testament prophet who begun to hear the voice of God as a young boy and followed it for the rest of his life. If we think of Boole as a sort of Samuel, then the "Calling of Samuel" panel in the Lincoln memorial window can be seen as giving symbolic representation of what those closest to George Boole, considered his political and religious calling: to articulate universal laws of reason subject to the same divine order as external nature. The three panels, read in terms of a Straussian interpretation of the story of Christ, symbolize historical stages leading up to an utopian vision of a future society where reason, symbolized by Christ, finally takes it rightful place as humanity's recognized teacher. Seen in the light of that interpretation, the Lincoln window (to a greater degree than the Cork window, which was subject to Irish religious sensitivities), should be understood as a Victorian argument for how to read George Boole.

Notes

1. What we know about the dedication of the window is gathered together in M.J. Kelly, "The Boole Window in the Aula Maxima, University College Cork," *George Boole: A Miscellany*, ed., Patrick D. Barry (Cork: Cork University Press, 1969), 25–34. The article from the *Cork Examiner* is reproduced there on pages 30–1. The Boole window at Cork: Panel 1, music and religion—St Augustine, St Stephen, and King David; Panel 2, navigation— Columbus, Vasco di Gama and a third unnamed figure; 3, fame as a female figure; 4, medicine— Harvey, Hippocrates, and Galen; 5, engineering and architecture—Archimedes and Phidias (two unnamed figures perhaps Leonardo Da Vinci and Dositheos to whom Archimedes wrote letters); 6, astronomy—Copernicus, Hipparchus, and Galileo; 7, mathematics—Bacon, Napier, and Newton; 8, mathematical logic — Boole, Aristotle, and Euclid; 9, philosophy — Pascal, Leibniz, and Descartes; 10, geography—Strabo and Ptolemy.

2. George Boole to M.C. Taylor, April 27, 1840, Boole Papers in UCC, BP/1/226.

3. Ivor Grattan Guiness, "Boole's Quest for the Foundations of his Logic," part 1 of editors introduction to *George Boole: Selected Manuscripts on Logic and its Philosophy*, eds, Ivor Grattan-Guiness and Gérard Bornet (Basel; Boston; Berlin: Birkhäuser 1997 [Science Networks; vol. 20]) xlvii.

4. Desmond Machale, *George Boole: His Life and Work* (Dublin: Boole Press Ltd, 1985), 105–11.

5. Mary Everest-Boole, *Collected Works* (4 vols) ed., E.M. Cobham (London: The C.W. Daniel Co., 1931).

6. Letter from H.J. Falk to his son, October 18, 1905, forwarded to Bertrand Russell. Reproduced in *George Boole: Selected Manuscripts*, xxiii. Mary Everest Boole had contacted Russell to seek his help in editing and publishing manuscripts relating to a sequel to *The Laws of Thought* that Boole had been working on. Many of those papers are now published as *George Boole: Selected Manuscripts*. Alphonse Gratry was a Catholic priest and logician whose two volume *Philosophie-logique* appeared in 1855. Mary Everest-Boole always claimed that George was very sympathetic to the mystical and religious approach to logic and mathematics in Gratry's work but there is no mention of Gratry in any of Boole's published or unpublished writings.

7. H.J. Falk to his son, October 18, 1905. Reproduced in *George Boole: Selected Manuscripts*, xxii.

8. H.J. Falk to his son, October 18, 1905. Reproduced in *George Boole: Selected Manuscripts*, xxii.

9. Luis m Laita, "Boolean logic and its extra logical sources: The testimony of Mary Everest Boole," *History and Philosophy of Logic* vol. 1 (1980): 37.

10. For a detailed account see Grattan-Guiness, "The Fate of Boole's Nachlass," *George Boole: Selected Manuscripts on Logic and its Philosophy, xviii–xxv*.

11. I have borrowed the term "afterlife" from recent work by cultural historians and literary critics and theorists interested in what they have called "afterlife studies." See, for example, Chris Brooks with Brent Elliot, Julian Litten, Eric Robinson, and Philip Temple, *Mortal Remains: The History and Present State of the Victorian and Edwardian Cemetery* (Exeter: Wheaton, 1989). Robert Douglas-Fairhurst, *Victorian Afterlives: The Shaping of Influence in Nineteenth Century Literature* (New York: Oxford University Press, 2002). Samantha Matthews, *Poetical Remains: Poets Graves, Bodies, and Books in the Nineteenth Century* (New York: Oxford University Press, 2004).

12. Dominick LaCapra has made the point that it should not be forgotten that archives are often expressions of the interests of those institutions that made them, and surely the interests of the Royal Society are also served by the rather safe and narrow image of Boole as mathematician and logician presented by the Boole papers at the Royal Society. For a useful discussion of the role of archives for the intellectual and cultural historian see LaCapra, *History in Transit: Experience, Identity, Critical Theory* (Ithaca and London: Cornell University Press, 2004), 22–34.

13. This correspondence has also been published. *The Boole—De Morgan Correspondence 1842–1864*, ed., G.C. Smith (Oxford: Clarendon Press, 1982).

14. This was suggested to me by the Archivist at the Boole Library at what is now University College Cork. According Grattan Guiness, the Boole papers in the Boole Library in Cork somehow "found there way to America seemingly in the family of Boole's elder daughter Mary Ellen (1856–19??) and were sold at auction to Cork University Library in 1983." See, *George Boole Selected Manuscripts*, xxv.

15. The Cork archive has also been used by George Machale to produce the best biography of Boole: *George Boole: His Life and Works*. See also, more recently, Dan Cohen, *Equations From God: Pure Mathematics and Victorian Faith* (Baltimore: Johns Hopkins University Press, 2007), chapter 3.

16. Work on the history of reading and of the book have helped demonstrate the importance of both the material form of a work and different reading contexts and practices as factors in the making of meanings. James Secord's account of the many ways in which the Victorian literary sensation *Vestiges of the Natural History of Creation* was read in his *Victorian Sensation* offers a good illustration of the importance of seeing a book as subject to different interpretations.

17. Machale, *George Boole*, 245.

18. *George Boole: A Miscellany*, 28–9.

19. Immediately after Boole's death former friends and colleagues, most notably Augustus De Morgan, petitioned the British government, however the pension did not begin until a year later.

20. *George Boole: A Miscellany*, 34.

21. Maurice was an important figure for the Broad Church Anglican movement of mid-nineteenth century Britain. As a former unitarian Maurice was a sympathetic figure for many of those with dissenting religious beliefs such as George Boole, indeed Boole went to hear Maurice talk whenever he was in London.

22. Mary Everest Boole, "Home-side of a Scientific Mind," *University Magazine* (1878), as reproduced in *Collected Works* (4 vols), London: The C.W. Daniel Company, 1931), 1: 1. George Boole did write poetry, some of which has been reproduced in Mary Everest's collected works and some of which has been published in Boole's biography by Machale See Everest Boole, *Collected Works*, 1: 81–2; 244–5; 245; 250. I do not discuss his poetry but for some commentary see Machale, *George Boole*, 171–81; and Laita, "Boolean Logic and its Extra-logical Sources," 50–2.

23. Mary Everest Boole also wrote that Boole was once "much vexed when he found out I had told them [his children] that their Father was "*a 'genius,'* as much as Tennyson or Dickens." He said that "they ought always to feel like all other children, and not think of themselves as exceptions to the rule." Everest Boole, "Homeside," *Collected Works*, 1: 5.

24. Matthews, *Poetical Remains*, 8.

25. [Theodore Watts], "Mr Robert Browning," *The Athenaeum*, December 21, 1889. As cited in Matthews, *Poetical Remains*, 2.

26. D.G. Charlton, *Secular Religions in France 1815–1870* (London: Oxford University Press, 1963).

27. Susan Faye Cannon, *Science in Culture: The Early Victorian Period* (New York: Dawson and Science History Publications, 1978).

28. For the blasphemy trials of the 1840s see Joss Marsh, *Word Crimes: Blasphemy, Culture, and Literature in Nineteenth Century England* (Chicago: University of Chicago Press, 1998), 78–126. *The Oracle* and other productions of the unstamped press also used Lamarckian evolutionary theory to attack the intellectual authority of the Anglican Church. See Adrian Desmond, "Artisan Resistance and Evolution in Britain," *Osiris*, 2nd series (1987), 3: 77–110.

29. Everest Boole, "Home-side of a Scientific Mind," *Collected Works*, 1: 7–8.

30. George Boole, "Clarke and Spinoza," *An Investigation of the Laws of Thought on which are founded the Mathematical Theories of Logic and Probabilities* (London: Walton and Maberly, 1854), 185–218.

31. Carl Schorske, *Thinking with History: Explorations in the Passage to Modernism* (New Jersey: Princeton University Press, 1998). Pugin is discussed in 8, 75–84.

32. [C. Winston], *An Inquiry into the Difference of Style observable in Ancient Glass Paintings, especially in England: with Hints on Glass painting by an Amateur*, 2 vols (Oxford) 1847) 1: 237. Quoted in Charles Sewter, *The Stained Glass of William Morris and his Circle* (New Haven and London: Yale University Press, 1974), 10.

33. For some discussion of the more secular and progressive movement in Victorian stained glass design see, Sewter, *The Stained Glass of William Morris*. Martin Lewis, *Victorian Stained Glass* (London: Barrie Jenkins, 1980), 21.

34. A declining Daniel O'Connell sided with the church while many in the more dynamic Young Ireland movement welcomed the idea of the non-denominational colleges. See R.F. Foster, *Modern Ireland 1600–1972* (London: Penguin, 1989), 315.

35. Machale, *George Boole*, 247.

36. Email communication with Tom Küpper of the Lincoln Cathedral Glazing Department, April 5, 2006. There is a brass plaque below the window, in Latin, which in translation reads: "In memory of George Boole LL.D Citizen of Lincoln. A man of greatest intellect and manifold learning, who being specially exercised in the severest sciences diligently explored the hidden recesses of mathematics and happily illuminated them by his writings. He was carried off by untimely death in the year 1864."

37. Everest Boole, "Homeside," *Collected works*, 1: 14–15.

38. John A. Murphy, *The College: A History of Queen's/University College Cork, 1845–1995* (Cork: Cork University Press, 1996), 48.

39. L.R. De Vericour, *Historical Analysis of Christian Civilisation* (London: John Chapman, 1850), 4.

40. De Vericour, *Historical Analysis*, 6.

41. Boole, *On the Right Use of Leisure: An Address, delivered before the members of the Lincoln Early Closing Association, Feb. 9th, 1847* (London: J. Nisbet & Co.; Lincoln: W & B Brooke, 1847), 9. A translation of Guizot's *History of Civilization* appeared in 1846. See, F. Guizot, *The History of Civilization, From the Fall of the Roman Empire to the French Revolution* trans. William Hazlitt (London: David Bogue, 1849), vi. A good account of Guizot's political philosophy is to be found in Pierre Rosanvallon, *Le moment Guizot* (Paris: Gallimard, 1985).

42. Other sources, almost certainly familiar to Boole, include Johann Gottlieb Fichte, *The Vocation of Man*, Ralph Waldo Emerson, *Essays*, and Richard Carlyle, *Sartor Resartus*. In fact, the question of self identity and self representation was an issue of considerable moment in the 1840s, an issue generally associated with the increasing experience of the city as populated by strangers and dominated by impersonal interactions of market exchange. The classic study is Richard Sennett *The Fall of Public Man* (New York: W.W. Norton & Co., 1992). See also James Secord, *Victorian*

Sensation: The Extraordinary Publication, Reception, and Secret Authorship of the Vestiges of the Natural History of Creation (Chicago and London: University of Chicago Press, 2000), 336–64.

43. Jan Goldstein, "Mutations of the Self in Old Regime and Postrevolutionary France," *Biographies of Scientific Objects*, ed., Lorraine Daston (Chicago: University of Chicago Press, 2000), 105–6. See also, Jan Goldstein, "Eclectic Subjectivity and the Impossibility of Female Beauty," *Picturing Science, Producing Art*, eds, Caroline A. Jones and Peter Galison (New York, Routlege, 1998), 360–78.

44. Victor Cousin, *Introduction à l'historie de la philosophie*, lesson 5, 9–10. Quoted in Goldstein, "Mutations of the Self," 106.

45. De Vericour, *Historical Analysis*, 3.

46. De Vericour, *Historical Analysis*, 434–5.

47. GB to De Morgan October 1850, reproduced in MacHale, *George Boole*, 94.

48. Cardinal Cullen to Archbishop Manning as quoted in Murphy, *The College*, 48.

49. George Boole, *The Claims of Science*, is reproduced in George Boole, *Studies in Logic and Probability*, ed., R. Rhees (London: Watts & Co., 1952), 187–211.

50. Boole, "Claims of Science," *Studies in Logic*, 188.

51. Boole, "Claims of Science," *Studies in Logic*, 197.

52. Daniel J. Cohen has recently described Boole's idea of the "twofold nature of humanity." See Cohen, *Equations from God*, 91. Cohen's emphasis on Kant as a resource for Boole is consistent with the picture I have sketched of Boole's notion of the self. It is my emphasis on morality that brings out a third element of the Boolean self, the individual will.

53. Boole, "Claims of Science," *Studies in Logic*, 198.

54. Boole, "Claims of Science," *Studies in Logic*, 198.

55. Boole, "Claims of Science," *Studies in Logic*, 199.

56. Boole, "Claims of Science," *Studies in Logic*, 200.

57. Boole, "Claims of Science," *Studies in Logic*, 200.

58. Boole, "Claims of Science," *Studies in Logic*, 202.

59. Boole, "Claims of Science," *Studies in Logic*, 202.

60. Mary Everest Boole, "Home-side," *Collected Works*, 1: 23.

"Some Wonders of the Microscope" and other tales of marvel: the popularization of science in late Victorian Britain

Gabriel K. Wolfenstein

> **SCIENCE** (Lat. *scientia*, from *scire*, to learn, know), a word which, in its broadest sense, is synonymous with learning and knowledge. Accordingly it can be used in connexion with any qualifying adjective, which shows what branch of learning is meant. But in general usage a more restricted meaning has been adopted, which differentiates "science" from other branches of accurate knowledge. For our purpose, science may be defined as ordered knowledge of natural phenomena and of the relations between them; thus it is a short term for "natural science," and as such is used here technically in conformity with a general modern convention.[1]

Science, as the above definition from the 1911 *Encyclopedia Britannica* suggests, was (as we see) a difficult term to pin down for the Victorians. This is not to say that they would have been confused by the term. After a fashion, Justice Potter Stewart's definition of pornography works equally well with the word science; "I know it when I see it." Yet it meant different things to different people.[2] For some, it described the collection of information about the natural world; for others, technological innovation; and for still others, it meant subjects like physics or chemistry. Part of this complexity arose from the fact that the practice of science was in flux in this period, as scientific work gradually moved from the sphere of the amateur to that of the professional.[3] It was, not, however, a clean break, and this process meant that the practice of science was taking place on a number of different levels. Surrounding this transformation—or perhaps even structuring it—were a number of basic questions. What is science? How does it proceed? Who is authorized to produce it?

As this chapter is concerned with the question of popularization—of the dissemination of ideas about science, in terms of both content and practices— the focus here is on how the larger public was brought into this conversation. Yet in some ways, the relationship between the general public and the

scientific practitioner is the most slippery, and the least studied.[4] Not so very long ago, Bernard Lightman suggested that we need to know more about how science was popularized in the Victorian period. In his directive, he suggested a number of places for the curious to search. "We need to know far more about how science was popularized during the Victorian period in magazines, journals, textbooks, children's literature, encyclopedias, and newspapers... ."[5] This chapter is meant to be a contribution to that project. Taking the instance of *The Strand Magazine*, I will suggest some of the ways in which the natural sciences were promoted and legitimated within the emergent worldview of the English middle class.

Yet the exploration of this question of popularization of science has begged a number of further questions. In what follows, then, I will address not only the issue of the promulgation of the scientific project, but also the issue of what a general reading public might have understood by the term, or idea, of science. Finally, through the discussion of the subjects of popularization and at least a meaning of science, this chapter is based on the argument that general content monthlies (and all periodicals for that matter) are best seen not in bits and pieces, individual articles culled from their pages, but rather as complete objects. That is to say, if one of the uses of publications like these is that they offer a lens with which to view the culture from whence they emerged, it behooves the historian to consider their content and advertising as a whole.[6]

Some background

In 1891, George Newnes published the first issue of *The Strand Magazine*. His editorial introduction reads, in part:

> It may be said that with the immense number of existing Monthlies there is no necessity for another. It is believed, however, that *The Strand Magazine* will soon occupy a position which will justify its existence. The past efforts of the Editor in supplying cheap, healthful literature have met with such generous favour from the public, that he ventures to hope that this new enterprise will prove a popular one.[7]

He would be proven right on both counts; the new enterprise was indeed popular, selling 300,000 with its first issue, and it was able to build on this successful debut, averaging 500,000, thereby certainly justifying its existence.[8]

Throughout its run, *The Strand* stayed true to Newnes's dictum. Though its content was wide ranging—from biography to fiction, from items of special interest to cartoons—this was not a publication that pushed the artistic and cultural boundaries, in the manner of *The Yellowbook* and more Wildean journals. It remained healthful in Newnes's sense of the word; non-risqué,

educational, informative, eminently middle class. Yet for this very reason, it has something to tell us. It is in the middle-of-the-road, after all, that we should be looking if we want to better understand the ideas and sensibilities that were in play for the ever increasing reading public at the end of the century. John S. North has suggested that the "periodical press began to act as a binding force in society, providing frequent and rapid communication among members of the many organizations that nourished Britain's growth and reminding the general public, through the daily newspapers, of the triumphs and challenges of empire."[9] It is in this spirit that I am approaching the *Strand*, suggesting that rather than solely reminding the public of the "triumphs and challenges of empire" it more importantly reminded them of what it meant to be Victorian. And science—with its Darwins and Huxleys and Kelvins and Maxwells—was eminently Victorian.

Why, then, *The Strand*? To be sure, given an interest in the popularization of science and technology, one might think that a magazine like *Nature* would be a better source. But precisely a publication like *The Strand*, with its broad ranging subject matter, helps us to better understand how scientific ideas and technological innovations were explained, marketed to, and popularized for a general reading public. For not only were there stories of wonder in its pages, but also discussions of new devices, examination of eminent personalities, and advertising that reflected this content. *The Strand* and other magazines of its type allow us to better view science in context, to understand the relationship between science, technology, and the myriad of other ideas and concepts that jostled for space in the market of objects and ideas at the end of the nineteenth century.

To this end, it is important to note that *The Strand* was not a publication dominated by scientifically themed literature. In its first ten years, from 1891 through the end of 1900, there were only 73 articles (excluding biographies of eminent scientists) that dealt with scientific or technological issues.[10] But, to look at this another way, there were as many as 73 articles over a ten-year span exposing the reading public to such ideas in a publication the primary focus of which was not science and technology. Either reading—cup half full or half empty—suggests it would have been difficult to escape the fact of scientific innovation. Put in the terms of *The Strand's* most popular inhabitant, changes were indeed afoot. This was clear both in terms of the types of ideas and objects discussed, and the narratives that were attached to them.

In what follows, I will examine five representative types of articles, to try to highlight the kinds of knowledge and information *The Strand's* readership would have identified as scientific. I will then turn to a brief discussion of the advertising which surrounded the magazine itself, suggesting that *The Strand's* readers were being invited to take part in the scientific project, at least in a small way. Finally, the chapter will conclude with a discussion of what science seems to have meant, at least to this magazine's readers.

The cows that ants milk

One of the most common types of articles were those which brought the natural world to the attention of the reader, as the series title, "Glimpses of Nature," suggests.[11] Though provocatively titled, "The Cows that Ants Milk" by Grant Allen (1848–99), was neither the fantastical creation of a writer of scientific romances (though it might have been), nor really remarkable in its focus or message. Allen was, among other things, a radical socialist and a writer of wide range, from short stories, to novels, from satire to feminism. But not the least of his many hats was that of popularizer of scientific ideas and innovations.[12]

In his writings, Allen made a point of making his subject matter accessible. But he also sought to make the seemingly common, remarkable. In this, "The Cows that Ants Milk" was no exception. The article quickly raises the lives of these cows (otherwise known as aphids) from insignificant insect, to the dynamic protagonist recognizable to any reader of Victorian fiction.

> But comparatively few are aware how strange and eventful is the brief life-history of these insignificant little beasts which we destroy by the thousands in our flower-gardens or conservatories with a sprinkle of tobacco water. To the world at large, the aphides, as we'll call them, are mere nameless nuisances—pests that infest our choicest plants; to the eye of the naturalist, they are a marvelous and deeply interesting group of animals, with one of the oddest pedigrees, one of the queerest biographies, known to science.[13]

These insects are more than mere nuisances; their lives are "strange," thus of interest to anyone. Moreover, their lives are "eventful" as well, suggesting that there is something to excite the imagination in the life-cycle of the seemingly mundane.

> these stick-in-the-mud creatures have yet, in the lump, a most eventful history—a history fraught with strange loves, with hairbreadth escapes, with remorseless foes, with almost incredible episodes. They have enemies enough to satisfy Mr. Rider Haggard or the British schoolboy.[14]

Almost from the start of the article, then, Allen seeks to bridge the gap between the everyday slaughterer of bugs and the naturalist. He suggests that even the most run of the mill creature, the mere nuisance, has a story to tell, a story of interest to not only the reader, but to science as well.

Much of the article is taken up by descriptions of the bugs, where they can be found, how they survive. Interspersed with the descriptions, are varieties of comparisons to human social, economic, and even political affairs, with all the chauvinisms of the British Empire. "Often they [speaking of the ants who "protect" their aphids] build, with mud, covered ways or galleries up to their particular herds, and erect earthen cowsheds

above them; they also fight in defense of their flocks, as a Zulu will fight for his oxen, or an Arab for his camels."[15] Throughout, the story of nature is told in anthropomorphizing terms, as the natural world is understood in very human terms.

Making the biological world comprehensible is only part of Allen's task, however. The other key component is the moral. For not only do aphids have a story to tell, but they also have a lesson to teach. Indeed, it was its very didacticism that marks the article in terms of both time and place. To say that there was something didactic about Victorian science, especially in its public form, might be an understatement, in this context especially. George Newnes not only wanted the work found in *The Strand* to be "safe, healthful" literature, but he also wanted his magazines to teach, to inculcate. In this, Grant Allen's work would rarely disappoint:

Many things, however, conspire to show that aphides did not always lead so slothful a life: they are creatures with a past, the unworthy descendants of higher insects, which have degenerated to this level through the excessive abundance of their food, and through their adoption of what is practically a parasitic habit. When life is too easy, men and insects invariably degenerate: struggle is good for us.[16]

Allen's narrative, with its hints of Charles Darwin and T.H. Huxley, seems to suggest that the Eloi and Morlocks[17] were not just fanciful visions, a scientific romance, but were eminently possible, and that we should ignore the lessons of the natural world at our own peril.[18] Like vegetables, "struggle is good for us," even if we need to examine "lower" creatures to become aware of that fact.

But this was not simply a latter-day morality tale, with the professional naturalist, educated in the recent evolutionary theory preaching from his soapbox. Though science and the natural world clearly have something to teach us, perhaps most interestingly, Allen suggests that this exploration is something we can all take part in:

[Y]et mischievous as they are, the tiny green aphides are well deserving of study both for their personal beauty and their singular life history. Everybody can observe them, because they are practically everywhere. If you have a garden, they swarm on every bush. If you grow flowers in your window, they live in every pot.... Go out into the parks or gardens and examine it for yourself; for every one of the facts I have mentioned in this paper can be verified with ease (if only you have patience) in fields or meadows in all parts of Europe.[19]

The scientific project of learning more about the world, of becoming learned, or perhaps becoming an expert, is accessible to everyone, as long as you have patience and opportunity. Stated the other way around, science is legitimated by its very accessibility.

Mysteries of sound

If one type of article brought nature to the reader, and perhaps the reader to nature, another sought to bring new discoveries to the fore, and maybe simultaneously to demonstrate that we were living in a time of progress. In "Mysteries of Sound," John Mackenzie Bacon—astronomer, aeronaut, and all around lecturer—presented the latest in understandings about how sound traveled. But he begins this very personal narrative not by describing these new theories, but rather by demonstrating the power of science to free us from superstition.

Bacon, starting adult life as a curate, abandoned this when his attack on Church attitudes toward science led to censure. From that point forward, he devoted his life to science, declining to preach until he could "have a lantern screen stretched across the chancel arch and a photograph of the Orion Nebula or some other glory of the heavens, to talk about."[20] It seems that it is in this very spirit that the article on the "Mysteries of Sound" was presented to *Strand* readers.

The article begins with a personal anecdote. When he was an undergraduate at Cambridge he had a room in the Old Court of Trinity, which had become available because during gloomy and windy November weather (not a rarity) there were "low, moaning sounds, as if some creature were in distress somewhere in the lane outside."[21] Not one to let a mystery go by, especially one that disturbed his studying, Bacon found that in "a side room a piece of wall-paper pasted across a chink had developed a crack, leaving two jagged or toothed edges, which, under certain conditions of draught, vibrated rapidly together, forming, as it were, a reed, and this producing the sound above described."[22] One of the first things we notice, then, is the ability of scientific exploration to de-bunk. In this homey way, it carries forward the project of enlightenment.

This demystification, however, makes less of an impression than Bacon's emphasis on the idea of progress. "We could cite," he noted, "many other examples of the apparent ignorance of everyday acoustical facts prevailing only a generation or two ago..."[23] He suggests that we live in a time of change, and of rapid change. The new discoveries were unknown merely a generation ago. "On scientific matters our grandfathers, apparently, were easily satisfied with such plausible theories as seemed fairly convincing and intelligible, and it was with reluctance that they admitted any facts tending to upset preconceived opinions."[24] Whereas formerly, for example, it was accepted that rain and mist would interfere with the passage of light, so rain and fog must "deaden sound." Experimentation, however, demonstrates that to be false.

This brings us to the second point implicit in the article. Bacon's piece, and many others like it, place a great emphasis on experimentation, and especially

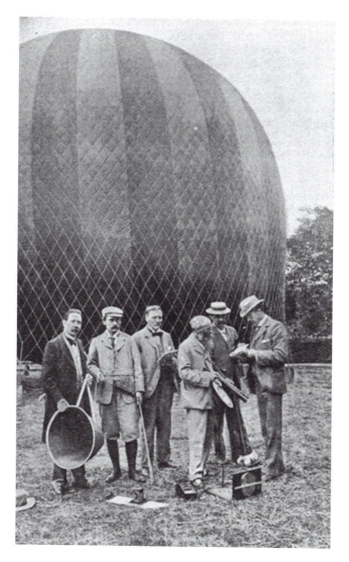

11.1 An exploration of sound via ballooning, with some of the scientific tools. *The Strand Magazine*, 16 (1898), 414

experimentation that anyone who was interested could do. Discussing the fact that humans have a limited range of sounds they can hear, he noted:

I have often gone out on my lawn just before nine o'clock on a still night, when the wind was either dead calm or else blowing softly from the south, and having accurate time, have listened with all my ears for the report of the evening gun at Portsmouth, forty miles away, but neither myself nor any friends who have been with me have ever succeeded in catching even the slightest suspicion of the sound.[25]

Birds, however, can hear it though, and squawk and flutter despite the apparent silence. For Bacon, these are all points for learning, didactic, but in a different way from Allen. "These and other lessons of Nature form an integral part of everyday life, yet they have received far from due attention."[26] The specific claim that he is making stems from his own research into the study of sound, and the use of balloons in furthering that research (Figure 11.1). But the general point that Bacon makes throughout is that while scientific research certainly depends on instruments and objects, nature will reveal her secrets—her laws—if we will only listen. If we listen carefully, what is found could turn, in his words, the "scientific world" on its ear.

This should not suggest that Bacon found instruments to be less than important. In fact, the article closes with a claim for progress, and suggests that part of the reason for this has been the invention or improvement of new instruments. "Principles are better understood. New methods have been found, and instruments of extreme delicacy introduced. Even the microscope has been called upon to lend its aid, and the trace of a suitable phonograph can be made to reveal to the eye differences of sound intensities difficult to compare by ear."[27] "Mysteries of Sound" is filled with modern instrumentation. From the balloons which allowed him to measure the speed and intensity of sound at different heights, to the recording devices that capture the results, Bacon's piece is inundated with new technologies, from the microscope to the kinematograph.

The message of the piece, however, is the more general one of progress. "Our memorandum-books are filled with notes, and we may at least assert that of all our previous results, noticed above, none have been disproved, while we fairly feel ourselves in hot pursuit of fresh and further fact."[28] Careful observation of nature, the use of instruments, sometimes just even listening, leads to more accurate facts. And more accurate facts lead to new theories and new laws, which one most always pursue.

The camera amongst the sea birds

If Bacon's article made the work of the professional scientist more accessible to the general reader, "The Camera Amongst the Sea Birds," by Benjamin Wyles offered the specific instrument—the camera—as a central and accessible component in the furtherance of science. The 1880s and 1890s were periods of remarkable innovation (as are they all, one might add), not the least of which was in the realm of photography and photographic equipment. New plates were developed which were easier to handle, shutter speeds increased, and cameras became increasingly portable. "New camera designs appeared with incredible rapidity, and photography changed from being a medium of the

professional to being a popular amateur pastime."[29] This shift is particularly interesting in the light of the transformation taking place in the sciences; from the realm of the amateur to increasing professionalization. As we shall see, this conjunction in the pages of *The Strand* suggests that the role of the amateur was shifting, rather than fading away. This is particularly evident in *The Strand*, which made quick use of the technology in its effort to have a picture (or at least an illustration) on every page.

But the camera was more than just illustrative, as Wyles's article suggests. Benjamin Wyles, a relatively anonymous Victorian photographer, placed the camera as a central tool in accurately capturing the natural world. Commenting on an earlier fraudulent picture of a single gull (as it was then beyond the technology to capture a bird in flight), he says:

[s]ince then, better lenses, shutters for rapid exposure, and, above all, the increased rapidity of the gelatino-bromide process, have combined to make the impossible of that day the practice of this, so that now a photographer with experience, under fairly favourable conditions, may depict not one, but many birds in flight, on a single plate.[30]

The first thing we notice from his description, beyond the technical innovation, is the emphasis on the new possibilities. Technical innovation has made the "impossible" of yesterday the commonplace of today.

The article is not, however, concerned only with the new technical possibilities of the camera. Wyles is also at pains to suggest the importance of this tool in the generation of new, accurate knowledge. "The wild sea bird," he states, "is the proverbial emblem of unfettered freedom, yet year after year she returns to rear her family where she herself first saw the light."[31] The importance of the camera is that it allows the observer to capture the proof of this observation. The photograph allows Wyles to demonstrate that in "October evidence of memory and of the communication of ideas may be seen."[32] The use of photographs to legitimate claims of memory is implicitly central to Wyles' project. The juxtaposition of massive numbers of gulls flying in close proximity to the point on the page where he is making his textual claim suggests that Wyles's claim is not mere opinion, but is substantiated by the truth of the photograph.

In the end, this article is more descriptive than prescriptive, and its purpose is to bring knowledge of the natural world to those who might never see it. "No foot of man or beast can reach them [the Pinnacles of Farne Island]; but we can get a fair view from the high parts adjacent" Wyles tells us with the accompanying image.[33] Here, the new technology has come to the aid of science, bringing the natural world again to the reader's doorstep. At the same time, however, the increasing availability of faster and cheaper cameras meant that more and more people were able to take part in this recording process.

Some wonders of the microscope

Instruments, then, were of great interest to the readers of *The Strand*, especially new ones, or ones that were suddenly accessible and promised to reveal a whole new world. Thus, in "Some Wonders of the Microscope," William G. FitzGerald, another proponent of the use of photographs in their ability to capture the world and a regular contributor to the new popular periodicals like *The Strand*, primarily presented images from the microscope (Figure 11.2). Yet even this collection of pictures had a moral:

A small instrument and a big subject. The microscope, through which Nature has revealed some of her most stupendous secrets, is one of the necessaries of modern life. Where would the bacteriologist be without it? Or the analytical chemist? Or the Home Office expert in a criminal case? Or the young man who wears spectacles and talks of diatomaceae? The young man who wears spectacles and talks of diatomaceae is generally an amateur microscopist who can find Paradise in a Hampstead pond...[34]

Again, the emphasis here is on accessibility, on the amateur, most of whom are "enthusiasts" as he remarks a few pages later. Here, Fitzgerald not only makes claims for the power of the instrument as a tool of knowledge gathering—as the microscope forces nature to "reveal" her well-kept secrets—but makes this technological innovation the necessity of not only modern science, but life itself. Chemistry, bacteriology, criminology, all rely on this increasingly accessible instrument. Even Paradise is attainable with this tool.

Its accessibility is in fact explicit within the article, as Fitzgerald offers a plug for a local firm. "The firm of Watson and Sons, of High Holborn, keep a stock of 40,000 microscopic specimens, and sell more than a thousand microscopes every year. You can buy an instrument for two or three pounds, or you can spend two or three hundred on one..."[35] Microscopy is something that spans the continuum from amateur to professional, and from one end of the class spectrum to the other.

Fitzgerald is clear that there are ranges of what one can do, however. The images that he reproduced for *The Strand* were not possible for the average amateur to capture with their own camera. "The apparatus for taking these photographs is rather elaborate and very costly," he notes.[36] Yet this is all the more reason for individuals to get their own microscopes. It is important for him to convey the fact that everything he is showing in the magazine could be seen by anyone with the proper tool and slides. The article itself presents a mélange of images whose purpose was to both present the secrets of nature as well as the new powers of modern science. We see images of the diatom and the lancet of the flea alongside a photo-micrograph of the Lord's Prayer, the "original of which occupies only the 1–318,000th part of an inch."[37] The article is both proof of the power of the microscope and an invitation to become part of—or at least to better understand—the power

your money being an exceedingly minute speck.

After this, the next microscopic curiosities seem rather tame. Here is seen a vase of flowers built up with infinite skill and patience by the mounter, who only used in his "picture" the scales and hairs from the wings and bodies of various butterflies, moths, and other insects (No. 16). Altogether 1,252 particles

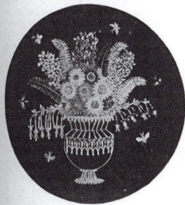

NO. 16.—VASE OF FLOWERS, CONSTRUCTED WITH THE HAIRS AND SCALES OF INSECTS.

had to be placed in position separately, yet you can hardly see the whole without the aid of a microscope—under which, of course, the design was executed. The original of this is a microscopic treasure, and treasures are "skeers and dear," as Mark Twain's aunt

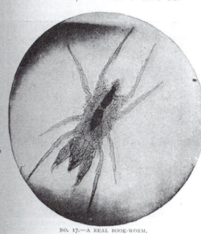

NO. 17.—A REAL BOOK-WORM.

remarked about the buckwheat cakes in a bad season.

Most microscopists are enthusiasts. Look at John Quekett, who, when only sixteen years old, gave a course of lectures on the microscope, his instrument being a home-made one, constructed from some pieces of brass bought at a rag-shop, a common roasting-jack, and an old-fashioned parasol! The ordinary amateur is for ever on the look-out for new subjects in general, or he may confine himself to one species; he may, for example, become a "diatomaniac." He is almost certain to upset people who like a piece of ripe Stilton, by producing microscopic photos of the ap-

NO. 18.—PART OF THE HUMAN SCALP, SHOWING HOW THE HAIRS GROW.

parently gigantic insects that inhabit that cheese. By the way, even mites have their likes and dislikes. For instance, this mite (No. 17) is like the flawless hero—never found out of books. He seems to be a studious mite—a bookworm in fact (his full title is *Cheiletus Eruditus*), and his greatest enemy is the industrious librarian.

Here is another interesting photograph. It shows part of the human scalp with the hairs growing; the roots of hairs that have not yet risen to the

NO. 19.—TOPS OF HAIRS FROM THE WHISKERS OF A LIONESS.

11.2 Microscopic slides, including a book worm, a vase of flowers created from the hairs and scales of insects, and part of a human scalp. *The Strand Magazine*, 12 (1896), 215

and importance of this device to both the science of nature, and the science of society.

Fitzgerald even suggests that being seen as being part of the scientific project was important to the late Victorian. "Many people," he notes, "like to have microscopes and microscopic 'furniture' about them, even though they don't know the stage from the eye-piece of the instrument. You see, these things give the room an imposing appearance as the abode of a scientist."[38] At least according to Fitzgerald, the appearance of being part of science was an important part of being modern. Whatever science was to readers of *The Strand*, they wanted to be part of it.

Cameras and microscopes, insects and balloons were of course not the only objects of scientific exploration offered to the readers of this magazine. There were of course other types of ideas and objects laid bare for *The Strand*'s readers. "Liquid Air" by Ray Stannard Baker, for example brought a new innovation, liquid oxygen, to the attention of the public. "A New Substance that promises to do the work of coal and ice and gunpowder." Baker, one of the great popularizers of his day, author of *The Boy's Book of Inventions: Stories of the Wonders of Modern Science* and others of similar ilk, suggested that Charles Tripler's innovation would one day change the world. "Much has yet to be done before liquid air becomes the revolutionizing power which Mr. Tripler prophesies ... When this is accomplished, liquid air must certainly take its place as the foremost source of the world's power supply."[39] In another entry, Herbert C. Fyfe explained the use of "The Röntgen Rays in Warfare." Even new professions (or at least professions in the process of re-invention) were lauded. "Weather watchers and recorders will be able to tell the engineer what is possible, if not probably, and he will construct his bridge accordingly. However much, therefore, we may laugh at the meteorological prognosticator, we cannot deny that the work of meteorology is of the very highest utility."[40]

A brief mention of the man in the deerstalker cap

Although I have, to this point, been discussing articles that directly promoted and popularized the natural sciences, it is well nigh impossible to discuss *The Strand* without making some sort of obeisance to its most famous denizen. The magazine was an early success, but it was not until the entrance of Arthur Conan Doyle's creation in July of 1891 that it secured first place in magazine popularity—and even then sales do not tell the entire story. Holmes's death in 1893 had an impact that today seems almost surreal. "If in protest rather than in sorrow, young City men that month put mourning crepe on their silk hats, there were others for whom the death of a myth was akin to a national bereavement. From that hour a literary cult of exceptional vitality began stirring

in the womb of time."[41] Though we can ignore Pound's melodrama, we should not underestimate the impact of Mr Holmes.[42] If nothing else, his popularity is highly suggestive of the broad appeal and wide readership of Newnes's creation.

From Doyle's first offering in *The Strand*, "A Scandal in Bohemia,"[43] we already see many of the characteristics of Holmes. His simple, yet amazing, deductive powers, his ability to disguise himself, his disdain for emotion, his use of drugs (opium and cocaine), all are described or played out. Only Moriarty, his archnemesis, is absent. We also see the staid and true Doctor Watson. Although Holmes is representative of the possibilities (and pitfalls) of modernity, it is Watson who is perhaps the sympathetic character. This tension, between the liminal Holmes and the everyman Watson, is not unimportant in our discussion of science and society.

As Watson first describes his absence from Holmes, he says: "My marriage had drifted us away from each other. My own complete happiness, and the home-centred interests which rise up around the man who first finds himself master of his own establishment, were sufficient to absorb all my attention… ."[44] The most important thing in life, then, is home and hearth. Watson goes about his (medical) practice, and all his interests, quite properly, emerge out of married life.

In addition, Watson displays all the courtesy which was required of him as a good Victorian. He offers to leave, when Holmes's guest, the King, arrives. More interestingly, he feels great anxiety about his part in deceiving Irene Adler:

> I do not know whether he was seized with compunction at that moment for the part he was playing [referring to Holmes laying on the couch in Adler's house], but I know that I never felt more heartily ashamed of myself in my life than when I saw the beautiful creature against whom I was conspiring, or the grace and kindliness with which she waited upon the injured man. And yet it would be the blackest treachery to Holmes to draw back now from the part which he had entrusted to me.[45]

There are at least two ways to view this passage. One is that Watson, here, displays the emotions and norms one might guess the average reader might sympathize with. Beauty and kindness are to be respected and applauded. Of course, one must keep one's promises (though we might wonder how far Watson would go before things become too "improper.") Ultimately he is able to harden his heart and justify his behavior, no matter how distasteful; one must do what must be done. Secondly, such a passage can be read as prescriptive, suggesting a proper kind of behavior. Both are no doubt in play here. But as we shall see, such behavior is ultimately insufficient to solve the crime, and by extension to understand the world. Watson, in this read, is the model of Victorian mediocrity. He does nothing by extremes. Though he is usually able to follow Holmes's logic, he can never figure it out for himself. He rarely initiates interaction, unless prodded or directed by Holmes. He has passions, as is evidenced by his mental struggling over

tricking Adler, but he is able to control them. He is, in other words, perfectly safe. Yet, as I will suggest below, we should not dismiss him as simply a foil to display Holmes's genius.

Mediocrity, however, is the very last word one might use to describe Holmes. In fact, as Watson describes him in the opening of story, he is really quite the opposite:

... while Holmes, who loathed every form of society with his whole Bohemian
soul, remained in our lodgings in Baker-street, buried among his old books,
and alternating from week to week between cocaine and ambition, the
drowsiness of the drug, and the fierce energy of his keen nature.[46]

It is Watson who is part of society, then, and is thus the representative figure. Holmes is to be admired and emulated, but not copied. The distinction, I believe, is important. We are to be amazed by Holmes, to utilize his methods, but only within the bounds of civility and civilization. For unlike the rest of us, Holmes never "spoke of the softer passions"[47] which would hinder his reasoning. Holmes is unique. This is what makes him so special, both as a fictive character, and within Doyle's fictional world.

For all the distance between Holmes and we the reader, in the redoubtable detective we have yet another vindication of the idea of science and the scientific method. Holmes represents the rational side of the Victorian world. For Holmes, as for Victorian science, everything is knowable. Even emotions have their use:

He was, I take it, the most perfect reasoning and observing machine that the world
has seen ... They [emotions] were admirable things for the observer—excellent for
drawing the veil from men's motive and actions. But for the trained reasoner to
admit such intrusions into his own delicate and finely adjusted temperament was to
introduce a distracting factor which might throw a doubt upon all his mental results.[48]

There are of course numerous ways to read Doyle's stories of Sherlock Holmes, as the large amount of historiography suggests. If we locate Holmes not just in 221b Baker Street, but within the periodical world of *The Strand*, a complex picture begins to emerge. Readers of *The Strand* were not unaware of the innovations and possibilities of science and technology. One function of Holmes, then, was to bring the idea of science (and the new science of criminology) to the attention of the reading public. Indeed, they were confronted with it with some regularity. But they seem to have seen science, or at least been offered a science, that was isomorphic with their own view of the world as simultaneously knowable and remarkable. With this in mind, we can see Holmes, and the Holmsian methodology of reasoning and observing, as a tool to be used like a microscope. It was available to even the most untutored amateur (Watson), but its ultimate fruition seems available only to the specialist.

What public?

Though I have focused on the articles and stories in the magazine, one of the points I have touched on in my brief gloss on Holmes is that it is important to see these various articles in their context. This means not only looking at the different types of articles found in *The Strand*; it also means looking at the advertising which surrounded the general content. Advertising is important for at least two reasons: one, it can tell us who was reading the magazine, or at least who was the intended audience. But second, it can also tell us, in this specific instance, what sort of scientific tools might have been available to Newnes's readers, and what sort of encouragement they might have found to become part of the scientific project, even if only in peripheral ways.

How can we know who was reading this material? If one is to believe Doyle, the answer is everyone. Writing to Greenhough Smith on his return from the Continent, he said: "Foreigners used to recognise the English by their check suits. I think they will soon learn to do it by their *Strand Magazines*. Everybody on the Channel boat, except the man at the wheel, was clutching one."[49] We can, of course, narrow this down. Both the cost and the advertising suggest that this was primarily a middle-class publication. Thomas Richards, in *The Commodity Culture of Victorian England*, states that "until the very end of the nineteenth century advertising consisted almost entirely of the bourgeoisie talking to itself."[50] But I do not believe this to be entirely the case—it was also the bourgeoisie replicating itself. And it was the bourgeoisie being talked to.

Advertisements ranged from "Allen Foster & Co." design your own clothing,[51] to art, to cures, to watches,[52] and pianos and bicycles. There were rugs to add to the elegance of your home, while at the same time advertising their durability.[53] "These goods cannot be distinguished from Real Brussels when laid down, and cannot be excelled in durability" the advert for the F. Hodgson & Son company stated, offering free shipping to anyone sending in "The Strand Magazine" carpet coupon. Prices ranged from four to twenty-two shillings.[54] "Keeps the hair in curl" yells Bates' Frizzetta (only 1/6 if bought from a Chemist or Hairdresser—post free for 3d extra.[55]

Advertisements for hair products and clothing were not the only things being sold in the pages of *The Strand* though. The ads which I will couple with the articles above were also found in most issues (if not always identical, at least similar). Though not found on the same page as in many modern advertisements, any reader looking through the ads for deals would certainly have noticed the adverts I have highlighted.

These ads are intended to be more than just illustrative. Through the juxtaposition of the articles with the advertising that literally sandwiched them, I propose that periodicals like *The Strand* not only promoted science in their stories and articles; they also provided some of the (at least) more

11.3 An advertisement for the "Sprite Cycle Company," from *The Strand Magazine*, 1, no. 3 (1891), iii

accessible tools needed for the scientific enterprise. Put slightly more crassly: *The Strand* not only sold its readers science, but also sold them, or provided them the opportunity to buy, the commodities of science.

If we return, then, and look at the non-fictive articles, their message of the participatory possibilities of science is emphasized by the advertising. Grant Allen, for example, suggested that his readers could go out and observe aphids in particular, but aspects of the natural world more generally, in the parks and gardens. The ability to explore more than just one's back yard (though presumable that too might have aphids) had been significantly expanding towards the end of the century. Part of what made this possible was the growth of bicycles, like the Sprite Cycle advertised in *The Strand*, to "suit every class" (Figure 11.3).

John Mackenzie Bacon emphasized the importance of time in his measuring of sound, concerned as he was with the effect weather and altitude had on the speed at which sound traveled. Conveniently, one could buy H Samuel's "Marvel" of a watch for only 10/6. It was a "*splendid* Watch in well-finished cases, of a special prepared metal, exactly resembling **Real Silver**. Goes to the fifth of a second. Looks equal to Watches *often sold retail at £5*" (Figure 11.4). Similarly, the phonograph mentioned in his article could also be found in the advertising matter; they were a "never-ending fund of Instruction and Amusement at Home" (Figure 11.5).

11.4 An advertisement for an H. Samuel watch, from *The Strand Magazine*, 10, no. 59 (1895), xiv

11.5 An advertisement for Edison's Home Phonograph, from *The Strand Magazine*, 15, no. 90 (1898), xxxii

Wyles's cameras—by Kodak of course, made for "cyclists, tourists," and "ladies"—could also be found (Figure 11.6). Microscopes were even advertised in the article itself. These are not, of course, one to one correlations. There is obviously a missing link between the objects advertised and the stories and articles; namely, the reader. Sadly, it is rare that autobiographies of an everyman or everywoman show up, indicating exactly how they "read" objects like *The Strand*. Yet the lack of that link

11.6 An advertisement for a Kodak Camera, from *The Strand Magazine*, 15, no. 90 (1898), i

does not mean that some sort of Piltdown man needs to be constructed to make sense of this material. That is, just because we are missing the voice of the reader does not mean we should ignore what was being read. Just as anthropology can construct plausible readings of the fossil record, so, too, can we construct such readings of the historical record, which is in its way, no less imperfect.

What might it all mean?

François Deloncle, in his well-illustrated "The First Moon-Photographs Taken with the Great Paris Telescope," written as a way of promoting the International Exhibitions, said: "[Such exhibitions] must also, if possible, mark an epoch in history by bringing science, which bids fair to completely revolutionize the world in the near future, home to the popular mind."[56] But the question still remains: what was the conception of science at issue here? Drawing together some strands from my analysis, I am suggesting that the understanding of science that readers would have taken away from the magazine included: progress, respect for and demystification of a scientific method, an inclination toward empiricism, an emphasis on the importance of instruments, and the utility of scientific knowledge and its general accessibility. They received a sense that the scientific project, in all its amorphousness, was an indelible and important part of their world, a world that was knowable, graspable, and one of wonderment.

The *Encyclopedia Britannica* understood the modern convention of science—roughly coterminous with the period in question—to be understood as "ordered knowledge of natural phenomena and of the relations between them." Such an understanding certainly pervades the material found in *The Strand*. But science was simultaneously far more, and far less, than that. It was, for some, simply a recording of the natural world. For others, it was innovation; the new devices which made study and observation possible.

It was something done by specialists. It was something done by everyone. Bacon stated that there was a "scientific world" separate from the rest. But it was not a world that was closed off, perhaps not to anyone. Most broadly, science represented the possibilities of the modern world, something everyone wanted to be part of, even if they didn't understand it.

At a later time, Sigmund Freud, seeking to legitimize psychoanalysis, placed his creation within the *weltanschauung* of science.

Ladies and Gentlemen,– Allow me in conclusion to sum up what I had to say of the relation of psycho-analysis in to the question of a *Weltanschauung*. Psycho-analysis, in my opinion, is incapable of creating a *Weltanschauung* of its own. It does not need one; it is a part of science and can adhere to the scientific *Weltanschauung*.[57]

Here, we might perhaps interpret the writers of *The Strand*, and the editorial presence which governed its content, as seeking to legitimate science by placing it within the *weltanschauung* of the British middle class, even if that only meant having a microscope on the mantle.

Notes

1. *Encyclopedia Britannica*, 11th Edition, 1911, vol. 24, 404.

2. This is of course the problem with Potter's definition.

3. This is not of course to indicate that the practice of science was at a standstill in the periods before or after the late Victorian. But the emergence of science and scientists in the second half of the nineteenth century brought with it its own special problems. Professionalization is of course a complex, and fraught, term, as Ruth Barton's recent work makes clear. See Ruth Barton, "'Men of Science': Language, Identity, and Professionalization in the Mid-Victorian Scientific Community," *Hist. Sci.*, xli (2003), 73–119. See also Jan Golinski, *Making Natural Knowledge: Constructivism and the History of Science* (Cambridge, 1998) and Adrian Desmond, "Redefining the X Axis: 'Professionals,' 'Amateurs' and the Making of Mid-Victorian Biology," *Journal of the History of Biology*, xxxiv (2001), 3–50.

4. This is not to say there is no work on the subject. Most recently, a excellent volume has emerged that is asking just these questions. G. Cantor, G. Dawson, G. Gooday, R. Noakes, S. Shuttleworth and J. Topham, *Science in the Nineteenth-Century Periodical: Reading the Magazine of Nature* (Cambridge: Cambridge University Press, 2004). The volume edited by Bernard Lightman, *Victorian Science in Context* (Chicago: The University of Chicago Press, 1997), particularly Lightman's, "Popularizing Victorian Science" and Paul Fayter's "Strange New Worlds of Space and Time: Late Victorian Science and Science Fiction" are good examples of recent work on the subject. Another good example is Peter Broks essay, "Science, the Press and Empire: Pearson's Publications, 1890–1914" in John M. Mackenzie, ed., *Imperialism and the Natural World* (Manchester: Manchester University Press, 1990) or Roger Cooter and Stephen Pumfrey's "Separate Spheres and Public Places: Reflections on the History of Science Popularization and Science in Popular Culture" (*History of Science*, vol. 32, 1994: 237–67).

5. Bernard Lightman, "Popularizing Victorian Science," in Bernard Lightman, ed., *Victorian Science in Context* (Chicago: The University of Chicago Press, 1997), 206.

6. Of course, focus and space constraints mean that in important ways I will not be following my own directive; I cannot look at all the articles, cartoons, advertising from even one single issue of *The Strand* here. But I hope that looking at some of the scientific-themed articles and stories in conjunction with the advertising offers a sense of what the potential of this approach might be.

7. George Newnes, writing as Editor of *The Strand* in *The Strand Magazine, An Illustrated Monthly*, 1 (1891), 3. Please note that most material from *The Strand* comes from the bound volumes, as in this

citation. However, when material is cited from individual issues of the magazine, issue numbers will be indicated.

8. See Reginald Pound, *The Strand Magazine, 1891–1950* (London: Heinemann, 1966), 32. We should, of course, be skeptical of these numbers, as Victorian periodical circulation figures were often inflated, but there is little doubt of the popularity of the magazine. And even if these numbers were off by 50 percent, they would still be impressive figures.

9. John S. North, "The Rationale— Why Read Victorian Periodicals?" in *Victorian Periodicals, A Guide to Research*, eds, J. Don Vann and Rosemary T. VanArsdel (New York: The Modern Language Association of America, 1978), 4–5.

10. I have chosen to count articles only, and have excluded for the sake of this chapter the biographical entries dealing with men, and a few women, of science (there were 11 of these during the period). The larger project will of course consider what readers might have learned from the fictional offerings as well.

11. There were a variety of long running series in *The Strand*, including those interested in science like "Glimpses of Nature" and "Some Curious Inventions."

12. Indeed, Allen saw himself as taking part in the scientific project, especially in his work on dynamics, though he was never accepted by contemporary physicists, ending up stuck on the wrong side of the growing professional/amateur divide.

13. Grant Allen, "The Cows that Ants Milk," in *The Strand*, 14 (1897), 12.

14. Allen, "The Cows that Ants Milk,"13.

15. Allen, "The Cows that Ants Milk,"17.

16. Allen, "The Cows that Ants Milk,"14.

17. These were the creation of H.G. Wells, a fellow traveler after a fashion of Allen, and found in Wells's *Time Machine*. The eloi and morlocks are the remnants of humanity which has devolved into two separate species, as discovered by the Time Traveller in the year 802,701.

18. Indeed, this was at least part of H.G. Wells's message in *The Time Machine*, the popular scientific romance from only two years before.

19. Allen, "The Cows that Ants Milk,"19.

20. John M. Bacon, as cited in W.B. Owen, "Bacon, John Mackenzie (1846–1904)," rev. Julian Lock, *Oxford Dictionary of National Biography*, Oxford University Press, 2004 [http://www.oxforddnb.com/view/article/30515, accessed September 24, 2006] .

21. John Bacon, "The Mysteries of Sound," in *The Strand*, 16 (1898), 408.

22. Bacon, "The Mysteries of Sound," 408.

23. Bacon, "The Mysteries of Sound," 411.

24. Bacon, "The Mysteries of Sound," 410.

25. Bacon, "The Mysteries of Sound," 412.

26. Bacon, "The Mysteries of Sound," 411.

27. Bacon, "The Mysteries of Sound," 412.

28. Bacon, "The Mysteries of Sound," 415.

29. Lynda Nead, "Animating the Everyday: London on Camera c. 1900," *Journal of British Studies*, 43, no. 1 (January 2004), 65.

30. Benjamin Wyles, "The Camera Amongst the Sea Birds," in *The Strand*, 4 (1892), 471.

31. Wyles, "The Camera Amongst the Sea Birds," 472.

32. Wyles, "The Camera Amongst the Sea Birds," 472.

33. Wyles, "The Camera Amongst the Sea Birds," 474.

34. William G. FitzGerald, "Some Wonders of the Microscope," in *The Strand*, 12 (1896), 210.

35. FitzGerald, "Some Wonders of the Microscope," 212.

36. FitzGerald, "Some Wonders of the Microscope," 210.

37. FitzGerald, "Some Wonders of the Microscope," 214. Lest we think this is only a Victorian conception of the possibilities of science, an examination of *Science News*, or any like minded publication, will show nano-guitars and the like as exemplars both of the powers of microscopy and the ability to manipulate matter on the smallest scale.

38. FitzGerald, "Some Wonders of the Microscope," 211–12.

39. Ray Stannard Baker, "Liquid Air," in *The Strand*, 17 (1899), 468.

40. Anonymous, "Weather Watchers and their Work," in *The Strand*, 3 (1892), 189.

41. Reginald Pound, *Mirror of the Century: The Strand Magazine 1891–1950* (New York: A.S. Barnes, 1966), 45.

42. The new wave of detective heroes which emerged after Holmes also speaks to the popularity of Doyle's creation.

43. There had been two previous Holmes mysteries: "A Study in Scarlet" and "The Sign of the Four" published in *Beeton's Christmas Annual* (1887) and *Lippincott's* (1890), respectively, but these had little impact. (Sam Moskowitz, ed., *Science Fiction by Gaslight* [Westport: Hyperion Press, Inc., 1968], 9.) The success of Holmes, then, also presents another argument for the success of *The Strand*.

44. Arthur Conan Doyle, "A Scandal in Bohemia," in *The Strand*, 2 (1891), 61.

45. Doyle, "A Scandal in Bohemia," 72.

46. Doyle, "A Scandal in Bohemia," 61.

47. Doyle, "A Scandal in Bohemia," 61.

48. Doyle, "A Scandal in Bohemia," 61.

49. Pound, *Mirror of the Century*, 63.

50. Thomas Richards, *The Commodity Culture of Victorian England, Advertising and Spectacle, 1851–1914* (Stanford: Stanford University Press, 1990), 7.

51. *The Strand*, 15, no. 90 (1898), iv.

52. *The Strand*, 15, no. 90 (1898), vii.

53. *The Strand*, 15, no. 90 (1898), ix.

54. *The Strand*, 15, no. 90 (1898), ix.

55. *The Strand*, 15, no. 90 (1898), xviii.

56. François Deloncle, "The First Moon-Photographs Taken With the Great Paris Telescope," in *The Strand*, 20 (1900), 493.

57. Sigmund Freud, *The Standard Edition of the Complete Psychological Works of Sigmund Freud*, vol. XXII, trans. James Strachey (London: The Hogarth Press and the Institute of Psychoanalysis, 1964) 181.

Orreries: mechanical and verbal

Hiroko Washizu

The initial inspiration for this chapter came as serendipity from research on Edgar Allan Poe's *Eureka* (1848)—a prose poem about the creation of the Universe—which was eventually turned into a paper entitled "The Universe in Cypher." The point raised there was, in short, to relocate Poe's theory of the Universe in the epistemological framework of cosmology at the beginning of the nineteenth century, when talk about the Universe was *not* about big bangs and black holes but inseparable from discussions about the cause or causes which had produced the Universe.[1] In this sense, it was less about cosmology than about cosmogony—that field of speculative theory about the formation of the Universe in general and the Solar System in particular. In conclusion, Poe's prose poem was interpreted as a verbal operation resembling the mechanism of the Universe explicated in the very poem itself.

The last point above has led in turn to a further investigation into a specific astronomical demonstration device called orrery, which this chapter discusses in three parts. First, a definition of the orrery as a mechanical presentation of the Solar System followed by its two metaphorical implications—respectively called "mechanistic" and "theistic" in this chapter mainly for the lack of better terms. Second, a discussion of "verbal" orreries or the model of the Universe depicted in written texts, with a special emphasis on Natural Theology in William Whewell's Bridgewater Treatise, *Astronomy and General Physics* (1833) where a metaphor of orrery serves to espouse the presence of the "Creator, Governor, and Preserver of the world." The discussion will include both the text proper written in 1833 and the preface added to the seventh edition in 1864—dates that encompass two important publications: Robert Chambers' anonymous publication of *Vestiges of the Natural History of Creation* (1844) and Charles Darwin, *Origin of Species* (1859). And third, a short discussion of another verbal orrery which, unlike Whewell's, presumes no supernatural realm, concluding with a brief return to Poe.

I.

Let us begin this section with an introduction of another American figure, who self-consciously attempted to present and represent the country at its infancy in a book he published in 1784. The book was modestly titled *Notes on the State of Virginia* but its author tried rather ambitiously to refute the French authority Comte de Buffon and his advocate the Abbé Raynal, especially their theory of supremacy of the Old World over "underdeveloped" and/or "degenerated" natural productions in the New World. In an unpropotionately long chapter on "Productions Mineral, Vegetable and Animal," Thomas Jefferson makes a comparison between natural productions in the two Worlds, by applying Buffon's own latest method of natural history to things American—to show by examples that those in the New are not inferior to those in the Old. He then mentions, as if they constituted an essential part of American natural productions, three great men that the young United States had already yielded in its very short history of nationhood: George Washington in military, Benjamin Franklin in philosophy, and David Rittenhouse in astronomy.[2] The last, less known today than the first two, was in fact a manufacturer of orreries—an instrument highly appreciated in Revolutionary America.

The orrery is a mechanical (usually clockwork) presentation of the heliocentric Solar System, named after Charles Boyle, 4th Earl of Orrery to whom this device was dedicated in 1704 by John Rowley who had in fact copied George Graham's planetarium. A typical grand orrery in the King George III Collection at the Science Museum in London has the Sun in gold at the center with a leg fixed to the machine whose inside mechanism controls its rotational movements. A white ball representing Earth is mounted on one of the concentric circle rings under the machine to revolve around the Sun. The ring around Earth is the revolutionary orbit of the Moon.[3]

The orrery is also a central piece in Joseph Wright's painting *A Philosopher Giving a Lecture on the Orrery, in Which a Lamp Is Put in the Place of the Sun* (1766). It shows how this clockwork device served an "enlightened" educational purpose for the idea of the Planetary System. As its subtitle shows, the light source in this picture is a lamp (hidden from sight) at the center of the orrery in the place of the Sun. Note that the philosopher here means a "natural philosopher," one who studies nature or the world of phenomena—as opposed to a moral philosopher who studies supernature or the world of ideas. Although the main figure here is identified as John Whitehurst of Derby—a horologist/clockmaker rather than a philosopher—he bears an unmistakable resemblance to the great natural philosopher Sir Isaac Newton.[4]

In the United States, an orrery was an essential part of the Holbrook School Apparatus (see Figure 12.1) in the age of the Lyceum Movement (featuring, among others, Ralph Waldo Emerson) and the Museum Movement (from Charles Willson Peale to P.T. Barnum).[5] Orreries in education are also

PART I.—DESCRIPTIVE.

FIG. 1.

COMMON SCHOOL SET.—PRICE, $20.

1. Orrery, $10.00
2. Tellurian, 6.00
3. Geometrical Solids, 1.25 Extra, $1.50
4. Terrestrial Globe, (5 inch.) 1.00
5. Numeral Frame,75 No. 2, .62½
6. Hemisphere Globe,75
7. Cube Root Block, (Extra,)50 Double, .75
8. Text-book,37½ Cloth, .50
9. Magnet,25 .37 .50 & upwards.

MISCELLANEOUS ARTICLES.

10. Brass Mounted Orrery, $12.50 and $15.00
11. Brass Mounted Celestial Sphere, . . . 6.00
12. Lane's Mechanical Paradox, or Gyroscope, 2.50 3,50 5.00 & up'ds.
13. Pointing Rods,50 .75
14. Double Slates, No. 1,45 No. 2, .56
15. Holbrook's Noiseless Drawing Slates, No. 1, .20 No. 2, .25
16. Holbrook's Drawing Book,08
17. Holbrook's Nois'less High Sch'l Slate, single, .25
18. " " " " double, .56

12.1 Advertisement of Holbrook School Apparatus Manufacturing Co., *American Journal of Education*, 1 (1856): 762. University of Tsukuba

mentioned in magazine articles such as one in *Household Words* (conducted by Charles Dickens) and the other in *Harper's New Monthly Magazine.* In a short story entitled "My Annular Eclipse" written by W.H. Wills, an orrery is employed somewhat mockingly to describe a professor who is all eager to explain the mechanism of a solar eclipse, producing two rolled handkerchiefs in images of the Earth (snuff-colored) and the Moon (white) and circulating them with his own hands around a lamp - on the roof of a carriage on his way to witness an actual eclipse.[6] "Patience is Genius!" is an essay criticizing a recent disposition to appreciate entertainment more than hard work on "the road to knowledge"—"labor-saving process" in education—citing the orrery as an instrument in such instant astronomy.[7] In favor of promoting joyful learning, Dionysius Lardner's bestselling *Hand-Books of Natural Philosophy and Astronomy* of 1852 mentions an "Electric Orrery."[8]

The orrery, however, was not for education only. It was also an amusement piece. Richard D. Altick's *The Shows of London* notes fun orreries on display at the beginning of the nineteenth century: the Abbé Winton's "Cosmorama"(1807–08), Charles Dibdin's "Astrologer"(1810), one at the English Opera House (1817), Adam Walker's "Eidouranio" (still on exhibit in 1821), its rival R.E. Lloyd's "Diastrodoxon" and Busby's Orrery (1822).[9] The *Punch* magazine notes an orrery exhibition at the Haymarket, London, in 1852.[10] On the American side, one is mentioned at the National Institute in 1845, a second at Harvard in 1863, and a third at Yale in 1865.[11]

Of course, this Enlightenment educational/entertainment apparatus was not without criticism. John Herschel, Astronomer Royal, the only son of the discoverer of Uranus and a long-time friend of Whewell, writes of "those very childish toys called orreries" in *A Treatise on Astronomy* (1833).[12] The 1865 Philadelphia edition of the *Chambers's Encyclopaedia* describes the orrery: "now regarded as a mere toy."[13] In Dickens' *The Uncommercial Traveller* (1863), the first-person narrator remembers his boyhood birthday with his little girlfriend—fringed with a memory of "a slow torture called an Orrery."[14]

What, then, is the point of taking up this outmoded gadget in discussing the "Visions of the Industrial Age"? Wasn't the apparatus already dead and gone or, at least, half-dead by the coming of the Industrial Age? The answer is both Yes *and* No. Yes, because the device as a model of the Universe had become banal by the first half of the nineteenth century. But also: No, because the orrery as a metaphor still kept a firm grip on the imagination of "philosophers," who can be classified into two camps according to their respective views of the Universe in relation to God.

The first camp of philosophers held that, like the orrery that needs an impetus to be set into motion, the Universe needs the Prime Mover at the very beginning of its operation. Here the metaphor became all the more

appropriate as the orrery could be moved not only to a predictable future but also to an imaginable past by turning the crank forward and backward. The Universe, accordingly, has become a mechanism created and operated by the First Cause or, better still, the Clockmaker God—and fixed occasionally by His miracles (as Newton, among others, believed)—just as orreries need a clockmaker for manufacture and repair.

The metaphor of the Clockmaker God, however, tossed a dilemma to theology: the incompatibility of God's Omniscience and Omnipotence. If the Clockmaker God knows everything, then all the harmony in the Universe is preset at Creation; hence no miracle is needed to repair the mechanism, which means no room to prove His Omnipotence. If the Clockmaker God can do anything, then His power to fix the world as He pleases suggests that the prefixed harmony of the mechanism at Creation was so imperfect that it needs revision, which ends up in questioning His Omniscience.[15]

Contrary to this "theistic" interpretation, the second camp insisted that the motion of the Universe is totally mechanistic, like an orrery working automatically on its clockwork, and thus requires neither participation nor intervention of the supernatural. This view of the Universe helped to promote the secularization of the world picture[16]—best exemplified in an episode of Simon-Pierre Laplace's reply to Napoleon Bonaparte. When the emperor asked the philosopher why there was not even a single mention of God in his entire book *Mécanique céleste*, Laplace is reputed to have answered that he had "no need for that particular hypothesis."[17]

Secularization of the world picture also promoted its temporalization. With the expulsion of the Supernatural Cause and the rise of new geology or earth sciences (supporting facts from geographical and geological fieldwork as well as influential ideas from the Laplacian nebular hypothesis[18] and other cosgomonical speculations), the age of the Earth (and accordingly its astronomical/geological parental organization—the Solar System) was extended beyond the biblical limit (4,000 to 6,000 years) to a length that had never been dreamed of before. The world was no longer a static stature still retaining its initial form all intact (whatever its beginning may be); it has undergone transformations, ever so slightly but steadily, over the years and years of age. The key figures in this development of ideas is, among many, Charles Lyell whose book *Principle of Geology* (3 vols) was published from 1830 to 1833. A copy of the first volume went aboard with a young naturalist named Charles Darwin on his *Beagle* expedition.[19]

It should be noted here, however, that, regardless of "theistic" or "mechanistic" import, these world views shared a common metaphor: that the Universe operates according to a certain law or laws, just as the clockwork planetarium moves on an operational mechanism invisible from spectators, and that the universal law(s) of the Universe can finally be discovered by the penetrating gaze of the philosopher, as depicted in Wright's picture.

II.

Confronted with these two philosophical camps of the Clockwork Universe, many notable nineteenth-century thinkers were determined to put God back into the newer cosmological system, most notably in writings on astronomy—ancient principles now refurbished with new discoveries and theories.[20] Let us now turn to some of the "verbal" orreries in astronomical writings.

William Paley's *Natural Theology* (1802), for example, starts with an example of the watch, reminding the reader of the Watch/Clockmaker God. "Suppose I had found a watch upon the ground," he claims, there should be a reason as to why it happens to be there, which presupposes a cause which explains the situation.[21] Here we have a case of argument from design: If there is anything as precise and contrived as a watch mechanism in nature, it does not fail to suggest a presence of the Supernatural Cause behind its presence, demanding human attempts at deciphering God's Design in Nature. Paley even compares God-created heavenly bodies with human inventions, including orreries; the obvious observation is that the former is far superior to the latter:

We have nothing wherewith to compare them [heavenly bodies]—no invention, no discovery, no operation or resource of art, which in this respect, resembles them. Even those things which are made to imitate and represent them, such as *orreries*, planetaria, celestial globes, etc., bear no affinity to them, in the cause and principle by which their motions are actuated.[22] (emphasis added)

Paley's book invited subsequent publications of many books in a similar vein during 1820s and 1830s. Among them were Thomas Dick, *The Christian Philosopher; or, the Connection of Science and Philosophy with Religion* (1823), John Pringle Nichol, *Views of the Architecture of the Heavens, in a Series of Letters to a Lady* (1838), the Bridgewater Treatises (1833–40) written by eight leading natural philosophers of the day, to prove "On the Power, Wisdom, and Goodness of God, as Manifested in the Creation," and their ninth (1837), added by Charles Babbage (of the difference engine fame).

The main point of Dick's *Christian Philosopher* is to reveal the "Devine Design" by employing the latest academic principles (see Figure 12.2).[23] Chapter I entitled "On the Natural Attributes of the Deity," for example, tries to prove, on the one hand, God's omniscience by pointing out the stable movement of the Universe and the precise operation of the planets, and, on the other hand, God's omnipotence by taking account of the infallible organization of the solar system, the diversity in plants and animals, the perfection of human eyeball—thereby emphasizing the Goodness or Benevolence of the Deity. The best illustration of the entire book is a strange picture of the planets and the eye intended to display the same God-ordained

12.2 Thomas Dick, *The Christian Philosopher; or, The Connection of Science and Philosophy with Religion* (1823; Philadelphia: Key & Biddle, 1833), frontispiece. University of Tsukuba

correspondence in their common shape of a sphere. A direct quotation from Paley indicating his influence ends the chapter.[24] Dick then goes on to enumerate various academic principles and practical arts to prove the attributes of the Deity. The book, in this sense, is not only an attempt to find a middle ground between religious and scientific principles but also to reconcile God's omniscience and omnipotence that the clockwork metaphor had brought out as paradoxical.

Nichol's *Architecture*, written in the form of a series of letters addressed to a lady à la Fontenelle's *Entretiens sur la pluralité des mondes*, reaches out from the solar system to a conceivable universe beyond to establish a reading of the "Great Book of the Universe."[25] After describing in Part I "The General Outlines of the Existing Universe" with an emphasis on telescopic observations, Part II ("Principle of the Vitality, or the Internal Mechanism of the Stellar Cluster") offers the one and only admissible theory for Nichol: the restoration of the vitalistic and "whole riches of the Almighty" to the mechanistic universe.[26] Part III gives a reinterpretation of the nebular hypothesis by resorting to the Newtonian mechanism-operating Deity (and thus undermining the Laplacian all-mechanistic view) concluding that "in splendid hieroglyphs the truth is inscribed."[27]

Though Dick's and Nichol's books enjoyed much popularity at publication, no book surpassed the popularity and longevity of Whewell's *Astronomy and General Physics, Considered with Reference to Natural Theology*.[28] The *Bridgewater Treatises* are themselves "the scientific best-sellers of the early nineteenth century," totaling more than 60,000 copies in print by 1850,[29] while *Astronomy* in its turn reached four editions by 1837, six in 1864.[30] Whewell himself was a man of titles: Fellow of Trinity College (1817), Fellow of the Royal Society (1820), Tutor of Trinity College (1823), Professor of Mineralogy (1828–32) and Moral Philosophy (1838–58) at Cambridge, Master of Trinity College (1841–66), president of the Geological Society(1837), several-time secretary and president (1841) of the British Association for the Advancement of Science (organization itself was established in 1831).[31]

Whewell, in fact, is an interesting figure in a much more academic respect, as he stood at the intersection of the new sciences of the 1830s–40s and the age-old (but still active—even today) religious idea which was then called Natural Theology. A polymath with vast knowledge in the fields of history and philosophy of science, mechanics and architecture, astronomy and general physics, moral philosophy, education, political economy, he more than any other deserved the title of "natural philosopher" or "man of science" in their older meanings.[32] He was, at the same time, the one who coined the word "scientist" in his review of Mary Somerville's *On the Connexion of the Sciences* in *Quarterly Review* in 1834.[33] According to Richard Yeo, Whewell's review attempted, on the one hand, to review Somerville's book, intended for popularizing the latest sciences, and, on the other hand, to promote the image

of science most significantly represented in the neologism "scientist" (the term is gender free) in the periodical press with a large circulation. His effort met with a partial success.[34] Whewell was also an advocate of the method of inductive sciences, with a twist unique to himself, pointing to the problem in "sciences" in 1830s, whose products were popular university textbooks such as *The History of the Inductive Sciences* (1837) and *The Philosophy of the Inductive Sciences* (1840). His 1858 publication of *Novum Organon Renovatum* has a clear resonance to the champion of the inductive sciences: Francis Bacon and his *Novum Organon* (1620).

And yet, Whewell's inductive scientific method in his Bridgewater Treatise has one unmistakable character: presumption of the existence of the supernatural behind the Law of Nature.[35] The Introduction defined this point as the objective of the book: to prove the existence of "a Creator, Governor, and Preserver of the world."[36] Then the methodology for the proof is stated: induction from individual facts to general laws, and from respective general laws to "colligation" (his neologism for mutual adaptation) of laws—thereby demonstrating the idea of "a harmonizing, a preserving, a contriving, an intending mind."[37] After the Introduction, three Books constitute the main body of the text: Terrestrial Adaptations, Cosmical Arrangements and Religious Views.

Book One abounds in machine images: the machinery of the earth (terrestrial), that of the atmosphere (meteorological), that of the ether (celestial)—all of which point to laws pointing to the presence of the Divine Author. Take, for example, the logic in explaining the "machine" of the terrestrial revolution in determining the length of the year: one natural year on earth is so adjusted and suitable to animal and vegetable sustenance there that even a minor change in its length would cause their "instant decay and rapid extinction."[38]

The machine image here is apparently framed within the pre-Darwinian epistemology. In the Darwinian theory of evolution, plants and animals are regarded as having survived a long history of adaptation to their environment. Failure means extinction. An ammonite fossil is thus an evidence of a failure in natural selection—as opposed to supernatural intervention. Or, according to a report by Norihiro Okada, whales and camels branched off from their common ancestor about 60 to 70 million years ago for the former to adapt to the sea and the latter to the desert.[39] For Whewell, however, the argument goes the other way round: the Divine Author could have done nothing wrong or unnecessary so that every act of Creation points to His Design—every Machinery in Nature is filled with His Intention.

An interesting twist of logic in a machine image makes its way into Chapter XVI on "Light":

The peculiar property thus belonging to vision, of perceiving position, is so essential to us, that we may readily believe that some particular provision has

been made for its existence. The remarkable mechanism of the eye (precisely resembling that of a *camera obscura*), by which it produces an image on the nervous web forming its hinder part, seems to have this effect for its main object. And this mechanism necessarily supposes certain corresponding properties in light itself, by means of which such an effect becomes possible.[40]

Here the eye is not only understood as a mechanism but also reduced to a human contrivance *camera obscura* (prototype of our camera) which originally imitated the structure of the eye itself. In this metaphor, perhaps against Whewell's intention, God becomes a Divine Mechanic, anthropomorphized to fit into human imagination.

The eye metaphor in fact is a pet topic, from Paley's eye-telescope comparison, Thomas Dick's perfect sphericity of planets and eyeball, Nichol's anatomical/structural function of the eye, and perhaps, last but not least, to Ralph Waldo Emerson's "transparent eye-ball" in his essay *Nature* (1836). This is after all an age that followed the Enlightenment—light for seeing—with a heavy emphasis on instrument-aided observations: examination, experimentation, exhibition, exposition, exploration.[41]

But return to Whewell's *Astronomy*, Book Two on "Cosmical Arrangement" starts with "The Structure of the Solar System" where the planets are represented as marble pellets moving inside a wide shallow round basin of smooth marble. This pellets-basin model is then compared to a planetarium:

Such a contrivance might form a *planetarium* in which the mimic planets would be regulated by the laws of motion as the real planets are; instead of being carried by wires and wheels, as is done in such machines of the common construction: and in this planetarium the tendency of the planets to the sun is replaced by the tendency of the representative pellets to run down the slope of the bowl.[42]

What is the main difference between this planetarium and the actual celestial Solar System? What keeps the celestial pellets from running down to the center? What keeps the planets in their orbits around the Sun? The law of universal gravitation is not enough. And the answer is all so obvious: the mechanism of the universe is "the work of an Intelligence."[43]

It is then no wonder that Whewell is reacting against Laplace's "Nebular Hypothesis" (Whewell's own naming)—a theory in cosmogony that the solar system was formed from a nebula (cloud of gas) rotating counterclockwise in a spiral and slowly collapsing into planets from the outermost Uranus (the most recent addition by William Herschel in 1781) to the inward Saturn, Jupiter and so on. He attacks the "arbitrary guesses and half-formed theories"[44] by raising questions about the cause of the mechanism of the Solar System: "When and how was this machinery constructed?" he asks, "Do we not, far more than ever, require an origin of this origin? an explanation of this explanation?"[45] The answer is again: "a First Cause, an Intelligent Author."[46]

The most important part for Whewell in *Astronomy* is, of course, Book Three on "Religious Views" where he attempts to prove that "the Creator of the Physical World is the Governor of the Moral World" as is stated in the title of Chapter I. The argument in this Book is no different from the other two Books: if the appearance of the Universe is reducible to "certain fixed and general laws," then the laws need "the Divine Power, Goodness and Superintendence […], agree[ing] in a remarkable manner with the views of the Supreme Being."[47]

Then Whewell misquotes, perhaps intentionally, the mechanical universe of Laplace to prove his own point (the original French is in the note):

But our more peculiar business at present is to observe that Laplace himself, in describing the arrangements by which the stability of the solar system is secured, uses language which shows how irresistibly these arrangements suggest an adaptation to its preservation as an *end*. If in his expressions we were to substitute the Deity for the abstraction "nature" which he employs, his reflexion would coincide with that which the most religious philosopher would entertain. "It seems that 'God' has ordered everything in the heavens to ensure the duration of the planetary system, by *views* similar to those which He appears to us so admirably to follow upon the earth, for the preservation of animals and the perpetuity of species."*

*Il semble que la nature ait tout disposé dans le ciel, pour assurer la durée du sustêm planétaire, par des vues semblables à celles qu'elle nous parait suivre si admirablement sur la terre, pour la conservation de individus et la perpétuité des espèces.—*Syst. Du Monde*, 442. (349–50)[48]

Whewell's strategy is obvious: first by "substitut[ing] the Deity for the abstraction 'nature'" (how could he dare?) and second by mistranslating "le ciel" (singular) to "the heavens" (which should be plural "les cieux" in French) thus adding quite a religious implication to where Laplace simply means the physical sky.[49]

Whewell's logic assumes an emphatic tone in the Preface to the seventh edition dated February 13, 1864—after the publications of Chambers' *Vestiges* in 1844 and Darwin's *Species* in 1859. Quoting authoritative texts from the Bible and Socrates and his own *Astronomy* in its former edition, he repeats the design argument for the First Cause. Naturally, he comes to a logical impasse: the inductive method he advocates refers less to material facts on which workable laws are based than on the evidence of design by which factual examples are selected. Here is the Catch-22 of induction:

But the same argument which I have urged against the Nebular Hypothesis would also, I conceive, refute this hypothesis [of natural selection] in this form: namely, the argument that the structure of animals at every stage of the word's history being thus derived by necessary causation from a previous state of the animal would, there must have been in that previous state of the germs of the adaptations which were afterwards produced; and that these germs and possibilities of adaptation must, in reality, contain evidences of design. The past

state of the animal world, out of which our present animal world was developed by natural causation, must contain evidence of design, *just as the egg contains evidence of design no less than the animal*. And this must be true, however far we go back in the history of the world, and however different the germs which we suppose to have existed in the womb of the past differ from the existing organized world:—however much the egg differs from the animal.[50] (emphasis added)

He thus ends up by resorting to a sort of Aristotelian teleology—instead of the acorn containing the germ of an oak tree, here we have: "the egg contains evidence of design no less than the animal." What started as an argument for the inductive method in sciences, which in theory reverses the deductive logic or a priori premise, ends up in fact pointing to the intelligence in nature filled with evidences of design.

This is no different from the problem to which Whewell tries to find a clue, not to say a solution, in his *History* and *Philosophy*. The first book is to establish "facts" in history (from the history of the inductive sciences themselves) to which to the inductive method is applied to draw out the philosophical ideas (again of the inductive sciences themselves) discussed in the second book. The facts chosen to be included in the first, however, need selections by principles which are only verifiable by the epistemological framework provided by the philosophical ideas in the second. Those ideas serving as criteria to settle facts out of jumbles of data are termed by the master of naming (Whewell himself) as "fundamental ideas" and the interplay between facts and ideas is called the "fundamental antithesis."[51]

The argument in the overall *Treatise on Astronomy*, therefore, is less about the relation between "religion" and "science" in our present-day understanding of the terms than about the epistemological compatibility between, on the one hand, particular facts in the physical world and, on the other hand, the universal law or laws which in theory are reachable through the inductive method of sciences best represented by Newton and Bacon and supported by Whewell.[52] This is no different from a dilemma that haunted many intellectuals in the period, including Poe in *Eureka* and Emerson in *Nature*[53] —the latter's *Essays, First Series* published in 1841, includes a chapter on the "Over-Soul" as the universal principle containing particular examples: "that Unity, that Over-soul, within which every man's particular being is contained and made one with all other."[54]

III.

Even though Whewell declined to review the anonymously authored *Vestiges of the Natural History of Creation* for *Quarterly Review*, the book instantly became a "Victorian Sensation." As James Secord points out, it presented a visual image typical of the Victorian period: "The first sentences—with its reference to the

JULY 19, 1845.]

THE EUREKA.

Such is the name of a Machine for Composing Hexameter Latin Verses, which is now exhibited at the Egyptian Hall, in Piccadilly. It was designed and constructed at Bridgwater, in Somersetshire; was begun in 1830, and completed in 1843; and it has lately been brought to the metropolis, to contribute to the " sights of the season."

The exterior of the machine resembles, in form, a small bureau book-case; in the frontispiece of which, through an aperture, the verses appear in succession as they are composed.

The machine is described by the inventor as neither more nor less than a practical illustration of the law of evolution. The process of composition is not by words already formed, but from *separate letters*. This fact is obvious; although some spectators may, probably, have mistaken the *effect* for the *cause*—the *result* for the *principle*, which is that of Kaleidoscopic evolution; and, as an illustration of this principle it is that the machine is interesting—a principle affording a far greater scope of extension than has hitherto been attempted. The machine contains *letters* in alphabetical arrangement. Out of these, through the medium of *numbers*, rendered tangible by being expressed by indentures on wheel-work, the instrument selects such as are requisite to form the verse conceived; the *components* of words suited to form hexameters being alone previously calculated, the harmonious combination of which will be found to be practically interminable.

THE EUREKA.

12.3 The "Eureka" Machine by John Clark, *London Illustrated News* (July 19, 1845). University of Tsukuba

12.4 Application of Mechanism to Periodical Journalism by George Cruikshank, *The Comic Almanack: An Ephemeris in Jest and Earnest, Containing Merry Tales, Humorous Poetry, Quips, and Oddities by Thackery, Albert Smith, Gilbert A. Beckett, The Brothers Mayhew, with many Hundred Illustrations by George Cruikshank and Other Artists*, Second Series, 1844–53 (London: Chatto and Windus, 1870–71), 120. University of Tsukuba

sun circled by planets circled by satellite moon—is a verbal orrery, calling up the central image of astronomical display."[55] This particular orrery, however, suggested neither First Cause nor Final Cause, creating anxiety for Whewell and other Bridgewater writers. It was its mechanistic view of the world that caused a scandalous dispute among the intellectuals.

Secord, besides pointing out the orrery image at the beginning, insists that *Vestiges* can be "*seen* as a museum of creation" (440) filled with images of scientific instrument expositions in the early 1840s in British cities. Exhibited there are two machines invoking particular interest. One of them, on display in 1845, was created, according to Altick's *Shows of London*, under the influence of the kaleidoscope of David Brewster (*Natural Magic*) and the difference engine by Babbage (*Ninth Bridgewater Treatise*), symbolically realizing a mechanistic worldview by composing Latin verse automatically - the "Eureka" (Figure 12.3).[56] A similar machine, whose "idea has been taken from *Eureka*, but very much elaborated," was drawn as the "New Magazine Machine" in *The Comic Almanack* (1846), producing essays, stories, and reviews mechanically only to displace altogether human authors (Figure 12.4).[57]

About the same time across the Atlantic, Edgar Allan Poe wrote an article entitled "Anastatic Printing"(1845).[58] Triggered by new improvements in the actual printing method in Germany in the 1840s,[59] this machine of Poe's invention and imagination (which Terence Whalen attributes to the influence of Babbage's difference engine) emphasizes one particular merit: it prints directly from handwritten manuscripts of the author, can reach a greater range of readers without any intervention from, in Whalen's phrase, "profit-oriented publishers."[60] The "New Magazine Machine" and Poe's "Anastatic Printing" emerging under the same influence around the same time thus marking an interesting contrast: the London machine operates on the mechanistic principle to get rid of the author; the Poe machine on a more "vitalistic" principle for direct connection between the author and the reader.

This contrast, in fact, is the major difference between the Eureka machine in London and Poe's prose poem *Eureka*. In this poetical essay published in 1848—after his struggles to establish himself as a professional writer and a magazinist—and one year before his untimely death—Poe unfolds his theory of the Universe with a logic moving from particular details to universal laws, back from universal laws to particular details only to repeat the procedure again—the procedure which Poe compares to "the Heart Divine."[61] It also points to the organic whole of *Cosmos* by Alexander von Humboldt to whom *Eureka* is dedicated—another endeavor to create a "vitalistic" mechanism of the Universe.[62]

Notes

1. The paper "The Universe in Cypher" (in Japanese) was first published in a co-edited book entitled *In Context: Epistemological Frameworks and Literary Texts* (2003), 339–59, and then revised and extended to be included as a chapter in *Daughters of Time: Art and Nature in Antebellum American Prose* (2005), 231–63.

2. Thomas Jefferson, *Notes on the State of Virginia*, ed., William Peden (Chapel Hill: University of North Carolina Press, 1982), 64.

3. Visit http://www.sciencemuseum.org.uk/collections/exhiblets/george3/orrery.asp for a moving orrery.

4. The resemblance to Newton is noted in "The Norton Anthology of English Literature" at http://www.wwnorton.com/nael/18century/topic.3/orrery.htm. Acknowledgment to Stacey Sloboda for the suggestion to compare pictures of Whitehurst and Newton.

5. Sally Gregory Kohlstedt, "Parlors, Primers, and Public Schooling: Education for Science in Nineteenth-Century America," *Isis* 81 (1990): 425–45. For an advertisement of Holbrook School Apparatus Manufacturing Co., see: *American Journal of Education* 1 (1856), 782. For further discussion of the Lyceum Movement and the Museum Movement, see: Carl Bode, *The American Lyceum: Town Meeting of the Mind* (Carbondale: Southern Illinois University Press, 1968), 10–15; George H. Daniels, *American Science in the Age of Jackson* (New York: Columbia University Press, 1968), 40–1; Donald M. Scott, "The Popular Lecture and the Creation of Public in Mid-Nineteenth-Century America," *Journal of American History*, 66 (1980): 791–809; Joel J. Orosz, *Curator and Culture: The Museum Movement in America, 1740–1870* (Tuscaloosa: University of Alabama Press, 1990).

6. *Household Works*, 18 (April 24, 1958): 434. Search on orreries in magazine sources was done on "Making of America" at: http://cdl.library.cornell.edu/moa.

7. Dionysus Lardner, *Hand-books of Natural Philosophy* (Philadelphia: Blanchard and Lear, 1853), 266.

8. *Harper's New Weekly Magazine*, 36, no. 6 (May 1853): 833.

9. Richard D. Altick, *The Shows of London* (Cambridge: Belknap, 1978), 364.

10. "On Orreries' Heads Orreries Accumulate," *Punch, or the London Charivari*, 20 (1851), 152 and "Another New Planet," *Punch, or the London Charivari*, 23 (1852), 270.

11. *The American Review*, 2, no. 3 (September 1945): 244; *The North American Review*, 97, 200 (July 1863): 146; *Harper's New Monthly Review*, 30, no. 180 (May 1865): 699. See also: I. Bernard Cohen, *Some Early Tools of American Science: An Account of the Early Scientific Instruments and Mineralogical and Biological Collections In Harvard University* (Cambridge: Harvard University Press, 1950), 156–157; Silvio A. Bedini, *Thinkers and Tinkers: Early American Men of Science* (New York: Scribner's, 1975), 165–8, 182, 327, 383–7, 391 and 401–5.

12. John Herschel, *A Treatise on Astronomy* (1833; London: Longman, 1851), 272. Reactions of John Herschel and Charles Dickens to orreries are mentioned (no page references) in: "World Wide Words: Michael Quinion Writes about International English from a British Viewpoint" at http://www.worldwidewords.org/weirdwords/ww-orr1.htm; Martin Beech, "The Mechanics and Origin of Cometaria," *Journal of Astronomical History and Heritage* 5 (2002): 155–63; Altick, *The Shows of London*, 365–6.

13. *Chambers's Encyclopaedia: A Dictionary of Universal Knowledge for the People* (Philadelphia: J. B. Lippincott & Co. and Edinburgh: W. & R. Chambers, 1865), 128.

14. Charles Dickens, *The Uncommercial Traveller* (London: Chapman & Hall, n.d.), 214.

15. For the discussion about the theological dilemma in the Clockwork God metaphor in relation to Herman Melville's "The Bell-Tower," see: Hiroko Washizu, "Two Clocks," *Daughters of Time*, 58–77 (in Japanese). For further discussion about the Clockmaker God metaphor, see: F.C. Faber, "The Cathedral Clock and the Cosmological Clock Metaphor," in *The Study of Time II*, eds, J.T. Fraser and N. Lawrence (New York: Springer-Verlag, 1975), 399–416; Samuel L. Macey, *Clocks and the Cosmos: Time in Western Life and Thought* (Hamden: Archon, 1980), 103–20 and 167–81; Gerhard Dohrn-van Rossum, *History of the Hour: Clocks and Modern Temporal Orders*, trans. Thomas Dunlap (Chicago: Chicago University Press, 1996), 284.

16. Secularization and temporalization of the world picture, especially in relation to the idea of the Chain of Being, are discussed in Arthur O. Lovejoy, *The Great Chain of Being* (1936; New York: Harper, 1960), 242–87.

17. For this famous episode, see: Michael J. Crowe, *The Extraterrestrial Life Debate, 1750–1900* (Mineola: Dover, 1999), 78; Edward Harrison, *Cosmology: The Science of the Universe*, 2nd ed. (Cambridge: Cambridge University Press, 2000), 96.

18. For Laplace's Nebular Hypothesis, see: Anon., "Astronomy of Laplace," *American Quarterly Review* (1830): 175–80; Anon., "Bowditch's Translation of the Mécanique céleste," *North American Review* (1839): 143–80; Gerald James Whitrow, "The Nebular Hypotheses of Kant and Laplace," *Actes* (12th Congres International d'Histoire des Sciences) (1968): 175–80; Roger Hahn, "Laplace's Religious Views," *Archive international d'histoire des sciences*, 8 (1955): 38–40; Stanley L. Jaki, "The Five Forms of Laplace's Cosmogony," *American Journal of Physics*, 44 (1976); 4–11; Ronald L. Numbers, *Creation by Natural Law; Laplace's Nebular Hypothesis in American Thought* (Seattle: University of Washington,

1977); Hahn, "Laplace and the Mechanistic Universe," in *God and Nature; Historical Essays on the Encounter between Christianity and Science*, eds, David C. Lindberg and Ronald L. Numbers (Berkeley: University of California Press, 1986), 256–76; Charles Coulston Gillispie, *Simon-Pierre Laplace, 1749–1827: A Life in Exact Science* (Princeton: Princeton University Press, 1997), 172–75.

19. This is a very famous episode established mainly by Darwin's *Autobiography*. One of the most recent example that mentions Darwin's reading of Lyell's *Geology* on the voyage of the *Beagle* is Sandra Herbert, *Charles Darwin, Geologist* (Ithaca: Cornell University Press, 2005), 49.

20. William Paley, *Natural Theology* (1802; New York: American Tract Society, n.d.), 9–10.

21. The Bridgewater Treatises in their cultural and religious context is discussed in: W.H. Brock, "The Selection of the Authors of the Bridgewater Treatises," *Notes and Records of the Royal Society of London*, 21 (1967): 162–79; John Hedley Brooke, "Natural Theology and the Plurality of Worlds: Observations on the Brewster-Whewell Debate," *Annals of Science*, 34 (1977): 221–86; Brooke, "The Natural Theology of the Geologists: Some Theological Strata," in *Images of the Earth: Essays in the History of the Environmental Sciences*, eds, L. J. Jordanova and Roy S. Porter (British Society for the History of Science, 1979): 39–64; John M. Robson, "The Fiat and Finger of God: the Bridgewater Treatises," in *Victorian Faith in Crisis: Essays on Continuity and Change in Nineteenth-Century Religious Belief*, eds, Richard J. Helmstadter and Bernard Lightman (London: Macmillan, 1990), 71–123; Jonathan Topham, "Science and Popular Education in the 1830s: the Role of the *Bridgewater Treatises*," *British Journal for the History of Science*, 25 (1992): 397–430; Topham, "Beyond the 'Common Context': The Production and Reading of the Bridgewater Treatises," *Isis*, 89 (1998): 233–62.

22. Paley, *Natural Theology*, 247.

23. Thomas Dick, *Christian Philosopher; or, the Connection of Science and Philosophy with Religion* (1823; Philadelphia: Key & Biddle, 1833). Dick also wrote "On Orreries or Planetariums," in *The Practical Astronomer*, vol. 1 of The Complete Works of Thomas Dick, LL.D (St Louis: Edwards & Bushnell, 1857), 179–83. For further readings on Dick, see: John A. Brashear, "A Visit to the Home of Dr. Thomas Dick: The Christian Philosopher and Astronomer," *Journal of the Royal Astronomical Society of Canada*, 7 (1913): 19–30; David Gavine, "Thomas Dick, LL.D, 1774–1857," *Journal of the British Astronomical Association*, 84 (1974): 345–50; J.V. Smith, "Reason, Revelation and Reform: Thomas Dick of Methven and the 'Improvement of Society by the Diffusion of Knowledge,'" *History of Education*, 12 (1983): 255–70; William J. Astore, *Observing God: Thomas Dick, Evangelicalism, and Popular Science in Victorian Britain and America* (Aldershot: Ashgate, 2001); Paul Collins, "Walking on the Rings of Saturn," in *Banvard's Folly: Thirteen Tales of Renowned Obscurity, Famous Anonymity, and Rotten Luck* (New York: Picador, 2001), 245–67.

24. Dick, *Christian Philosopher*, 114–15.

25. John Pringle Nichol, *Views of the Architecture of the Heavens, in a Series of Letters to a Lady* (1837; New York: Dayton & Newman, 1842), 40.

26. Nichol, *Views of the Architecture of the Heavens*, 32.

27. Nichol, *Views of the Architecture of the Heavens*, 115.

28. William Whewell, *Astronomy and General Physics, Considered with Reference to Natural Theology* (1833), 7th ed. (Cambridge: Deighton, Bell and Co. and London: Bell and Daldy, 1864; Bristol, England and Sterling, USA: Thoemmes, 2001).

29. Topham, "Science and Popular Education in the 1830s," 397.

30. Harvey W. Becher, "William Whewell's Odyssey: From Mathematics to Moral Philosophy," in *William Whewell: A Composite Portrait*, eds, Menachem Fisch and Simon Schaffer (Oxford: Clarendon, 1991): 12. Richard Yeo gives a slightly different number: "seventh edition in 1864" — Richard Yeo, *Defining Science: William Whewell, Natural Knowledge and Public Debate in Early Victorian Britain* (Cambridge: Cambridge University Press, 1993), 118. Michael Ruse writes the seventh in 1864 as the final ("William Whewell: Ominiscientist," in *William Whewell: A Composite Portrait*, 114).

31. A.W. Heathcote, "William Whewell's Philosophy of Science," *British Journal for the Philosophy of Science* 4 (1954): 302; Jack Morrell and Arnold Thackray, *Gentlemen of Science: Early Years of the British Association for the Advancement of Science* (Oxford: Clarendon, 1981), 425–30 and 539; Richard Yeo, *Introduction to History of the Inductive Sciences by William Whewell* (Bristol and Sterling: Thoemmes, 2001), v–xi. For biographical facts, see also: I. Todhunter, *William Whewell, D.D., Master of Trinity College, Cambridge: An Account of his Writings with Selections from his Literary and Scientific Correspondence*, 2 vols. (London: Macmillan, 1876).

32. The terminology of subjects mentioned here follows the titles of *Collected Works* edited by Yeo.

33. William Whewell, "Mrs Somerville on the connexion of the sciences," *Quarterly Review* 51 (1834): 54–68. For the coinage of the word "scientist," see: Sydney Ross, "'Scientist': The Story of a Word," *Annals of Science*, 18 (1969): 65–86.

34. Yeo, *Defining Science*, 109–112.

35. For the moral and theological dimensions of Whewell, see: Richard Yeo, "William Whewell, Natural Theology and the Philosophy of Science in Mid Nineteenth Century Britain," *Annals of Science* 36 (1979): 439–516.

36. Whewell, *Astronomy and General Physics*, 2.

37. Whewell, *Astronomy and General Physics*, 14.

38. Whewell, *Astronomy and General Physics*, 15.

39. Visit http://www.mainichi.co.jp/news/selection/archive/199908/31/083/e032-400/html and http://abcnews.go.com/sections/science/DailyNews/whale_hippo_990830html for the article by Prof. Norihiro Okada, Tokyo Institute of Technology, about the ancestral relation between whales and camels (in Japanese). To be more exact with the news on website, the common ancestor is established between whales and hippopotami (to which camels are related).

40. Whewell, *Astronomy and General Physics*, 131–32.

41. For vision in the nineteenth century, see: Jonathan Crary, *Technique of the Observer: On Vision and Modernity in the Nineteenth Century* (Cambridge: MIT, 1990); Thomas L. Hankins and Robert J. Silverman, *Instruments and the Imagination* (Princeton: Princeton University Press, 1995), 148–77.

42. Whewell, *Astronomy and General Physics*, 153–54.

43. Whewell, *Astronomy and General Physics*, 169.

44. Whewell, *Astronomy and General Physics*, 183–4.

45. Whewell, *Astronomy and General Physics*, 188.

46. Whewell, *Astronomy and General Physics*, 189.

47. Whewell, *Astronomy and General Physics*, 295.

48. Whewell, *Astronomy and General Physics*, 349–50. The Laplace quote is footnoted in the original.

49. Whewell, *Astronomy and General Physics*, xvi–xvii.

50. Acknowledgment to Raphael Lambert, University of Tsukuba, for assistance in the French–English translation.

51. For Whewell's philosophical and theoretical ideas, see: Manachem Fisch, *William Whewell, Philosopher of Science* (Oxford: Claredon, 1991); John Wettersten, "William Whewell: Problems of Induction vs. Problems of Rationality," *British Journal for the Philosophy of Science*, 45 (1994): 716–42.

52. For the Baconianism of Whewell and his contemporaries, see: Richard Yeo, "An Idol of the Market-Place: Baconianism in Nineteenth Century Britain," *History of Science*, 23 (1985): 251–98.

53. For the discussion of the problem between material facts and ideal law in relation to Emerson's *Nature*, see: Hiroko Washizu, "'Evolving' Nature: Early Emerson 1833–1836," *Daughters of Time*, 213–30.

54. Ralph Waldo Emerson, "The Over-Soul," Chapter IX, *Essays, First Series*, eds, Alfred R. Ferguson and Jean Ferguson Carr (Cambridge: Harvard University Press, 1987), 157–75. The relation between "religion" (particularly monotheistic Christianity) and "science" (as it was formed at the beginning of nineteenth century) will be discussed in my forthcoming "William Whewell: the 'Scientist' and the Design Argument." Acknowledgment to Minsoo Kang for calling my attention to this interesting and huge problem.

55. James A. Secord, *Victorian Sensation: The Extraordinary Publication, Reception, and Secret Authorship of Vestiges of the Natural History of Creation* (Chicago: University of Chicago Press, 2000), 440. The first sentence of *Vestiges* reads as follows: "It is familiar knowledge that the earth which we inhabit is a globe of somewhat less than 8000 miles in diameter, being one of a series which revolve at different distances around the sun, and some of which have satellites in like manner revolving around them"([Robert Chambers,] *Vestiges of the Natural History of Creation and Other Evolutionary Writings*, ed., James A. Secord (Chicago: University of Chicago Press, 1994), 1).

56. Secord, *Victorian Sensation*, 440; Altick, *The Shows of London*, 356–7.

57. Secord, *Victorian Sensation*, 447.

58. Edgar Allan Poe, "Anastatic Printing," *Broadway Journal*, 1 (Jan 1845): 15, rpt. in *The Complete Works of Edgar Allan Poe*, XIV, ed., James A. Harrison (New York: AMS, 1965), 153–9.

59. See: http://www.ephemera-society.org.uk/articles/anastatic.html

60. Terence Whalen, *Edgar Allan Poe and the Masses: the Political Economy of Literature in Antebellum America* (Princeton: Princeton University Press, 1999), 53–4 and 262–3.

61. Edgar Allan Poe, *Eureka* (New York: Putnam, 184), rpt. in *The Complete Works of Edgar Allan Poe*, XVI, ed., James A. Harrison (New York: AMS, 1965), 179–315.

62. Acknowledgment to Hiroyo Sugimoto (University of Tsukuba) for technical assistance, William Sell (The Last Word) for editorial. Much thanks to all the participants in the symposium on "Visions of the Industrial Age" at Loyola Marymount University on May 12–13, 2006, for their warmest welcome and encouragement.

Part V
Exposing the modern

Stripped: Gustave Caillebotte and the carcass of modern life

Paula Young Lee

The French post-Impressionist painter, Gustave Caillebotte (1848–94), is best known for large canvases showing fashionable Parisians strolling through broad boulevards, marking the expanded scale and tempo of the Second Empire city. However, one of Caillebotte's most memorable paintings paused on the side of the street, showing a full-size, freshly dressed carcass of a calf, ready for wholesale (Figure 13.1). Informed by materialist values, this flesh is disturbing to see. But was it troubling to nineteenth-century viewers? Does the "problem" of this image reside in the representation of an unconventional nude, or in the frank revelation of the animal origins of meat?

To acknowledge the semblance between animal flesh and the human frame results in "indiscreet" hallucinations; to insist on the resemblance is predictably offensive.[1] As Douglas Druick has pointed out, *Veau à l'étal (Veal on Display)*, c. 1884, ventured into this troublesome realm, by offering the pink and tender flesh of the calf as if it were a "femme fatale" lovingly adorned by the butcher.[2] He compared the calf's "feminized" body to the trapeze artist, Miss La La, the subject of Edgar Degas' painting, *Miss La La au Cirque Fernando*, 1879. Nonetheless, while both canvases exploited the dynamic tension between voyeurism and display, there were significant differences between their compositions. Degas showed Miss La La suspended by her teeth and viewed from a deforming angle, pushing her high up in one corner of the asymmetrical canvas. By contrast, Caillebotte positioned his carcass in the middle of the frame, emphasizing a symmetrical position that flattened the amputee's stilled torso. The palette is light and clear, infused with pinks and violets that suggest tiny blood vessels still pulsing with life beneath the shaved epidermis. This carcass is thoroughly washed, no viscera or *disjecta membra* are in evidence, and the conventional garland is

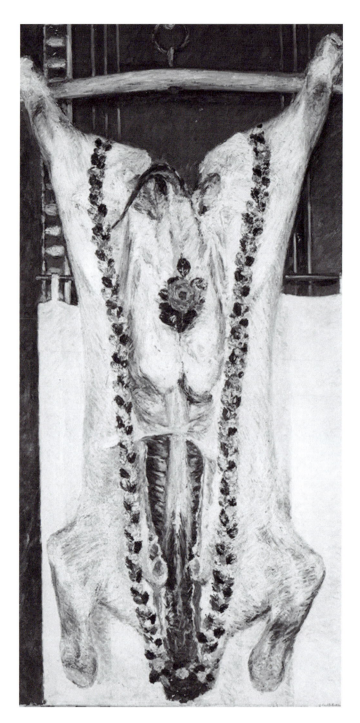

13.1 Gustave Caillebotte, *Veau a l'étal*, oil on canvas, 1883 (private collection). Photo: Réunion des musées nationaux

fresh, signaling that the meat has not been sitting out long enough to become putrid. Firm of flesh, free of decay, and smelling of roses, this veal appears to be an excellent value. As painted by Caillebotte, this offering does not inspire repugnance. Instead, as Druick noted, "the carcass has been dressed in an overtly coquettish fashion, the rose applied to the 'breast' suggesting a corsage adorning the décolletage of a fashionable beauty." In sum, this carcass is conceived as a delirious object of desire, both a scrumptious hack of fresh meat as well as the remains of a stupid hussy, known as a *veau* (calf) according to the slang of the period.[3]

In this case, however, the seductive body is physically inverted along with the conventional signs of sociability, and the rose is not located at her "breast" but is covering his sex.[4] Akin to a male transvestite, the young carcass has been carefully dressed to obscure the biological markers of sexual identity, and draped in the contemporary markers of bourgeois desirability. By being stripped of its hide, the male calf's body reveals the cultural codes of femininity enacted through public display, even while confronting the sexual taboos represented by the consumption of meat. The following essay explores the themes of inversion, masquerade and disguise that can be traced through Caillebotte's painting. Its objective is to situate this work inside a specific cultural context fraught with competing markers of social position. Notably, the exploration of ambiguous genders and sexualities emerged as a recurring theme in French literature of this period. For example, Joris-Karl Huysmans' decadent novel, *A Rebours (Against the Grain)*, 1884, finds the aristocratic protagonist Des Esseintes in love with Miss Urania, a well-muscled female trapeze artist performing in the *Cirque*. Night after night, he watches her, mesmerized with lust and adoration. But as he gazes:

> her pretty allurements, her feminine affectations fell more and more into the background while in their stead were developed the charms attaching to the agility and vigour of a male. In a word, after being a woman to begin with, and then something very like an androgyne, she now seemed to become definitively and decisively and entirely a man.[5]

Des Esseintes contrives a sexual liaison with Miss Urania, but is disappointed by her "stupidity" and sexual "Puritanism" (i.e. refusal of anal sex, then known as "Uranisme"). He quickly discards her, but acknowledges that her flesh, being that of a "sound and wholesome animal," was more robust and satisfactory than other women's "sweetmeats." Later, it is with a "strangely attractive" male street urchin with "cherry" lips and "swaying hips" that Des Esseintes finds his "most alluring liaison ... never had he run such risks, nor had he ever been so well content with such a grievous sort of satisfaction." Throughout the novel, Des Esseintes's reluctant carnality expresses itself through the eating of meat, as his effete sensibilities are

both repulsed by and attracted to the blood and fat of animal flesh-food. He is offended by modern life and the vulgarity of sex, yet he does not abstain: he is merely contemptuous of his desires.

This essay argues that *Veau à l'étal*, painted the same year that *A Rebours* was published, can be similarly viewed in gendered layers that were selectively deceptive. Just as Miss Urania's beads and spangles were calculated distractions, so too was Caillebotte's veal carcass ornamented with conspicuous signs of feminine seduction. In both instances, they masked the pitiless transactions of the marketplace, where the control and circulation of buyers, audiences, sellers, and performers, reiterated a bourgeois ideology of patriarchal authority in Second Empire Paris. They admitted that sexual transactions took place with a kind of homogenous indifference, while refusing to moralize or narrate the irreducible materialism driving these exchanges. Yet if the transactions themselves were neutral, exchanging francs for flesh, the tastes of buyers were subjective, reflecting variable and distinct communities framed around sexual orientations. Offering a site where public and private domains collided, Caillebotte's artfully contrived carcass served a refined palate that possibly went "against the grain," turning conventions upside down while quietly masquerading in convention.

In late-nineteenth-century Paris, a slaughtered calf was one more ordinary delicacy available for purchase at Les Halles Centrales (constructed 1854–66), the famed wholesale food market, where a "spectacle of edibles (*nourritures*)" delighted the eye and tempted the stomachs of thousands of hungry consumers.[6] By the late nineteenth century, meat had replaced bread as the subsistence food that commanded the popular imagination, yet quality cuts were too expensive for the working class to afford. Their frustrations were explored by Emile Zola's *Le ventre de Paris* (*The Belly of Paris*), 1873, which evoked the sumptuous display of body parts at Les Halles to collapse the distance between physical pleasure and death. Rendered impotent by poverty, Zola's protagonist, Florent, presses his face into the iron grating surrounding the marketplace and stares at the delightful cornucopia of carcasses, "all streaked with yellow fat and sinews, and with bellies yawning open." Florent passes through sidewalks laden with "pallid calves' feet and heads, the rolled tripe neatly packed in boxes, the brains delicately set out in flat baskets, the sanguineous livers, and purplish kidneys." The tempting sight leads Florent to be "attacked by a sort of rage," but he does not understand why. His confusion reflects the economic disparities that allowed the bourgeoisie to enjoy luxuries beyond the proletarian's means, but not beyond his fantasies and desires.

Unfulfilled hunger became a classed state, coded to the kinds of foods that were out of the economic reach of the masses but were dangled, Tantalus-like, in front of them. Hunger thus became a way to symbolically

express the illegitimate lusts that threatened a moral order already destabilized by the incursions of industrialization in the social landscape, for it fixated on surplus foods that constantly provoked the desire for gratification but were not required for survival. Inside the capitalist city, the display of "forbidden" food became a metaphor for transactional sex, the kind that was not reproductive but purely commercial, indulgent, capitalizing, and capitalistic. Yet if sexual satisfaction could be bought, it sometimes came with hidden costs. A taste for veal in particular was linked to the sale of youthful bodies in the bourgeoning sexual market, a purchase that promised carnal pleasure but also carried the potential of infection. "Calf" (*veau*) was slang for a particular kind of soft young girl, whose pale, "adipose" flesh was especially likely to transmit venereal diseases to unwitting young men, who tended to see these "lymphatic" creatures as harmless, easy, and stupid:[7]

O you, studious youths,	*O vous, jeunes étudiants,*
If for calves you have the hots,	*De veaux si vous êtes amants,*
Be afraid, be very afraid of the pox.	*Craignez, craignez fort la vérole.*

Over the 1870s and 1880s, ribald examples of human "meat" for sale had appeared in *La Caricature* and other similar venues, repeatedly mocking the sexual peccadilloes of Parisian society with a knowing wink that diffused critical responsibility. In 1883, for example, the canvas that "everyone was talking about" was not *Veal on Display* (which was exhibited only once before the Caillebotte retrospective of 1994), but Georges Antoine Rochegrosse's *Andromaque*, a showpiece for the annual Salon (Figure 13.2). This "outrageous" canvas depicted a dramatic scene from the Trojan War, which showed Astynax, the son of Hector, being "snatched by the Greeks from his mother, Andromache." Critic Edmond About found much to admire about the painting's dramatic force and ambition. Still, Andromache's figure, "with its enormous breasts, large thighs and ballooning belly," fell short of an "ideal princess," and there was something odd about the fact that certain historical details looked as if they had been "exhumed by Schliemann, the wise and patient grocer (*épicier*)."[8] Overall, he concluded, "there are too many cadavers, too many severed heads, too much coagulated blood, and too many hanged bodies. But the fury that cuts across this carnage is truly young and entirely French."

So many body parts were scattered across *Andromaque* that a parody appeared in *La Caricature* which cast it as a "cannibal's butcher shop (*charcuterie anthropophagique*)" (Figure 13.3). A broken female cadaver became a generous plate of sausage links, and piles of severed heads reappeared as heaping loaves of bread. The parody also copied the row of human corpses strung up in the background of Rochegrosse's painting,

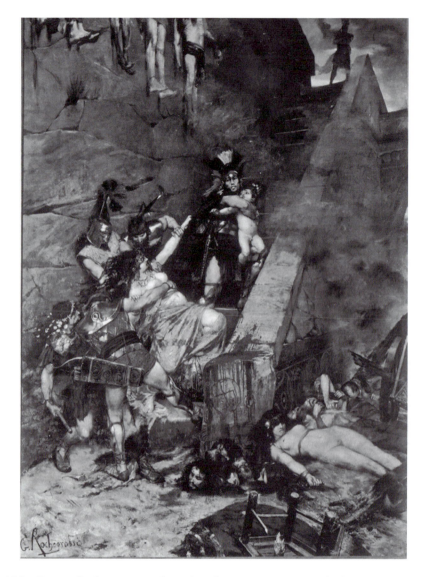

13.2 Georges Rochegrosse, *Andromache*, oil on canvas, 1883. Musée des Beaux-Arts, Rouen. Photo: Réunion des musées nationaux

but labeled them for sale as first-quality carcasses of fresh muscle meat. Customers could purchase slabs of "*hommstecks* (mansteaks)" and "*femmestecks* (womansteaks)" just as they might order cuts of beef and veal. But because these quality meats were expensive, *La Caricature* pointed out, impoverished clients might decide to steal a fatty child on their own, and grind him up into sausages.[9]

A TRAVERS LE SALON, — par A. ROBIDA

Le chef-d'œuvre du Salon.— Devant ce furieux morceau, les petites nymphes plus ou moins anémiques pâlissent, les petits saints, les petits soldats, les petites dames, les petits Espagnols frémissent.... Racine, l'auteur de l'autre Andromaque, celle qui est en vers, s'évanouit d'horreur.

Andromaque, par Georges Rochegrosse.
Charcuterie anthropophagique pendant le siège de Troyes. Homm-steaks de premier choix et tendres l'emm-steaks. Des clients malhonnêtes, ne pouvant se payer un gigot, essayent d'emporter un enfant pour en faire de la chair à saucisses.

Les Grecs académiques de la tradition traitent ceux de Rochegrosse de sauvages et déclarent que ces Peaux-rouges sont incapables de parler en alexandrins.

13.3 A. Robida, "A travers le Salon [Andromache]," *La Caricature*, 1883. Photo: Special Collections, University of Michigan Library

In this satirical context, steaks were literally priced too high for many to reach, encouraging the poor to steal and kill for their second-quality meats. A caricature could directly substitute humans for animals and suppose them equally edible: that was the joke. But the image's deft elision of man into meat also exposed the unspoken terms of an expanding cultural field, informed by the pitiless imperatives of industrial capitalism and its abstraction of lives

into labor-units. *Andromache* raised these themes through allusions to slavery in the ancient world. *Veal on Display* discarded the literary veils, stripping the working body to its animal essentials, and exposing the contemporary underbelly of capitalism as monstrously soulless and hollow. By painting the pale white carcass of a lymphatic calf, rather than the carcass of a pig, sheep, or cow, Caillebotte embedded his painting inside anxious dialogues regarding the buying and selling of human labor. The unresolved ethics regarding the commonplace abuses of the marketplace partly accounted for the hypocritical prominence of the prostitute's image in artistic and popular representation, for she was commodity, workforce, and waste all at once. Just as euphemisms such as "public girl" (*fille publique*) and "crazy virgin" (*vièrge folle*) avoided the ugly directness of naming a woman as a prostitute, Caillebotte's exploration of purchasable sex took refuge in the commercialized banality of the carcass. By depicting a bovine carcass gaily decorated with garlands, Caillebotte combined the reality of raw meat with the orgiastic release of carnage. The image eroticized the institutionalized violence that brought this "fashionable coquette" into being, even while thrusting the abject flesh forth as the subject of the painting.

In the society of the spectacle, the feminine body was the conflicted symbol of consumerism, giving rise to the primacy of the venal goddesses such as Zola's fictional prostitute Nana, or the Moulin Rouge performer known as La Goulue ("the Glutton"). In the history of art and art criticism, however, the potent collision of death with desire has been most consistently evoked by Edouard Manet's now-canonical *Olympia*, 1865, a painting of a naked reclining courtesan and her African maid, delivering her a large bouquet of colorful flowers. For Symbolist poet Paul Valéry, Manet's painting revealed "the primitive barbarism and ritual animality" of prostitution, raising the specter of moral sickness lurking in Olympia's tired flesh. Appalled by her brazen nudity and dull stare, art critics of the period characterized Olympia as a "hottentot Venus" who had died of "yellow fever,"[10] and likened her bony body to a "putrefied" corpse displayed in the Morgue, where the anonymous dead were stripped of their clothing and placed out on slabs for public inspection, perchance identification.[11] For audiences of the period, in other words, she was visibly marked as undesirable sexual purchase, as betrayed by her pallid tones, the decomposing state of her body, and the soulless stare of an animal.

The ubiquity of analogies between prostitutes such as Olympia and various kinds of ignoble animals (including "spiders," "toads," "apes" and, "gorillas"), reveal the degree to which public dialogues over the sex trade were aligned with debates over the regulation of meat, as both were narrated through the rising rhetoric of social hygiene, augmented by the fear of incurable diseases. The axis of these dialogues was food. For rather than simple poverty or starvation, it was overwhelming hunger that convinced a poor, desperate

woman to sell her body. For liberal reformer Alphonse Esquiros, there were two kinds of prostitutes: those who were promiscuous "by nature," and those who entered the profession due to external "circumstances." Yet even "prostituées de race" were not driven by their libidos. Instead, they were victims of their stomachs, for "everyone knew" that an "honorable living" could not satisfy their terrible cravings. A woman gripped by one of these "cursed appetites" (*faims maladives*) could consume enough at one sitting to feed "fifteen or eighteen" adults.[12] Crushed by the expense, a poor household would throw her out, forcing her to endure a "thousand deprivations" and commit her taste buds to "abstinence." Maddened by hunger, she would turn to beggary and theft. Eventually, however, she would resort to eating twigs, bark, grass, and other raw plants like a "herbivore," causing her to suffer "frightful" gastritis. Such humiliations would make her appreciate the "ample tables" of brothels, and she would gratefully accept prostitution as the only means to soothe her grumbling stomach. For Esquiros, this affliction was the "scourge of the poor and the delight (*jouissance*) of the rich," for these hapless women, rendered vulnerable by their overwhelming hunger, would allow their bodies to sate the sexual appetites of the wealthy, reinforcing classed relationships inside a consumer society.

Because it literalized the socio-economic relations enacted by capitalism, this hierarchical configuration was both grossly crude and tacitly sanctioned. Inside the *métier* itself, there was a loose hierarchy from *grande horizontale* to streetwalker, with prices scaled accordingly. Yet certain "devouring girls" (*filles dévorantes*) professed unusual tastes for boys that even offended hardened sensibilities, in part because they reversed the cycle of consumption and turned the client's flesh into food that could satisfy sexual and regular appetites simultaneously:

These miserable girls, known to their colleagues by the disgusting name of *gouapeuses* [~skanks] have made debauchery into a trough. Their insatiable bellies are like a shadowy cave which swallows every day, along with food, their honor and freedom.[13]

Such girls would never stop or be satisfied, Esquiros lamented, and they violated public morality as they took each perverse bite. The larger, more disturbing problem was that any female might be gripped by lascivious appetites, provoked by the very proximity of delicacies that shoved temptation down their throats. In sum, Esquiros argued that the combination of "gourmandise" and poverty rendered a vacillating woman susceptible to surrendering her virtue, but it was capitalism itself that produced prostitution, which was systemic, not individual.

As described by historian Philippe Robert-Jones, the journal *La vie parisienne* finally invited censorship in 1880 when it published an engraving by Hy entitled "How They Eat Asparagus."[14] It offered a series of vignettes that opened with a group of nubile women staring at market window display

in an attitude of "lèche vitrine" (licking the window, i.e. standing with their tongues hanging out), entranced by the display of stiff phallic vegetables such as carrots, young eggplants, and thick stalks of asparagus, all standing on end. The vignettes that followed focused on the young women's response to being served asparagus in fine restaurants. Some swallowed the stalk with gusto, whereas others chewed with "incertitude." One helpless beauty not only took it from the "wrong" end but missed her mouth entirely, obliging the nearest man to present himself as her helpful instructor. The obvious allusions to fellatio were followed by an equal-opportunity celebration of cunnilingus, "Comment ils mangents les moules" (How They Eat Mussels), which appeared in *L'Evénément parisien*. This caricature illustrated a variety of modern men who appreciated this special dish, but took the concept one step further by featuring a female aficionado of seafood. It was true, the journal demurred, that women were generally not very interested in mussels. "But if she develops a taste for them, it becomes a mania (*une folie*)."[15]

The jump from libertinage to lesbianism was too much: *L'Evénément* had already been forced to withdraw its cover for August 1880, and this illustration only contributed to the furor over the indecency of public images. Suggestive imagery was popping up everywhere, ranging from the ephemeral (and extremely vulgar) *Gazette grivoise*, to the largely mainstream, satirically oriented *La Caricature*, which in 1880 parodied Honoré de Balzac's *Peau d'ane* (Magic Skin) with "Le Porte-Bonheur de Pornocratés, histoire fantastique" (The Fantastical Story of Pornocrates's Good Luck Charm), by author/illustrator Trick.[16] In Balzac's tale, the charmed skin of an ass grants all wishes, but it shrinks every time a wish is granted, and takes a bit of the owner's life along with it. In Trick's tale, a provincial truffle dealer named Ernest Pornocratés goes to Paris to sate his "ferocious" libido. To assist his seductions, he hangs a little gold pig charm around his neck, prompting the Devil to offer a deal: Ernest will be able to seduce anyone he desires by rubbing the gold pig. But the charm will grow in size each time a wish is granted, and it will never shrink back. Overjoyed, Pornocratés rubs his talisman, and the Devil makes good on his promise. Intoxicated by success, Ernest begins to rub it constantly. The gold pig hanging around his neck grows monstrously large, yet Pornocratés is unwilling to give it up. The charm eventually becomes larger in size than the man, springs to life, and makes a slave out of the truffle merchant, who ends up on all fours being whipped and ridden by the laughing pig, implying a deviant turn towards masochism and homosexuality in the masturbatory quest for sexual fulfillment.

Gleefully, in 1882 *La Caricature* published a special issue mocking "La grande epidémie pornographique" (The Great Pornographic Epidemic, Figure 13.4).[17] The cover showed a dewy ingénue astride a plump pig, both of which were carried aloft on the shoulders of sows and hogs with festive hats and human bodies. Beneath, the captions lamented the "horrible"

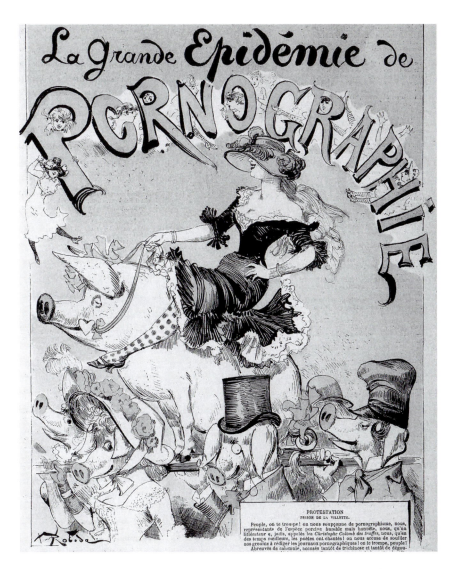

13.4 "La grande epidémie pornographique (The great pornographic epidemic), in *La Caricature*, 1882. Photo: Special Collections: University of Michigan Library

disease of trichinosis, which struck men aged "16 to 78." This appetite for forbidden food was the ultimate in bad taste, facilitating the rapid spread of the "pornographic virus" through the boulevards of Paris. The larger lesson, however, was that appearances were deceiving: both pig and prostitute might appear healthy, but their flesh could be diseased. In the 1880s, the general public was battling the corrosive effects of food-borne infections, a reflection of growing epidemiological awareness combined with the politics of social

hygiene. The threat of trichinosis had prompted French protectionists to reject the import of American pork, raising public concern for the lax sanitary standards regarding the meat industry as a whole.[18] Notably, other dietary staples such as bread, wine, and cheese were largely exempt from the cascading fear of parasitic infections lurking in slaughtered meat. Though the health problem posed by trichinosis was far from being a myth, the social anxiety swirling around animal flesh transformed the pig into a scapegoat: the spread of trichinosis played out moralizing themes that had no medical connection to the etiology or prophylaxis of the disease. Were the "poor but honest" pigs at the centralized Parisian slaughterhouses at La Villette the source of this "distasteful" affliction? No, they protested: "Our lard is pure!" As they complained, their impoverished condition not only made them the hapless targets of this disease, but also made them pay for a social problem that was ultimately caused by others.

For *La Caricature*, the woes of pigs were a pretext. The actual subject of its special issue was the precipitous rise of sexual consumerism and the decline of moral standards, a volatile combination strongly linked to the explosion of print culture and its promiscuous indulgence of images. In the 1880s, for example, several luxury editions of the late-seventeenth-century *Contes et nouvelles en vers*, composed by Jean de La Fontaine, featured "Le Villageois qui cherche son veau" (The Countryman Who Went Looking for His Calf).[19]

A *Countryman*, one day, his calf had lost,
And, seeking it, a neighbouring forest crossed;
The tallest tree that in the district grew,
He climbed to get a more extensive view.
Just then a lady with her lover came;
The place was pleasing, both to spark and dame;
Their mutual wishes, looks and eyes expressed,
And on the grass the lady was caressed.
At sights of charms, enchanting to the eyes,
The gay gallant exclaimed, with fond surprise:—
Ye gods, what striking beauties now I see!
No objects named; but spoke with anxious glee.
The clod, who, on the tree had mounted high,
And heard at ease the conversation nigh,
Now cried:—Good man! who sees with such delight;
Pray tell me if my calf be in your sight?

An 1884 edition featured three sets of illustrations for each tale: a 1762 version by Charles Eisen (1720–78) (Figure 13.5), a 1774 version by Jean-Honoré Fragonard (1732–1806), and a final version by an unidentified nineteenth-century artist. Both Fragonard and Eisen were established eighteenth-century academic artists identified with the Rococo style, whose eroticized work was formerly confined to a handful of aristocratic viewers. Their versions of this illustration were very similar, seducing the eye with their expert control of line

13.5 Charles Eisen, "Le Villageois qui cherche son veau," in Jean de La Fontaine, *Contes de la Fontaine*, Amsterdam: 1762, vol. 2. Typ 715.62.509 (A), Department of Printing and Graphic Arts, Houghton Library, Harvard College Library

and tone, while stressing the lubricious tone of the dialogue by their choice of scene and placement. Without apology or embarrassment, they made it clear to their sophisticated audience that the "calf" was not the whole woman, but was specifically her vagina.

In the manner of Fragonard's painting *The Swing, c.* 1766, the lady's gallant peers up her skirt. He gazes at intimate parts that are hidden from our own voyeuristic gaze, for the female sex is that no-thing, par excellence, which is seen yet is not seen. (As the gallant exclaims: "Que vois je! Et que ne vois-je pas!", or what translates literally as "What I am seeing! And what I am not seeing!"). Subjected to physical and symbolic displacement, her genitals are recapitulated in the lover's *tricorne* located in the lower right corner. Upended, the hat's convex interior is exposed, inviting us to peer inside its dark and humid depths, the better to ascertain that there is nothing but a void. From the overhead angle, the countryman's gaze is also directed between the lady's thighs, even as he positions himself between outstretched tree limbs that approximate the receptive position of her legs. Yet instead of envisioning sexual conquest, the bumpkin remains blind to all except his quest to find his own lost "thing," i.e. his social-sexual potency. Losing his cow means losing his livelihood; without it, he cannot perform as a "good man," but requires another to act in his stead. ("Homme de bien, qui voyez tant de choses,/Voyez-vous point mon veau?") Thus the bumpkin never sees any part of the woman because he is symbolically castrated, and his blinkered eyes cannot penetrate the forest of symbols. As a result, only one man enjoys visual authority. The other is stuck up a tree.

Regardless of the vantage point from which the woman was seen, her body was the projective site of anxious masculinity enacted through a compromised gaze. Because her sex eluded the capacity of representation, it was the vexed and dangerous sign of male incompetence. For, as David Kunzle has written, "what is woman when she has discarded her outer clothes, and her physical (and moral) degeneracy stands exposed?"[20] The terrifying answer, as Olympia's body had showed, was "nothing at all" (*rien de tout*): she was either a gaping void, or a "shapeless" mass that slipped through the fingers, eluded the eye, and defied legitimate order.[21] As Gerald Needham has argued, *Olympia* quoted the graceless nudity of pornographic photographs, the market for which was steadily rising as reproductive technology made such images cheaply available.[22] Nonetheless, though they shocked bourgeois sensibilities, the photographs were barely more lascivious than academic nudes and rehearsed many of the same conventions. Their relative state of modesty stood in stark contrast to a cache of images seized by the Paris police in the 1840s, which frankly exposed the "striking beauties" at which Fragonard's gallant had been peering. Dispensing with the rest of the female body, these photographs were so resolutely gynecological in emphasis that they were delivered to Ambroise Tardieu (1818–79), a prominent medical professor at

the University of Paris. Because the camera had been thrust between each woman's legs, Tardieu commented, the eye "penetrates so far" into the vagina that it seemed held open by some artificial means. That "singular level of obscenity" prompted him to conduct an extended experiment on the residents in Saint-Lazare women's prison, whom he posed in exactly the same positions as his "horrible" images. Quite literally, his gaze—the gaze of social hygiene and corporeal regulation—was a phallic instrument, legitimized by medical science but still profoundly dehumanizing. From studying this "very large" population of inmates, most of whom were prostitutes, he concluded that the astonishing dimensions of certain vaginas he had seen in the obscene photos were perfectly "natural" in some women.[23]

Obsessed with codifying the flesh, Tardieu's search for the "material traces and physical effects" of prostitution was a symptom of social anxiety, as was his belief that sexual proclivities were causally linked to visible traits (qua "deformities") of the genitals. Clucking away in disapproval, he produced seven revised French editions of *Etude medico-légale sur les attentats aux moeurs* (Medical-Legal Study of Offenses Against Morality, first edition, 1857). Ten years into his influential project, Tardieu expanded his map of moral physiology to include homosexuals and male prostitutes. For him, the fact that male streetwalkers "frequently" dressed as girls posed a major threat to social stability. Whether they disguised themselves as females to please their customers or to fool the police, these youths could achieve such a "complete metamorphosis" of appearance that it was impossible to discern the ruse based solely on visual inspection. The incompetence of the public eye was such that in 1853, cross-dressing for men and women had been criminalized in France. For Tardieu, this "mélange of both sexes of prostitutes," i.e. a homosexual man dressed as a heterosexual woman, was the truest form of "promiscuity." It was also a matter of acute interest for the public welfare, for the cross-dressed male prostitute "proved" that "pederasts" (i.e. homosexuals) were capable of intercourse with women.[24] *Sartor resartus*: the transvestite as bisexual.

This kind of ambiguity reinforced Tardieu's desire to find the inalterable physiological signs of male deviancy, such as a flaccid penis that is "too voluminous," which signaled a choked sexual impulse that had no legitimate outlet. Indeed, Tardieu noted, sometimes the "strangled" male organ is so outsized that it suggests "the muzzle of certain animals."[25] Tellingly, Tardieu's analogy may help explain the critical attention on the "extraordinary extending" muzzle of a cow in a field, painted by Caillebotte a few years before he ventured its carcass.[26] Critic Louis Leroy complained:

with what disdain for form Monsieur Caillebotte has treated the muzzle of
a certain heifer at pasture and the head of the goat, her companion: the one,
indefinitely elongated, looks as though it had been put through a rolling mill;
the other ... looks like nothing at all. Which is pushing independence too far.

[avec que dédain de la forme M. Caillebotte a traité le muffle de [sic] certaine génisse au pasturage et la tête de la chèvre, sa compagne: l'un, allongé indéfiniment, à l'air d'avoir été passé au laminoir; l'autre … n'a l'air de rien de tout. Ce qui est pousser l'indépendance trop loin (ellipses in original).][27]

That muzzle was strangely unable to go in the expected (heterosexual) direction, as noted by Draner's convoluted question: "le veau, en est-ce bien un? [the calf, is it really?]"[28] This question was a paraphrase of Baudelaire's famous query, "Est-ce un chat, décidement? [Is that really a cat?]" in reference to the black smear dirtying the end of Olympia's well-used bed. To connect that illegible cat to this muzzled calf suggests a sexual theme informing this painting, expressed through a visual pun that juxtaposed that scandalous "pussy" against a transgressive "penis." It was sufficiently obvious to amuse the critics, who found the canvas so "phenomenally" funny that any viewer would collapse in "wild laughter" in front of it.[29] As painted by this "most virile" artist,[30] the calf was both phallic and feminine, prompting Draner to decide that it belonged inside a "museum of antediluvian antiquities" next to other animals assembled from mismatched parts. Three years later, Leroy referred to Caillebotte's painting of "a calf" as "legendary," and though his remark was tinged with sarcasm, it confirms that there was something more operating here than just a bucolic image of farm animals grazing.[31]

When La Fontaine's peasant exclaimed, "Good man! who sees with such delight; Pray tell me if my calf be in your sight?" one might well ask that same question of *Calf in a Landscape*. The central animal is a "calf" (*veau*), but also "heifer" (*génisse*), and "cow" (*vache*). None of these terms were mutually exclusive, and all three clustered around the attributes of youth and femininity. Yet the shifts reflect ambiguities of age and gender that exempted the goat, even though she appeared to be "nothing at all," exactly like Olympia's troublesome body. Interested only in eating the grass, the goat went unnoticed.[32] Only the bovine muzzle was the legitimate object of the viewer's attention, insofar as it was that "thing" which was not only visible but possessed the capacity for Pinocchio-like extension. But what if Baudelaire's and Draner's questions were meant to raise another possibility? What if, by asking "is that really a calf/cat?" they were suggesting that these feminine creatures were not female? For Baudelaire, at least, was surely aware that the phrase echoed Théophile Gautier's poem, "Contralto," in *Emaux et camées*, 1853, which asked of an uncanny statue of troubling beauty: "Est-ce un jeune homme? Est-ce une femme,/Une déesse, ou bien un dieu?" (Is it a young man? Is it a woman? A goddess, or rather a god?). Whether asked of supine prostitutes or curious cows, the question reveals underlying ambiguities of gender and sexuality that were still manifest in nakedness. They demonstrated how easily a passive body with no clothes still resisted categorization, a state of indeterminacy that was politically inadmissible because it could not be regulated. That these bodies were "animal" merely exacerbated the fact that

they were really "pushing independence too far," while becoming profoundly deranged objects of desire because of their disobedience.

Caillebotte treated the subject matter of the calf just three times. Though not conceived as a group, they were all painted during the final years of his career, and they addressed this animal in three different states: living, dressed, and disarticulated. The first canvas was his "masterpiece" of a living calf in a field. The second showed the calf as a carcass, artfully dressed for commercial sale. The third canvas was *Tête de veau et langue de boeuf* (*Calf's Head and Ox Tongue*), c. 1882, which featured the calf's head next to an extracted tongue (Figure 13.6). When the painting was exhibited for the first time in 1894, the descriptive title identified the tongue as belonging to an "ox."[33] Nonetheless, it is not inevitable that it came from a castrated male. The meat trade's preference for slaughtering steer and oxen both contribute to that notion, but it is that organ's irresistible resemblance to a penis that cements the gendered reading. The resemblance helps imbue the long, thin, flattened, slightly bent and pointed configuration of that red-tipped tongue with something of the grotesque, for it is dangling and impotent, challenging the viewer to view this most eloquent of organs as a mute and powerless object.

For art historian Michael Fried, this painting's "thematics of silence" was connected to the viewer's inability to identify with these distinctive body parts, resulting in a kind of staged protest against human subjugation.[34] Caillebotte's painting revels in the ragged bloody stump of the head and pushes the severed end of the tongue squarely into the viewer's face. Yet his treatment of these bloody chunks achieved an "oddly gay appearance,"[35] filling the canvas with the clear light of a kind of spiritual nihilism.[36] Just as there is an unusually large disjuncture between the gritty materialism of the "realist" subject and the looseness of the "impressionist" style, it is arguably the case that the calf's head and ox's tongue are not the subjects of this painting, in the same way that the carcass in *Veal on Display* is perhaps best understood as a "nude" rather than a "still life." For Caillebotte has not painted meat but the conventions of public display, conventions that neutralized these raw parts of all meaning except their viability inside a capitalist economy. He has, in other words, painted the dissimulations and redirections that swirl around the flesh, and demonstrated how that flesh escaped the parameters of "just looking."

The society of the spectacle fetishized the gaze. But as Tardieu feared, the gaze was insufficient on its own, for it could not penetrate beyond the carefully crafted surfaces to prevent the illicit sexual exchanges from occurring. In this context, the politics of body were also potentially the politics of gender. If the ox's tongue is also understood as a phallic object, what if that phallus did not attend to heterosexual interests? What if the strategies of market display also implied the policing of sexual behavior? In Caillebotte's calf paintings, the transaction of the flesh operated as the pure exchange of signs, allowing the unseeable subject of sex to be mediated through the interplay of coded

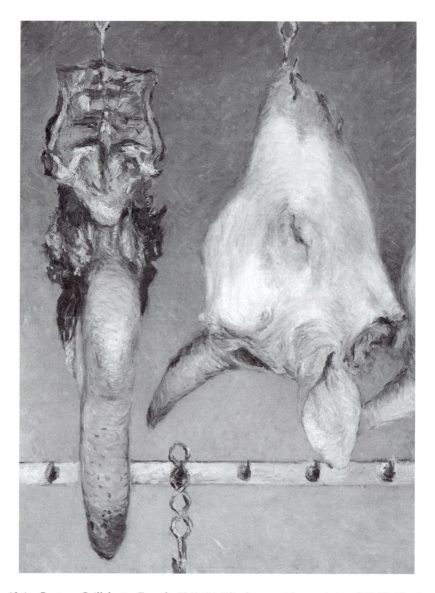

13.6 Gustave Caillebotte, French, 1848–94, *Tête de veau et langue de boeuf* (Calf's Head and Ox Tongue), 73 × 54 cm, oil on canvas, *c.* 1882. Major Acquisitions Centennial Endowment, 1999.561, The Art Institute of Chicago

surfaces. It is probably not coincidental that the skinny, funnel shape of Caillebotte's ox tongue identified the penis of a sodomite, or that *Veal on Display* was the feminized body of a male turned upside down and decorated with fresh flowers. It might be argued that *Veau à l'étal* offers us a biologically sexed body performing ambiguous gender roles, much like the alluring Jacques

Silvert in Rachilde's novel *Madame Adonis*, 1884, published the same year that Caillebotte crafted this painting. Not only is Jacques a "fleshly delight," whose maleness is "fresh and pink like a girl," but when this working-class man first encounters his future lover, Raoule (an aristocratic woman with masculine habits), he appears half-naked and entwined in sweet-smelling, artificial flowers.

A garland of roses spiraled round his body and over his loose-hanging smock; fat satin roses, velvet-skinned and garnet-red, passing between his legs, running up to his shoulders and wound about his neck.

Jacques becomes Raoule's "mistress," yet externally, their relationship retains the appearance of heterosexual normalcy, i.e. a sexual relationship between a biological man and biological woman. The outsider's gaze cannot penetrate their shifting identities.

As Katherine Gantz points out, it is their mode of relating to each other, not their genitals or clothing, which exposes their shared "queerness."[37] Though it is as a "man in love" that the biological woman Raoule regards the feminine and feminized object of her desire, Jacques, it is his naked body, "stripped of his rags, [exposing] the flesh of a guttersnipe," which she covets as a man desirous of another man. In other words, their bodily urges are (sometimes) homosexual, but their sentiments (mostly) reiterate traditional male-female roles, especially in their confirmation of normative expressions of social power by making Jacques, the "woman" in this relationship, the poor brother of a flower maker. Between them, sexual identities and sexual desires are in a state of constant flux, marked by passionate instabilities and the whims of lovers. Consequently, *Madame Adonis* is not a "traditional" work of gay and lesbian fiction, for neither Raoule nor Jacques can be categorized as being homo/hetero/bisexual in orientation. Their sexes and their selves are multiples at all times, hence do not yield readily to visual inspection, not even as they gaze on each other.

By similarly offering itself as a transitional object inside shifting parameters of desire, *Veal on Display* drew from and extended the ambiguities of class, race, gender, and commercialization which were so scandalously inaugurated by *Olympia*, but without the confrontational qualities of a body that could stare or talk back. Notably, these traits were shared by Caillebotte's unique finished study of a male nude, *Man at his Bath*, 1884 (National Gallery, London), completed a year after *Veal on Display*. Seen from behind, the man stands up straight, toweling himself off after his bath. His face cannot be seen, but his testicles are clearly visible between his legs, and the strangely wrenched and "bizarrely small"[38] left arm bears a noteworthy resemblance to the stumpy limbs of the calf carcass, which holds the same splay-legged stance. However, there is no pictorial tradition for male prostitutes—though ephebes from Ganymede to Bara are another matter—and it is precisely the

frank representation of flesh for sale that links *Olympia* to this "coquettish" calf despite the exchange of human for animal.

Various caricatures of *Olympia* by Bertall, Cham, and others had made the hand covering her hardworking crotch bloom into an enormous bouquet of flowers. Caillebotte took that bouquet and replaced it with a single rose. This timeless symbol of temporal love was identified with the courtesan, but it also resorted to the "visual stratagems of flowers" that, according to Marcel Proust, served as the homosexual's secret code.[39] Elaborately contorted, hothouse flowers were the perfect metaphor for a desire that could not be openly revealed yet desperately sought to be recognized by others of like kind. Homosexual houses of prostitution survived by constantly changing locations,[40] but in respectable neighborhoods, even regular brothels were disguised, appearing to naïve eyes to be just another dignified *hôtel*. Passers-by would miss the signal or misunderstand its meaning, for it was just a certain kind of flower placed inside the window.[41] One presumes either roses or orchids, for the former invoked venal love, whereas the latter resembled female genitals, wherefore Olympia adorned herself with these blossoms. However, both of these interpretations assume a heterosexual spectator inside a similarly binary (man-woman, human/animal) cultural structure. By contrast, historian Harold Beaver has pointed out that "orchid" was the Greek word for testicles, and was understood as such by Proust in the *Sodome and Gomorrhe* cycle of *Recherche de temps perdu*.[42] For the bourgeois aesthete homosexual viewer, in other words, the orchid was a mimetic sign of biological maleness, and a symbol of male sexual receptivity. Thus Proust's foppish Jupien "posed himself with the coquetry that the orchid might have adopted on the providential arrival of the bee," and the older M. de Charlus responds with a series of glances that were "infinitely unlike the glances we usually direct at a person whom we do or do not know." The contortions of Proust's language evokes the hide-and-seek dance of the public homosexual exchange, which by its very convolutions allows the men to see in each other "a compatriot with whom an understanding then grows up of itself, both parties speaking the same language," i.e. the visual language of flowers.

What, then, should be made of the rose displayed on the belly of Caillebotte's dressed calf? Inside various visual traditions, the use of the rose as a sign for anal sex has long been evident, appearing in paintings such as Hieronymous Bosch's *Garden of Earthly Delights*.[43] But, in everyday life, the use of colorful vegetation to enliven the display of fresh carcasses followed the centuries-old conventions of the meat trade, and thus was neither Caillebotte's invention nor a quotation of an established (albeit obscure) artistic convention. But the use of decorative beds of greenery and garlands existed in the first place because the butcher's art was already steeped in the allusory language of flowers. As ethnographer Noëlle Vialles has discussed, the most skillful butchers knew how to make a bovine carcass appear like a sculpture, using the knife to

enhance the contours of the flesh and leaving behind a fine white film, in a process known as "glazing." To "flower" the meat specifically referred to the removal of the hide, making small incisions in the surface muscles that would produce "an abstract design" akin to the "raked sand of a Zen garden."[44]

Hence, for the hungry proletariat, this flower probably meant nothing: it was an ordinary ornament used by nineteenth-century butchers to enliven the sight of the carcass. For the heterosexual bourgeois consumer, it was perhaps an allusion to the coquettishness of the courtesan, a means to seduce the eye through the mainstream conventions of femininity. But for any frequenter of the demi-monde, the flower was an indicator of homosexual availability, for it was understood that the "rosette," located at the opening of the anus, was the male version of a hymen. Its intact state signaled that the young man was a "virgin," at least as anal sex was concerned. He would also be serving as the passive partner, wherefore the active partner was known as a "Chevalier de la rosette," the Knight of the Little Rose.[45]

Feminine, passive, young, but biologically male, the calf's carcass topped off the gaping yawn of the ventral cavity with a dainty red flower, draped it all in fresh garlands and hoped for interested buyers. But as the hysterical public health dialogues of the 1880s had made clear, the marketplace mantra was *caveat emptor*: buyer beware. Was this firm flesh what it seemed to be? Was its blood impure, tainted, or perhaps fatally diseased? The butcher's systematic disarticulation converted the dead flesh into edible meat, but it accomplished this task by clothing this flesh in cultural a/illusions. Despite its stripped condition, the veal carcass was not naked. By being virtue of being "dressed," the slaughtered body became a seductive nude.

Whether the deceptions were practiced by prostitutes or butchers, the ruthless terms of the marketplace had made it clear that the flesh could be shaped into something so profoundly unnatural that it was at once the perfect emblem of modernity as well as the despised evidence of its failures. In both cases, these new professionals abstracted the traces of horrific social violence into a floating set of cultural signs—fresh flowers, clean sheets, pure whiteness—while ignoring the deepening gap between matter and its meaning. The sensual distractions, offering the visceral pleasures and instant gratification, compensated for the ethical questions raised by the peddling of powerless flesh as a socially acceptable practice. Hovering between male and female principles, offering itself as carnal satisfaction for sale, Caillebotte's carcass was a seductive, monstrous thing that was "either headless or limbless and never really alive": the carcass of modern life.[46]

Notes

1. Douglas Druick, "*Veau à l'étal*," in *Gustave Caillebotte, 1848–1894* (ex. cat., Grand Palais, Paris/Art Institute of Chicago) (Paris: Réunion des musées nationaux, 1994), cat. no. 109, 329; idem, "Calf in

a Butcher's Shop (*Veau à l'étal*)," in Anne Distel et al., *Gustave Caillebotte: Urban Impressionist* (ex. cat. Grand Palais/Art Institute of Chicago) (Chicago and New York: Art Institute of Chicago/Abbeville 1995), cat. 95, 248.

2. Douglas Druick, "Still Lifes," in *Gustave Caillebotte: Urban Impressionist*, 235. The scholarship on this painting is largely confined to catalog entries. See Marie Berhaut, *Caillebotte, sa vie, son oeuvre: catalogue raisonné des peintures et pastels*, Paris: Wildenstein Institute, 1978, cat. 221; Berhaut, rev. ed. (Paris: Wildenstein Institute, 1994), 43, and cat. 243,165.

3. Alfred Delvau, "Veau," *Dictionnaire érotique moderne* (Bale: Imprimerie de Karl Schmidt, *c.* 1850), 365.

4. Calves slaughtered for veal are usually, but not necessarily, males. In the case of Caillebotte's painting, the determination that he painted a male animal was made by veterinarian Michael Galvin, whom I thank for his assistance.

5. Joris Karl Huysmans, *A Rebours* [1884], excerpted in *The Dedalus Book of Sexual Ambiguity*, ed., Emma Wilson (Sawtry, UK: Dedalus Press, 1996), 151; on puritanism, 152; on "wholesome animal" and "sweetmeats," 153, all other quotes, 157.

6. Jeanne Gaillard, *Paris, La Ville, 1852 — 1870* (Paris: 1977), 267; L.R. Berlanstein, *The Working People of Paris, 1871–1914* (Baltimore: Johns Hopkins, 1984), 46–55.

7. "Boucherie," "Vache," "Veau," and "Viande," in Delvau, *Dictionnaire érotique moderne*, 364, 365, 368.

8. Edmond About, *Quinze Journées au Salon de Peinture et de Sculpture (année 1883)* (Paris: Librairie des bibliophiles, 1883), 17–18 (Day Two). Additional criticism appears in J. Valmy-Baysse, *Georges Rochegrosse, sa vie, son oeuvre* (Paris: Société d'Edition et de Publications, 1910).

9. A. Robida, "A travers le Salon [Georges Rochegrosse, *Andromaque*, 1883]," *La Caricature*, no. 177 (May 19, 1883), 1. Rochegrosse was later selected to illustrate a luxury edition of Théophile Gautier, *La Chaine d'or* (Paris: A. Ferroud, 1896).

10. Geronte, "Le Salon de 1865. Lettres au Jury de l'Exposition, Les Execentriques et les grotesques," *Gazette de France* (June 30, 1865): "Cette Vénus hottentote, au chat noir, exposée toute nue sur son lit, comme un cadavre sur les dalles de la Morgue, cette Olympia de la rue Mouffetard, morte de fièvre jaune et déjà parvenue à un état de décomposition avancée."

11. Paul de Saint Victor, "Le Salon de 1865," *La Presse* (May 28, 1865), quoted in Bataille, *Manet*, p. 74; Victor de Jankovitz, "Etude sur le Salon de 1865, Besancon 1865, 67–8, quoted in T.J. Clark, *The Painting of Modern Life: Paris in the Art of Manet and His Followers*. (Princeton, NJ: Princeton University Press, 1984), 96, who also cites similar remarks made by Lorentz, Victor Fournel, Ego, Félix Deriège, and other critics, 96–8. I am reliant on Clark for these sources.

12. Esquiros, *Vièrges folles*, 1844, 51–2.

13. Esquiros, *Vièrges folles*, 1844, 53. "Ces misérables, connues parmis les compagnes sous le nom dégoutant de *gouapeuses*, ont fait de la debauche une mangeoire. Leur ventre insatiable est comme une caverne tenebreuse dans laquelle s'engloutissent chaque jour, avec la nourriture, leur honneur et leur liberté." Delvau's *Dictionnaire érotique moderne*, 1850, offers the following definitions: "*Gouapeuses*: Petite drôlesse qui préfère la rue à l'atelier, le vagabondage au travail, et qui s'amuse avec les quequettes des polissons de son âge en attendant l'occasion d'amuser les pines des messieurs plus âgés" (211). "*Quequette*: Priaps d'enfant" (324).

14. Philippe Roberts- Jones, *De Daumier à Lautrec: Essai sur l'histoire de la caricature française entre 1860 et 1890* (Paris: Les Beaux-Arts, 1960), 72–6.

15. "Comment ils mangents les moules (How They Eat Mussels)," *L'Evénément parisien* (December 5–12, 1880).

16. Trick, "Le Porte-Bonheur de Pornocratés, histoire fantastique," *La Caricature*, no. 37 (September 11, 1880), 6–7.

17. "La grande epidémie pornographique," special issue of *La Caricature* (May 6, 1882).

18. Alessandro Stanziani, "Food Safety and Expertise: The Trichinosis Epidemic in France, 1878–1891," *Food and Foodways*, 10, no. 4 (January 2003): 209–37.

19. Jean de La Fontaine, "Le Villageois qui cherche son veau," [*c.* 1690] in *Contes et nouvelles en vers, ornés d'estampes d'Honoré Fragonard, Monnet, Touzé, et Milius*, ed., Anatole de Montaiglon (Paris: P. Rouquette, 1883, vol. 2), 187. INHA 8 Y 352; English translation, "The Countryman Who Sought His Calf," Project Gutenberg online resource.

20. David Kunzle, "The Corset as Erotic Alchemy: From Rococo Galanterie to Montaut's Physiologies," *Art News Annual*, 28 (1972): 115–16.

21. Théophile Gautier, *Le Moniteur universel*, June 24, 1865, quoted in Theodore Reff, *Manet: Olympia* (New York: Viking, 1977), 18.

22. Gerald Needham, "Manet, *Olympia*, and Pornographic Photography," *Art News Annual*, 38 (1972), 111–22. On prostitution in modern Paris, see Alain Corbin, *Les filles de noce: misère sexuelle et prostitution, 19e et 20e siècles* (Paris: Aubier Montaigne, 1978).

23. Ambroise Tardieu, *Etude medico-légale sur les attentats aux moeurs* [1857], 4th ed. (Paris: J.-B. Baillière et fils, 1862), 12–13, and plate 2 (at end of text).

24. Tardieu, *Etude medico-légale sur les attentats aux moeurs*, 4th ed., 1862, 156–7. On the association of "pédérastie" and homosexuality ("sodomie") in nineteenth–century France, as well as Tardieu's larger influence, see *Homosexuality in Modern France*, eds, Jeffrey Merrick and Brian Ragan (New York: Oxford University Press, 1996).

25. Ambroise Tardieu, *Etude medico-légale sur les attentats aux moeurs*, 5th ed. (Paris: J.-B. Baillière et fils, 1868), 185: "c'est le gland qui, etranglé à sa base, s'allonge quelquefois démesurément, de manière à donner l'idée du museau de certains animaux."

26. Bertall, "Exposition des Indépendants, Ex-Impressionistes, Demain Intentionists," *L'Artiste* (June 1879), quoted in Varnedoe, *Caillebotte*, 1987, 193. This painting does not appear in the catalogues and catalogue raisonnés of Caillebotte's work listed in fn. 1–2. See caricature by Draner, indicated in fn. 28.

27. Louis Leroy, "Beaux-Arts" (April 17, 1879), quoted in Varnedoe, *Caillebotte*, 192.

28. Draner, "Chez MM. les peintres indépendents," *Le Charivari* (April 23, 1879), reproduced in Varnedoe, *Caillebotte*, 1987, 184, accompanied by caricature. Caption: "Le veau (en est-ce bien un?) phénoménal.—Destiné au musée des antiquités anté-diluviennes."

29. Louis Besson, "Mm. Les Impressionistes," *L'Evénement*, 11 (April 1879) quoted in Varnedoe, 192.

30. Emile Zola, "Le Naturalisme au Salon," *Le Voltaire* (June 18–22, 1880), quoted in Varnedoe, *Caillebotte*, 194.

31. Louis Leroy, "Exposition des Impressionistes," *Le Charivari* (March 17, 1882), quoted in Varnedoe, 196.

32. Bertall, "Exposition des Indépendants …," quoted in Varnedoe, *Caillebotte*, 193.

33. Galeries Durand-Ruel, *Exposition retrospective d'oeuvres de G. Caillebotte*, Paris, June 1894, entry 94, 7, facsimile reproduction of catalog in *Modern Art in Paris: Two Hundred Catalogues of the Major Exhibitions*, 47 vols, ed., Theodore Reff (New York and London: Garland Press, 1981), series II, vol. 1.

34. Michael Fried, "Caillebotte's Impressionism," *Representations*, no. 66 (Spring 1999): 34.

35. Douglas Druick, "Calf's Head and Ox Tongue," *Gustave Caillebotte: Urban Impressionist*, cat. 95, 250.

36. Gloria Groom, "Calf's Head and Ox's Tongue," *Art Institute of Chicago Museum Studies*, 30, no. 1 (2004): 66.

37. Katherine Gantz, "The Difficult Guest: French Queer Theory Makes Room for Rachilde," *South Central Review*, 22, no. 3 (Fall 2005): 113–32.

38. Fried, "Caillebotte's Impressionism," 33.

39. On roses, orchids, and courtesans, see Reff, *Olympia*, 106–10. On Proust, flowers, and homosexuality, see Harold Beaver, "Homosexual Signs," *Critical Inquiry*, 8, no. 1 (Autumn 1981): 100–101, and George Bauer, "Gay Incipit, Botanical Collections, Nosegays, and Bouquet," in *Articulations of Difference: Gender Studies and Writing in French*, ed., Dominque Fisher and Lawrence R. Schehr (Stanford: Stanford University Press, 1997).

40. Tardieu, *Etude medico-légale*, 159.

41. Esquiros, *Vièrges folles*, 100. Esquiros does not indicate which type of flower gave the signal, but orchids are presumed for their exoticism as well as their purported resemblance to female genitalia, and roses for the reasons discussed by Reff, above.

42. Beaver, "Homosexual Signs," 102.

43. See Michael Camille, *Medieval Art of Love: Objects and Subjects of Desire* (New York: Abrams, 1998); James Saslow, "Closets in the Museum: Homophobia and Art History," in *Lavender Culture*, eds,

Karla Jay and Allen Young (New York: NYU Press, 1994), 215–27; and idem, *Pictures and Passions: A History of Homosexuality in the Visual Arts* (New York: Viking, 1999). Thanks are owed to Diane Wolfthal for her insightful remarks.

44. Roland Barthes, *Mythologies* [1957] (Paris: Le Seuil, 1970), 102–3, paraphrased in Noëlle Vialles, *Animal to Edible*, translated from the French by J.A. Underwood (Cambridge, England: Cambridge University Press, 1994), 58. Vialles notes that this language is specific to bovines, i.e. a pig carcass is never "dressed."

45. Delvau, "Rosette," *Dictionnaire érotique moderne*, 334.

46. Writer Bongrand at painter Claude Lantier's funeral, announcing that he is "lucky to be away from it all, instead of wearing himself out, as we do, producing offspring who are either headless or limbless and never really alive." Emile Zola, *L'Oeuvre*, 1886.

Puff marries Advertising: commercialization of culture in Jean-Jacques Grandville's *Un Autre Monde* (1844)

Haejeong Hazel Hahn

Introduction

In Jean-Jacques Grandville's masterpiece, *Un Autre Monde*, Puff (also "Puff" in French) fashions himself as a neo-god. He creates two other neo-gods, Crack (Krackq) and Chatterbox (Hahblle), and the three depart for separate adventures in the realms of the sky, earth, and sea, parodying contemporary Parisian society.[1] *Un Autre Monde* was a revolutionary book, in which images were illustrated by texts. It was also an extremely ambitious book: in the epilogue Grandville proclaimed that he created a whole world—no small task. And what a world of complex, strange, and fantastic imagination! It is little wonder that when *Un Autre Monde* was rediscovered in the 1930s by the Surrealists, they foremost admired the singular and uncanny character of its images. Others, inspired by Walter Benjamin, have used Grandville's individual images to explore and illustrate theories of modernity and varied aspects of modernization.[2] Yet *Un Autre Monde* as a whole, both images *and* text, has received little sustained analysis.[3] This essay treats the phenomena of advertising and the commercialization of culture as significant themes in the book, and also discusses the book's narrative structure. I argue that the book contains a quasi-encyclopedic anatomy of contemporary styles of rhetoric and techniques of advertising. It not only demonstrates the astuteness of Grandville's observation of contemporary mores, but also reveals the complexity and sophistication of contemporary advertising practices, which provided a fertile ground for Grandville's imagination. The aim of this essay is to enhance the understanding of both the uniqueness of *Un Autre Monde* and its embeddedness in contemporary culture.

No previous work by Grandville prepared readers for *Un Autre Monde*, which generated much controversy, partly because it was so difficult to

tell precisely to what genre it belonged. Grandville was a respected artist who was a main contributor to Charles Philipon's influential journals of political satire, *La Caricature* and *Le Charivari*. His reputation had been firmly established by *Les Métamorphoses du Jour* (1829), an album of lithographs that satirized Parisian mores by depicting animals dressed as humans. His work that preceded *Un Autre Monde*, *Scènes de la vie privée et publique des animaux* (1842–44), was a great success. Grandville's posthumous *Les Fleurs Animées* (1847), 52 plates of "personified flowers" in floral high fashion, would also be an instant commercial and critical success. In addition to multiple French editions, American, Belgian, and German editions would be published in the next two decades.[4]

However, when *Un Autre Monde* was serialized in 1843 and 1844 in 36 installments, it was a critical failure, which awed, baffled, and even angered its audiences.[5] Théophile Gautier wrote in 1847 that Grandville's images "lack clarity and present to the eye nothing but rebuses that are difficult to guess."[6] Baudelaire later echoed Gautier's view, criticizing Grandville's allegorical method as a dualist combination of literary spirit and artistic craft in which "everything is allegory, allusion, hieroglyphics, rebuses."[7] Joseph Méry, in a posthumous tribute of 1849, spoke of *Un Autre Monde* and *Les Fleurs animées* as the result of "an exploration that was extreme, singular, almost mystical" that cost "an incredible effort."[8] He did not elaborate further on *Un Autre Monde* but preferred to speak of Grandville's more acclaimed works. In an 1853 article on Grandville's art, Charles Blanc typically chose to bypass *Un Autre Monde*, in favor of his "romantic" works.[9] Champfleury, in the first monograph on caricature, *Histoire de la caricature moderne* (1865), did not even mention *Un Autre Monde*.[10] It appears then that to most of Grandville's contemporaries, all of *Un Autre Monde* seemed like an incomprehensible puzzle. At the end of the book Grandville in fact included a rebus addressed to the reader.

What kind of enigma then is *Un Autre Monde*? Grandville's complex and fabulous images are about multiple transformations, inversions and voyages. While *Un Autre Monde* is foremost a work of caricature along the style of *Le Charivari*, it also belongs to the literary genre of fantastic voyages that satirize contemporary society, such as Swift's *Gulliver's Travels*.[11] It covers a vast subject matter, and it is partly a reworking of classical mythology and part science fiction. The impossibility of simplifying Grandville's project is evident in the subtitle of the work:

Transformations, Visions, Incarnations, Ascensions, Locomotions, Explorations, Peregrinations, Excursions, Stations, Cosmogonies, Fantasmagories, Reveries, Frolics (*Folâteries*), Practical Jokes, Whims, Metamorphoses, Zoomorphoses, Lithomorphoses, Metempsycoses, Apotheoses and Other Things.

The list of themes, including a host of nineteenth-century neologisms and ending with "Other Things," suggests that the list is very long, perhaps endless.

This apparently chaotic ambition, verging on nonsense, evidently bewildered contemporary readers. Grandville was deeply interested in Baroque allegory, analogy, and correspondence, and the subtitle seems to suggest that the work is about an apparently structure-less series of images based on the principle of permanent mutation.[12]

The list of themes in the subtitle belies the fact that the book has a very distinct narrative structure and is far from just a series of complex images. The narrative has a *mise-en-abyme*, or story-within-a-story, format.[13] I argue that the stories of *Un Autre Monde* are layered in four frames, in a series of *mises-en-abymes*. Each frame constitutes a story which is both a process of creation and also a journey of experimentation, adventure, and education. Along with satire and voyage, creation is a main theme of the work, which contains scenes of creation and metamorphoses. The "other world" is seen through the eyes of Puff and his friends. Their adventure is framed successively in the adventures of Pencil and Pen, Grandville the artist, and the reader. The format allowed for references not only to contemporary culture, but to the book itself as an artifact of diverse creative processes, to the author himself, and finally to the reader, who must be drawn in to experience the book. The narratives seem to address the manifold process of the commercialization of culture during the July Monarchy, when advertising was coming into its own with attendant controversy, and the world of publishing and journalism was rapidly changing and expanding. From 1830 French publishing entered a period of unheard-of growth in the production of printed material in all its forms, enabled by dramatic improvements in the technology of paper production and reprographics, rising literacy rates and a great demand for new books and periodicals. The Parisian population doubled from about half a million in 1801 to a million in 1851. Urbanization and improved transportation enabled the publishing industry to produce and distribute printed material on a massive scale. Despite censorship, countless books, newspapers, journals, magazines, and prints were published. The period 1830 to 1850 marked the golden age of the illustrated book in France.[14] The popularization of images turned salons and galleries into sites of entertainment.[15] Innovations like the newspaper serial novel and new forms of advertisements transformed the press. The roles of advertising and journalism form an important theme in *Un Autre Monde*, which even determines the course of the narrative. When situated in this original context, *Un Autre Monde* turns out to be a key document of the period that literally embodies the processes of the creation of a book.

The outer two frames introduce the reader to the other world and also present the artist Grandville. The first image of the book, the cover image, depicts "another world." It is seen from the point of view of the reader who, from a vertiginous vantage point, confronts this other world, a globe which is no doubt eccentric, as tennis rackets are playing tennis by themselves. The

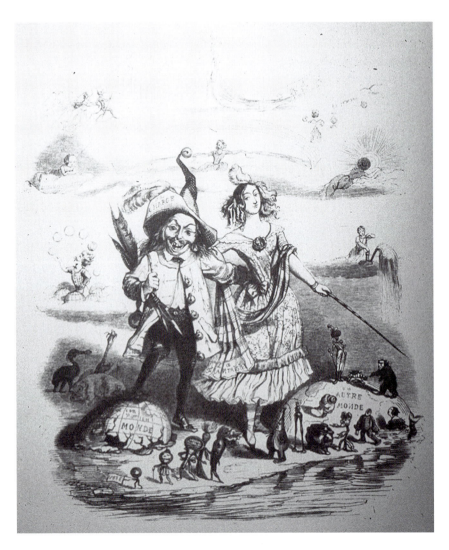

14.1 Grandville (artist). Frontispiece. Lithograph. Jean-Jacques Grandville, *Un Autre Monde* (Paris: P.H. Fournier, 1844). Author's collection

image beckons the reader to embark on a voyage into this world. The reader then is the first protagonist of the story. This frame constitutes the boundaries of the book itself and signifies the journey of the reader who opens, reads, and closes the book. The next image, the frontispiece (Figure 14.1), depicts "caricature" — a self-portrait of Grandville, accompanied by his favorite muse, "imagination," linking the battered old world to "another world" that holds fresh possibilities. Thus introducing the second protagonist and the second frame of the book, the image refers to the artist as the creator

14.2 Grandville (artist). Epilogue. Lithograph. Jean-Jacques Grandville, *Un Autre Monde* (Paris: P.H. Fournier, 1844), n.p. Author's collection

of the book and suggests that the adventure of the artist, guided by his imagination, is about to start.

The prologue and the epilogue (Figure 14.2) frame the next story, about the journey of Pencil, that comments on the conditions of artistic creation and is therefore the story of the creation of the book itself. Pencil and Pen discuss the idea of images being illustrated by texts. Pencil, wanting freedom, embarks on a journey, leaving Pen behind. The book would be an experiment shaped by the adventures of Pencil that explore the narrative possibilities of

images. The text was mainly written by Taxile Delord, the editor in chief of *Le Charivari*, working from Grandville's notes and interpreting his images.[16] Delord's name appeared only with the image of the epilogue. Grandville's images are both steeped in contemporary culture and incontestably unique. Delord's text, witty but far from a masterpiece, doesn't do justice to Grandville's images, which partly explains why scholars have neglected the text.[17] However, the very prosaic nature of the text also has the effect of more concretely linking the images to other contemporary formulae. The relationship between the text and image is further complicated by the fact that Grandville's images are highly allegorical and therefore already text-driven. While I will distinguish between the visual and textual narratives as much as possible, the two will occasionally merge, as it is impossible to tell to what extent Delord's text was based on Grandville's notes. At the time of publication there were rumors that Taxile Delord didn't exist, adding to the confusion in the reception of the book.[18]

Puff, the main protagonist of the book, is introduced in the first chapter. He recreates himself and creates Crack and Chatterbox, who embark on journeys to observe and experience the world. What follows is a series of stories about various parts of the universe that treat topics like politics, art, music, feminism, entertainment, and industrialization. These stories constitute what in many ways is a mirror image of Paris. Other stories are about more esoteric subjects like the beginning of the universe, the kingdom of marionnettes or a revolution in the vegetal kingdom. *Un Autre Monde* is thus composed of a series of worlds that are successively entered, travelled, and, at the end, left. Such a structure, encompassing multiple viewpoints, self-conscious references to the book as an artifact, and beckoning to the reader to make sense of the book, makes *Un Autre Monde* a strikingly unique project.

Puff and his friends

The first words of the book proper are: "My name is Puff. That says enough." It is clear that to contemporaries "puff" is a familiar term. Puff was an inventor but too many people wanted to know his secret, and he was killed by advertising (*réclame*) which gave away his secret. Now he transforms himself into a neo-god. A little bit later Puff is reintroduced: "Puff, as you no doubt guessed, was a journalist."[19] Who then is Puff, this inventor-journalist-neo-god? He is a kind of a charlatan. He is a composite image of several popular types that had been extensively featured in satires. During the July Monarchy enormous developments in illustration led to a massive profusion of caricatures, propelled by a new bourgeois taste for them. In 1844 La Maison Aubert, of which Philipon was a primary partner, was producing more than four million prints a year.[20]

The image of Puff can be traced to Honoré Daumier's Robert Macaire series, which was commissioned by Philipon for *Le Charivari* between 1836 and 1838. This association is underlined by Puff's reference to Macaire as his uncle.[21] Macaire assumed multiple identities at ease and was also deft at using advertising, a modern method of manipulation. Like Daumier, Grandville worked closely with Philipon and was the most prominently featured artist of *La Caricature*, contributing brilliant political and social commentary, until the journal ceased publication after restrictive censorship laws were passed in 1835.

Puff is a former journalist who pulls off schemes in order to feed himself, underlining the association of journalism, publicity and charlatanism. While he is "a mere inventor," his inventions include fake newspaper articles *(canards)*. He is a harmless version of Macaire, someone used to recreating identities. In this period advertising terms like *s'afficher* (publicize oneself) or *puff* (hype) were frequently used to expose what was seen as the new, insidious, and powerful forms of charlatanism. Philippe Hamon remarks that the word *puff*, popular at mid-century, fit in a system with a series of words like *toc*, *chic*, and *krach*, all referring to "a world of 'emptiness,' of 'wind' and 'void,' or of 'fakes' and lies," all of them "formally monosyllabic and expressive onomatopoeias with negative connotations."[22] Dr. Puff's creation of Crack and Chatterbox, both referring to such forms of utterance, signifies the multiplication of the same. "Puff" also has another connotation, that of smoke, and possibly hashish. The image shows smoke, with a monster-like face, possibly suggesting that these protagonists, and the "other world" itself, are the pigment of imagination aided by hashish.[23] In Gustave Courbet's "Self Portrait (Man with a Pipe)" from *c.* 1848–49 the pipe seems to underline the depiction of the artist as a bohemian, and Grandville's depiction of smoke might have been both an inside joke and a way to assert the identity of himself as a bohemian artist with long hair. His caricatural self-portrait appeared in the journal *L'Illustration* in 1843 along with an article that celebrated him as an artist of great talent. The self-portrait accentuated his eccentric and bohemian characteristics.

The steam-powered concert

The first adventure of Puff is the invention of "The Steam-Powered Concert." Along with contemporary musical fashion, industrialization, and railroads, a major theme of this episode is the hype surrounding these phenomena. Puff is adept at a publicity campaign that mobilizes all the modern techniques of advertising. The campaign not only publicizes Puff's invention, but consists of a series of tributes to the inventor himself that are disseminated through various advertising media. Puff's illustrated posters cover "all the

intersections."[24] True to his calling, Puff donnes himself as "Dr. Puff" and reviews his own invention in a journal, *Le Galoubet littéraire et musical* as "the first human-mechanical concert of the incomparable Dr. Puff": "Thanks to this admirable invention, colds, extinctions of voices or bronchitis no longer exist. The voices ... are safe from any accident."[25] Grandville and Delord satirize both advertisements of pseudo-medical products and the practice of authors reviewing their own books, which was a widespread practice in France. Publishers sent to the press "please-inserts" of books, publicity that were to be published in the guise of proper reviews.[26] Modern advertising— commercial advertising using the mass media—was a phenomenon that was only firmly established in the 1830s, and by the 1840s forms of advertising were still quite unstable. Emile de Girardin's *La Presse* and Armand Dutacq's *Le Siècle*, both established in 1836, were the first dailies to be based on advertising revenue and halved subscription rates, and also the first to publish serial novels. Auguste Commerson's weekly *Le Tam-Tam*, established in 1835, was the first paper to be entirely based on advertising revenue and distributed free of charge. Commerson's weekly *Le Tintamarre*, founded in 1843, the same year as the serialization of *Un Autre Monde*, carried the most number of advertisements during the July Monarchy and were distributed free of charge to 2,000 cafés. Widespread in the French press were editorial advertisements—advertisements written in the guise of articles or reviews.[27] While *Le Tintamarre* and *Le Tam-Tam* condemned editorial advertising and made fun of it, *La Presse*'s fashion column was full of editorial ads. Balzac wrote in 1842 that the ubiquity of "puff," which had replaced the word *canard* since several years before, means that "a *Fait-Paris* [short news item on Paris] can often become the recommendation of a bargain, a book, an enterprise," that one can make the whole press sing one's praises. During election times, Balzac lamented, short notices and current event sections of the press become "terrible" and that "a cloud of electoral canards" cover all of France. He protested that the *réclame* (advertising, especially editorial advertising) has killed the critique in the dailies.[28] Balzac used the term "puff" to mean editorial advertising, criticizing the blending of news and advertising and the commercialization of the press.

Dr. Puff's program for "The Steam-Powered Concert" shows some of the tropes of advertising of the period in absurdist ways. It starts with "The Rail-Notes," proceeds to "The Explosion," "The Cars Burst by Themselves" and to "The Locomotive."[29] The train and Puff are associated through the puff of the smoke from the train. The idea of "The Steam-Powered Concert" alludes to the vogue of Berlioz and Liszt, for high-powered performances and tremendous virtuosity in music.[30] It also refers to widespread publicity for railroads. At the time railroad companies were actively disseminating posters, newspaper articles, and texts such as guidebooks to further their interests, in the midst of a phenomenal speculation boom for railroad

construction that started in 1842.[31] Havas Agency, consolidated in 1835 into an agency of information, was already functioning as an office for state propaganda.[32]

Grandville comments on the exaggerated claims of publicity that drive such phenomena. Dr. Puff's own review of the event describes the concert as "The first human-mechanical concert" with a motto, "In this century of progress, the machine is a perfected man."[33] By replacing human agency with the mechanical, Grandville breaks away from contemporary satires on publicity or railroads and takes a leap into a futuristic vision, which is also based on the traditional fascination with automata. A "vaporian" harp is played by an extremely young virtuoso, a mechanical infant. The review continues: "His orchestra can defy those of all the conservatories of the universe."[34] The fact that the inventor is a god, who is also a former failed inventor, links the comic with the cosmic. The review celebrates the feat of producing high notes in rapid succession, then announces that the day's giveaway to the subscribers are portraits of several musicians, facsimiles of their writings, and diverse original pieces of their composition. Then a dark note slips into the review; an "unfortunate accident" marked the end of the concert, when an *ophicléide*, overcharged with harmony, exploded into fireworks of sharp notes, leaving "a cloud of musical smoke and flames of melody" in the atmosphere.[35] This wonderfully surreal image also invokes the idea of a train accident and perhaps pollution. The review ends with yet more praise of Dr. Puff, this time of his modesty, that Dr. Puff "has lavished on all his assistants the care of his art with a disinterest above all praise."[36] This strange review satirizes the comic absurdity of contemporary journalism, which sprinkled announcements of giveaways and other editorial advertisements into news.

Puff further demonstrates the laws of fashion and success by immediately deciding to replace his musicians with something new. He knows that, despite all the publicity, the vogue of "The Steam-Powered Concert" can't last, that as he is "too neo-god not to know that nothing gets old faster than success."[37] He decides to open a shop with a sign: "Disguises by Night and by Hour at the Contradance." He distributes a prospectus entitled "Physiological Disguises."[38] Ever in search of a new project, Puff then almost sets about to create artificial vegetables but opts instead to write a book. All these activities suggest that Puff is indeed a charlatan, ever in need of new ideas and inventions.

Satire of Paris

In other episodes of *Un Autre Monde*, distant voyages into topsy-turvy lands lead to a confrontation with an other that is a mirror image of the self. The voyage of Crack and Chatterbox is a series of satires of contemporary Paris.

They start out by distancing themselves from Paris and thus changing their perspectives. Hahblle, flying in a balloon, watches scenes in the streets of Paris from high in the air. In "Young China," people amuse themselves by watching "French shadow plays" (ombres françaises), a reference to the popular Chinese shadow plays (ombres chinoises). The Elysian Fields, where ancient Greeks amuse themselves, is a mirror image of the Champs-Elysées.

Noticeable on the Elysian Fields is a public urinal, a modern monument that also serves as an advertising medium. At the time theater posters were posted on urinals. The prevalence of advertising in Paris is also expressed in the image "April Fool's Fish" in which fish are fishing for men, dangling baits like jewelry and other objects. One bait is "gold medal to the first 10,000 subscribers," which alludes to the competing offers of giveaways to journal subscribers.[39] Advertising signals jarring dehumanization in an image of a fashionable promenade at Longchamps. Luxury clothes and accessories stroll by themselves without their usual raison-d'être. Canes and coats promenade arm in arm. "Dresses, hair ornaments, scarves, diamonds, all that sums up the beauty, luxury or reputation of a person are here; only the person is absent."[40] The image satirizes a society in which correct appearances, donning of the right tailor's suits, is deemed of crucial importance. In caricatures from 1829 and 1830 Philipon had depicted the "fashionables" on Longchamps as marionettes and mannequins rather than real people.[41] Grandville's image is not only about the absence of the person but about inanimate objects becoming animate and as in "The Steam-Powered Concert" marks a drastic revision of the relationship between identities and commodities. Grandville implies that the qualities of the person are in fact irrelevant to the formation of a reputation. As Walter Benjamin pointed out, Grandville's image implies that commodities themselves are endowed with their own significance.[42] Delord's text comments that the customer is in fact only a means of advertising commodities: "Tailors, hatters, boot makers and dressmakers have found the means to suppress man, who served as a live shop sign. Advertising simplified and improved itself."[43] This seems to underline the power of advertising and also the fear of replacement by objects through commodification. Longchamps had been long known for its seasonal parade of the elite of Paris displaying themselves in fine carriages. By the early 1840s the promenade became much less exclusive and more commercial. In 1842 there were 4,000 carriages, most of which were unremarkable carriages and advertising vehicles, some of which were shaped like "pots, hats, mustard jars, ink bottles, wax cans [or] nursing bottles."[44] Such displays of vehicles shaped like commodities might be a direct source of Grandville's image. At the same time, "specialty shops" and magasins de nouveautés— prototypes of department stores—had been proliferating since the 1820s and partaking in the formation of a mass consumer society.[45]

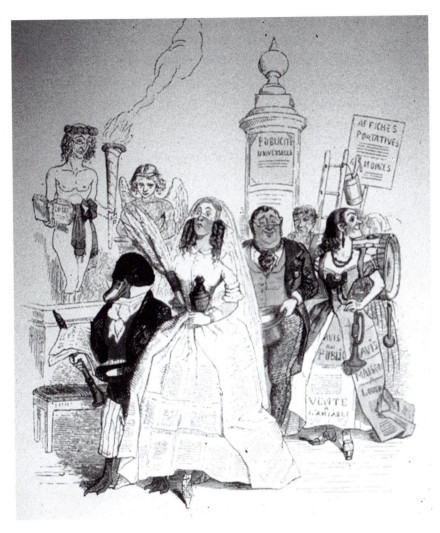

14.3 Grandville (artist). "The Wedding of Puff and Advertising." Lithograph.
Jean-Jacques Grandville, *Un Autre Monde* (Paris: P.H. Fournier, 1844), n.p. Author's
collection

The Marriage of Puff and Advertising

In a key episode of *Un Autre Monde* Puff marries Lady Réclame (Figure
14.3), daughter of Annonce (Classified Ad) and sister of Canard (fake
news). As we have seen, *"réclame"* meant advertising and especially
editorial advertising. They meet when Annonce solicits Puff with a
handout describing the virtues of her daughter. The episode seems to
parody the work of matrimonial agencies. The De Foy agency, founded in

the 1820s, advertised widely: "*MARIAGES. L'honorable Maison DE FOY la première de l'Europe.*"[46] A prevalent view of *réclame* can be seen in Daumier's caricature, "*L'annonce et la réclame*" of 1839, which condemned pseudo-medical advertisements.[47] Daumier wrote regarding another caricature of his, which criticizes editorial advertising, that "advertisements are in general a very useful invention for the industry and consumers. However, too often, this method of publicity is exploited by charlatanism, intrigue and ridicule."[48] Michele Hannoosh notes that the reason Puff says he is killed by Réclame is because advertising rendered the secrets of the inventor banal, generating replicas.[49] Hannoosh thereby emphasizes the destructive effect of advertising on privacy. I would add that the marriage of Puff and Réclame addresses contemporary associations of "*réclame*" with "charlatan" and "puff" that redoubled their pejorative connotations and the perception of their influence. The marriage is narrated in a form of a brochure, "The Origins of Advertising." It bespeaks yet another process of creation and outlines the creation myth of advertising, which matches and rivals the creation myth of Dr. Puff and his friends. "Newspaper will beget Classified Ad, Classified Ad will beget Canard and Réclame; Réclame will beget Brochure; Brochure will beget ..."[50] In this manner different forms of advertising would proliferate ad infinitum. Georges Roque in *Ceci n'est pas un Magritte* notes that in the nineteenth century advertisements created prestige for commodities by using images of ancient mythology, whereas in the twentieth century advertising "auto-legitimates through the production of its own mythology."[51] Grandville's image can be interpreted as anticipating the production of advertising's own mythology, by depicting the mythology of advertising and underlining its potential power. The multiplication of advertisements was described by Sainte-Beuve in "Literature industrielle (Industrial literature)" in 1839; he lamented that "the newspapers became larger; the advertisement was born, remaining modest for a while; but it was the infancy of Gargantua ... The consequences of the advertisement were fast and infinite ..."[52]

At the wedding of Puff and Réclame, Réclame's dress is made up of newspaper articles. Delord comments that the witnesses are a current-events column and the serial novel, two contemporary inventions into which advertisements were inserted.[53] The depiction of a urinal displaying an advertisement for an advertising agency, "Universal Publicity," accurately reflects a contemporary practice. The older female on the right-hand side also emblematizes publicity. The drum and the trumpet stand for loud advertising, complementing clandestine, new advertising like Réclame, a seemingly chaste maiden. Delord's text notes that wedding guests include journalists, folders, distributors, criers, and billposters. Wedding gifts include classified ad spaces, a clientele, 100,000 addresses, and consumer products such as medical products and cosmetics. The groom brings

futuristic inventions, including an aerial locomotive.[54] Such a grouping fits right in with contemporary perceptions of advertising, which was widely considered a tool for promoting quack medicine, inferior products, and useless inventions. The episode, however, also takes up the view of advertising as an increasingly threatening hand of commercialism infiltrating culture. Lady Réclame's dowry includes "the exclusive right to praise, recommend and celebrate" not just consumer products but the novels of a certain M.***.[55] At the time the cultural milieu was highly sensitive to what seemed like an inevitable mixing of culture and commerce via advertising.

Grandville and Delord also offer examples of editorial advertisements that confound political and commercial interests. Chatterbox finds himself in a mysterious capital in which "fire was not fire."[56] A battle between feminists and their opponents is raging. One party promotes the adoption of a law allowing women to wear men's clothes and manners, and the opposition opposes it. The anti-feminist newspaper reports that the "opposition just obtained a triumph. Its consequences would threaten the entire social state." The article ends with an editorial advertisement: "We take this opportunity to announce to our readers that Scottish knickers still look very nice, and that the cosmetics called *A la Burgrave* is the only one patented for preventing the loss of hair and teeth." The pro-feminist opposition paper argues exactly the opposite, including the argument of the advertisement: "We eagerly seize this opportunity to warn our subscribers that Scottish knickers still look very bad, and that the cosmetics called *A la Burgrave* is the only one patented for accelerating the loss of hair and teeth."[57] Such a satire of political and commercial editorials highlights not only the unintentionally comic nature of such articles but also the presence of advertising as a force of diversion and strange effects. Editorial advertisements were supposed to inform and amuse.

The theme of the commercialization of culture continues to motivate the story. In the apocalyptic last chapter, which marks the end of the other world and thus the end of the story, the three neo-gods air their grievances about cultural decadence and the merchandising of minds.[58] The neo-gods lament that "[g]randeur of reputation is proportional to the dimensions of the poster," and that the "fourth page of the newspaper" — classified ads — far from being a democratic forum for public communication, is a method of "accumulating wealth" by "boosting celebrity."[59] Grandville's image (Figure 14.4) of the mechanization of literary production, the manufacturing of the serial novel, is akin to Balzac's depiction of publishing in *Wild Ass's Skin* as "a stock of capital in which ideas are bartered and sold for so much a line."[60] Whereas Balzac emphasizes the financial aspect of publishing, Grandville's image suggests a fear of mechanization, which is implicit in other images as well. A machine spurts out a flood of newspapers and brochures. Self-delivering mechanical New-Year's gifts (Figure 14.5) will do away with

14.4 Grandville (artist). "Mechanized Literary Production." Lithograph. Jean-Jacques Grandville, *Un Autre Monde* (Paris: P.H. Fournier, 1844), n.p. Author's collection

human agency in consumption. At the time exchanging New-Year's gifts had become a firmly established commercial ritual. Initially mostly books and albums were exchanged, but increasingly "[e]very new thing that taste or ingenuity can invent" was exchanged.[61] Specialty shops organized exhibitions to attract shoppers around the holidays. Giroux organized "beautiful Salons of New Year's Gifts" as well as an exhibition of Robert Houdin's automata.[62]

The neo-gods decide to put their misery to an end by self-destructing. After the three neo-gods hug themselves to death, they are laid on a monument, self-aggrandizing for no apparent reason. The widow Réclame, who only pays tribute to herself, "takes the occasion to announce" the latest advertisement. Puff marries Réclame, then dies, reenacting the story of his former life. Perhaps the survival of Réclame foreshadows the future course of the commercialization and mechanization of culture.

14.5 Grandville (artist). "New-Year's Gifts that Deliver Themselves." Lithograph. Jean-Jacques Grandville, *Un Autre Monde* (Paris: P.H. Fournier, 1844), n.p. Author's collection

The use of episodes and the closure of frames

An important feature of the narrative structure of *Un Autre Monde* is its use of episodes, a clever strategy that enables the author to continue on indefinitely in a serial fashion. The observations of the three protagonists could go on indefinitely, so long as they don't run out of the universe to explore, anticipating the widespread use of such a structure. Umberto Eco in *De Superman au surhomme* has analyzed the narrative structure of the modern serial employing such strategies.[63] The adventures of the three protagonists in *Un Autre Monde* come to a closure when they die. This closure had been foreseen from the beginning, as each of the four stories forming the frames demands to be ended sometime. The structure, however, allows the end to arrive at an appropriate time.

Now that the story of the three protagonists is over, the book makes a transition to the next frame. In the epilogue, Pencil has returned from its journey and is proud of having "invented a world." Pen reports that pens of Paris have been criticizing Pencil's efforts, for being "obscure, monotonic [and] hieroglyphic," that the creator is "only satirical while trying to be philosophical" and that he "respects nothing." However, Pocketknife cajols the other two into declaring together that "*Un Autre Monde* is a masterpiece," and that "[p]roclaiming our merit ourselves is the best form of an epilogue we could choose."[64] Thus the story of the creation of the book completes itself in a self-praise and a sales pitch. Such self-referentiality comments on the artistic, social, and economic forces at work and on the constant need to publicize oneself. In the next image, the reader is addressed directly through a rebus depicting an Egyptian obelique with inscriptions—a popular form of rebus at the time—and a man banging his head against it.[65] The puzzle is also a tribute to the reader, who faces a caricature of one. The answer to the riddle is a tip from the artist: "Ah, believe me, dear reader, do not behave like this [imbecile who is breaking his head in order to solve me.]"[66] The rebus is the entire book, which the reader must interpret. The rebus also stands for the process of creating the book, in which images and texts are juxtaposed so that images become texts, rather than the other way around.

The next image, that of the epilogue (Figure 14.2), refers to the role of the artist, Grandville. It depicts the unveiling of an altar dedicated to "sketch," made up of the letters JGJ. This is also something of a visual puzzle made up of letters, since one has to figure out that JGJ stands for Grandville's initials JJG. This image marks a transition from the story of Pencil and Pen to that of the artist, Grandville. This monument reaffirms the role of the artist, accompanied by the shadowed writer, "T. Delord." The final image depicts another monument, "UN AUTRE MONDE," made from images and words. The monument seems to form a boundary between the sea and the sky as well as an exit from the other world. There is a sunset, signifying the end of something. Finally the perspective of the viewer is removed out of the other world. Close the book—the journey is over.

Grandville's transgressions

Baudelaire argued that Grandville, neither philosopher nor artist, had a "morbidly literary mind, always in search of bastard means to introduce his thought into the domain of the plastic arts ... From the perception of dualism, the viewer derives only uneasiness—fear, confusion, and unintelligibility."[67] Baudelaire was clearly perturbed by Grandville's difficult images and the mixing of genres, the juxtaposition of references to classical myths and futuristic visions. One source of the difficulty of

Grandville's images was that he stretched the principle of inversion to new and extreme ways. His depiction of animals went beyond conventions for allegorical purposes into a disconcerting illustration of animals donning human disguises. The grand question of the origin of the world is answered when a "celestial mechanism was entirely revealed, thanks to the negligence of its owner, who on this day had forgotten to close his cloud shutters." An old, frail magician blows soap bubbles "into the infinite." A conjuror juggles "nothing less than universes."[68] The origin of the universe is nothing but a conjuror's trick. Critics and the public did not take to caricatures that dared to transgress the boundary between caricature and philosophy. It appears that the public was also baffled by the attempt to transgress the boundary between high and popular art. Early nineteenth-century critics were interested in popular imagery partly because it represented an alternative, powerful tradition to the high art as historical evidence. At the same time at first little distinction was made between "popular," "primitive", and "caricature."[69]

Advertising as foreseen by Grandville

Walter Benjamin suggested that "The enthronement of the commodity and the glitter of distraction around it was the secret theme of Grandville's art ..."[70] As we have seen, *Un Autre Monde* also depicted the distraction created by various forms of advertising. The very *raison d'être* of advertising was distracting and grabbing attention. Moreover, editorial advertisements confused issues and changed the subject in newspaper articles. It can be theorized that Grandville recognized the sense of advertising having to go out of itself, into journalism, philosophy, literature, or travelogue, in order to become respectable and dissimulate into other genres.

Perceiving a "close link that unites advertising to the cosmic," Benjamin suggested that Grandville's works are "sibylline books of '*publicité*.' Everything that he presents in the embryonic form of a joke, a satire, finds, with advertising, its veritable blooming."[71] Indeed, Grandville's "cosmic and comic" images would become overt and literal in advertisements for the *magasins de nouveautés* of the mid-nineteenth-century, which made claims of cosmic proportions: "Les Magasins du Louvre, the biggest department store in the Universe."[72] Just as Grandville's images made fun of vanity, fashion, and advertising, other satires of advertisements were popular. *Le Tintamarre* grasped the comic nature of the preposterous claims of department stores. It parodied *La Chaussée d'Antin*'s announcement that it carried 11 million meters of fabric: "this store *alone* could dress up a kind of a tent above all the railroads in France, *which would be very pleasant in summer, during the heat*."[73]

Adopting a definition of fetishization as the attribution to a product of a quality not inherent in it, we can ask: To what extent did advertisements attribute arbitrary qualities to products during the July Monarchy, and how do Grandville's images compare to contemporary and future advertisements? George Rocque's concept of inserting advertising into the world is useful here.[74] In a world in which the concept of advertising itself was relatively new, how did advertisements associate products' qualities with any other qualities? Advertisements from the 1830s and earlier usually associated products with sources of authority and prestige, such as the king, Napoleon, God or goddesses. Many advertisements from early on did not just describe products but referred to values and sentiments and used fashionable themes such as the antique, the imperial and the oriental.[75] The exotic and scenes of trade were also popular. An advertising image for Parfumerie Moderne from the 1830s shows two merchants, perhaps Turkish and Chinese, and a scene of trade. Also present are goddesses and cherubs, symbols of prestige, and a set of images of fashionably dressed women. Jarring images were used as well at times. A mysterious and modern image in an advertisement from the 1830s shows a mouth with shiny teeth, set in a triangle with the word "USE." The triangle refers to the trinity, God, so "USE" is God's command. The image uses the popular classical framework, but it is a very striking image in that instead of the usual eye, there is a mouth, as the product advertised is for dental use. Moreover, there is absolutely no description of what the product does.[76] Here only a striking image consisting of a mouth with shiny teeth and a triangle referring to the ultimate source of authority is used for persuasion. The theme of the cosmic, as this example shows, was present in advertisements from early on, but commodities themselves were not aggrandized, nor, in advertisements of the July Monarchy, do products replace human agency as in Grandville's images.

Gigantic or free-floating, autonomous commodities appeared in advertisements in the 1900s. An advertisement from *c.* 1895 for ball bearings illustrates a literal rendering of Grandville's satire. Personified planets surround the globe, which turns because it is set in ball bearings. Unlike in images from the first half of the century, a product is set not only outside a shop or above Paris but is what makes the earth turn. The organic and inorganic are reversed and juxtaposed, and a semi-nude demigoddess, sitting on the globe, is a source of authority but also appears as an available female unlike in images from the first half of the nineteenth century.

Georg Simmel's analysis of the "historical process of differentiation" is applicable to the development of advertising.[77] As commodities acquire increasingly important status, advertisements place increasing distance between the subject and the object, the commodity. A typical example is an advertisement for Van Houten chocolate, in which a bottle of the chocolate

is carried by an eagle in the wilderness. Another advertisement depicts the same motif, except the eagle and the bottle are framed. This image, further distancing the viewer from the object by adding another frame, turns the commodity into an artistic subject, an item for interior decoration. Besides conquering the natural environment, commodities conquer the immediate environment. In turn-of-the century advertisements commodities become unnaturally bigger and permeate both the interior and the exterior. Rather than being handled by human beings, they surround or even submerge them.[78]

Conclusion

To Grandville's contemporaries it was the complexity of his images, such as apparently arbitrary associations and futuristic visions, and the interchanging of the organic and the inorganic and the human and the mechanical, that were troubling. These are precisely the qualities that fascinated his twentieth-century admirers. While the dimensions of self-referentiality of *Un Autre Monde* were misunderstood or simply unnoticed, these make the book all the more compelling. The book can be interpreted as displaying the process of creation of the book itself, from conception to finish, and sought to engage the reader to puzzle out the images. The containment of an eccentric imagined world—and the limitless scope of the work—inside the modest story of Pencil and Pen points to the power of the imagination. Another source of the unease produced by the book was the way it went beyond satire into philosophical musings, laying bare contemporary mores through defamiliarization, whereas satires were supposed to exaggerate reality but remain recognizable. Grandville's satire of the comic and absurd in contemporary phenomena, notably advertising practices and the commercialization of culture, also perhaps foresaw what was to come.

Notes

1. Jean-Jacques Grandville, *Un Autre Monde* (Paris: P.H. Fournier, 1844).

2. See Walter Benjamin, "Exposé de 1935" and "Exposé de 1939" in *Paris, Capitale du XIXe siècle* (Paris: Cerf, 1989). On contemporary mores and culture as the source of Grandville's art, as well as Grandville's social and artistic milieu, see Philippe Kaenel, *Le Métier d'illustrateur 1830–1880: Rodolphe Töpffer, J.-J. Grandville, Gustave Doré* (Paris: Éditions Messene, 1996); *Grandville: dessins originaux*, exhibition catalogue, Musée des Beaux-Arts of Nancy (Paris: L'Imprimerie Moderne du Lyon, 1986).

3. Peter Wick characterizes it as "a visionary and highly illusionistic fantasy—almost a forerunner of Star Wars." Peter A. Wick, "Introduction," in Jean-Jacques Grandville, *The Court of Flora: Les Fleurs animées* (NY: George Braziller, 1981), 3.

4. Wick, *The Court of Flora*, 3.

5. According to Stanley Applebaum the public was "respectfully awed and disconcerted, and many people today still view the book as a random collection of whimsies and eccentricities." Stanley Applebaum ed., *Bizarreries and Fantasies of Grandville: 266 Illustrations from "Un Autre Monde" and "Les Animaux"* (New York: Dover, 1974), xii.

6. Théophile Gautier, "Granville [sic]," in *Histoire de l'art dramatique en France depuis vingt-cinq ans* (Paris: Magnin, Blanchard et Cie, 1858–59), V, 64. The obituary appeared in *La Presse*, March 29, 1847. Cited in *Grandville: dessins originaux*, 7.

7. Charles Baudelaire, *Œuvres complètes*, ed. Claude Pichois (Paris: Gallimard, 1976–77), II, 558, 604.

8. Joseph Méry, in Grandville, *Etoiles, dernière féerie. Astronomie des dames par Cte Foelix* (Paris: G. de Gonet, 1849), xi.

9. Charles Blanc, "Grandville (1803–1847)" in *Les Artistes de mon temps* (Paris: Firmin-Didot, 1876), 275–312. The article is also in G. Havard's 1854 edition of *Métamorphoses du Jour*.

10. Champfleury was nostalgic for the bygone period of "romantic," "*pittoresque*" illustrations. Kaenel, *Le Métier d'illustrateur*, 6.

11. *Grandville: Dessins originaux*, 340. Grandville in fact illustrated *Voyages de Gulliver dans des contrées lointaines* in 1838.

12. On Grandville's use of allegory see Michele Hannoosh, "The allegorical artist and the crises of history: Benjamin, Grandville, Baudelaire," in *Word & Image*, 10: 1 (January–March 1994), 38–54; Hannoosh, *Baudelaire and Caricature: From the Comic to an Art of Modernity* (University Park: Penn State Press, 1992), 158–72. For the influence on Grandville of the doctrine of correspondences stemming from the mythical and utopian-socialist traditions, as well as the idea of metamorphosis that dates back to Ovid, see Christoph Asendorf, *Batteries of Life: On the History of Things and Their Perception in Modernity* (Berkeley: University of California Press, 1993), 36–40.

13. *Mise-en-abyme*, originally a term of art history, had been used in earlier works. Jan Potocki's *The Manuscript Found in Saragossa* (*c.* 1790–1815), for example, consists of many stories-within-stories. The narrative of Potocki's work, however, is straightforward and does not play with the viewpoints of the author nor is it self-referential. These aspects would become common in the modern and the postmodern novels of the twentieth century. See Linda Hutcheon, *Narcissistic Fiction* (Waterlow, Ont: Wilfrid Laurier University Press, 1980).

14. Réjane Bargiel-Harry and Christophe Zagrodzki, *The Book of the Poster* (Paris : Editions Alternatives, 1985), 12.

15. Maurice Crubellier, "L'Élargissement du public," in Roger Chartier and Henri-Jean Martin eds, *Histoire de l'édition française v.3 Le temps des éditeurs. Du romantisme à la Belle Époque* (Paris: Fayard, 1990), 15–41: 31; Petra ten-Doesschate Chu and Gabriel Weisberg, eds, "Introduction," *The Popularization of Images: Visual Culture under the July Monarchy* (Princeton, N.J.: Princeton University Press, 1994), 4.

16. Annie Renonciat, *La Vie et l'œuvre de J.J. Grandville* (Paris: ACR Édition, 1985), 230. Delord also wrote the texts of Grandville's *Cent proverbs* (1844) and *Fleurs animées* (1847). For interpretations of the pencil and pen episode, see Kaenel, "Autour de J.-J. Grandville: les conditions de production socio-professionnelles du livre illustré 'romantique'," *Romantisme: Revue du XIXème Siècle* 43 (1984): 45–62.

17. Applebaum characterizes the text as "generally a lame, hotchpotch attempt to group and interpret pictures that were conceived independently." Appelbaum, ed., *Bizarreries and Fantasies of Grandville*, xi.

18. Michel Melot, "Le Texte et l'image," in Roger Chartier and Henri-Jean Martin, eds, *Histoire de l'édition française* v. 3 (Paris: Fayard, 1990), 336.

19. Grandville, *Un Autre Monde*, 9–10, 17.

20. *Album-revue de l'industrie parisienne* (Paris: H.L. Delloye, 1844). On La Maison Aubert see James Cuno, "Charles Philipon, La Maison Aubert and the Business of Caricature in Paris, 1829–1841," *Art Journal*, 43 (Winter 1983): 347–54.

21. Grandville, *Un Autre Monde*, 10.

22. Philippe Hamon, *Expositions: Literature and Architecture in Nineteenth-Century France*, trans. Katia Sainson-Frank and Lisa Maguire (Berkeley: University of California Press, 1992), 133n. Hamon focuses on the Second Empire, but such words were popular also in the July Monarchy.

23. Thanks to James Rubin for this idea.

24. Grandville, *Un Autre Monde*, 19.

25. Grandville, *Un Autre Monde*, 18.

26. Gérard Genette, *Paratexts: Thresholds of Interpretation*, trans. Jane E. Lewin (Cambridge: Cambridge University Press: 1997), 104–16.

27. On editorial advertising see Theodore Zeldin, *France 1848–1945, v.2 Intellect, Taste and Anxiety* (Oxford: Oxford University Press, 1977), 513–4; Richard Terdiman, *Discourse/Counter-Discourse: the Theory and Practice of Symbolic Resistance in Nineteenth-Century France* (Ithaca: Cornell University Press, 1985), 123–4; Hazel Hahn, "Boulevard Culture and Advertising as Spectacle in 19th-Century Paris," in Alexander Cowan and Jill Steward eds, *The City and the Senses: Urban Culture Since 1500* (Aldershot: Ashgate, 2006), 156–77.

28. Balzac, "Monographie de la Presse Parisienne," in Paul de Kock et al., *La Grande Ville. Nouveau tableau de Paris, comique, critique et philosophique*, v.2 (Paris: Au Bureau Central des Publicatoins Nouvelles, 1842): 146–7.

29. Grandville, *Un Autre Monde*, 17.

30. Applebaum ed., *Bizarreries and Fantasies of Grandville*, 2.

31. Marc Martin, *Trois siècles de publicité en France* (Paris: Éditions Odile Jacob, 1992), 77.

32. Gérard Lagneau, *Les Institutions publicitaires, fonction et genèse: Thèse pour le Doctorat d'etat ès Lettres et Sciences Humaines* (Académie de Paris. Université René Descartes. Sciences Humaines, 1982), 299.

33. Grandville, *Un Autre Monde*, 17–18.

34. Grandville, *Un Autre Monde*, 18.

35. Grandville, *Un Autre Monde*, 22–23.

36. Grandville, *Un Autre Monde*, 17–18.

37. Grandville, *Un Autre Monde*, 35.

38. Grandville, *Un Autre Monde*, 45–8, images 44—8.

39. Grandville, *Un Autre Monde*, 62.

40. Grandville, *Un Autre Monde*, 70.

41. Charles Philipon, "Longchamps," *La Silhouette*, v. II, 29; Philipon, "Les Fashoinables," *La Silhouette*, v. I–II, 45, printed in Martine Contensou, *Balzac et Philipon associés: Grands fabricants de caricatures en tous genres* (Paris: Paris Musées, 2001), 20.

42. Walter Benjamin, *Charles Baudelaire: A Lyric Poet in the Era of High Capitalism* (London: Verso, 1983), 165.

43. Grandville, *Un Autre Monde*, 70.

44. Madame de Girardin, cited in John Grand-Carteret, *XIXe siècle en France. Classes, moeurs, usages, costumes, inventions* (Paris: Firmin-Didot et Cie., 1893), 686.

45. On *magasins de nouveautés* see *Au Paradis des Dames: nouveautés, modes et confections 1810–1870*, exhibition catalogue (Paris: Paris Musées, 1992); Hazel Hahn, "Fashion Discourses in Fashion Journals and Madame de Girardin's *Lettres parisiennes* in July-Monarchy France," *Fashion Theory: the Journal of Dress, Body and Culture*, 9, 2 (June 2005): 205–27.

46. *Le Tintamarre*, June 23, 1867, 8. This is also a satire of the French custom of mothers with eligible daughters soliciting prospective sons-in-law while keeping their daughters away from men. For a discussion of this custom see Frances Trollope, *Paris and the Parisians in 1835* (New York: Harper & Brothers, 1836).

47. *La Caricature*, May 5 and June 9, 1839; Loys Delteil, *Le Peintre-Graveur illustré: Honoré Daumier* (Paris: L'Auteur, 1925–30), n.621–2.

48. *Le Charivari*, March 13, 1838; Delteil, n.535.

49. Michele Hannoosh, "The allegorical artist and the crises of history," 46.

50. Grandville, *Un Autre Monde*, 233.

51. Georges Roque, *Ceci n'est pas un Magritte: Essai sur Magritte et la publicité* (Paris: Flammarion, 1983), 132.

52. Charles-Augustin Saint-Beuve, "La littérature industrielle," quoted in John Lough, *Writer and Public in France: from the Middle Ages to the Present Day* (Oxford: Oxford University Press, 1978), 317.

53. Grandville, *Un Autre Monde*, 239.

54. Grandville, *Un Autre Monde*, 237–240.

55. Grandville, *Un Autre Monde*, 239.

56. Grandville, *Un Autre Monde*, 45.

57. Grandville, *Un Autre Monde*, 74–5.

58. Grandville, *Un Autre Monde*, 271.

59. Grandville, *Un Autre Monde*, 276.

60. Balzac, *Wild Ass's Skin*, trans. Herbert J. Hunt (London: Penguin, 1977), 67.

61. *The Illustrated London News*, December 24, 1842, 524.

62. *L'Illustration*, November 25, 1843, 207.

63. Umberto Eco, *De Superman au surhomme*, trans. Myriem Bouzaher (Paris: Grasset, 1978).

64. Grandville, *Un Autre Monde*, 288–92.

65. For the vogue for the rebus with Egyptian hieroglyphs see Kaenel, *Le Métier d'illustrateur*, 227.

66. *"Ah! crois-moi, ami lecteur, ne fais pas comme cet [imbécile qui se casse la tête pour me deviner.],"* Applebaum, 7.

67. Charles Baudelaire, *Œuvres complètes*, II, 598, 600.

68. Grandville, *Un Autre Monde*, 139–42, images 140, 142.

69. Francis Haskell, *History and Its Images: Art and the Interpretation of the Past* (New Haven: Yale University Press, 1993), 382.

70. Walter Benjamin, *Charles Baudelaire*, 165.

71. Walter Benjamin, *Paris, Capitale du XIXe Siècle*, 195, 191.

72. *Lebende Bilder aus dem modernen Paris*, 4 vol. (Cologne: 1863–1866) II, 292–4, cited in Benjamin, *Paris, Capitale du XIXe Siècle*, 194.

73. *Le Tintamarre*, cited in *Lebende Bilder aus dem modernen Paris*, II, 292–4, cited in Benjamin, *Paris, Capitale du XIXe Siècle*, 194.

74. Georges Roque, *Ceci n'est pas un Magritte*.

75. Madeleine Fargeaud, "Balzac, le commerce et la publicité," *L'Année Balzacienne* (1974), 187–98.

76. Bibliothèque Nationale de France. Print and Photography Department. File "Publicités Parfumerie 1830–39." "Poudre dentifrice conservatrice désinfectante."

77. Georg Simmel, *The Philosophy of Money* (London: Routledge, 1990), 76.

78. For turn-of-the-century British advertisements see Thomas Richards, *The Commodity Culture of Victorian England: Advertising and Spectacle, 1851–1914* (Stanford: Stanford University Press, 1990); Lori A. Loeb, *Consuming Angels: Advertising and Victorian Women* (Oxford: Oxford University Press, 1994); Anne McClintock, *Imperial Leather: Race, Gender and Sexuality in the Colonial Contest* (New York: Routledge, 1995).

"Awful, moony light": the visual and the colonial Other in Wilkie Collins's *The Moonstone*

Carla Spivack

The industrial age was also the imperial age;[1] visions of the industrial age were also visions of empire. As Britain's colonies took up more and more of the world's surface, their images and emblems seeped back home, into the nooks and crannies of British domestic culture, permanently changing its visual fabric. John Jarndyce's Bleak House is as good an illustration as any other of this development. Its winding passages and hidden rooms are filled with, among other things, "mangles ... and three cornered tables, and a native Hindu chair, which was also a sofa, a box and a bedstead, and looked in every form something between a bamboo skeleton and a great bird cage, and had been brought from India nobody knew by whom or when ... [prints of] numbers of surprising and surprised birds ... the death of Captain Cook ... and the process of preparing tea in China, as depicted by Chinese artists."[2] Other Victorian novels are filled with similar depictions. My purpose in this chapter is to draw out the implications of this ocular invasion for nineteenth-century culture, offering Wilkie Collins's detective novel *The Moonstone* as illustration. I will show a contest in the novel between the scopic power of the colonial Other and that of the dominant culture of the colonizers, a contest which, in *The Moonstone*, is central to the mystery's inception and to its solution. The idea of "imperial seeing"—the gaze of the colonizer as a gaze of control and domination—is not new: in *Imperial Eyes: Travel Writing and Transculturation*, Mary Louise Pratt shows that much European travel writing about the "Orient" was characterized by an implicit invisible viewer who wields a dominant, all seeing gaze which symbolically exerts control and takes possession of what it sees.[3]

Many scholars have observed that imperialism is a scopic regime. As Homi Bhabha, Paul Greenhalgh, and Timothy Mitchell, among others, have pointed out, the organizing economy of colonialism is the colonizing gaze. This gaze

is the system of surveillance over the bodies, landscapes, geographical, and domestic spaces of the colonized. The Colonial and Indian Exhibition in London in 1886, and the Exposition Coloniale Internationale in Paris in 1931 displayed for domestic audiences imitation native villages, oriental streets, whirling dervishes, and belly dancers, spreading the colonized world out before them as a spectacle.[4]

But this spectacle can threaten the very power it seems to acknowledge, because colonization is always incomplete. There is always that part, which, in the words of Luce Irigaray, "resists and explodes every firmly established form, figure, idea or concept."[5] Homi Bhabha calls this the "uncanny of cultural difference."[6] Colonialism seeks to project this uncolonized other outwards, as the cultural Other, but it has a way of turning back onto the colonizing subject, appearing to have always "already" been there, and fracturing its sense of a stable self. This is the danger of the visual: it threatens to overwhelm the beholder. The panoramas of the 1886 Exhibition, and of the 1931 Exposition counteract this effect by offering the spectacle of the Other as an object of visual control.

Before turning to the analysis of *The Moonstone*, I will offer some examples of the ways visual emblems of the colonial Other invaded and/or pervaded the Victorian novel. At the beginning of Dickens's *Edwin Drood*, for example, Jasper, the protagonist, waking from an opium-induced stupor, raises himself from an unkempt bed, and looks around him. Trying to "piece together" his "scattered consciousness" he at first rejects the possibility that he is in "an ancient English cathedral town [i.e. Canterbury, where the novel takes place]"—in fact, in England at all. A rusty iron spike on the bedstead at first confuses him: there is no iron spike in front of Canterbury Cathedral, and he imagines instead that he is in a particularly gruesome episode from the Arabian Nights: "Maybe it is set up by the Sultan's orders for the impaling of a horde of Turkish robbers, one by one." This image is followed by visions of clashing cymbals, scimitars, dancing girls, and white elephants. But the cathedral tower refuses to go away, and no "writhing figure" appears on the spike, which suddenly turns out to be "so low a thing as the rusty spike on the top of a post of an old bedstead that has tumbled all awry," and the sleeper is fully awake.[7]

This opening passage presents in capsule form the way the encounter between the colonizing gaze and the visual colonial Other destabilizes the self. The pieces of Jasper's consciousness are "scattered" by his encounter with the Other—in his case, specifically the encounter with opium, which brings about the dreadful visions of spikes and torture. These images seem to have invaded and overtaken not only Jasper's consciousness, but even the homey "English Cathedral town"—perhaps England itself. And the method of conquest is alarming, at the very least: impaling, a form of invasion which splits the physical self up through the middle. For the moment, however, the

stable self, and England, win: the cathedral tower asserts itself and the sleeper awakes.

While there has been much discussion of the role of alterity in the study of the verbal texts of empire, less attention has been paid to the role of the colonial Other in its visual form.[8] As this passage makes clear, however, this encounter is an important one. Non-verbal imagery is at least as powerful, and perhaps more powerful, than verbal. As the opening of *Edwin Drood* and other passages cited below demonstrate, the visual has the power to undermine a stable sense of identity and selfhood.

Indeed, the appearance of the moonstone in Collins's novel stages a similar encounter, this time between respectable English society and a symbol of empire, the diamond which was stolen from the forehead of a deity during the battle for Seringapatam, during the Sikh wars which won for Britain another large swath of empire.[9] As Gabriel Betteredge, the staid English butler, describes it as it appears in the hand of Rachel Verinder, it inspires awe not only in her cousins, the perpetually excited and shrill "Bouncers," but in Betteredge's prosaic mind as well:

Lord bless us! It *was* a diamond! As large, or nearly, as a plover's egg! The light that streamed from it was like the light of the harvest moon. When you looked down into the stone you looked down into a yellow deep that drew your eyes into it so that they saw nothing else. It seemed unfathomable: this jewel, that you could hold between your finger and thumb, seemed unfathomable as the heavens themselves. We set it in the sun, and then shut the light out of the room, and it shone awfully out of the depths of its own brightness, with a moony gleam in the dark. No wonder Miss Rachel was fascinated; no wonder her cousins screamed. The Diamond laid such a hold on *me* that I burst out with as large an "O" as the Bouncers themselves.[10]

A close look at this passage reveals the moonstone's destabilizing effects. The diamond seems almost to be its own source of light—not like the sun, source of clarity and dispeller of shadows, but like the moon, caster of half-light and mystery. With the sun shut out of the room is the diamond's glow a mere reflection or something else? Looking "down into" it, the viewer loses perspective, and the sense of surrounding objects. There is a feeling of being overwhelmed; everything else in the room loses tangibility. Indeed, the viewer's eyes "saw nothing else" and there is complete loss of perspective. And no further proof is needed of the stone's disruptive effects on the boundaries of the self than the fact that the stodgy Betteredge finds himself imitating the screeching, giggly cousins who are his antithesis, and whom he ridicules. Appropriately enough in this context, we also learn that another aspect of the Moonstone's uniqueness is that there is "a defect, in the shape of a flaw, at the very heart of the stone."[11] It is as if the diamond bears the mark of its own effect on those around it—and, in its own way, refuses to reveal a stable core.

A third and final example confirms the destabilizing effect these visual encounters with the colonial Other have on the self. Here is E.M. Forster's description of the Marabar hills and the Marabar caves in *A Passage to India*:[12]

> There is something unspeakable in these outposts [the Marabar hills]. They are like nothing else in the world, and a glimpse of them makes the breath catch. They rise abruptly, insanely, without the proportion that is kept by the wildest hills elsewhere, they bear no relationship to anything dreamt or seen … Having seen one [Marabar cave], having seen two, having seen three, four, fourteen, twenty four, the visitor returns to Chandrapore uncertain whether he has had an interesting experience or a dull one or any experience at all. He finds it difficult to … keep them apart in his mind, for the pattern never varies, and no carving, not even a bees'-nest or a bat distinguishes one from the other … [When] the visitor arrives … and strikes a match … another flame rises in the depths of the rock and moves toward the surface like an imprisoned spirit.[13]

Again, this imagery presents a visual experience which resists proportionality — the hills cannot be described in relation to anything else, a feature they share with the moonstone, which cannot be accurately valued because its size and color are not like any other diamond. Both the caves and the moonstone refuse to "bear a relationship to anything dreamt or seen." The caves, in addition, cannot be described or even distinguished from each other — they threaten the very idea of separate identity. Again, like the moonstone, they seem to produce their own light out of what should be a mere reflection. These characteristics, taken together, are the traits of the colonial Other which appear again and again to threaten the stability of the self. It threatens the notion of a separate, stable identity by confusing distinctions between self and Other, but it also resists incorporation into familiar fields of reference and categories of meaning. By seeming to produce its own light, it knocks the imperial viewer off his perch of mastery, implying that it, not the colonizer, is the source of the gaze.

D.A. Miller, in *The Novel and the Police*, argues that *The Moonstone* depicts the emergence in the nineteenth century of all-encompassing and yet largely invisible regimes of control and surveillance. Thus, the mystery is solved not by the detective sergeant or any other locatable agent of investigation, but by the mere natural unfolding of events over the course of time. Miller suggests that this process dramatically increases what he calls the "network of police power" by making it invisible, and yet as omnipresent as reality itself. Although it cannot be seen, it has the effect of putting all of reality under a policing surveillance.[14] I wish to build on Miller's insights by discussing the role of the colonized Other in this scheme. Miller brilliantly describes the scopic and pervasive nature of this policing power; I suggest that an important part of its emergence is colonialism and the destabilizing effect of its attendant alterity within this emerging regime.

The diamond's disruptive influence continues throughout the night of Rachel Verinder's birthday party, and Betteredge half recognizes it, in retrospect, for what it is: "Looking back on the birthday now ... I am half inclined to think that the cursed diamond must have cast a blight on the whole company."[15] He observes at the time that "this festival was not prospering as other like festivals had prospered before it."[16] Despite his plying them with wine, "there were gaps of silence in the talk ... [w]hen they did use their tongues again, they used them ... in the most unfortunate manner and to the worst possible purpose ... [w]hen they ought to have spoken they didn't speak; or when they did speak they were perpetually at cross purposes."[17] These "cross purposes" all serve to disrupt aristocratic Victorian social order and propriety. Franklin Blake, for example, Rachel's favored suitor who has just returned from years of foreign travel, regales "the maiden aunt of the Vicar of Frizinghall" with speculation about a married woman's admiration for a man "not her husband,"[18] insults an authority on bull breeding by expounding on how to do it properly, and cheerfully mocks the local MP's anxiety about the spread of democracy in England. Indeed, Blake's peculiar conversational forays seem to be the main source of the social disruption at the dinner, and Betteredge surmises that they all emerge from Blake's exposure to foreign culture. The conflicting national facets of Franklin Blake's character, Betteredge theorizes—"those French and Italian and German sides of him—came out in the most bewildering manner."[19]

Blake's behavior keeps getting worse. Finally, after offending a series of listeners with views emerging from—if we agree with Betteredge - the French, German and Italian parts of his personality, "the English side of him turned up in due course," and he proceeds to insult the medical profession, represented at table by Dr. Candy.[20] Blake is led to confess that he has been having trouble sleeping, but scoffs at Candy's suggestion that he embark on a course of medical treatment. Angry at this mockery of his profession, Candy—as it turns out at the end of the novel—secretly slips opium into Blake's after dinner brandy and soda—and the mystery is underway. As readers know, under the influence of the opium, which exacerbates his anxiety about the moonstone, Blake steals into Rachel's room that night and removes the diamond for safekeeping, and is tricked by the real villain, Godfrey Ablewhite, into handing it to him as he leaves his cousin's room, still in a stupor. If Betteredge is right, and Collins allows us to think that he is, it is the fracturing of Blake's identity due to the influences of his foreign travels which is the source of the harm—the unease at dinner, the theft of the diamond, the estrangement of Rachel from her mother and from him, etc. Thus, otherness destabilizes not only the individual's self but the collective, communal self as well.

The argument between Blake and Candy about the value of medicine is full of references to darkness and blindness. Blake insists that "a course of

medicine, and a course of groping in the dark, meant, in his estimation, one and the same thing" and scorns the doctor's advice as an example of "the blind leading the blind."[21] It is also by literally "groping in the dark" that Blake later removes the diamond from Rachel's room. These references at the beginning of the novel all suggest the need for the institution of a regime of visual power. The dislocation at the heart of the novel arises not just from Blake's fragmentation, but also from the inability to see. Blake, sleepwalking, cannot see what he is doing when he takes the diamond. Conversely, though, the diamond seems spookily able to cast its own light. The "blindness" which plays a role in the mystery is a result of bringing the stone into the house because the stone, by seeming to emit light on its own, threatens the mastery of the imperial gaze.

The references to blindness also arise in reference to Blake's recently discontinued habit of smoking, his subsequent sleeplessness, and the proper cure—a series of matters brought on by another colonial import, tobacco. The tobacco Blake smoked had been probably grown in, and imported from, the Americas. At the novel's resolution, when Jennings, Bruff, and Rachel watch Blake re-enact the theft, under the influence of the second, prophylactic dose of opium, their vigil asserts visual control over the events brought upon the family by the appearance of the moonstone. And this is not only visual control, it is specifically the kind of visual control inherent in the imperial gaze: Bruff and Betteredge eagerly peer at the drugged Blake "through a crevice left in the imperfectly drawn curtains of the bed."[22] In other words, they watch him without his being able to see them, which is exactly how the dynamics of the imperial gaze described by Mary Louise Pratt work. By removing themselves from the scene and surveying it as if they were not there, they position themselves as the prime movers—which, in fact, having dosed Blake with opium to see the results, is what they are.

The foregoing has shown that scopic power is contested from the beginning of the novel. Another example, this time from the Indians' perspective, confirms this. In the first few pages, before the moonstone has even arrived at the Verinder house and before the birthday party has taken place, Penelope, Betteredge's daughter, comes upon three Indian jugglers—Brahmin priests in disguise, it later turns out, who are following the moonstone and plotting to get it back—whom the butler had just booted off the estate. She and her friend follow them as they walk back along the road, hiding behind the hedge which bordered the Verinder lawns, and spy on them as they conduct a series of "extraordinary tricks"—they turn to a little English boy they have with them, pour black ink into the palm of his hand, and tell him to look into the ink where he can "see" Franklin Blake ("the English gentleman from foreign parts"). The boy "sees" Blake in the ink and reports that he will travel on that very road when he returns to the house that night, and that he will have the moonstone on him.[23]

This "hocus pocus," as Betteredge calls it, stages a moment when the Indians, and the alterity they represent, make a play to contest the imperial power of seeing. The Indians here seem to be practicing a native version of clairvoyance, a subject which fascinated Collins. He most likely took the above episode from an article in an 1867 issue of *Notes and Queries* about native Indian practices of prophetic "seeing."[24] He was somewhat credulous about the whole topic, and published a series of essays in *The Leader* about his own—allegedly successful—experiments with it. In any event, one of Collins's contemporaries, the writer G.H. Lewes, took him to task for his gullibility in another article in *The Leader* called "The Fallacy of Clairvoyance." According to Lewes, Collins's fallacy was "the interpretation of *dreaming* power as *seeing* power."[25] The clairvoyant, according to Lewes, describes people and objects she dreams up, but what she claims to *see* is shaped by the suggestive power of those around her. In other words, the clairvoyant merely produces dream imagery which she then—perhaps subconsciously—reshapes to conform to the expectations of those around her. There is no power here to see and to control. Thus the contest between Collins's credulity and Lewes's skepticism is a debate about power: if the boy can really locate Blake's whereabouts at a given time by gazing into the pool of ink, this *vision* will give the Indians power over him, which they can use to waylay and murder him. If what the boy sees is really nothing more than a *dream* image, product of the wishful thinking of his keepers, it conveys no such power.

The "celebrated Indian traveler," Murthwaite, also a guest at the birthday party, who "had penetrated in disguise where no European had ever set foot before," represents Lewes's viewpoint in the novel. He expresses confidence that the performance Penelope witnesses is merely "a development of the romantic side of the Indian character ... the boy no doubt reflected what was already in the mind of the person mesmerizing him."[26] Expressing this view, Murthwaite denies the colonized—in the forms of the Indians here—visual power. The fantasy that they can physically locate Franklin Blake and the diamond, in order to waylay him and steal it back on his way home, is, according to Murthwaite, just that—a fantasy. Their visions convey no power. We are perhaps not surprised to learn that Murthwaite has a "very steady, attentive eye;"[27] no mist rises in *his* head to cloud *his* sight. By the same token, we are not surprised to learn that Blake's years of travel have "left nothing of his old self except the bright, straightforward look in his eyes,"[28] nor that Sergeant Cuff, called in to solve the mystery, has "eyes, of a steely light grey [which] had a very disconcerting trick, when they encountered your eyes, of looking as if they expected something more from you than you were aware of yourself."[29]

The problem which the novel presents is, however, that Murthwaite's analysis is at least potentially incorrect. The Indians' boy in fact accurately predicts Franklin Blake's travels that night, and the only thing that prevents

his murder on his homeward road is the fact that he repeatedly and suddenly changes his plans and means of travel. The Indians have seen with partial accuracy, and have been thwarted in their purpose only by Blake's evasions. We do not know, whether, at the time the boy made his prediction, Blake had yet changed his plans. The question, then, of the Indians' power to see, and to control, rather than merely to dream, is not resolved.

Two other visual traits surrounding the diamond bear mentioning: the redecorated door to Rachel's "boudoir," as Betteredge calls it, and the "Indian cabinet" in which she decides to keep the diamond the night after her birthday celebration. Blake and Rachel, driven by what Betteredge calls the perennial problem of gentlefolks, i.e. "their own idleness,"[30] decide to strip and repaint the door to Rachel's room. They finish on the birthday, and "proud enough they were of it," Betteredge assures us: it is now covered in "griffins, birds, flowers, cupids, and such like—copied from designs made by a famous Italian painter whose name escapes me: the one, I mean, who stocked the world with Virgin Maries and had a sweetheart at the baker's."[31] The decorated door creates a visual barrier to Rachel's room—already exoticized by the stiffly British butler's use of the word "boudoir"—and indeed, to mental equilibrium itself: Betteredge admits its beauty, but complains that the griffins and other devices were "so many in number, and so entangled in flowers and devices, and so topsy-turvy in their actions and attitudes, that you felt them unpleasantly in your head for hours after you had done with the pleasure of looking at them." Collins's "Italian painter" is most likely Raphael,[32] whose High Renaissance Catholic imagery ("Virgin Maries") creates a portal of alterity in the Anglican Verinder household. And, with its allusions to the Virgin Mary, the door creates a portal to the alterity that is the feminine as well.

Then, after her birthday dinner, Rachel, refuses to let her mother keep the diamond overnight, but is also afraid to leave it on her dressing table for fear that "it might take to shining of itself, with its awful moony light in the dark—and that would terrify her in the dead of night." Finally she "bethought herself" of her Indian cabinet, and decides to "put the Indian diamond in the Indian cabinet for the purpose of permitting two beautiful native productions to admire each other." The moonstone's power to disrupt, which we have already seen in action at the dinner table and in its mysterious power to emit its own light, is now paired with another visual emblem of the Other—and they are to exercise, in Rachel's fanciful terms, their mutual gaze. The Indian cabinet, like Rachel's decorated door, and, I suggest, like the Hindu chair in Bleak House and all the other detritus of empire scattered throughout Victorian novels, visually materializes the disruptive power of the Other in the heart of Victorian domesticity. It is certainly fitting that the diamond be housed in such a curio, and that the relationship between the two be expressed in Rachel's fanciful visual metaphor of mutual admiration.

As noted, visual symbols of alterity in *The Moonstone*, like the decorated door and the Indian cabinet, link colonial alterity with the feminine, specifically, with feminine sexuality. The decorated door is not only the door that leads to the moonstone, but it is also the door to Rachel's bedroom; its devices include cupids and flowers, reminiscent of the painter whose mistress was a baker's daughter; Blake and Rachel work on it together, "their heads together, busy as bees," inspiring speculation among the servants as to their possible marriage. When Blake steals into Rachel's room, smearing the still wet paint on the door with his nightgown, and reaches into the Indian cabinet to take the diamond for safekeeping, he is metaphorically "taking" Rachel's virginity as well. This initial act of metaphorical seduction is recuperated later in the book, when Rachel, refusing to see or communicate with Blake, is tricked into a meeting with him under the pretext of visiting her lawyer's house to spend the day with his wife and daughters. The lawyer, Bruff, gives Blake a "large key" and instructs him to use it to "let yourself in to the garden, and make your way in by the conservatory door … cross the small drawing-room, and open the door in front of you which leads into the music room" where he will find Rachel alone.[33] As he follows these instructions, Blake hesitates just outside the final door, the door to the music room, to "rouse his manhood" before confronting her.[34]

I suggest that the recuperation this scene presents is a necessary part of the novel's overall project. It replaces the images of India in the first metaphorical scene of seduction—Blake's' theft of Rachel's "jewel"—with distinctly British domestic images—the garden, the conservatory, the music room—which serve the same function. Both are sets of symbols which carry a double meaning, that of Rachel's bodily boundaries and sexuality. But now those symbols are home grown, rather than foreign and exotic. To put it another way, the scene in the music room separates the feminine exotic from the colonial exotic, making the penetration of the former both safe and even salutary. In his first incursion into Rachel's/the diamond's "space," Blake— albeit unconsciously—sets their world on its head. In the second, which is now "merely" the penetration of Rachel's boundaries alone, he begins to mend that harm.

Up until this point, Rachel has been inscrutable to the reader and to everyone else in the novel. Even her mother cannot persuade or command her to explain herself. She leaves the Verinder estate without an explanation; she cuts off communication with Blake without saying why. It is her outburst in the music room—that she knows he took the diamond because she saw him do it—that begins to unlock the mystery. In another of the many displacements in the novel, solving—"penetrating"—the mystery of the moonstone means solving—"penetrating"—the mystery of Rachel. The feminine, stripped, so to speak, of its connection with the Other, becomes a way to master that Other. Secure knowledge of Rachel, uncovering her "true" thoughts and feelings,

is a way to begin the uncovering and conquest of more threatening forms of otherness which have fractured the self.

Healing for this fractured self seems to come in a peculiarly modern form; here it is possible to speculate about the relationship between this early experience of colonialism and the development of psychoanalysis. Freud published *The Interpretation of Dreams* in 1900.[35] In 1868, 12 years after Freud was born, in *The Moonstone*, another doctor sat beside a prone patient, transcribed his fragmented, semi-conscious thoughts and assembled from them a coherent narrative about identity, personal history and the unconscious. This proleptic practitioner is the doctor Ezra Jennings, his patient is the delirious Dr. Candy, and the narrative he pieces together contains part of the solution to the mystery by revealing Candy's deception and Blake's opium induced state that night. In conducting this "analysis," Jennings brings to light hidden aspects of Blake's identity and deeds of which he is unconscious. In this way, he solves the mystery by performing the work of both the novel and psychoanalysis: Jennings "appropriates" the material of Dr. Candy's delirium just as Franklin Blake "appropriates" the memories of the guests at the birthday party.[36]

Ronald Thomas argues that both *The Moonstone* and *Edwin Drood* enact power of forces in the self which are "produced by the dreamer and yet are entirely outside the authority of his or her conscious will."[37] I agree as far as this goes, but it does not go far enough: equally important are what comes before these forces are even configured as a product of the self—the power of the colonial Other to call them into being. Adding this to the analysis makes clear that these forces must be put under control, and suggests that such control is to be exercised as control of the colonized exotic, or what I have been calling the colonial Other.

This control is enacted through a kind of homeopathy. In a letter to his mother, Collins reports that another of his detective novels, *The Woman in White*, is keeping an old lady out of the grave by "homeopathic dose of a chapter at a time."[38] The idea of "homeopathic doses" of something frightening or exotic also operates in *The Moonstone* in several forms. As noted above, Rachel serves this purpose: at the beginning, Rachel is associated with some aspects of otherness: she is inscrutable even before the diamond disappears; she is the diamond's recipient, targetted, for unknown reasons by her vindictive Uncle Herncastle; she has the Indian cabinet in her room. The opium administered by Ezra Jennings at the end of the novel to undo the harm the first dose caused, functions similarly. This combination—a small dose of the exotic controlled by the technical and scientific skill of the domestic—turns out to be the best prophylactic against the threatening Other.

The timing of the novel provides a context for its concern with the disruptive effects of the presence of the Other—specifically, the colonial Indian Other. Collins wrote *The Moonstone* in 1867–68, but backdated it to a critical period in the colonization of India, the time of the Sikh Wars. He also

wrote it after the cataclysmic Sepoy Rebellion of 1857—the British called it The Mutiny—a crucial turning point in the history and ideology of British India and the cause of contention between Collins and his mentor Dickens. The rebellion was sparked by a rumor among the Bengal army that the cartridges of their new Enfield rifles, whose ends had to be bitten off before use, had been greased with pork and cow fat, causing both Hindu and Muslims to commit sacrilege. Widespread unrest throughout the colony, however, also preceded the Mutiny, although British analysts downplayed this aspect. The British saw it as treachery; Indian nationalists have called it the first Indian war of independence. In any case, both sides committed atrocities, and the Indian massacre of women and children at Cawnpore, became a rallying cry for British vengeance.[39]

The Mutiny delivered a severe shock to the self image of the British raj and its conception of its role in India. A dominant theme was that of treachery and betrayal, and in the Mutiny's wake, race replaced culture as the defining category. Racial difference was highlighted when seemingly loyal and docile sepoys turned on their benefactors and committed acts of shocking violence—especially the alleged rape of white women, an aspect which was emphasized and constantly reiterated in the discourse about the Mutiny. The Mutiny helped replace the narrative of the transcendent and civilizing role of education with that of the ineradicability of racial difference. Among other related developments, intermarriage with native women ceased to be approved or even accepted, and an influx of white women after 1857 sought to transplant British domestic manners and accoutrements.[40] All in all, "the outrage at what had been done to them, the bitterness of learning to fear those who ought to have feared them, was translated into the building of a protective racial barrier, aiming to ensure the separation of the colonizing society from what it had colonized."[41]

The resolution of the mystery of the moonstone lies in the repair of several fractured selves—that of Godfrey Ablewhite as well as that of Franklin Blake, but also the fractured self of the community the moonstone so memorably disrupted at Rachel Verinder's birthday dinner. In order to discover what really happened that night, Blake decides to assemble a narrative by soliciting and putting together accounts of its events by everyone who was present. This narrative "knitting," so to speak, stitches the torn community back together by identifying and banishing—indeed, killing—its guilty member and returning the moonstone to its rightful place in the forehead of the god of the moon in his Indian temple. We eventually learn that Franklin Blake is in one sense the culprit. He did indeed "steal" the diamond, under the influence of opium secretly administered to him by Dr. Candy. We learn later still that, as he emerged from Rachel's room that night with the diamond in his hand, Godfrey Ablewhite was also present, and told Blake to give it him for safekeeping, which the latter, still in a stupor, obediently did. Finally, we

discover that Ablewhite stole the diamond to cover deficits in a trust from which he had embezzled, and is killed by the Brahmin priests, as they finally recover the sacred gem.

To dwell first on Blake's reintegration of self, it is a tortuous process. It turns out that Candy, the doctor who slipped him the opium, came down the next day with the illness that ends up destroying his memory, and is thus unable to return to the Verinder house and reveal the secret, as planned. In the delirium brought on by his illness, however, he does reveal the truth: as he lies in bed, he mumbles incoherently, and his assistant Jennings, who is writing a book about delirium, writes down his "wanderings" in shorthand out of professional curiosity. Jennings then tries to make sense of the doctor's "wanderings" by piecing them together in the following manner:

I reproduced my shorthand notes, in the ordinary form of writing — leaving large spaces between the broken phrases, and even the single words, as they had fallen disconnectedly from Mr Candy's lips ... I filled in each blank space on the paper, with what the words or phrases on either side of it suggested to me as the speaker's meaning; altering over and over again, until my additions followed naturally on the spoken words which came before them, and fitted naturally into the spoken words which came after them.[42]

What he pieces together is the story of Candy's administration of opium to the unknowing Blake. Armed with this knowledge, Blake engages Betteredge, Mr Bruff the lawyer, and Rachel herself, to stage a reenactment of the birthday night. The reenactment seems to explain Blake's involvement, but still fails to clear up the location of the diamond, because it ends with Blake standing on the landing outside Rachel's room, and heedlessly dropping the diamond he thinks he holds in his hand onto the carpet. It does, however, absolve Blake of any culpability, and completes the process of returning him to Rachel's affections and to the community at large.

Jennings's methods of transcription and interpretation strongly resemble the methods of Freudian psychoanalysis — indeed, his ministrations are complete with a reclining patient. In *The Interpretation of Dreams*, Freud describes the performance of analysis of a patient this way:

We must aim at bringing about two changes in him: an increase of the attention he pays to his own psychical perceptions and the elimination of the criticism by which he normally sifts the thoughts that occur to him. In order that he may be able to concentrate his attention on his self observation it is advantageous for him to lie in a restful attitude and shut his eyes.[43]

I am not literally equating Jennings transcriptions with Freudian analysis, of course: among other things, an important component of analysis is the patient's attitude of attentiveness to his own emerging thoughts, and this is an element with is arguably lacking in the case of the delirious Dr.

Candy. Nonetheless, however, the similarities seem striking, and it may be possible to theorize a connection: Jennings's transcription of apparently random associations and subsequent fashioning of them into a coherent narrative which reveals to someone an episode of his life hitherto hidden from consciousness. The fact that the "patient" who delivers the disjointed associations and the person whose hidden past they reveal are different people emphasizes the social, even communal, nature of the repair being effected. The "cure" in this case restores Blake not only to himself, but to the community as well (not in the least because it enables him at last to marry Rachel, cousin and wealthy aristocrat), and in doing so, it restores the community to itself.

Why is psychoanalytic technique—to name it anachronistically—suited to achieving this cure? Jennings's technique is effective because it assembles incoherent fragments into a coherent *verbal* narrative. He is able to mend the harm of the moonstone because he constructs a verbal and logical account with which to resist its visual disruptions. It may be possible to connect the account Jennings pieces together with the travel writing described by Mary Louise Pratt in that its author, like the authors she analyzes, is invisible. Jennings disappears form Candy's narrative, yet in his control of it and hence of the plot's resolution, he is the most powerful person in it. But there is more than this to solving the mystery. The second part of the resolution occurs when it finally emerges that the person into whose hand Blake dropped the diamond was Godfrey Ablewhite, the seemingly virtuous philanthropist and ladies committee man, who, it turns out, embezzled from a trust fund under his care and—worse— kept a mistress at Bath.

This aspect of the ending offers two forms of resolution: to an extent, the effect of the Other is displaced onto a member of the community— Ablewhite — and thus integrated only in order to be banished. It also gets rid of the moonstone itself, because certain aspects of the Other cannot be integrated and can only be safely deposited in their native setting where their effect is removed. Finally, it displaces the most troubling aspect of Blake's fractured self—the Other-induced splintering of the self into numerous facets—onto Ablewhite, whose split is binary—benevolent appearance, criminal reality—and therefore much simpler, for it can masquerade as mere hypocrisy.

This article has tried to suggest that Collins's *Moonstone* accomplishes a great deal of social "work" in the context of the anxieties surrounding British colonialism in India in the post Mutiny years. Of course, Collins's backdating of the events of the novel disguises that aspect of the novel's concerns, displacing them, in an example of a strategy repeated throughout the novel, onto a substitute source of anxiety, the earlier Sikh wars. The moonstone of the novel's title is a dramatically visual emblem of empire, which brings its

disruptive force into the heart of English domesticity and undermines the household and the community around it. Because the visual effects of such emblems was so powerful, new strategies evolved to address them and keep or regain control in the face of them. My analysis of *The Moonstone* suggests that both the practice of psychoanalytic technique and the narrative form of the novel may have been of aid in responding to this threat and in developing these strategies.

Notes

1. Ronald Thomas, *Dreams of Authority: Freud and the Fictions of the Unconscious* (Ithaca: Cornell University Press, 1990), 200.

2. Charles Dickens, *Bleak House* (Cambridge: Cambridge University Press, 1987), 303.

3. Mary Louise Pratt, *Imperial Eyes: Travel Writing and Transculturation* (London: Routledge, 1992).

4. Homi Bhabha, *Location of Culture* (London: Routledge, 1994), 85; Timothy Mitchell, *Colonizing Egypt* (Berkeley: University of California Press, 1988).

5. Luce Irigaray, *Speculum of the Other Woman*, trans. Gillian C. Gill (Ithaca: Cornell University Press, 1985), 55.

6. Bhabha, *Location of Culture*, 85.

7. Charles Dickens, *The Mystery of Edwin Drood* (Oxford: Oxford University Press, 1982), 1.

8. An exception to this is Jeff Nunokawa, "For Your Eyes Only : Private Property and the Oriental Body in Dombey and Son," in *Macropolitics of Nineteenth Century Literature: Nationalism, Exoticism and Imperialism* (Philadelphia: University of Pennsylvania Press, 1991), 138.

9. Wilkie Collins, *The Moonstone* (Oxford: Oxford University Press, 1999), x–xxi. All subsequent quotes are from this edition.

10. Collins, *The Moonstone*, 37.

11. Collins, *The Moonstone*, 66.

12. *A Passage to India* was published in 1924, but is considered a late Victorian novel.

13. E.M. Forster, *A Passage to India* (New York: Harcourt Brace, 1924), 123–5.

14. D.A. Miller, *The Novel and the Police* (Berkeley: University of California Press 1988), 37–50.

15. Collins, *Moonstone*, 66.

16. Collins, *The Moonstone*, 66.

17. Collins, *The Moonstone*, 66–7.

18. Collins, *The Moonstone*, 69.

19. Collins, *The Moonstone*, 68.

20. Collins, *The Moonstone*, 69.

21. Collins, *The Moonstone*, 69.

22. Collins, *The Moonstone*, 419.

23. Collins, *The Moonstone*, 18.

24. Collins, *The Moonstone*, 474, n. 17–18.

25. Collins, *The Moonstone*, 475, n. 17–18.

26. Collins, *The Moonstone*, 282.

27. Collins, *The Moonstone*, 65.

28. Collins, *The Moonstone*, 27.

29. Collins, *The Moonstone*, 96.

30. Collins, *The Moonstone*, 69.

31. Collins, *The Moonstone*, 51.

32. Collins, *The Moonstone*, 479, n. 51.

33. Collins, *The Moonstone*, 336–7.

34. Collins, *The Moonstone*, 338.

35. Sigmund Freud, *The Interpretation of Dreams*, trans. James Strachey (New York: Norton and Co, 1960).

36. For a discussion of the commonality of the psychoanalysis and the novel, see Thomas, *Dreams of Authority*, 18.

37. Thomas, *Dreams of Authority*, 236.

38. Collins, *Moonstone*, xxv.

39. This account of the Mutiny is taken from Patrick Brantlinger, *Rule of Darkness: British Literature and Imperialism 1830–1914* (Ithaca: Cornell University Press, 1988), 200ff.

40. Catherine Hall, "Of Gender and Empire: Reflections on the Nineteenth Century," in Philippa Levine, ed., *Gender and Empire* (Oxford: Oxford University Press, 2004), 72.

41. Hall, "Of Gender and Empire," 73.

42. Collin, *Moonstone*, 370.

43. Freud, *The Interpretation of Dreams*, 101.

Bibliography

Abney, W. de W. "Are Instantaneous Photographs True?" *International Annual of Anthony's Photographic Bulletin and American Process Year-Book* (1889): 285–7.

About, Edmond. *Quinze Journées au Salon de Peinture et de Sculpture (année 1883)*. Paris: Librairie des bibliophiles, 1883.

Abrams, M.H. *Natural Supernaturalism: Tradition and Revolution in Romantic Literature*. New York: W.W. Norton & Company, 1971.

Adams, Henry. *The Education of Henry Adams*. Oxford: Oxford University Press, 1999.

Adams, Steven. *The Barbizon School and the Origins of Impressionism*. London: Phaidon, 1994.

Album-revue de l'industrie parisienne. Paris: H.L. Delloye, 1844.

Aldington, Richard, ed. *The Religion of Beauty: Selections From the Aesthetes, With an Introduction by Richard Aldington*. London: William Heinemann Ltd, 1950.

Allen, Grant. "The Cows that Ants Milk." *The Strand*, 14 (1897): 12–19.

Altick, Richard D. *The Shows of London*. Cambridge: Belknap, 1978.

_____ *Victorian People and Ideas*. New York: Norton & Co, 1973.

American Journal of Education, 1 (1856): 775–87.

The American Review, 2, no. 3 (September 1945): 244.

Anonymous. "Weather Watchers and their Work." *The Strand*, 3 (1892): 182–9.

"Another New Planet." *Punch, or the London Charivari*, 23 (1852), 270.

Arago, Dominique François. "Report." In *Classic Essays on Photography*, edited by Alan Trachtenberg, 15–25. New Haven: Leete's Island Books, 1980.

Arendt, Hannah. *The Life of the Mind*. New York: Harcourt Brace & Company, 1978.

Asendorf, Christoph. *Batteries of Life: On the History of Things and their Perception in Modernity*. Trans. Don Reneau. Berkeley: University of California Press, 1993.

Astore, William J. *Observing God: Thomas Dick, Evangelicalism, and Popular Science in Victorian Britain and America*. Aldershot: Ashgate, 2001.

"Astronomy of Laplace." *American Quarterly Review* (1830): 175–80.

Bach, Friedrich Teja, Margit Rowell, and Ann Temkin. *Constantin Brancusi, 1876–1957*. Ex. cat. Philadelphia: Philadelphia Museum of Art, 1995.

Bacon, John. "The Mysteries of Sound." *The Strand*, 16 (1898): 408–13.

Bailly-Herzberger, Janinine. *Correspondance de Camille Pissarro Tome 1–5*. Paris: Éditions du Valhermeil, 1988.

Baker, Ray Stannard. "Liquid Air." *The Strand*, 17 (1899): 459–68.

Baldwin, Gordon. *Looking at Photographs: A Guide to Technical Terms*. Los Angeles: J. Paul Getty Museum in association with British Museum Press, 1991.

Bale, Edwin. "Mr. Timothy Cole and American Wood Engraving." *The Magazine of Art* (1893): 138–9.

Balzac, Honoré de. "Monographie de la Presse Parisienne." In *La Grande Ville. Nouveau tableau de Paris, comique, critique et philosophique*, v.2, edited by Paul de Kock et al., 129–208. Paris: Au Bureau Central des Publicatoins Nouvelles, 1842. 129–208.

———— *Wild Ass's Skin*. Trans. Herbert J. Hunt. London: Penguin, 1977.

Bargiel-Harry, Réjane, and Christophe Zagrodzki. *The Book of the Poster*. Paris: Editions Alternatives, 1985.

Barringer, Tim. *Men at Work: Art and Labour in Victorian Britain*. New Haven and London: Yale University Press, 2005.

———— *Reading the Pre-Raphaelites*. New Haven and London: Yale University Press, 1999.

———— "The South Kensington Museum and the Colonial Project." In *Colonialism and the Object: Empire, Material Culture, and the Museum*, edited by Tim Barringer and Tom Flynn, 11–27. New York: Routledge, 1998.

Barron, Louis. *Les Environs de Paris*. Paris: Maison Quantin, 1886.

Barrows, Susanna. *Distorting Mirrors: Visions of the Crowd in Nineteenth Century France*, New Haven: Yale University Press, 1981.

Barry, Patrick D., ed. *George Boole: A Miscellany*. Cork: Cork University Press, 1969.

Barthes, Roland. *Camera Lucida: Reflections on Photography*. Trans. Richard Howard. New York: Hill and Wang, 1981.

———— *Mythologies*. Paris: Le Seuil, 1970.

———— *Mythologies*. Trans. Annette Lavers. New York: Noonday Press, 1972.

———— *S/Z*. New York: Hill and Wang, 1992.

Bartlett, George Hartnell. *Pen and Ink Drawing*. Boston: Riverside Press, 1903.

Barton, Ruth. "'Men of Science': Language, Identity, and Professionalization in the Mid-Victorian Scientific Community." *History of Science*, xli (2003): 73–119.

Bataille, Georges. *Manet: études biographique et critique*. Geneva and New York: Skira, 1955.

Batchen, Geoffrey. *Each Wild Idea: Writing, Photography, History*. Cambridge, MA: MIT Press, 2001.

Baudelaire, Charles. *Œuvres complètes*. Edited by Claude Pichois. Paris: Gallimard, 1976–1977.

———— "The Modern Public and Photography" [1859]. In *Classic Essays on Photography*, edited by Alan Trachtenberg, 83–9. New Haven: Leete's Island Books, 1980.

———— "The Painter of Modern Life." In *The Painter of Modern Life and Other Essays*, edited by J. Mayne, 1–40. London: Phaidon, 1964.

Bauer, George. "Gay Incipit, Botanical Collections, Nosegays, and Bouquet." In *Articulations of Difference: Gender Studies and Writing in French*, edited by Dominque Fisher and Lawrence R. Schehr, 64–82. Stanford: Stanford University Press, 1997.

Beaver, Harold. "Homosexual Signs (In Memory of Roland Barthes)." *Critical Inquiry*, 8, no. 1 (Autumn 1981): 99–119.

Becher, Harvey W. "William Whewell's Odyssey: From Mathematics to Moral Philosophy." In *William Whewell: A Composite Portrait*, edited by Menachem Fisch and Simon Schaffer, 1–29. Oxford: Clarendon, 1991.

Bedini, Silvio A. *Thinkers and Tinkers: Early American Men of Science*. New York: Scribner's, 1975.

Beech, Martin "The Mechanics and Origin of Cometaria." *Journal of Astronomical History and Heritage*, 5 (2002): 155–63.

Beecher, Jonathan. *Charles Fourier: The Visionary and His World*. Berkeley: University of California Press, 1986.

Beegan, Gerry. *The Mass Image: A Social History of Photomechanical Reproduction in Victorian London*. Basingstoke: Palgrave Macmillan, 2008.

Bell, Quentin Bell. *The Schools of Design*. London: Routledge and Kegan Paul, 1963.

Benjamin, Walter. *The Arcades Project*. Trans. Kevin LcLaughlin. Cambridge: Harvard Belknap Press, 1999.

———— *Charles Baudelaire: A Lyric Poet in the Era of High Capitalism*. ans. Harry Zohn. London: Verso, 1983.

———— *Paris, Capitale du XIXe siècle*. Trans. Jean Lacoste. Paris: Cerf, 1989.

———— *Selected Writings, Volume 3*. Trans. Michael W. Jennings. Cambridge: Harvard Belknap Press, 1996–2003.

———— *Selected Writings, Volume 4*. Trans. Michael W. Jennings. Cambridge: Harvard Belknap Press, 1996–2003.

———— "The Work of Art in the Age of Mechanical Reproduction." In *Illuminations: Walter Benjamin, Essays and Reflections*, edited by Hannah Arendt. Trans. Harry Zohn, 217–51. New York: Schocken Books, 1968.

Bennett, Tony. *The Birth of the Museum: History, Theory, Politics*. London and New York: Routledge, 1995.

Bergson, Henri. *Creative Evolution*. Trans. Arthur Mitchell. New York: Henry Holt, 1911.

Berhaut, Marie. *Caillebotte, sa vie et son oeuvre: catalogue raisonné des peintures et pastels*. Paris: La Bibliothèque des Arts, 1978; and rev. ed., Paris: Wildenstein Institute, 1994.

Berigny, Charles, ed. *Collection de 350 dessins, relatifs à l'art de l'ingénieur et lithographiés à l'École royale des Ponts et Chaussées*. Paris: École royale des Ponts et Chaussées, 1817–21.

Berlanstein, Lenard R. *The Working People of Paris, 1871–1914*. Baltimore: Johns Hopkins University Press, 1984.

Berman, Marshall. *All That is Solid Melts into Air*. New York: Penguin Books, 1982.

Berson, Ruth, ed. *The New Painting: Impressionism 1874–1886, Documentation, vol. I*. San Francisco: Fine Arts Museum of San Francisco, 1996.

Besson, George. "Pictorial Photography—A Series of Interviews." *Camera Work*, 24 (October 1908): 13–23.

Bhabha, Homi. *Location of Culture*. London: Routledge, 1994.

Bierce, C.S. "Notes on Process Matters in the USA." *Process Photogram*, 75 (March 1900): 41.

Blackburn, Henry. *The Art of Illustration*. London: W.H. Allen, 1894.

———— *The Art of Illustration*. 2nd ed. Edinburgh: John Grant, 1901.

Blake, William. *The Portable Blake*. New York: Penguin Books, 1974.

Blanc, Charles. *Les Artistes de mon temps*. Paris: Firmin-Didot, 1876.

Blosseville, Auguste. "Chez Rodin." *Les Droits de l'Homme*, May 12, 1898.

Boardman, John. *Greek Sculpture: The Classical Period*. London: Thames and Hudson, 1985.

Bode, Carl. *The American Lyceum: Town Meeting of the Mind*. Carbondale: Southern Illinois University Press, 1968.

Bogart, Michele H. *Advertising, Artists and the Borders of Art*. Chicago: University of Chicago Press, 1995.

Bois, Victor. *Les Chemins de fer français*. Paris: Hachette, 1853.

Bonner, Geraldine. "Paris Sight Seeing in the Rain." *The Argonaut* (San Francisco), December 3, 1900.

Boole, George "*The Claims of Science especially as founded in its relation to human nature*. In *Studies in Logic and Probability*, edited by R. Rhees. London: Watts & Co., 1952, 187–211.

———— *An Investigation of the Laws of Thought on which are founded the Mathematical Theories of Logic and Probabilities*. London: Walton and Maberly, 1854.

_____ *Mathematical Analysis of Logic: Being an Essay towards a Calculus of Deductive Reasoning*. 1847; New York: Philosophical Library, 1948.

_____ *On the Right Use of Leisure: An Address, delivered before the members of the Lincoln Early Closing Association, Feb. 9th, 1847*. London: J. Nisbet & Co.; Lincoln: W & B Brooke, 1847.

Booth, Charles. *Life and Labour of the People in London*. London: Macmillan, 1903.

Borzello, Frances. *Civilising Caliban: The Misuse of Art 1875–1980*. London and New York: Routledge & Kegan Paul, 1987.

Bourdieu, Pierre, *Distinction: A Social Critique of the Judgement of Taste*. Trans. Richard Nice. Cambridge: Harvard University Press, 1984.

_____ Alain Darbel, and Dominique Schnapper. *The Love of Art European Art Museums and Their Public*. Stanford, CA: Stanford University Press, 1991.

"Bowditch's Translation of the Mécanique céleste." *North American Review* (1839): 143–80.

Brantlinger, Patrick. *Rule of Darkness: British Literature and Imperialism 1830–1914*. Ithaca: Cornell University Press, 1988.

Brashear, John A. "A Visit to the Home of Dr. Thomas Dick: The Christian Philosopher and Astronomer." *Journal of the Royal Astronomical Society of Canada*, 7 (1913): 19–30.

Braun, Marta. *Picturing Time: The Work of Etienne-Jules Marey (1830–1904)*. Chicago: University of Chicago Press, 1992.

Brett, David. *Rethinking Decoration: Pleasure and Ideology in the Visual Arts*. Cambridge: Cambridge University Press, 2005.

Brettell, Richard, et al. *A Day in the Country: Impressionism and the French Landscape*. Los Angeles: Los Angeles County Museum of Art, 1984, 1990.

Bretell, Richard, and Joachim Pissarro. *The Impressionist and The City: Pissarro's City Paintings*. New Haven: Yale University Press for the Royal Academy of Arts, 1992.

Brettell, Richard R. *Pissarro and Pontoise: The Painter in a Landscape*. New Haven: Yale University Press, 1990.

Bricka, Charles. *Cours de chemin de fer, professé à l'École nationale des ponts et chaussées*. Vol. 1, *Études, construction, voie et appareils de voie*, Encyclopédie des travaux publics. Paris: Gauthier-Villars et fils, 1894.

Brock, W.H. "The Selection of the Authors of the Bridgewater Treatises." *Notes and Records of the Royal Society of London*, 21 (1967): 162–79.

Broks, Peter. "Science, the Press and Empire: Pearson's Publications, 1890–1914." In *Imperialism and the Natural World*, edited by John M. Mackenzie, 141–63. Manchester: Manchester University Press, 1990.

Bromhead, H.W. "Some Contemporary Illustrators." *The Art Journal* (1898): 268–72, 303–6.

Brooke, John Hedley. "Natural Theology and the Plurality of Worlds: Observations on the Brewster-Whewell Debate." *Annals of Science*, 34 (1977): 221–86.

_____ "The Natural Theology of the Geologists: Some Theological Strata." In *Images of the Earth: Essays in the History of the Environmental Sciences*, edited by L.J. Jordanova and Roy S. Porter, 39–64. British Society for the History of Science, 1979.

Brooks, Chris with Brent Elliot, Julian Litten, Eric Robinson, and Philip Temple. *Mortal Remains: The History and Present State of the Victorian and Edwardian Cemetery*. Exeter: Wheaton, 1989.

Brose, Eric Dorn. *The Politics of Technological Change in Prussia: Out of the Shadow of Antiquity, 1809–1848*. Princeton; Princeton University Press, 1993.

Broude, Norma. *Gustave Caillebotte and the Fashioning of Identity in Impressionist Paris*. New Brunswick, NJ: Rutgers University Press, 2002.

Brown, George E. ed. *Finishing the Negative*. London: Dawbarn and Ward, 1901.

Brown, H. Lamont. "Engraved Half Tones." In *Penrose Annual: Process Year Book*. London: A.W. Penrose & Co, 1896.

Brown, Joshua. *Beyond the Lines: Pictorial Reporting, Everyday Life, and the Crisis of Gilded Age America*. Berkeley: University of California Press, 2002.

Brown, Nicola, Carolyn Burdett, and Pamela Thurschwell, eds. *The Victorian Supernatural*. New York: Cambridge University Press, 2004.

Buck-Morss, Susan. *The Dialectics of Seeing*. Cambridge: MIT Press, 1999.

Butler, Ruth. *Rodin: The Shape of Genius*. New Haven: Yale University Press, 1993.

Butler, Samuel. *Erewhon*. New York: Penguin Books, 1970.

———— *A First Year in Canterbury Settlement and Other Early Essays*. London: Jonathan Cape, 1923.

Camille, Michael. *Medieval Art of Love: Objects and Subjects of Desire*. New York: Abrams, 1998.

"Camille Pissarro 1830–1903." *Apollo* (November 1992).

Cannon, Susan Faye. *Science in Culture: The Early Victorian Period*. New York: Dawson and Science History Publications, 1978.

Cantor, Geoffrey, and Shuttleworth, Sally. *Science Serialized: Representation of the Sciences in Nineteenth-Century Periodicals*. Cambridge: MIT Press, 2004.

Cantor, Geoffrey, et al. *Science in the Nineteenth-Century Periodical: Reading the Magazine of Nature*. Cambridge: Cambridge University Press, 2004.

La Caricature, May 5 and June 9, 1839.

Carlyle, Thomas. *Critical and Miscellaneous Essays*. London: Chapman and Hall, 1899.

Caron, François. *Histoire des chemins de fer en France*. Paris: Fayard, 1997.

Cate, Phillip Dennis, ed. *Breaking the Mold: Sculpture in Paris from Daumier to Rodin*. Ex. cat. Rutgers: Jane Voorhees Zimmerli Art Museum, 2005.

"Ce qu'on voit sur un chemin de fer." *Le Magasin pittoresque*, 29 (1861): 123–6.

Cerullo, John. *The Secularization of the Soul*. Philadelphia: Institute for the Study of Human Issues, 1982.

Chambers's Encyclopaedia: A Dictionary of Universal Knowledge for the People. Philadelphia: J.B. Lippincott & Co. and Edinburgh: W. & R. Chambers, 1865.

Chambers, Robert. *Vestiges of the Natural History of Creation and Other Evolutionary Writings*, edited by James A. Secord. Chicago: University of Chicago Press, 1994.

Le Charivari. March 13, 1838.

Charlton, D.G. *Secular Religions in France 1815–1870*. London: Oxford University Press, 1963.

Chéroux, Clément. *The Perfect Medium: Photography and the Occult*. New Haven: Yale University Press, 2004.

Childs, Elizabeth C. "Habits of the Eye: Degas, Photography, and Modes of Vision." In *The Artist and the Camera: Degas to Picasso*, by Dorothy Kosinski et al., 73–87. Ex. cat. New Haven: Yale University Press, 1999.

———— "The Photographic Muse." In *The Artist and the Camera: Degas to Picasso*, by Dorothy Kosinski et al., 24–33. Ex. cat. New Haven: Yale University Press, 1999.

Chincholle, Charles. "La Statue de Balzac." *Le Figaro* (May 12, 1898).

Chu, Petra ten-Doesschate and Gabriel Weisberg, eds. *The Popularization of Images: Visual Culture under the July Monarchy*. Princeton: Princeton University Press, 1994.

Cladel, Judith. *Rodin: The Man and His Art with Leaves from His Note-Book*. Trans. S.K. Star. New York: The Century Co., 1918.

Clark, T.J. *Farewell to an Idea*. New Haven: Yale University Press, 1999.

———— *The Painting of Modern Life*. Princeton: Princeton University Press, 1984.

———— "Should Benjamin have Read Marx?" *Boundary*, 2, 30, no. 1 (2003): 31–49.

Cohen, Dan. *Equations From God: Pure Mathematics and Victorian Faith*. Baltimore: Johns Hopkins University Press, 2007.

Cohen, I. Bernard. *Some Early Tools of American Science: An Account of the Early Scientific Instruments and Mineralogical and Biological Collections In Harvard University.* Cambridge: Harvard University Press, 1950.

"Collection privée du marquis de Sade!" *L'Illustration*, June 30, 1900.

Collignon, Édouard. *Les travaux publics de la France: Chemins de fer.* Vol. 2 of *Les travaux publics de la France*, edited by Léonce Reynaud. Paris: J. Rothschild, 1883. Reprinted with additional photographs as *Les chemins de fer au XIX^e siècle, d'après l'œuvre de Léonce Reynaud "Les travaux publics de la France."* Paris: Presses de l'École nationale des Ponts et Chaussées, 1988.

Collins, Paul. "Walking on the Rings of Saturn." In *Banvard's Folly: Thirteen Tales of Renowned Obscurity, Famous Anonymity, and Rotten Luck*, 254–67. New York: Picador, 2001.

Collins, Wilkie. *The Moonstone.* Oxford: Oxford University Press, 1999.

"Comment ils mangents les moules (How They Eat Mussels)." *L'Evénément parisien* (December 5–12, 1880).

Conrad, Peter. *The Victorian Treasure-House.* London: Collins, 1973.

Contensou, Martine. *Balzac et Philipon associés: Grands fabricants de caricatures en tous genres.* Paris: Paris Musées, 2001.

Cook, Edward T. *A Popular Handbook to the National Gallery, Vol. 2.* London: Macmillan & Co., 1888.

Cook, E.T., and Alexander Wedderburn, eds. *The Works of John Ruskin.* London and New York: George Allen, 1903–12.

Cooter, Roger, and Pumfrey, Stephen. "Separate Spheres and Public Places: Reflections on the History of Science Popularization and Science in Popular Culture." *History of Science*, 32, 1994: 237–67.

Corbin, Alain. *Les filles de noce: misère sexuelle et prostitution, 19e et 20e siècles.* Paris: Aubier Montaigne, 1978.

Cornforth, John. "Arabian Nights in the Mall." *Country Life*, 183 (May 18, 1989): 246–9.

Crane, Walter. *On the Decorative Illustration of Books Old and New.* London: G. Bell, 1896.

Crary, Jonathan. *Suspensions of Perception: Attention, Spectacle, and Modern Culture.* Cambridge MA: MIT Press, 1999.

———. *Technique of the Observer: On Vision and Modernity in the Nineteenth Century.* Cambridge: MIT, 1990.

Crook, J. Mordaunt. *The Dilemma of Style.* Chicago: University of Chicago Press, 1987.

Crookes, William. "Contributions to Molecular Physics in High Vacua." *Proceedings of the Royal Society of London*, 28 (1878–79): 477–82.

———. "Notes of Seance with D.D. Home." *Proceedings of the Society for Psychical Research*, 6 (1889–90).

———. "Part Of The Presidential Address Delivered to the British Association At Bristol, Sept., 1898." *Proceedings of the Society for Psychical Research*, 14 (1898–99): 2–5.

———. *Radiant Matter, A Lecture Delivered to the British Association for the Advancement of Science at Sheffield Friday, August 22, 1879.* London: Davey, 1879.

———. *Researches in the Phenomena of Spiritualism.* London: J. Burns, 1874.

Crowe, Michael J. *The Extraterrestrial Life Debate, 1750–1900.* Mineola: Dover, 1999.

Crubellier, Maurice. "L'Élargissement du public." In *Histoire de l'édition française.* v.3. *Le temps des éditeurs. Du romantisme à la Belle Époque*, edited by Roger Chartier and Henri-Jean Martin, 15–41. Paris: Fayard, 1990.

Cuno, James. "Charles Philipon, La Maison Aubert and the Business of Caricature in Paris, 1829–1841." *Art Journal*, 43 (Winter 1983): 347–54.

Dadoun, Roger. "*Metropolis*: Mother-City—"Mittler"—Hitler." In *Close Encounters: Film, Feminism, and Science Fiction*, edited by Constance Penley, Elisabeth Lyon, Lyn Spigel, Janet Bergstrom, 133–59. Minneapolis: University of Minnesota Press, 1991.

Dagognet, François. *Etienne-Jules Marey: A Passion for the Trace*. Trans. Robert Galeta with Jeanine Herman. New York: Zone Books, 1992.

D'Albe, E.E. Fournier. *The Life of Sir William Crookes*. London: T. Fisher Unwin Ltd, 1923.

Damisch, Hubert. *Theory of /Cloud/: Towards a History of Painting*. Palo Alto: Stanford University Press, 2001.

Daniel, Malcolm, and Barry Bergdoll. *The Photographs of Édouard Baldus*. New York: Metropolitan Museum of Art; Montreal: Canadian Centre for Architecture, 1994.

Daniels, George H. *American Science in the Age of Jackson*. New York: Columbia University Press, 1968.

Danius, Sara. *The Senses of Modernism: Technology, Perception, and Aesthetics*. Ithaca: Cornell University Press, 2002.

Davanne, Alphonse, Maurice Bucquet, and Léon Vidal. *Le Musée Rétrospectif de la Photographie à l'Exposition Universelle de 1900*. Paris: Gauthier-Villars, 1903.

Debusschère, Henri. "Par ici, par là." *La Presse* (February 12, 1912).

DeKosky, Robert K. "William Crookes and the Fourth State of Matter." *Isis*, 67, no. 1 (March 1976): 36–60.

Delclaux, Marie-Pierre. *Rodin: A Brilliant Life*. Paris: Éditions du musée Rodin, 2003.

Delpire, Robert. "Avant-propos." In *Le Temps d'un mouvement. Aventures et mésaventures de l'instant photographique*, 5. Ex. cat. Paris: Centre National de la Photographie, 1986.

Delteil, Loys. *Le Peintre-Graveur illustré: Honoré Daumier*. Paris: L'Auteur, 1925–1930.

DeLue, Rachael Ziady. "Pissarro, Landscape, Vision, and Tradition." *Art Bulletin*, 80, no. 4 (December 1998): 718–36.

Delvau, Alfred. *Dictionnaire érotique moderne*. Bale: Imprimerie de Karl Schmidt, *c.* 1850.

Denis, Rafael Cardoso. "Teaching by Example: Education and the Formation of South Kensington." In *A Grand Design: The Art of the Victoria and Albert Museum*, edited by Malcolm Baker and Brenda Richardson, 107–16. New York: Harry N. Abrams, 1997.

Desjours, Jean, and Bertrand Lemoine. *Le grand œuvre: Photographies des grands travaux, 1860–1900*. Paris: Centre national de la photographie, 1983.

Desmond, Adrian. "Artisan Resistance and Evolution in Britain." In *Osiris*, 2nd series (1987), 3: 77–110.

——— "Redefining the X Axis: 'Professionals,' 'Amateurs' and the Making of mid-Victorian biology." *Journal of the History of Biology*, xxxiv (2001): 3–50.

Deswarte, Sylvie, and Raymond Guidot. "Gustave Eiffel et les grands ponts métalliques du XIXe siècle." *Monuments historiques*, 3 (1977): 74–9.

De Vericour, L.R. *Historical Analysis of Christian Civilisation*. London: John Chapman, 1850.

Dick, Thomas. *Christian Philosopher; or, the Connection of Science and Philosophy with Religion*. Philadelphia: Key & Biddle, 1833.

——— "On Orreries or Planetariums." In *The Practical Astronomer*, vol. 1 of *The Complete Works of Thomas Dick, LL.D*, 179–83. St Louis: Edwards & Bushnell, 1857.

Dickens, Charles. *Bleak House*. Cambridge: Cambridge University Press, 1987.

——— *Hard Times*. New York: Penguin Books, 1995.

——— *The Mystery of Edwin Drood*. Oxford: Oxford University Press, 1982.

——— *The Uncommercial Traveller*. London: Chapman & Hall, n.d.

Didi-Huberman, Georges. *L'Empreinte*. Ex. cat. Paris: Éditions du Centre Georges Pompidou, 1997.

Distel, Anne, et al. *Gustave Caillebotte: Urban Impressionist*. Paris: Reunion des Musées nationaux; Chicago: Art Institute of Chicago; New York: Abbeville Press, 1995.

Doane, Mary Ann. *The Emergence of Cinematic Time: Modernity, Contingency, the Archive*. Cambridge, MA: Harvard University Press, 2002.

Doran, Barbara Gusti. "Field Theory in Nineteenth Century Britain." In *Historical Studies for the History of Science*, edited by Russel McCormmach. Princeton: Princeton University Press, 1975.

Douglas-Fairhurst, Robert. *Victorian Afterlives: The Shaping of Influence in Nineteenth Century Literature*. New York: Oxford University Press, 2002.

Dowling, Linda. *The Vulgarization of Art: The Victorians and Aesthetic Democracy*. Charlottesville: University Press of Virginia, 1996.

Doyle, Arthur. *The Case for Spirit Photography*. New York: George H. Doran Company, 1923.

Doyle, Arthur Conan. "A Scandal in Bohemia." *The Strand,* 2 (1891): 61–75.

Druick, Douglas, et al. *Gustave Caillebotte, 1848–1894*. (Ex. cat., Paris, Galeries nationals du Grand Palais; Chicago, Art Institute). Paris: Réunion des musées nationaux, 1994.

Dubois, Ph. "Chez Rodin." *L'Aurore*, May 12 (1898).

Dulière, Cécile, ed. *Victor Horta: Mémoires*. Bruxelles: Atelier Vokaer, 1985.

Dumas, Alexandre. *Pictures of Travel in the South of France*. London: Offices of the National Illustrated Library, s.d. [1850s].

Duplomb, Charles. *Histoire des Ponts de Paris*. Paris: J. Mersch, 1911.

Durand-Claye, Léon. "Notes prises au cours de routes. Annexe. Lever des plans et nivellement … ." Lithographed text, 1884. Fonds anciens, Bibliothèque de l'École nationale des Ponts et Chaussées (ENPC), Champs-sur-Marne, France.

Duve, Thierry de. "Time Exposure and Snapshot: The Photograph as Paradox." *October,* 5 (Summer 1978): 113–25.

Dyce, William. "Universal Infidelity in Principles of Design." *Journal of Design and Manufactures,* 5 (August/September 1851): 158–61.

Dyson, George B. *Darwin among the Machines: The Evolution of Global Intelligence*. Cambridge: Perseus Books, 1997.

Eagleton, Terry. *The Ideology of the Aesthetic*. Oxford, UK and Cambridge, MA: Blackwell, 1990.

Eco, Umberto. *De Superman au surhomme*. Trans. Myriem Bouzaher. Paris: Grasset, 1978.

École nationale des Ponts et Chaussées (ENPC). "Conférences sur la photographie par M. A[lphonse] Davanne." Lithographed text, 1883. Fonds anciens, Bibliothèque de l'ENPC, France.

——— "Conférences sur la photographie par M.L. Bordet, ancien élève de l'École polytechnique." Lithographed text, 1888. Fonds anciens, Bibliothèque de l'ENPC, France.

Eiffel, Gustave. *Les grandes constructions métalliques: Conférence à l'Association française pour l'avancement des sciences, le 10 mars 1888*. Paris: Chaix, 1888.

Elsen, Albert E. *In Rodin's Studio: A Photographic Record of Sculpture in the Making*. Ithaca: Cornell University Press, 1980.

Elsen, Albert, et al. *Rodin & Balzac. Rodin's sculptural studies for the monument to Balzac from the Cantor, Fitzgerald Collection*. Beverly Hills: Cantor, Fitzgerald and Co., 1973.

Emerson, Ralph Waldo. "The Over-Soul." In *Essays, First Series*, edited by Alfred R. Ferguson and Jean Ferguson Carr, 157–75. Cambridge: Harvard University Press, 1987.

Encyclopedia Britannica, 11th Edition, 1911.

Esquiros, Alphonse. *Vièrges folles*. Paris: Le Gallois, 1844.

Everest-Boole, Mary. *Collected Works* (4 vols), edited by E. M. Cobham. London: The C.W. Daniel Co., 1931.

Faber, F.C. "The Cathedral Clock and the Cosmological Clock Metaphor." In *The Study of Time II*, edited by J.T. Fraser and N. Lawrence, 399–416. New York: Springer-Verlag, 1975.

"Fall of the Suspension-Bridge at Angers." *Illustrated London News*, 16 (April 27, 1850): 282.

Fargeaud, Madeleine. "Balzac, le commerce et la publicité." *L'Année Balzacienne* (1974): 187–98.

Faure, Alain. *Paris Careme-Prenant: du Carnaval à Paris au XIXeme Siècle*. Paris: Hachette, 1978.

Ferris, Alison. *The Disembodied Spirit*. Brunswick: Bowdoin College Museum of Art, 2003.

Figuier, Louis. *Les Merveilles de la science I*. Paris: Furne, Jouvert, 1867.

"Fine Etching for Women." *Process Photogram*, 4, 39 (1897): 10–11.

Fisch, Manachem. *William Whewell, Philosopher of Science*. Oxford: Claredon, 1991.

Fischer, Peter S. *Fantasy and Politics: Visions of the Future in the Weimar Republic*. Madison: University of Wisconsin Press, 1991.

FitzGerald, William G. "Some Wonders of the Microscope." *The Strand*, 12 (1896): 210–16.

Flores, Carol A. Hrvol. *Owen Jones: Design, Ornament, Architecture, and Theory in an Age in Transition*. New York: Rizzoli, 2006.

Forster, E.M. *A Passage to India*. New York: Harcourt Brace, 1924.

Foster, R.F. *Modern Ireland 1600–1972*. London: Penguin, 1989.

Forster-Hahn, Françoise. "Marey, Muybridge and Meissonier: The Study of Movement in Science and Art." In *Eadweard Muybridge: The Stanford Years, 1872–1882*, 84–109. Ex. cat. Stanford: The Stanford Museum of Art, 1972.

Foucault, Michel. *The Order of Things: An Archeology of the Human Sciences*. New York: Vintage Books, 1970.

Fox, Nichols. *Against the Machine: The Hidden Luddite Tradition in Literature, Art, and Individual Lives*. Washington D.C.: Island Press, 2002.

Freedberg, David. *The Power of Images: Studies in the History and Theory of Response*. Chicago: University of Chicago Press, 1989.

Freud, Sigmund. *The Interpretation of Dreams*. Trans. James Strachey. New York: Norton and Co., 1960.

_____ *The Standard Edition of the Complete Psychological Works of Sigmund Freud*, Vol. XXII. Trans. James Strachey. London: The Hogarth Press and the Institute of Psychoanalysis, 1964.

Fried, Michael. "Caillebotte's Impressionism." *Representations*, 66 (Spring 1999): 1–51.

Frizot, Michel. "Speed of Photography: Movement and Duration." In *A New History of Photography*, edited by Michel Frizot, 242–57. Köln: Könneman, 1998.

Gadamer, Hans-Georg. *Truth and Method*. Translated by Joel Weinsheimer and Donald G. Marshall. London: Sheed & Ward, 1989.

Gaillard, Jeanne. *Paris, la ville, 1852–1870: l'urbanisme parisien à l'heure d'Haussmann*. Paris: H. Champion, 1977.

Galeries Durand-Ruel. *Exposition retrospective d'oeuvres de G. Caillebotte* [Paris, June 1894]. In *Modern Art in Paris: Two Hundred Catalogues of the Major Exhibitions*. 47 vols, edited by Theodore Reff. New York and London: Garland Press, 1981, series II, vol. 1.

Gamble, William. "Halftones in 'News' Printing." *Process Photogram and Illustrator* (August 1905): 138–9.

_____ "Process in Magazine and Book Illustration." In *Penrose*, edited by W. Gamble. London: A.W. Penrose and Co., 1897.

Gantz, Katherine. "The Difficult Guest: French Queer Theory Makes Room for Rachilde." *South Central Review,* 22, 3 (Fall 2005): 113–32.

Gauld, Alan. *Mediumship and Survival: A Century of Investigations* (London: Heinemann, 1982).

Gautier, Théophile. *La Chaine d'or.* Paris: A. Ferroud, 1896.

———— *Histoire de l'art dramatique en France depuis vingt-cinq ans.* Paris: Magnin, Blanchard et Cie, 1858–59.

Gavine, David "Thomas Dick, LL.D, 1774–1857." *Journal of the British Astronomical Association,* 84 (1974): 345–50.

Gay, Peter. *Weimar Culture: The Outsider ad Insider.* New York: W.W. Norton, 2001.

G.C. "Obsèques de Meissonier." *Le Figaro* (February 4, 1891).

Geffroy, Gustave. "L'Imaginaire." *Le Figaro,* August 28, 1893.

Genette, Gérard. *Paratexts: Thresholds of Interpretation.* Trans. Jane E. Lewin. Cambridge: Cambridge University Press: 1997.

Gentil-Garou. "Notes Fantaisistes, L'Homme qui marche." *Liberté du Sud-Ouest* (Bordeaux), February 19, 1912.

Geronte, "Le Salon de 1865. Lettres au Jury de l'Exposition, Les Execentriques et les grotesques." *Gazette de France* (June 30, 1865).

Gillispie, Charles Coulston. *Simon-Pierre Laplace, 1749–1827: A Life in Exact Science.* Princeton: Princeton University Press, 1997.

Gillespie, Neal C. "Divine Design and the Industrial Revolution: William Paley's Abortive Reform of Natural Theology." *Isis,* 81, no. 2 (1990): 214–29.

Georges-Michel. "Rodin et les trois beautés de Rome." *Gil Blas* (February 17, 1912).

Gettings, F. *Ghosts in Photograph: the Extraordinary Story of Spirit Photography.* New York: Harmony Books, 1978.

Goldstein, Jan. "Eclectic Subjectivity and the Impossibility of Female Beauty." In *Picturing Science, Producing Art,* edited by Caroline A. Jones and Peter Galison, 360–78. New York, Routlege, 1998).

———— "Mutations of the Self in Old Regime and Postrevolutionary France." In *Biographies of Scientific Objects,* edited by Lorraine Daston, 86–116. Chicago: University of Chicago Press, 2000.

Golinski, Jan. *Making Natural Knowledge: Constructivism and the History of Science.* Cambridge: Cambridge University Press, 1998.

Gombrich, E.H. *Art and Illusion: A Study in the Psychology of Pictorial Representation.* Princeton: Princeton University Press, 1960.

———— *In Search of Cultural History.* Oxford: Clarendon Press, 1969.

———— *The Sense of Order: A Study in the Psychology of the Decorative Art.* London: Phaidon, 1979.

Graber, Oleg. *The Mediation of Ornament.* Princeton: Princeton University Press, 1992.

Grad, Bonnie L., and Timothy A. Riggs. *Visions of City and Country: Prints and Photographs of Nineteenth-Century France.* Worcester, MA.: Worcester Art Museum; New York: American Federation of Arts, 1982.

Grand-Carteret, John. *XIXe siècle en France, Classes, moeurs, usages, costumes, inventions.* Paris: Firmin-Didot et Cie., 1893.

"La grande epidémie pornographique." special issue of *La Caricature* (May 6, 1882).

Grandville, Jean-Jacques. *Un Autre Monde.* Paris: P.H. Fournier, 1844.

———— *Bizarreries and Fantasies of Grandville: 266 Illustrations from "Un Autre Monde" and "Les Animaux."* Edited by Stanley Applebaum. New York: Dover, 1974.

Grandville: Dessins originaux. Exhibition Catalogue. Musée des Beaux-Arts of Nancy. Lyon: L'Imprimerie Moderne du Lyon, 1986.

Grattan Guiness, Ivor and Gérard Bornet, eds. *George Boole: Selected Manuscripts on*

Logic and its Philosophy. Basel; Boston; Berlin: Birkhäuser, 1997 [Science Networks; vol. 20].

Green, Nicholas. *The Spectacle of Nature: Landscape and Bourgeois Culture in Nineteenth-Century France.* Manchester: Manchester University Press, 1990.

Greenwood, Thomas. *Museums and Art Galleries.* London: Simpkin, Marshall and Co., 1888.

Gretton, Tom. "Signs for Labour-Value in Printed Pictures After the Photomechanical Revolution: Mainstream Changes and Extreme Cases Around 1900." *Oxford Art Journal,* 28, no. 3 (2005): 371–90.

Groom, Gloria. "Calf's Head and Ox's Tongue." *Art Institute of Chicago Museum Studies,* 30, no. 1 (2004): 66.

Grunfeld, Frederic V. *Rodin: A Biography.* New York: Henry Holt and Co., 1987.

Guillemin, Amédée. *Simple explication des chemins de fer: Construction, mécanisme, matériel, exploitation.* Paris: Hachette, 1862.

Guizot, F. *The History of Civilization, From the Fall of the Roman Empire to the French Revolution.* Trans. William Hazlitt. London: David Bogue, 1849.

Haas, Robert Bartlett. "Eadweard Muybridge, 1830–1904." In *Eadweard Muybridge: The Stanford Years, 1872–1882,* 11–35. Ex. cat. Stanford: The Stanford Museum of Art, 1972.

Hahn, Hazel. "Boulevard Culture and Advertising as Spectacle in Nineteenth-Century Paris." In *The City and the Senses: Urban Culture Since 1500,* edited by Alexander Cowan and Jill Steward, 156–71. Aldershot: Ashgate, 2006.

———— "Fashion Discourses in Fashion Journals and Madame de Girardin's *Lettres parisiennes* in July-Monarchy France." *Fashion Theory: the Journal of Dress, Body and Culture,* 9, no. 2 (June 2005): 205–27.

Hahn, Roger. "Laplace and the Mechanistic Universe." In *God and Nature; Historical Essays on the Encounter between Christianity and Science,* edited by David C. Lindberg and Ronald L. Numbers, 256–76. Berkeley: University of California Press, 1986.

———— "Laplace's Religious Views." *Archive international d'histoire des sciences,* 8 (1955): 38–40.

Hall, Catherine. "Of Gender and Empire: Reflections on the Nineteenth Century." In *Gender and Empire,* edited by Philippa Levine. Oxford: Oxford University Press, 2004.

Hall, T.H. *The Spiritualists.* London: Duckworth, 1962.

Hamon, Philippe. *Expositions: Literature and Architecture in Nineteenth-Century France.* Trans. Katia Sainson-Frank and Lisa Maguire. Berkeley: University of California Press, 1992.

Hankins, Thomas L. and Robert J. Silverman. *Instruments and the Imagination.* Princeton: Princeton University Press, 1995.

Hannoosh, Michele. "The Allegorical Artist and the Crises of History: Benjamin, Grandville, Baudelaire." *Word & Image,* 10, no. 1 (January–March 1994): 38–54.

———— *Baudelaire and Caricature: From the Comic to an Art of Modernity.* University Park: Penn State Press, 1992, 158–72.

Harbou, Thea von. *Metropolis.* Trans. anonymous. Rockville: Sense of Wonder Press, 2001.

Harper's New Monthly Review, 30, no. 180 (May 1865): 699.

Harper's New Weekly Magazine, 36, no. 6 (May 1853), 833–5.

Harrison, Edward. *Cosmology: The Science of the Universe,* 2nd ed. Cambridge: Cambridge University Press, 2000.

Harrison, Michael."Art and Philanthropy: T.C. Horsfall and the Manchester Art Museum." In *City, Class, and Culture: Studies of Social Policy and Cultural Production*

in Victorian Manchester, edited by Alan J. Kidd and K.W. Roberts, 120–47. Manchester: Manchester University Press, 1985.

———. "Art and Social Regeneration: The Ancoats Art Museum." *Manchester Region History Review* VII (1993): 63–72.

———. "Social Reform in Late Victorian and Edwardian Manchester With Special Reference to T.C. Horsfall." PhD diss., University of Manchester, 1987.

Hartrick, A.S. *A Painter's Pilgrimage Through Fifty Years*. London: Cambridge University Press, 1939.

Haskell, Francis. *History and Its Images: Art and the Interpretation of the Past*. Yale: Yale University Press, 1993.

Hauptmann, Gerhart. *Lineman Thiel and Other Tales*. Trans. Stanley Radcliffe. London: Angel Books, 1989.

Heathcote, A.W. "William Whewell's Philosophy of Science." *British Journal for the Philosophy of Science*, 4 (1954): 302–14.

Hegel, Georg Wilhelm Friedrich. *Aesthetics: Lectures on Fine Art*. Trans. T.M. Knox. Oxford: Clarendon Press, 1975.

Hepworth, T.C. *The Camera and the Pen*. Bradford: Percy Lund, 1897.

Herbert, Robert and Eugenia. "Artists and Anarchism: Unpublished Letters of Pissarro, Signac, and Others—I." *Burlington Magazine*, 102, 692 (November 1960): 517–22.

Herbert, Robert L. *Impressionism: Art, Leisure and Parisian Society*. New Haven: Yale University Press, 1988.

Herbert, Sandra. *Charles Darwin, Geologist*. Ithaca: Cornell University Press, 2005.

Herf, Jeffrey. *Reactionary Modernism: Technology, Culture, and Politics in Weimar and the Third Republic*. Cambridge: Cambridge University Press, 1984.

Herschel, John. *A Treatise on Astronomy*. London: Longman, 1851.

Hewison, Robert Ian Warrell and Stephen Wildman. *Ruskin, Turner and the Pre-Raphaelites*. London: Tate Gallery Publishing, 2000.

Hilton, Timothy. *John Ruskin: The Early Years*. New Haven: Yale University Press, 2000.

———. *John Ruskin: The Later Years*. New Haven, CT: Yale University Press, 2000.

Hodson, James Shirley. *A Historical and Practical Guide to Art Illustration in Connection with Books, Periodicals and General Decoration*. London: Sampson Low, 1884.

Horsfall, T.C. *The Government of Manchester. A Paper Read to the Manchester Statistical Society, November 13th, 1895, With Additions*. Manchester: J.E. Cornish, 1895.

House, John: "Anarchist or Esthete? Pissarro in the City." *Art in America* (November 1993): 141–43.

———. "Camille Pissarro's Idea of Unity." In *Studies on Camille Pissarro*, edited by Christopher Lloyd, 15–34. New York: Rutledge & Kegan Paul, 1986.

Household Works, 18 (April 24, 1958), 433–6.

Houssaye, Arsène. "De la poésie, de la vapeur, et du paysage." *L'Artiste*, 3rd ser., 1 (1844): 98–101.

Howard, Maurice and Michael Snodin. *Ornament: A Social History*. New Haven: Yale University Press, 1996.

Hunt, John Dixon. *Gardens and the Picturesque*. Cambridge: MIT Press, 1992.

Hutcheon, Linda. *Narcissistic Fiction*. Waterlow: Wilfrid Laurier University Press, 1980.

Hutton, John G. *Neo-Impressionism and the Search for Solid Ground*. Baton Rouge: Louisian State University Press, 1994.

Huxley, T.H. "Letter to the Committee Dec. 12, 1869." In *Report on Spiritualism of the Committee of the London Dialectical Society Together with the Evidence, Oral and Written and a Selection from the Correspondence*. London: Longmans, Green, Reader and Dyer, 1871.

_____ "The Struggle for Existence in Human Society." *Nineteenth Century,* 23 (February 1888): 161–80.

Huysmans, J.K. *Against the Grain (A Rebours).* Trans. anonymous. New York: Dover, 1969.

Huyssen, Andreas. *After the Great Divide: Modernism, Mass Culture, Postmodernism.* Bloomington: Indiana University Press, 1986.

The Illustrated London News, 1, no. 33 (December 24, 1842): 524.

L'Illustration, 2, no. 39 (November 25, 1843): 207.

Irigaray, Luce. *Speculum of the Other Woman.* Trans. Gillian C. Gill. Ithaca: Cornel University Press: Ithaca, 1985.

Ives, Frederick E. *The Autobiography of an Amateur Inventor.* Philadelphia: Privately published. 1928.

Jaki, Stanley L. "The Five Forms of Laplace's Cosmogony." *American Journal of Physics,* 44 (1976): 4–11.

James, Frank A.J.L. "Of 'Medals and Muddles' The Context of the Discovery of Thallium: William Crookes' Early Spectro-Chemical Work." *Notes and Records of the Royal Society of London,* 39, 1 (1984): 65–90.

Janson, H.W. "Realism in Sculpture: Limits and Limitations." In *The European Realist Tradition,* edited by Gabriel P. Weisberg, 290–301. Bloomington: Indiana University Press, 1982.

Jefferson, Thomas. *Notes on the State of Virginia,* edited by William Peden. Chapel Hill: University of North Carolina Press, 1982.

Joanne, Adolphe. *Géographie du département de la Haute-Marne.* Paris: Hachette, 1881.

_____ *Guide de Paris à Saint-Germain, à Poissy et à Argenteuil,* Paris: Hachette, 1856.

Jones, Gareth Steadman. *Outcast London.* Oxford: Clarendon Press, 1971.

Jones, Owen. "Gleanings from the Great Exhibition of 1851." *Journal of Design and Manufactures,* 5 (June 1851): 89–93.

_____ *The Grammar of Ornament.* London: Day and Son, 1856.

_____ "On the Influence of Religion upon Art." In *Lectures on Architecture and the Decorative Arts.* London: Strangeways and Walden, 1863.

_____ *On the True and False in the Decorative Arts.* London: Strangeways and Walden, 1863.

Jussim, Estelle. *Visual Communication and the Graphic Arts: Photographic Technologies in the Nineteenth Century.* New York: Bowker, 1974.

Kaenel, Philippe."Autour de J.-J. Grandville: les conditions de production socio-professionnelles du livre illustré 'romantique'." *Romantisme: Revue du XIXème Siècle,* 43 (1984): 45–62.

_____ *Le Métier d'illustrateur 1830–1880: Rodolphe Töpffer, J.-J. Grandville, Gustave Doré.* Paris: Editions Messene, 1996.

Kahn, Gustave. "Les Mains chez Rodin." In *Auguste Rodin et son Oeuvre,* by Octave Mirbeau et al., 28–9. Paris: Editions de 'La Plume,' 1900.

Kasson, John F. *Civilizing the Machine: Technology and Republican Values in America, 1776–1900.* New York: Grossman, 1976.

Kelly, M.J. "The Boole Window in the Aula Maxima, University College Cork." In *George Boole: A Miscellany,* edited by Patrick D. Barry, 25–34. Cork: Cork University Press, 1969.

Kern, Stephen. *The Culture of Time and Space, 1880–1918.* Cambridge: Harvard University Press, 1983.

Killen, Andreas. *Berlin Electropolis: Shock, Nerves, and German Modernity.* Berkeley: University of California Press, 2006.

Kingsley, Charles. *His Letters and Memories of His Life, Edited by His Wife.* London: Henry S. King & Co., 1877.

Klein, John. "The Dispersal of the Modernist Series." *Oxford Art Journal,* 21, no. 1 (1998): 118–32.

Kitton, F.G. "The Art of Photo-Etching and Engraving." *The British Printer,* 7 (1894): 218–31.

Kohlstedt, Sally Gregory. "Parlors, Primers, and Public Schooling: Education for Science in Nineteenth-Century America." *Isis,* 81 (1990): 425–45.

Koven, Seth."The Whitechapel Picture Exhibitions and the Politics of Seeing." In *Museum Culture : Histories, Discourses, Spectacles,* edited by Daniel J. Sherman and Irit Rogoff, 22–48. Minneapolis : University of Minnesota Press, 1994.

Kracauer, Siegfried. *From Caligari to Hitler: A Psychological History of the German Film.* Princeton: Princeton University Press, 1947.

Kranakis, Eda. *Constructing a Bridge: An Exploration of Engineering Culture, Design and Research in Nineteenth-Century France and America.* Cambridge, MA: MIT Press, 1997.

Krauss, Rosalind E. "The Originality of the Avant-Garde." In *The Originality of the Avant-Garde and Other Modernist Myths,* 151–70. Cambridge, MA: MIT Press, 1985.

Kuhn, Thomas S. "Energy Conservation as an Example of Simultaneous Discovery." In *Essential Tensions: Selected Studies in Scientific Tradition and Change,* 66–104. Chicago: University of Chicago Press, 1977.

Kulper, Amy Catania. "Of Stylized Species and Specious Styles." *The Journal of Architecture,* 11, no. 4 (September 2006): 391–406.

Kundera, Milan. *Immortality.* Trans. Peter Kussi. New York: Grove Weidenfeld, 1990.

Kunzle, David. "The Corset as Erotic Alchemy: From Rococo Galanterie to Montaut's Physiologies." *Art News Annual,* 28 (1972): 115–16.

LaCapra, Dominick. *History in Transit: Experience, Identity, Critical Theory.* Ithaca and London: Cornell University Press, 2004), 22–34.

Ladd, Henry Andrews. *The Victorian Morality of Art: An Analysis of Ruskin's Esthetic.* New York: Octagon Books, 1968.

La Fontaine, Jean de.*Contes de la Fontaine, avec illustrations de Fragonard* (reprint of Didot edition of Year III–1795). Paris: J. Lemonnyer, 1883.

———— "Le Villageois qui cherche son veau" [c. 1690]. In idem, *Contes et nouvelles en vers, ornés d'estampes d'Honoré Fragonard, Monnet, Touzé, et Milius,* edited by Anatole de Montaiglon. 2 vols. Paris: P. Rouquette, 1883.

———— *Tales and Fables of La Fontaine.* Paris: J. Lemmonyer, 1884.

Lagneau, Gérard. *Les Institutions publicitaires, fonction et genèse: Thèse pour le Doctorat d'etat ès Lettres et Sciences Humaines.* Académie de Paris. Université René Descartes. Sciences Humaines, 1982.

Laird, Pamela Walker. *Advertising Progress: American Business and the Rise of Consumer Marketing.* Baltimore: Johns Hopkins University Press, 1998.

Lajoux, Jean-Dominique. "Marey, Muybridge et les femmes." In *Marey/Muybridge: pionniers du cinéma. Rencontre Beaune/Stanford,* 90–105. Beaune: Palais des Congrès, 1995.

Laita, Luis M. "Boolean Logic and Its Extra Logical Sources: The testimony of Mary Everest Boole. In *History and Philosophy of Logic,* vol. 1, edited by I. Grattan-Guiness, 37–60. Tunbridge Wells: Abacus Press, 1980.

Lampert, Catherine, et al. *Rodin.* Ex. cat. London: Royal Academy of Arts, 2006.

Landes, David S. *The Unbound Prometheus: Technological Change and Industrial Development in Western Europe from 1750 to the Present.* Cambridge; Cambridge University Press, 1969.

Landow, George P. "Ruskin's Version of 'Ut Pictura Poesis'." *The Journal of Aesthetics and Art Criticism,* 26, no. 4 (1968): 521–8.